THE
FEMALE BODY
IN
WESTERN CULTURE

THE

FEMALE BODY

IN

WESTERN CULTURE

contemporary perspectives

EDITED BY

SUSAN RUBIN SULEIMAN

HARVARD UNIVERSITY PRESS
CAMBRIDGE, MASSACHUSETTS
LONDON, ENGLAND

All but the Introduction and three of the essays in this book (those by Carol Armstrong, Mary Ann Caws, and Margaret Miles) first appeared in Volume 6, Numbers 1–2 (1985) of *Poetics Today,* published for the Porter Institute for Poetics and Semiotics, Tel Aviv University, by Israel Science Publishers, Jerusalem.

This book is printed on acid-free paper, and its binding materials have been chosen for strength and durability.

Library of Congress Cataloging-in-Publication Data
Main entry under title:

The Female body in western culture.

 Includes bibliographies.
 1. Women in art—Addresses, essays, lectures. 2. Nude
in art—Addresses, essays, lectures. 3. Erotica—
Addresses, essays, lectures. 4. Women—Miscellanea—
Addresses, essays, lectures. 5. Arts, Modern—20th
century—Addresses, essays, lectures. 6. Civilization,
Occidental—Addresses, essays, lectures. I. Suleiman,
Susan.
NX652.W6F46 1986 305.4 85-27255
ISBN 0-674-29871-3

ACKNOWLEDGMENTS

The majority of these essays first appeared in a special issue of *Poetics Today* (volume 6, nos. 1-2, 1985). I wish to thank the editor of *Poetics Today*, Benjamin Hrushovski, for his enthusiastic support of the project from the start, and Brian McHale and Sharon Himmelfarb for seeing it through the various stages of journal publication. To Margaretta Fulton of Harvard University Press, my warm thanks for helping me transform the special issue into a book.

I am grateful to the Rockefeller Foundation, whose Humanities Fellowship in 1984 greatly facilitated the writing of my own essay as well as my editorial work.

My research assistant, David McCarthy, provided invaluable help, both with the research for my own essay and with the editing of the others. I am grateful, as always, to Susan Fuerst for her good cheer and expert typing, and to Anne Gilbert for her calm efficiency.

S.R.S.
Cambridge, Massachusetts
July 1985

CONTENTS

Introduction 1

EROS

(Re)Writing the Body: The Politics and Poetics of Female Eroticism 7
SUSAN RUBIN SULEIMAN

The Somagrams of Gertrude Stein 30
CATHARINE R. STIMPSON

In Praise of the Ear (Gloss's Glosses) 44
THOMAS G. PAVEL

DEATH

Dangling Virgins: Myth, Ritual, and the Place of Women
in Ancient Greece 57
EVA CANTARELLA

Speaking Silences: Women's Suicide 68
MARGARET HIGONNET

Death Sentences: Writing Couples and Ideology 84
ALICE JARDINE

MOTHERS

Stabat Mater 99
JULIA KRISTEVA

The Matrix of War: Mothers and Heroes 119
NANCY HUSTON

ILLNESS

The Rest Cure: Repetition or Resolution of Victorian Women's Conflicts? 139
ELLEN L. BASSUK

The Clinical Eye: Medical Discourses in the "Woman's Film" of the 1940s 152
MARY ANN DOANE

Interpreting Anorexia Nervosa 175
NOELLE CASKEY

IMAGES

The Virgin's One Bare Breast: Female Nudity and Religious Meaning in Tuscan Early Renaissance Culture 193
MARGARET R. MILES

"This Heraldry in Lucrece' Face" 209
NANCY J. VICKERS

Edgar Degas and the Representation of the Female Body 223
CAROL M. ARMSTRONG

Sexuality at a Loss: The Films of F. W. Murnau 243
JANET BERGSTROM

Ladies Shot and Painted: Female Embodiment in Surrealist Art 262
MARY ANN CAWS

Jean Rhys: Poses of a Woman as Guest 288
ALICIA BORINSKY

DIFFERENCE

Woman as a Semiotic Object 305
CHRISTINE BROOKE-ROSE

Sexuality, Sin, and Sorrow: The Emergence of Female Character (A Reading of Genesis 1–3) 317
MIEKE BAL

The Politics of Women's Bodies: Reflections on Plato 339
MONIQUE CANTO

Rereading as a Woman: The Body in Practice 354
 NANCY K. MILLER

Female Fetishism: The Case of George Sand 363
 NAOMI SCHOR

Huysmans: Writing Against (Female) Nature 373
 CHARLES BERNHEIMER

Notes on Contributors 387

Illustration Credits 390

INTRODUCTION

SUSAN RUBIN SULEIMAN

That the female body has occupied a central place in the Western cultural imagination hardly comes as news. In the visual arts—from the prehistoric Venus of Willendorf to the countless representations of nymphs, goddesses, odalisques, and the Virgin Mother, right down to the images that grace our billboards and magazine covers — as in poetry, mythology, religious doctrine, medical and psychoanalytic treatises, and prose narratives of all kinds, we find ample testimony to the fascination that the female body has exerted on our individual and collective consciousness. And simultaneously with its attraction, we find testimony to the fear and loathing that that body has inspired: beautiful but unclean, alluring but dangerous, woman's body (can we say that it is always, in some sense, the mother's body?) has appeared mysterious, duplicitous — a source of pleasure and nurturance, but also of destruction and evil. Mary and Pandora, in sum.

It was while reflecting along these lines — my reflection being inspired by the extraordinary growth of feminist theory and criticism over the past decade, on the Continent as in the United States — that I was first prompted to undertake this collection of essays. As the title of the book makes clear, modesty was a virtue I decided to dispense with, at least as a start. If one were going to deal with this subject at all, clearly one had to be bold, aiming for the widest possible vision — in the range of disciplines and approaches, as in the variety and time span of the topics treated. I therefore formulated my starting questions in the broadest, most ambitious terms: What "place(s)" has the female body occupied in the Western imagination, and in the symbolic productions of Western culture, over the past two thousand years? What shifts, slippages, or displacements of that body have occurred or might occur in our own time, and what would be the cultural consequences of such displacements?

If the female body has always been with us (together with the male), in what might appear as a kind of timeless continuity, it is clear that the questions we ask about it and the places we accord it in our own discourse can only be contemporary: bound to the present, determined by our own specific historical situation. In that sense the subtitle of this book, "Contemporary Perspectives," is redundant: what other perspectives

could we claim to have, if not those of our own time and place? And yet the subtitle has an informative, nonredundant function as well, for it emphasizes a necessary awareness of the specificity (and the limits?) of the views presented here, even as it suggests a quasi-programmatic, quasi-polemical statement about what it means to speak in a contemporary way about this apparently eternal subject.

To be aware of the specificity or the limits of one's views is to realize that unchanging truths, even about something as concrete, as biologically "fixed" as the human body, are impossible to arrive at. The cultural significance of the female body is not only (not even first and foremost) that of a flesh-and-blood entity, but that of a *symbolic construct.* Everything we know about the body — certainly as regards the past, and even, it could be argued, as regards the present — exists for us in some form of discourse; and discourse, whether verbal or visual, fictive or historical or speculative, is never unmediated, never free of interpretation, never innocent. This is as true of our own discourse as of those we might seek to analyze or criticize.

Such a salutary self-consciousness does not mean, however, that choice is impossible, that all discourses must be considered equal in value and relevance. On the contrary, an awareness of our own time-bound specificity can empower us to declare our positions, our questions, our choices, for what they are: important to us, here, today. Chosen, not given. It is not an accident, for example, that this volume of contemporary perspectives on the female body has not made room for the discourse or the images of the pornography industry, which is all too contemporary and too much with us. Nor is it an accident that all of the essays included here, despite their divergences in style, discipline, and point of view, can be qualified in one way or another as feminist. That is the programmatic or polemical aspect of the enterprise, suggesting that not everything we see and hear today deserves to be called contemporary; that it is not enough to be *of* our time in order to be *with* our time (contemporary, from the Latin *com,* together, with, and *tempus,* time).

So much for what might be called the underlying premises, or the beginning intentions, of this volume. To what degree the realized work matches the ambitions of its conception I cannot say, being too close to it for dispassionate judgment. I am extremely pleased, as editor, by the shape the volume has taken over the two and a half years of its growth. About the shape, I shall say a few words.

The thematic subheadings under which the essays are grouped were not decided in advance; they suggested themselves to me only after I had read all of the essays several times. Once they did suggest themselves, however, they acquired a kind of self-evident necessity: yes, these were obviously the right words from which to start thinking about the female body in our culture. I especially liked the way they made possible the juxtaposition of essays whose relatedness was not immediately evident, while separating others that might have appeared to belong together.

Thus Eva Cantarella's essay on female death in Greek civic rituals and society is separated from Monique Canto's reflections on Plato's theories about women in the city; but it is united with Margaret Higonnet's exploration of female suicide and with Alice Jardine's thoughts about Beauvoir's problematic farewells to those who mattered most to her: Sartre and her mother. Monique Canto's essay, in turn, receives a particular lighting by being juxtaposed with the questions about sexual difference — questions that are themselves significantly varied — raised by Christine Brooke-Rose, Mieke Bal, Nancy Miller, Naomi Schor, and Charles Bernheimer.

In a similar way, Margaret Miles's essay on the multiple religious and secular meanings of the "Virgin with one bare breast," which apparently belongs next to Julia Kristeva's reflections on the Virgin Mother and Nancy Huston's essay on mothers, becomes even more interesting when juxtaposed with other essays that deal with images; and these latter essays are themselves united and divided by the *kind* of images they focus on: rhetorical (Nancy Vickers), cinematic (Janet Bergstrom), pictorial (Carol Armstrong and Mary Ann Caws), or metaphorical, as in the pose (Alicia Borinsky).

Under the sign of Eros, one finds an unexpected yet resonant conjunction between Thomas Pavel's playful "praise of the ear" and Catharine Stimpson's deft descriptions of "Lifting Belly" and other Steinian "somagrams," while my essay seeks to explore some of the possible connections between female sexuality, feminist politics, and a "feminine" poetics. Under Illness, Ellen Bassuk's essay resonates uncannily with Mary Ann Doane's, Bassuk portraying a real-life situation and Doane analyzing the same situation as represented in a film genre; Noelle Caskey brings yet another perspective on female illness by attempting to understand the dynamics of that quintessentially feminine disease in modern culture, anorexia nervosa.

Over and above the order and shape produced by the grouping of the essays, what must be emphasized is the significant convergence of all the essays around a limited number of problems and questions, and in some cases around a tentative vision, or wish, for the future. This convergence is all the more remarkable given that there was no preliminary consultation among the contributors, and especially given the wide range of approaches, topics, and disciplines represented.

On second thought, the convergence may not be all that surprising, even while remaining significant. What, after all, are the problems that come up again and again, seen each time from a different angle? Having power versus lacking it, speaking versus keeping silent, acting versus supporting action, existing for oneself, as subject, versus existing for the other, as object. These are familiar oppositions, and in a sense they are all subsumed by a single other one: male versus female. Julia Kristeva shows us how the discourse of the Church Fathers "created" the Virgin Mother, and counterpoints this showing with her own discourse as a non-

virginal mother who is also a daughter. Nancy Huston shows how the counterterm — but also, in a paradoxical way, the homologue — of "hero" in our mythologies is "mother." Nancy Vickers shows us Shakespeare's Lucrece as the prize in a rhetorical contest by male speakers; Christine Brooke-Rose shows us women schematized and "reduced" in the models of male semioticians; Mieke Bal shows female character defined and categorized by male readers of our "first story," Genesis; Nancy Miller shows us women as they are read, and more importantly written (on or about) by the male pen; Mary Ann Caws and Carol Armstrong show the female model, as well as the female viewer, caught by the brush or the camera of male artists. And so on.

All of this is sobering, as a view of our past and of our present. And whither the future? It would be a gross injustice (as well as an impossible task) to try to reduce such a rich variety of essays to a single answer; yet it seems to me that insofar as any answer is suggested, it lies somewhere in the direction of blurred gender boundaries, that is, in a critique of traditional, absolute male/female oppositions — and this includes the oppositions I myself have emphasized in the preceding paragraphs. For as many of these essays show, even in the past, traditional oppositions have been subverted in unexpected ways and unexpected places: in some of Degas's paintings of women, for example (despite his well-known misogyny), in Murnau's images of "feminized" men, in George Sand's "fetishism" (supposedly a "male" perversion), in Jane Austen's "domestic" novels.

Androgyny in a new key? Why not? Or better still, androgynandry, gynandrogyny. The possibility of such multiple blurrings (which are not an attempt to deny difference, as Charles Bernheimer shows Huysmans doing, but rather an attempt to redraw and mix up the lines of differences in new, energizing ways) is the "dream" my own essay ends with; but I see it as well, suggested if not always explicitly stated, in the essays by Armstrong, Bal, Bergstrom, Caws, Kristeva, Miller, Schor, Stimpson. It is, I think, a dream worth pursuing.

EROS

(RE)WRITING THE BODY:
THE POLITICS AND POETICS
OF FEMALE EROTICISM

SUSAN RUBIN SULEIMAN

> I had a feeling that Pandora's box contained the mysteries of
> woman's sensuality, so different from man's and for which man's
> language was inadequate. The language of sex had yet to be in-
> vented. Anais Nin (1969:100)

As the general outcry — both for and against — that followed the
publication of Kate Millett's *Sexual Politics* in 1969 made clear, the
question of women's bodies and women's sexuality is a highly loaded
one. It has implications both for politics — that is, for the relations
of power and control that govern a society — and for literature,
or the production of verbal constructs that in some ways reflect
and in some ways help to create those relations. The program
implicit in Millett's analyses, which were soon to be followed by
others, and which coincided with the rise of the women's movement
as an international phenomenon, seemed as clear as it was urgent.
Women, who for centuries had been the *objects* of male theorizing,
male desires, male fears and male representations, had to discover
and reappropriate themselves as *subjects*; the obvious place to begin
was the silent place to which they had been assigned again and again,
that dark continent which had ever provoked assault and puzzlement
("Was will das Weib?"). The call went out to invent both a new
poetics and a new politics, based on women's reclaiming what
had always been theirs but had been usurped from them: control
over their bodies and a voice with which to speak about it.

Over the past decade and a half, we have seen this program, if
not fully realized, at least fully embarked on. There have occurred
real, measurable changes in women's lives — for example, the
laws liberalizing abortion in the United States and in France —
as a result of it. At the same time, the program itself, both in its
theoretical formulations and in the kind of imaginative writing
that can be thought to correspond to it, has evolved over the years.
What seemed, at first, an unproblematic desideratum — let woman
speak her own body, assume her own subjecthood — has become
problematized, complicated by increasingly difficult questions:

what exactly do we mean when we speak of woman as subject, whether of speech or writing or of her own body? Is there such a thing as *a* — (or *the*) — subject? Is there such a thing as woman's body, woman's sexuality? Is there such a thing as woman, or, for that matter, man? These questions — which become inevitable the moment one begins seriously to think about the body or about sexuality, whether male or female — did not originate in the contemporary women's movement or in contemporary feminist thought; but the latter has evolved to encompass them and has infused them with a new urgency, whether in the form of analytical discourse or imaginative elaboration.

In what follows I should like to support and illustrate this statement by discussing what I see as three examplary gestures of reappropriation in the works of some American, French and English women writers. I call these gestures exemplary, not in order to suggest that they ought to function as models to follow, but because they represent three different possibilities for — and constitute so many actual manifestations of — the contemporary attempt, by women, to rewrite and rethink the female body and female sexuality.

EQUAL RIGHTS, OR TELLING IT WITH FOUR-LETTER WORDS

The two novels, both American, that I shall focus on first were published in the same year, 1973. Erica Jong's *Fear of Flying* became a national best-seller, with several million copies sold in hardback and paperback editions; Rita Mae Brown's *Rubyfruit Jungle*, first published by a small feminist press in New York, sold an astonishing 70,000 copies in that edition before being bought and distributed by Bantam Books, after which it sold a great many more. Both of these works are exceptionally good first novels, by poets who have a real flair for language. I happen to think that neither Jong nor Brown has written anything as good since, although they have each published other novels, but that is another matter, for what interests me is not their work in general but these particular books.

Why these two? Because they correspond, although in somewhat different ways, to what might be called the first wave of the American women's movement. They can be thought of as fictional counterparts to books like The Boston Women's Collective's *Our Bodies Our Selves*, also first published in 1973, or Shere Hite's *Sexual Honesty, By Women for Women*, published in 1974 and later expanded into the *Hite Report on Female Sexuality*. The impulse behind these works was perhaps most succinctly summed up in one of the editorial statements of the *Hite Report*: "researchers must stop telling women what they *should* feel sexually, and start asking them what they *do* feel sexually" (Hite 1981:60). *Fear of Flying* and *Rubyfruit Jungle* are fictional manifestations of the same impulse. Both are obviously autobiographical, narrated in the first person

by heroines who are struggling to define themselves sexually and artistically, and who are aware of the tangle of contradictions implied by that combination where women are concerned. Both novels have an undeniable freshness and vitality in the use of language; I think that this is due partly to their lack of inhibition in using "unladylike" four-letter words, and partly to their ironic awareness of their own unconventionality. The uninhibited, humorously flaunting use of obscenities in a novel signed by a woman and published by a major press (*Fear of Flying* was published by Holt, Rinehart and Winston) in the year 1973, constituted in itself a significant gesture, both in terms of sexual politics and in terms of what I am calling sexual poetics.

The story told in *Fear of Flying* is well-known, so I do not need to repeat it. What I wish to argue is that Jong's use of obscene language — which was generally recognized as a "first" in American fiction by a woman — was a self-conscious reversal of stereotypes, and in some sense a parody of the language of the tough-guy narrator/heroes of Henry Miller or Norman Mailer. I did a quick count of the number of times the word "fuck" or its variant appears in the first chapter of the novel; in the space of fourteen pages it appears fourteen times, including once in the title of the chapter (the famous "zipless fuck"). That kind of accumulation must, I contend, be interpreted as parodistic. What is involved here is a reversal of roles *and* of language, in which the docile and/or bestial but always silent, objectified woman of male pornographic fiction suddenly usurps both the pornographer's language and his way of looking at the opposite sex. In one of the passages analyzed by Kate Millett, the narrator/hero of Miller's *Sexus* says about a woman: "She had a small juicy cunt, which fitted me like a glove" (Millett 1971:3–8). Jong's narrator/heroine, Isadora, says about her husband: "I fell in love with Bennett partly because he had the cleanest balls I had ever tasted" (Jong 1971:30).

Among the negative reviewers of *Fear of Flying*, some of the most harshly critical were women: "Complaints, complaints, all in the same vacuous language. . . Endless discontent," wrote Patricia Meyer Spacks about the heroine (1974:284). And Millicent Dillon, writing in *The Nation* about what she called the "new bawd" (as opposed to the old bawds we find in Chaucer or Cervantes), spoke disapprovingly of the attempt to fuse "vulgarity with self-discovery and self-conscious art" (1975:220). What I find surprising is that no one noticed — or at any rate, no one gave its due to — the self-irony that accompanied the complaints and the vulgarity; nor did anyone give proper weight to the allusions that occasionally surfaced in the text, undercutting both the heroine and her male predecessors. At the end, for example, when Isadora looks at her body soaking in the bathtub, what does she see? "The pink V of my thighs, the

triangle of curly hair, the Tampax string fishing the water like a Hemingway hero. . ." (p. 310). This is neither self-pitying, nor vacuous, nor vulgar; it is self-ironic, and a wonderfully irreverent reflection on the *machismo* of "Papa."

Am I suggesting that *Fear of Flying* is a great novel, with no lapses in taste or style, no unevenness in language or tone or vision? No, I am not. I am not even suggesting that it is a great *feminist* novel, despite the repeated, often quite moving reflections of the heroine on the difficulties of being both a sexual woman and an artist — or even merely a daughter — in our world. It is, however — or was in 1973 — a significant book, both stylistically and in terms of feminist politics. For the latter, its significance lies not so much in the occasional didactic commentaries (some of which are, as I say, quite moving, but others, especially today, sound merely like clichés), but rather in the usurpation of four-letter words to talk about a woman's sexual desires and fantasies. A phrase like "how to make peace between the raging hunger in my cunt and the hunger in my head" (p. 154) is shocking, not only because it implies that a woman feels hunger in both places (indeed, that she possesses both places), but perhaps above all because of the coupling of the first person possessive pronoun with the obscene noun, a combination that did not exist in serious fiction in English before Jong's book.

At this point, it becomes interesting to take another look at the "flying" of its title: by a felicitous coincidence, Isadora Wing (whose name is already a program) is preoccupied with precisely the activity that some French feminists have proclaimed as the emblem of women's writing: flying, *voler*, which in French also means to steal. Claudine Herrmann, in a well-known book (1976), calls women writers *Les voleuses de langue* — the thieves of language, or more exactly, the usurpers and subverters of a certain kind of "male" language. An anonymous reviewer writing in the *London Observer* noted that in *Fear of Flying*, "Most of the narrative tricks are filched from the men, to be brandished in their faces and elsewhere, with undisguised relish" (1976:29). That filching is, I think, what makes this book significant.

Rubyfruit Jungle is a somewhat different case. Whereas the "message" (to put it heavy-handedly) of a book like *Fear of Flying* might be stated as "women too are entitled to speak of their fantasies obscenely, and to view men as sexual objects," the "message" of *Rubyfruit Jungle* is that women have a right to speak of, and to recount in detail their enactments of, their sexual desire for other women. The narrator/heroine of *Rubyfruit Jungle* is unabashedly, enthusiastically, a lover of women. She has had sex with men too, but they simply don't compare — as she puts it, the difference is like the "difference between a pair of roller skates and a Ferrari" (p. 199). Here again, we have to see the tradition against

which this kind of statement — which is of course funny but also serious — is being made. One finds plenty of lesbian sex scenes in male pornography; in fact, sex between women is a stock element in pornography from Sade on. But as a number of commentators, including most recently Nancy Huston in her book, *Mosaïque de la pornographie*, have pointed out, lesbian scenes in Sade and elsewhere are always subordinated to a male gaze and above all to male desire. "To the enigmatic question 'What do women do together?' the pornographers give the answer that is most reassuring to them: 'the same thing.' To imagine a genuinely other kind of relation would be too threatening" (Huston 1982:87, my translation. See also Scholes 1982). In other words, what is absent from the lesbian scenes of pornographers, and Huston rightly insists that pornography, even when not written by men, has always traditionally been written for a male public, is the reality of women's desire for other women. It is against this background that *Rubyfruit Jungle*, with its celebration of lesbian desire and lesbian pleasure, becomes fully significant.[1]

One must be careful not to overstate the case, however, either for *Rubyfruit Jungle* or for *Fear of Flying*. If the popularity of these books is, on the one hand, a positive sign, suggesting that the American public is ready to admit some real changes in what is considered an acceptable story or an acceptable use of language by women, it may also be a sign that neither book is felt to imply a genuine threat to existing ways of seeing and being between the sexes. Like modern capitalism, modern patriarchy has a way of assimilating any number of potentially subversive gestures into the "mainstream," where whatever subversive energy they may have possessed becomes neutralized. The two blurbs on the front and back covers of the paperback edition of *Rubyfruit Jungle* are, in this sense, extremely revealing. On the front, above the title, one reads: "A novel about being different and loving it." By the time we turn to the back, however, what we see is: "Being different isn't really so different." And indeed, the adventures of Molly Bolt, who rises from "a dirt-poor ole Southern girl" to become a New York film-maker fits into the schema of any number of American picaresque

1. For an excellent discussion of the lesbian novel in English, see Stimpson (1981). She discusses two major patterns in lesbian fiction: "the narrative of damnation" or guilty lesbianism, whose prototype is Radclyffe Hall's *The Well of Loneliness*; and the narrative of "the lesbian's rebellion against social stigma and self-contempt," a more recent trend of which *Rubyfruit Jungle* may be considered an example. I find it interesting, however, that Brown's heroine never has to "rebel" against self-contempt, for she is self-assured and non-guilt-ridden from the beginning. This is in marked contrast to the more predictable "guilt-self-acceptance" pattern of another recent lesbian novel, *Who Was That Masked Woman?* (Koertge 1981).

tales, just as the adventures of Isadora Wing fit into the familiar pattern of the *Bildungsroman* with an artist-hero, where the moment of self-discovery coincides with the decision to write a novel.

This suggests that what may be needed is not merely the usurpation of old narrative structures and old words by new speakers, however important these may be as a first step, but the inventing of new structures, new words, a new syntax that will shake up and *transform* old habits of thought and old ways of seeing.

CELEBRATING DIFFERENCE, OR
WRITING (AND READING) OTHERWISE

As my reader has probably guessed, the writers I shall discuss under this heading are known in the United States — and no doubt elsewhere — by the general, somewhat misleading label of "New French Feminists" (see Marks and Courtivron 1980). I shall concentrate on the work of three writers who, in the context of *French* women's writing and theorizing and politics, are poles apart, and who would no doubt reject any attempt to talk of them together. This apparent incompatibility does not disturb me; however, what I find more disturbing is dealing with an extremely complex topic — a topic, furthermore, which is constantly shifting, since the writers in question continue to produce and to modify their ideas — in the space of a few pages. I shall attempt the task nevertheless, keeping in mind the specific context of this essay and allowing in advance for an inevitable "time lag" between the works I discuss and those that are still being written.

How has the injunction: "Reclaim your body!" functioned in the context of recent French feminist writing and theory? To answer that question one must begin with the work of Luce Irigaray, who in her book, *Speculum de l'autre femme* (1974), was the first to present a massive, closely reasoned critique of the Freudian theory of feminine sexuality, not only as it was formulated by Freud, but also as it was developed and reformulated by the "French Freud," Lacan. At the risk of a tremendous generalization, one can say that all of Irigaray's critique, both as presented in *Speculum* and in a subsequent book, *Ce Sexe qui n'en est pas un* (1977), is directed against the cornerstone of Freudian and Lacanian theory: the primacy of the phallus. It is the erection — if one may put it that way — of the phallus to the status of transcendental signifier that enabled Lacan to theorize the exclusion of women from the symbolic, that is, from the Law of the father and from language. Furthermore, Irigaray argues, it is the phallus — or rather its physical counterpart, the penis — posited as the single standard for the measure of sexual pleasure that has rendered Freudian-Lacanian theory incapable of recognizing, much less accounting for, the real existence and the specific nature of feminine sexuality and feminine

pleasure. The insistence on the uniqueness, and the unicity, of the erect phallus has rendered impossible the realization that woman's sexuality is not one but multiple, not based on the gaze that object-ifies but on the touch that unites, not on the stiffness of strictly localized, free-standing forms but on the melting together of diffuse, multiple, functionally nondifferentiated elements: "Woman's sex is all over [her body] . . . the geography of her pleasure is much more diversified, multiple in its differences, complex, subtle, than is imagined . . . within an imaginary that is too strictly centered on one and the same" (Irigaray 1977:28).[2]

How is this view of the female body and its pleasure linked to language and writing? Putting it slightly differently, how can the recognition of a hitherto repressed female eroticism embody itself in texts that might be called "feminine?" Irigaray's claim is that the recognition of the specificity of female eroticism necessarily implies a recognition of the specificity of women's relation to language. In opposition to the logic of "phallic" discourse — characterized by linearity, self-possession, the affirmation of mastery, authority, and above all of unity — feminine discourse must struggle to speak otherwise. "Si nous continuons à nous parler le même langage, nous allons reproduire la même histoire" ("If we continue to speak the same language, to each other and to ourselves ['nous parler' has both meanings], then we shall reproduce the same story and the same history"); so begins the concluding text of *Ce Sexe qui n'en est pas un*, "Quand nos lèvres se parlent" ("When Our Lips Speak Together"), in which Irigaray attempts, not so much to theorize about, but actually to *write* a "feminine" text. I will not analyze this text in detail (it has been commented on by Burke 1980 and by Gallop 1983), but simply point out those elements in it that appear most significant in the context of the present discussion.

First, it is a text that celebrates love between women. What is most specific about such a love? The fact that the lovers are not "enigmas" for each other — do not represent "the other" for each other, which is always the case between a man and a woman — but are, rather, in a relation of absolute reciprocity in which the notions of "giving" and "receiving" have no place. "When you say I love you — here, close to yourself, close to me — you are saying I love me. You don't 'give' me anything in touching yourself, in touching me: touching yourself again through me" (1977:206). In the perfect reciprocity of this relation, there is no place for an economy of exchange, or of opposition between contraries. The lovers are neither two nor one, neither different nor the same, but un-different (*indifférentes*).

2. All translations from the French are my own. Irigaray's *Speculum* and *Ce Sexe*. . .have recently been published in English: *Speculum of the Other Woman*, trans. Gillian C. Gill, and *This Sex Which Is Not One*, trans. Catherine Porter (Ithaca: Cornell University Press, 1985).

Second, this text celebrates a state of being, and a form of communication, in which binary oppositions become nonpertinent. Now if we recall that all of our traditional linguistic and logical categories are based on binary opposition, then the "scandalousness" of Irigaray's attempt becomes immediately evident. Not only the scandalousness, but also, in a sense, the impossibility: Irigaray's text is haunted by the question, "How to speak without using the 'old' male language?" This question punctuates her text with a kind of obsessive regularity: "But how to say otherwise, I love you?" "How to say it?" "How to speak in order to get out of their partitions, checkerings, distinctions, oppositions. . . How to disenchain ourselves, alive, from their conceptions?" (pp. 207, 211). At one point, she raises the possibility that perhaps there is no point in trying to say it at all; since the two bodies feel the same things at the same time, there is no need to speak. But she immediately rejects that idea: "If we do not invent a language, if we do not find *its* language, our body will have too few gestures to accompany its (hi)story" (p. 213). For women to be silent is not the solution: "Don't cry. One day we will succeed in saying ourselves. And what we shall say will be even more beautiful than our tears. All fluid" (p. 215).

To invent a language in which to speak about woman's pleasure and woman's love for woman — indeed, a language that will be addressed exclusively *to* women — this is, I think, the utopian ideal that Irigaray's text seeks both to project and in some approximate way to exemplify.

A number of feminist theorists, in England and in France, have criticized what they see as the essentialism of Irigaray's position, which seems to base everything on the female body without asking to what extent the body — whether male or female — is a cultural construct, not a "natural" given. Some of these attacks are, as Carolyn Burke has pointed out (1981:302–303), themselves quite reductive, and do not take sufficient account of the complexity — nor, one might say, of the metaphorical quality[3] — of Irigaray's discourse. And yet, it seems increasingly clear that the ideal of a "woman-language" modeled on, even if not actually produced by, the female body — a language that women alone can speak, for other women "together" and whose privileged subject, in every sense of the term, is woman — is unsatisfactory. For although Irigaray's ire — and irony — are rightfully directed at the male logic of exclusion, which cannot take account of the real existence of "the other" and which divides the world into simple binary categories, the logic

3. Jane Gallop (1983) has emphasized the potentially revolutionary, or at least revisionary, role of metaphor, especially the metaphor of the lips, in Irigaray's conception of both "female writing" and female sexuality.

of her own discourse leads to a similar exclusion in reverse. The structure of the pronouns in "Quand nos lèvres se parlent" is revealing: *je, tu, nous*, eux — I, you, we, *them. They* are outside us, *they* are what we are not, *they* are the enemy. Even if we assume that "they" refers not to all or only men but to a particular and particularly pernicious mode of discourse or of thought, I am bothered by the absolute nature of the opposition.

In fact, Irigaray's more recent works suggest that she herself did not consider the exclusionary logic of "Quand nos lèvres se parlent" as her permanent ideal. In *Amante marine* (1980), a set of essays "about" Nietzsche, the first long essay consists of meditative fragments addressed directly to the male philosopher. Although the tone is accusatory, the fact that the female speaker chooses this form of direct address, using the familiar "tu," suggests a recognition of the other as a possible interlocutor. This possibility is even more emphasized in *Passions élémentaires* (1982), which is a set of fragments addressed to a male lover. The lover is accused of a certain blindness, and of the traditional male attempt to imprison the beloved woman in his rigid conception of her. At the same time, it is — albeit tentatively — suggested at the end that a real dialogue and a genuine encounter between the lover and the female speaker might be possible, one in which each would retain his/her difference even while uniting with the other. Furthermore, it is interesting that Irigaray's poetic *language* — may we call it "feminine?" — does not change in moving from the celebration of love between women to the — tentative — celebration of a — possible — love between a man and a woman. Perhaps Jane Gallop is right in claiming that the emphasis on a "female homosexual economy, a female narcissistic ego," is for Irigaray but the first step, necessary in order to find both an adequate representation of herself and an adequate language, but not something that can or should be raised to the status of an ideology (Gallop 1982:74).[4]

Besides Irigaray who is primarily a theorist, two other French women writers have emerged as exemplary in their attempt to forge a new language to speak about the female body, and to fuse this language with a radical, female-centered politics: Hélène Cixous and Monique Wittig. It has become almost a critical commonplace to *oppose* Cixous's and Wittig's writing practices as well as their conceptions of female sexuality (see, for example, Wenzel 1981 and Crowder 1983). Indeed, they have been associated with two

4. In her latest book at the time of this writing, Irigaray reaffirms the necessity of women's actively creating a "world for women" [*monde pour elles*], in opposition to the existence "for the other" which has been women's traditional place and role. Such an affirmation of self love, or love for "the same," essentially, a woman's love for her mother, is the necessary precondition for any love for the other, or love between women and men (Irigaray 1984:106).

ideologically opposed groups in France: Cixous, until recently, was linked to the Psych et Po group and published her books at the group's publishing house, the Editions des Femmes (she formally broke with the group and with the publishing house in 1983); Wittig, on the other hand, identifies herself as a Marxist feminist and has been associated with the journal *Question féministes*, a strong critic of the Psych et Po group. In the context of my present discussion, however, Cixous and Wittig rejoin each other in at least two ways: in their theoretical as in their fictional writing, they explicitly or implicitly criticize and seek to displace patriarchal language, culture, and narrative. And this critique appears, in both, to lead to the elaboration of a fictional world — and to a corresponding poetics — that is exclusively female.

Cixous's is the more complicated itinerary. In her first novels, before 1975, and scholarly writings (e.g., the major study of Joyce 1968), she seems to have identified with male poets and traditional male symbols like the sun (cf. *Portrait du soleil*, 1973). Somewhat later, in her first theoretical writings on "écriture féminine" (1975), she alternated between a view one could call essentialist — affirming that women should "write their bodies," with "white ink" (mother's milk), and so on — and a more complex view that insisted on the potential bisexuality in writing. In good Derridean fashion, she was careful to point out that the bisexuality she had in mind was not that of the hermaphrodite, who represents a "fantasy of unity" or a myth of totality, but rather the bisexuality of a "dual" or even multiple subject, who is not afraid to recognize in him or herself the presence of both sexes, not afraid to open him or herself up to the presence of the other, to the circulation of multiple drives and desires. She then went on to say, however, that for historical and cultural reasons, it is women who today have the greatest potential for realizing this kind of bisexuality, and for practicing the kind of writing that results from it. Men, with a few notable exceptions among the poets, have been too prone to fall victim to the ideology of phallocentrism, whence their submission to the rule of logic, syntax, linearity, homogeneity, and realist representation. Cixous called, instead, for a kind of writing that would break open the chains of syntax, escape from the repressiveness of linear logic and "story-telling" and allow for the emergence of a language "close to the body." This language, linked, for Cixous, to the voice and the body of the mother, would allow the "wildness" of the unconscious to emerge over the tame reasoning of the superego or the Law (Cixous 1975a,b; also 1976).

Since these essays were published, Cixous has produced, among other works, ten long texts she calls "fictions," all of which are both reflections on and examples of the kind of writing she was calling for. The first one in the series, *Souffles*, which inaugurated Cixous's

collaboration with the Editions des Femmes, is a wonderfully rich and complex book, whose title recalls one of the programmatic statements of the *Jeune née* essay: "By writing herself [the verb "to write" is being used transitively], woman will return to that body that has been more than confiscated from her. . . In censuring the body, one censures at the same time breathing [*le souffle*] and speech" (1975a:179).

The title of *Souffles* suggests both the breathing and the speech that come when censorship over the body is lifted; it also suggests strong emotion or labor or passion, in all of which one "breathes hard." Cixous's text exploits all of these associations of the word, and merges all of them into a single metaphoric complex that runs throughout the book: that of *giving birth (naissance, accouchement, enfantement)*. The primary voice who speaks in the text and who says "I" fantasizes several violent scenes of birth, both by herself and by another — perhaps her own — mother. She herself harbors a number of mothers within her, and eventually gives birth to a young woman who is perhaps another version of herself. She also gives birth to this text, which is "delivered" from her body. Throughout there is a tremendous verbal energy and a kind of breathlessness. Although the book is divided into sections of varying length, each one further divided by variations in typography and by blank spaces between passages, the feeling one has is not one of fragmentation, but rather of effusion, as if everything were being written in a single breath.[5]

Besides the metaphoric complex of birth images, one extremely interesting feature of *Souffles* is the way it sets in motion two different kinds of intertextuality. On the one hand, there is what one might call a positive or affirmative intertextuality, consisting of quotations from and allusions to the writings of Jean Genet, who actually appears as a "character" — to the extent that there are any characters — in the text, as well as of a whole series of puns on Genet's name (e.g., *Je-nais*, which brings us back to the birth images); on the other hand, there is a negative or critical intertextuality which consists of ironic rereadings of major texts in our culture, especially of *the* major text, that of Genesis, which brings us back yet again to the problematics of birth and of origins. At the end of a long section which recounts the narrator's simultaneous discovery, as a little girl, of beauty, theft, and the ridiculousness of the "great white master" (this section recounts an incident in which

5. In one of her most recent works, *Ou l'art de l'innocence* (1981), Cixous writes that she has never been able to revise and reread her texts, making them easier to follow. On the contrary, she says: "I have never been able to turn back, I've never been able to write with a reading following the text and leading it along, I'm always following behind sentences running forward with all their might" (1981:53).

the little girl saw a beautiful medallion in a store and stole it, but was caught and punished — to no avail, for she did not succeed in feeling guilty), she tells us that around that time she first read Genesis, "in her own way." Her favorite character in that story was the serpent, whom she imagined as a

> tall black serpent, all head and a tail covered with diamonds. I found his beauty reassuring, in contrast with the sugariness of the members of the other characters. As for Eve, whom I found silly (still just as infantile, even though she was grown up), I urged her to eat the fruit. It was there, I discovered, that masculine falsification comes in, and everything is in the commentary (pp. 180—181).

If "everything is in the commentary," then an integral part of the new "feminine" poetics is to reappropriate, by means of ironic rereadings — and rewritings — the dominant cultural productions of the past. Cixous made this explicit about her work in a 1977 interview: "I found myself in the classic situation of women who, at one time or another, feel that it is not they who have produced culture. . . Culture was there, but it was a barrier forbidding me to enter, whereas of course, from the depths of my body, I had a desire for the objects of culture. I therefore found myself obliged to steal them. . . So that in a sense [culture] is always there [in her works], but it is always there in a displaced, diverted, reversed way. I have always used it in a totally ironic way" (Cixous 1977:485).

I want to come back to the figure of Jean Genet, and the role he plays in *Souffles*. He figures not only as the emblematic thief who is outside the Law of the "great white masters," but also as the emblematic bisexual writer. The narrative "I" refers to him as her precursor, her ally, and as the mother of his texts; at the end of the book, she speaks about a "maternal father, a man of good and transparent femininity" who has given her a child (p. 220). Significantly, however, if one looks at Cixous's books subsequent to *Souffles*, one discovers that this figure of the feminine man — as well as that of the bisexual woman — has gradually been eliminated, to be replaced by figures who are all female, not to say "all woman." *Ou l'art de l'innocence*, for example, begins by saying that men, the men the narrator used to know, do not really like language, that they are afraid of language, and goes on to develop a quite absolute opposition between the way women — that is to say "we," *nous* — view language and the way men — "they" — do. From her original celebration of Joyce, Kleist, Genet and other male poets in whom she saw allies or precursors in "bisexual writing," Cixous seems to have moved to an exclusive celebration of the feminine, as embodied only in women.[6]

6. This move is also suggested by a shift in her scholarly activities: for the past few years, she has devoted her seminar at the University of Paris VIII almost exclusively to a study

What about Wittig? She is an extremely interesting and powerful writer, whose intellectual allegiances and theoretical statements place her in strong opposition to both Cixous and Irigaray, but whose imaginative works manifest a number of similar preoccupations, both formal and thematic. Unlike Cixous and Irigaray, Wittig categorically rejects the notion of "écriture féminine," as well as the very notion of "woman" (*femme*) or of "femininity." In an often-cited essay, Wittig denounced the concept of an ontological difference between the sexes as a creation of heterosexual bourgeois capitalist thought. For her, the difference between the sexes is not ontological, or even biological, but political:

> for us there is no such thing as being-woman or being-man. 'Man' and 'woman' are political concepts of opposition. . . It is the class struggle between women and men which will abolish men and women. The concept of difference has nothing ontological about it. It is only the way that the masters interpret a historical situation of domination . . . for us, this means there cannot any longer be women and men, and that as classes and as categories of thought or language they have to disappear, politically, economically, ideologically (Wittig 1980:108).

This leads Wittig to the provocative conclusion that

> it would be incorrect to say that lesbians associate, make love, live with women, for 'woman' has meaning only in heterosexual systems of thought and heterosexual economic systems. Lesbians are not women (1980:110).

What is suggested in this essay is that, just as the aim of the Marxist class struggle is to abolish all social and economic classes, the aim of the feminist class struggle is to abolish sexual categories as we have known them. Lesbians and gay men seem designated to lead this struggle, since they are already outside the confines of sexual categorization. If we look at Wittig's imaginative works — starting with *Les Guérillères*, which was her second book but the first to deal explicitly with this problematic — we see an attempt to embody this program in a new kind of writing; but we also see, paradoxically, the most radical kind of binarization, and the most radical elimination of "the other" that it is possible to imagine.

Les Guérillères, published in 1969, has become a classic in the genre of the feminist Utopia — a genre inaugurated by Charlotte Perkins Gilman's *Herland* (1915). *Les Guérillères* is different, however, for it is not, strictly speaking, a narrative text. In the traditional Utopia — *Herland* conforms to this model — a basically descriptive impulse (describing how things might be "elsewhere," as a corrective to the "here and now") is grafted onto a simple narrative schema: a stranger arrives in the land, finds out all about it, then returns

of the great Brasilian woman writer, Clarice Lispector, about whose work she has published several articles and a book (*Vivre l'orange*, 1979). It is possible that Cixous's work will change once again after her break with the Editions des Femmes. See note 7.

to tell the tale. Wittig does away with the narrative frame and writes a series of descriptive fragments in the present tense, all of them having as their subject (both grammatically and in terms of content) "elles," the *guérillères* of the title, who are modern reincarnations of the Amazons. Theirs is an exclusively female world of warriors, with its goddesses, its sacred book — called *le féminaire* — its history, myths, rituals, games, celebrations, and symbols, the chief of these being the circle, symbol of the vulva. The word "femme" occurs extremely rarely, and is never used to designate "elles." By contrast, however, the descriptive fragments are interspersed with pages bearing a series of women's names, of all nationalities, from antiquity to the present, printed in capital letters. Even more insistently, the language of the text feminizes the French indefinite pronoun, "quelqu'un," which is morphologically masculine, to yield the "ungrammatical" pronoun "quelqu'une," a somebody who is female; it also systematically uses the female designation of animals, so that even the animal world around the *guérillères* consists — linguistically, at least — of only the female of the species.

Wittig, like Cixous, practices both a positive and a negative intertextuality. Among her positive intertexts in *Les Guérillères* are works by Marx, Mao Tse-Tung, and the Vietnamese tactician of guerilla warfare, General Giap. Her negative intertexts include Lacan, but her characteristic move is to present rewritten, feminized versions of classical and Christian myths: the golden fleece, for example, is described as "one of the names given to the hairs that cover the pubis" (p. 60); the grail cycle is reread and rewritten in terms of the symbol of the vulvar circle, which explains the round table, the spherical cup, as well as the blood it contains. As for Eve, she appears in the story of a naked woman who walks among the fruit trees in an orchard. Her "beautiful body is black and shining," and her hair consists of "thin moving snakes that produce music at each of her movements"; thus the biblical Eve, who is here shown *alone* in the garden, with only her snakes for company, is conflated with the Medusa, who is also a key figure in Cixous's writing and whose name evokes an indirect mockery of Freud's theories about female castration (Freud 1940). These rereadings and rewritings accomplish two complementary objectives: they appropriate positive but male-oriented symbols like the golden fleece or the holy grail by feminizing them; and they reverse negative, female-associated symbols like the head of the Medusa by endowing them with a positive value.

Although I have said that there is no narrative line in *Les Guérillères* — an absence reinforced by the exclusive use of the present tense — there is something like an internal evolution among the fragments. Around the middle of the book, for example, there is a fragment which *criticizes* the earlier symbolism of the circle and

the glorification of the vulva. Such symbols belong to a dead culture, not to the new world toward which "elles" are advancing (p. 102). Similarly, there is a movement towards what might be called a reconciliation with the enemy — at the end of the book, when something like a final struggle has been won, "elles" make peace with the surviving men, who are young, long-haired, and non-violent. The very last fragment, where suddenly the adjective "nous" appears (together with a first-person possessive signaling the presence of a personal narrator who is part of "elles"), describes a triumphant celebration at which the assembled crowd — which is designated only by the feminine form "nous toutes" — sings the International and remembers those who died for liberty.

Les Guérillères, then, combines a massive feminization of culture, history, and language, with a Marxist vision of class struggle followed by the abolition of all conflict. But the fact that only "nous toutes" are left suggests not so much a decategorization of masculine/feminine, as the elimination of one category — or perhaps the assimilation of one category by another, so that where there were two there is now one; and that one is female, as the grammar of the text insistently indicates.

This elimination becomes quite explicit in Wittig's two books subsequent to *Les Guérillères: Le Corps lesbien* (1973), which consists of a series of lyrical fragments addressed to a beloved, and *Brouillon pour un dictionnaire des amantes* (1976). This latter book, written in collaboration with Sande Zeig, consists of a series of alphabetically arranged fragments, which do not quite "add up to" but nevertheless do produce a fractured account of human history from an original Golden Age through an age of chaos to a new age of glory. There are two extremely striking things about this account: firstly, it traces all the conflicts of human history to a primordial conflict between "mothers," also called "women," who gradually became sedentary, and the bands of Amazons, or *amantes*, who continued the migratory way of life that characterized the Golden Age. (It was the "mothers," who insisted on building houses and cities, who caused the decline into chaos). Secondly, the dictionary does not contain a single mention of the word "man" or any equivalent thereof. This may be read as a parodic — but also polemical — reversal of the way men have written human history — eliminating women — throughout the ages, just as Wittig's systematic feminization of grammatical categories is a reversal of the traditional norm, according to which the masculine form is the "universal" one.

I admire Wittig's writing enormously (as I do Cixous's), but I have serious reservations about the separatist politics implicit in her poetics.[7] Other commentators have praised Wittig for the "all-

7. Such a politics seems to me equally implicit in some of Cixous's recent works, especially

female contexts and texts" she has created (Wenzel 1981:279), and for the fact that in her texts "male culture is eliminated," male language "overthrown by lesbian language," and male discourse silenced "to allow textual and linguistic space for the development of the new language" (Crowder 1983:128). I am troubled by the conflictual vocabulary — elimination, overthrow, silencing — of such praise, which in some way echoes the conflictual vocabulary and militant stance of Wittig's texts themselves.

On one level this may be merely a heterosexual bias on my part, or even a kind of fear (the heterosexual woman's fear of being "contaminated" by lesbianism?). But on another level, there are good theoretical reasons for my demurral. Is one going to do away with the confines of sexual categorization, whether in language or in life, by eliminating one of the terms altogether? Does not the eliminated term become reinscribed by its very absence? Feminist critics have often deplored the masculine fantasy of "men without women," which is deeply anchored in our culture and has a very long history. What a book like *Brouillon pour un dictionnaire des amantes* makes me realize is that I find the opposite fantasy just as distressing, and, ultimately, just as impoverishing.

It can be objected that the violence Wittig does to traditional (male?) syntax and vocabulary, and to what might be called a corresponding mythical or historical memory (as in *Le Corps lesbien*, when she speaks about heel of "Achillea, the well-named one who very much loved Patroclea") is today salutary and necessary, in the face of centuries of similar violence directed against women's words, language and memory by patriarchal institutions and patriarchal writing. It can also be objected that Wittig's commentators are more simple than she, for has she not, after all, said that "lesbians are not women"? Perhaps Wittig's *amantes,* whom I read as "female lovers," are not women, not female at all. Perhaps they represent a whole new species, neither man nor woman, their age of glory being precisely that age in which the strict boundaries of sex, as of class, will have been transcended.[8] But if so, then we are once again

in *Ou l'art de l'innocence*. But it is most clear in Wittig's. (In at least one recent text, Cixous seems once again to be celebrating bisexuality, or an undecidable merging of genders. See Cixous 1983, from which I quote in my last section). I should say that in personal conversations both Wittig and Cixous have insisted that they are not separatists. Here is one place where "real life" politics diverges from what I see as a "poetic politics." Possibly, my notion of a politics implicit in a poetics needs to be revised, or refined. For now, I shall stick to it.

8. This is what Wittig herself suggested, in a conversation at Harvard University (March 1983). Although I understand the theoretical argument, I have trouble superimposing it on my reading of Wittig's texts. On the question of the "mothers versus Amazons" opposition, which I find quite problematic, Wittig stated she now has some regrets. If she and Zeig ever redid *Brouillon*, she would want to de-emphasize that conflict.

entrapped by language, which does not have a "third term" — a term that would not be neuter, genderless, but gender-undecidable (or better still, gender-multiple). Today, if I am reading French, I must read the *amantes* as female, and Wittig's age of glory as single-sexed.

Have we hit a dead-end? Is there no alternative to "equal rights," in which all the old structures remain in place, only the roles are reversed — woman on top, or to the celebration of difference, which turns out to be a celebration of one sex, not two? From here on, we can only dream. But is that not what stories, poems, have always invited us to do?

"INCALCULABLE CHOREOGRAPHIES," OR, DREAMING BEYOND THE NUMBER TWO

My reflections here, as well as my subtitle, were inspired by the intersection of a number of heterogeneous texts. I would like therefore to begin by quoting a few fragments, which I shall not try to explicate individually but whose resonance with each other — and with our discussion so far — will, I hope, become evident.

This first fragment is from an essay by the English feminists Beverly Brown and Parveen Adams, "The Feminine Body and Feminist Politics":

> What can be said of the political task of feminism set up as a control of the feminine body and feminine sexuality is that it is dominated by the conception of unities — the unity of the body, the unity of sexuality, the unity of control, the overarching unity of the individual formed by their coincidence and ultimately, a unity of the body of women. Analyses in terms of unities hold out the prospect of liberation — unities can be grasped and will not finally escape us (p. 44).

The second fragment is from another essay by Parveen Adams, "The Distinction Between Sexual Division and Sexual Differences":

> It could be said that one of the paradoxical effects of feminism as a political force has been to force the recognition of the diverse and unexpected character of the organisation of sexual differences. It has proved a difficult and contentious problem as to how to analyse the effects of anything from social policy to artistic practices in respect to the organisation of sexual differences. But to reduce these problems to the simplifications of an always already antagonistic relation between two social groups who are frozen into a mutually exclusive and jointly exhaustive division is an obstacle both to feminist analysis and political practice (p. 57).

Finally, there is this fragment from a recently published text consisting of a written dialogue between Jacques Derrida and Christie V. McDonald. At the end of this dialogue, McDonald asks the question:

> If we do not yet have a "new" "concept" of woman, because the radicalization of the problem goes beyond the "thought" or the concept, what are our chances of "thinking 'difference' not so much before sexual difference, as you say, as taking off 'from' " it?

To this question Derrida replies not by proposing an answer (what kind of an answer, in the sense of a stated position, or a position statement, could one give?) but by speaking about desire, and a dream:

> As I dream of saving the chance that this question offers, I would like to believe in the multiplicity of sexually marked voices. I would like to believe in the masses, this indeterminable number of blended voices, this mobile of non-identified sexual marks whose choreography can carry, divide, multiply the body of each individual, whether he be classified as "man" or as "woman" according to the criteria of usage. Of course, it is not impossible that desire for a sexuality without number can still protect us, like a dream, from an implacable destiny which immures everything for life in the figure 2. [. . .] But where would the "dream" of the innumerable come from, if it is indeed a dream? [. . .] Then too, I ask you, what kind of a dance would there be, or would there be one at all, if the sexes were not exchanged according to rhythms that vary considerably? In a quite rigorous sense, the exchange alone could not suffice either, however, because the desire to escape the combinatory itself, to invent incalculable choreographies, would remain (pp. 75–76).

The dream, then, is to get beyond not only the number one — the number that determines unity, of body or of self — but also beyond the number *two*, which determines difference, antagonism, and exchange conceived of as merely the coming together of opposites. That this dream is perhaps impossible is suggested. Its power remains, however, because the desire it embodies is a desire for both endless complication and creative movement.

What would a story — or a text — inspired by such a dream look like? Cixous, in one of her most recent texts, writes about love as a dance between persons of undecidable gender:

> And then if I spoke about a person whom I met and who shook me up, herself being moved and I moved to see her moved, and she, feeling me moved, being moved in turn, and whether this person is a she [*un elle*] and a he [*une il*] and a he [*une il*] and a she [*un elle*] and a shehe [*une ellil*] and a heshe [*une ilelle*], I want to be able not to lie, I don't want to stop her if she trances, I want him, I want her, I will follow her (1983:118).

Language is here shaken up, the way the speaking "I" is shaken up: *shehe, heshe*. But if there is a story, it is only fleetingly suggested. If we want narrative, perhaps we must turn to fantasy, or science fiction. Or we can turn to Angela Carter's novel, first published in England in 1977, *The Passion of New Eve*.

As its title suggests, this is yet another rewriting of an old story. In fact, it is a rewriting of many stories, ranging from Greek mythology and the Bible to *Faust, Wuthering Heights, Pilgrim's Progress*, and Virginia Woolf's comic novel, *Orlando*. Like Orlando, the hero of Carter's novel is a modern-day Tiresias, a hero who becomes a heroine. Evelyn, a young fair-haired Englishman, comes to the United States and follows the labyrinthine path of his destiny,

which leads him to a violent new birth: Evelyn becomes Eve. This is no mere story of a sex-change, however — no transsexual fantasy where everything remains the same and the signs are simply inverted (Gore Vidal's *Myra Breckenridge* is a good example of that genre). Evelyn's story — which, unlike Orlando's, is narrated retrospectively in the first person, thus immediately raising the quintessentially modern question: who speaks? — is a heterogeneous combination of mythic realism, science fiction and allegory, with elements of a *Bildungsroman*, a picaresque tale, a quest romance, and a Hollywood love story. It is also — and that is why I find it so interesting in the present context — a lyrical, quasi-hallucinatory exploration of some of the questions I have been raising, first and foremost the question of the female body, female selfhood, and the problematic relation between masculine and feminine.

Well, what is the story? It quite defies summary, that is one of its charms, and one of the ways in which Carter succeeds in producing a new kind of writing even while remaining within the bounds of a certain "traditional" narrative logic. Whereas Cixous and Wittig innovate by refusing linear narrative, and by systematically fragmenting their texts, Carter multiplies the possibilities of linear narrative so that what results is a dizzying accumulation.

"The last night I spent in London, I took some girl to the movies and, through her mediation, I paid you a little tribute of spermatozoa, Tristessa" (p. 5). So the narrative begins. Tristessa, we find out, is an ageing Hollywood screen idol, now in seclusion in Southern California but at one time the very embodiment of melancholy femininity and the focus of Evelyn's adolescent fantasies. (The cultural referent for Tristessa is obviously Greta Garbo).

The day after this renewed — and, it will turn out, prophetic — encounter with the woman of his dreams, Evelyn flies to New York: a mythical New York where packs of rats roam the streets and civil war is about to break out between blacks and whites. Here he meets a young black prostitute, Leilah, "the night's gift," whom he follows "deep into the geometric labyrinth of the heart of the city" (p. 21). Leilah, as seen by Evelyn, is all flesh and all woman, at once infinitely seductive and infinitely repugnant: "She seemed to me a born victim" (p. 28). She becomes pregnant, gets an illegal abortion which almost kills her, and winds up in the hospital, sterilized.[9] Evelyn then leaves New York and heads West for the desert, where, "among the bleached rocks and untenanted part of the world, I

9. Lest all this seem intolerably racist/sexist, let me jump ahead a bit: much later, Eve will meet a very different Leilah and discover that Evelyn's earlier perception of her was an illusion, either due to his own blindness or to her conscious deception. (Leilah, now called Lilith, turns out to be "Mother" 's daughter, the graduate of an East Coast university, a black feminist militant, etc. This is only one of the accumulated plot-twists in the novel).

thought I might find that most elusive of all chimeras, myself" (p. 38).

That is indeed what he finds, although not quite as he expected. In the California desert he is captured by an underground community of women, whose emblem, which they wear imprinted on their T-shirts, is a broken phallus. This is a scientific-military society of Amazons (with some intertextual echoes of *Les Guérillères*, which Carter may or may not have intended), led by a black female doctor they call Mother. She is a monstrous, "self-created" symbol of maternity, with four breasts (the other women, by contrast, have only one breast) and a gigantic belly. But she is also a demonically skilled plastic surgeon, who proceeds to perform the operation that converts Evelyn into Eve, not before mating with him, however, in a union for which the text evokes, among other antecedents, Oedipus' encounter with his mother and Faust's encounter with the Mothers.

Textually, as well as in terms of its narrative content, this episode is an unsettling mixture of lyricism, grotesque comedy, and a kind of epic grandeur. When Mother tells Evelyn, shortly before his operation, "Embrace your fate, like Oedipus — but more brave than he! [. . .] I am the Great Parricide, I am the Castratrix of the Phallocentric Universe, I am Mama, Mama, Mama!" (p. 67), one does not know whether to guffaw or to shrink in awe. The particular effect of this text owes much to its tonal heterogeneity, which it is unfortunately difficult to convey without extensive quotations.

Evelyn, then, is castrated to resounding Hosannah's piped into the operating room. And not only castrated, but turned into a biological female, with all the necessary organs including a uterus. Mother's idea is to produce her own version of the Virgin birth by impregnating the "new Eve" with Evelyn's sperm, which was collected after his mating with Mother herself. This plan is prevented from being carried to completion by Eve's escape from Beulah — for that, ironically, is the name of this underground Amazonia (Beulah is the name given to Israel in the book of Isaiah, and also appears in *Pilgrim's Progress* as the land of peace). No sooner does Eve escape from Mother, however, than she falls into the clutches of a demonic Father: only a few miles away from Mother and her army of virgins lives Zero the poet, with his harem of slavishly devoted wives. Just as Mother is at once a mythical and monstrous version of the feminine, Zero is a mythical and monstrous version of manhood. He worships his own penis, and demands its worship by his wives. His only way of relating to women — who he believes are "fashioned of a different soul substance from men, a more primitive, animal stuff" (p. 87) — is by rape. Like Mother, Zero dreams of instituting a totalitarian rule by reproducing his own kind. Corresponding to her dream of remaking the world by producing a child who would be born of a

single being is his dream of "printing out new Zeros" and repopulating the continent with his own offspring. But alas, he is sterile, and he is convinced that the fault for this lies — here the plot thickens and becomes circular — with Tristessa. Zero believes that she is a "dyke," and has cast a spell over him.

So Zero spends his time flying over the desert in his helicopter, hunting for Tristessa's hideaway. And one day he finds it. Here begins the most extraordinary of Eve's adventures, the one prepared from the very beginning of the novel and now encountered in its circular movement. For what Zero and his harem discover, when they invade Tristessa's crystal palace and find her, still beautiful beneath her white hair, lying on top of a glass coffin, what they discover, when they strip her naked, is that Tristessa is . . . a man. Or rather, s/he has the physical appendages of maleness even while continuing to manifest the famous signs, and beauty, of her quintessential femininity.

What follows is a mock wedding, where two people are married but both are the bride and both are the groom. Eve is dressed as the groom in this ceremony, while Tristessa is outfitted with the wedding gown s/he wore in *Wuthering Heights*. All of this is grotesque, but at the same time eerily beautiful. Equally eerie is the fact that Eve has fallen in love with Tristessa, as a woman loves a man, as a woman loves another woman, as a man loves a woman, and — although this possibility is not exploited by the text — as a man loves a man. Their union in the desert, after they escape from the crystal palace, leaving Zero and his wives to die a fantastic death, is, if not the enactment of an incalculable choreography, certainly that of a dizzying dance in which it is impossible to say who is woman and who is man, where one sex or one self begins and the other ends.

I shall not continue "telling the story" — in any case, it becomes increasingly difficult to summarize, and increasingly fantastical. I have offered this partial reading not because I think that Carter's novel provides an "answer" to the riddle of sexuality, whether male or female.[10] What it does do, and I think superbly, is expand our notions of what it is possible to dream in this domain, and thereby criticize all dreams that are too narrow. Mother, who seeks to break all phallic towers, and Zero, who seeks to erect them, are both caricatures, living by outmoded symbols. It is to the desire, or dream, of going beyond the old dichotomies, of imagining "unguessable modes of humanity" (p. 77), that *The Passion of New Eve* succeeds in giving textual embodiment.

10. For the sake of some literal-minded readers, I want to emphasize that I do *not* consider castration or sex change operations as "solutions," political or other! My reading of *The Passion of New Eve* is not referential, but in a particular way, allegorical: the "meaning" residing not in the specific narrative content, but in the possibilities of sexual role-playing and fluid gender boundaries that the narrative suggests.

REFERENCES

Adams, Parveen, 1979. "A Note on Sexual Division and Sexual Differences," *m/f* 3, 51—58.

Anonymous, 1976. Brief review of *Fear of Flying, London Observer* March 28, 1976, p. 29.

Boston Women's Collective, 1973. *Our Bodies Our Selves* (Boston).

Brown, Beverly and Parveen Adams, 1979. "The Feminine Body and Feminist Politics," *m/f* 3, 35—50.

Brown, Rita Mae, 1977 (1973). *Rubyfruit Jungle* (New York: Bantam Books).

Burke, Carolyn, 1980. Introduction to Luce Irigaray's "When Our Lips Speak Together," *Signs* 6:1, 66—68.

1981 "Irigaray Through the Looking Glass," *Feminist Studies* 7:2, 288—306.

Carter, Angela, 1982 (1977). *The Passion of New Eve* (London: Virago Press).

Cixous, Hélène, 1968. *L'Exil de James Joyce, ou l'art du remplacement* (Paris: Grasset).

1973 *Portrait du soleil* (Paris: Denoël).

1975a "Sorties," in: H. Cixous and C. Clément, *La Jeune Née* (Paris: 10/18), 114—245.

1975b "Le Rire de la Méduse," *L'Arc* 61, 39—54.

1975c *Souffles* (Paris: Eds. des Femmes).

1976 "Le Sexe ou la tête?," *Cahiers du GRIF* 3, 5—15.

1977 "Entretien avec Françoise van Rossum-Guyon," *Revue des Sciences Humaines* 44:168, 479—493.

1979 *Vivre l'orange* (Paris: Eds. des Femmes).

1981 *Ou l'art de l'innocence* (Paris: Eds. des Femmes).

1983 "Tancrède continue," *Etudes Freudiennes* 21—22, 115—132.

Crowder, Diane Griffin, 1983. "Amazons and Mothers? Monique Wittig, Hélène Cixous and Theories of Women's Writing," *Contemporary Literature* 24:2, 117—144.

Derrida, Jacques and Christie V. McDonald, 1982. "Choreographies," *Diacritics* 12:2, 66—76.

Dillon, Millicent, 1975. "Literature and the New Bawd," *The Nation* Feb. 22, 1975, p. 219—221.

Freud, Sigmund, 1940(1922). "Medusa's Head," in: J. Strachey, ed., *The Standard Edition of the Complete Psychological Works* (London: The Hogarth Press), 18, 273.

Gallop, Jane, 1982. *The Daughter's Seduction: Feminism and Psychoanalysis* (Ithaca: Cornell UP).

1983 *"Quand nos lèvres s'écrivent*: Irigaray's Body Politic," *Romanic Review* 74:1, 77—83.

Gilman, Charlotte Perkins, 1979 (1915). *Herland* (New York: Pantheon Books).

Herrmann, Claudine, 1976. *Les Voleuses de langue* (Paris: Eds. des Femmes).

Hite, Shere, 1974. *Sexual Honesty By Women for Women* (New York: Warner Paperback Library).

1981 *The Hite Report, A Nationwide Study of Female Sexuality*, new revised edition (New York: Dell).

Huston, Nancy, 1982. *Mosaïque de la pornographie* (Paris: Denoël/Gonthier).

Irigaray, Luce, 1974. *Speculum de l'autre femme* (Paris: Eds. de Minuit).

1977 *Ce Sexe qui n'en est pas un* (Paris: Eds. de Minuit).

1980 *Amante marine: de Friedrich Nietzsche* (Paris: Eds. de Minuit).

1982 *Passions élémentaires* (Paris: Eds. de Minuit).

1984 *Ethique de la différence sexuelle* (Paris: Eds. de Minuit).

Jong, Erica, 1974 (1973). *Fear of Flying* (New York: Signet).

Koertge, Noretta, 1981. *Who Was That Masked Woman?* (New York: St. Martin's Press).

Marks, Elaine and Isabelle de Courtivron, eds., 1981. *New French Feminisms. An Anthology* (New York: Schocken Books).

Millett, Kate, 1971 (1969). *Sexual Politics* (New York: Avon Books).

Nin, Anaïs, 1969. *The Diary of Anaïs Nin*, vol. III (1939—1944) (New York: Harcourt Brace Jovanovitch).

Scholes, Robert, 1982. "Uncoding Mama: the Female Body as Text," in: *Semiotics and Interpretation* (New Haven: Yale UP), 127–142.

Spacks, Patricia Meyer, 1974. "Fiction Chronicle," *The Hudson Review* 27:2, 283–295.

Stimpson, Catharine R., 1981. "Zero Degree Deviancy: The Lesbian Novel in English," *Critical Inquiry* 8:2, 363–379.

Wenzel, Hélène Vivienne, 1981. "The Text as Body Politics: An Appreciation of Monique Wittig's Writings in Context," *Feminist Studies* 7:2, 264–287.

Wittig, Monique, 1969. *Les Guérillères* (Paris: Eds. de Minuit).

1973 *Le Corps lesbien* (Paris: Eds. de Minuit).

1980 "The Straight Mind," *Feminist Issues* I:1, 103–110. (First published as "La Pensée Straight." *Questions Féministes* February.)

Wittig, Monique and Sande Zeig, 1976. *Brouillon pour un dictionnaire des amantes* (Paris: Grasset).

THE SOMAGRAMS OF GERTRUDE STEIN

CATHARINE R. STIMPSON

"Behind thoughts and feelings, my brother," wrote Nietzsche in "The Despisers of the Body" in *Thus Spake Zarathustra*, "there is a mighty lord, an unknown sage — it is called Self; it dwelleth in thy body, it is thy body." But when we represent the body, we must transmute our dwelling into a ghost-ridden, ghost-written language. Soma must become a somagram.

The somagrams of Gertrude Stein — hers and ours about her — illustrate this well-worn axiom. They reveal something else as well: attempts — hers and ours — to fix monstrous qualities of the female body. Like all monstrosities, we despise them, and thus we seek to fix, to repair them. However, like all monstrosities, we also need them, and thus we seek to fix, to stabilize them. We often toil in vain.

For those who would represent her, Stein's body presents an alarming, but irresistible, opportunity. For her body — the size of it, the eyes, nose, sweat, hair, laugh, cheekbones — was at once strange, an unusual presence, and special, an invigorating one. Increasingly indifferent to "feminine" norms of dress, style, and action, Stein herself appeared to behave as if that strangeness — like her writing itself — was more special than strange, at once original and right.

Mixing attraction and repulsion, those who represented her often choose to stress Stein's size. Clearly, she was fat, but her fatness is also a signifier valuable because capacious enough to absorb contradictory attitudes towards the female body. In a complementary act, Stein's representors also note how thin Alice B. Toklas was. They make the women, partners in life, counterparts in proportion. So doing, they sharpen divisions within Stein's domestic union.

For Stein's admirers, weight is a sign of life. She is, in all ways, outsized. Poignantly, in some photographs of her when she was tired and dying, she is much thinner. For Mabel Dodge Luhan, Stein's body is attractively exceptional rather than ludicrously freakish:

> Gertrude Stein was prodigious. Pounds and pounds and pounds piled up
> on her skeleton — not the billowing kind, but massive, heavy fat. She wore
> some covering of corduroy or velvet and her crinkly hair was brushed back
> and twisted up high behind her jolly, intelligent face. She intellectualized
> her fat, and her body seemed to be the large machine that her large nature
> required to carry it.
>
> Gertrude was hearty. She used to roar with laughter, out loud. She had
> a laugh like a beefsteak. She loved beef. . . (Luhan 1935:324).

Picasso, in his 1906 portrait, the most famous visual representation
of Stein's body, drapes immense breasts, buttocks, hips, and thighs
in dark cloth. However, the face and body are powerful. Because
the browns and oranges of the sitter's clothing blend with the browns
and oranges and dark blues of the background, the body seems at
home, in place.

For more ambivalent admirers, Stein's fatness is a fact that they,
and she, must transcend. Saying that Stein weighed two hundred
pounds, less impartially judging that ugly, and then equating beauty
and erotic love, Alfred Kazin states: "Stein and Toklas were certainly
not beautiful, so their physical love for each other is all the more
impressive" (Kazin 1977:33). A chatty biography for children
begins with an unhappy adolescent Gertrude wishing that she
"weren't so large," and gazing enviously at the "slender grace" of
her more flirtatious, and feminine, friends. However, this Gertrude
consoles herself by being "different in more important ways" as well.
Splitting lively mind from lumpy body, Gertrude reminds herself
that her mind is "quicker" than that of those friends (Wilson
1973:1).

Stein's detractors reverse the response of her genuine admirers.
To them, her physical fatness is nothing less than proof of a hideous
cultural and psychological overrun. She is nothing less than ". . . [a]
. . . ten-ton granite American expatriate" (Corke 1961:370). At their
most hostile, such detractors — men and women alike — go on to
comment on Stein's Jewishness. Katherine Anne Porter, whose
stiletto persistently flicked out at Stein, sneered at her as ". . . a
handsome old Jewish patriarch who had backslid and shaved off
his beard" (Porter 1952:43). Inevitably, detractors of Stein's body
conflate her mind and body. They then disdain and fear her work.
They seek to neutralize the threat to a dominant ideology of the
well-spoken Christian lady that her potent combination of nature
and culture offers: the body that she lived in; the family religion she
more or less abandoned; the writing she never abandoned.

In a subtle maneuver, to picture Stein as fat also deflected the
need to inscribe her lesbianism fully and publically. One could offer
a body, but not an overtly erotic one. One could show some
monstrosity, but not too much. Although people referred to such
"mannish" characteristics of Stein's as her sensible shoes, no-one
spoke openly of her lesbianism until after her death in 1946. Her

friends protected her desire for privacy. Her detractors evidently found the taboo against mentioning lesbianism stronger than their desire to attack. Moreover, a popular icon of the lesbian, which *The Well of Loneliness* codified — that of a slim, breastless creature who cropped her hair and wore sleek, mannish clothes — did little to reinforce an association between the ample Stein and deviancy. She may have cropped her hair, with Toklas as her barber, but she wore flowing caftans, brocaded vests and woollen skirts.

After her death, Stein's lesbianism became more than a pronounceable, permissible subject for investigation. In the 1960s, in the women's movement and the gay movement, it stimulated celebration. In popular culture, her lesbianism evoked crass, but affectionate jokes, as if it were odd but fun. In *The National Lampoon*, for example, "Gertrude Steinbrenner," a "Lesbo Boss," who looks like a hybrid of George Steinbrenner and Picasso's Gertrude Stein, buys the New York Yankees and feistily brings her team into the modernist movement. Her cubist field has eight bases; Diaghilev inspires her uniforms (Barrett 1982).[1] Significantly, in the same period, critics begin to reinterpret her Jewishness. It no longer deforms her, but rather, like her sexuality, gives her the subversive perspectives of marginality.

Stein was, of course, far more than the fat lady of a Bohemian circus. She was a serious modernist, whose formal experiments were as radical, if not more so, as those of any other modern writer. The fact that her work provokes so much ridicule and anxiety — which oftens masks itself as ridicule — is one mark of her radicalism. Not even Stein's most ardent detractors can dismiss her, try though they might. Confronting such an alliance of body and literary activity, people, whether supporters or detractors, drew on two mutually contradictory sets of metaphors to depict her. The incompatibility of these sets itself reflects the difficulty, which Stein ultimately transcended, of having such a body devoted to such a cultural task.

The first set of metaphors domesticates Stein. Meant to praise, and to honor the monstrous lesbian as crafter, they also replace her securely within the woman's traditional domain of the home. Because Stein's fatness also evokes the association of the fleshy female body with fertility, a Venus von Willendorf, this taming language has an added resonance. In 1922, Sherwood Anderson, one of her most loyal friends, wrote effusively of meeting her in Paris the year before:

> In the great kitchen of my fanciful world in which I have, ever since that morning, seen Miss Stein standing, there is a most sweet and gracious aroma.

1. See, too, the cartoon strips of T. Hachtman, first in the *Soho News* and then gathered in Hachtman (1980). My thanks to Albert Sonnenfeld for bringing the Barrett piece to my attention.

Along the walls are many shining pots and pans, and there are innumerable jars of fruits, jellies and preserves. Something is going on in the great room, for Miss Stein is a worker in words with the same loving touch in her strong fingers that was characteristic of the women in the kitchen of the brick houses in the town of my boyhood. She is an American woman of the old sort . . . who cares for the handmade goodies (White 1972:24).

In the same year, Man Ray took his famous photograph of Stein and Toklas at 27 rue de Fleurus. Toklas, in a low chair, and Stein, in an easy chair, sit on either side of the fireplace. Between them is wooden table, above them paintings. Toklas wears a dress with ruffled collar and sleeves. The vaster Stein is clad in habitual items from her wardrobe: woolly socks, sandals, a blouse with a broach at the throat, a flowered jacket.[2] Indeed, several of the most widely circulated photographs of Stein frame her at home — in Paris or in the country.

The second set of metaphors inverts such cozy portraits of Stein at home by the range. In them, she is beyond society and social control, beyond ordinary sexuality, and therefore, beyond the need for sexual control. If the first set of metaphors drains monstrosity of its threat by enclosing it, the second does so by casting it out and away from daily history. In part, these metaphors transmogrify Stein into a sacred monster — to be sought after by some, cursed by others. Describing Stein after a walk in the Tuscan hills, Mabel Dodge Luhan oracularizes her:

. . . when she sat down, fanning herself with her broad-brimmed hat with its wilted, dark brown ribbon, she exhaled *a vivid steam around her* (italics mine, Luhan 1935:327).

In 1920, a head of Stein that Jacques Lipchitz sculpted — with a topknot of hair, high cheekbones, narrow oval eyes — helped to create a linkage between Stein and Buddha. Sinclair Lewis, as an insult, called her "Mother Superior." Moving between polarities, Sherwood Anderson,

. . . was the first of several hundred people to liken her to a monk. Some religious quality about her unadorned habiliments brought to mind not so much a nun as a monk. There was something sexless about her, too, a kind of dynamic neuter. She was a robe surmounted by a head, no more carnal than a portly abbot (Rogers 1948:39).

Such distancing metaphors also eject Stein back into time past. With suspicious frequency, her viewers compare her to a Roman emperor or well-born citizen. In Picabia's portrait of 1933, she stands — in a striped, toga-like robe. Two years later, an interviewer wrote:

2. The best collection of reproductions of paintings, photos, and sculptures of Stein is in Hobhouse (1975).

The hair is close-cropped, gray, brushed forward or not brushed at all but growing forward in curls, like the hair of Roman emperors (Preston 1935: 187).

Physically, her strong bones, and that hair, made such an identification plausible. Psychologically, she seemed Roman in the persistence and ease of her will — especially, in a conjunction of metaphors, when she was at home. As Roman, Stein could also be "mannish," without any direct declaration of lesbianism.

Hemingway's is the saddest engagement with the Roman metaphor. In his memoirs the now-alienated man, who was once surrogate son and brother, took revenge on Stein. He first remembers being responsive to her body. Describing it, he performs one of his standard rhetorical moves: rummaging through a number of non-Anglo-Saxon cultures for tropes to express pleasure. Stein has beautiful eyes, a "German-Jewish" face, "immigrant hair," and the face of an Italian peasant woman (Hemingway 1964:14). Centering his erotic recall on his relationship with Stein, Hemingway refers to Toklas only as "the friend." However, Hemingway centers his bitterness on that friend. For, he tells us, the relationship with Stein ended, although not formally, when he once went unexpectedly to 27 rue de Fleurus. He overheard Toklas speaking to Stein "as I had never heard one person speak to another; never, anywhere, ever" (p. 118). Given Hemingway's experience, his adverbial stresses seem disingenuous. Despite this, he goes on to tell of hearing Stein beg "Pussy" for mercy. In his shock, he strips both women of their bodies and reduces them to invisible, but scarring voices. His final word for Stein tries to restore the power of which the scene has denuded her: she is again "Roman" (p. 119).

Stein's somagrams of her body partially resemble and reinforce the patterns of representation I have outlined. For example, in the erotic celebrations of her relationship with Toklas, she famously and notoriously acts out the part of "Caesar."[3] Whether they resemble others' representations of her or not, her somagrams are never radically visceral or visual. She is no physiological blueprinter. In her salon, she also ". . . frowned on anything that smacked of vulgarity" (Mellow 1974:324). She might voyeuristically provoke gossip and displays, but she believed in discretion. To measure her reticence one might compare her to Apollinaire in 1909. She was writing "Ada," the lyrical portrait about her growing relationship with Toklas, and "Miss Furr and Miss Skeene," a witty short story about a disintegrating relationship between two other women. Neither has any explicit sexual detail whatsoever. Meanwhile,

3. The translation of Stein's private sexual language begins with Bridgman (1970). It continues with Simon (1977); Stimpson (1977); Fifer (1979); Stimpson (forthcoming), with further references.

Apollinaire was publishing and endorsing the first anthology of the works of Sade.

Nevertheless, during her career, Stein's somagrams became freer and more flexible, as she became less monstrous to herself. Her happiness with Toklas diluted the guilts and stains of a homosexuality that violated the "decent" norms of the heterosexual bourgeois family to which Stein had once been committed. She was increasingly confident of herself as a writer, even boisterously so. So doing, she became more sympathetic to women's aspirations and talent (DeKoven 1983:137). Though Stein was never a public feminist, during the 1920s she began to cut the cord she and Western culture had tied between masculinity and towering creativity.

Her body also enlivens her writings, be they somagrams or not, be they lyrics, meditations, or diary-like notations. For her texts read as if her voice were in them, as if she were speaking and dictating as much as writing. Unlike a Charles Olson, Stein lacks a theory about the relationship of the poetic line to the human breath. Nevertheless, she illustrates that "The best writing is energized by speech, and the best speech surges forward like a wave. . . In poetry, writing is not the same as speech, but is transformed by speech. . ." (Vernon 1979:40). Once, when Stein was objectifying mutton in *Tender Buttons*, written in 1911 but not published until 1914, she mused and teased, "A sign is the specimen spoken" (Stein 1971: 182). Stein's work is liveliest when read and heard; when our own o/aural talents lift her words from the page and animate them in an informal or formal, private or public, theatrical environment.

Stein's somagrams became freer and more flexible in at least two entwined ways, which in turn entwine psychology and rhetoric. Firstly, she modified her motives for being discreet when she wrote about the female body. In the first decade of the twentieth-century, she was fearful of what she might say, of what she might confess — to herself and others. She disguised her own lesbian experiences by projecting them onto others or by devising what William Gass, one of her most scrupulous and sensitive critics, has called her "protective language":

> . . . a kind of neutralizing middle tongue, one that is neither abstractly and impersonally scientific nor directly confronting and dramatic, but one that lies in that gray limbo in between. . . (Gass 1972:89).

Perhaps her fear was never wholly to disappear. Still, Stein was later to see the body as but one element in a larger physical, emotional, social, linguistic, and metaphysical universe.[4] Even in *Q.E.D.* (1903), Stein wrote about women's bodies as signifiers of

4. My position modifies that of Wilson (1952). He believes that Stein's denial of her sexuality was greatly responsible for much of the opacity of her prose. See too Phelps (1956).

psychic and national types: the body of Helen Thomas demonstrates the American version of an "English handsome girl"; that of Mabel Neathe the American version of an older, decadent Italian aristocracy; that of Adele (based on Stein herself) the values of a young, hearty, middle-class woman. In *Q.E.D.* too, the lesbian triangle of Helen, Mabel, and Adele is less an erotic intrigue, though Adele's introduction to erotic experience matters, than an arena of power plays. For Stein, I believe, too great a preoccupation with the body would grossly swell its importance. Though some inhabitants of the twentieth-century might be skeptical, such a belief is legitimate, not a prude's rationalization of sexual repression. Stein once said that sex, like violence, was the root of much emotion. Nevertheless, it was but part of a whole; sexual passion was less than passion conceived as "the whole force of man."[5]

> Literature — creative literature — unconnected with sex is inconceivable. But not literary sex, because sex is a part of something of which the other parts are not sex at all (Preston 1935:191).

Throughout her writing, Stein so places the female body that it merges with, and gives way to, other activities. For example, in 1940, in *Ida*, Stein has a passage about Ida's adolescence. She simultaneously alludes to menstruation and slides away. The double process of allusion and slippage both evokes the body and dissipates its presence:

> And so Ida went on growing older and then she was almost sixteen and a great many funny things happened to her. Her great-aunt went away so she lost her great-aunt who never really felt content since the orange blossoms had come to visit her. And now Ida lived with her grandfather. She had a dog, he was almost blind not from age but from having been born so and Ida called him Love, she liked to call him naturally she and he liked to come even without her calling him (Stein 1971:340).

In her blurring, the boundaries of gender identity themselves decompose. Female and male become fe/male. "Arthur angelic angelica did spend the time," Stein gossips (Stein 1975:39). As she wipes out punctuation marks, she makes it equally possible that someone is telling Arthur about Angelica; that angelic Arthur is spending time with Angelica; that angelic Angelica is spending time with Arthur; that two angels are spending time together; or that Arthur and Angelica are one heavenly creature.

Invariably, inevitably, the body fuses with writing itself. Stein merges herself with her work, and that unity with the world. Look at "Sacred Emily," a 1913 piece in which Stein first said, "Rose is a rose is a rose." Its first line is "Compose compose beds" (Stein

5. To adopt Stein's terms, the body may belong to the realm of "identity," not to the more significant realm of "entity."

1968:188). Multiply punning, the line refers to gardens and to flowering beds; to making beds, that site of sleep and sex; to making beds musical, and to making beds a language game. Even in "Lifting Belly," Stein's most ebullient record of her life with Toklas, sexual tension, foreplay, and climax interweave with other, fragmenting sensations and phenomena to create ". . . a tense we might call 'present sensual. . .'" (Retallack 1983:251). The phrase "Lifting belly" becomes both a repetitive synecdoche for a repeated, repeatable sexual act and a generalized metonymy for Stein's life at large. Because the poem has such a successful de-centering device, almost any group of lines, pulled out at random, inflects the 'present sensual' tense:

> Lifting belly is a credit. Do you care about poetry?
> Lifting belly in spots.
> Do you like ink.
> Better than butter.
> Better than anything.
> Any letter is an alphabet.
> When this you see you will kiss me.
> Lifting belly is so generous.
> Shoes (Stein 1980:48).[6]

Indeed, in Stein's more abstract writing, the body disappears into language utterly, or becomes an example of a linguistic category. Kisses may illustrate, not the body in action, but a problematic grammatical class: the noun.

Stein's second demonstration of a freer, more freeing, more flexible sense of women's bodies is her growing ability to represent the body as a site of pleasure. In her work in the first part of the twentieth-century, the experience of eros, for heterosexual and homosexual women alike, breeds frustration, anxiety, and guilt — particularly for more vulnerable and powerless women. For heterosexual women, eros is inseparable from a fated, dutiful maternity. No matter what their sexuality, women's bodies are mortal. In *Three Lives*, Good Anna dies after an operation, Melanctha dies in a home for poor consumptives, Gentle Lena dies, worn out after three pregnancies, giving birth to a fourth child, itself still-born.

Then, in 1909, Stein began to write of sexuality with pleasure (Schmitz 1983:194–196). To be sure, she continued to remember sexual trauma and unhappiness. In *How to Write*, published about thirty years after Stein's wretched entanglement with May Bookstaver, she has a long, broody paragraph about Mabel Haynes, Stein's rival for May's allegiance, and about Mabel's subsequent career as wife and mother (Stein 1975:222). Stein could also write ambivalently about sexuality. In *Tender Buttons*, she ends her first

6. Note that "shoes" puns on "choose" and "chews."

section "Objects," with "This Is The Dress, Aider." "Aider" puns on "To aid" and "Ada," that surrogate name for Toklas. Only two lines long, the meditation replicates the rhythms of an act that seems at once richly pleasurable and violent. Stein, in *Tender Buttons* and elsewhere, was to become more and more skillful in imitating the rhythms of an act in order to name it without resorting to, and consorting with, jaded old nouns. "This Is The Dress" ends: "A jack in kill her, a jack in, makes a meadowed king, makes a to let" (Stein 1971:176). The act seems to be sexual, but it may, of course, also be anything that follows a pattern of building and releasing tension. The last three words, for example, may allude to "a toilet," which, in turn, may be the process of getting dressed, or of going to the bathroom, or of both.

To be sure, too, Stein never lost her sense of the body's fragility. In the 1930s, she was, as if it were a minor obsession, to work and rework the stories of two mysterious, sinister deaths near her country home. In one, Madame Pernollet, a hard-toiling hotel-keeper's wife in Belley, has died — five days after falling onto a cement courtyard. In the second, a Madame Caeser (that Roman word again) had been living with a Madame Steiner (another extension of Stein's own name). However, an Englishwoman has interrupted their idyll. After some complications, she is found dead. Despite the fact that she has two bullets in her head, she is declared a suicide. As if to compensate for such a sense of fragility, and to declare her own power over the body, Stein, in the 1930s, was to give the author herself the power to destroy. In *Everybody's Autobiography* she notes, with aplomb:

> ... Give me new faces new faces new faces I have seen the old ones... Having written all about them they ceased to exist. That is very funny if you write all about any one they do not exist any more, for you, and so why see them again. Anyway that is the way I am (Stein 1973:118).

In spite of such strong residual memories and perceptions, Stein's eventual delight in the female body spins and rushes through her work, inseparable from her pleasure in food, or a dog, or the land-scape, or a French hat. "It is very pretty," she writes, "to love a pretty person and to think of her when she is sleeping very pretty" (Stein 1975:359). Because she is happy as both carnal participant and observer, as both actor and audience, she sites/cites her body, and that of her partner/s, in a "magic theater" (Fifer 1979:473). However, the celebration of the body is more than a performance. Inverting the puritanism that Stein never fully escaped, the celebration of the body can be ethically charged as well. For it becomes ". . . at its climax a celebration of the capacity we have for emotion, for 'care,' the tenderest mode of human feeling and behavior" (Secor 1982:304).

Given this, Stein's coding of sexual activities ceases to be a suspect evasion and becomes, instead, a privileged, and a distinguished, "anti-language." The sociolinguist, M.A.K. Halliday, writes of anti-languages as the speech of anti-societies, "set up within another society as a conscious alternative to it" (Halliday 1976:570). The anti-language has several purposes: to display a speaker's abilities, to preserve secrecy, to act out a "distinct social structure" (p. 572); to socialize people into that structure. In brief, the monsters speak up within, and for, their lair. Halliday writes, not of homosexual anti-societies, but of criminal underworlds, prisons, and vaudeville. Nevertheless, Stein and Toklas, in their own home and in the social circles they inhabited, were citizens of a homosexual anti-society. For that home, and for those circles, Stein, as part of her vast experiments, uttered an anti-speech that has become more public as the dominant society has become less hostile to her subjects.

Whether or not her anti-language is "female" as well is a far more perplexing matter. In 1976, Ellen Moers rightly suggested that Stein deploys landscape to project and to represent female sexuality. In so doing, she extends a female literary tradition (Moers, p. 254). Stein does often resort to nature to emblemize female sexuality, female being, and her own creativity. In one of her later presentations of self-as-writer, Stein brought together two complementary quasi-natural metaphors: the fountain — traditionally masculine, and the womb — invariably feminine.

> Technique is not so much a thing of form or style as the way that form or style came and how it can come again. Freeze your fountain and you will always have the frozen water shooting into the air and falling and it will be there to see — oh, no doubt about that — but there will be no more coming...
> You cannot go into the womb to form the child; it is there and makes itself and comes forth whole — and there it is and you have made it and have felt it, but it has come itself... (Preston 1935:188).

Stein also belongs to the history of women writers as women writers for reasons other than her landscape imagery. They include her cultural marginality, her interest in domesticity, and her teasing of patriarchs and of gender relations. Moreover, her lesbianism — the sexual deposition of her body, her choice of a woman as lover/companion — helped to give her the distance she needed to reform English literature and the homely security she needed if she were to be such an intrepid pioneer.[7]

The question of a women's tradition provokes yet another query: that of its causes. Clearly, a common history and culture, not a common psychobiology, can determine a women's tradition. When

7. Secor (1982), DeKoven (1983), and Schmitz (1983) persuasively analyze Stein as an anti-patriarchal writer. I am writing a longer work on Stein that will treat her as an anti-patriarchal writer, with strong moorings to the patriarchy.

Stein adapted George Eliot's landscape metaphors, even as she devised her own, she could have done so because she had read, and admired, Eliot as a precursor; because she had read, and admired Eliot's texts as texts that were, in part, *about* women's experiences. However, since Moers's work in the mid-1970s, attempts to adjectify Stein's work as "female" have entangled that work far more deeply with Stein's femaleness as femaleness, as an elemental condition, inseparable from the body.

Some of these efforts derive from critics who owe a strong theoretical allegiance to United States radical feminism. As they construct the world, they profoundly genderize it. Knowing, thinking, writing — all are dualistic, male or female. Two such critics claim:

> Patriarchal expressive modes reflect an epistemology that perceives the world in terms of categories, dichotomies, roles, stasis, and causation, while female expressive modes reflect an epistemology that perceives the world in terms of ambiguities, pluralities, processes, continuities . . . complex relationships (Penelope and Wolfe 1983:126).

From them, Stein, a woman deep within the process of creation, is a prophet of a female expressive mode emerging fully in the late twentieth-century.

Other critics genderize the world less radically. They reflect the influence of a liberal United States feminism that fears casting "femaleness" and "maleness" in the eternal bronze of an essential. Nevertheless, they, too, deploy contemporary theories of the female to place Stein as a writer. Subtle, supple, finely intelligent, Marianne DeKoven adapts the theories of Kristeva and Derrida to distinguish between two languages: our conventional, patriarchal speech, and an experimental, anti-patriarchal speech. The former celebrates the triumph of the male over the female; the post-Oedipal over the pre-Oedipal; the father's dictionary over the mother's body; meaning over things; the linear over the pluridimensional — in brief, the signified over the signifier. For DeKoven, Stein is the great, subversive experimental writer in English. Rejecting the repressions of patriarchal language, locating herself in the psychosocial position of women, loving the play of the signifier, Stein necessarily reclaims the mother's body as well (DeKoven 1983).

I admire such ideas, and resist them. Elsewhere I have tangled with my general ambivalance about "female" writing.[8] Let me now think more particularly of Stein. To begin, she was a fresh, brilliant, thoughtful literary theoretician. To be sure, in her theory and practice, she praised the spontaneous, the immediate "flow" of language from writer to page. Nevertheless, banks of theory line that flow, rocks of theory interrupt it, bridges of theory cross it.

8. For more comment, see Jardine (1981) and Stimpson (1983).

For better or worse, Stein is utterly impure: linear as well as pluri-
dimensional, "male" as well as "female," the fountain as well as the
womb.

Given this, one might argue that Stein clinches the case for
Kristeva (Kristeva 1980). First, like male avant-garde writers, Stein
reaches back and down into pre-Oedipal speech. Next, she shows how
pre- and post-Oedipal mix; how the semiotic and the symbolic play
off and against each other. However, studies of the ways in which
children actually acquire language render suspect the terms "pre-
Oedipal" and "post-Oedipal," as well as a picture of childhood that
transforms children into boys and girls whose primary schooling in
language is first with the mother's body and then with the father's
rule. Of course, the sex of the parent still matters to the child. A
mother's voice, for example, has a different frequency than that of
a father. Nevertheless, in the acquisition of language, infants may
share a mentality and competence that transcends sex and gender —
be it their own, or that of the parents.

A characteristic of that mentality and competence is the sur-
prisingly early age at which they adopt, and adapt, rules. First, at
ten to twelve months, children demonstrate a "holophrastic speech,"
single word utterances used to express complex ideas about their
environment (Dale 1972). Next, at about eighteen to twenty months,
they progress to two-word utterances: a "pivot word" that appears
in the same position in every phrase, an "open word" that changes.
Next, children do more word combinations, formulate noun phrases,
and differentiate classes of modifying words. Even as infants,
children are regulatory, rule-making, rule-analyzing creatures who
seek to combine creativity with patterns, self with laws, needs with
necessities. As a leading linguist writes:

> It is striking how little difficulty a child has with any of the general mechan-
> isms of language: the notion of a sentence, the establishment of word classes
> and rules for combining them, the concept of inflections, the expression of a
> wide variety of meanings, and more. All are present from a very early age. . .
> As impressive as the complexity of child language is, it appears to be out-
> stripped by the uses to which a child wants to put it . . . the child is above
> all attempting to express his own ideas, emotions, and actions through
> whatever system he has thus far constructed. . . (Dale 1972:50).

In brief, when Gertrude and her brother Leo were little, they
grasped, grappled with, and broke the rules of language *as children*,
each with his or her individual being. As they grew up, they entered
an adult world. As Stein knew, it gave men more power than women
— including greater power over and within the female body. Because
of this, we can legitimately call this world "post-Oedipal." Stein's
sense of her own monstrosity in this world — as a sexual being, as a
marginal cultural citizen — influenced her writing, and her soma-
grams. However, laboring with language in this world, Stein came to

believe that women were in many ways more capable than men. Women could assume power over and within language, over and within their bodies. Resiliently, she transformed the monstrous into pleasure and into art. Because of this, we can call her a visionary of the "post-post-Oedipal."

If we do so, however, we must limit our Oedipal vocabulary to a way of talking about historical experience and various social uses of language. Stein's texts, including her somagrams, warn us against going on to genderize grammar itself. Her literary language was neither "female," nor an unmediated return to signifiers freely wheeling in maternal space. It was instead an American English, with some French twists and a deep structure as genderless as an atom of platinum. It could bend to patriarchal pressures, or lash against them. It could label and curse monsters, or, finally, respond to a monster's stubborn and transforming will.

REFERENCES

Barrett, Ron, 1982. "A Portrait of Gertrude Steinbrenner," *National Lampoon* July, 70–73.

Bridgman, Richard, 1970. *Gertrude Stein In Pieces* (New York: Oxford UP).

Corke, Hilary, 1961. "Reflections on a Great Stone Face," *Kenyon Review* XXIII:3 (Summer), 367–389.

Dale, Philip S., 1972. *Language Development: Structure and Function* (Hinsdale, Illinois: Dryden Press).

DeKoven, Marianne, 1983. *A Different Language: Gertrude Stein's Experimental Writing* (Madison: University of Wisconsin Press).

Fifer, Elizabeth, 1979. "Is Flesh Advisable? The Interior Theater of Gertrude Stein," *Signs: Journal Of Women in Culture and Society* 4:3 (Spring), 472–483.

Gass, William, 1972. "Gertrude Stein: Her Escape from Protective Language," in: *Fiction and the Figures of Life* (New York: Vintage Books), 79–96.

Hachtman, T., 1980. *Gertrude's Follies* (New York: St. Martin's).

Halliday, M.A.K., 1976. "Anti-Languages," *American Anthropologist* 78:3 (September), 570–584.

Hemingway, Ernest, 1964. *A Moveable Feast* (New York: Charles Scribner's Sons).

Hobhouse, Janet, 1975. *Everybody Who Was Anybody: A Biography of Gertrude Stein* (New York: G.P. Putnam's Sons).

Jardine, Alice, 1981. "Pre-Texts for the Transatlantic Feminist," *Yale French Studies* 62, 220–236.

Kazin, Alfred, 1977. "Gay Genius and the Gay Mob," *Esquire* 88:6 (December), 33–34, 38.

Kristeva, Julia, 1980. *Desire in Language: A Semiotic Approach to Literature and Art*, ed., Leon S. Roudiez (New York: Columbia UP).

Luhan, Mabel Dodge, 1935. *European Experiences*, Vol. II of *Intimate Memories* (New York: Harcourt, Brace and Co.).

Mellow, James R., 1974. *Charmed Circle: Gertrude Stein and Company* (New York: Praeger Publishers).

Moers, Ellen, 1976. *Literary Women: The Great Figures* (Garden City, New York: Doubleday and Co.).

Penelope, Julia and Susan J. Wolfe, 1983. "Consciousness as Style: Style as Aesthetic," in: Barrie Thorne, Cheris Kramarae and Nancy Henley, eds., *Language, Gender and Society* (Rowley, MA: Newbury House Publishers, Inc.), 125–139.

Phelps, Robert, 1956. "The Uses of Gertrude Stein," *Yale Review* XLV:4 (June), 603.

Porter, Katherine Anne, 1952. *The Days Before* (New York: Harcourt, Brace and Co.).

Preston, John Hyde, 1935. "A Conversation," *Atlantic Monthly* CLVI (August), 187–194.

Retallack, Joan, 1983. "High Adventures of Indeterminacy," *Parnassus* 11:1 (Spring/Summer), 231–262.

Rogers, W.G., 1973 (1948). *When This You See Remember Me: Gertrude Stein In Person* (New York: Avon Books).

Schmitz, Neil, 1983. *Of Huck and Alice: Humorous Writing in American Literature* (Minneapolis: University of Minnesota Press).

Secor, Cynthia, 1982. "Gertrude Stein: The Complex Force of Her Femininity," in: Kenneth W. Wheeler and Virginia Lee Lussier, eds., *Women, The Arts, and the 1920s In Paris and New York* (New Brunswick: Transaction Books), 27–35.

Simon, Linda, 1977. *The Biography of Alice B. Toklas* (Garden City, New York: Doubleday and Co.).

Stein, Gertrude, 1968 (1922). *Geography and Plays*, with a Foreword by Sherwood Anderson (New York: Something Else Press, Inc.).

 1971 *Writings and Lectures* 1909–1945 ed., Patricia Meyerowitz (Baltimore: Penguin Books).

 1973 (1937) *Everybody's Autobiography* (New York: Vintage Books).

 1975 (1931) *How To Write* with a New Preface and Introduction by Patricia Meyerowitz (New York: Dover Publications).

 1980 *The Yale Gertrude Stein*, ed. Richard Kostelanetz (New Haven and London: Yale UP).

Stimpson, Catharine R., 1977. "The Mind, the Body, and Gertrude Stein," *Critical Inquiry* 3:3 (Spring), 489–506.

 1983 "Feminism and Feminist Criticism," *Massachusetts Review* XXIV:2 (Summer), 272–278.

 forthcoming "Gertrice/Altrude," in: Ruth Perry, ed., *Mothering the Mind* (New York: Holmes and Meier).

Vernon, John, 1979. *Poetry and The Body* (Urbana: University of Illinois Press).

White, Ray Lewis, ed., 1972. *Sherwood Anderson/Gertrude Stein, Correspondence and Personal Essays* (Chapel Hill: University of North Carolina Press).

Wilson, Edmund, 1952. *Shores of Light* (New York: Farrar, Straus and Young).

Wilson, Ellen, 1973. *They Named Me Gertrude Stein* (New York: Farrar, Straus and Giroux).

IN PRAISE OF THE EAR (GLOSS'S GLOSSES)

THOMAS G. PAVEL

After forty, Gloss, who once had been the most fervent reader of all my friends, turned away more and more from the company of books. For a while, he still leafed through old favorites, *Agamemnon, Tamburlaine, Molloy*, but soon even these dignified friends of his youth lost their grip on him. "I don't understand the black signs before my eyes anymore," he complained to me. "Some are larger, some smaller. The lines often stop soon after the middle of the page. In such cases, columns of figures run down along the white margin. When I still followed the signs, there were lines which filled me with tremor. Listen:

> Now clear the triple region of the air
> And let the majesty of heaven behold
> Their scourge and terror tread on emperors. . .

or:

> Watch me closely. I take a stone from the right pocket of my greatcoat, suck it, stop sucking it, put it in the left pocket of my greatcoat. . .

The rest I forget. It's a pity, since these are not beauties to be reflected in small fragments. How can I convey the majesty of the horns and trombones in the second movement of the Fifth Symphony, just by humming a couple of bars?"

"But, Gloss," I intervened, "not so long ago you still enjoyed declaiming long set-speeches about ravenous desires, gods, blood, stones, heavenly bodies. . ."

"Perhaps. Today, however, even if I tried, which I don't, I wouldn't hear the words, my own voice. Books must indeed be derelict, a theory which I never deigned to consider before. Books are too well concocted, too eagerly coveting the calm glitter of irreversible achievement. They repel me now, as I have no strength to stand up to their luster. But perhaps it was we who didn't measure up to their demands? Too much pride? Too much conceit? Weren't

we the fathers, the authors of these considerable feats of the mind, forever enshrined in their resistent ideality? And then, suddenly, remember? the crumbling down, an eidetic storm, fast cross winds, forgetfulness, rebellion, the poisoning of wells and rivers, the sacrifice of our own kind. For what fathers are ever obedient to their sons?"

His eyes turned away from me.

"Signs were demonically inverted," he went on, "texts grew a venomous bark around them, but I expected the stem to pursue its noble, hidden life. It was my task, I believed, to keep the core from drying out, and since the written word had failed us, only the vividness of the voice remained to be counted upon. For a while, I tried to recover the balance of the world by warming up dead writings, holding them close against my voice. But somehow my utterances stopped short of being effective. Not that they were too frail for their task. On the contrary, the flaw lay rather in their assurance, in their monotonous pride. It felt as if through my mouth someone else was shouting 'Friends, Romans, contrymen, lend me your ears,' as if the radiance of my accent was but a trap designed to allure defenseless, vacant minds. Fortunately, there was no-one around to listen. Lone beholder of my own performance, I shook my ears in displeasure. The sentiment was insidiously developing that far from redeeming the fatigue of the written words, the efforts of the voice actually caused their decay."

At that time, I didn't fully grasp his point, but I didn't venture to ask questions, since Gloss's answers were always less precise than his first statements.

<p align="center">*</p>

Less than six months after his second divorce, Gloss got entangled in a passionate, exclusive love-affair with a woman barely twenty years of age. To his embarrassed friends, Gloss claimed that he had at last uncovered the reasons for the failure of Western metaphysics.

"As the Doctor Elusorius has shown," he emphatically told me, "we staked it all on the force of our voice, as if indeed we could purely and perfectly hear ourselves while speaking. But the emission we perceive is in no sense ours. Too many mediating mechanisms let their grating and creaking be heard along with the impulse, covering it like a transcendental jamming device." Gloss's speeches took off all too easily. "Similarly troubled," he went on in a meditative tone, "the lover loses all sense of orientation in the arms of his beloved. Is he himself experiencing love's labors and the anguish of pleasure? Can we purely and perfectly sense ourselves while loving? Here too the emission is in no way ours. Immersed in somatic turmoil, overpowered by dispersive forces, the grammatical subject fades away like a distant station dissembled by static.

"No, it was never we who immediately heard the circling about of our voices. We weren't equipped to penetrate the camouflage and detect the fading signal. But our ears couldn't help feeling the inadequacy. And so," he submitted hesitantly, "for metaphysics to arise as fictional immediacy between speech and audition, a vicarious ear was needed that would cancel the gap between our estranged voice and debilitated hearing, a perfect ear, having free access to our innermost inaudible vibrations, an ear more intimate to us than our own flawed intimacy."

I thought that his silence invited reply, but before I could start, he resumed:

"Then — but of course there is no genuine anteriority in this realm, these being not events but intermingled oily streams in the ontological flux: *toujours déjà* . . . — then, in a kind of gnostic procession, the thickened voice was separated from the perfect ear, each granted a body and a sex. Males, who received the gift of tongues, became *phonophores*, carriers of articulated sound. A splendid mission! Propelled by the rhythmic energy of breath, they ran vociferating endless sentences through the unfolding tabernacles of light."

At this point, Gloss went into a complicated purple passage, in which he linked the potentially infinite generative power of human grammars with the unfocused flow of temporality, only to merge them both, in a swift, decisive maneuver, into the relentless, repetitious, unfocused staging of male sexuality. His knowledge of the sources astounded me: he not only had digested phenomenology, linguistics, psychoanalysis and various other theories, some of which curiously bore names of cities, but also deftly referred to medical anthropology and to animal behavior, and adroitly extended game-theoretical economic models to libido and pre-marital affection. He dismissed as spurious my prudent suggestion that perhaps we don't know enough about the inner workings of the voice, he ridiculed conceptual analysis as phallocratic mania, and proceeded to classify the wrongdoings of masculine utterance: autocratic discourse (sin of duress) versus rhetoric (the vice of flexibility), magnanimity (the illusion of transcendent values) versus romanticism (the fallacy of immanent ones), charisma versus aggression (self-explanatory, he stressed), as well as scores of other categories, which I did not keep record of. The meek voice had its own trappings, to be sure: control and seduction, politeness and intimacy, charm and reproach softly echoed the louder transgressions.

None of these abuses could, however, have been perpetrated, he insisted, if woman hadn't been *toujours déjà* constituted into a perfect ear. How did this happen? Gloss didn't elaborate on the transhistorical procession that, he thought, made temporality itself possible, dividing and letting flow — these were his own words —,

in the same movement, speech, embodied sexuality, and the wager of history. For more detail, he sent me to the *Enneads* and to the *Zohar*, but I didn't follow the lead and for a while had no more glimpses into Gloss's effervescent mind.

*

Then it turned out that his paramour was the single mother of a three-month old baby. Gloss himself broke the news, in his usual high-pitched, precipitous enunciation. The circumstance moved him considerably, in so far as it appeared to offer new evidence for his gyno-acoustic convictions. His friend could hear her daughter's slightest moan, sounds below the threshold Gloss assured me, and uttered from beyond the critical distance. Our survival depends on maternal hearing; special substances secreted by the alerted body virtually force the mother to run to her crying child.

In his early years at Kron, Gloss had earned a somewhat questionable living as a censor with the Repertory Theater, a position that put him in close touch not only with the ever-suspicious local authorities, but also with the most famous dramatic texts, which, with an adept hand, he pruned of potentially harmful passages, and offered, thus mutilated, to the poor performances of a third-rate resident company. Molière was one of the old warhorses of the enterprise, and at that time Gloss exuberantly admired the tact and decorum of his plays, which on several occasions he diligently scrutinized, scissors in hand, looking in vain for unwholesome lines.

Alluding to those happy days, "Do you remember Agnès in *The School for Wives*?" I teased him. "She believed that children are begotten through the ear."

"Indeed they are! She is right," retorted Gloss. "What good does it do her tutor Arnolphe to have, for a while, the laughs on his side? And what advantage does he derive from mastering speech, almost to a monopoly? Power over words is the most difficult to share," he said, with his eyes running over the bookshelves. He found the book in a pile behind his armchair. "Arnolphe intends to stay in control and to protect his ward from the exuberant, corrupting practices of discourse. Listen to him:

> O learned ladies, heroines of the age,
> Gushers of sentiment, I say that you,
> For all your verse, and prose, and billets-doux,
> Your novels, and your bright accomplishments,
> Can't match this good and modest ignorance.

"In a sense, Arnolphe's enterprise appeals to me, since there is nothing a priori wrong with watching over a young soul surrounded by dangers and temptations. Does not Agnès herself cooperate, by offering an essential clue to the best strategy? She asks whether children are begotten through the ear: thus, Agnès hints that she,

a woman and a childbearer, spontaneously conceives of herself as centered around the organ of hearing. Of course, the conceited tutor fails to catch the indication! He is stubbornly treating Agnès like a voice. Fatal policy! His efforts are sometimes preventive in so far as isolation is supposed to keep her from learning the dangerous utterances. But sometimes he takes a normative stand, for instance when he forces Agnès to read aloud *The Maxims of Marriage*, the clumsiest apology for female servitude. Notice his way of commending the text."

Gloss turned a few pages and declaimed in his old-fashioned way, vibrating the *r*'s:

> 'T was written by some man of pious life,
> And I want it to be your only conversation.

"Some man of pious life!" Gloss exclaimed. "The inept pamphlet must be of Arnolphe's own invention. And he is so explicit! "I want it to be your only conversation." Arnolphe attempts a *transfer of voice*. Having evicted all other sources of speech from Agnès's surroundings, he proceeds to the implantation of his own discourse in Agnès's mouth. To turn a woman into a vocal automaton! How misconceived the approach! For, since Agnès, of her own accord, is but an ear, to train her as a voice cannot but misfire." Gloss shook his first towards me and, unfolding his fingers one after another, said: "First, ears cannot be effectively protected. Unable to close, like lips, lacking ear-lids, hearing stays always on the alert. Second, sound-proofing does not function well. Stuffing the ear with wax (Ulysses' technique[1]) doesn't suffice. Isolation of the ear's drum does not prevent sound vibrations from reaching the interior labyrinth via the skull's bones. Third, imprinting traces on a faithful memory is a typically vocal technique. But the ear functions by anticipation and interpretation. Incidentally, this contrast explains why Arnolphe is so obsessed with marital fidelity. The very definition of voice and malehood is threatened by the slightest flaw in ideality and perfect repetition. The ear, however, needs a different air, repetition dulls its acuity, the vacuum of ideality nullifies its operation."

I tried to protest, but once his voice reached a certain pitch, it was far from easy to stop Gloss's delivery.

"The acoustic structure of consciousness displays a meontic rhythm. With each temporal pulsation a resonating space is projected, whose enigmatic deployment both captures sound and

1. In a conversation whose transcript I was unable to recover, I asked Gloss whether the encounter between Ulysses and the sirens doesn't contradict his conceptions. My friend vehemently denied this, arguing that Ulysses' is the story of ritual change of sex for initiation purposes. Attached to the symbolically explicit mast, the hero temporarily turns into a woman, all ears, all vulnerable to the birds' (another male symbol) seductive voices.

renders it possible. Nothing is farther from passivity, nothing less susceptible to action predications either." In a lower tone, he confessed: "On the rare occasions when my fleeting intuitions remain with me an instant longer, I seem to apprehend the inexpressible movement carrying me away, shaping me up, as elusive as astral revolution, as decisive as historical conglutination. Some call this inaudible movement attention, but it would be wrong to reduce an all-encompassing structure to a local faculty of the mind." And then, with a tremor, he uttered the calculated finale: "If 'attention' must be used, then let us be aware that here we encounter in awe the transcendent attentive breath moving upon the surface of the waters."

*

I never knew how serious Gloss's conjectures were; his half-statements, ambivalences and self-contradictions always bewildered me. Meditating on his identification of the female body with an ear, I was tempted to dismiss it as yet another of his histrionic myths, a counterpart perhaps to the old topos of the silent woman; but I could not help telling myself that even when invented by capricious, playful minds, myths have a way of secreting an unexpected kind of truth. And if intensity of belief grants myth an additional validity, then my friends's opinions were worthier than most, since in spite of his moodiness, Gloss stood behind each of his successive whims with unparalleled fervor and frightening intensity. As usual, he again failed to construct a coherent argument and to bring some natural or historical proofs in support of his allegations, leaving me with the unrewarding task of justifying an allegory I did not necessarily want to believe in. The metaphor of woman's body as an ear haunted my imagination: to conjure it away I tried to link it to particulars of the social positions assigned to woman in the past or the present. I remembered that, as sociolinguists assure us, cross-culturally, women speak better, more correct idiolects of their language than men, which suggests a natural sensibility of the female ear; yet, the ideal of the silent woman as well as the widespread norm asking women to speak in a low voice, seems to signal culturally determined attempts to mutilate the female voice. But were these attributable to what would today be called phallocracy? Gloss, as I knew him, would have argued back, reminding me that most often gods and beauty are conceived of as silent.

Sometimes I told myself that perhaps natural and historical grounding would ludicrously contradict Gloss's intentions. To compare the entire body to an ear and then to extract metaphysical qualities from physiological traits resembles the venerable practice of modeling moral and philosophical notions after bodily activities. As even superficial acquaintance with etymology shows, our intel-

lectual terms derive from words that originally designate humble realities; and who does not know that the light, the shadow, and the eye constitute the metaphorical core of traditional epistemology? In a sense, to build a semiotics of the ear appeared to me quite archaic, since the nobler functions, such as sight, breath, and speech ceased long ago to offer the favorite ground for theoretical tropes: many of our contemporaries fell back on the excretory-reproductory organs. But having known Gloss for a long time, I was quite assured that he disliked this practice, and it occurred to me that one of his aims may have been to remind me and himself that older metaphors are still available, waiting to be explored.

For, in spite of his vocabulary, which he often borrowed from the latest fad, Gloss was an old-fashioned person. In one of our conversations he praised virginity, noting that the female body is the only ear whose drum must be broken in order to allow it to hear. "But what can be detected by such audition?" Gloss wondered. "The deaf musician presses his chin on a wooden stick propped against his piano, trying to grasp a faint vibration. Likewise, women in love cling in rapture-torture to their lovers' bodies, as a last resort against dreaded silence. How incomparably keener is the calm ear of innocence!" Another time he asserted that the worst sin is not to listen; he went on to say that we live in a narcissistic time, when no-one lends his ear to the utterance of his neighbor, the faculty of discerning the sound of truth being lost. He deplored the decay of courtship, of patient seduction, which he believed to be the *sine qua non* of semiotic proficiency in matters of love — and beyond. Is difference not born from deferral? And so on.

*

On seduction he was to meditate again, and quite soon. Only a few days later, his paramour's baby found a prospective father. The candidate, a man in his early twenties, turned up after a journey to India, and undertook to win back the affection of his forlorn beauty. The presence of a rival stirred Gloss's feelings beyond anything he had experienced before. He stood up to fight for his sentiment, to the extent of offering his beloved financial support, even, some say, marriage and adoption of the child. Certainly, as a repentant seducer, his opponent had the upper hand; nonetheless, to the utter displeasure of his friends, Gloss, who was playing the part of savior and provider, stood a good chance of prevailing. He didn't harass his lady with pleas and promises. Claiming to have learned strategy from *The School for Wives*, he played down his advantages and emphasized his imprecise, but ardent feelings.

I should have refrained from mentioning Molière's comedy to Gloss in the first place. The play became an obsession. He took me to a rather predictable performance of it, in which Arnolphe, who

wore the outfit of a Nazi officer, cruelly abused Agnès, dressed as a camp prisoner. Horace, the young lover, had the appearance of a punk rock singer, winning Gloss's noisy approval.

"Admire this man's tact," he told me after the performance, on the cold, slippery streets. "Horace's first encounter with Agnès consists simply of a lengthy dumb show. When he is later accepted into her company, he reinforces Agnès's image of herself as a reverberating ear. Remember?

> He said to me, in the most charming fashion
> Things which I found incomparably sweet,
> And never tire of hearing him repeat,
> So much do they delight my ear, and start
> I know not what commotion in my heart."

Muffled by the snow, Gloss's voice moved calmly through the night. We stopped in front of his house. He grabbed the fur lapel of my coat and insisted:

"To activate the anticipating powers of the ear, meaning must be reduced to an alluring minimum. A multitude of barely perceptible caresses elicits more arousal than explicit touches. Likewise, the lover's murmur awakens the ear by its very diffuseness. Seduction consists in letting the voice espouse the anticipating ear in its very dispersion. To broadcast is to be spread around, to let one's voice be overcome and scattered by the moving vortex of the ear. To such an approach Agnès shall not resist. The acoustic structure of consciousness is designed precisely to be maximally aroused by, and in turn maximally to encourage the diffuse voice. The impalpable fit succeeds instantaneously, and if the two lovers' happiness depended only on consent, the comedy would be over before it began."

I politely declined his invitation for a drink. Stamping my feet, I listened to his concluding voice:

"As the matter stands, the only motive for action and suspense lies in Horace's ambivalence. With Agnès, he lets himself be led by the fuzzy but flawless logic of the ear. With Arnolphe, by contrast, he indulges in the well-articulated but inept logic of the voice. The itch for explicitness and the vanity of speech push him over and over again to confide the details of his adventures to Arnolphe, whose links with Agnès he should have guessed much earlier. Pride of voice should lead him to catastrophe. The comedy sometimes borders on melodrama. If in the end the older man fails, it is only thanks to the law of the genre which gently intervenes to appease the tensions and mitigate the consequences."

I left chilled to the bone, determined to avoid classical theater for a while.

*

Physiognomists are right: our traits and movements entertain close links with our fate. Gloss, who exhibits an impetuous, heavy gait, impulsive gestures, the face of a bull-dog, seems to attract sudden, swift blows of destiny. Once again the inevitable occurred without delay. Within a few days, the young object of his passion decided to share her apartment with the prodigal father and stopped seeing Gloss, refusing furthermore to answer his insistent telephone calls. Deeply affected, Gloss considered suicide, expatriation, taking vows, and changing careers. I was a witness to his long deliberations, during which he referred bitterly to the phenomenology of the ear: it now seemed to him that all these speculations missed their point; strategy didn't matter, voice or ear meant the same, it was the young anyway who succeeded, after forty life wasn't worth living, etc. Genuinely worried by his spasmodic, hurried delivery, by his prostrated look, by his increased solitude, I tried to help, but to no avail; he didn't lend his ear to my consolations, nor did he listen to my advice. In one detail of his lamentations I found, however, a glimmer of hope: in the midst of his sorrow, Gloss never blamed his former girl-friend:

"There were two possible reasons for her choice: either my voice wasn't supple enough to let itself be shown the path, or her ear didn't orient its calling power towards me. Or perhaps it did, though only with ephemeral force. But, then, how is "ephemeral" possible? Why do we mostly think in terms of yes or no, as if when a key is touched, the sound shall reverberate forever? How should we handle forgetfulness, betrayal, loss, end of sound? Besides the self-indulgent verbiage on finitude, what do we know about tenure and termination? The violence of our passions we can discern, but not their depth, that is to say, their duration."

Eyes closed, the lowered chin pressing the rings of fat, he went on:

"To eliminate the noise, to clear the voice! Again and again, the misdeed won't be found but within ourselves. No Plotinian generation and corruption process bred the flaw! We ourselves separated voice and ear, each of us sliding down his own slope, perseverant, unrestrained. We demand to be heard, but do we know how to detect the silent beams projected by the ear? And even when we measure the extent of our ignorance, where shall we turn for training?"

During the following weeks, my friend became less communicative; he frequently took long walks to the surrounding hills, where he once paid a visit to the Benedictine Abbey; he also met with Rabbi Nachman, a Hasid who served in a small synagogue close to the Irish neighborhood, and, in addition, consulted a psychologist and signed up for an aerobics course.

With such diverse medicine, Gloss recovered his serenity soon enough. The only further allusion to this episode, which his friends labelled "the acoustic period," came when, in a different context, Gloss recommended to my attention the following passage:

The same words (e.g., a man says to his wife: 'I love you') can be common-place or extraordinary according to the manner in which they are spoken. And this manner depends on the depth of the region in the man's being from which they proceed without the will being able to do anything. And by a marvelous agreement they reach the same region in him who hears them. Thus, the hearer can discern, if he has any power of discernment, what is the value of the words.

But he made no comment. By that time, he was already seeing an unattached, active, outgoing, sensitive, artistic, nature-loving woman, and enjoying the reading of *Pilgrim's Progress.*[2]

2. The quotations from Molière were adapted from Richard Wilbur's translation. The last quotation comes from Simone Weil. I wish to express my gratitude to Christine Brooke-Rose and Susan Suleiman, whose patient criticisms and encouragement made this paper possible.

DEATH

DANGLING VIRGINS:
MYTH, RITUAL, AND THE PLACE OF WOMEN IN ANCIENT GREECE

EVA CANTARELLA

1. In Diogenes Laertius's lives of the philosophers (Diog. Laert. 6, 52),[1] we come across an unusual anecdote: one day, Diogenes the Cynic, while strolling among the olive groves, saw several hanged maidens swinging from the branches of the trees. At this sight, he exclaimed: "If only all trees bore such fruit!" Is this a case of particularly acute misogyny? Perhaps. But, beyond the initial impression, what is most surprising about the episode is not Diogenes' hatred of women. In a society, such as that of the Greeks, which completely excluded women from social, cultural, and political life, feared them and scorned them, misogyny not infrequently reached levels of particular intensity.[2] It is sufficient to turn to one famous example among many: Hippolytus's invective against woman in Euripides' tragedy of the same name (*Hipp.* 616 sq.):

> "Oh Zeus, whatever possessed you to put an ambiguous misfortune amongst men by bringing women to the light of day? If you really wanted to sow the race of mortals, why did it have to be born of women? How much better it would be if men could buy the seed of sons by paying for it with gold, iron, or bronze in your temples and could life free, without women in their houses. . ."

I could give further examples and they would confirm that Hippolytus's opinion of women was anything but singular (see Cantarella 1981:35). What is most surprising in Diogenes' anecdote is not the philosopher's misogyny, but something else: his complete

1. All citations of classical works follow the format of the Oxford Classical Dictionary. These works are not listed in the References at the end of this essay.
2. For a general view of women's condition in ancient Greece, see Pomeroy (1975), Boulding (1975:244), Shaps (1979), Lefkowitz (1981), Lefkowitz and Fant (1982), Cantarella (1981).

lack of wonder at seeing several girls hanging from a tree.[3] Indeed, Diogenes Laertius's story creates the impression that for a Greek it was quite normal to see hanged women swinging from trees along the road. And what if this impression contained some element of truth? What if, in some way, the anecdote had a basis in reality?

2. The frequency of female hangings in Greek texts is, in effect, such as to make legitimate this hypothesis, that is, that the link between girls and the *brochos* — the mortal noose — might not be occasional, fortuitous, or merely accidental; that between girls and *brochos* in Greece there might be a constant, consolidated, almost institutional link. Numerous considerations support this idea.

The *brochos*, the noose that swings one in the air, is, in effect, the privileged instrument of female death.[4] In the Homeric poems, the noose is the instrument with which Epicaste (Jocasta's Homeric name) kills herself after having discovered the horror of her incestuous marriage (*Od.* 11, 269). In Sophocles' tragedy, Antigone uses the noose to kill herself. By hanging, she escapes the tyrant Creon's sentence which condemned her to being buried alive (*Ant.* 1204). In a series of myths, female suicides by hanging are *aitia*, that is, they explain religious rites, the structure of which is uniform throughout the Greek territory.

Which myths? Let me start with a Laconian rite. In Caryae a feast was celebrated in Artemis's honor in which dancing choruses of Spartan virgins took part (Paus. 3, 10, 7). The feast celebrated an event: "cum luderent virgines, meditatus ruinam omnis chorus in arborem nucis fugit, et in ramo eius pependit" (Schol. Stat. *Theb.* 4, 225). The event celebrated was as follows. While dancing, the maidens who made up the chorus had been frightened by a menace. To escape it, they hanged themselves from a walnut tree and, as the text proceeds to narrate, were reborn in the form of fruit hanging from the branches.

It is not difficult to imagine the nature of the menace. The frequency of rape in Greek myths leaves little room for doubt. But we are interested in something else, the fact that the rite celebrated a hanging of virgins which, in this particular instance, had been a collective hanging.

Let me move on to a second example. Plutarch describes a feast celebrated in Delphi, called Charila (*Quaest. Graec.* XII, 293 E). The myth that explained this ceremony tells of Charila, a little orphan who, in times of great need, had gone, along with a crowd, to petition the king for food. But the king, in repulsing the crowd, had kicked the child. And, poor as she was, the proud child hanged

3. See Brelich (1969:444, n. 2).
4. See King (1983), Loraux (1984a and 1984b).

herself by her belt. After this, the hardships of the city became so aggravated that the oracle was called upon, and declared that Charila's death must be expiated. Thus we have the rite in question. Every eight years, a feast was celebrated in Delphi in which the "king," after having distributed cereal among the people, kicked a doll representing Charila. The doll was then carried in procession up to the place where Charila had hanged herself and it was buried in the earth with a noose around its neck.[5]

A third example: in Thessaly, in Melitaea, a tyrant by the name of Tartarus sent his soldiers to capture maidens and bring them back to the palace where he would rape them. One Virgin, Aspalis, managed to escape the outrage by hanging herself before the arrival of the soldiers. To avenge her death, her brother Astigite then dressed up as a woman and, in his sister's place, was brought before the tyrant whom he killed. The people now proclaimed Astigite king and searched for Aspalis's body so that it could be buried. Upon reaching the scene of the suicide they failed to find the maiden's body. It had mysteriously disappeared and, in its place, a new body had appeared which was called *Aspalis Aimelete Hekaerge*. This event was celebrated every year in Melitaea by a rite in which the virgins of the village killed a goat and hanged it, as Aspalis had hanged herself (Ant. Lib., *Met.* 13; Nilsson 1967:235; Brelich 1969:444).

I can give still further examples. In Athens, a feast called *chytroi* (the pots) was celebrated every year with the cooking of a special food called *panspermia* (*FGrH* 115 F 347a). What interests us here is another phase of the celebration during which the maidens sat on swings. Here, too, a myth explains the reason for the rite. After Orestes avenged his father Agamemnon by killing Aegisthus and Clytemnestra, Erigone, their daughter, swore her parents' revenge. She followed Orestes to Athens in the hope of punishing him, but when Orestes was acquitted, she became distraught and hanged herself.[6]

Yet here, too, the maiden's suicide had ill-omened consequences: Athenian maidens, in imitation of Erigone, killed themselves en masse, thus endangering the future of the city which was left almost entirely without marriageable women. When the oracle was, as usual, called upon, a single answer was given: to avoid Athens's demise, swings had to be built so that girls could rock on them (Hyg. *Fab.* 130). Why? I shall return to this point later; for now let me just say

5. On the feast, with different interpretations, see Usener (1875:182), Jeanmaire (1939: 407 sq.), Nilsson (1967:460), Brelich (1969:428, 443), Gernet (1968:231).

6. *Et. M.* 42, 3 (*aiora*). See also Hesych. *aletis*; Hyg. *Fab.* 122; Paus. 2, 18, 6–7; *FgrH* 239 A 25. According to another version of the myth, Erigone was the daughter of an Athenian citizen named Icarius, and hanged herself when she discovered that her father has been killed: see Apollod. *Bibl.* 3, 14, 7; Hyg. *Fab.* 130; Ael. *V.H.* 7, 28.

that swings symbolized both death by hanging (see also Festus 212 L), and were considered capable of producing magic effects, thus exorcizing the ill effects produced by hanging (Serv. *ad Georg.* II, 389).

3. The noose was not only the privileged instrument of female suicide, but also, very often, that with which women were killed.

Let me begin here with a Rhodian legend told by Pausanias. Helen, in exile from Sparta after the death of Menelaus, asked her friend Polyxo for assistance. But Polyxo, whose husband had been killed in the Trojan War, decided to use the occasion for her revenge: she made her slaves dress up as Erinyes and sent them to hang Helen (Paus. 3, 19, 6). Even more interesting than the Rhodian legend, which tells of a hanging for revenge, are those texts which refer to hangings as punishment.

Upon his return to Ithaca, Ulysses kills Penelope's suitors and those dependents of the house who have been unfaithful to him. But he chooses different deaths for men and women. Melanthius, the unfaithful goatherd, is killed by a sort of primitive crucifixion (*Od.* 22, 187–193), while the maidservants are hanged: "Like doves and turtle-doves caught in a net, their heads were in a row and around each one's neck was a *brochos*, so they died in the saddest way. And with their feet they kicked the air: but briefly, not for long" (*Od.* 22, 465–473).

Besides hanging women, making them swing in the air for some time, though not necessarily until death, was a form of punishment mentioned in Greek texts. "Do you remember when you hung high . . . and you hung in the air amongst the clouds?," Zeus asks his wife Hera in the *Iliad*, to remind her what happened to her when she was disobedient, and to warn her what will happen if she continues being disrespectful towards her husband (*Il.* 15, 18–21).

4. But why did Greek women, alive or dead, hanged or on swings, seem destined to dangle in empty space? Although it is not conclusive evidence for the Greek world, an observation concerning hanging in Rome may be pertinent.

In commenting on the death of Queen Amata, who hanged herself, Servius recounts that when the king Tarquinius Superbus had the sewers built those who had been forced to do this work, which was considered vile, hanged themselves. Tarquinius then ordered the cadavers to be crucified (Serv. *ad Aen.* XII, 603). While clearly unreliable on a historical level, the story is nonetheless significant, because of the explanation Servius gives of Tarquinius's gesture. The king had the hanged cadavers crucified to punish them for killing themselves by an *informe* — that is infamous — death.[7]

7. On this episode see Voisin (1979:422).

That the Romans considered hanging infamous is confirmed by other authors and in particular by Livy, who, in commenting on the death of Quintus Flavius Flaccus, writes that he died the most disgraceful death imaginable because he hanged himself (Liv. 42, 28). But why was hanging oneself so unbecoming? Pacatus, a fourth century writer, proposes an explanation. Death by hanging, Pacatus writes, is *inusta femineae mortis infamia*: it is a feminine death, unworthy of a man. A man, in fact, must kill himself with a sword (*Pan. Theod.* 28, 4). The link between woman and the noose was therefore perceived by the Romans as well.

But let me return to Greece. What are, in this culture, the reasons for such a close, continuous, almost obsessive relationship between hanging and the female sex?

5. I believe that to understand this it is necessary to recall the rites of initiation and, more particularly, the so-called rites of passage characteristic of societies organized according to divisions of the population by age groups.[8] It is well known that in these societies the passage of an individual from one age group to the next is accompanied by a series of rites which, beyond the sometimes relevant local variants, present common characteristics: the person undergoing initiation must, in order to pass into the next age group, symbolically die as far as the previous group is concerned and be reborn into the new group after a period of segregation, or isolation, during which he or she lives apart from the community and often outside the rules of civic life.[9]

The symbolism is clear. The rite of passage (specifically, in this case, the passage from the pre-pubertal to the pubertal age) signifies the death of the adolescent and the birth of an adult: in the case of male initiation, a man capable of fighting, and, in the case of female initiation, a woman capable of marrying and having children. The existence of rites of passage in Greece, intuited by scholars such as Jeanmaire, Brelich, Gernet and Burkert, has been confirmed by recent studies, which, from a different perspective and with reference to different cultural areas, have identified the characteristics of some of these rites.[10]

The hypothesis that in Greece, before the birth of the city states, societies were organized according to age groups is now accepted by most scholars, as is the idea that many religious ceremonies of the classical age retained the concept of the ancient rites of passage. I will limit myself to one example, which is in itself famous, the

8. See Van Gennep (1909), Eliade (1958), Brelich (1961 and 1969), Gluckman (1962).
9. For a list of different types of segregation, see Brelich (1969:29).
10. For the Dorian area see Calame (1977 and 1982). For the Attic zone see Lincoln (1979 and 1981).

ceremony known as *Thesmophoria*. Every year in Athens the story of Persephone, also called Kore, the maiden, was re-enacted in celebration. According to the story, one day while picking flowers, Persephone was abducted by Hades, the king of the underworld who had fallen in love with her and took her to the underground. Demeter, Kore's mother, managed to obtain her release from Zeus. Thanks to her mother's intervention, Persephone was able to see the light of day again (*Hymn. Hom. Dem.*).[11]

It is difficult not to notice the similarity between the myth of Persephone and the typical scheme of the rites of passage. Nor can one not be tempted to interpret the abduction as symbolic death, the months passed with Hades as a period of segregation, and her return to earth as a resurrection. Furthermore, it is impossible not to notice the analogy between this myth and the myths examined above.

Let me return briefly to these, in the light of what has been said. At Caryae, the virgins hanging from the tree are reborn in the form of walnuts. In Thessaly, in place of the hanged Aspalis's body, a new body appears which is honored as if it were hers although it is not. In both cases, then, a death and a resurrection: but a resurrection in a new and different form, which clearly symbolizes the change in the girl's status, her new social place.

Only the myth of Charila may, at first sight, not correspond to this schema. Charila is not resurrected. But the feast that celebrates her story, at Delphi, is connected with another feast, Herois. Plutarch, briefly explaining the significance of this feast, notes its mysticism, which was, he says, known to the Thyiades. It emerged from the representation of the return (*anagog*) of Semele (Plut., *Quaest. Graec.* XII, 293 C—E). Two very short, but nevertheless highly significant, remarks by Plutarch give the important role played by the same Thyiades during the Charila feast. (They were the ones who carried the Charila-puppet in procession to its burial.) The connection between the two feasts is then seen to be very likely, and once the connection is established, the character of the two Delphian feasts very clearly shows the structure of a rite of passage, characterized (like the Kore story) by a *kathodos* (descent, e.g., the puppet burial in Charila) followed from an *anodos* (ascent, e.g., the return of Semele in Herois).[12]

I shall now return to the girls rocking on swings during the feast celebrating Erigone. Balancing on a swing, in Greece, far from being just a girl's game, was also a rite. The scene painted on the Berlin vase nr. 2589 (*ARV*[2] 1131, 7; Deubner, 18; Nilsson, 37, 2), one

11. On the Thesmophoria see Lincoln (1972 and 1981), Chirassi Colombo (1979).
12. See Jeanmaire (1939:408).

of the best known swing-paintings of Greek art, is anything but insignificant from our perspective.

a) Under the image of the girl on the swing are three letters ΑΛΗ; these are the first three letters of the name Aletis, the vagabond, Erigone's nickname and also the name of the song that the girls used to sing during the feast (Ath., 14, 618 e; Pollux 4, 55; Hesych., s.v. *aletis*).[13]

b) Far from being a simple piece of wood, the swing is a throne, complete with wooden legs and covered with a drapery.

c) Last but not least, the girl is pushed by a satyr. The symbolic value of the rite is easily perceived: swings are connected with sexual intercourse.

But death by hanging – as I have already noted – is also connected with sexual intercourse.[14] Among the diseases that can affect virgins, the *Corpus Hippocraticus* lists a type of epilepsy, characterized by its very peculiar consequences: the propensity of sick virgins to commit suicide by hanging themselves. Luckily, according to the text, recovery from such an ailment is very easy. Since it is caused by sexual abstinency (or more precisely by the refusal of the virgin to be married), the disease disappears upon marriage (*Corp. Hipp.*, VIII, 464–471).

Let me now come back to the connection established by Pausanias between the swing and death by hanging. In describing a painting by Polignotus, representing Phaedra on a swing grasping a rope on each side, Pausanias comments that Phaedra's attitude "though quite gracefully drawn, makes us infer the manner of her death" (Paus., 10, 29, 3).

What if, finally, we connect the sequence "swing–hanging–sexual intercourse" with the initiation rites, specifically with the feminine rite of passage from the prepubertal to the pubertal age?

To conclude so far:

a) During those rites, a virgin had to disappear and a *viripotens* woman had to take her place.

b) During the feast in honor of Erigone, in whose structure we recognized the schema of a rite of passage, girls rocked on swings.

c) The swing symbolized both sexual intercourse (the event that transforms a girl into a woman) and hanging, the type of death we met in the various initiation myths we discussed.

Let me add that Aletis, Erigone's nickname and the name of the song in her honor means "the vagabond," a name evoking a person detached from her usual milieu, cut off from the community. And let us recall, finally, that the symbolic death of initiation is accompanied, and sometimes represented, by a period of isolation: is there

13. Daremberg and Saglio, s.v. *aiora*.
14. See Lefkowitz (1981:12), Campese-Manuli-Sissa (1983:149), King (1983:109).

anything more separate, more isolated than a person on a swing, raised above the earth, suspended in mid air?

Are we entitled, on these grounds, to suggest that swinging was a pattern of ritual death during the female rites of passage from the prepubertal to the pubertal age? I believe we are. As Picard already showed (1928:47), swinging was a fertility rite from oldest antiquity; thanks to its several meanings, rocking on a swing helped girls to leave virginity behind and emerge as women fit for reproduction.

6. Once established, the relation between swinging–hanging and the feminine symbolic death of initiation may suggest a further consideration. Both in hanging and in rocking on a swing, women are detached from the ground, separated from earth. But since oldest antiquity, the Western imagination has closely connected women with the earth.

As far as Greek fantasy is concerned, Hesiod tells us that Zeus, enraged with Prometheus, decided to send among the mortals Pandora, the first woman, in order to chastize them. Beautiful, appearing like a chaste virgin, possessing grace and skill in female endeavors, Pandora had nonetheless the "soul of a dog and a deceiving character," was "full of lies and deceitful words." She was for men, clearly, nothing but a "*dolos amechanos*," an inescapable trap, an evil which was all the more serious because all the more attractive (*kalon kakon*: Hes., *Op*. 59 sq.).[15] And how was Pandora made? Of earth (*Op*. 61). Thus it was the earth, the material out of which women had been created, with which the female sex was identified: the earth, which before becoming a *patria* was "mother earth,"[16] a fruit-bearing mother, like women. And women's role in Greek culture and society shows very clearly how strong this identification was.

I shall limit myself to one example. Women, in Athens, could not inherit the paternal estate. If an Athenian citizen died leaving only a female heir, the daughter, called *epicleros*, had to transmit the paternal estate to a male: obviously, one born of her. To avoid any alien blood in this male, the law states that the *epicleros*, must marry her closest relative, as a rule, her paternal uncle, and that, if she is already married, she is to be taken from her husband and assigned to the function that the city ascribes to her: that of producing "fruit" for her family.[17]

The identification between woman and fruit-bearing material was not, in fact, limited to the Greek world. Even though they did not "mythologize" it, the Romans also had this idea clearly in mind.

15. See Loraux (1981).
16. On the connection women-earth see Bachofen (1948).
17. See Schaps (1979:25).

Thus in the Republic, the Roman jurists debated this issue: must a female slave's children be considered "fruit"?

The problem arose for a precise reason. According to the law, fruit belonged to the owner of the mother-object. But when the mother-object was held in usufruct, it belonged to the usufructuary. Now a slave could also be held in usufruct, and in that case her fruit, that is her children, would have to belong to the usufructuary. But this fruit was too precious for the class of slave owners to accept the risk of losing it without putting up a fight. That is why in the Republican age the jurists began debating the issue;[18] until that time, nobody had ever doubted that the slave's children were fruits.

But let me go back to the subject I started with: the dangling virgins. In addition to the symbolic value of a fertility rite, could swinging have the further meaning suggested by the identification of women and earth? Was perhaps this identification and the fact that swinging, like hanging, separated women from the earth, the reason why hanging was a kind of death particularly appropriate for the female sex?

In effect, it is difficult to imagine a better way to symbolize the death of a woman than by separating her from the earth. But even apart from this additional suggestion, what I discussed before seems to me sufficient to propose a hypothesis: the noose was not a type of death that women chose by chance, without reason. By hanging themselves (and by being hanged) women reproduced in the city an archaic, pre-city image which — while at this point deprived of its original meaning — remained in the memory of the Greeks. The link between women and the noose, which is so frequent in literature and in iconography, is founded on a quasi-institutional link.

7. But what happened when precivic society was replaced by a political one? What happened with the birth of the city-state?

With the new organizational model, a new way of classifying individuals came into being. In the pre-city societies, age groups were divided by sex: what placed an individual in a specific group was first of all — even before his or her age — his or her sex. Thus, the fundamental dichotomy between bodies was male/female.

With the advent of the city, things changed. At the basis of city organization a new and different dichotomy was imposed: that between free and slave. Freedom and slavery became the poles of a new opposition which, in the terms of the Roman jurists, soon became the new *summa divisio personarum* (Gai., *Inst.* 1, 19). Now

18. During the second century B.C. the problem was discussed by the jurist Brutus, whose opinion is expressed in Justinian's *Corpus Iuris Civilis* (*Digesta* 7, 1, 68 pr.); the echo of the discussion was still living in the second century A.D. (*Digesta* 22, 1, 28 pr.).

an individual's life patterns were inexorably determined and differentiated according to whether one was free or a slave.

The old dichotomy was thus replaced by a new one, which means that a natural criterion was replaced by a legal and artificial one. But the Greeks did not perceive the latter as such. The Greek city, as one can infer from Aristotle's works, perceived the difference between free and slave as being equally natural to the sexual one. A slave is "different" from a free man, Aristotle explains, because he is without *logos*, that is without reason, without power of deliberation (*Pol.* 1245 b). This made the slave "naturally" different from the free person and therefore justified the slave's subjection, rendered it inevitable, and made him an "object" and not a "subject" of law.

This is too well known to dwell upon, however. Suffice it to say that the opposition between free and slave was not, historically, the first basic dichotomy of Greek organization. It came into being with the city and, with the solidification of the city, took the place of the male/female opposition which, in the precivic age, far from being merely a biological distinction, had been one of the cornerstones (or rather the first cornerstone) of social organization.

Several traces of this primitive fundamental dichotomy still survived, in some form, in the culture of the Greek city-states. In grafting its structures on to the old tribal structures at the moment of its birth, the city respected its ancestors' rites and symbols, not only by reproducing them in civic festivals (as in the celebration of Charila at Delphi or the feast of Chytroi at Athens), but also by transferring the memory of the ancient female "death" of initiation into a real and tangible practice, a lethal choice which put women in their place, where it was right for them to be, even when leaving life. Deprived of its symbolic value, separated from the social and religious context which had produced it, hanging continued to be, in fact and in social evaluation, a characteristically female death. The sign of female nature and of its difference continued to determine not only the lives of women, their social and legal status, but also their road to death.

REFERENCES

Bachofen, J.J., 1948 (1861). *Das Mutterrecht* (Basel: K. Meuli).
Boulding, E., 1975. *The Underside of History* (Boulder, Colorado: Westview).
Brelich, A., 1961. "The Historical Development of the Institution of Initiation in Classical Age," *Acta Antiqua* 9, 3–4:267–283.
 1969 *Paides e Parthenoi* (Rome: Ateneo).
Burkert, W., 1972. *Homo necans: Interpretation altgriechischer Opferriten und Mythen* (Berlin: Walter de Gruyter).
Calame, C., 1977. *Les choeurs de jeunes filles en Grèce archaïque* (Rome: Ateneo).
 1981 "Hélène (le culte d')," in: *Dictionnaire de Mythologies* (Paris: Flammarion).

Campese, S., P. Manuli and G. Sissa, 1983. *Madre materia: Sociologia e biologia della donna greca* (Torino: Boringhieri).

Cantarella, E., 1981. *L'ambiguo malanno: Condizione e immagine della donna nell'antichità greca e romana* (Rome: Editori Riuniti).

Chirassi Colombo, I., 1979. "Paides e gynaikes: note per una tassonomia del comportamento rituale nella cultura antica," *Quaderni urbinati di cultura classica* 30, 25.

Daremberg, C. and E. Saglio, 1877 sq. "Dictionnaire des antiquitées grecques et romaines" (Paris: Hachette).

Deubner, L., 1956. *Attische Feste* (Berlin: Akademische Verlag).

Eliade, M., 1958. *Birth and Rebirth: The Religious Meanings of Initiation in Human Culture* (New York: Harper).

Gernet, L., 1968. *Anthropologie de la Grèce antique* (Paris: Maspero).

Gluckman, M., ed., 1962. *Les rites de passage: Essays on the Ritual of Social Relations* (Manchester: University of Manchester Press).

Jeanmaire, H., 1939. *Couroi et courètes: essai sur l'education spartiate et sur les rites d'adolescence dans l'antiquité hellénique* (Lille: Bibliothèque universitaire).

Jones, J.W., 1956. *The Law and Legal Theory of the Greeks* (Oxford: Clarendon).

King, H., 1983. "Bound to bleed: Arthemis and Greek women," in: A. Cameron, A. Kuhrt, eds., *Images of Women in Antiquity* (London/Camberra: Croom Helm).

Lacey, W.K., 1968. *The Family in Classical Greece* (London: Thames and Hudson).

Lefkowitz, M., 1981. *Heroines and Hysterics* (London: Duckworth).

Lefkowitz, M. and M.B. Fant, 1982. *Women's Life in Greece and Rome* (London: Duckworth).

Lincoln, B., 1979. "The Rape of Persephone: a Greek Scenario of Women's Initiation," *Harvard Theological Review* 72:3–4, 223–235.

 1981 *Emerging from the Chrysalis: Studies in Rituals of Women's Initiation* (Cambridge, Massachusetts: Harvard UP).

Loraux, N., 1981. *Les enfants d'Athéna. Idées athéniennes sur la citoyenneté et la division des sexes* (Paris: Maspero).

 1984a "Epouses tragiques, épouses mortes. La mort des femmes dans la tragédie grecque," in: *La femme et la mort* (Travaux Univ. Toulouse-Le Mirail) Série A, No. 27.

 1984b "Le corps étranglé," in: *Actes de la Table Ronde: "Du châtiment dans la cité. Supplice corporel et peine de mort dans le monde antique"* (Roma: Ecole Française de Rome).

Nilsson, M.P., 1967. *Geschichte der Griechischen Religion* (Third edition, Munich: Beck).

Picard, Ch., 1928. "Phèdre à la balançoire et le symbolisme des pendaisons," *Revue Archaeologique* 5:28, 47–64.

Pomeroy, S.B., 1975. *Goddesses, Whores, Wives and Slaves* (New York: Schocken Books).

Schaps, D.M., 1979. *Economic Rights of Women in Ancient Greece* (Edinburgh UP).

Usener, H., 1875. "Italische Mythen," *Rhein. Mus.* 30, 182 ff. Reprinted in: *Kleine Schriften*, vol. 4, 39ff.

Van Gennep, A., 1909. *Les Rites de passage* (Paris: Nourry).

Voisin, J.L., 1979. "Pendus, crucifiés, *oscilla* dans la Rome païenne," *Latomus* 38:2, 422–450.

SPEAKING SILENCES: WOMEN'S SUICIDE

MARGARET HIGONNET

The death of a beautiful woman is, unquestionably, the most poetical topic in the world.

E. A. Poe, *The Philosophy of Composition*

I. INTERPRETATIONS: SUICIDE AS SIGN

Suicide, like woman and truth, is both fetish and taboo. A symbolic gesture, it is doubly so for women who inscribe on their own bodies cultural reflections and projections, affirmation and negation. In the nineteenth century, women's suicide becomes a cultural obsession. As Baudelaire suggests, the captain of this century — bracketed by Goethe's *Werther* and Durkheim's *Le Suicide* — is death.

To take one's life is to force others to read one's death. For when we categorize a death we do not record a pure fact (if any such exist). Rather, we produce a reading that depends upon the physical and subjective context: natural or unnatural death, homicide or suicide. As with all human actions, we ask questions about free will and determinism. In the case of suicide the hermeneutic task is particularly elusive. Only when the primary evidence has been destroyed does the trace exist to be followed and interpreted. Interpreters bring to the task different conceptions of the natural, different private and public aims or fears. Consequently, almost a century after Durkheim we do not have reliable national or comparative statistics, a problem that undermines Durkheim's own arguments. The difficulty or even impossibility of reaching a "correct" reading has led some to consider suicide a random phenomenon that corresponds to the infinite variety of human motivations. Women's voluntary deaths are even more difficult to read than men's because women's very autonomy is in question and their intentions are therefore opaque.

Long conversations with Patrice and Anne Higonnet helped shape this article; Guy Cardwell, Carolyn Heilbrun, Susan Suleiman, and Irene Tayler helped test my ideas.

To embrace death is at the same time to read one's own life. The act is a self-barred signature; its destructive narcissism seems to some particularly feminine. Some choose to die in order to shape their lives as a whole; others fragment life to generate the energy of fission or elision. In their deaths, many are obsessed with projecting an image, whether to permit aesthetic contemplation or to provoke a revolution in thought. The desire to control one's own life may extend into manipulation of the lives of survivors — and women are thought to be particularly prone to this motive. The act may be dedicated, like a poem, to someone in particular. In order to limit the intrinsic ambiguity of the act, many suicides are doubled by explanatory texts. Cato reads Plato's *Phaedrus*. Madame Butterfly's intertext is a sword inscription: "Death with honor is better than life without honor." Lucretia must explain her gesture to distinguish herself from other women: *nec ulla impudica lucretiae exemplo vivet*. Language becomes action; action becomes and yet requires language.

The very means of suicide may be taken as a key to motive. Thus Freud finds sexual wish fulfillments: "To poison oneself is to become pregnant; to drown is to bear a child; to throw oneself from a height is to be delivered of a child" (Freud 1955, Vol. 18: 162n). The ways in which women choose to die differ from those chosen by men. Men jump, and shoot themselves. Today, women more often take sleeping pills, drink household poisons, or turn on the kitchen stove, although guns are gaining. The cynical view is that women deliberately employ ineffective methods.

In fact suicide is nowhere a predominantly female problem. Women commit suicide roughly half as often as men. Modern statistics for the voluntary deaths of women are more uniform from country to country than for any other factor of analysis, such as religion, wealth, or health. Women's sex protects them, even in countries that institutionalize female suicide, like India. At the same time, the tables indicate that women make attempts that do not end in death two to three times as often as men (Baechler, Durkheim, Shneidman and Farberow). When women represent the death of the self on their bodies, they do so in a gesture that remains open-ended.

These statistics are a rough measure of actuality. They directly conflict with our mythic vision of suicide as feminine. As a general matter we seem to imagine death as a return to the mother. More specifically, as Freud argues in "The Theme of the Three Caskets," we identify the *choice* of death with the third casket — the pale and dumb third sister, the White Goddess, or Atropos. Thus in Mayan mythology, the supreme ritual offering of one's own life was represented by a goddess, Ixtab (Dresden Codex, Museo Nacional de Antropologia, Mexico D.F.). The perception of suicide in the modern West betrays a far more ambivalent symbolic function given to both

women and death by bourgeois culture. At least since the eighteenth century, this performative utterance has been interpreted as a set of increasingly *feminine* symptoms, whether of individual or social illness. Indeed, it is startling to realize the extent to which the nineteenth century feminized suicide.

The historical interest of the subject lies in the ideological contradictions it makes manifest. What concerns us most here is the gap between what we know about this act when it is undertaken by women, and its representation and interpretation.

II. SUICIDE IN AN AGE OF HIGH CAPITALISM

That ideologically grounded interpretation determines the debate over suicide and even its "factual" perception can be seen in the radical shift in attitudes at the end of the eighteenth century. Parallel to the shift in epistemes Foucault and critics like M. H. Abrams have traced from Linnaean classification and mechanism to analysis and organicism, is the shift from a moralistic but potentially heroic vision of suicide to a more scientific yet demeaning acceptance of the act as illness.

Classical instances of women's suicide are perceived as masculine: Antigone, Cleopatra, Hasdrubal's wife, and Arria, who stabbed herself to encourage her husband and said, *Paete, non dolet.* Charlotte Corday, the self-appointed Girondiste martyr of the French Revolution, is one of the last in this tradition. She was immediately perceived as a man, a Cato, although her body was subjected posthumously to a degrading sexual examination sketched by one of David's pupils.

Beginning in the eighteenth century, this violation of social norms is treated as a malady; the victims of suicidal depression are subject to "vapors," to be treated by better food, travel, or elevating literature. To "cure" the symptoms of such radical choice is to deny their voluntary nature. In effect, the very notion of suicide as an intentional act dissipates in the course of its scientific reassessment. An extreme instance of the newly passive female suicide may be found in the story of a French lover who pushed his pregnant mistress into the Seine. "We live," he explained, "in an age of suicide; this woman gave herself to death."

To medicalize suicide is to feminize it. Since much of the scientific literature perceived woman as an abnormal man, the link between her genetic defect and suicidal illness was readily made. Furthermore, the traditional perception of women's weak character, which I will discuss in the next section, helped assimilate them to the image of suicide as a phenomenon of mental breakdown. The feminization of suicide was also prepared by the eighteenth-century cult of the Man of Sensibility, which reformulated the Greek congeries of meanings around *pathos:* passion, passive suffering, pathos.

In the Romantic period, the focus of aesthetics shifts from action (Aristotle) to character (Herder, Coleridge). Accordingly, in literary depictions of suicide, the focus shifts from function to motive. At the same time, the stock motives for suicide narrow in range and become more "feminine" than in classical times. After the French Revolution voluntary death is depoliticized. This pattern is visible in the case of men as well as women. The century starts with the Catonian, republican sacrifice of a Jacopo Ortiz, but his story is already Wertherized: an impossible love occupies far more verbal and emotional space than the plight of Napoleonic Italy. Keats yearns to experience love perpetually — "or else swoon to death." One of the great expressions of Romantic idealism, Shelley's "Adonais" closes its poetic quest with an image that precisely marks the new perception of suicide as somehow passive: his spirit's bark is "driven" far from the shore of life. Later in the century, Wagner links Schopenhauer's darkly idealist view that life's aim is death with Romantic, transcendental love in his *Tristan and Isolde;* the symmetry of the lovers' duets underscores the new identification of men's experience with women's.

This nineteenth-century reorientation of suicide toward love, passive self-surrender, and illness seems particularly evident in the literary depiction of women; their self-destruction is most often perceived as motivated by love, understood not only as loss of self but as surrender to an illness: *le mal d'amour.* The eighteenth century still offers in *Emilia Galotti* a forceful suicide like Lucretia's that links sexual to political abuse of power. The great literary suicides of the nineteenth century, Emma Bovary and Anna Karenina, imply disintegration and social victimization rather than heroic self-sacrifice. The means of death are accordingly remythologized. Classically, an Antigone as weaver of her own destiny hanged herself. Eighteenth-century heroines like Clarissa accommodated the official condemnation of suicide by a form of anorexia, in which they lingered pallidly, relishing in anticipation the reception of their message. Gradually, in what we may call a development of the Ophelia complex, the suicidal solution is linked to dissolution of the self, fragmentation to flow. The abandoned woman drowns, as it were, in her own emotions.

The social illnesses that seemed central to Durkheim are complexly linked to contaminated femininity. Ironically, the woman who attempts to escape from the patriarchal economy of sexual exchange becomes entangled in the symbolic nets of the new consumer economy. Her struggle to liberate herself emotionally is overlaid by signs of profligacy; these in turn are interpreted as symptoms of a degeneracy whose only cure is death. This logic projects onto women's unleashed sexuality the causes as well as the costs of

commodity fetishism; the century exorcises its wicked spirits by sacrificing the old fetish to the new.

It is revealing that the most famous literary suicide of the pivotal period is a Man of Sensibility whose virtues turn out to be symptomatic of his fatally feminine susceptibility. Werther's weakness is indicated from the outset: hypersensitive, too excited by Nature to be able to read, unable to control his feelings or to consider the pragmatic situation in shaping his behavior. In his famous debate with Albert, who condemns suicide as foolish, vicious, and cowardly, Werther argues that to break down under passion is "a fatal illness." "Human nature has its limitations... I find it just as astonishing to say that a man who takes his own life is a coward, as it would be improper to call a man a coward who dies of a pernicious fever" (Goethe 1962:59). When Albert objects to Werther's generalizations, the best instance of a natural and inevitable "sickness" Werther can find to defend his position is that of a girl who had drowned herself when abandoned by a lover who was "her all." Werther associates his own "fever" with madness and with women destroyed by love. His insistent quest for mirrors of his own condition reflects the (feminine) narcissism that Hagstrum notes — "Werther is driven, deep within, by love of self and love of similitude" (1980: 263). His tale is framed by allusions to Leonore, whose unrequited love for him apparently destroyed her, and to Lessing's *Emilia Galotti*. Among the several male foils to Werther's plight, the closest is Heinrich, the former secretary of Lotte's father; Heinrich too is feminized, collecting herbs and flowers in an Ophelia-like madness. These feminine analogues reinforce the ambiguities of Werther's death.

III. FRAGMENTED IDENTITY

Suicide is interpretation. Its subject-object has always been identity and *ethos*. The problem of women's identity as separate from, yet potentially part of society emerges with particular clarity in the nineteenth century; indeed, the "woman question" crystallizes the issues of bourgeois individualism. The earlier, carnivalesque, unruly "woman on top" becomes the madwoman in the attic; Bertha Rochester's plunge from the roof doubles Jane Eyre's flight into the unknown barren heath. Women's self-sought deaths are ambiguous within this historical context. They may affirm identity or erase it.

The breakdown of one's sense of identity is conventionally considered a major factor in suicide by modern psychologists like Horney or Farberow. It is assumed that women commit suicide less often than men because they have weaker or more fluid ego boundaries. Recent work by Dinnerstein and Chodorow indicates that girls form their identity in a gender continuum with their

mothers, whereas boys use gender distinction as a means of forming a separate identity. Because of their identity in gender with their mothers or because of social training, women have always tended to perceive themselves through their relationships to family rather than as isolated individuals.

Where literature links suicide to the disintegration of identity, the catalysts differ by gender. Men identify themselves with their political standing, their heroic self-image. We can, of course, point to instances of devotional male suicide parallel to the woman's *suttee:* Saul's swordbearer, or Antony's Eros. But the dominant example of male disintegration would be a figure like Sophocles' Ajax, whose military dignity has been destroyed along with the animals he slaughtered in his madness. And even Ajax *rationally* chooses death as the only way to salvage the honor sullied when Odysseus won Achilles' shield.

For our fictions of women, suicidal disintegration far more often has to do with their sexual and amorous relationships. Traditionally, myths of female suicide have focused on two themes: defeated love and chastity. The insistent representation of women — rather than men — who commit suicide for love complements the familiar assumption that woman lives for love, man for himself. If Brutus commits suicide for the nation, Portia commits suicide in order not to live without Brutus. "Defeated" love may stem either from an accident-like death that separates the two lovers or, more frequently perhaps in literature than life, from abandonment. The woman who loses her man is perceived to lose herself; she follows him, like Hero after the drowning of Leander, or despairs fatally at her betrayal, like Dido. The loss of the man fuses with that of life. Thus Tennyson describes his Mariana in a setting of death — blackest moss, broken sheds, crowing nightfowl — that symbolizes her state of mind, the breakdown of her "confounded" senses when abandoned by her lover.

If the theme is unsurprising, it may be notable that many of those traditionally linked to it are women distinguished for their accomplishments in non-amorous domains. Their suicide, as reported by writers like Plutarch or Vergil, ironically undercuts that professional dimension in their lives. Aeneas regretfully quits Dido for the future of the race; Dido neglects her kingdom to mount a funeral pyre whose flames visible from afar will remind Aeneas of their love. Feminist critics like Annis Pratt see identity itself as the cost of female desire: "until only very recently, the biological price of erotic initiative has been unwanted pregnancy or abortion, and the psychological price paid by the woman who indulges in her own sexuality, an abortion of selfhood" (1977: 88–89).

Love itself can, of course, be taken as a form of suicide for a woman. Freud, who threatened suicide himself should he lose his

fiancée, says, "In the two opposed situations of being most intensely in love, and of suicide, the ego is overwhelmed by the object, though in totally different ways." (Freud 1957, Vol. 14:252) — We may ask, using Nancy Miller's categories for eighteenth and nineteenth-century novels, whether the "euphoric" plot resolved by a marriage without describable future is not more static and fatal to its heroine than the "dysphoric" plot that takes her to a dramatic suicide. Mrs. Dalloway's narrow white bed links her imaginatively to the shell-shocked Septimus, a stratagem integrating sexual and political fictions typical of Virginia Woolf's art. Phoenix-like, the woman as lover dies into a "higher" dedication to a masculine self. The perversion of this romantic ideal of self-abnegation can be traced back to the sublimated erotic appeal of female Christian martyrs, and forward to the nineteenth-century cult of the beautiful corpse, studied by Mario Praz. The vaporization of women as lovers finds extreme expression in variations on the *Liebestod.* Tristan's death provides the only material cause for that of Isolde.

Much like love or lost love, rape has been affiliated with the breakdown of a woman's identity. The focus on chastity, of course, involves that precisely which distinguishes woman as woman, and does so in terms of possession by a man, fetishistically. If woman is taken to be a commodity, rape means total devaluation: reified, then stolen, she has no essence left to justify her continuing existence. Trespass necessitates *trépas.* This ambiguous identification of women with their bodies ironically colors the defence of women's suicide from ancient times to the present. Even in periods that generally condemned self-murder, Church fathers and the patriarchy endorsed it in the face of rape (Ambrose, Jerome, Donne). Saint Sophronia properly protected herself thus against assault, albeit at the expense of herself. More insidiously, suicide serves magically to purge the assaulted body, in a sense displacing responsibility for the violation. Augustine was exceptional in condemning the suicide of chastity on the ground that true chastity is that of the soul.

Although the catalyst is physical assault, the suicide of chastity may have metaphysical implications. To know a woman is to possess her. But truth, unlike knowledge, cannot be possessed. For Nietzsche, therefore, woman was a metaphor for the ineffability of truth. To erase the body is a radical way of erasing the violence of knowledge or pseudo-truth.

A woman may thus choose death after defilement, not to confirm her status as property, but to reaffirm her autonomy. The story of Lucretia is instructive on the virtual illegibility of this message. Lucretia's violation exemplifies social and political tyranny. Lucretia destroys herself after she has been doubly reified as a sexual object. First her husband, Collatinus, too proud of her beauty and virtues to rest content with his private enjoyment, invites his kinsman Tarquin

to observe his wife. For Collatinus, Lucretia is a physical possession for speculative enjoyment. Tarquin, whose father's tyranny oppresses the nation, presses beyond speculative to actual enjoyment of Lucretia when her husband is absent. This rape then betrays both the Tarquins' reliance upon force to obtain their political ends and Collatinus' implicitly oppressive sexual politics. When Lucretia finally turns the dagger against herself, she has traditionally been understood to be affirming the patriarchal value of her chastity and fidelity to her husband. Shakespeare poignantly remarks on her internalization of Tarquin's aggression, "She bears the load of lust he left behind." Yet her gesture points to more pervasive familial and political structures, still pertinent to modern cultures that tolerate marital rape and dictatorships.

The physical control of Collatinus and Tarquin is reinforced by their abuse of language. Lucretia has become a verbal boast; and if she does not submit to the rape she will be killed with a black slave, her reputation defiled. Against these verbal constructs of what she is as woman, Lucretia must set her own. She calls upon family and friends to hear her story and know her in her difference. Such use of language is revolutionary: she calls on her family to avenge her and cast off the tyranny of the Tarquins. Her defiant act precipitates a general rebellion, as the Botticelli *cassetta* at the Gardner Museum in Boston shows: she strikes herself, surrounded by armed Romans. The subsequent rebellion is led by the family friend Brutus. When writers after Livy stressed the political role of Brutus, as Ian Donaldson has argued (1982), they undertook the masculine domestication of an essentially revolutionary, heroic instance of female suicide.

But chastity is no longer a code word for female value, and already in the nineteenth century those writers concerned with women's liberation realized that the Lucretia myth would have to be transformed. In Ibsen's demystifying *Hedda Gabler,* the protagonist is a modern Lucretia, abandoned to the sexual blackmail of Judge Brack by her proud but ineffectual husband and barred by social convention from politics. This underlying myth helps explain her ambiguity as heroic victim, which has split commentators. At the same time, Ibsen rewrites chastity as Hedda's frigidity; he makes the "huntress of men," the whore, Diana's namesake. By inserting Mrs. Elvsted, he further complicates the interpretation of Hedda as victim. Hedda's marketing of her own marriage, her admittedly cowardly fixation on the hierarchical values represented by General Gabler, and her "pretty illusions" about a Dionysiac fulfillment she can experience only vicariously or by sublimation (pistol-shooting, violent piano-playing), all contrast strangely with the passionate Thea's indifference to social condemnation. Yet Thea is no heroine; her commitment to a revolutionary, proleptic history is simply the reflex of her dedication to Eilert Løvborg. Hedda, whose force and

independence could make her a modern woman, destroys the future, both imaginative and generative. Her suicide is not revolutionary but sterilely aesthetic.

As *Hedda Gabler* shows, in the nineteenth century the theme of female identity comes to focus on the disparity between individual aspiration and social actuality. The death of the heroine may be attributed to the deficiencies of social institutions: she attacks her own body, having introjected society's hostility to her deviance. Her gesture is symptomatic of social illness. Or her death may be referred to the dangers of individualism itself. Selfhood, with its reflexive doubling, constitutes fragmentation of the self. Woman typically is just such a fragmented self, perceived in mirrors and through others. Because of their identification with mirrors, women's individualism further threatens to take the form of narcissism. For the romantics, solipsism was the horrifying obverse of individualism; the Fichtean *Ich* was understood to cut the self off from all anchoring otherness, i.e. from objective reality, and thereby to unleash a devouring ego.

Emma Bovary's self-mythologizing climaxes in suicide in a way that seems to betray Flaubert's fears of his own narcissistic psychology and aesthetic. We are not surprised that in her last moments "she asked for her mirror and remained bent over it for some time" (Flaubert 1965: 237). Her suicide reflects back on her life in a way that unmasks her transcendental desires as narcissistic, through a parody of the erotic "blazon," the love poem that enumerates the parts of a woman's body.

When Emma hastily crams her mouth full of poison we are inevitably reminded of her restless craving for escape from ennui and insatiate desires. Flaubert doubles the image of a transcendental quest with one of sensuous needs as extreme unction is applied to what we may call her erogenous zones, upon the mouth that had "cried out in lust," upon the nostrils "that had been so greedy of the warm breeze and the scents of love." She embraces the crucifix: "then she stretched forward her neck like one suffering from thirst, and glueing her lips to the body of the Man-God, she pressed upon it with all her expiring strength the fullest kiss of love that she had ever given" (p. 237). It is perhaps not irrelevant to this ironic juxtaposition that Christ's death on the cross was regarded by early Church fathers as a suicide.

Emma's disintegration is both physical and spiritual. The arsenic she eats repeats the self-sought corruption of her heart and mind by literary falsehoods as well as by her lovers' lies, in an ironically materialized reenactment of *Don Quixote*.

IV. WOMAN AND SOCIETY: THE MASCULINE PERSPECTIVE

Flaubert, who confessed that he dreamed of suicide in his youth, could say that he himself was Madame Bovary. Yet even those

nineteenth-century male writers most sympathetic to women's plight in bourgeois life subvert the heroism of women's voluntary deaths in their focus on social and masculine victimization; the reliance on social explanation which climaxes in the realistic novel — and in Durkheim underplays the heroine's choice — at the same time that its social determinism exculpates us of our complicity in the functioning of social institutions.

One of the triumphs of Flaubert's art is the ironic imbrication of Emma's self-delusions and *la bêtise sociale*. Emma herself considers her act, perhaps in the light of the novels that had poisoned her imagination, as heroic: "now her plight, like an abyss, loomed before her. She was panting as if her heart would burst. Then, in an ecstasy of heroism that made her almost joyous, she ran down the hill...and reached the pharmacy" (p. 229). Werther had described the suicide: "Petrified, out of her mind, she stands in front of the abyss. All is darkness around her. . . She feels alone, abandoned; and blindly, cornered by the horrible need in her heart, she jumps and drowns her torment in the embrace of death" (pp. 60—61).

But his shift to an externalized depiction of the dying woman indicates that, here, Flaubert is not Emma Bovary. In the broader view, Emma dies not so much by her own choice as by the victimizing effects of a society that imprisons young women in convents and then in traditional families and perverts their hopes for individual self-fulfillment through an ideology of romantic love and bourgeois consumption. Though sensuous in appearance, her desires are ideological constructs that have little to do with instinctuality: they have been fostered by the trivial wish-fulfillment novels she consumed at the convent. As Walter Benjamin has argued in connection with Baudelaire (1978), the devaluation of the material world by Christian allegory is paralleled and surpassed by the nineteenth century's devaluation of the material world by commodity fetishism.

Flaubert's social criticism cuts two ways. Emma rejects traditional values, and, appropriately enough, her home, emblem of woman's constricted world, is seized on the day she decides to take her life. Yet she embraces false values: a mix of nostalgia for aristocratic luxuries with an appetite for contemporary novelty that parallels the modern "scientific" thinking of Homais. When she links feudal decoration (her Gothic *prie-dieu* or her first lover) to fashion in her attempt to retrieve a habitable interior, her confusions exemplify perfectly the utopian phantasmagorias or ambiguities that Benjamin calls the "law of dialectics seen at a standstill" (1978:157).

The feminization of suicide in the nineteenth-century goes hand in hand with a — realistic yet disturbing — denial of woman's ability to choose freely. Even Anna Karenina, one of the most compassionately drawn heroines of nineteenth-century fiction, is shown to vacillate in

her last moments. Tolstoy makes her act manipulative and vengeful: "I shall punish him and escape from everyone and from myself." He also deprives it of dignity through small but acute details. Held back by her red handbag, she struggles free and carefully throws herself on the tracks at the right moment. Yet just as she drops, Tolstoy tells us "she was terror-stricken at what she was doing. 'Where am I? What am I doing? What for?' She tried to get up" (Tolstoy 1965:798). As a result, the car that hits her is "something huge and merciless" that overwhelms her, an emblem of larger social forces beyond her control.

This trend in nineteenth-century fiction and drama finds an extreme formulation in Strindberg's *Miss Julie*. When the valet Jean hands his mistress the razor with which she will kill herself, he commands her to do the deed and she walks offstage in a hypnotic stupor. The reversal of their social relationship in this moment is a superficial irony, for his is indeed the voice of a larger, patriarchal social order. Strindberg has "motivated the tragic fate of Miss Julie with an abundance of circumstances." She has been driven forward by her improper upbringing, heredity, her menstruation, and the aphrodisiac stimulus of Midsummer Night's Eve. But her doom is dictated by social conventions and by the author's belief in woman's passivity. For all his irony about the brutal, cynical spectacle of life, Strindberg insists that woman is a "stunted form of human being,"[1] inferior to man in strength, sensitivity and initiative. The educated "half-woman" who has won equal civil rights — today we might speak of androgynous woman — "represents degeneration." Women, like children and the half-educated, he says, "still retain a primitive capacity for deceiving themselves and for letting themselves be deceived, that is, for succumbing to illusions and responding hypnotically to the suggestions of the author" (Strindberg 1974:566, 568, 564). The logic of this "modern" tragedy is purely circular.

V. EASY DEATHS

We can see a strange paradox in the nineteenth-century male overdetermination of women's suicides. Most significantly, these are treated as a virtually involuntary form of surrender to social forces. Yet Emma Bovary, Anna Karenina, Hedda Gabler, Miss Julie all die in violent ways that accentuate the finality of what used to be called self-murder. By contrast, both in fact and in literature women perceive their own suicides in ways that could be described as visionary rather than violent.

From time immemorial, women have been thought to seek an easy way out, a painless and beautiful way of dying. Cleopatra, Plutarch

1. Standard English translations omit the additional manuscript material from Strindberg's remarkably misogynist introduction to *Miss Julie*.

tells us, spent her last weeks searching for the quickest and least painful means. In Shakespeare too, her search for the right poison reinforces — at least from a Roman perspective — the image of narcissism and cowardice. She has taken mandragora to sleep out the gap of time: "Now I feed myself with most delicious poison" (Antony and Cleopatra: Act I, Sc. 5). And of course she has taken flight from the battle of Actium. From her own perspective, however, the bite of the asp resembles the nibble of an infant at her breast, as well as the sexual embrace of the lover, Antony, whom she is about to join. The layering of death and birth images transforms the asp to ouroboros. At the same time, she selects means that will mar neither her physical splendor in life nor the Roman glory of her death, in patent contrast to Antony's botched and protracted suffering. Her asps not only escape inspection by the guard but leave scarcely any trace. Appropriately, then, her mode of dying is almost as much a puzzle as are her life and character, and the artistic mystery of her Eastern grandeur eludes the reifying inquiry of the materialist Octavius Caesar.

The search for easeful death leaves its trace on the literature written by nineteenth-century women. Of course, in their representations of female suicide, these writers address many of the same social and psychological issues that preoccupy men. The tension between free will and social determinism, between autonomous affirmation of identity and the breakdown of identity remain central, no matter what the sex of the writer. Nonetheless, there are curious differences: women tend to treat the suicides of their own sex as if they were somehow not definitive, and they tend to minimize the physical anguish of death. (We must remember that for women the suicide attempt is often not final.) Although men like Keats also call on "soothest Sleep" to "seal the hushéd casket of my soul," they are not in the end deceived by this "fancy." By contrast, Christina Rossetti yearns to be "sleeping at last in a dreamless sleep locked fast." One explanation for the special function of death in this woman poet's imagination lies in her poem "From the Antique": "I wish and I wish I were a man: / Or, better than any being, were not" (Rosetti 1896:78). The only way for a woman to attain a state of wholeness may be to move beyond the body.

The heroine drifts into destruction, often literally carried by water that reflects the fluidity of her own identity. The unknown in death takes shape as uncertaintly of act and motive. Read affirmatively, the image of the flood for Maggie Tulliver illuminates a dimension of mystical transcendence in female suicide. Similarly, because it is in swimming that Edna Pontellier in Kate Chopin's *The Awakening* has found release and independence, her death has been interpreted as a quest for oceanic oneness or an affirmation of the *anima* (Chopin 1976:202, 218, 221).

Women do not, however, often assign to the self-destruction of their own sex such clear teleology. Kate Chopin's *Awakening*, for example, fades into a dream-like engulfment of consciousness by the waves of the past. Her regressive death brings into play destructive ambiguities in the relationship of woman to child. As Nina Auerbach has noted, "In the ideology of Victorian womanhood, marriage signalled not maturity but death into a perpetual nursery. Thus paradoxically, the intact child is in securest possession of the mobility and power of her potential adult future" (1983:52—53). The immature, romantic conception of sexuality as painless and passive ecstasy marks Edna's adolescent hopes and her final thoughts as she surrenders to the water. Chopin underlines the irony of this illusion by detailing the pain of childbirth in her penultimate scene and by delineating sympathetically Edna's need to free herself from the demands of her children. "I would give my life for my children, but I would not give myself" (Chopin, p. 48). Chopin suggests that most women pass from a thoughtless and at best impulsive childhood to a mechanical adulthood measured by the involuntary rhythms of childbearing and rearing. Edna has difficulty finding a path between the two, a mode of reflective development and integration. In the heroine's inability to write her own story, we see in turn Chopin's impasse in writing a nineteenth-century female *Bildungsroman*; the nineteenth-century version of this genre dictates a "voyage in" that is turned toward death (Hirsch 1983:23—48).

The problem of will foregrounded in these novels can be distinguished from the problem of feminine passivity traced by most male writers. Chopin sets the leitmotifs of feminine regression against others that mark the possibility of independence, artistic and personal. Though shrivelled and dark, poor and isolated, Mlle. Reisz is the significant mother of the motherless Edna; her music and sympathy liberate Edna's own art and mediate her passions. Self-assertion for a woman in the face of social constraints entails high costs. But there is choice, rather than social victimization. The path toward freedom for Edna is negative: she sheds everything external to herself, first the routines and *bienséances* of the alien Créole culture, then her family and home, and finally her clothes and herself. The original title of this *Künstlerinroman* was *A Solitary Soul*.

The ambiguity with which the woman author represents female suicide may betray what Freud described as the universal denial of our own death: our unconscious "does not believe in its own death; it behaves as if it were immortal." Although she must deny her own death, the author can, nonetheless, experience death through her work. As it happens, this double experience lies behind Freud's explanation of our response to tragedy: "There alone too the condition can be fulfilled which makes it possible for us to reconcile

ourselves with death; namely, that behind all the vicissitudes of life we should still be able to preserve a life intact" (Freud Vol. 14, p. 291, 296). The woman author is, as it were, reading her own death in that of her protagonist. One problem with this explanation, however, is that it does not apply equally to the descriptions by men of their male protagonists' suicides.

An alternative line of inquiry presents itself. It can be argued that the fluidity and lack of finality in these deaths is the narratological equivalent of women's actual avoidance of a final statement in their suicide attempts. We need to study further possible parallels between women's adaptive procedures in constructing their lives and their modifictions of rigid formulas in their fictions. When nineteenth-century women subscribe to the genre of the *Bildungsroman*, they envision a journey not to socially defined order but inward and downward to the unknown, and they bring the finality of women's generically imposed deaths into question.

In summary, the disparities between act and attempt, between fact and perception, have made female suicide an extreme instance of the hermeneutic problem. Sociologically speaking, for woman, the sign of voluntary death has been cut loose from its referent. The attempt expresses not merely a deathwish but an incommunicable or impossible life-wish. As in so many other aspects of women's lives, it is the appearance or the representation rather than an "essence" that matters. As Simone de Beauvoir said, "women have been pretexts rather than agents. The suicide of Lucretia has had value only as a symbol" (Beauvoir 1953:162).

The literary transcription of this physical "discourse" or allegory exacerbates these contradictions and at the same time exploits them for dynamic effects. Women's suicide has given shape to some of the greatest works of literature, from *Antigone* to *Anna Karenina*. It is a theme which in various periods has permitted writers to explore the relationship of *Sein* to *Schein*, to juxtapose silent resistance with the dominant discourse, and to demonstrate the costs of the social order to the individual. For all this, the woman in the suicide tends to disappear. Although the nineteenth century first recognized statistically the differences between men's and women's suicide rates, when it displaced onto women the literary burden of suicide, it symbolically represented more than it knew. The great works on the subject written by men in the nineteenth century reduce to a subtext the facts of women's suicide. The voluntary act often appears involuntary; the quest for autonomy is replaced by breakdown of identity.

In literature written by women, by contrast, we find ambiguities that disturb the norms of genre and of female socialization. Epimethean, these works force us to read backward from the ultimately unknown charcter of death and of woman to our presumptions about motive, genre, and social order. The decisive

moment is no longer decisive. The transformation of act into image in many of these women's works brings into play three central features of women's experience: its elusively subjective character, the constriction of independent activity into dependent mediation, and the fundamental fusion of communication with silence.

REFERENCES

Alvarez, A., 1971. *The Savage God: A Study of Suicide* (London: Weidenfeld and Nicolson).

Auerbach, Nina, 1982. "Falling Alice, Fallen Women, and Victorian Dream Children," in James Kincaid and Edward Guiliano, eds., *Soaring with the Dodo: Essay on Lewis Carroll's Life and Art, English Language Notes* 20:2, special issue.

Baechler, Jean, 1975. *Les Suicides,* intro. Raymond Aron (Paris: Calmann-Levy).

Beauvoir, Simone de, 1953. *The Second Sex,* trans and ed. H. M. Parshley (New York: Knopf).

Benjamin, Walter, 1978. *Reflections: Essays, Aphorisms, Autobiographical Writings,* trans. Edmund Jephcott (New York: Harcourt Brace Jovanovich).

Chodorov, Nancy, 1978. *The Reproduction of Mothering. Psychoanalysis and the Sociology of Gender* (Berkeley: University of California Press).

Chopin, Kate, 1976 (1899). *The Awakening* (New York: Norton).

Dinnerstein, Dorothy, 1977. *The Mermaid and the Minotaur: Sexual Arrangement and Human Malaise* (New York: Harper & Row).

Donaldson, Ian, 1982. *The Rapes of Lucretia: A Myth and its Transformations* (Oxford: Clarendon).

Durkheim, Emile, 1951. *Suicide: A Study in Sociology,* trans. John A. Spaulding and George Simpson (New York: Free Press).

Fedden, Henry Romilly, 1938. *Suicide: A Social and Historical Study* (London: Peter Davies).

Flaubert, Gustave, 1965 (1856). *Madame Bovary,* ed., and trans., Paul de Man (New York: Norton).

Freud, Sigmund, 1953—74. *The Standard Edition of the Complete Psychological Works,* ed., James Strachey et al. (London: Hogarth Press).

1953 (1920) "The Psychogenesis of a Case of Homosexuality in a Woman," in *Standard Edition,* Vol. 18.

1957 (1917) "Mourning and Melancholia," in: *Standard Edition,* Vol. 14.

1957 (1915) "Our Attitude Towards Death," in: *Standard Edition,* Vol. 14.

Goethe, Johann, 1962. *The Sorrows of Young Werther,* trans. Catherine Hutter (New York: New American Library).

Hagstrum, Jean, 1980. *Sex and Sensibility: Ideal and Erotic Love from Milton to Mozart* (Chicago: University of Chicago Press).

Hirsch, Marianne, 1983. "Spiritual *Bildung*: The Beautiful Soul as Paradigm," in: Elizabeth Abel, Marianne Hirsch, and Elizabeth Langland, eds., *The Voyage In: Fictions of Female Development* (Hanover: University Press of New England), 23—48.

Horney, Karen, 1950. *Neurosis and Human Growth* (New York: Norton).

Miller, Nancy, 1980. *The Heroine's Text: Readings in the French and English Novel* (New York: Columbia UP).

Pratt, Annis, 1977. *Archetypal Patterns in Women's Fiction* (Bloomington: Indiana UP).

Praz, Mario, 1970 (1933). *The Romantic Agony,* trans. Angus Davison (London: Oxford UP).

Rossetti, Christina, 1896. *New Poems* (New York: Macmillan).

Shneidman, Edwin and Norman Farberow, 1961. "Statistical Comparisons between Attempted and Committed Suicides," in: Norman L. Farberow and Edwin S. Shneidman, eds., *The Cry for Help* (New York: McGraw-Hill), 19—47.

Strindberg, August, 1974. "Preface to Miss Julie, 1888," trans. E.M. Sprinchorn, in: *Dramatic Theory and Criticism: Greeks to Grotowski*, ed., Bernard F. Dukore (New York: Holt Rinehart Winston), 564–574.

Tolstoy, Leo, 1965 (1878). *Anna Karenina*, rev. trans. and ed., Leonard J. Kent and Nina Berberova (New York: Modern Library).

DEATH SENTENCES:
WRITING COUPLES AND IDEOLOGY

ALICE JARDINE

> "To write is to embalm the past [. . .], it leaves it a bit congealed — like a mummy." Simone de Beauvoir

> "Mummy — from Low Latin: a dead body preserved in a dry state from putrefication; . . . or, figuratively, a dark, thin person". . . . Webster's Dictionary

As my reader may or may not have had time to remark, there is a moment of modest ambiguity in my title — if only in terms of the signified. At the first level, there is the question of writing couples, of what it means to "write couples," to write-in-couples with/as/ through ideology. At the second level, there is the perhaps — but only perhaps — more referential question of the "Writing Couple," couples who write, and their shared ideology.

In order to open the way for and approach the first sense in which I evoke "Writing Couples" quickly, let me briefly invoke the other, larger title which brings this text here (today), our entitlement-so-to-write: *Poetics Today*. Let me infuse "poetics" into the title and re-mark it "Writing Couples and The Ideology of Poetics." And let me concentrate on today.

Today, then, "The Ideology of Poetics." By "ideology," I do not mean here the everyday sense of the term — one ideology as opposed to another; capitalist versus communist ideology, etc.; nor even — although this definition might be closer to our concerns here — Paolo Valesio's definition of ideology as decayed, dead rhetoric (Valesio 1980). I will remain in fact hopelessly Althusserian on just this one point and invoke his now infamous definition of ideology as "the 'representation' of the Imaginary relationship of individuals

Earlier versions of this paper were presented both at a special session of the 1982 MLA organized by Naomi Schor, entitled "Intimate Influences: The Writing Couple," and at the Seventh Columbia University Colloquium on Poetics (November 1983) organized by Michael Riffaterre, entitled "The Poetics of Ideology." I am grateful to Nancy Miller for her careful readings and suggestions at each rewriting. Translations in text are my own unless otherwise indicated.

to the Real conditions of existence" (Althusser 1971:162). Through this definition, I would insist upon ideology as the conceptual glue of culture, that which makes culture seem natural, that which holds any cultural system together, that which, in fact, makes any system of relationships appear natural.

By "poetics," I mean something relatively straightforward: that theoretical discourse which would desire to account for what may certainly be called here, after Jakobson, "the poetic function" (Jakobson 1960) — as well as that discipline concerned with theories of literature.

My concern, under the title of "The Ideology of Poetics," is with that conceptual, cultural glue which insists upon naturalizing, holding together, indeed *reifying* any poetics grounded in and dependent upon binary opposition, whether those oppositions are static — structural — or put into movement — dialectical. As Hélène Cixous has put it:

> Always the same metaphor: we follow it, it transports us, thru all of its figures, everywhere discourse organizes itself. The same thread, or *tresse double*, leads us, if we read or speak, across literature, philosophy, criticism, centuries of representation, of reflection.
>
> [Western] thought has always worked by opposition [...] the law organizes the thinkable thru oppositions (whether as irreconcilable dualities or incorporative, uplifting dialectics). And all of these couples of oppositions are *couples*. Might that not mean something? That logocentrism forces all thought — all concepts, all codes, all values to submit to a system of 2 terms, might that not be in relationship to "the" couple: man/woman? (Cixous 1975:116).

The question of "the couple" has become the object of contemporary philosophical fascination, where *all* metaphysical couples are in the process of being discoupled, recoupled differently and urgently: active/passive, form/matter, speech/writing, conscious/unconscious. This work has been pursued by some of us because these couples, intrinsic to the ensemble of symbolic systems in the West (cf. Cixous 1976: esp. p. 7), would indeed appear to be modeled on *the couple*: Man/Woman, Masculine/Feminine.

Since Lacan at the very least, it has been made quite clear, particularly in France, that One never writes without the Other, One never writes Alone; One is always at least two, usually more: One is always coupled with Others. My hand is moved across the page according to different scripts, different readings, with different names, different faces, on ready or distant call. The lone *cogito*, fully in control of a message, even if in anguish while finding it, has been thrown on the philosophical junkheap; the lonely image of the lone author, always male, remains alive only for die-hard romantics. The couple, therefore, has not only become the privileged *object* of contemporary interpretive fascination, but has become its doubled *subject* as well.

Couples. We tend to think in couples even when we try very hard not to; we revise the concept of the couple, we re-write it, we mediate it in new ways, but couples are very hard to get away from. It's just the way we think in the West, have been trained to think — based on the force of the *copula*, of copulation (cf. Derrida 1972).

The question of copulation brings us to the second not unrelated level of what I mean by "Writing Couples," the "Writing Couple": here and now, the historically heterosexual, famous, totally necessary to each other, oh too human, writing couple.[1] For there would appear to exist a seeming historical necessity for the heterosexual woman who wants to create, to write — and be read — to couple herself, in fact or fantasy, albeit if only temporarily, with a man who also writes or wrote, a famous man in her life or in her writing — if not the *necessity*, then the *desire* to do so, under the illusion that it will be easier that way. . . Anyone who has tried to write "on" or with women who write has undoubtedly run across this problem at some point. My own most intimate textual encounters have been with Virginia and Leonard, Lou Andreas and Friedrich, Julia and Philippe, Simone and Jean-Paul.

How this second way of reading the words "writing couples" is linked to the first, should become clear in what follows. And while I will be insisting upon this second more biographemic sense of the term "Writing Couple," the first, more philosophical sense should not and, indeed, cannot be forgotten. Nor can we forget the *very* famous couple, "literature and philosophy." For what Plato called "the ancient quarrel between poetry and philosophy" is being acted out once again at the end of the twentieth century — with the stakes involved in whether this couple stays together or separates getting higher by the day. What follows is, then, a first gesture towards exploring the various possible ideologies and logics of "writing couples," towards establishing a typology of coupling, especially in relationship to the maternal body. Here I will be able to look only at a first kind of possible configuration for male and female, a first kind of occidental glue. I will be exploring very explicitly the poetics of an ideology that insists upon killing the mother and therefore, although more implicitly, will be exploring the ideology of the poetics responsible for that murder.

*

1. "Historically heterosexual" for two reasons: first, because I am using the word "heterosexual" in its everyday sense. That is, we are concerned here primarily with the couple consisting of a man and a woman as historically defined — although such dominant forms of heterosexual logic can of course appear in the most unlikely places. But, secondly, I also want to underline the potential for, the possibility of, new logics for radical heterosexualities, beyond the hetero/homo dualism, and especially beyond the common and conservative notion of heterosexuality which, as Jane Gallop has put it, "has always been a veiled homosexuality, one modality of desire, one libidinal economy" (Gallop 1982:127).

For many reasons, not the least important of which is the current hysteria surrounding the couple "literature and philosophy," it was the writing couple Simone de Beauvoir and Jean-Paul Sartre that came to occupy the center of my attention as I began to think about writing couples at the intersections of literature and philosophy, poetics and ideology, modernity and feminist theory. The decision made me very nervous.

First, because Sartre and Beauvoir do, of course, represent for many *the couple*, not only in a general "People Magazine" kind of way, but also, I think, within a certain feminist fantasy: Beauvoir is the woman who managed to find a man with whom to share her intellectual passion without sacrificing either "intimacy" or "independence," as she herself might put it. Because of the strong grip this feminist fantasy holds on a certain heterosexual imaginary, especially here in the United States, I hesitated to continue the tradition.

Second, Sartre and Beauvoir do incarnate, in an embarrassingly old-fashioned way, the philosophy/literature split and its most idealistic kind of synthesis: "they each do a little of both," but Sartre is the philosopher and Beauvoir is the novelist, they say. As Nancy Miller has reminded me, the way in which Beauvoir has positioned her texts to deal only with that which Sartre's undeniably classical philosophical discourse cannot deal with is a problem in itself.

Third, Beauvoir and Sartre, as a couple, provide perhaps too easy a symbol of the old *versus* all that is new in the realm of poetics and literary theory. Sartre did not want to represent any formal, theorized poetics; he proposed, nonetheless, a theory of language and literature that is no longer acceptable to many theorists and writers of modernity, for example Roland Barthes, who highlighted his differences with Sartre early and irrevocably (Barthes 1953). In fact, in one of Sartre's last interviews, when pressed by Beauvoir to be more precise about what he meant when he qualified *Les Mots* as "literary," he replied simply, "It was full of clever tricks, artful writings, word-plays almost."[2]

Finally, and most importantly perhaps, Beauvoir and Sartre are no longer a couple. There have been so many deaths of the Fathers in France over the past few years: Lacan, Barthes, Sartre, Foucault. Talking about any one of these four Dead Fathers can be painful — what one has to say becomes so quickly elegiac or vulturesque . . . and Sartre was of course, *The Father* for intellectual France.

Beauvoir has been left alone, at home, but as a Widow for France,

2. My translations. Simone de Beauvoir, "Entretiens avec Jean-Paul Sartre" in *La Cérémonie des adieux* (CA) (1981:276). All further page references in text.

not as France's Mother. By what authorization may I write of a "them" now?

But I will, because one of the things the thousands of people (including myself) who walked behind Sartre's coffin in Montparnasse were saying was that we both can and cannot continue, now, without the couple, Beauvoir and Sartre; that, in any case, no one can continue to think/write in the ways that it is urgent for us to think/write in the West without first having written and thought with Sartre the philosopher. Phenomenology, empiricism, metaphysics, the *ego cogito*, the Imaginary, the Other, dialectics, even "ideology," or "poetics," become just so many contemporary buzz words unless one has recognized that 25 years of French thought have been transcribing those words through Sartre, *against* Sartre — killing the Father. Foucault was one of the very few to recognize that fact. And what of our still-alive-feminist-mother? My thoughts of her are haunted by this death of a monolithic couple and its discourse.

Thinking in a soundly referential, biographical way, there is not much new to say about this somewhat mysteriously, perhaps only superficially heterosexual couple. But the insistent questions keep repeating themselves. How was it that they actually managed to remain a couple? They were always sleeping in separate beds — next door, down the street, in the other room, in different cities. And then there were all of Sartre's "contingent women" — so lovingly and openly laid before our eyes in so many places — Melina, Camille, *la fiancée*, Mme Morel, M, Olga, *la femme lunaire*. As Sartre himself put it, "I was more a masturbator than an 'intercourser' of women" (CA, p. 385).

Many people have remarked upon this strange set of affairs, especially feminists: "except for Sartre, Beauvoir is wonderful." That is, the feminist response to this couple is usually divided, ambivalent, an ambivalent reaction most recently evoked by Carol Ascher's very moving imaginary letter to Beauvoir in her book, *A Life of Freedom*. Ascher questions Beauvoir's way of:

> capping a description of pain and ambiguity with the assertion that the period or relationship was a success. It's a little like the *deus ex machina* of Socialism or genderless roles — the seal of the present or future riding in on a white horse to blot out historical suffering. [. . .] It is as if you must put a stamp or seal on your memories in order to go on" (Ascher 1981:111).

It is always these last capping sentences that are cited as tokens of Beauvoir's courage and wisdom by her feminist admirers, never their discursive placement or the blackest pages of passion, despair, and rage they negate.

As *feminist fantasy*, the Beauvoir-Sartre phenomenon has never been described so succinctly as by Beauvoir herself:

. . . we might almost be said to think in common. We have a common store of memories, knowledge and images behind us; our attempts to grasp the world are undertaken with the same tools, set within the same framework, guided by the same touchstones. Very often one of us begins a sentence and the other finishes it; if someone asks us a question, we have been known to produce identical answers. The stimulus of a word, a sensation, a shadow, sends us both traveling along the same inner path, and we arrive simultaneously at a conclusion — a memory, an association — completely inexplicable to a third person [. . .] Our temperaments, our directions, our previous decisions, remain different, and our writings are on the whole almost totally dissimilar. But they have sprung from the same plot of ground (Beauvoir 1965a:643).

I read and reread the passages of her memoirs and interviews where Beauvoir continually speaks (of) this strange, disembodied "we" — and into this dark continent of pure, clear, platonic couplehood, I began to imagine, between the lines, a make-believe letter from Beauvoir to Sartre containing the following words:

You put yourself in my mouth, and I suffocate. . . Continue to be also outside. Keep yourself/me also outside. Don't be engulfed, don't engulf me, in what passes from you to me. I would so much like that we both be here. That the one does not disappear into the other or the other into the one (Irigaray 1979:9—10).[3]

These lines are from Luce Irigaray's *Et l'une ne bouge pas sans l'autre*. I evoke them here so as to provide a space of slippage in my own discourse — and eventually, I hope, in Beauvoir's — from writing in this comfortable descriptive tone towards writing more uncomfortably about the most intimate Other possible for any writer and, most especially, for any woman writer: *the mother*.

The issue of how to think about the relationships among women/ writing/maternity is among the most important in feminist thinking today, especially in France. It is important to recall here that when Hélène Cixous states in her seminars that the vast majority of women writers to date have written within a masculine economy, one of her first and most often repeated examples is Beauvoir. The classical writing economy, the one that belongs to a *masculine* economy, according to Cixous, requires two conditions: for anyone to write, they need (1) maternal love and support, and (2) paternal identification. How this is true for men writing in a patriarchal culture is fairly clear. Male writers have needed the loving support of their muses, mistresses, or mothers in order then to put them aside, deny them, reject them, idealize them or kill them in their writing, but, in any case, to *ingest* them so as better to evacuate them, purify themselves, and identify with the Father — if only then to kill him like the good sons they are.[4] According to Cixous, in a patriarchal culture, a

3. I adopt here Jane Gallop's translation of this passage (Gallop 1982:114).
4. Barthes put it more mildly, but never flinched faced with his recognition that "L'écrivain est quelqu'un qui joue avec le corps de sa mère." Cited by Susan Suleiman (1977).

woman's writing depends in great part upon her relationship with her imaginary father. For her, Beauvoir provides the classic case of a woman writer who has "chosen" to write within the masculine economy just described: she identified with the Father and rejected the Mother. It is, in fact, Beauvoir who has come to represent, for a number of contemporary French women theorists, the proto-typical father-identified-feminist: *Athena* — the one who has no need of a mother.

Most obviously, and still at the most referential level, Beauvoir provided what has remained, in spite of everything, *the* feminist myth: the baby *versus* the book. When she says, "I have never regretted not having children insofar as what I wanted to do was to write" (Beauvoir 1965b:36), she means it and feminists have believed in her sincerity. In the classical feminist economy, you cannot have them both; you cannot have it all.

Over the past few years this mutual exclusivity has been seriously questioned — more referentially in this country, more theoretically in France (see Suleiman 1985). To concentrate here on the latter, for women theorists like Cixous, Luce Irigaray, or Julia Kristeva, Beauvoir's decision not to have children in the world might be seen as but an acting out of her complete denial of the maternal, of her refusal of the maternal body within a classical male economy — a refusal of the maternal body's most intimate influences upon her own body and body of work. For these women, Beauvoir's work represents an exemplary denial of woman, of the mother, and it is against the Beauvoirian myth of Anti-Maternity that they set out 10 years ago to *revalorize the maternal* for women: in and through women's writing for Cixous; before and on the other side of our writing for Irigaray; because of marginal men's and women's writing for Kristeva.

Our monolithic heterosexual couple has been decidedly displaced, but it has not disappeared. In order to think about what for me has turned out to be a battle between the old and new mothers — a battle in which my desire not to deny any of them has proven somewhat futile — and in order not to lose sight of *the couple* as our subject, I turned to Beauvoir's last published book: *La Céré-monie des adieux*.[5] I took with me to that text two questions: (1) what *did* Beauvoir do with the jealousy, anger and rage at Sartre that I evoked earlier and (2) *what about* mothers? What about Beauvoir's mother? What I found was most troubling — more than troubling, frightening. How to talk about it without denying my own first feminist mother? I am really not sure I can move without her.[6]

5. It is difficult to call *Lettres au Castor* (1983) *Beauvoir*'s most recent book to date, as some have, since it includes only Sartre's letters.
6. The often painful question of how to explore more freely the political and intellectual

La Cérémonie des adieux is a very strange book; first of all, in its form. It is a ceremony — a sacred rite — in two parts: the first part is written by Beauvoir as an account of Sartre's last ten years — as a narrative, it moves forward most methodically; the second part of the book, twice as long as the first, is the transcription of an oral, taped interview between Sartre and Beauvoir done entirely in the summer of 1974. There is no visible link between the two parts. Neither novel, memoirs, nor biography, the *Cérémonie* is an ambitious project of writing-*qua*-oral-history that, even while a monument to Sartre, is a kind of strange simulacrum of Sartre's own last uncompleted project: a book he wanted to be written truly by two people — not by Sartre and Beauvoir, but by Sartre and his intellectual son Victor (Benni Levi) where, as he puts it, ". . . a thought could exist really formed by you and me at the same time," exactly what Beauvoir had always described as Sartre's and her own economy (CA, p. 126).

This book is, however, remarkable as other than simply monument or simulacrum. The first part of the book is the first thing Beauvoir has ever written and published unseen by Sartre; the second part is completely different — familiar, already said and published to the point of explicit repetition. This book is cut up, cut down the middle, not a simulacrum of and monument to Sartre, but to his death. It is the particularly intense quality of the first part of the book that solicits attention: a flood of words to embalm the past; a compulsion, seeming obligation, *to say everything* about another cut-up-body-to-be-"entombed" — that of Sartre: a corpus in decomposition.

What is so disturbing about this discourse is not that Sartre's referential, historical body is somehow rendered more mortal, less deified — that would be laudible; but rather that this body named Sartre is cut up by the violence of (Beauvoir's) discourse — an explosion of words with razor edges.

*

A few pages of politics and then the body-talk begins — with the mouth of course: an abscess in the mouth, a threat of the flu (CA, p. 22).

differences between feminist mothers and daughters without repeating Oedipal, biological, history-patterns, is being increasingly asked today. In a sense, that question serves as palimpsest to Luce Irigaray's *Et l'une ne bouge pas sans l'autre*. My generation's search for new ways to explore new conceptual territories *with* our mother(s) and grandmother(s), with respect and without denying their experience, is what is at stake. For one of my own first, shaky attempts, cf. my "Interview with Simone de Beauvoir" (1979).

But then the well-recognized "capping sentences" appear: "In spite of these health worries, Sartre continued his political activities" (CA, p. 23).

More pages of referential recounting, ticking off the days. But then there were his teeth, he had to get false teeth: he was afraid — "for obvious symbolic reasons," she says (CA, p. 24).

Politics, politics. His eating habits. Ingestion: "a bit of sausage, some chocolate." He begins to tremble, sputter, jabber — "his mouth was a bit twisted" (CA, p. 31).

After the mouth come the hands that can no longer grip, perform, act upon the material world — that function Sartre valued the most (CA, pp. 32–33).

1972 — more politics, more voyages, until Sartre finally begins to wet his pants and leave brown stains where he was sitting; ruining his clothes; acting like a child, just before he's off on more trips, seeing more people until finally he begins to lose — his arteries, his veins, his nose, his skin, his head. He forgets. He can't get it right, and finally, he loses his eyes. While "eating messily" — "his mouth soiled with food" (CA, p. 75) — Sartre goes blind. "And my eyes. What about my eyes?" he asks (CA, p. 88). And his bladder and intestines are completely out of control.

The unrelenting stream of words occasionally betrays an almost comic relief: he still shaved himself, "very well in fact thanks to a [new] electric razor". . . (CA, p. 97). And he is, after all, still seeing such a lot of women: Sylvie on Sunday, Liliane on Thursday; Michèle on Monday and Friday — and the other days it is Arlette (CA, p. 117). But Sartre's kidneys and intestines only get worse with all this feeding. The doctor talks about cutting off his toes, his feet, his legs.

> He seemed more and more tired, he was beginning to get open wounds and scabs and his bladder was not working — it became necessary to do bypass surgery and when he got up, now very rarely, he trailed behind him a little plastic bag full of urine. . . (CA, p. 154).

I do not cite these sentences to provoke disgust (or sadness), but to try and evoke the horror of this discourse without reprieve, where there is no *arrêt de mort* — no one death sentence and/or reprieve but *only death*. I felt that I had finally discovered what Beauvoir had done with her anger and rage.

Why would Beauvoir do this? How could she so coldly dissect, for the entire world, this supposedly beloved body with, at times, the edges of Sartre's own words?

In Paris, it has been suggested by critics and reviewers across the political spectrum that this book is Beauvoir's revenge on Sartre. But revenge for what? For his love affairs with all those contingent women? For writing with his pseudo-son Victor his last book, the ideal book, the one she had always wanted to write with him?

No, I do not think things are that clear cut *or* that banal.

Julia Kristeva (among others) has defined *le récit*, narrative, in the following way: "Narrative is, in sum, the most elaborate kind of attempt on the part of the speaking subject, after syntactic competence, to situate his or her self among his or her desires and their taboos; that is, at the interior of the Oedipal Triangle" (Kristeva 1980:165). These days, in the wake of deconstruction, schizoanalysis, and feminist post-Freudianism, it is difficult to feel comfortable speaking of Oedipus. But I do think this book may be an instance of one last way for the feminist, in this case Beauvoir, to act out the Oedipal Triangle. Might this not be Beauvoir's last attempt at writing her truest family romance? After all, she wrote so many in the past, both in her memoirs and her novels. One thing is certain. In this narrative, Beauvoir is placing herself in relation to only one privileged body, the female body, the one that has been designated as female by Western, and more importantly and most paradigmatically by Sartre's own philosophical discourse. It is the body that Sartre hated: his own, of course, but more relevantly, the one that smells, bleeds, and falls apart; the one that is sometimes too large, sometimes too small — *the Maternal Body*. Sartre became "too female"; his body must be desexed, evacuated, the narrative body must be purified of what Kristeva has called the ab-ject, of its abjection, that which the discourse of mastery cannot tolerate. This is the ceremony we read. *Eschatologies*. This book is a Tomb, its cadaver purified by the logos with ultimate lucidity.

Sartre has been seen as filling many roles in Beauvoir's Family Romance — her father, her son, her brother. But never her mother — the one *with* the phallus.

And what of Beauvoir's other mother? The weak one, *without* the phallus?[7]

I returned with some trembling to that other Tomb-Book, *Une Mort Très Douce* (*A Very Easy Death* — Beauvoir 1964) and read it simultaneously with this second Tomb. Another tomb, where Beauvoir's other mother is also buried in and by narrative. I read as her (dark, thin?) mother's body "decomposed" in the same way as Sartre's; with amazement, I listened to the same rush of words. Is that because all bodies disintegrate in the same way? No, I do not

7. On the phallic mother as organizing fantasy for the denial of sexual difference, see esp. Kristeva (1974 and 1980).

think so. These two bodies are too linked by their classical sameness and difference:

> His open wounds were terrifying to look at (but happily they were hidden from him, covered up): large purplish red patches [. . .] gangrene was attacking his flesh. . . (CA, p. 155).

The decomposing body named Sartre is never sexed; the sexual organs, the wounds of this (textual) body are hidden, covered up.

Not those of that other "reprieved cadaver" (1964:28) — Beauvoir's "biological" mother whose rotting flesh and scars are described uncovered in the full light of the daughter's vision. Here I invoke the full Greek/Indo-European force of the word "ideology": the *eidos*, the logos of the image, visible idea, vision.[8] The mother's revealed sex and uncovered sex organs force Beauvoir the daughter to turn her gaze away, towards the window — out into the garden, so as to avoid seeing:

> her strained belly, creased in minuscule wrinkles, shriveled, and her shaved pubis [. . .] Seeing my mother's sex organs (*voir le sexe de ma mère*): that gave me quite a shock. No body existed less for me — nor existed more (1964:27).

The scars of this maternal body are not covered, but exposed in words — an open body, its belly the object of devouring cancer. Dead-alive, "she's rotting alive," as Beauvoir's sister put it (1964: 118).

With or without the phallus, good or bad, both versions of this body-of/in-writing must be subjected to catharsis, must be purified by the *Logos* (cf. Kristeva 1980). Beauvoir purifies and exorcizes it — like all writers who fear that which would threaten the integrity of their discourse. She must evacuate the dangerous body, the poisoned body, so that she may continue to write.

Just after Sartre's death, Beauvoir wants to lie down, stretch out, against his body — close and alone — under the sheets.[9] She cannot, of course, because of the poisonous gangrene that has taken over this textual cadaver. Incest is denied because of the poisoned body — she does lie down next to Sartre, but separated from him by the thin white sheet between them. She sleeps.

But she does not dream, as she once did at the side of that other deathbed, of her other mother's bed, while she was grieving the death of *her* mother:

8. On how the relationships among the Idea, the Image, and Vision are valorized within the traditional male libidinal economy, see Irigaray (1974).

9. I cannot here explore this complex desire and its implications with(in) the state of mourning; but this is the place to reveal one of my important intertexts here: the work of Melanie Klein. Cf., esp., her "Mourning and its Relation to Manic-Depressive States" (1940).

I spent the night by her side; forgetting my distaste for this nuptial bed where I was born, where my father died, I watched her sleep [. . .] Usually, I thought of her with indifference. In my sleep, however — where my father appeared very rarely and then only in a dull way — [my mother] often played *the essential role*: she became confused with Sartre, and we lived happily together. . . (1964:146—147) (My emphasis).

*

Turning to a man for nurturance in this culture is one thing; but when doing so involves revalorizing the fantasy of the all-powerful phallic mother, the difficult exploration of sexual difference may become impossible.

Is there a way to move out of the Family Romance without a certain existential feminism turning men into our mothers?; without revalorizing the phallic mother?; without reinforcing an ideology that requires this particular kind of coupling; or a poetics that must ultimately silence the mother's tongue? Is there a way to write without embalming the past?; without writing tombs? Without dismembering the female body; without killing other women in the name of epistemological purity; without killing our mothers, the mother in us?

At the end of *L'Invitée* (*She Came to Stay*), leaving Xavière to die in her bed, Françoise reflects "It was she or I, It shall be I" (Beauvoir 1975:406—407).

Our mothers and grandmothers have done, without a doubt, what it was they had to do. But it is, at least for this daughter, that sentence "It shall be I," *the* patriarchal sentence increasingly turned feminist — that new kinds of feminist subjects need to begin un-coupling and rewriting, without repeating the death sentences of the past.

REFERENCES

Althusser, Louis, 1971. *Lenin and Philosophy* (New York: Monthly Review).
Ascher, Carol, 1981. *Simone de Beauvoir: A Life of Freedom* (Boston: Beacon Press).
Barthes, Roland, 1953. *Le Degré zéro de l'écriture* (Paris: Seuil).
Beauvoir, Simone de, 1964. *Une mort très douce* (Paris: Gallimard Folio).
 1965a *Force of Circumstance*, trans. Richard Howard (New York: G.P. Putnam's Sons).
 1965b "Interview," *Paris Review* 9:34 (Spring—Summer), 23—40.
 1975 *She Came to Stay*, trans. Y. Moyse and R. Sehouse (Glasgow: Fontana Books).
 1981 *La Cérémonie des adieux* (Paris: Gallimard).
Cixous, Hélène, 1975. "Sorties," in: *La Jeune née* (Paris: 10/18).
 1976 "Le sexe ou la tête," *Les Cahiers du GRIF* 13 (October), 5—20.
Derrida, Jacques, 1972. "Le supplément de copule," in: *Marges* (Paris: Minuit).
Gallop, Jane, 1982. *The Daughter's Seduction* (Ithaca: Cornell UP).
Irigaray, Luce, 1974. *Speculum de l'autre femme* (Paris: Minuit).
 1979 *Et l'une ne bouge pas sans l'autre* (Paris: Minuit).
Jakobson, Roman, 1960. "Linguistics and Poetics," in: Thomas Sebeok, ed., *Style in Language* (Cambridge, Mass.: MIT Press), 350—377.
Jardine, Alice, 1979. "Interview with Simone de Beauvoir," *Signs* 5:2, 224—236.

96 ALICE JARDINE

Klein, Melanie, 1975(1940). "Mourning and Its Relation to Manic-Depressive States," in: *Love, Guilt and Reparation* (London: Hogarth Press).

Kristeva, Julia, 1974. *La Révolution du langage poétique* (Paris: Seuil).

1980 *Pouvoirs de l'horreur* (Paris: Seuil).

Sartre, Jean-Paul, 1983. *Lettres au Castor* (Paris: Gallimard).

Suleiman, Susan, 1977. "Reading Robbe-Grillet: Sadism and Text in *Projet pour une révolution à New York*," *Romanic Review* (January), 43–62.

1985 "Writing and Motherhood," in: S. Garner, M. Gohlke, C. Kahane, M. Sprengrether, eds., *The M(other) Tongue: Essays in Feminist and Psychoanalytic Interpretation* (Ithaca: Cornell UP).

Valesio, Paolo, 1980. *Novantiqua: Rhetorics as a Contemporary Theory* (Bloomington: Indiana UP).

MOTHERS

STABAT MATER

JULIA KRISTEVA

THE PARADOX: MOTHER OR PRIMARY NARCISSISM

If, in speaking of a *woman*, it is impossible to say what she *is* — for to do so would risk abolishing her difference — might matters not stand differently with respect to the *mother*, motherhood being the sole function of the "other sex" to which we may confidently attribute existence? Yet here, too, we are caught in a paradox. To begin with, we live in a civilization in which the *consecrated* (religious or secular) representation of femininity is subsumed under maternity. Under close examination, however, this maternity turns out to be an adult (male and female) fantasy of a lost continent: what is involved, moreover, is not so much an idealized primitive mother as an idealization of the — unlocalizable — *relationship* between her and us, an idealization of primary narcissism. When feminists call for a new representation of femininity, they seem to identify maternity with this idealized misapprehension; and feminism, because it rejects this image and its abuses, sidesteps the real experience that this fantasy obscures. As a result, maternity is repudiated or denied by some avant-garde feminists, while its traditional representations are wittingly or unwittingly accepted by the "broad mass" of women and men.

FLASH — an instant of time or a timeless dream; atoms swollen beyond measure, atoms of a bond, a vision, a shiver, a still shapeless embryo, unnameable. Epiphanies. Photos of what Christianity is no doubt the most sophisticated symbolic construct in which femininity, to the extent that it figures therein — and it does so constantly — is confined within the limits of

This essay first appeared, under the title "Héréthique de l'amour," in *Tel Quel,* no. 74 (Winter 1977). It was reprinted under the present title in Kristeva, *Histoires d'amour* (Paris: Denoël, 1983). This is the first English translation, very slightly shortened from the original. Translated by Arthur Goldhammer.

is not yet visible and which language necessarily surveys from a very high altitude, allusively. Words always too remote, too abstract to capture the subterranean swarm of seconds, insinuating themselves into unimaginable places. Writing them down tests an argument, as does love. What is love, for a woman, the same thing as writing. Laugh. Impossible. Flash on the unnameable, woven of abstractions to be torn apart. Let a body finally venture out of its shelter, expose itself in meaning beneath a veil of words. WORD FLESH. From one to the other, eternally, fragmented visions, metaphors of the invisible.

the *Maternal*.[1] By "maternal" I mean the ambivalent principle that derives on the one hand from the species and on the other hand from a catastrophe of identity which plunges the proper Name into that "unnameable" that somehow involves our imaginary representations of femininity, non-language, or the body. Thus, Christ, the Son of man, is in the end "human" only through his mother: as if Christic or Christian humanism could not help being a form of maternalism (which is precisely the claim that has been made repeatedly, in a characteristically esoteric fashion, by certain secularizing tendencies within Christian humanism). Yet the humanity of the Virgin mother is not always evident, and we shall see later just how Mary is distinguished from the human race, for example by her freedom from sin. At the same time, however, mysticism, that most intense form of divine revelation, is vouchsafed only to those who take the "maternal" upon themselves. Saint Augustine, Saint Bernard, and Meister Eckhart, to name just three among many, assume the role of virgin spouse to the Father, and Bernard even receives drops of virginal milk on his lips. Comfortable in their relation to the maternal "continent," mystics use this comfort as a pedestal on which to erect their love of God; these "happy Schrebers," as Philippe Sollers calls them, thus shed a bizarre light on modernity's psychotic lesion, namely, the apparent incapacity of modern codes to make the maternal — i.e., primary narcissism — tractable. Rare and "literary" if always rather oriental, not to say tragic, are the mystics' contemporary counterparts: think of Henry Miller's claim to be pregnant or Artaud's imagining himself to be like "his girls" or "his mother." It is Christianity's Orthodox branch, through the golden tongue of John Chrysostom among others, that will consecrate this transitional function of the Maternal by referring to the Virgin as a "link," a "surrounding," or an "interval," thereby opening the way to more or less heretical attempts to identify the Virgin with the Holy Spirit.

1. For information about matters not covered here, see the two books that provided much of the basis for the reflections contained in this paper, Warner (1976) and Barande (1977).

Many civilizations have subsumed femininity under the Maternal, but Christianity in its own way developed this tendency to the full. The question is whether this was simply an appropriation of the Maternal by men and therefore, according to our working hypothesis, just a fantasy hiding the primary narcissism from view, or was it perhaps also the mechanism of enigmatic sublimation? This may have been masculine sublimation, but it was still sublimation, assuming that for Freud imagining Leonardo — and even for Leonardo himself — taming the Maternal — or primary narcissistic — economy is a necessary precondition of artistic or literary achievement.

Yet this approach leaves many questions unanswered, among them the following two. First, what is it about the representation of the Maternal in general, and about the Christian or virginal representation in particular, that enables it not only to calm social anxiety and supply what the male lacks, but also to satisfy a woman, in such a way that the community of the sexes is established beyond, and in spite of, their flagrant incompatibility and permanent state of war? Second, what is it about this representation that fails to take account of what a woman might say or want of the Maternal, so that when today women make their voices heard, the issues of conception and maternity are a major focus of discontent? Such protests go beyond sociopolitcal issues and raise "civilization's discontents" to such a pitch that even Freud recoiled at the prospect: the discontent is somehow in the species itself.

A TRIUMPH OF THE UNCONSCIOUS IN MONOTHEISM

It seems that the epithet "virgin" applied to Mary was an error of translation: for the Semitic word denoting the social-legal status of an unmarried girl the translator substituted the Greek *parthenos*, which denotes a physiological and psychological fact, virginity. It is possible to read this as an instance of the Indo-European fascination (analyzed by Georges Dumezil) with the virgin daughter as repository of the father's power. It may also be interpreted as an ambivalent, and highly spiritualized, evocation of the underlying mother goddess and matriarchy, with which Greek culture and Jewish monotheism were locked in combat. Be that as it may, it remains true that Western Christendom orchestrated this "error of translation" by projecting its own fantasies on it, thereby producing one of the most potent imaginary constructs known to any civilization.

The history of the Christian cult of the Virgin is actually the history of the imposition of beliefs with pagan roots upon, and sometimes in opposition to, the official dogma of the Church. Admittedly, the Gospels acknowledge the existence of Mary. But they allude only in the most discreet way to the immaculate conception, say nothing at all about Mary's own history, and seldom

depict her in the company of her son or in the scene surrounding his crucifixion. Thus we read, for example, in Matthew 1.20, that "the angel of the Lord appeared unto him in a dream, saying, Joseph, thou son of David, fear not to take unto thee Mary thy wife: for that which is conceived in her is of the Holy Ghost." And Luke 1.34 has Mary saying to the angel, "How shall this be, seeing I know not a man?" These texts open a path, narrow to be sure but quickly widened by apocryphal additions, that leads to the possibility of pregnancy without sex, wherein a woman preserved from penetration by a male conceives solely with the aid of a "third person" or, rather, non-person, the Spirit. On the rare occasions when the Mother of Jesus does appear in the Gospels, it is in order to signify the fact that the filial bond has to do not with the flesh but with the name; in other words, any trace of matrilinearity is explicitly disavowed, leaving only the symbolic tie between mother and son. Witness, for example, Luke 2.48–49: "And his mother said unto him, Son, why hast thou thus dealt with us? behold, thy father and I have sought thee sorrowing. And he said unto them, How is that ye sought me? wist ye not that I must be about my Father's business?" And John 2.3: "The mother of Jesus saith unto him, They have no wine. Jesus saith unto her, Woman, what have I to do with thee? mine hour is not yet come." Or again, John 19.26–27: "When Jesus therefore saw his mother, and the disciple standing by, whom he loved, he saith unto his mother, Woman, behold thy son! Then saith he to the disciple, Behold thy mother! And from that hour that disciple took her unto his own *home*."

From this rather meager programmatic material an irresistible complex of images grew, essentially along three lines. The first involved attempts to establish an analogy between the Mother and the Son by developing the theme of the immaculate conception; by inventing a biography for Mary paralleling that of Jesus; and, by freeing Mary in this way from sin, freeing her also from death: Mary passes away in Dormition or Assumption. The second involved granting Mary letters of nobility, making use of a power which though exercised in the afterlife was nonetheless political, in that she was proclaimed queen, endowed with the attributes and paraphernalia of royalty, and simultaneously declared Mother of the divine institution on earth, the Church. Finally, the relationship to Mary and of Mary was revealed as the prototype of the love relationship; it consequently followed the development of those two fundamental subcategories of Western love, courtly love and love of the child, and thus became involved in the whole range of love-types from sublimation to asceticism and masochism.

NEITHER SEX NOR DEATH

The idea to model an imaginary life of Mary on that of Jesus seems

to have come from the apocryphal literature. The story of Mary's miraculous or "immaculate" conception by Anne and Joachim after a long childless marriage, as well as the depiction of her as a pious young woman, first appears in apocryphal sources at the end of the first century. It may be found in its entirety in the Book of James as well as the Gospel according to pseudo-Matthew (which became the inspiration of Giotto's frescoes). The "facts" were cited by Clement of Alexandria and Origen but not officially recognized, and although the Eastern Orthodox church tolerated the stories without difficulty, they were not translated into Latin until the sixteenth century. The West was not slow, however, to glorify the life of Mary, using methods of its own, albeit still of Orthodox inspiration. The first Latin poem on Mary's birth, entitled "Maria," was the work of Hroswitha of Gandersheim (d. before 1002), a poet and playwright as well as a nun.

In the fourth century the notion of an immaculate conception was further developed and rationalized by grafting the Church Fathers' arguments for asceticism onto the spirit of the apocrypha. The logic of the case was simple: sexuality implies death and vice versa, so that it is impossible to escape the latter without shunning the former. A vigorous proponent of asceticism for both sexes was Saint John Chrysostom, who has the following to say in *On Virginity*: "For where there is death, there too is sexual coupling; and where there is no death, there is no sexual coupling either" (Warner 1976:52). Though combatted by Saint Augustine and Saint Thomas, Chrysostom was not without influence on Christian doctrine. Augustine, for example, condemned "concupiscence" (*epithumia*) and asserted that Mary's virginity was in fact merely a logical prerequisite for the chastity of Christ. The Orthodox church, which was doubtless the heir to a more violent matriarchy prevalent in the East, was bolder in emphasizing Mary's virginity. A contrast was drawn between Mary and Eve, life and death, as in Saint Jerome's *Twenty-second Letter*: "Death came through Eve, but life has come through Mary"; and Irenaeus wrote that through Mary "the guile of the serpent was overcome by the simplicity of the dove and we are set free from those chains by which we had been bound to death" (Warner 1976:54, 60). There were even some rather tortuous debates over the question whether Mary remained a virgin after giving birth: thus in A.D. 381 the Second Council of Constantinople, under the influence of Arianism, placed greater stress on Mary's role than did official dogma and proclaimed her perpetual virginity, and the council of A.D. 451 declared her *Aeiparthenos*, forever virgin. Once this position was established, it became possible to proclaim that Mary was not merely the Mother of man or Christ but the Mother of God, *Theotokos*, as the patriarch Nestor did, thus deifying her once and for all.

The strained eardrum wresting sound from the heedless silence. Wind in the grass, the cry of a gull in the distance, echoes of the waves, of sirens, of voices, or of nothing? Or his, my new-born child's, tears, syncopated spasm of the void. Now I hear nothing, but my eardrum continues to transmit this sonorous vertigo to my skull, to the roots of my hair. My body is no longer mine, it writhes, suffers, bleeds, catches cold, bites, slavers, coughs, breaks out in a rash, and laughs. Yet when his, my son's, joy returns, his smile cleanses only my eyes. But suffering, his suffering – that I feel inside; that never remains separate or alien but embraces me at once without a moment's respite. As if I had brought not a child but suffering into the world and it, suffering, refused to leave me, insisted on coming back, on haunting me, permanently. One does not bear children in pain, it's pain that one bears: the child is pain's representative and once delivered moves in for good. Obviously you can close your eyes, stop up your ears, teach courses, run errands, clean house, think about things, about ideas. But a mother is also marked by pain, she succumbs to it. "And you, one day a sword will pass through your soul."

The highly complex relationship between Christ and his Mother served as a matrix within which various other relations – God to mankind, man to woman, son to mother, etc. – took shape; this relationship soon gave rise to questions involving not only *causality* but also *time*. If Mary is prior to Christ, and if he, or at any rate his humanity, originates with her, then must she not too be immaculate? For otherwise a person conceived in sin and carrying sin within herself would have given birth to a God, and how could this be? Some apocryphal writers suggested with imprudent haste that Mary had indeed been conceived without sin, but the Fathers were more cautious. Saint Bernard refused to celebrate Saint Mary's conception by Saint Anne and in this way attempted to impede the assimilation of Mary's life to that of Christ. But it was Duns Scotus who transformed this hesitation about promoting a mother goddess to a position within Christianity into a logical problem, in order to safeguard both the Great Mother and logic. He took the view that Mary's birth was a *praeredemptio*, based on an argument of congruity: if it is true that it is Christ alone who saves us by his redemption on the cross, then the Virgin who bore him can only be preserved from sin "recursively," as it were, from her own conception up to the moment of that redemption.

Pitting Franciscans against Dominicans, the battle that raged around the Virgin intensified on both sides, for and against, dogma versus clever logic, until finally, as is well known, the Counter Reformation overcame all resistance: from then on Catholics have venerated Mary in her own person. The Company of Jesus successfully concluded a

process initiated by popular pressure filtered through patristic asceticism, and managed, without explicit hostility or blunt repudiation, to gain control of that aspect of the Maternal (in the sense I mentioned earlier) that was useful for establishing a certain equilibrium between the sexes. Oddly though inevitably, it was when this equilibrium was first seriously threatened in the nineteenth century that the Catholic Church, in 1854, gave the Immaculate Conception the status of dogma (thus showing itself to be more dialectical and more subtle than the Protestants, who were already engendering the first suffragettes). It is frequently suggested that the flourishing of feminism in the Protestant countries is due, among other things, to the fact that women there are allowed greater initiative in social life and ritual. But one wonders if it is not also due to Protestantism's *lacking* some necessary element of the Maternal which in Catholicism has been elaborated with the utmost sophistication by the Jesuits (and which again makes Catholicism very difficult to analyze).

That entity compounded of woman and God and given the name Mary was made complete by the avoidance of death. The fate of the Virgin Mary is more radiant even than that of her son: not having been crucified, she has no tomb and does not die, and therefore she has no need of resurrection. Mary does not die but rather — echoing Taoist and other oriental beliefs in which human bodies pass from one place to another in a never-ending cycle which is in itself an imitation of the process of childbirth — she passes over.

This transition is more passive in the east than in the west: the Orthodox Church holds to the doctrine of *Koimesis*, or Dormition, which in some iconographic representations has Mary becoming a little girl held in the arms of her son, who now becomes her Father; she thus passes from the role of Mother to that of Daughter, to the great pleasure of students of Freud's "Three Caskets."

Not only is Mary her son's *mother* and his *daughter*, she is also his *wife*. Thus she passes through all three women's stages in the most restricted of all possible kinship systems. Adapting the Song of Songs, Bernard of Clairvaux in 1135 glorified Mary in the role of beloved spouse. But long before that, Catherine of Alexandria (martyred in A.D. 307) imagined herself receiving the wedding ring from Christ aided by the Virgin; and later Catherine of Siena (d. 1380) entered into a mystical marriage with Christ. Was it the impact of Mary's role as Christ's beloved and spouse that was responsible for the rapid spread of Mariolatry in the West after Bernard and thanks to the Cistercians? "*Vergine Madre, figlia del tuo Figlio,*" exclaimed Dante, who perhaps best captures the combination of the three feminine roles — daughter-wife-mother — within a whole, where they lose their specific corporeal identities while retaining their psychological functions. The nexus of these three functions is the basis of immutable and atemporal spirituality: "the

fixed term of an eternal design," as *The Divine Comedy* magisterially puts it.

By contrast, in the West, Mary's transition is more active: in the Assumption she rises body and soul to another world. Celebrated in Byzantium as early as the fourth century, the feast of the Assumption came to Gaul in the seventh century under the influence of the Eastern Church, but the earliest visions of the Virgin's assumption (all women's visions, and most notably that of Elisabeth of Schonan, d. 1164) date back no farther than the twelfth century. The Vatican did not declare the Assumption to be dogma until 1950 — and even then (we may speculate) only to calm widespread anxieties over death in the aftermath of the most lethal of all wars.

FIGURE OF POWER

Turning now to the question of "power," an image of *Maria Regina* dating as far back as the sixth century can be found in Rome's Santa Maria Antiqua. It is interesting to observe that it is Mary, woman and and mother, who takes it upon herself to represent the supreme terrestrial power. Christ is king, but it is neither Jesus nor his Father that one sees wearing crowns, diadems, sumptuous robes, and other external signs of abundant material wealth. The Virgin Mary became the center of this twisting of Christian idealism in the direction of opulence. When she later assumed the title of Our Lady, moreover, it was by analogy with the noble lady of the feudal court. The Church later became wary of Mary's role as repository of power and tried to put a halt to it, but it nevertheless persisted in popular and artistic imagery — witness Piero della Francesca's impressive painting *Madonna della Misericordia*, which was disavowed in its time by the Catholic authorities. Yet not only did the papacy venerate Christ's mother increasingly as it consolidated its power over the towns, it also openly identified the papal institution itself with the Virgin: Mary was officially proclaimed Queen by Pius XII in 1954 and *Mater Ecclesiae* in 1964.

EIA MATER, FONS AMORIS!

Ultimately, several fundamental features of western love converge in Mary. Initially, the cult of the Virgin, which assimilated Mary to Jesus and pushed asceticism to an extreme, seems to have contrasted sharply with courtly love for the noble lady, which constituted a social transgression but nothing of a physical or moral sin. Yet even in its carnal beginnings courtly love had this in common with Mariolatry, that both Mary and the Lady were focal points of men's aspirations and desires. Furthermore, by dint of uniqueness, by the exclusion of all other women, both were embodiments of an absolute authority that was all the more attractive because it seemed not to be subject to the severity of the father. This feminine power must have

been experienced as power denied, all the more pleasant to seize because it was both archaic and secondary, an ersatz yet not less authoritarian form of the real power in the family and the city, a cunning double of the explicit phallic power. From the thirteenth century, helped by the establishment of ascetic forms of Christianity, and especially after 1328, when the Salic Laws — prohibiting inheritance by daughters — were promulgated, making the beloved lady quite vulnerable and tinging love for her with every shade of the impossible, the Marian tradition and the courtly tradition tended to merge. With Blanche of Castille (d. 1252), the Virgin explicitly became the focus of courtly love, combining the qualities of the desired woman and the holy mother in a totality as perfect as it was inaccessible. Enough to make any woman suffer and any man dream. And indeed one *Miracle of Our Lady* tells of a young man who abandons his fiancée for the Virgin after Mary reproaches him in a dream for having left her for an "earthly woman."

The smell of milk, dew-drenched greenery, sour and clear, a memory of wind, of air, of seaweed (as if a body lived without waste): it glides under my skin, not stopping at the mouth or nose but caressing my veins, and stripping the skin from the bones fills me like a balloon full of ozone and I plant my feet firmly on the ground in order to carry him, safe, stable, unup-rootable, while he dances in my neck, floats with my hair, looks right and left for a soft shoulder, "slips on the breast, swingles, silver vivid blossom of my belly" and finally flies up from my navel in his dream, borne by my hands. My son.

*

A night of vigil, fitful sleep, the child's gentleness, hot mercury in my arms, caress, tenderness, defenseless body, his or mine, sheltered, protected. Another wave rises under my skin after he falls asleep — belly, thighs, legs: sleep of the muscles not the

Meanwhile, alongside this ideal that no individual woman could possibly embody, the Virgin also served as a mooring point for the humanization of the West, and in particular for the humanization of love. It was again in the thirteenth century, with Saint Francis, that this tendency took shape, producing representations of Mary as a poor, modest, and humble woman as well as a tender, devoted mother. Pietro della Francesca's celebrated *Nativity*, now in London, which Simone de Beauvoir was too quick to see as a defeat for women because it depicts a mother kneeling before her new-born son, actually epitomizes the new cult of humanist sensibility. For the high spirituality that assimilated the Virgin to Christ, the painting substitutes an altogether human image of a mother of flesh and blood. Such maternal humility has inspired the most widespread of pious images and comes closer than early images to women's "real-

brain, sleep of the flesh. The watchful tongue tenderly remembers another abandonment, my own: decorated lead at the foot of the bed, a hollow, the sea. Childhood regained, recreated, dreamed-of peace, in sparks, flash of the cells, moments of laughter, a smile in the black of a dream, night, an opaque joy that holds me fast in my mother's bed and propels him, a son, a butterfly drinking dew from his hand, there, beside me in the night. Alone: she, I and he.

life" experience. Although it is to some degree tinged with female masochism, it also exhibits a compensating measure of gratification and ecstasy, in that the mother bows her head before her son but not without a boundless pride in the knowledge that she is also his wife and daughter. She knows that she is destined to that eternity (of spirit or species) of which every mother is subconsciously aware, and in relation to which the devotion, or even the sacrifice, of motherhood is but a ridiculously small price to pay. And that price is all the more easy to bear in that, compared with the love that binds mother to son, all other "human relationships" stand revealed as flagrant imitations. The Franciscan representation of the Mother adequately captured certain essential aspects of maternal psychology, thus not only bringing large numbers of worshipers into the churches but also extending the Marian cult to a remarkable degree, as is shown by the large numbers of churches that were dedicated to Our Lady. The humanization of Christianity through the cult of the Mother also led to a new interest in the humanity of the man-father: the celebration of family life brought Joseph to prominence in the fifteenth century.

WHAT BODY

Of the virginal body we are entitled only to the ear, the tears, and the breasts. That the female sexual organ has been transformed into an innocent shell which serves only to receive sound may ultimately contribute to an eroticization of hearing and the voice, not to say of understanding. But by the same token sexuality is reduced to a mere implication. The female sexual experience is therefore anchored in the universality of sound, since the spirit is *equally* given to all men, to all women. A woman has only two choices: either to experience herself in sex *hyperabstractly* (in an "immediately universal" way, as Hegel would say) so as to make herself worthy of divine grace and assimilation to the symbolic order, or else to experience herself as *different*, other, fallen (or, in Hegel's terms again, "immediately particular"). But she will not be able to achieve her complexity as a divided, heterogeneous being, a "fold-catastrophe"[2] of the "to-be" (or, in Hegel's terms, the "never singular").

2. The allusion is to René Thom's theory of catastrophes. (Translator's note.)

The lover gone: now comes oblivion, but the pleasure of the sexes remains, and nothing is missing. No representation, sensation, memory. The brazier of vice. Later, forgetfulness returns, but now as a fall – of lead – gray, pale, opaque. Oblivion: a blinding, choking, yet tender mist. Like the fog that devours the park, swallowing its branches, wiping out the rusty new sun and clouding my eyes.

Absence, brazier, oblivion. Scansion of our loves.

Leaving, in place of the heart, a hunger. A spasm that spreads, that travels down the vessels to the ends of the breasts, to the tips of the fingers. It palpitates, bores a hole in the emptiness, erases it, and little by little takes up residence. My heart: an immense, beating wound. A thirst.

Anxious, guilty. The *Vaterkomplex* of Freud at the Acropolis? The impossibility of existing without repeated legitimation (without books, map, family). Impossibility – depressing possibility – of "transgression."

Or of the repression in which *I* passes to the Other, what I desire from others.

Or this murmur of emptiness, this open wound in my heart which means that I exist only in purgatory.

I desire the Law. And since it is not made for me alone, I run the risk of desiring outside the law. Then, the narcissism thus awakened that wants to be sex, wanders inflated. In the transport of the senses, I come up

The virgin mother's ample blue gown will allow only the breast to be seen of the body underneath, while her face will gradually be covered with tears as the stiffness of the Byzantine icons is slowly overcome. Milk and tears are the signs *par excellence* of the *Mater dolorosa* who began invading the West in the eleventh century and reached a peak in the fourteenth. From then on she has never ceased to fill the Marian visions of all those, men and women (or frequently male child, female child) who suffer the anguish of some maternal frustration. That orality – the threshold of infantile regression – manifests itself in connection with the breast whereas the spasm that comes at eroticism's eclipse is associated with tears should not be allowed to obscure what milk and tears have in common: both are metaphors of non-language, of a "semiotic" that does not coincide with linguistic communication. The Mother and her attributes signifying suffering humanity thus become the symbol of a "return of the repressed" in monotheism. They reestablish the nonverbal and appear as a signifying modality closer to the so-called primary processes. Without them the complexity of the Holy Spirit would no doubt have been mutilated. Returning through the Virgin Mother, they instead found fertile soil in art – painting and music – of which the Virgin would of necessity become both patron and privileged object.

empty-handed. Nothing reassures because only the law makes permanent. Who calls this suffering ecstasy? It is the pleasure of the damned. Thus we witness the emergence of the "virginal Maternal" function in the symbolic economy of the West: from the high Christic sublimation which she aspires to achieve and at times transcends, to the extralinguistic realms of the unnameable, the Virgin Mother occupies the vast territory that lies on either side of the parenthesis of language. She adds to the Christian Trinity, and to the Word which gives it its coherence, a heterogeneity that they subsume.

The ordering of the maternal libido is carried farthest in connection with the theme of death. The *Mater dolorosa* knows no male body except that of her dead son, and her only pathos (which is sharply distinguished from the sweet and somewhat absent serenity of the lactating Madonnas) comes from the tears she sheds over a corpse. Since resurrection lies in the offing, and since as the Mother of God she ought to know that it does, nothing justifies Mary's anguish at the foot of the cross unless it is the desire to feel in her own body what it is like for a man to be put to death, a fate spared her by her female role as source of life. Is the love of women who weep over the bodies of the dead a love as obscure as it is ancient, nourished by the same source as the aspiration of a woman whom nothing satisfies, namely, the desire to feel the thoroughly masculine pain of the male who, obsessed with the thought of death, expires at each moment of ecstasy? Still, Mary's suffering has nothing of tragic excess about it: joy and indeed a kind of triumph supplant her tears, as if the conviction that death does not exist were an unreasonable but unshakeable maternal certainty, upon which the principle of resurrection must have rested for support. The majestic figure of this woman twisted one way by desire for the male cadaver and the other by a denial of death — a twisting whose paranoid logic should not go unmentioned — is served up in magisterial fashion by the well-known *Stabat Mater*. All belief in resurrection is probably rooted in mythologies dominated by the mother goddess. True, Christianity found its vocation in the displacement of this bio-maternal determinism by the postulate that immortality belongs primarily to the Name of the Father. But it could not achieve *its* symbolic revolution without drawing on the support of the feminine representation of biological immortality. Is it not the image of Mary braving death depicted in the many variations of the *Stabat Mater* which (in the text attributed to Jacopone da Todi) enraptures us even today in musical compositions from Palestrina to Pergolesi, Haydn, and Rossini?

Listen to the "baroquism" of the young Pergolesi (1710–1736) dying of tuberculosis while writing his immortal *Stabat Mater*. His musical invention, which, conveyed through Haydn, would be heard

again in Mozart, is no doubt his only form of immortality. But when we hear the cry, *"Eia mater, fons amoris!"* ("Hail, mother, source of love"), referring to Mary confronting the death of her son, is it merely a residue of the baroque era? Man surmounts death, the unthinkable, by postulating instead — in the stead and place of thought as well as of death — maternal love. That love, of which divine love will be no more than a not always convincing derivative, is psychologically perhaps just a memory, prior to the primary identifications of the primitive shelter that guaranteed the survival of the newborn child. Logically in fact, that love is an unfurling of anguish at the very moment when the identity of thought and the living body breaks down. When the possibilities of communication are swept away, the last remaining rampart against death is the subtle spectrum of auditory, tactile, and visual memories that precede language and reemerge in its absence. Nothing could be more "normal" than that a maternal image should establish itself on the site of that tempered anguish known as love. No one is spared. Except perhaps the saint or the mystic, or the writer who, by force of language, can still manage nothing more than to demolish the fiction of the mother-as-love's-mainstay and to identify with love as it really is: *a fire of tongues*, an escape from representation. For the few who practice it, then, is modern art not a realization of maternal love — a veil over death, assuming death's very place and knowing that it does? A sublimated celebration of incest. . .

ALONE OF ALL HER SEX

Incommensurable, unlocalizable maternal body.

First there is division, which precedes the pregnancy but is revealed by it, irrevocably imposed.

. . . Then another abyss opens between this body and the body that was inside it: the abyss that separates mother and child. What relationship is there between me or, more modestly, between my body and this internal graft, this crease inside, which with the cutting of the umbilical cord becomes another person, inaccessible? My body and . . . him. No relation. Nothing to do with one another. Nothing to do from the first gestures, cries, steps,

Among the many art objects and archeological curiosities that Freud collected were innumerable statuettes of mother goddesses. Yet in the work of the founder of psychoanalysis this interest is alluded to only discreetly. It does come up in his study of Leonardo, where Freud considers artistic creation and homosexuality and in so doing discovers the influence of an archaic mother figure, which is thus seen in terms of its effects on man, and more particularly on the curious function he sometimes has: that of changing languages. Elsewhere, in analyzing changes that occurred in monotheism, Freud emphasizes

well before *his* personality has made him my opposite: the child, *he* or *she*, is irremediably another. That "there is no relation between the sexes" (Lacan) is not much of a surprise in the face of this bolt of lightning that blinds me on the brink of the abyss between me and what was mine but is now irremediably alien. Try to imagine this abyss: dizzying visions. No identity lies therein. A mother's identity survives only thanks to the well-known fact that consciousness is lulled by habit, wherein a woman protects herself along the frontier that divides her body and makes an expatriate of her child. A kind of lucidity, however, might restore her, cut in two, one half alien to the other — fertile soil for delirium. But also, and for that very reason maternity along its borders destines us to experience a frenzied ecstasy to which by chance the nursling's laugh responds in the sunlit ocean's waters. What is the relationship between him and me? No relation, except that abundant laughter into which some sonorous, subtle, fluid identity collapses, gently carried by the waves.

*

From that time in my childhood, fragrant, warm and soft to the touch, I retain only a memory of space. Nothing of time. The smell of honey, the roundness of things, silk and velvet under my fingers, on my cheeks. Mama. Almost nothing visual — a shadow that plunges into black-

the fact that Christianity, in opposition to the rigor of Judaism, reduced the gap between itself and pagan myth by incorporating a preconscious recognition of a maternal feminine. But one looks in vain to Freud's case studies for insight into mothers and their problems. It might seem as though maternity were a remedy for neurosis which *ipso facto* eliminated the need for a woman to seek that other remedy, psychoanalysis. Or that in this area psychoanalysis deferred to religion. Broadly speaking, the only thing that Freud has to say about maternity is that the desire to have a child is a transformation of penis envy or anal compulsion, which led him to discover the equation child = penis = faeces. This discovery does indeed shed a good deal of light not only on male fantasies concerning childbirth, but also on female fantasies insofar as they conform to the male ones, which they largely do in their hysterical labyrinths. Still, about the complexities and difficulties of the maternal experience Freud has absolutely nothing to say, though it may interest students of his work to note that he reports his mother's efforts to prove to him one day, in the kitchen, that his body was not immortal but would eventually crumble like pastry dough, or to look closely at the bitter photographs of Frau Martha Freud, the wife, which tell a whole story without words. Thus Freud's successors were in effect left an entire dark continent to

ness, absorbs me or disappears in a few flashes of light. Almost no voice, in its placid presence. Except perhaps, from a later time, the sound of quarreling: her exasperation, her being fed up, her hatred. Never direct, always restrained, as if, though deserved by the stubborn child, the mother's hatred could not be received by the daughter, was not destined for her. A hatred without a recipient, or rather, whose recipient was no "ego" and which, troubled by this absence of receptivity, attenuated itself by irony or collapsed in remorse before its arrival. In some women this maternal aversion can work itself up to a delayed spasm, like a slow orgasm. Women no doubt reproduce between them the peculiar, forgotten forms of close combat in which they engaged with their mothers. Complicity in the non-said, connivance in the unsayable, the wink of an eye, the tone of voice, the gesture, the color, the smell: we live in such things, escapees from our identity cards and our names, loose in an ocean of detail, a data-bank of the unnameable. Between individuals there is no communication but a matching of atoms, molecules, scraps of words, fragments of phrases. The community of women is a community of heirs apparent. Con-

explore, and Jung was the first to plunge in with his whole panoply of esoteric notions, which is not to say that he did not succeed in calling attention to certain prominent features of the unconscious that not only have a bearing on maternity but still have not yielded to analytic rationality.[3]

Those interested in what maternity is for a woman will no doubt be able to shed new light on this obscure topic by listening, with greater attentiveness than in the past, to what today's mothers have to say not only about their economic difficulties but also, and despite the legacy of guilt left by overly existentialist approaches to feminism, about malaise, insomnia, joy, rage, desire, suffering, and happiness. At the same time we can also try to gain a clearer picture of the Virgin, that prodigious structure of maternality that the West has erected; the foregoing remarks merely record a few episodes in a history that refuses to come to an end.

What is it then, which, in this maternal figure who alone of all her sex departed from the customary ways of both sexes, allowed her to become both an object with whom women wished to identify and an object that those responsible for maintaining the social and symbolic

3. For example, Jung noted the "hierogamic" relations between Mary and Christ, as well as the peculiar overprotection of the Virgin with respect to original sin, which places her on the fringes of humanity. He also lays a good deal of stress on the acceptance of the Assumption as dogma by the Vatican, which Jung regarded as a significant advantage of Catholicism over Protestantism (Jung, 1964).

versely, when the other woman appears as such, that is, in her singularity and necessary opposition, "I" am seized to the point where "I" no longer exist. There are then two possible ways of carrying out the rejection that affirms the other woman as such. Either, unwilling to know her, I ignore her and, "alone of my sex," I amically turn my back on her: hatred that has no recipient worthy of its virulence turns into indifferent complacency. Or else, offended by the other woman's obstinate persistence in believing herself to be singular, I refuse to accept her claim to be the recipient of my hatred and find respite only in the eternal return of physical blows, of hatred striking out — blind, heedless, but obstinate. . . . In this weird feminine seesaw that swings "me" out of the unnameable community of women into single combat with another woman, it is perturbing to say "I." The languages of great civilizations that used to be matrilinear must avoid, do avoid the use of personal pronouns: they leave it up to the context to distinguish the protagonists, and take refuge in tones of voice to recover a submerged, transverbal correspondence of bodies. A piece of music whose so-called oriental civility is suddenly interrupted by acts of violence, murders, bloodbaths: isn't that what "women's discourse" would be? Wasn't stopping the motion of that seesaw one of the things Christianity wanted to accomplish? Stop it, free women from its rhythm, and

order felt it necessary to manipulate?

I want to suggest the following hypothesis: that the "virginal maternal" is a way — and, I might add, not a bad way — of coping with female paranoia.

— The Virgin assumes her female denial of the other sex (of man), but subjugates it by setting a third person against the other: I am a Virgin, *I* conceived not by *you* but by *Him*. This results in an immaculate conception, untainted by man or sex, but still a conception, out of which comes a God in whose existence a woman does therefore play an important part, provided that she acknowledges her subservience.

— The Virgin assumes the paranoid desire for power by turning a woman into the Queen of Heaven and the Mother of earthly institutions — the Church. But she then suppresses her megalomania by kneeling before the child-god.

— The Virgin obliterates the desire to murder or devour through a strong oral investment — the breast; she attaches a positive value to suffering — the sob; and she encourages replacement of the sexual body by the ear of understanding.

— The Virgin assumes the paranoid fantasy of being excluded from time and death, through the very flattering image associated with the Dormition or Assumption.

— Above all, the Virgin subscribes to the foreclosure of the other woman — which funda-

install them definitively in the bosom of the spirit? All too definitively. . . . mentally is probably a fore-closure of the woman's mother — by projecting an image of the One, the Unique Woman: unique among women, unique among mothers, and, since she is without sin, unique also among humans of both sexes. But this recognition of the desire of uniqueness is immediately checked by the postulate that uniqueness is achieved only by way of exacerbated masochism: an actual woman worthy of the feminine ideal embodied in inaccessible perfection by the Virgin could not be anything other than a nun or a martyr; if married, she would have to lead a life that would free her from her "earthly" condition by confining her to the uttermost sphere of sublimation, alienated from her own body. But there a bonus awaits her: the assurance of ecstasy.

Striking a shrewd balance between concessions to and constraints upon female paranoia, the representation of virgin motherhood seems to have crowned society's efforts to reconcile survivals of matrilinearity and the unconscious needs of primary narcissism on the one hand with, on the other hand, the imperatives of the nascent exchange economy and, before long, of accelerated production, which required the addition of the superego and relied on the father's symbolic authority.

Now that this once carefully balanced structure seems in danger of tottering, the following question arises: to what aspects of the feminine psyche does this representation of the maternal offer no answer, or at any rate no answer that is not too coercive for women in this century to accept?

The weight of the "non-said" (non-dit) no doubt affects the mother's body first of all: no signifier can cover it completely, for the signifier is always meaning (sens), communication or structure, whereas a mother-woman is rather a strange "fold" (pli) which turns nature into culture, and the "speaking subject" (le parlant) into biology. Although it affects each woman's body, this heterogeneity, which cannot be subsumed by the signifier, literally explodes with pregnancy — the dividing line between nature and culture — and with the arrival of the child — which frees a woman from uniqueness and gives her a chance, albeit not a certainty, of access to the other, to the ethical. These peculiarities of the maternal body make a woman a creature of folds, a catastrophe of being that cannot be subsumed by the dialectic of the trinity or its supplements.

Nor is there any less silence concerning the mental and physical suffering associated with childbirth and, even more, with the self-denial implicit in making oneself anonymous in order to transmit social norms which one may disavow for oneself but which *one must* pass on to the child, whose education is a link to generations past. But, with the ambivalence characteristic of masochism, this suffering

goes hand in hand with jubilation, whereby a woman ordinarily averse to perversion allows herself to engage in "coded" perversity, a perversity that is absolutely fundamental, the ultimate basis of all social life, without which society would be unable to reproduce itself or maintain its notion of a normative household. This perversion does not involve a Don Juan-like fragmentation or multiplication of objects of desire. Rather, it is immediately legalized, not to say "paranoized" (*paranoisée*) by the effects of masochism: any sexual "profligacy" is acceptable and therefore insignificant provided a child is born to suture the wounds. The feminine "father-version" (*père-version*) lies coiled in the desire of the law as desire of repro- duction and continuity; it raises female masochism to the status of a structural stabilizer — countering structural deviations — and, by assuring the mother of a place in an order that surpasses human will, provides her a reward of pleasure. This coded perversion, this close combat between maternal masochism and the law, has always been used by totalitarian regimes to enlist the support of woman, indeed, quite successfully. Still, it is not enough to "denounce" the reac- tionary role that mothers have played in the service of "dominant male power." It is necessary to ask how this role relates to the bio- symbolic latencies implicit in maternity; and having done that, to ask further how, now that the myth of the Virgin is no longer capable of subsuming those latencies, their surfacing may leave women vulnerable to the most frightful forms of manipulation, to say nothing of the blindness, the pure and simple contempt, of progressive activists who refuse to take a closer look at the question.

Also neglected by the virginal myth is the question of hostility between mother and daughter, a question resolved in magisterial but superficial fashion by making Mary universal and particular but never singular: "unique of all her sex." For more than a century now, our culture has faced the urgent need to reformulate its representations of love and hate, inherited from Plato's *Symposium*, the trouba- dours, and Our Lady, in order to deal with the relationship of one woman to another. Here again, maternity points the way to a possible solution: a woman rarely, I do not say never, experiences passion — love or hate — for another woman, without at some point taking the place of her own mother — without becoming a mother herself and, even more importantly, without undergoing the lengthy process of learning to differentiate herself from her own daughter, her simulacrum, whose presence she is forced to confront.

Finally, the foreclosure of the other sex (of the masculine) can apparently no longer be done under the auspices of the hypostasized third person through the intermediary of the child: "Neither I nor you but he, the child, the third, the non-person, God, who in any case I am in the final analysis." Since foreclosure does occur, what it now requires, in order for the feminine being who struggles with it

to hold her own, is not deification of the third party but counter-investment in "blue-chip shares," i.e., in redeemable *tokens of power*. Feminine psychosis today sustains itself through passion for politics, science, art, in which it becomes engrossed. The variant of that psychosis that accompanies maternity may be analyzed, more easily perhaps than other variants, in terms of its rejection of the other sex.

The love of God and for God inhabits a hiatus: the space delineated on one side by sin and on the other by the hereafter. Discontinuity, lack, and arbitrariness: the topography of the sign, of the symbolic relation that posits all otherness as impossible. Love, here, is nothing but the impossible.

For a mother, on the other hand, curiously, the arbitrariness that is the other (the child) goes without saying. For her the impossible is like this: it becomes one with the implacable. The other is inevitable, she seems to say, make a God of him if you like; he won't be any less natural if you do, for this other still comes from me, which is in any case not me but an endless flux of germinations, an eternal cosmos. The other proceeds from itself and myself to such a degree that ultimately it doesn't exist for itself. This maternal quietude, more stubborn even than philosophical doubt, with its fundamental incredulity, eats away at the omnipotence of the symbolic. It sidesteps the perverse denial ("I know it, but *still*") and constitutes the basis of social bonding in general (in the sense of "resembling others and, ultimately, the species"). Such an attitude can be frightening if one stops to

What purpose does this rejection serve? Surely it does not allow any sort of pact between "sexual partners" based on a supposed preestablished harmony deriving from primordial androgyny. What it does allow is recognition of irreducible differences between the sexes and of the irreconcilable interests of both — and hence of women — in asserting those differences and seeking appropriate forms of fulfillment.

These, then, are among the questions that remain unaddressed even today, after the Virgin. Taken together they point to the need for an ethics appropriate to the "second" sex that some say has recently been experiencing a renaissaince.

Nothing guarantees that a feminine ethics is even possible, however; Spinoza explicitly excluded women (along with children and lunatics) from ethics. If it is true that an ethics for the modern age is no longer to be confused with morality, and if confronting the problem of ethics means not avoiding the embarrassing and inevitable issue of the law but instead bringing to the law flesh, language, and *jouissance*, then the reformulation of the ethical tradition requires the participation of women. Women imbued with the

think that it may destroy everything that is specific and irreducible in the other, the child: this form of maternal love can become a straitjacket, stifling any deviant individuality. But it can also serve the speaking subject as a refuge when his symbolic carapace shatters to reveal that jagged crest where biology transpierces speech: I am thinking of moments of illness, of sexual-intellectual-physical passion, death. . . . desire to reproduce (and to maintain stability); women ready to help our verbal species, afflicted as we are by the knowledge that we are mortal, to bear up under the menace of death; mothers. For what is ethics divorced from morals? Heretical ethics — *herethics* — may just be that which makes life's bonds bearable, that which enables us to tolerate thought, and hence the thought of death. "Herethics" is *a-mort, amour. Eia mater, fons amoris*. Let us listen again, therefore, to the *Stabat Mater*, and to music, all music. It swallows goddesses and strips them of necessity.

REFERENCES

Barande, Ilse, 1977. *Le Maternel singulier* (Paris: Aubier-Montaigne).

Jung, Carl Gustav, 1964. *Réponse à Job*, trans. Roland Cahen (Paris: Buchet-Chastel).

Warner, Marina, 1976. *Alone of All Her Sex. The Myth and Cult of the Virgin Mary* (London: Weidenfeld and Nicolson).

THE MATRIX OF WAR:
MOTHERS AND HEROES

NANCY HUSTON

While doing research over the past few years in an attempt to piece together what might be called the "fragments of a warrior's discourse" in Western culture, I came across the following Gnostic conundrum: "How long will men make war? — As long as women have children." At first glance, the answer is reminiscent of the paraphrases for "Forever" familiar to us from childhood riddles ("Until the ocean goes dry") or from Shakespeare's *Macbeth* ("Until/ Great Birnam wood to high Dunsinane hill/Shall come against him" — IV, i). Upon closer examination, however — or rather, after further reading in the course of which I encountered the analogy between warmaking and childbearing countless times — the ancient riddle seemed to me to require a cause-and-effect interpretation: "If women would only stop having children, men would stop making war." This could be a truism, of course, for if women stopped having children there would obviously *be* no men to make war. Alternatively, it could imply — and this is the interpretation explored in the present essay — that men make war *because* women have children. I shall first evoke a number of mythical and historical archetypes involving the themes of heroism and chastity, valor and virginity, and then go on to analyze the striking equivalence between maternal and military service.

I. THE SAMSON COMPLEX

Unlike Son of Sam, the ripper who caused every brunette in the Bronx and Brooklyn to tremble during the summer and fall of 1980, the biblical Samson was famous for honorable reasons, since he massacred mostly men — that is, until Delilah brought his career

This article is an excerpt, adapted and translated by the author, from her correspondence with Samuel Kinser; see Nancy Huston and Sam Kinser, *A L'Amour comme à la Guerre* (Paris: Seuil, 1984).

to a halt by cutting off his . . . hair. (Actually, it was not Delilah but a Philistine who shaved Samson's seven plaits from his head — see *Judges* XVI, 30 — but it is surely significant that *everybody* has got this wrong, from John Milton to Cecil B. De Mille.) The question immediately — but rarely — raised by this legend is the following: *why* did Samson lose his strength when he had his hair cut off? To say that head-shaving is symbolic castration, as almost everyone has since Freud, is not really to answer the question. At most, it raises another, even more disturbing query: is men's murderous energy the same thing as their sexual energy? (And if it is, how does one explain that nowadays, in most armies of the Western world, recruits are systematically shaved on the first day of their military service?)

In point of fact, hair and sexuality have been carrying on an intimate relationship for a long time, although their interaction has taken different forms in different countries and centuries. Psychoanalyst Charles Berg has analyzed, for instance, the struggle between Cavaliers and Roundheads that took place at the beginning of the seventeenth century:

> The Cavaliers, who wore their hair long, indulged in women and wine and generally expressed their libidinous impulses. The Roundheads, who cut their hair short, were Puritans — symbolically and mentally they cut off their penis — albeit they assumed substitutive and compensatory aggression (Leach 1958:153).

One could hardly be more explicit. Dr. Berg's interpretation of hair symbolism is quoted in an article by the English anthropologist Edmund Leach, entitled "Magical Hair." Leach confesses to having a certain repugnance for the generalizing tendencies of psychoanalytic theory, but he is led, after a survey of all the available data on the subject, to conclusions which do not differ vastly from those of Dr. Berg: "Long hair = unrestrained sexuality; short hair or partially shaved head or tightly bound hair = restricted sexuality; closely shaved head = celibacy" (Leach 1958:153—154).

If such is indeed the case — and one need only think of hippies and monks to confirm it on an intuitive level — there is in fact nothing inconsistent about cutting off young soldiers' hair: it signifies, first of all to the recruits themselves, and then to their civilian audience, that male sexuality in the Army is rigorously controlled, not to say eliminated, with the evident intention of increasing the soldiers' capacity for murder, that is, of diverting energy that would have been directed towards (against?) women and directing it towards (against) enemy troops.

Indeed, Samson's defeat came long before his haircut; it occurred when he succumbed to Delilah, placing a woman's will above his own. When the Philistines penetrated his tent in the middle of the night, he had already been made a eunuch. The crucial message of the Samson and Delilah story has nothing to do with hair, but rather

with the equivalence between a man's libido and his ability to kill.

Although heroes have always been perceived as eminently manly, the proof of their virility has been not in love-making but in war-making. What is implied is that they *could* make love, that they would be extraordinary lovers, and that every woman would be more than happy to receive their embraces; but they actually spend surprisingly little of their time in bed. Contact with women is perceived as debilitating, enervating and ultimately destructive of virility, whereas battles can apparently indefinitely regenerate the strength of males.

Numerous ethnologists have described the rites of sexual abstinence that precede military expeditions in primitive societies. Among the New Guinea Trobrianders studied by Malinowski for instance, there were a limited number of circumstances which required total sexual abstinence: war, long boat trips, gardening (a male prerogative), one or two magical rites, and . . . a certain number of "physiological crises" in women, such as pregnancy and nursing. (What a strange coincidence — pregnancy produces the same effects as war! But I mustn't get ahead of myself.) Entering into detail, Malinowski proceeds to explain that

> . . . there are definite penalties which would fall on the individual transgressor. Should he indulge in intercourse, a hostile spear would pierce his penis or his testicles. Should he sleep nose to nose with his sweetheart, he would be hit on the nose or thereabouts. Were he to sit even on the same mat with a girl, his buttocks would not be safe from attack (Malinowski 1929: 383).

Malinowski's informer may have been pulling another part of his anatomy, but this does not prevent the scientist from drawing the "scientific" conclusion which automatically results from all these data: "No doubt the men were far too engrossed in the excitement of the fighting to turn any attention to the more usual and therefore, perhaps, less absorbing sport of love" (p. 414).

Love is a "sport." It mobilizes the same impulses and interests as war, but it is more prosaic and predictable; above all, it diverts the attention — and the tensions — that should be reserved for combat. No attempt is made to elucidate the nature of this "should be": Malinowski, like most other authors — and probably most human beings — does not problematize the existence of combats *per se*, whence it follows that he does not problematize either the intrinsic value of brute force in males or the need for keeping females away from them at critical moments.

James Frazer, in *Taboo and Perils of the Soul*, attributes the primitive practice of pre-war sexual abstinence to the principle of sympathetic magic, according to which "close contact with women would affect [the warriors] with feminine weakness and cowardice" (1911:164). As for Marie Bonaparte, she has at least the merit of

pointing out that such beliefs are by no means restricted to "primi-tive peoples": she evokes them in an attempt to account for the myth of "adulterated wine," apparently widespread during World War Two: the wine was said to have been drugged by the authorities in order to cause impotence in recruits. "In both cases," writes Bonaparte, "an internal command — imperative taboo among the primitives, neurotic inhibition among the civilized — is projected onto external powers by the imagination of the soldiers or warriors" (1950:65).

Is it possible that men created a taboo, an imperative of sexual abstinence prior to war, because fear had made them to all intents and purposes *impotent* at that time? This hypothesis would be attractive were it not for the fact that with prostitutes — before, during and after war — soldiers notoriously do *not* have their tails between their legs. Bonaparte, however, is not concerned with those women; she is concerned only with legitimately "possessed" women, and she analyzes the adulterated-wine myth in the best Freudian tradition by reducing it to the dimensions of a family romance. In this perspective, the Enemy represents and ressuscitates the Father:

> In order to acquire the right to vanquish him later on, one must first appease him with sacrifice; thus [the soldiers] sacrifice what is most precious to them: the possession of women. . . . [H]aving been symbolically expiated in advance, the original crime can be victoriously re-enacted upon the body of the enemy (p. 68).

War, then, is nothing but the reflection of the

> original double Oedipal crime, the murder of the father immediately followed by the triumphal appropriation of his women. . . . The sexual excesses committed by certain European soldiers as soon as the combats were over were an indirect celebration of this archetypal triumph (p. 68).

Apart from its schematic character, this explanation — advanced by a woman — deprives women of the power that is traditionally attributed to them in almost all varieties of the Samson Complex. This power is sometimes seductive (as in the case of Delilah or Mata Hari) and sometimes reproductive (as in pregnant and nursing women, whose states of "physiological crisis" visibly impress and frighten men).

The paradigm of the enigmatic power of females is perhaps the magic of Circe against which Ulysses must defend himself. Hermes warns Ulysses, before he approaches the witch's dwelling, that she will urge him to share her bed, and that he must first make her swear that she "has no other evil hurt that she is devising against you/So she will not make you weak and unmanned, once you are naked" (Homer 1967:X, 300–301). Ulysses goes to Circe, accusing her of having perfidious designs against him: "You treacherously,/ask me to go into your chamber, and go to bed with you/so that when

I am naked you can make me a weakling, unmanned" (pp. 340–343). By what means could she have made him a weakling? And why would the condition for Ulysses' "unmanning" have been his nudity? Surely a magic capable of turning men into pigs could not be hindered by mere shirts and shoes. Homer does not enlighten us on these points, but it would seem that the defeat his hero dreads is linked to the act of copulation itself.

Indeed, the Samson Complex is by no means limited to the military; it rears its head wherever men are required to prove their strength. It is a hackneyed theme of the media, not only in cultural products destined for mass consumption (such as *Superman Two*, in which Clark Kent must renounce all his powers if he wishes to marry Lois Lane), but in commentaries on the most mundane heroic exploits — take, for instance, the following description of tennis champion Bjorn Borg in a French leftist newspaper:

> Suddenly, he has a sore shoulder, sore stomach muscles, he misses a match because his knee hurts, he has blisters on his hands and feet. . . . "Borg on the decline," say some: his marriage with Mariana may have gotten the better of his rage (*Libération* May 25, 1981).

Whether the pretext is "contamination" or the "incest taboo," women's "cowardliness" or their "sorcery," the belief that contact with the female world inhibits men's capacity to fight is so deeply rooted in our minds that we forget to ask ourselves *why men fight*.

II. CÛCHULAINN AND COUVADE

The following might be read as a kind of bedtime story. It is not a true story, but truth is the last thing we require of the words which accompany us over the edge of consciousness into the realm of dreams or mythology. This story, and a thousand others like it, have been told to little boys and girls from time immemorial, and have contributed every bit as much as true stories to shaping their vision of the world.

Cûchulainn, the Champion of Ulster, was the son of Princess Dechtire. Although Dechtire was the wife of Sualtim, Sualtim was not the father of Cûchulainn. "For, during the wedding feast, Lugh of the Long Arms, god of the day star, had turned himself into a gnat and drowned himself in Dechtire's drinking-cup. It was of him that she conceived the child who later came into the world" (Roth 1927:5).

The heroic qualities of the child were evident right from the start. Before Cûchulainn's milk teeth were fully grown in, he struck dead a gigantic dog that had threatened to leap at him. By the age of six, he had grasped not only a sword, but also the crucial fact that for a warrior, narrative is more important than life itself: "Little do I care whether I live a century or a day," he declared, "provided that the renown of my exploits haunts the memories of men" (Roth,

pp. 18—19). From then on, his life was nothing but a series of battles, in the course of which his body would swell up, his eyes would flash lightning, and dazzling rays would emanate from his forehead. One day, he returned from combat still animated by this heroic fury, and Morann the Judge

> gave prudent counsel: thrice fifty naked virgins were sent to meet the hero. Cûchulainn lowered his eyes and, out of modesty, turned his head. The virgins immediately laid hands on him and plunged him into icy water. But so ardent was his wrath that the suddenly boiling water caused the staves to burst. They plunged him then into a second vat; the water bubbled furiously, rose up and overflowed. In the third vat, the water still grew hot, but no longer overflowed (p. 22).

Cûchulainn aspired to marry the blonde princess Emer, but when he expressed this aspiration to her in no uncertain terms — "White and immaculate is the warm plain of thy throat, the sweet plain of thy tender breast" — she answered him even more unambiguously: "No man shall rest there who has not, by his valor, proved himself worthy of love" (p. 28). Therefore Cûchulainn set off to conquer Glory. He apprenticed himself to a sorceress and learned from her a thousand military secrets. He engaged in combat with the dangerous Amazon Aiffe; having vanquished her, he pinned her to the ground, his heel upon her throat. She beseeched him to spare her life and he agreed, but on one condition: "I want to take my pleasure with you, so that you may bear me a son" (p. 35).

When the son, duly born, came of age, Cûchulainn imposed on him three magic obligations: never should he reveal his country or his name to a stranger; on no occasion should he humiliate himself; and thirdly, he should refuse combat with no assailant, however formidable. (These obligations were to bring about, many years later, the hero's downfall: Cûchulainn is an Oedipus in reverse; he eventually kills his own son without knowing his identity, and is thereafter cursed with ill-fortune.)

Now, it happened that several generations earlier, there had lived in this same kingdom of Ulster a peasant by the name of Crundchu, and with him a fairy by the name of Macha. One day, at the grand assembly of the Ulates, which Macha had refused to attend under pretext that she was nine months pregnant, the horses of the king won all the races. Crundchu stupidly boasted that his wife could run faster than this prodigious team, whereupon the king ordered that Macha be summoned and her swiftness put to the test that very day. Despite the protestations of the fairy, who was already in the throes of labor, Crundchu insisted that she pit herself against the horses of the king. She finally consented. Upon arriving first at the finish line, she screamed most horribly and gave birth to twins.

> When all the men in the crowd heard the woman's scream, they were struck down so that there was not, in any of them, more strength than in a woman

in the throes. "From now on," Macha told them, "you shall suffer the same loss of face as you imposed on me. When [times] are hardest, each of you, the inhabitants of this province, shall have no more strength than a woman in childbed, and this for as long as a woman remains lying-in, five days and four nights, to the ninth generation" (Dumézil 1968:610).

Thus it was that once a year, all the men of Ulster became incapable of defending their country. The curse did not, however, affect our hero Cûchulainn (he not being the son of a Ulate), and very fortunately so, for during one of these ill-fated periods he had to engage in single-handed combat against the entire army of Ferdiad from Erin. He managed to hold the enemy at bay until the men of Ulster recovered their manly courage.

The story goes on, from one exploit to another, from one conquest to another. . . . Cûchulainn naturally ends up marrying blonde Emer, and it is Aiffe's jealousy that brings about the catastrophe: it is she who arranges for Cûchulainn to fight and murder his own son, after which he loses all taste for life — that is, in his case, the taste for taking lives — and there remains nothing for him to do but die.

What, one might ask, is the moral of the story? Let us retrace the itinerary of Cûchulainn step by step, and attempt to extrapolate the more general pattern of which it is a part.

To begin with, like virtually every hero, Cûchulainn is not the product of a mere sexual conjunction between mortals. Many erudite pages have been devoted (by Otto Rank and Joseph Campbell among others) to studying the phenomenon of miraculous births. In his *Morphology of the Folk-tale*, Vladimir Propp distinguishes three main types of this ubiquitous theme. The mother's pregnancy, according to Propp, can be either "intentional (a fish which is eaten, etc.), accidental (a swallowed pea, etc.), [or] forced (a girl is abducted by a bear, etc.)" (Propp 1958:107).

When the hero is indeed born of a mother, it is the second type which occurs with the greatest frequency — such is indeed the case for the conception of Cûchulainn. Often, however, the hero is not born of a mother at all, but of a *father*. In Scythian legend, for example, Batraz is the offspring of a frog and a man named Xaemyc and emerges from an abcess in the latter's shoulder (Dumézil 1978:23sq); the Greeks had Athena spring from Zeus's head and Dionysus from his thigh; these examples could be multiplied *ad libitum*. Claude Lévi-Strauss inventoried several dozens of them, collected from primitive societies, in his *Mythologiques* (see the motif entitled "Pregnant Men") though he neglected to include those which are closest and most familiar to our own culture, such as the engendering of Adam by a male god and the subsequent extraction of the first woman from the body of the first man.

Sometimes the capacity for gestation and delivery is attributed neither to a mother nor to a father but to a *stone*: here one might

invoke the birth of the Scythian hero Soslan:

> A shepherd, moved by the beauty of Satana but separated from her by a wide, fast-flowing stream, projected his semen over the waves to the opposite bank, where it struck the stone upon which Satana was sitting. Satana took the stone home with her, and after nine months it gave birth . . . to a baby boy (Dumézil 1978:50).

This birth is astonishingly similar to that of the first Athenian:

> Hephaistos, the god of technology, one day desired the virgin Athena, goddess of Athée. She took to her heels; he pursued her; she managed — barely — to escape. She threw to the ground the piece of wool which had served to wipe the god's sperm from her leg, and the earth thus fecundated produced the child Erichtonius (Loraux 1982:250).

With stones and dirt like that, one wonders, who needs women? And what must one conclude from these incredibly pervasive *mis*-conceptions?

It would seem than men have difficulty accepting the too-preponderant role played by women in reproduction; that they prefer to deny it, or to skirt the issue, or to attribute to themselves the specifically female and somewhat terrifying power of giving birth. Of course, it would be absurd to require that myths and legends accurately reflect reality. Since in the present case reality is disagreeable to men, it is quite understandable that they should have attempted to rectify it, or at least to edulcorate it in their favor, through countless fictional narratives.

Apart from his supernatural birth, the hero is immediately distinguishable from common mortals by one trait and only one: his strength. His value derives wholly from his valor (*valere* in Latin means "to be strong"), as is suggested by the frequent semantic convergence of words for "force" and words for "masculinity": the Greek *andres*, of course, but also our own *virility*; in the Celtic tongue, according to Marie-Louise Sjoestedt, ". . . all the words for 'hero' express the notions of fury, ardour, tumescence, speed"; *cur* or *caur*, one of the words for "hero," is connected with a root which means "to swell," and it was said that Cûchulainn, "in the fury of combat, inflate[d] himself and swell[ed] like a bladder full of air"(Sjoestedt 1949:58–59).

The phallic connotations of this tumescence are clear — whence, most likely, the fact that Emer, before consenting to marry Cûchulainn, demanded proofs of his "valor." This is another virtually universal literary theme: a woman cannot love and admire a man until he has demonstrated his physical superiority over other men. Examples are the *geiss* imposed on lovers by their mistresses in Celtic mythology, or the *assais* of the troubadors; in fairy tales, the princess has the right to ask her suitor a riddle or to require that he perform prodigious feats (this is what Propp calls her "sphere of action").

Thus, the second salient aspect of the Cûchulainn story seems to be the logical consequence of the first: given that women are "marked" by their capacity for having children (whatever efforts may be made to minimize or even to eradicate the importance of that fact), men have been compelled to find a similarly distinctive trait for themselves, something that could ratify, as it were, their masculinity. And the trait they have chosen to emphasize is that of physical strength, even if this has meant depriving women of *their* physical strength, and sometimes going so far as to mutilate them, in order that in one area at least male supremacy could remain irrefutable.

Finally, in the singular episode involving Macha the fairy, men are condemned to experience the pangs of childbirth precisely when they should be defending their country. In a sense, it can be said that the suffering specific to parturition here *takes the place* of the suffering specific to war.[1] It is significant that in the legends of the Scyths, for whom bravery is just as strongly associated with chastity as for the Celts — hence Cûchulainn's diverting his gaze from the naked virgins — males are also affected with a "female malady" as the result of a curse: according to Herodotus, when the Scyths invaded Asia, renounced marching upon Egypt and beat a hasty retreat, some of them pillaged the temple of Aphrodite Ourania in Ascalon; as punishment, they and their descendants were struck with a "women's illness." This is possibly an *a posteriori* mythologization of the couvade ritual. In any case, the appropriation of feminine corporeal signs by men — whether through mimicry of pregnancy, labor or menstrual periods — seems to occur with astonishing frequency in warlike peoples, and invariably entails a temporary abstention from warmaking activity.

The symbolic equivalence between childbirth and war might be said to be one of the rare constants of human culture. Before going on to examine the ways in which the two phenomena are analogous and complementary, I shall attempt to show that they have traditionally been perceived as mutually exclusive.

III. VIRGINITY AND VALOR

Is there a rational, purely economic explanation for the fact that women do not hunt? Is there anything inevitable about the fact that hunting has always been a primarily male activity? Even those societies in which women are allowed to hunt systematically exclude *mothers* from the pursuit of big game. The latter is a strictly male

1. Similarly, in the *Iliad*, when Agamemnon is wounded, Homer compares his sensations to those of a woman about to give birth: "Comparable to the throes/a writhing woman suffers in hard labor/sent by the goddess of Travail, Hera's/daughters, twisters, mistresses of pangs, the anguish throbbed in Agamemnon now" (XI, 275).

prerogative; it has been endowed for that reason with incommensurable prestige and surrounded by a fantastic quantity of mythical and ritual material — which in turn contribute to the enhancement of its prestige.

Hunting as human beings practice it has very little in common with predation among different animal species. It is not an activity intended merely to fill stomachs. There are laws which regulate the killing and consumption of animals by human beings (obviously unthinkable in the animal world); these laws involve a sense of the *sacred,* from which women are generally excluded. (Though women may be, and often are, idealized as the embodiment of Sacredness itself — in many myths it is to women that spirits or divinities reveal the use of indispensable tools or magic masks — they virtually never preside over religious mysteries.)

Whatever discontinuity there may be between hunting and war — the latter is admittedly not the automatic outcome of the former — it must be significant that women have been excluded from *both* these realms of violence imbued with sacrificial mystery. The reasons for this must be more complex than the pragmatic considerations often advanced by specialists — it is more convenient for women to look after gathering food and raising children, given that they are "immobilized" by pregnancy and nursing, while men go off to the hunt together. Rather, I would suggest that it is the act of giving birth itself which is considered to be profoundly incompatible with the act of dealing death.

One of the strongest indications that it is as *mothers* that women are excluded from life-taking activities is the fact that as *virgins* they are not. It is possible to trace this tradition all the way back to the beginning of recorded history. Western civilization's first historian, Herodotus, recounts that among the Auses of Libya

> They hold an annual festival in honor of Athene, at which the girls divide themselves into two groups and fight each other with stones and sticks. . . . If any girl, during the course of the battle, is fatally injured and dies, they say it is a proof that she is no maiden (Herodotus 1954:IV, 180).

It would be tempting to make the connection between this custom and the cases mentioned earlier, from Samson to Ulysses, in which sexual contact resulted in military impotence. However, women's chastity, though it is like men's associated with bravery, is not endowed with the same meaning. Whereas it is a mysterious female "contamination" or "magic" that impairs the belligerence of male warriors, for female warriors things are considerably more concrete. Here, for instance, is what happens when, in the legend of the *Nibelungen,* Gunther finally succeeds in deflowering the indomitable Brünhilde: "Rightfully he lay there, making love./Much she had to be forgetful of;/Both wrath and modesty. She paled at the touch/Of

his embrace. Ah! love had ebbed her strength so much!/No stronger than any woman then was she" (*Nibelungen* 1962:681, 682). The contact with the male body is not a source of temporary infection or befuddlement; it is a source of permanent defeat, by virtue of the metaphor which likens the penis to a deadly weapon. Virginity is seen as an invisible armor, and the hymen as a shield designed to protect both the body and the soul of the young girl. Once it has been pierced, once she has succumbed to this first paradigmatic wound, all other wounds become possible. The deflowered female body is irremediably permeable, irreversibly vulnerable.

Thus, it is not by chance that the warrior goddess in honor of whom the women described by Herodotus were fighting was herself a virgin. In like manner, Allecto, the warrior-goddess in Vergil's *Aeneid*, is described as a "grief-inspirer, whom sad wars/And passions, and inveiglements delight"; she is addressed by Juno as a "Virgin, child of the night" (Vergil 1963:7, 325 sqq). Camilla, a more positive character of the same epic, "ever keeps in virgin purity/Love of her weapons and her maiden state" (11, 570 sqq). The Walkyries and practically all hunter-goddesses are also represented as virgins, and it can hardly be a coincidence that the Amazons, in almost every description of them extant, are said to have excised their femininity in some way. According to many accounts, they cut off one of their breasts — a doubly determined (erotic and motherly) feminine sign — in order to shoot with bow and arrow.

Of course, the mutual exclusiveness between war — or hunting — and motherhood is largely mythical. However, myths are not passive objects that one can choose to contemplate, or not to contemplate, at one's leisure. They are powerful acting forces which influence the behavior of those who hear and transmit them. Thus, even if there is no wholly convincing physiological justification for it, the mythical exclusiveness between motherhood and war can very well be *actualized* — and, consequently, any number or real cases can appear to "confirm" it. For example, "lady warriors" were ostensibly a "dread feature of the army of old Dahomy. . . . There existed a crack corps of virgin warriors, whose virginity . . . was safeguarded by the infliction of a horrible death in case of moral lapses" (Veale 1968:62). The most glorious female warrior in European history was none other than the *Maid* of Orleans, Joan of Arc. And today, in the egalitarian Israeli army, as in the project for a women's draft currently under study in Greece, women who have children are automatically exempted.

The idea that the loss of virginity makes women vulnerable, or that motherhood deprives them of their capacity to fight, is another proof of the specifically human nature of war. In the animal world, on the contrary, there is nothing more ferocious than a mother;

one has only to think of the proverbial combativeness of lionesses and she-bears when their cubs are in danger. It is not from sheer benevolence that men have sought to spare the "weaker" members of society the gruelling tasks of weaponry. Rather, hunting and warring have been institutionalized as the *sacred privileges* of the male, which he could share with the female only in fantasy — or, in reality, only temporarily — and only to the extent to which she had not yet taken advantage of the privilege of *her* sex by becoming a mother. Women's exclusion from these activities is consonant with their exclusion from the sacred in general, and the latter exclusion is intensified wherever maternity — actual or potential — comes into play: it is absolute for pregnant or menstruating women, as well as for nursing mothers.

When women do take part in the sacred, it is because they have either renounced motherhood or gone beyond it. As virgins, they have the right to carry the Holy Grail, or to enter a nunnery; among the Celts they could become magicians or prophetesses; among the Aztecs they could be sacrificed to the Sun God. As widows, they often "retrieve" their chastity and acquire new magical powers. But as mothers, they are inhabited by the ignominious forces of the natural world and must therefore be prevented from having anything to do with the spiritual.

This brings us to the heart of the *mater*.

IV. MOTHERHOOD AND THE MILITARY

Tolstoy might very well have chosen, for his grandiose novel *War and Peace*, the title Woody Allen later used as parody: *Love and Death*. The sections of the book that alternate with those describing the invasion of Russia are anything but peaceful; simply, whereas the latter deal with men's relationship to men, the former deal with men's relationship to women: they are every bit as conflictual, and their conflicts are very similarly coded. During a recent rereading of the novel, I wept when Prince Andrei succumbed to his battle-wounds. His wife, the sweet "little princess" with the fuzzy upper lip (whom he had left alone during several months of her pregnancy in order to go off to war) had died in childbirth several hundred pages earlier, but I had shed no tears for her — despite the fact that hers is the only "glorious death" accessible to women.

In his brilliant introduction to *Problems of War in Ancient Greece*, Jean-Pierre Vernant writes that,

> Whereas boys' rites of passage signify their admittance to the condition of the warrior, for the girls associated with them in these same rites, and often themselves subjected to a period of exclusion, the initiatory trials have the value of a preparation for marriage. Here as elsewhere, both the connection and the polarity between the different types of institutions are emphasized. Marriage is to the girl what war is to the boy: to both, these moments repre-

sent the accomplishment of their respective natures as they emerge from a state in which each still partook of the other (1968:15).

Of course, it is not marriage itself which so radically inflects the itinerary of the young girl, but what marriage implies, its *raison d'être* as a social institution: the reproduction of the species, and more specifically, for the girl as an individual, childbirth. In Greece, the rapprochement between combat and confinement is not only ritual but lexical as well: the two events are informed by one and the same vocabulary. According to Nicole Loraux, *luchos* signifies, on the one hand, "the place for lying down" and, on the other hand, "the name of the ambush, and later of the armed troops themselves"; *ponos* is "one of the words that designates the pains of labor" and also "the name of a long and toilsome effort, such as that of the Achean warriors in the *Iliad*, engaged in an interminable labor of war, or that of the Hesiodic man"; *teiroménè* is "the woman in confinement, while the man overcome by pain that Agamemnon's horses carry off to the hollowed ships is nothing but a broken king (*teiroménon basilèa*)" (Loraux 1981:41, 44, 55).

Moreover, when these sufferings end in death — that is, when a member of either sex loses his or her life in the fulfillment of his or her patriotic duty, this death is *consecrated*. At Sparta, according to Plutarch, ". . . it was forbidden to inscribe the names of the dead upon their tombstones, except for men who had fallen in war and women who had died in childbirth" (Loraux 1981:37). Similarly, on the funerary *relievos* of those who died at Athens, ". . . no allusion was made to the nature of the death, with two exceptions; the death of a soldier, the death of a parturient woman" (Loraux 1981:39).

The analogy between war and childbirth hinges on what might be called reciprocal metaphorization. It is impossible to determine whether men decided to confer social prestige upon labor pains so that women might partake, at least to some extent, in the glory of battle — or whether, conversely, they strove to invent for themselves a suffering as dignified, as meritorious and as spectacular in its results as that of childbirth. Although childbirth indubitably has biological precedence over war, neither phenomenon can be said to have symbolic precedence, and therefore only the *interaction* between the two can be the object of analysis.

Vernant refers to the ceremonies of preparation for marriage and war as "rites of passage." In the well-known study by that title, Arnold Van Gennep makes an inventory of puberty ceremonies among primitive peoples: here again, the ceremonies serve to mark the entry of the child into adult life. It would be tedious to enumerate all the cases which seem to me evocative; I shall restrict myself to a single one — which happens to be reminiscent of the Samson

Complex. Among the Masai, says Van Gennep, the boys go through a ritual consisting of nine different stages; at the end, "[w]hen they are healed, their heads are shaved; when their hair grows back sufficiently to be combed, they are called *mûrrani*, or warriors"; as for the girls, following the fourth and final stage of their initiation, "when they are healed, they are married off" (Van Gennep 1960: 85). The underlying logic of these extremely widespread ritual practices is the following: the children of both sexes must prepare themselves, through some form of violence, for the fulfillment of their respective adult "destinies." Girls are taught (through clitoridectomy or various other operations designed to make them seductive and marriageable) that only motherhood can make women of them; boys are taught (through circumcision, fistfights, athletic competitions and the like) that only war can make men of them.

Though it is so widespread as to seem quasi-natural, this dichotomy remains somewhat problematic, if only because war is a homosexual institution and marriage a heterosexual one. When a man fights, he fights another man, but when a woman marries, she does not marry another woman. Marriage and reproduction require the participation of both sexes; it is therefore surprising that they should be conceptualized as specifically "female" spheres.

A possible explanation for this anomaly is the relatively abstract nature of paternity. Given that the father does not participate directly in either pregnancy, delivery or nursing, his relationship to his child is usually, at least for the first year following conception, much less concrete than the mother's. This is why many societies have elaborated ceremonies in which the father "gives birth" symbolically to his infant shortly after birth (Christianity has baptism; in the Jewish religion it is the father's prerogative to name the child, and so forth). Yet it does not suffice for the father to lay claim to his collaboration in the reproductive process: later on, at puberty, additional rites are required in order to guarantee the child's fully belonging to his or her sex. Generally speaking, the girl's integration is in continuity with her past: all she has to do is imitate her mother (with whom she has always lived) and she will be adequately prepared for her life as a mother. The boy, on the other hand, must be expelled from the female milieu and initiated into manhood — virtually always defined as aggressiveness.

Many sociologists and sociobiologists have attempted to find a rational justification for the choice of aggressiveness for males as an equivalent to motherhood for females. Lionel Tiger, in his bestselling study *Men in Groups*, suggests that

> In view of the importance of hunting and quasi-hunting behavior among human males. . ., bondless aggressionless males are in/a real sense equivalent to childless females. . . . [F]riendless inhibited males . . . possibly do not experience the male equivalent of child reproduction, which is related to

work, defence, politics, and perhaps even the violent mastery and destruction of others (1969:191).

Tiger does not ask himself *why* "hunting and quasi-hunting behavior" is a male prerogative — this is apparently self-evident, despite the fact that the "evidence" for it is in flagrant contradiction with contemporary social reality (how does one manage to consider work and politics as male preserves in the United States in the latter half of the twentieth century?).

According to the French social theorist Roger Caillois, if "war is compared to childbirth with such insistence," it is because war "expresses without intermediary society's lower depths, the necessarily horrible, visceral impulses that intelligence can neither comprehend nor control" (1951:129). Caillois invokes Kierkegaard's *The Diary of a Seducer*, in which the narrator Johann expresses exactly the same conviction:

> Diana has always been my ideal. . . . She knew that her *raison d'être* in life depended upon her virginity and so she guarded it tenderly. The rumor has reached me, from some obscure corner of the philological world, that she had some conception of the terrible pains her mother had gone through at her birth. This may have frightened her off, for which she is hardly to be blamed. I say with Euripides that I would rather go through three wars than through a single childbirth (Kierkegaard 1932:157).

Given the fact that they *cannot* give birth, it is perhaps not surprising that men say they would *rather not* give birth; that they prefer their own distinctive "lower depths," war. The only problem is that the preferences of men often become the cultural values of humanity as a whole. This is why tales of war are received as exalting and tragic, whereas tales of childbirth are thought to be empty gossip. If women's "wars" generate less discourse than men's "childbirth," it is partly because the latter is a planned, organized, collective phenomenon, whereas the former is experienced in solitude. But discourse plays a large part in determining the way in which we see the world. How many times have we read that a nation which never makes war becomes "sterile," and that blood must be shed in order for it to recover its "fertility"? How many revolutions have been compared to "labor pains," violent convulsions preceding the "birth" of a new society?

In these lyrical flights of the imagination, war is sometimes described as the mother and sometimes as the child. Thus, whereas the Greek philosopher Heraclitus stated that "War is the mother of all things" (Bouthoul 1969:14), the German military theoretician Clausewitz stated that "War develops in the womb of State politics; its principles are hidden there as the particular characteristics of the individual are hidden in the embryo" (Bouthoul 1969:21–22); whereas an early twentieth-century proverb held that "Germany is never so happy as when she is pregnant with a war," the French

Admiral Antoine Sanguinetti still more recently postulated that "Violence is the matrix of societies" (Pierre 1979:33). Finally, though the list could go on and on, prize-winning author Ernst Jünger, in a book entitled precisely *War, Our Mother*, informs us that "Combat is not exclusively destruction, it is also a virile form of regeneration" (1934:118).

Well, why not? The only thing objectionable about these metaphors is that, given the invasion of the discursive field by war and warlike values, it is *this* "regeneration" which has paradoxically become the model for the one which had served *it* as a model. Thus, by a kind of supreme irony, many feminist authors now describe childbirth in such a way as explicitly to assimilate it to war.

Marilyn French, in *The Women's Room*, writes that when you are pregnant,

> You're like a soldier in a trench who is hot and constricted and hates the food, but has to sit there for nine months. He gets to the point where he yearns for the battle [that is, the delivery of the child], even though he may be killed or maimed in it. . . . Pregnancy is the greatest training, disciplining device in the human experience. Compared to it, army discipline . . . is soft (1978:69—70).

Phyllis Chesler, in *Women and Madness*, insists on the fact that "*All* women who bear children are committing, literally and symbolically, a blood sacrifice for the perpetuation of the species" (1972:31). And in the utopian feminist society described by Monique Wittig in *Les Guerrillères*, "When the child is born, the midwife whoops and cries in the manner of the women at war. This means that the mother has vanquished as a warrior, and that she has captured the child" (1969:100).

Thus, we have come full circle, and the moral of the story — as gleaned by almost everyone — seems to be: "Make war, not love." Literature, mythology and history teach us that it is impossible to live in society with impunity. The social contract requires that every member of each sex pay his or her tithe of suffering: women are required to breed, just as men are required to brawl.

For centuries, this paradigm must have functioned as a truism. But it so happens that over the past forty years, and for the first time in history, the situation has been radically and irreversibly transformed. Today, humanity is threatened by two explosions, one nuclear and the other demographic. By virtue of having fulfilled their respective duties too well, men and women run the risk of disappearing from the surface of the earth. Concomitantly, two new phenomena have appeared which run counter to these catastrophic tendencies, namely pacifism and contraception. Since World War Two, and especially in industrialized countries, increasing numbers of men have chosen — through conscientious objection or desertion — not to accomplish their military service, while increasing numbers

of women have chosen — through contraception or abortion — not to accomplish their maternal service.

These phenomena are extremely important, yet it is far from certain that they will be able to reverse the course of history, especially since they are counteracted by the "unisex" ideal of contemporary society. Men are becoming more and more preoccupied with the reproductive process, as is indicated by the mind-boggling recent advances in the field of artificial insemination, test-tube babies, genetic and hormonological manipulation, and so forth; in the almost-foreseeable future, it will be possible to bypass the womb altogether in the production of children. Women, on the other hand, are clamoring to enter military institutions, convinced that full citizenship is not possible if one cannot participate in the defence of one's country and that true equality will never be achieved until the army, last bastion of machistic values, goes co-ed. These trends towards sexual indifferentiation of child-bearing and war-making activities reinforce our perception of war as something "natural," a "given" of human experience on a par with procreation. Eliminating women from reproduction and integrating them into destruction tends to obfuscate the psycho-historical matrix of war, and may prevent us from ever understanding it sufficiently to bring it to an end.

REFERENCES
(Translations from the French are mine unless otherwise indicated.)

Bonaparte, Marie, 1950. *Mythes de guerre* (Paris: Presses Universitaires de France).
Bouthoul, Gaston, 1969. *La Guerre* (Paris: Presses Universitaires de France).
Caillois, Roger, 1951. "Le Vertige de la guerre," in: *Quatre Essais de Sociologie contemporaine* (Paris: Olivier Perrin).
Chesler, Phyllis, 1972. *Women and Madness* (New York: Avon Books).
Dumézil, Georges, 1968. *Mythe et épopée* (Paris: Gallimard).
 1978 *Romans de Scythie et d'alentour* (Paris: Payot).
Frazer, James, 1911. *Taboo and Perils of the Soul* (London: Macmillan).
French, Marilyn, 1978. *The Women's Room* (New York: Jove Books).
Herodotus, 1954. *The Histories*, trans. A. de Selincourt, rev. A.R. Burn (Harmondsworth, Middlesex: Penguin Books).
Homer, 1967. *The Odyssey*, trans. Richard Lattimore (New York: Harper & Row).
 1974 *The Iliad*, trans. Robert Fitzgerald (New York: Doubleday).
Jünger, Ernst, 1934. *La Guerre, Notre Mère* (Paris: Albin-Michel).
Kierkegaard, Sören, 1932. *The Diary of a Seducer* (Ithaca, N.Y.: The Dragon Press).
Leach, Edmund, 1958. "Magical Hair," *Journal of the Royal Anthropological Institute*, Vol. 88, Part II.
Loraux, Nicole, 1981. "Le Lit, la guerre," *L'Homme*, XXI:1, 37–67.
 1982 "Les Bénéfices de l'autochtonie," *Le Genre Humain*, 3–4, 238–253.
Malinowski, Bronislaw, 1929. *The Sexual Life of Savages* (London: Routledge & Sons).
Nibelungen, Song of the, 1962. Trans. F.G. Ryder (Detroit: Wayne State Univ. Press).
Pierre, Michel, 1979. "Des Flots de sang aux flots d'encre," *Magazine Littéraire* no. 154, 33–34.

Propp, Vladimir, 1958(1928). "Morphology of the Folk-tale," trans. Laurence Scott, *International Journal of American Linguistics* 24:4.

Roth, Georges, 1927. *La Geste de Cûchulainn* (Paris: H. Piaza).

Sjoestedt, Marie-Louise, 1949. *Gods and Heroes of the Celts* (London: Methuen & Co.).

Tiger, Lionel, 1969. *Men in Groups* (London: Nelson).

Van Gennep, Arnold, 1960. *The Rites of Passage*, trans. M. Vizedom & G. Caffee (Chicago: University of Chicago Press).

Veale, E.J.P., 1968. *Advance to Barbarism* (New York: Devin Adair).

Vergil, 1963. *The Aeneid*, trans. T.H. Delabère May (New York: Bantam Books).

Vernant, Jean-Pierre, 1968. *Problèmes de la Guerre en Grèce Ancienne* (The Hague: Mouton).

Wittig, Monique, 1969. *Les Guérillères* (Paris: Eds. de Minuit).

ILLNESS

THE REST CURE:
REPETITION OR RESOLUTION
OF VICTORIAN WOMEN'S CONFLICTS?

ELLEN L. BASSUK

INTRODUCTION

During the late nineteenth century, Victorian doctors frequently administered S. Weir Mitchell's famous "rest cure" to women with severe nervous symptoms. These included patients diagnosed as hypochondriacs, hysterics, and most commonly, neurasthenics.[1] Supposedly, many benefited but others, such as Charlotte Perkins Gilman and Virginia Woolf, became even sicker and condemned both Mitchell and his treatment.[2] Certainly, the rest cure was less barbaric than leeching, cauterization and "normal" ovariotomy-procedures that were also used to treat women with nervous ailments (Bassuk unpublished; Currier 1886). But it too seemed sadistic, controlling, and intrusive.

The analysis of any treatment, however, must be carried out within the context of its time. To understand how Victorian doctors and patients rationalized the widespread use of the rest cure, one must explore underlying medical, cultural, and social assumptions about women. Only by examining primary medical texts and journals can we begin to unravel the symbolic meanings of this treatment. Such an analysis can also provide important insights into how medical care is often strongly influenced by prejudicial, culturally-

1. Victorian doctors' conception of nervous disease was markedly different from ours. They believed that hysteria, neurasthenia and hypochondria imperceptibly merged into each other, had similar exciting causes and resulted from structural lesions in the brain cortex. The inability to identify the organic defect was ascribed to unsophisticated detection techniques, or to the fact that the problem only occurred at the molecular level. Psychodynamic concepts of etiology had not yet been introduced.

2. For detailed description of Mitchell's unsuccessful treatment of Charlotte Perkins Gilman, Jane Addams, Winifred Howells (daughter of William Dean Howells), and Virginia Woolf, see Poirier (1983); also Sicherman (1977).

bound beliefs about women and their bodies. After describing the physical and psychological aspects of the rest cure, this essay explores the medical rationale for Mitchell's treatment and ends with a discussion of the symbolic meanings of both the nervous symptoms and the cure.

PHYSICAL ASPECTS: REST, SECLUSION, AND EXCESSIVE FEEDING

Early in August, 1885, S. Weir Mitchell, a prominent Philadelphia neurologist, was asked to see Mrs. S., aged 37, whose history can be summarized as follows:

> As a girl of 16 she had a severe neuralgic illness, extending over months: excepting that, she seems to have enjoyed good health until her marriage. Soon after this she had a miscarriage, and then two subsequent pregnancies, accompanied by albuminuria and the birth of dead children. During gestation I was not surprised at all sorts of nervous affections, attributing them to uremia. The next pregnancy terminated in the birth of a living daughter, now nearly 3 years old; during it she had curious nervous symptoms—e.g., her bed flying away with her, temporary blindness and vasomotor disturbances. Subsequently she had several severe shocks from the deaths of near relatives, and gradually fell into the condition in which she was when I was consulted. This is difficult to describe, but it was one of confirmed illness of a marked neurotic type. Among other phenomena she had frequently recurring attacks of fainting. These were not attacks of syncope, but of such general derangement of the balance of the circulation that cerebration was interfered with. She was deaf and blind; her face often flushed, sometimes deadly cold; her hands clay-cold, often blue, and difficult to warm with the most vigorous friction. These attacks passed off in from twenty minutes to a couple of hours (Mitchell 1885b:136ff).

Despite consultation with various physicians, her condition worsened. Because of an ill-defined uterine problem and acute tenderness of the spine, she could no longer sit, stand, or ride in a carriage. Completely bed-ridden, she was unable to care for herself or her family. To complicate matters further, her nervous irritability increased to the point where the ringing of a bell, the sound of a voice or the light touch of her husband's hand made her cry out. In short, she became untouchable. S. Weir Mitchell was called to evaluate her weakening condition. After careful examination, he wrote: "She was a naturally fine and highly cultivated woman, greatly emaciated, with a dusky sallow complexion and dark rings round her eyes. I could find no evidence of organic disease of any kind" (Mitchell 1885b:140). He recommended the rest cure, carried out in London away from her country house. Because of the severity of her symptoms, she was anesthetized during the entire 200 mile trip. One week after Mitchell began treatment, Mrs. S. felt markedly better and in five weeks was driving around London comfortably seated in an open carriage for two hour periods. Three months later, she had embarked on a world tour with her husband via India, Japan, and San Francisco.

What was this seemingly remarkable treatment? In 1872 S. Weir Mitchell developed the rest cure or rest treatment, as it was called, to treat soldiers with battle fatigue (Mitchell 1904). It remained popular for the next 50 years. Theoretically used to treat both men and women, most patients described in the literature were nervous females who were suffering from battle fatigue on the homefront (Mitchell 1885a:57ff). Although doctors were unable to identify structural defects associated with hypochondria, hysteria and neurasthenia, they nevertheless believed that these ailments involved lesions of the brain cortex (Byford 1897). In addition to nervous diseases, Mitchell broadened the indications for the rest cure to include cardiac (valvular disease), renal (Bright's disease), and neurologic disorders (many illnesses such as meningitis, chronic myelitis, and locomotor ataxia). In practice, the majority of women treated in this manner were similar to Mrs. S.; they had severe or "obstinate" nervous symptoms and chronic pelvic complaints (Mitchell 1885a:265). But many were not as fortunate as Mrs. S.; they did not recover.

Before beginning treatment, the doctor promised the patient a "positive cure" provided that she relinquished control to the physician and "concerned herself with nothing but following directions" (Byford 1897:182). Mitchell made it clear to his patients that he was in total control and that their feelings, questions, and concerns must be disregarded. As Mitchell commented "she credits you with knowing, and so wins the fight" (Mitchell 1888:132).

Once the doctor established control, he began treatment which consisted of complete rest, seclusion, and excessive feeding (Martin, 1887). Its cornerstone was bed rest for six weeks to two months, but the length of time and completeness of rest were individually determined. Mitchell made use of "every grade of rest . . . from repose on a lounge for some hours up to entire rest in bed. At first, and in some cases for four to five weeks, I do not permit the patient to sit up or to sew or write or read, or to use the hands in any active way except to clean the teeth. . . I arrange to have the bowels and water passed while lying down, and the patient is lifted onto a lounge for an hour in the morning and again at bedtime, and then lifted back again into the newly-made bed" (Mitchell 1900:66). The nurse spoonfeeds the patient, gives her a sponge bath, administers vaginal douches and rectal enemas, and may read to her for brief periods. After a fortnight, Mitchell allowed these readings to occupy from one to three hours per day.

To offset the ill-effects of prolonged immobility and confinement to bed, the patient was subjected to various passive exercises such as massage, electricity, and hydrotherapy. In addition to preventing muscle atrophy without tiring the patient, these exercises were thought to act systemically by stimulating the nutritive processes,

thereby restoring vital energy and general health (Mitchell 1875). Sometimes to facilitate rest and relaxation, the doctor administered specific medicines such as sleeping pills. Tonics, stimulants and nutriments were given to improve general health and promote digestion; none were thought to act specifically. Their therapeutic effectiveness and safety when used alone were always a subject of debate.

To ensure complete rest, the patient was removed from her usual environment and assigned to the care of a professional nurse who was the doctor's agent. If Mitchell thought it advisable, close relatives were either excluded or allowed only brief visits. To eliminate any possible sources of worry and anxiety, news from home was carefully censored. Mitchell believed that major relationships and responsibilities contributed significantly to the formation of the patient's nervous disorder. Seclusion from the family, he thought, was invariably beneficial.

Once under Mitchell's care and confined to bed, the patient was started on an exclusive diet of milk, administered in four-ounce doses every two hours (Karrell 1866:102). Its effect was to fatten the patient. Although Mitchell admitted that he did not understand the relationship between adipose tissues and the general state of health, he assumed that each person should have some surplus fat to fight moral or mental strain and fevers (Mitchell 1900:28ff). Gaining weight, he felt, was associated with an improvement in the quantity and quality of blood, and was always accompanied by a ruddier color – a certain sign of physical health. Mitchell (1891:33) complained that it was a "physical failure," particularly of city-bred women, to be thin, this and probably interfered with their capacity to produce healthy children. Unlike today, the ideal Victorian woman was obese.

PSYCHOLOGICAL ASPECTS: "MORAL REEDUCATION"

Although the rest cure may seem needlessly controlling and intrusive to us, Mitchell's uses of various psychotherapeutic approaches, which he called moral reeducation, and his attention to the interaction between the patient and her caretakers were unique for this period. Reeducation consisted of teaching the patient "principles of philosophy, patience, resignation and consolation" (Hartenberg 1914:152). This was accomplished through the use of various techniques such as suggestion, logical argument, and support of the patient's will power. Most important, the doctor discussed with the patient ways in which she expressed and managed emotions and how she scheduled daily activities.

Mitchell thought that for physicians to administer the rest cure successfully they must have certain personality characteristics. These included an eye for detail, earnestness, firmness, tact, patience,

persistence, and an ablity to determine and implement the sick-room schedule. Although these are cetainly admirable qualities, Mitchell went much further. Rather than viewing women as consumers with right to ownership of their bodies, he felt that they should abdicate control of treatment to their doctors, who were usually male. This was particularly necessary with bedridden nervous women who, Mitchell thought, were profoundly selfish and tyrannical. As Oliver Wendell Holmes said, they were like "vampires sucking the blood of the healthy people of a household" (Mitchell 1877:31). Their impulses were evil, exerting a negative influence on everyone around them, and therefore must be curbed. Although invalids demanded constant pity, Mitchell (1888:45) warned physicians that expressing sympathy would only be "enfeebling to energetic utility."

Once the patient began to benefit physically from the rest cure Mitchell began the process of "moral reeducation," which focused on a discussion of how to keep feelings under control. Mitchell's objective was "to make clear to her how she is to regain and preserve domination over her emotions" (Mitchell 1888:8). Women, he thought, were too emotionally expressive, perhaps even "hysterical," certainly prone to inappropriate displays of feeling which weakened physical endurance. The "habit of yielding too easily to the expression of all and any emotion, or of cultivating to excess the outward manifestation of feeling" (Mitchell, John K. 1909:38) was thought to be a predisposing cause of nervous disorders. Therefore, women had "to regain and preserve domination over their emotions" and avoid any loss of self-control (Mitchell 1888:8). Mitchell wanted his patients to promise that they would fight "every desire to cry, or twitch or grow excited" (Mitchell 1885a:38), and for those women whose illnesses were precipitated by their self-sacrificing role as caretaker for a sick family member, they had to learn to control their excessive maternal impulses. Similarly, women should be stopped from sharing their feelings with others — a habit that not only made "matters worse" but inevitably bored the listener (Mitchell, John K. 1909:41).

To counteract women's "shortcomings," Mitchell advocated a system that enouraged order, control, and self-restraint. He felt that women should model their lives on the principles underlying the rest cure. John K. Mitchell, S. Weir's son, summarized this approach in his book, *Self-Help for Nervous Women* (1909). Consistent with his father's treatment, he advocated that women acquire good habits by repatterning their routine daily activities. Just as the rest cure carefully scheduled every minute of the day, a woman should methodically plan her time including leisure activities: "A system is what is wanted, a methodical planned system, elastic enough to be livable, and yet exact enough to hold one to the performance of certain duties at certain stated times. Hours for rest, hours for

leisure, hours for pleasure, must enter into such a schedule as well as appointments for work and food and duty. Rise at a certain time, have meals punctually; if you go out, go out with a list of what you intend to do in the order in which you mean to do it" (Mitchell, John K. 1909:91).

Both father and son advocated that women be more like men, but not equal to them. They should run their households and their domestic lives according to male "rules." In psychiatric jargon, they should become less hysterical and more obsessional. Hysteria, which is sometimes considered a caricature of femininity, is characterized by a specific style of expressing feelings and organizing thoughts.[3] Hysterics are flamboyant, expressive, superficially seductive, and prone to inappropriate outbursts of emotion. Cognitively, they process events in a global and impressionistic manner, paying little attention to detail. In contrast, an obsessional style, more characteristic of men, is somewhat rigid and intellectualized. Unlike the hysteric, the obsessional person focuses on the smallest details and is often involved in moral imperatives or "I shoulds." Within this system, feelings, spontaneity, and whimsy are restricted. Generally speaking, the Mitchells as well as many of their contemporaries believed that the obsessional characteristics of "masculinity" were more desirable than the emotional and expressive style of most women.

MEDICAL RATIONALE

Mitchell's use of rest was consistent with Victorian assumptions about the causes of disease in both men and women. To remain healthy, persons must achieve a harmonious relationship with their environment and a balance among bodily organs. Anything that upset this balance, causing undue strain, might decrease a person's resistance and impair nutrition. Rest, proper diet, and exercise were necessary for maintaining good health and preserving the "golden mean." To prevent disease, a person must lead a measured and temperate existence, allowing no indulgences or excesses (Gray 1885a, 1885b; Yellowlees 1885).

In 1871 Mitchell wrote an article for Lippincott's Magazine that he later converted into a book, *Wear and Tear, or Hints for the Overworked* (Mitchell 1891). Like other physicians of this period, he believed that the accelerated pace of contemporary life, ushered in by rapid industrialization, heightened Victorians' vulnerability to disease. To prove his point, Mitchell noted that deaths from nervous diseases in Chicago had increased almost 21 times from what they

3. Hysteria may be a so-called "normal" personality style. If hysterical patterns are greatly exaggerated, combined with severe bodily complaints, or manifested by dissociative or conversion symptoms, they may form a hysterical neurosis necessitating treatment.

had been in 1852. He felt that this was due to "the strain on the nervous system resulting from the toils and competitions of a community growing rapidly and stimulated to its utmost capacity" (Mitchell 1891:28ff). He listed five major causes of nervous disorders in women. These included: sudden shock, severe domestic strain (usually nursing a sick family member), acute illness, chronic disturbances of nutrition, and normal reproductive physiology (Mitchell 1888:119).

Like his contemporaries, Mitchell believed that women were fundamentally inferior to men and that their nervous systems were more irritable; both "facts" contributed to a woman's greater susceptibility to disease. And female irritability was firmly rooted in women's reproductive physiology and sexuality. "The great physiological revolutions of a woman's life" such as menstruation, menopause, lactation etc., were viewed as a frequent cause of nervous disorders (Mitchell 1888:119). In fact, normal female functions or femininity were considered diseases (Loewenthal 1886; Smith-Rosenberg 1974).

Unlike in men, women's organs were not considered equal; the reproductive organs dominated. With increasing knowledge of endocrine function, the ovary began to supplant the uterus as the ruling organ and was viewed as the offending agent in various diseases (Barnes 1890). Physicians believed in a theory known as "reflex irritation": a sympathy or connection existed between all bodily organs (Bassuk unpublished; Decke 1881; Englemann 1877). Thus, nervous symptoms such as those experienced in hysteria or neurasthenia could be caused by a local irritation in the ovary or uterus that was then transmitted electrically via nerve impulses to the brain (Clarke 1894; Sims 1893; Wells 1886). Mitchell believed that diseases of the reproductive organs were an inextricable part of nervous disorders in women, thus accounting for the necessity of vaginal douches and other local gynecological treatments in those receiving the rest cure (Currier 1886; Tauszky 1881).

The belief in the primacy of the reproductive organs in women was used to support the notion that a woman's major responsibility was to propagate the race. Because doctors also assumed that each organism possessed a finite amount of vital energy and was a closed system, anything that diverted women's energy from the reproductive function, such as education or work outside the home, must be avoided (Foster 1900; Smith-Rosenberg 1974). An 18 year old girl, for example, who became tense about an upcoming examination was diverting energy from normal physiological functions such as menstruation. Her worries might ultimately impair her ability to bear sturdy children.

In his writings, Mitchell (1891) questioned the wisdom of the school curriculum, suggesting that it severely overtaxed the average

girl. "There are in the physiological life of women disqualifications for continuous labor of the mind" (Mitchell 1885a:15). He implied that women developed illnesses precisely because of their unfeminine strivings (Wood 1974). He recommended shortening a woman's school hours and modifying her course of instruction. Mitchell also strongly opposed the progressive idea that every woman be given the opportunity to become a teacher. Instead, he felt that the function of school was to prepare women for their role as the "source and center of the home" (Mitchell, 1891:55).

Mitchell insisted that women were irreversibly constrained by their bodies and should not aspire beyond traditional domestic roles. He commented that "the woman's desire to be on a level of competition with men and to assume his duties, is I am sure, making mischief, for it is my belief that no length of generations of change in her education and modes of activity will ever really alter her characteristics. She is physiologically other than the man. I am concerned with her now as she is, only desiring to help her in my small way to be in wiser and more healthful fashion what I believe her Maker meant her to be, and to teach her how not to be that with which her physiological construction and the strong ordeals of her sexual life threaten her as no contingencies of man's career threaten in like measure or like number the feeblest of the masculine sex" (Mitchell 1888:13). Any attempt by a woman to seek "equality" to a man was destined to fail.

THE SYMPTOMS AND THE CURE: SYMBOLIC MEANINGS
Imagine such a treatment. Under the paternalistic, authoritarian control of a male physician, the Victorian woman regressed physically and emotionally. Isolated from her family and children and her usual responsibilities, she was put to bed and taught complete submission; even her arms and legs were moved for her. Every orifice was invaded — by vaginal douches, enemas and milk feedings. Then when she was fatter and ruddier, she was told what to think and how to express her thoughts. Yet, some women, like Mrs. S., recovered. Others, such as Charlotte Perkins Gilman (1892, 1935), bitterly decried both Mitchell and the rest cure. In "The Yellow Wallpaper," a short story that appeared in the 1892 issue of *The New England Magazine*, Gilman described her experience by inventing a female protaganist who starts to go mad as a result of the "cure." While undergoing the treatment, Gilman herself felt that she was teetering on the edge of a nervous breakdown. Only when she resumed her normal work three months later did she finally recover.

Why did many women seem to improve while some became even more ill? Although Mitchell and others (Allen 1977; Veith 1977) claimed that most women benefited, no long-term data are available. Perhaps a significant percentage of these women relapsed over time.

If they improved, as Mrs. S. appeared to, it would be useful to analyze the curative aspects of the treatment. However, without access to the patients or to data, we can only speculate about reasons for the positive outcome.

To understand the rest cure, we must try to decode the symbolic meaning of the symptoms. Symptoms often represent compromise solutions, ways of negotiating contradictory or warring impulses. A wish is sometimes met with a prohibition or defense; if the conflict is not successfully resolved, the opposing desires may be condensed into a symptom.

What were Victorian women struggling with? Because of their physiology, Victorian women were taught to view themselves as inferior to and dependent on men. They were told only to strive for a domestic life focused on the needs of husband and children. But not all women were prepared for the sometimes overwhelming responsibility of running a household. Neurasthenic and hysterical symptoms may have served several "purposes." Rather than functioning as capable household managers, some Victorian women regressed and became bedridden, thus abdicating their role as caretakers and ensuring that they were cared for and protected by others. Similarly, some women may unconsciously have "used" their symptoms to avoid their own "forbidden" desires and, in certain cases, the sexual demands of authoritarian husbands. By regressing to a more infantile position that was primarily aimed at being taken care of, Victorian women avoided confronting their own sexual feelings and conflicts.

Perhaps these symptoms also had a more adaptive fuction. They may have helped women to escape from the more repressive aspects of family roles, as well as from difficult physical demands, particularly the pain and risks of childbearing. Although adaptive in a sense, the end result of the symptoms was costly. It reinforced the Victorian image of the delicate, sickly woman who could not even take care of her family responsibilities — frequently, the only source of her self-esteem (Smith-Rosenberg 1972:671).

During the late nineteenth century when the rest cure emerged, many middle class women had started to question traditional roles. Conflicts between autonomy and dependence, sexual expression and repression, activity and passivity, may have been more intense than during earlier periods. Paradoxical impulses and wishes had actively surfaced and stereotyped views of masculinity and femininity were starting to be questioned. Women experienced greater autonomy and power at home, reflected in part by the smaller size of families (Smith 1974). As Linda Gordon (1974, 1977) has documented, it was also during this period that the concept of "voluntary motherhood" enjoyed increasing popularity. Its proponents wanted to make it possible for women to gain some control over their bodies by providing a way to avoid pregnancy. Birth control did not mean

the use of devices; it implied periodic or complete abstinence. But it allowed women the right to refuse their husbands and to participate in decisions about sexuality and motherhood. "What gave the concept [of voluntary motherhood] substance was that it was acompanied by another, potentially explosive, conceptual change: the reacceptance of female sexuality" (Gordon 1974:56). Women began to believe that their sexual drives were "natural" and that these impulses could be indulged "without the intention of conceiving children" (Gordon 1974:64).

Within the context of potentially increased independence both inside and outside the family and the possibility of greater sexual expression, many women developed emotional symptoms, became bedridden and then received the rest cure. True resolution of Victorian woman's conflicts meant that she must abandon her symptoms and transcend both her physiology and traditional domestic roles. Does the story of Mrs. S. imply such an outcome? Some authors believe that stories such as this confirm the curative nature of Mitchell's treatment and the personal growth of his patients (Allen 1977; Veith 1977). They argue that Mitchell was an intuitive, empathic therapist who encouraged libidinal gratification, permitted regression and countered overly severe superego injunctions from the mother (Allen 1977:294). Although such an analysis accurately reflects various components of the treatment, it does not explain why women like Mrs. S. improved.

Was the rest cure merely a controlled recapitulation of Victorian woman's conflicts, but this time "played out" with the physician? In modern day language, was it a transference cure? — a theory that might provide an explanation of why some women improved. According to psychoanalysis, this concept implies that the patient developed an idealizing or narcissistic transference to the therapist (Paolino 1981:113). At the same time, the relationship between the patient and physician reactivates earlier unresolved preoedipal and oedipal conflicts with parents (Goldberg 1980:330).[4] Freud wrote "often enough the transference is able to remove the symptoms of the disease itself, but only for a while — only for as long as it itself lasts. In this case, the treatment is a treatment by suggestion. . ." (Freud 1913:143). In other words, the transference becomes the vehicle of change. And because of the power projected onto the therapist by the patient, he can effect change by using various psychotherapeutic techniques, such as suggestion. These techniques, however, do not attempt to resolve the underlying conflicts.

4. The broadened concept of transference to include reactivated preoedipal concerns — namely the unsuccessful resolution and completion of the earlier stages of development (i.e., separation-individuation) — derives from Heinz Kohut's contributions to self psychology. A discussion of Victorian women's conflicts, therefore, should go beyond sexual conflicts to issues involving autonomy and identity — psychology of the self.

What were the ingredients of Mitchell's treatment that might qualify it as a transference cure? First, the relationship between the physician and patient was central to the outcome (Mitchell 1888). The doctor took over. His charisma ensured the rapid establishment of rapport and trust. We can speculate that the physician embodied both the wishes for the full-breasted nurturant mother (through the agent of his nurse who fed the patient an exclusive milk diet) and for a powerful, all-knowing man who told her what to feel and how to behave.

Second, one of the major components of Mitchell's approach was the use of suggestion. He scoffed at the idea that suggestion was merely manipulation; rather, it comprised "the whole range of persuasion, counsel and many forms of appeal" (Mitchell 1908:2035). Mitchell described how he convinced the patient to exercise more self-control and to abandon her symptoms. "We may reason, implore, counsel, appeal to duty, affection, taste, desire for health and what it brings; and, as the case suggests, be a sternly judging moralist or the humorous comrade of the minute and despatch (sic) some sad symptom with the disguised counsel of a jest" (Mitchell 1908:2036). Mitchell used any technique that seemed to work, but he did not explore the meaning of the symptoms. He was unimpressed with the "etiological role of sexual deprivation. Although he spoke of the 'false relationships with husbands' that could cause neuroses, he nevertheless categorically rejected all sexual implictions. He described Freud's writings as 'filthy things' that could be consigned to the fire" (Veith 1977:53).

Although Mitchell rejected the role of sexuality in hysteria and neuarasthenia, his treatment can be viewed as libidinally gratifying, but in a controlled and manageable way. Undoubtedly, some women may have felt physically assaulted and severely threatened by the need to submit physically to a man or to a woman (vaginal douches, rectal enemas etc). In fact, their sexual conflicts may have been reenacted. Others however, clearly felt safe and cared for.

Mitchell's genius was that he seemed able in general, to intuit the proper balance of treatment ingredients, including effective supportive psychotherapeutic approaches. For many women, he offered care and protection, a respite from adult sexuality and sexual expression, and a prescription for dealing with troublesome desires and wishes. Rather than retreating to bed, the Victorian woman could now retreat to her physician who was idealized and credited with extraordinary power and knowledge.

We can speculate that for some Victorian women the rest cure recapitulated elements of the patient's earlier conflicts with parents and later with husband and family, but within a safer context and with a more successful outcome. Not only did it offer an acceptable model for avoiding independent strivings and sexual expression, but

it also reinforced the Victorian viewpoint about the inferiority of women without undermining their self-esteem. Once "cured," the Victorian woman could assume a pseudo-independent style of functioning at home. Since her behavior was entirely dictated by rules established by her all-knowing doctor, she did not have to take responsibilty or to assume "ownership" of seemingly autonomous activities — or, for that matter wishes and desires. She now ran her home according to a rigid schedule while maintaining an infantile dependence on her doctor. Aspirations that threatened the tranquility of domestic life no longer constituted a threat; they were ruled out by overcontrol and suppression. But superficial adaptation was also costly; it affirmed the success of Mitchell's "moral reeducation" and the women's resignation to the limitations of traditional domestic roles.

It now appears more clear why Charlotte Perkins Gilman and some other early feminists did not benefit from Mitchell's treatment. Their unwillingness or inability to form idealizing transferences to their physicians may have provided a vehicle for escaping traditional domestic roles. Their refusal to be "cured," although painful and entailing its own costs, ensured greater personal growth and the potential for identifying and working through conflict rather than putting it to rest.

REFERENCES

Allen, David S., 1977. "Basic Treatment Issues," in: M.J. Horowitz, ed., *Hysterical Personality* (New York: Jason Aronson Inc.), 285—328.

Barnes, Robert, 1890. "On the Correlations of Sexual Functions and Mental Disorders of Women," *The British Gynaecological Journal* 6, 390—430.

Bassuk, E.L. (unpublished). "'Normal' Ovariotomy, 1872—1893: Sadism or Humanitarian Health Care?"

Byford, H.T., 1897. *Manual of Gynecology*, Second edition (Philadelphia: P. Blakiston, Son and Co.).

Clarke, Augustus P., 1894. "The Relation of Hysteria to Structural Changes in the Uterus and its Adnexa," *American Journal of Obstetrics* 30, 477—483.

Currier, A.F., 1886. "Local vs. General Treatment in Gynaecology," *New York Medical Journal* 43, 258—262.

Decke, T, 1881. "The Condition of the Brain in Insanity," *American Journal of Insanity* 37, 361—392.

Englemann, G.J., 1877. "The Hystero-neuroses with Especial Reference to the Menstrual Hystero-neuroses of the Stomach," *Transactions of the American Gynecological Society* 2, 483—518.

Foster, G.W., 1900. "Common Features in Neurasthenia and Insanity. Their Common Basis and Common Treatment," *American Journal of Insanity* 56, 385—417.

Freud, S., 1953—1974 (1913). "On Beginning the Treatment," in: *Standard Edition* 12: 121—144 (London: Hogarth Press).

Gilman, Charlotte Perkins, 1980 (1892). "The Yellow Wallpaper," in: Ann. J. Lane, ed., *The Charlotte Perkins Gilman Reader* (New York: Pantheon).

 1972 (1935) *The Living of Charlotte Perkins Gilman: An Autobiography* (New York: Arno Press).

Goldberg, Arnold, ed., 1980. *Advances in Self Psychology* (New York: International Universities Press Inc.)

Gordon, Linda, 1974. "Voluntary Motherhood; The Beginnings of Feminist Birth Control

Ideas in America," in: M.S. Hartman and L.W. Banner, eds., *Clio's Consciousness Raised* (New York: Harper and Row) 54—71.

1977 *Woman's Body, Woman's Right* (England: Penguin Books).

Gray, John P., 1885a. "Hints on the Prevention of Insanity," *American Journal of Insanity* 41, 295—304.

1885b "Insanity: Its Frequency: And Some of Its Preventable Causes," *American Journal of Insanity* 42, 1—45.

Hartenberg, P., 1914. *Treatment of Neurasthenia* (Edinburgh, Glasgow, London: Henry Frowde and Hodder and Stoughton).

Karell, P., 1866. "On the Milk Cure," *Edinburgh Medical Journal* 12, 97—122.

Loewenthal, R., 1886. "A New Explanation of the Process of Menstruation," *Journal of the American Medical Association* 7, 93.

Martin, F., 1887. "Hystero-Neurasthenia, or Nervous Exhaustion of Women, Treated by the S. Weir Mitchell Method," *Journal of the American Medical Association* 8, 365—368.

Mitchell, John K., 1909. *Self-Help for Nervous Women* (Philadelphia: J.B. Lippincott and Co).

Mitchell, Silas Weir, 1877. *Nurse and Patient, and Camp Cure* (Philadelphia: J.B. Lippincott and Co).

1885a *Lectures on Diseases of the Nervous System Especially in Women* (Philadelphia: Lea Bros. and Co).

1885b *Fat and Blood*, Fourth edition (Philadelphia: J.B. Lippincott and Co).

1888 *Doctor and Patient* (Philadelphia: J.B. Lippincott and Co).

1891 *Wear and Tear, Or Hints for the Overworked*, Fifth edition (Philadelphia: J.B. Lippincott and Co).

1900 *Fat and Blood: An Essay on the Treatment of Certain Forms of Neurasthenia and Hysteria* Eighth edition (Philadelphia: J.B. Lippincott and Co).

1904 "The Evolution of the Rest Treatment," *Journal of Nervous and Mental Diseases* 31, 368—373.

1908 "The Treatment by Rest, Seclusion, etc., In Relation to Psychotherapy," *Journal of the American Medical Association* 50, 2033—2037.

Paolino, T., 1981. *Psychoanalytic Psychotherapy* (New York: Brunner Mazel).

Poirier, S., 1983. "The Weir Mitchell Rest Cure: Doctor and Patients," *Women's Studies* 10, 15—40.

Sicherman, B., 1977. "The Uses of a Diagnosis: Doctors, Patients, and Neurasthenia," *Journal of History and Allied Sciences* 32, 33—55.

Sims, H. Marion, 1893. "Hystero-Epilepsy. Report of Seven Cases Cured by Surgical Treatment," *Transactions of the American Gynecological Society* 18, 282—297.

Smith, Daniel Scott, 1974. "Family Limitation, Sexual Control and Domestic Feminism in Victorian America" in: M.S. Hartman and L.W. Banner, eds., *Clio's Consciousness Raised* (New York: Harper and Row).

Smith-Rosenberg, Carroll, 1972. "The Hysterical Woman: Sex Roles and Conflict in Nineteenth Century America," *Social Research* 39, 652—678.

1974 "Puberty to Menopause: The Cycle of Femininity in Nineteenth Century America" in: M.S. Hartman and L.W. Banner, eds., *Clio's Consciousness Raised* (New York: Harper and Row).

Tauszky, R., 1881. "The Causes and Treatment of Metrorrhagia and Menorrhagia," *American Journal of Medical Sciences* 81, 67—82.

Veith, Ilza, 1977. "Four Thousand Years of Hysteria," in: M.J. Horowitz, ed., *Hysterical Personality* (New York: Jason Aronson Inc.), 9—93.

Wells, T. Spencer, A. Hegar, and R. Battey 1886. "Castration in Mental and Nervous Disorders, A. Symposium," *American Journal of Medical Sciences* 92, 455—490.

Wood, Ann Douglas, 1974 (1973). "'The Fashionable Diseases': Women's Complaints and Their Treatment in Nineteenth-Century America" in: M.S. Hartman and L.W. Banner, eds., *Clio's Consciousness Raised* (New York: Harper and Row).

Yellowlees, D., 1885. "The Causes and Prevention of Insanity," *British Medical and Surgical Journal* 113, 145—147.

THE CLINICAL EYE:
MEDICAL DISCOURSES IN THE "WOMAN'S FILM" OF THE 1940s

MARY ANN DOANE

An important component of what Michel Foucault refers to as "the fantasy link between knowledge and pain" (1973:x) is the association, within patriarchal configurations, of femininity with the pathological. Disease and the woman have something in common — they are both socially devalued or undesirable, marginalized elements which constantly threaten to infiltrate and contaminate that which is more central, health or masculinity. There is even a sense in which the female body could be said to harbor disease within physical configurations that are enigmatic to the male. As is frequently noted, the word "hysteria" is derived from the Greek word for "uterus" and the 19th century defined this disease quite specifically as a disturbance of the womb — the woman's betrayal by her own reproductive organs. The patient whose discourse is read and interpreted at the origin of psychoanalysis, as the text of the unconscious, is the female hysteric. As Phyllis Chesler points out, "Although the ethic and referent of mental health in our society is a masculine one, most psychoanalytic theoreticians have written primarily about women" (1972:75). It is thus as an aberration in relation to an unattainable norm that the woman becomes narratively "interesting," the subject for a case history. A narrativization of the woman which might otherwise be fairly difficult is facilitated by the association of women with the pathological.

This tendency to "medicalize" the woman is particularly strong in a cinematic genre often referred to as the "woman's film" or "woman's picture." The "woman's film" is a group of American films produced during the 1930s and 1940s which deal with a female

This essay is a shortened and slightly revised version of a chapter from a book I am currently writing on "the woman's film" of the 1940s.

protagonist and issues or problems specified as "female" — problems revolving around domestic life, the family, the maternal, self-sacrifice, romance, etc. Often popularly known as "weepies" or "tear-jerkers," these films were addressed to a female spectator and, at least partially for this reason, are only now becoming the focus of a critical attention made possible through the conceptual framework of feminist theory. The genre provides a particularly rich image-repertoire of classical feminine poses — those associated with sacrifice and hence masochism, hysteria, and paranoia. Furthermore, because theories of spectatorship in the cinema have been dominated by the analysis of the male spectator (Metz 1975:14—76, Mulvey 1975:6—18), the terms of address in the "woman's film," terms which make it a somewhat aberrant form of the classical Hollywood text, open up a space for a potentially radical feminist rewriting of that theory.

One extremely significant sub-genre of the woman's film, most prominent in the 1940s when Hollywood attempted on a rather large scale to incorporate and popularize psychoanalysis as the latest medical "technology," is a cluster of films which depict female madness, hysteria, or psychosis. These films manifest an instability in the representation of female subjectivity and situate the woman as the object of a medical discourse.[1] As the example of hysteria and the more modern conceptualization of hormones and their effects indicate, the border between physical and mental illness is often of little consequence in the medicalization of femininity. Represented as possessing a body which is over-present, unavoidable, in constant sympathy with the emotional and mental faculties, the woman resides just outside the boundaries of the problematic wherein Western culture operates a mind/body dualism. Hence the illnesses associated with women in the many films of the 1940s which activate a medical discourse are never restricted or localized — they always affect or are the effects of a "character" or an essence, implicating the woman's entire being. In the majority of the films discussed here, the female character suffers from some kind of mental illness: depression, nervous breakdown, catatonia, amnesia, psychosis. Yet even in the films which focus on a physical illness or defect, such as *Dark Victory* (1939), or *A Woman's Face* (1941),

1. The films discussed in this essay as contributors to this problematic include: *Dark Victory* (Edmund Goulding 1939); *A Woman's Face* (George Cukor 1941); *The Cat People* (Jacques Tourneur 1942); *Now Voyager* (Irving Rapper 1942); *Guest in the House* (John Brahm 1944); *Lady in the Dark* (Mitchell Leisen 1944); *Dark Mirror* (Robert Siodmak 1946); *A Stolen Life* (Curtis Bernhardt 1946); *The Locket* (John Brahm 1946); *Shock* (Alfred Werker 1946); *Possessed* (Curtis Bernhardt 1947); *Johnny Belinda* (Jean Negulesco 1948); *The Snake Pit* (Anatole Litvak 1948); *Beyond the Forest* (King Vidor 1949); *Whirlpool* (Otto Preminger 1949).

where it is a question of a brain tumor and a facial scar respectively, the discovery or the treatment of the illness initiates a radical change in the very life styles of the women concerned. In *Beyond the Forest* (1949), Bette Davis ostensibly dies of peritonitis, the effect of a self-induced miscarriage, but her death is really caused by an irrepressible and feverish desire to leave her small town life behind and take the train to Chicago.

This blurring of the boundaries between the psychical and the somatic is predicated upon a shift in the status of the female body. When it is represented within mainstream classical cinema as spectacle, as the object of an erotic gaze, signification is spread out over a surface — a surface which refers only to itself and does not simultaneously conceal and reveal an interior. Such a fetishization of the surface is, of course, the very limit of the logic of this specular system, a limit which is rarely attained since it implies that there is no attribution of an interiority whatsoever and hence no "characterization" (this extreme point is most apparent in certain Busby Berkeley musical numbers). The logical limit nevertheless exemplifies the system's major tendency and entails that the body is both signifier and signified, its meaning in effect tautological. The female body exhausts its signification entirely in its status as an object of male vision. In films of the medical discourse, on the other hand, the female body functions in a slightly different way: it is not spectacular but symptomatic, and the visible becomes fully a signifier, pointing to an invisible signified. The medical discourse films attribute to the woman both a surface and a depth, the specificity of the depth being first and foremost that it is not immediately perceptible. A technician is called for — a technician of essences, and it is the figure of the doctor who fills that role. Medicine introduces a detour in the male's relation to the female body through an eroticization of the very process of knowing the female subject. Thus, while the female body is despecularized, the doctor-patient relation is, somewhat paradoxically, eroticized.

The logic of the symptom — so essential to an understanding of the films of the 1940s which activate a medical discourse — is caught within the nexus of metaphors of visibility and invisibility. The symptom makes visible and material invisible forces to which we would otherwise have no access; it is a delegate of the unconscious. But even outside the specifically psychoanalytic postulate of the unconscious, the organization of clinical experience, as Foucault points out, demands the elaboration of a multi-levelled structure.

> The structure, at once perceptual and epistemological, that commands clinical anatomy, and all medicine that derives from it, is that of *invisible visibility*. Truth, which, by right of nature, is made for the eye, is taken from her, but at once surreptitiously revealed by that which tries to evade it. Knowledge *develops* in accordance with a whole interplay of envelopes. . . (Foucault 1973:165—166).

It is the task of the doctor to *see through* this series of envelopes and reveal the essential kernel of truth which attempts to escape the eye. Physiology and psychoanalysis share this system which posits a relation between different levels — a surface and a depth, visibility and invisibility. In breaking away from biology it was perhaps inevitable that Freud should do so through recourse to an illness, hysteria, in which the body is transformed into a text — enigmatic but still decipherable. In his case history of Dora (another "woman's narrative"), Freud posits a privileged relation between hysteria and the somatic. "Somatic compliance" is the concept Freud elaborated to designate the process whereby the body complies with the psychical demands of the illness by providing a space and a material for the inscription of its signs. He analyzes a case of a female hysteric whose contorted face can be read as a direct translation into physical terms of the verbal cliché for an insult — a "slap in the face." In *Studies on Hysteria*, Freud and Breuer delineate the types of symptoms which require that the body act as the expression of the illness: neuralgias and anaesthesias, contractures and paralyses, hysterical attacks, epileptoid convulsions, tics, chronic vomiting and anorexia, disturbance of vision, etc. (1966:38).

From the nineteenth to the twentieth century, however, hysteria is subdued and the relation between mental disturbances and the space of the body is modified. In the 1940s films of the medical discourse, neuroses and even psychoses are evidenced not by contorted limbs and paralysis but by a marked lack of narcissism on the part of the sick woman. The illness of the woman is signalled by the fact that she no longer cares about her appearance. In the beginning of *Possessed* (1947), when Joan Crawford — clearly demented — walks the city streets misrecognizing every man for the one she has just killed, she is represented as quite plain, in documentary style shots, without make-up, in stark contrast to scenes in flashback of an earlier time when she was not yet ill. Still the victim of a psychosis at the end of the film, she never quite regains her "looks." This despecularization of the woman is present in films such as *Now Voyager* (1942) and *Johnny Belinda* (1948) as well. In both films the woman's illness is registered as an undesirable appearance. Charlotte (Bette Davis), in the beginning of *Now Voyager*, wears glasses, clumsy shoes, an unattractive dress, and is presented as being overweight, with heavy eyebrows and a harsh hairstyle. Belinda (Jane Wyman), before she meets the doctor in *Johnny Belinda*, is dirty and unkept, her hair uncombed. In these films, as well as in *A Woman's Face*, the woman's "cure" consists precisely in a beautification of body/face. The doctor's work is the transformation of the woman into a specular object. Nevertheless, the woman's status as specular object of desire is synonymous with her "health" — her

illness is characterized as the very lack of that status. The narratives thus trace a movement from the medical gaze to the erotic gaze in relation to the central female figure, activating a process of despecularization/respecularization.

The lack or impairment of a narcissism purportedly specific to femininity is hence symptomatic in these films. Although Rosa Moline (Bette Davis) begins in *Beyond the Forest* with a strong desire to constitute herself as spectacle, her fever at the end of the film is signified by her misapplication of make-up as she gazes into the mirror. Her lipstick exceeds the outline of her mouth and eyeliner is drawn on in a crooked line far from the boundary of the eye. Her dress askew as well, she is the figure of an impaired narcissism. The pathetic nature of her condition is emphasized by the fact that the signs of her excessive desire are inscribed upon her body in a hyperbolic manner. Because narcissism is the convergence of desire on the subject's own body, its opposite — over-investment in an object relation — is also symptomatic of a serious deficiency of narcissistic libido. In *Possessed*, Louise's (Joan Crawford) illness is depicted as over-possessiveness, as a relentless desire for a man who no longer loves her.

However, the classical film — and the medical discourse film, whatever its particularities, does belong to this category — also manifests a profound ambivalence on precisely this issue of the woman's narcissism. For its logic entails the possibility of a woman being overly narcissistic as well, a condition which inevitably signifies evil tendencies on her part (this is, in fact, the case in *Beyond the Forest*). The constant subtext accompanying the text of spectacle in the classical cinema proclaims that outward appearances do not matter, that an essential core of goodness may be veiled by a mis-leading, even unattractive exterior. The spectacular aspect of classical cinema, its concentration upon visual pleasure, carries within it its own denial. Hence, too great an insistence by the woman herself on her status as image for the male gaze is prohibited — it is un-seemly, wrong-headed and potentially indicative of an illness asso-ciated with misplaced ambition. *Dark Mirror* (1946) links psychical disturbance to female narcissism and violence, via the shattered mirror acting as an endpoint to its long first shot and a more general emphasis upon mirrors throughout its narrative about twin sisters. In *Caught* (1949), the medicalization of Leonora (Barbara Bel Geddes) is synonymous with her despecularization. At the end of the film, the obstetrician's final diagnosis of Bel Geddes consists of a rejection of the object which at the beginning of the film epitom-ized the woman's desire, a mink coat ("If my diagnosis is correct, she won't want that anyway"). Because the mink coat is associated with femininity as spectacle and image — its first inscription in the film is within the pages of a fashion magazine —, the doctor's

diagnosis has the effect of a certain despecularization of the female body. That body is, instead, symptomatic, and demands a reading.[2]

Hence, there are two strong yet contradictory impulses within the classical cinema concerning the representation of the female body. The body is either fetishized as an object of beauty or de-emphasized as totally non-revelatory, even deceptive — this is the logic of "appearances can be deceiving." Yet the overwhelming force of the drive to specularize is manifested by the fact that the second impulse is not concretized through the representation of "ugly" or even "unattractive" women. When a woman is designated as "plain" within the classical cinema, she is not really "plain" in relation to any contemporary standards of attractiveness (Joan Fontaine in *Rebecca*, purportedly contrasted with the beautiful but significantly absent Rebecca, is a good example of this). Furthermore, instead of going so far as actually to depict a woman as having a face or body coded as unattractive — and unchangeably so — in order to demonstrate that it is the "interior" which really "counts," the classical text multiplies its figures of feminine beauty. This is particularly the case in identical twin films of the 1940s such as *Dark Mirror* and *A Stolen Life* (1946). In each film, the twin sisters look exactly alike but are essentially different. In *A Stolen Life*, the major male character refers to one twin as "cake" and the other "icing," comparing them on the basis of a distinction between substance and excess. But because the two women are identical in appearance, a specialist is often needed to allay the effects of this "double-vision" on the part of the male, to penetrate the surface. In *Dark Mirror*, one of the twins has committed a murder and the other covers up for her, one is paranoid and the other relatively healthy. Because it is impossible to differentiate between the two on the basis of appearance — both are played by Olivia de Havilland —, a psychiatrist is needed to *see through* the surface exterior to the interior truths of the two sisters, in other words, to perform a symptomatic reading.

In this branch of the "woman's film," the erotic gaze becomes the medical gaze. The female body is located not so much as spectacle but as an element in the discourse of medicine, a manuscript to be read for the symptoms which betray her story, her identity. Hence the need, in these films, for the figure of the doctor as reader or interpreter, as the site of a knowledge which dominates and controls female subjectivity. A scenario of reading is provided within the films themselves, a hermeneutics of pathology which requires that the body approximate a two-levelled text. The doctor's look in the cinema, because it *penetrates*, appears to be closer to what Foucault

2. For a more extensive analysis of the medical discourse in *Caught*, see my article, "*Caught* and *Rebecca*: The Inscription of Femininity as Absence," *Enclitic* 5:2/6:1 (Fall 1981/ Spring 1982), 75—89.

describes as the medical glance rather than the gaze. The gaze observes an exterior, it scans a field, expanding in a horizontal rather than a vertical direction; it is "endlessly modulated" while the glance "goes straight to its object."

> The glance chooses a line that instantly distinguishes the essential; it therefore goes beyond what it sees; it is not misled by the immediate forms of the sensible, for it knows how to traverse them; it is essentially demystifying. . .
> (Foucault 1973:121).

The symptomatic reading which the doctor performs in these films by means of the instrument of the glance[3] unveils a previously invisible essence, ultimately the essence of the female character concerned. The ideology which the films promote therefore rests on a particularly extreme form of essentialism.

But the logic of the symptom might be used to read the film texts differently. Althusserian theory and strategies of interpretation derived from it assume that what is invisible, what the symptom indicates, is not an essence, as in the films, but a structure, a logic, in short, an ideological systematicity which is by definition unconscious. A symptomatic reading in this sense reveals what is excluded as the invisible of a particular discourse, what is unthought or what the discourse wishes very precisely not to think.

> . . . the invisible is the theoretical problematic's non-vision of its non-objects, the invisible is the darkness, the blinded eye of the theoretical problematic's self-reflection when it scans its non-objects, its non-problems without seeing them, *in order not to look at them* (Althusser and Balibar 1970:26).

The non-object of the woman's film, what ceaselessly exceeds its grasp, is what would appear to be dictated by its own logic — the coherent representation of female subjectivity. Breakdowns and instability in the representation of female subjectivity are evident in all types of the woman's film, but in the films of the medical discourse they receive a special twist. For these incoherencies and instabilities do not remain unseen or unrecognized by the texts; on the contrary, they are recuperated as the signs of illness or psychosis. In this way, the purported subject of the discourse, the woman, becomes its object, and her lapses or difficulties in subjectivity are organized for purposes of medical observation and study. The doctor is thus a crucial figure of constraint. Nevertheless, there are leakages which are manifested as symptoms in the body of the text as a whole.

3. Future references to the look of the doctor will make use of the term "gaze" despite Foucault's very important distinction, in this context, between the glance and the gaze. I continue to utilize "gaze" due to its connotative relation to temporality. While the glance is rapid, punctual, momentary, gaze implies a sustained process of looking which more accurately describes the strategy of the films. For my purpose, the most significant aspect of Foucault's distinction is its correlation with the opposition surface/depth.

The genre which is most frequently described as the site of this "return of the repressed" is the melodrama. Geoffrey Nowell-Smith, for instance, explicitly compares certain strategies of the melodrama with the mechanism of what Freud designated as conversion hysteria. The text is seen as analogous to the body and "the film itself somatises its own unaccommodated excess, which thus appears displaced or in the wrong place" (Nowell-Smith 1977:117). The hysteria frequently attributed to the female protagonist in the woman's film often proliferates, effecting a more general "hystericization" of the text as a body of signifiers.

Such textual hysterical symptoms are, as Althusser points out, "failures in the rigour" of the discourse, the "outer limits of its effort" (1970:86), sites of the collapse or near-collapse of its own logic. In the films of medical discourse, these breaking points or ruptures cluster in several different areas; in what follows I shall concentrate on the assimilation of psychoanalysis within the Hollywood cinema, on narration and the woman's access to language and vision, and on the eroticization of the doctor-patient relation. The films I shall examine in some detail — *The Cat People* (1942), *Possessed* (1947), and *Beyond the Forest* (1949) — were not chosen on the basis of their "typicality." Rather, in the spirit of symptomatic reading, they are all in some ways extreme instances, limit-texts which inadvertently reveal the weaknesses or breaking points of a contradictory ideological project, that of a classical genre addressed to a female spectator.

PSYCHOANALYSIS IN THE HOLLYWOOD CINEMA

It is not at all surprising that the medical figure in many of these films is a psychoanalyst, a psychiatrist, or a psychologist (Hollywood often makes no distinction between these three categories). For 1940–1950 is the decade of the most intense incorporation of psychoanalysis within the Hollywood system. Films like *Lady in the Dark, Spellbound* (1945), *The Cat People, Shock* (1946), *Nightmare Alley* (1947), and *The Snake Pit* (1948), exploited a growing curiosity about psychoanalysis and psychology. This incorporation is synchronous with a more general popularization of psychoanalysis in the late 30s and 40s which was at least partially stimulated by the influx of European refugee analysts, psychiatrists, and intellectuals at this time (Schneider 1977:615). The movie industry called upon psychoanalytic authorities and experts to act as consultants for its productions and to guarantee the authenticity of its representations. Both *Dark Mirror* and *Sleep My Love* (1948) brought in psychoanalysts as technical advisors, and advertised that fact.[4]

4. See the Press Books for *Dark Mirror* (International Pictures 1946) and *Sleep My Love* (United Artists 1948).

The popularized version of psychoanalysis rejects what Freud theorized as a polymorphously perverse sexuality which is only gradually channelled in socially acceptable ways. Instead, it uses psychoanalysis to validate socially constructed modes of sexual difference which are already in place, although potentially threatened by a war-time reorganization. Hence, it is not surprising that women far outnumber men as patients in these films (in a film like *Spellbound* (1945), where precisely the opposite may appear to be the case since Ingrid Bergman is a psychoanalyst and Gregory Peck her patient, it can in fact be demonstrated that she is ultimately constituted as analysand — she suffers from a frigidity constantly associated with intellectual women in the cinema). When psychoanalysis *is* activated in relation to a male patient diagnosed as suffering from some form of neurosis or psychosis, the effects of the pathological conditions are often held in check, restricted and localized by linking the illness directly to a war trauma (e.g. in *Home of the Brave* (1949) and the documentary *Let There Be Light* (1946)). What is diagnosed in the women patients is generally some form of sexual dysfunction or resistance to their own femininity. (*Now Voyager, The Snake Pit*, and *Lady in the Dark* are examples of this tendency). Psychoanalysis is used very explicitly to reinforce a status quo of sexual difference.

While most of these films situate the psychoanalyst as a kind of epistemological hero, the guarantor of the final emergence of truth, Hollywood is also cognizant of the potential excesses of psychoanalysis and its methods, of the other side of a science which purports to manipulate the mind. This problematic is elaborated in films like *Shock* (1946), *Sleep My Love* (1948), and *Whirlpool* (1949). *The Cat People* is by far one of the most intriguing of this group of films which investigate the unscrupulous or suspect dimension of psychoanalysis, for it elaborates and plays on two of the most important premises of the films of the medical discourse: the specification of the doctor or of the psychoanalyst as the pivotal figure linking the visible and the invisible in the construction of knowledge (about the woman); and the constitution of the female body as symptomatic and hence a vehicle of hysteria.

The Cat People, focusing on a woman's problem — what might even be termed a woman's domestic problem since it concerns the happiness of her marriage — is exemplary of the extent to which the horror film acts as intertext of the woman's film. Irena (Simone Simon) is obsessed with a legend concerning the Serbian village of her origin. This legend maintains that sexuality and/or jealousy causes the women of the village to be transformed into great cats, panthers, who take the men as their prey. According to the legend, a King John liberated the village by killing many of the cat people (Irena keeps a statue of King John on a horse, his sword raised high,

impaling a cat). In America, Irena meets Oliver Reed (Kent Smith) who describes himself as a "good old Americano" and who attempts to dispel Irena's belief in the Serbian legend. Oliver falls in love with Irena and marries her; however, because Irena fears what the legend delineates as the effects of sexuality, their relationship remains platonic. Kind and understanding at first, Oliver gradually becomes tense and dissatisfied and urges Irena to see a psychoanalyst, Dr. Louis Judd. When Irena refuses to return to the psychoanalyst because he is interested in her "mind" rather than her "soul," Oliver begins to get more and more interested in the "girl at the office," Alice, who is contrasted with Irena in every way. While Alice defines love as "understanding" and "you and me," Oliver describes his feeling for Irena as an obsessive need to watch and touch her because "there's a warmth when she's in the room," despite the fact that he admits he does not know her at all. Irena's jealousy of Alice triggers several events which convince both Alice and Oliver that Irena can and does metamorphose into a panther. The psychoanalyst, however, a supreme rationalist, resists this hypothesis and is killed by the panther/Irena after he attempts to kiss her. Before dying, the psychoanalyst manages to stab Irena fatally with his cane/knife and she dies after letting loose the panther at a nearby zoo.

The Cat People is, on the one hand, the dramatization of a quasi-psychoanalytic scenario — the surfacing of the invisible, chaotic forces of instinct or the unconscious.[5] On the other hand, the film demonstrates the limits of psychoanalysis and rationality in general when faced with femininity. Forcing an equation whereby the unconscious = female sexuality = the irrational, the film can claim that the impotence of psychoanalysis stems from the unfathomable nature of its object of study — the woman and her sexuality. The psychoanalyst's insistence upon rationalizing entails that he cannot *see* the "invisible" of the woman precisely because it is coincident with the irrational and hence outside the range of his professional vision. In moving from an opening text constituted by a quote from the scientist, Dr. Louis Judd, to an ending epitaph from a poem by John Donne, the film sustains a strict opposition between science and poetry, the rational and the irrational. This opposition is mapped onto what in 1942 was necessarily another heavily loaded opposition — that between the native and the foreign, the "good old Americano" and the Serbian, the familiar (Alice) and the strange (Irena). *The Cat People* transforms the unconscious or the instinctual not only into an object which is, by definition, outside the grasp of psychoanalysis, but also into an object which incites its murderous

5. The analysis of *The Cat People* which follows owes a great deal to discussions I had with Deborah Linderman about the film in Spring 1983.

impulses — it is the psychoanalyst's phallic cane/knife which kills Irena. Yet, her death demands that of the psychoanalyst; it entails the death of a science which purports to include what should remain excluded: female sexuality and all that is beyond conscious reason.

Thus, the psychoanalyst, rather than acting as a link between rationality and irrationality, between visibility and invisibility, becomes the figure of their absolute disjunction. This problematic has the effect of safeguarding visibility, rationality and the native/familiar from what is absolutely other. The film would like very much to believe that the symptom does not inhabit the norm, that visibility and invisibility, correlated with rationality and irrationality, occupy two entirely different spaces. Yet, the *mise-en-scène* belies the possibility of such a desire and hence the film operates on the epistemological threshold of the classical text's organization of the seen and the unseen and the dialectic which insures simultaneously their interaction and their separation. It dwells on the mixture, the composite, the effect of a transgression of barriers.

Although the image is indubitably the register of truth in the classical cinema, the place where knowledge resides (see MacCabe 1974:7–27), there is also a kind of truth which is invisible, which cannot be imaged. The supernatural is one instance. The truth of a person is another. *The Cat People* conflates the two in the character of Irena. In the horror film in general, the unseen may appear to have a greater degree of truth value than the seen. This is why the horror film emphasizes the edge of the frame as a border and exploits the phobia attached to the truth of the unseen. But this fetishization of the frame-line as border guarantees that the invisible remains an alien external entity, excluded from a discourse which privileges the evidence of the eyes — once it is visible, the monster of the horror film can be fought and subdued. The very technology of the cinema automatically protects the realm of visibility against otherness. Yet *The Cat People* unwittingly elaborates a formal textual logic which, paradoxically, interiorizes the frame-line, constituting the division between visibility and invisibility not as a limit but as an alien internal entity. Such a strategy accomplishes what Samuel Weber claims is characteristic of the mechanism of repression — it establishes "a relation to exteriority at the core of all that is enclosed" (1982:47).

The Cat People does so by consistently elaborating a discourse on barriers, a discourse on the same and the other. Such, for instance, is the significance of the scene which dwells on the chain separating Irena from the panther in the cage at the zoo. Irena, pacing back and forth in front of the chain which in a way imprisons her, is the mirror image of the panther pacing in its cage. But the film has no difficulty in visualizing either Irena or the panther. What it cannot incorporate within the terms of its image system is the transposition

of one into the other. In the famous scene in which Irena "stalks" Alice, her transformation into a panther is represented by the movement from the sound of high heels to silence on the soundtrack. Irena's subsequent metamorphosis back into a woman is signified by the gradual conversion of tracks of paws into those of high heels.

Thus, what is most true for the film is never directly imaged — the compatibility and substitutability of feline and female. The narrative is a literalization of the idea that the female body is symptomatic and hence the vehicle of hysteria. The mechanism which Freud pinpointed as characteristic of hysteria — conversion, "the translation of a purely psychical excitation into physical terms" (1963a: 70—71) — is hyperbolized when the return of repressed sexuality demands the transformation of the woman's entire body into the symptom. The film depicts an extreme instance of "somatic compliance." And the choice of symptom is not innocent. In his article, "On Narcissism: An Introduction," Freud compares the self-sufficiency and inaccessibility of the narcissistic woman to that of "cats and the large beasts of prey" — as well as that of the child, the criminal, and the humorist. The cat is the signifier of a female sexuality which is self-enclosed, self-sufficient, and, above all, objectless. This sexuality, in its inaccessibility, forecloses the possibility of knowledge, thus generating a string of metaphors — cat, criminal, child, humorist (Freud 1963b:70). *The Cat People* designates female sexuality as that excess which escapes psychoanalysis; it is that which inhabits the realm of the unknowable. On the one hand, this is a well-worn figure, particularly in another genre of the period, the *film noir*. On the other hand, not only does female sexuality escape the objectification of the medical discourse but, by means of psychoanalysis' own formulation — conversion hysteria — that femininity returns to kill the representative of psychoanalytic authority. The female body is entirely subsumed by the symptom. As the zoo-keeper points out, quoting the Bible, the panther is the figure of a failed mimesis: "Like unto a leopard but not a leopard." For the biblical text the panther is unnameable. Similarly, the film demonstrates that the woman, in becoming most like herself, that is, the embodiment of female sexuality, must become *other*. What we are left with is the asexual Alice, perfect and unthreatening mate for the "good old Americano."

NARRATION AND FEMALE SUBJECTIVITY
Because the implementation of psychoanalysis in the cinema is forcefully linked to a process of revelation, to an exposure of the answer to the text's hermeneutic question, it is inseparable from issues of narration and the woman's access to language and vision — issues which are intensified within the context of the "woman's film's" attempt to foreground female subjectivity. The tendency in these

films to organize narrative as a memory which is retrieved is evoca-
tive of Freud and Breuer's famous claim, *"Hysterics suffer mainly
from reminiscences"* (1966:42). The study of hysteria and the films
of the medical discourse are quite close in their revelation of a
curious and dynamic interaction between the narrativization of the
female patient and her inducement to narrate, to become a story-
teller as a part of her cure. Breuer represents his relation to Fräulein
Anna O. as that of listener but it is clear that her stories are not
always spontaneous.

> I used to visit her in the evening, when I knew I should find her in her
> hypnosis, and I then relieved her of the whole stock of imaginative products
> which she had accumulated since my last visit. It was essential that this
> should be effected completely if good results were to follow. When this was
> done she became perfectly calm, and next day she would be agreeable,
> easy to manage, industrious and even cheerful; but on the second day she
> would be increasingly moody, contrary and unpleasant, and this would
> become still more marked on the third day. When she was like this it was not
> always easy to get her to talk, even in her hypnosis. She aptly described this
> procedure, speaking seriously, as a 'talking cure,' while she referred to it
> jokingly as 'chimney-sweeping.' She knew that after she had given utterance
> to her hallucinations she would lose all her obstinacy and what she described
> as her 'energy'; and when, after some comparatively long interval, she was
> in a bad temper, she would refuse to talk, and I was obliged to overcome her
> unwillingness by urging and pleading and using devices such as repeating a
> formula with which she was in the habit of introducing her stories (Freud and
> Breuer 1966:64—65).

Later in the analysis, when Breuer was forced to separate from his
patient for several weeks, he claims that "the situation only became
tolerable after I had arranged for the patient to be brought back to
Vienna for a week and evening after evening made her tell me three
to five stories." Without Breuer, "her imaginative and poetic vein
was drying up" (1966:66).

The woman's assumption of the position of narrator is thus
constituted as therapeutic, an essential component of her cure.
Furthermore, there is a compulsiveness attached to this requirement
— the woman must channel all of her energy into narrativity and thus
exhaust the other more aggressive or "unpleasant" tendencies she
might possess. However, *Studies on Hysteria* also demonstrates, very
curiously, that the woman's imagination, her story-telling capability,
is not only therapeutic but disease-producing as well. For it is day-
dreaming which instigates the illness in the first place — an un-
controlled and addressee-less daydreaming. Freud and Breuer,
referring to the hypnoid states which are associated with hysteria,
claim: "They often, it would seem, grow out of the day-dreams
which are so common even in healthy people and to which needle-
work and similar occupations render women especially prone"
(1966:47). The pathological aspect of the female relation to crea-
tivity, daydreaming, and mental productions in general is also under-

lined by Breuer in his introduction of Anna O. to the reader. After citing the "extremely monotonous existence in her puritanically minded family," he maintains that "She embellished her life in a manner which probably influenced her decisively in the direction of her illness, by indulging in systematic daydreaming, which she described as her 'private theater' " (1966:56).

The distinction between the two types of narrativity — an excessive narrativity as one of the causes of illness and a constant incitement to narrate as a therapeutic strategy — might at first appear to rest on another distinction between two different species of narrative: story as fantasy or imagination unleashed and story as history, as an accurate reflection of past events. The opposition would thus be one between fantasy and mimesis, where mimesis would be endowed with curative powers. While this explanation might prove attractive since the dangers imputed to daydreaming reside in the fact that it is totally unanchored, unrestrained and independent of referent or reference, we know that the necessity for historical truth in fantasy was never established for Freud. *Psychical* truth was most important and in this respect it was virtually impossible for the subject to lie, for the narrative to become *too* fantastic. Rather, the distinction between the two types of narrativity has more to do with the structuring effect of the presence or absence of a narratee — the doctor. The daydream is produced by the woman for herself. It is thus not only prone to excess and non-utility — an unnecessary by-product of "needlework and similar occupations" — but it feeds that narcissistic self-sufficiency to which women are always prey. The woman's narrative acumen is thus transformed into the symptom of illness. Her narrative cannot stand on its own, it must be interpreted. Narration by the woman is therefore therapeutic only when constrained and regulated by the purposeful ear of the listening doctor. By embedding her words in a case history, psychoanalysis can control the woman's access to language and the agency of narration. In Breuer's account, the woman, "narrated-out," loses her energy, becomes pliable and subdued. The logic seems to be this: if the woman must assume the agency of speech, of narration, let her do so within the well-regulated context of an institutionalized dialogue — psychoanalysis, the hospital, the court of law. Psychoanalysis and the cinema alike present the woman with a very carefully constructed relation to enunciation.

That is why, in the films, the woman's narration is so often framed within an encompassing discourse. *The Locket* (1946), constructed as flashback within flashback — only the central one the property of the woman who is the subject of all the stories — is an extreme instance of this. And if the woman hesitates, in the manner of Anna O., she is compelled to tell, to produce an account of herself. In *Possessed*, the mute Louise (Joan Crawford) is given an

injection which induces a series of flashbacks constituting the cinematic narrative. In *Shock* (1946), a female victim of amnesia is also given an injection so that the doctor can discover what she knows, what she has seen.

A medical discourse thus allows this group of films to bracket the speech of the woman, her access to language, and in some instances to negate it entirely. The attribution of muteness to the woman is by no means rare in these films. In *Shock, Possessed*, and *The Spiral Staircase* (1946), the female character loses the power of speech as the result of a psychical trauma, while in *Johnny Belinda* she is deaf/mute from birth. But in all cases language is the gift of the male character, a somewhat violent "gift" in the case of *Shock* and *Possessed* where the woman is induced to talk through an injection, and more benign, paternalistic in *Johnny Belinda* where the doctor provides Belinda with sign language.

The phenomenon of the mute woman is, however, only an extreme instance of a more generalized strategy whereby the films manage simultaneously to grant the woman access to narration and withhold it from her. The woman's narrative reticence, her amnesia, silence, or muteness all act as justifications for the framing of her discourse within a masculine narration. Thus, Louise's flashback narration in *Possessed* is situated by the doctors/listeners as the discourse of a madwoman. What is really at issue with respect to specifically filmic narration is not control of language but control of the image. For there is a sense in which vision becomes the signifier of speech in the cinema. Within the context of a psycho-analytic dramatization in particular, the flashback structure acts as the metaphor of speech in the doctor-patient relation. The flashback is the most explicit and frequent signifier of the process of narration in a cinema which is, in general, assumed to be narrator-less in its capture and reproduction of unfolding events. The great instability of the flashback as a signifier of narration, however, is that beyond the point of its introduction, the flashback effectively erases the subject of the enunciation in the same manner as the rest of the classical text, its organization partaking of the same material of representation. The very term "flashback" implies the immediacy of the past in the present. Flashback narration should therefore, and often does, assume the same reality-effect, the same impartiality, as the framing filmic discourse.

But when the woman's illness or madness rationalizes the limited attribution of narrational authority to her, the flashback structure can easily become destabilized, uncertain, especially if her delirium is allowed to infiltrate and contaminate the image. This is the case in *Possessed*, which at a particular moment departs radically from the logic of the classical text. In the middle of Louise's flashback account, she describes a scene in which she strikes her own stepdaughter who

then falls down a long flight of stairs. This scene, in which Louise apparently kills her stepdaughter, is situated only retrospectively and traumatically as a subjectivized scenario — the image, in effect, lies. The sequence is in no way demarcated initially as a hallucination.

Possessed is structured as Louise's flashback account of her life, told to two doctors and prompted by an injection. The audience of the film is thus represented within the text: the spectator's eye becomes that of a doctor and the spectator is given, by proxy, a medical or therapeutic role. Although the narrative is presented as subjective, the spectator always knows more than the female character, is always an accomplice of the diagnosis. The scene on the stairway just described, however, is an important exception to this rule of the narrative. The revelation after the fact that the scene is hallucinatory is jolting, for it involves the image in a deviation from the truth. The viewer of the film is drawn into Louise's illness, into her hallucination. The spectator is therefore no longer diagnosing, but becomes a part of what is diagnosed, forced into sharing her illness. In this way the filmic trajectory, at least momentarily, collapses the opposition between clarity and blurring of vision. An image which purportedly carries a generalizable truth and a guarantee of knowledge is undermined by the revelation that it is the possession not only of a single character, but of a madwoman. As Foucault points out, in the classical paradigm "madness will begin only in the act which gives the value of truth to the image" and madness is "inside the image, confiscated by it, and incapable of escaping from it" (1965:94). In a limited moment *Possessed* unveils, through the representation of a distorted female subjectivity, that collective and naturalized madness — the investment in an image — which supports the cinema as an institution.

The woman's problematic relation to the image thus accompanies a delineation of her failure or lack with respect to language. And in many ways the disturbance or development into crisis of the relation between the image and truth that she causes is potentially much more dangerous, given the epistemological framework of the classical text. The woman's deficient relation to the image disrupts filmic signification to such an extent that it is easier and safer to displace the representation of this deficient relation to the level of narrative content rather than to the organization of narration. Hence the films of the medical discourse often attribute to their female characters aberrations in seeing. As the field of the masculine medical gaze is expanded, the woman's vision is reduced. Although in the beginning of *Possessed*, extreme and extended point-of-view shots are attributed to Joan Crawford as she is wheeled into the hospital, she is contradictorily *represented* as having an empty gaze, seeing nothing, blinded by the huge lamps aimed at her by the doctors. In *Shock*, the woman is made ill by an image. Like Jimmy Stewart in

Rear Window, the female protagonist in *Shock* looks out the window when she should not, and sees what she should not have seen — a husband murdering his wife. But unlike *Rear Window*, the woman goes into shock as a result of this sight, of this image which suggests itself as a microcosm of the cinema-spectator relation. The murderer turns out to be a psychiatrist who is called in to treat the catatonic woman suffering from what she has seen. All of his efforts are directed toward making her forget the image and maintaining her in a state in which she is unable to articulate her story. In *Dark Victory*, difficulties in vision, and ultimately, blindness, are not the disease itself but major — and extremely significant — symptoms of a brain tumor. At the end of the film, the major character's heroism is delineated as her ability to mime sight, to represent herself as the subject of vision.

In *Shock*, the female protagonist is dazzled by an image; in *Dark Victory*, she points out, to her doctor-husband, a shining brightness which is only a signifier of her blindness; and in *Possessed* the woman, totally confused, is dispossessed of a focused gaze. The films of the medical discourse activate the classical paradigm wherein, as Foucault points out, madness is understood as dazzlement, an aberration of seeing: ". . . delirium and dazzlement are in a relation which constitutes the essence of madness, exactly as truth and light, in their fundamental relation, constitute classical reason" (1965:108). To be dazzled is not to be blinded by darkness but by too much light — too fully to possess the means of seeing, but to lack an object of sight. The doctor, on the other hand, as the figure of classical reason itself, always possesses not only a limited and hence controllable light, but an object to be illuminated — the woman. Over and over in these films, the scenario of a doctor training a light on a woman, illuminating her irrationality with his own reason, is repeated — in *Dark Victory, Lady in the Dark, The Cat People, Possessed, A Woman's Face*. In *The Snake Pit*, Dr. Kik demonstrates the mechanism of psychoanalysis to his female patient with a dark room and a light switch analogy: "If you know where the switch is, you don't even have to know how it works." Light is the figure of rationality in these films. But light also enables the look, the male gaze, it makes the woman specularizable. The doctor's light legitimates scopophilia and is the mechanism by means of which the films of the medical discourse insure the compatibility of rationality and desire.

THE EROTICIZATION OF THE DOCTOR-PATIENT RELATION

Desire is not absent from the doctor-patient relation. On the contrary, that relation is eroticized in many of the films. In *Dark Victory, A Woman's Face, Dark Mirror*, and *Johnny Belinda*, a benevolent and paternalistic relation of doctor to patient is almost imperceptibly transformed into an amorous alliance. As Foucault

stresses, the doctor and the patient form a "couple" in complicity against disease and madness (1965:274). It was perhaps inevitable that this complicity should be mapped onto a heterosexual relation within a classical cinema which depends so heavily upon the couple for its narrative configurations and its sense of closure. The language of medicine and the love story become interchangeable. Sexuality or the erotic relation is thus given scientific legitimation in the figure of the doctor who acts simultaneously as a moral and social guardian.

By disturbing the structure wherein the couple is medicalized, perverting its figures, *Beyond the Forest* unveils the punitive nature of illness in the classical text and in some ways acts as a negation of the medical discourse. The charitable humanitarianism of a doctor-husband is refused by a patient-wife whose sexuality and desires cannot be contained but, instead, act as a fever which ultimately consumes her. Rosa Moline (Bette Davis) rejects the benevolence of her doctor-husband, knocks the medicine out of his hand, and acts out her illness as an exaggerated narcissism. The film activates a classical city/country opposition in which Rosa's major desire — to take the train to Chicago and leave behind what she perceives as the boredom and claustrophobia of small town life — is embodied in the soundtrack's insistent repetition of the song "Chicago, Chicago." Rosa puts on her best clothes and walks to the station every day simply to *watch* the train departing for Chicago, simultaneously becoming a spectacle herself for the gaze of the townspeople. Her fascination with the train is a fascination with its phallic power to transport her to "another place."

Beyond the Forest begins with a documentary-like voice-over introducing the town, Loyalton, Wisconsin, and describing it as a factory town whose major source of income, a saw-mill, is constantly visible in the background. Noting the unrelenting image of the "hot glow of sawdust," the voice-over refers to the saw-mill's "flickering which burns through the eyelids at night if the shades aren't pulled down" (an "if" of the narration which becomes a *scene* in the narrative when Rosa, unable to sleep, is forced to remind her husband to pull down the shade). Shots of the saw-mill's flame abound in the film and the fire and the heat are associated with a repressed sexuality. Rosa's problem is that she cannot maintain the repression, cannot channel her energies into the family ("You certainly go in for mass production, don't you?" Rosa tells a woman who has just had her eighth child, and Rosa refers to her own pregnancy as a "mark of death"). She is the epitome of excessive female desire: "Think of all the things I could have," she tells her husband; in a shot of her studying a book of Accounts Receivable in her drive to get money, the only segment of her body in frame is a hand with painted nails. Rosa's usurpation of the position of

desiring subject is also evidenced by the fact that she is specified as having a "good eye" — she can shoot, both pool and guns. The film constructs a clearly legible metonymic chain connecting fire, heat, passion, desire, fever, and death. Rosa figuratively burns up, is consumed by a fever at the end of the film: unrepressed female sexuality leads to death.

Rosa's death-walk to the train at the end of the film is, in a sense, a parody of her earlier walks in which, dressed in her fanciest attire, she is clearly pleased to elicit a masculine whistle. But this time it is spectacle gone berserk — feminine spectacle deprived of a masculine spectator. Having knocked the medicine out of her husband's hand, thus forcing him to travel a large distance for more, Rosa dresses herself up, with the help of her maid, in order to catch the ten o'clock train to Chicago. Maddenned by the fever and with an unquenchable thirst, Rosa misapplies lipstick and eye-liner, producing a grotesque image of herself, and unsteadily walks toward the train station. Just short of her desired goal, there is a cut and the camera assumes a position on the other side of the tracks. The whistle blows, the train begins to pull out and Rosa's dead body, outstretched toward the train, can be seen between sets of wheels.

In *Beyond the Forest*, the woman's desire to desire is signified by a fever, in other words, a symptom — a symptom which, as in *The Cat People*, consumes and destroys her. The symptom for the woman, as sign or inscription upon her body, gives witness to a dangerous over-closeness which precludes the possibility of desire. The mechanism of symptom-formation as it is described in relation to femininity differs markedly from that attributed to masculinity. While Freud refused to define hysteria as a disease which afflicted only women (there were male hysterics as well), he nevertheless aligned it closely with femininity, producing a binary opposition of types of neuroses: "there is no doubt that hysteria has a strong affinity with femininity, just as obsessional neurosis has with masculinity. . ." (1959:69). The mechanisms for effecting repression and hence symptom formation are significantly different in the two types of illnesses. In hysteria the mechanism is that of "*conversion into somatic innervation*" (somatic compliance), while obsessional neurosis makes use of the "method of *substitution* (viz. by displacement along the lines of certain categories of associations)" (Freud 1962:175). In hysteria, in other words, the body is in compliance with the psyche while in obsessional neurosis the body can be bracketed or elided altogether by a displacement along a line of psychical representations. Foucault speaks of a theme common to hysteria and hypochondria: "Diseases of the nerves are diseases of corporeal continuity. A body too close to itself, too intimate in each of its parts, an organic space which is, in a sense, strangely constricted" (1965:154). Because desire is constituted by the opera-

tions of substitution and displacement in relation to an object, the female hysteric, her symptoms inscribed upon her body, is denied any access to a desiring subjectivity. She can only futilely and inelegantly, like Rosa Moline in *Beyond the Forest*, desire to desire.

There are thus two major aspects of hysteria which are relevant to the woman's incorporation within a medical discourse in these films; first, hysteria is characterized by the mechanism of conversion and uses the body as the space for the inscription of its signs; and secondly, it is strongly linked to narrativity, both in relation to its cause (excessive daydreaming) and its treatment (the "talking cure"). The narrativization of the female body is by no means specific to the genre of the "woman's film" in the Hollywood cinema. But in this group of films the female body is narrativized differently. The muteness which is constantly attributed to the woman is in some ways paradigmatic for the genre. For it is ultimately the symptoms of the female body which "speak," while the woman as subject of discourse is absent. The female body thus acts as a vehicle for hysterical speech. The marked ease of the metonymic slippage in these films between the woman, illness, the bed, muteness, blindness, and a medical discourse indicates yet another contradiction in the construction of a discourse which purportedly represents a female subjectivity. If the woman must be given a genre and hence a voice, the addition of a medical discourse makes it possible once again to confine female discourse to the body, to disperse her access to language across a body which now no longer finds its major function in spectacle. Yet, despecularized in its illness, that body is nevertheless interpretable, knowable, subject to a control which is no longer entirely subsumed by an erotic gaze. If interpretation is not possible, if the medical figure is incapable of relating a surface to a depth, of restoring an immediacy of vision so that the surface matches the interior, then the disease is invariably fatal.

A PATHOLOGY OF FEMALE SPECTATORSHIP

With the exception of *Dark Victory* and *Now Voyager*, the films of the medical discourse do not encourage or facilitate spectatorial identification with their diseased female protagonists. Rather, they take the form of a didactic exercise designed to produce some knowledge about the woman. If female spectatorship is constituted as an oscillation between a feminine and a masculine position,[6] the films of the medical discourse encourage the female spectator to repudiate the feminine pole and to ally herself with the one who diagnoses, the one with a medical gaze. Identification with a female character

6. See Laura Mulvey, "Afterthoughts . . . inspired by *Duel in the Sun*," *Framework* 15/16/17 (Summer 1981), p. 13, and my article, "Film and the Masquerade: Theorising the Female Spectator," *Screen* 23:3–4 (Sept./Oct. 1982), pp. 74–84.

is then allowable to the extent that she and the doctor form a "couple" as the condition of a cure. But the "properly feminine" aspect of spectatorship is not altogether lost — it is, instead, represented *within* the films across the female body in its illness.

Female spectatorship is generally understood in its alignment with other qualities culturally ascribed to the woman — in particular, an excess of emotion, sentiment, affect, empathy. That is why "women's films" are often referred to as "weepies." From this perspective, the female gaze exhibits, in contrast to male distance, a proximity to the image which is the mark of over-identification and hence, of a heightened sympathy. But the concept of sympathy is a physiological/medical one as well, of particular interest to the female subject. The meaning of "sympathy" in physiology and pathology is, the Oxford English Dictionary tells us, "a relation between two bodily organs or parts (or between two persons) such that disorder, or any condition, of the one induces a corresponding condition in the other." Sympathy connotes a process of contagion within the body, or between bodies, an instantaneous communication and affinity. In female spectatorship, it is a capitulation to the image, an over-investment in, and over-identification with, the story and its characters. Unable to negotiate the distance which is a prerequisite to desire and its displacements, the female spectator is always, in some sense, constituted as a hysteric. And yet, the films of the medical discourse, precisely by encouraging the female spectator to ally herself with the one who diagnoses, attempt to de-hystericize their spectator, to "cure" her.

By activating a therapeutic mode, the films of the medical discourse become the most fully recuperated form of the "woman's film." The therapy put into effect in relation to the spectator completely forecloses the possibility of a feminine position, freezing the oscillation between feminine and masculine poles which is characteristic of female spectatorship. The clinical eye is a most masculine eye. The female spectator, in becoming de-hystericized (distanced from the female character who suffers from the disease of femininity), must also become defeminized, must don the surgical gown. The marginal masochism which remains — linked to the pleasure of being "under the knife" — is subsumed beneath the overwhelming need to appropriate the only gaze which can see, the medical gaze which knows and can diagnose.

Nevertheless, the connotations attached to female spectatorship — a heightened sympathy, constriction and over-closeness, the immediacy of the process of contagion — are not lost in these films. Rather, these mechanisms are represented within the texts as elements of the disease. This process of narrativizing female spectatorship is parallel to the strategy discussed earlier, whereby the woman's purportedly deficient relation to the image is internalized by the

texts and thematized as the blindness — actual or metaphorical — of the female protagonist. The internalization and narrativization of female spectatorship constitutes an extremely strong process of recuperation, containing the more disruptive aspects of female spectatorship by specifying them as pathological. The illness of the female character is not accidental but essential, implicating her entire being. For this reason, her body becomes the privileged site for the representation of sympathy as an over-closeness, a disorder of contagion. In other words, the sympathy usually activated in the film/spectator relation in the woman's picture is, in these films, reflected and reinscribed in the medical mapping of the woman's body *within* the text — a mapping which ultimately owes more to the nineteenth century than to the twentieth. According to Foucault,

> Diseases of the nerves are essentially disorders of sympathy; they presuppose a state of general vigilance in the nervous system which makes each organ susceptible of entering into sympathy with any other. . . . The entire female body is riddled by obscure but strangely direct paths of sympathy; it is always in an immediate complicity with itself, to the point of forming a kind of absolutely privileged site for the sympathies; from one extremity of its organic space to another, it encloses a perpetual possibility of hysteria (1965: 153–154).

In hysteria, the paradigmatic female disease, the body is in sympathy with the psyche to the extent that there is no differentiation between them. Illness affects and defines her whole being. The ease with which the woman slips into the role of patient is certainly linked to the fact that the doctor exercises an automatic power and mastery in the relation, which is only a hyperbolization of the socially acceptable "norm" of the heterosexual alliance. The doctor-patient relation is a quite specific one, however, which unrelentingly draws together power, knowledge, the body and the psyche in the context of an institution. Therein lies its force in convincing the woman that her way of looking is ill.

REFERENCES

Althusser, L. and E. Balibar, 1970 (1968). *Reading Capital* (London: New Left Books).
Chesler, P., 1972. *Women and Madness* (New York: Avon Books).
Foucault, M., 1965 (1961). *Madness and Civilization*, trans. Richard Howard (New York: Random House).
　　1973 (1963) *The Birth of the Clinic: An Archaeology of Medical Perception*, trans. A.M. Sheridan Smith (New York: Pantheon).
Freud, S., 1959. *Inhibitions, Symptoms and Anxiety*, trans. Alix Strachey (New York: W.W. Norton & Company).
　　1962 (1896) "A Case of Chronic Paranoia," in: James Strachey et al., eds., *The Standard Edition of the Complete Psychological Works*, vol. III (London: The Hogarth Press and the Institute of Psychoanalysis), 174–189.
　　1963a (1965) *Dora: An Analysis of a Case of Hysteria*, ed. Philip Rieff (New York: Collier Books).

1963b (1914) "On Narcissism: An Introduction," in: *General Psychology Theory*, ed. Philip Rieff (New York: Collier Books), 56—82.

Freud, S. and J. Breuer, 1966 (1895). *Studies on Hysteria*, trans. and ed., James Strachey (New York: Avon Books).

MacCabe, C., 1974. "Realism and the Cinema: Notes on some Brechtian theses," *Screen* 15:2, 7—27.

Metz, C., 1975. "The Imaginary Signifier," *Screen* 16:2, 14—76.

Mulvey, L., 1975. "Visual Pleasure and Narrative Cinema," *Screen* 16:3, 6—18.

Nowell-Smith, G., 1977. "Minnelli and Melodrama," *Screen* 18:2, 113—118.

Schneider, I., 1977. "Images of the Mind: Psychiatry in the Commercial Film," *American Journal of Psychiatry* 134:6.

Weber, S., 1982. *The Legend of Freud* (Minneapolis: University of Minnesota Press).

INTERPRETING ANOREXIA NERVOSA

NOELLE CASKEY

Anorexia nervosa, a disease largely limited to females, has been in evidence in Western society since the seventeenth century but its increasing incidence has brought it to the attention of a wider group of theorists — including feminists and Jungians — than was previously the case. In this essay, varying views of anorexia will be examined — most notably those of Hilde Bruch, Salvador Minuchin and Peter Dally and Joan Gomez — in an attempt to detect an underlying dynamic that explains the distinctive features of the disease in relation to each other and to a particular family configuration.

Each of the researchers mentioned above focuses on a particular aspect of the disease: Bruch looks at disturbances in the anorexic's experience of her inner states, while Minuchin examines the anorexic's family as a system, and Dally and Gomez consider the disease from a developmental standpoint. Most often psychoanalytic theory on anorexia, which treats the disease as an oral impregnation phobia, has provided the framework through which researchers have considered the problem. However, psychoanalytic theory, with its emphasis on the anorexic's fear of sexual maturity (e.g. Szyrynski 1973; cited in Boskind-Lodahl 1976) has largely ignored both cultural factors and the accompanying cognitive/intellectual disturbances that distinguish *anorexia nervosa*. It will be suggested below that Jungian theory offers a way to reconcile these differing perspectives on the disease in such a way that the features focused on by different writers are accounted for and placed in relation to each other.

FAT IS FEMININE

Our consideration of *anorexia nervosa* must begin with a consideration of the cultural and biological interrelationship of fat and femininity, since anorexia is, above all else, a phobic fear of fat. Amenorrhea, the suppression of menstruation, another widely cited distinguishing feature of anorexia (as are the cognitive and visual distortions

discussed below) is often mentioned in support of the psychoanalytic view of the disease, but because of the way the female physiognomy works, body fat and menstruation are intimately connected.

Before considering the anorexic's fear of fat and what it means, let us take a moment to explore the special role played by body fat in female sexual development. To begin with, the accumulation of body fat in certain areas of the body is a precondition for menarche. Until a critical body weight is reached, menstruation will not begin, and, as anorexics well know, menstruation may be suppressed by once again bringing body weight below this critical point. The accumulation of fat in the hips, thighs, and breasts in prepuberty or early adolescence is not only a necessary condition for first menstruation, it is also a signal that this process is about to begin. Thus, biologically, there is an association between the development of fatty deposits (i.e. the development of secondary sexual characteristics) and the onset of menstruation, an association that comes to have critical significance for the anorexic population.

However, this association between female sexuality and fat in certain areas of the body is not limited to early puberty and the onset of menstruation. The intimate interplay between fat cells and female hormones continues throughout a woman's life, and, for the most part, lies beyond the bounds of her own control. During pregnancy, for example, there is an *unexplained* 12 to 15 pound gain in body weight. Research cited by Anne Scott Beller (1977:85) shows that this is invariant for both diet and culture: pregnant Indian tea pickers show this weight gain without any change in diet or activity.

It is well known that fat constitutes a higher percentage of body weight for females than for males. Some of this is the layer of subcutaneous fat which men lack, and which research suggests has some survival value for women as well as for the children they carry. Furthermore, the *distribution* of body fat is also controlled by hormones, with hips, thighs and upper arms predisposed to serve as collectors of excess calories. (Think of Valerie Harper as Rhoda in the TV series of the same name saying, "I don't know why I'm eating these brownies when I could just apply them directly to my hips.")

From sexual maturation to the end of life, body fat, by its relation to female hormones, is essentially resistant to the conscious wishes of its owner. And it is a direct consequence of her sexuality that she is faced with this "problem." Fat and femininity cannot be separated physiologically. But not all women in all cultures show equal degrees of fat accumulation, which suggests that culture itself imposes some regulation on this process. In cultures where women and men are more nearly on a parity in terms of work and diet (i.e., in some agrarian cultures of Southeast Asia) they are more nearly equivalent in body size than they are in countries where sharp distinctions in

men's and women's work activity are maintained. In these — predominantly Western — cultures, the difference in relative size between women and men becomes much more pronounced; there is, in addition, greater variation in body size within the female population (Beller 1977).

Generally, this somatotypically differentiated population coexists with an economic and social structure in which men function as primary wage-earners or laborers, and women function primarily as child-rearers and nurturers. Thus, in these cultures, fat becomes an indicator of division of labor, and in those cultures in which significant differences in status are attached to wage-earning versus child-rearing, this sexually determined body difference becomes an indicator of social status as well.

The presence or absence of fat, then, and its perceived status in a given culture seem to vary in response to economic and social factors as well as biological ones. Beller and Bruch are both quick to point out that in subsistence level cultures, fat had high value as an indicator of prosperity and as a guarantee for the birth and survival of children. As late as the nineteenth century, abundance of female flesh was valued in Western culture as aesthetically pleasing. One has only to look at the glowing nudes of Renoir with their loving auditions of women's bodies to realize that something has drastically altered our perception of female bodies since his time.

The incidence of anorexia has risen sharply since the end of World War II and it is nowhere more prominent than in the middle and upper middle classes of the most technologically advanced nations. It does not take much imagination to see a relationship between this fact and changes in the economic and sexual status of women. As the level of work activity expected of women comes closer to that expected of men, Beller has suggested, body shapes change accordingly. From the point of view of the potentially anorexic population, this has two consequences. According to Bruch (1978:viii-ix), "Growing girls can experience this liberation as a demand and feel that they *have* to do something outstanding. Many of my patients have expressed the feeling [. . .] that there were too many choices and they had been afraid of not choosing correctly."

These and other remarks Bruch cites (1978) make explicit the perceived "male" nature of the ideal toward which these young women are striving. And this ideal is not limited to activity and performance; it holds especially for the model of female physical beauty which today is one of slimness and proto-androgynous athletic activity. In *The Obsession: Reflections on the Tyranny of Slenderness* (1981), Kim Chernin is explicit about the underlying image of male beauty sought by women who worry about their weight:

I reverted to a fantasy about my body's transformation from this state of im-
perfection to a consummate loveliness, the flesh trimmed away, stomach flat,
thighs like those of the adolescent runner on the back slopes of the fire trail,
a boy of fifteen or sixteen, running along there one evening in a pair of red
trunks, stripped to the waist, gleaming with sweat and suntan oil, his muscles
stretching and relaxing, as if he'd been sent out there to model for me a vision
of everything I was not and could never be. I don't know how many times
this fantasy of transformation had occupied me before, but this time it ended
with a sudden eruption of awareness, for I had observed the fact that the
emotions which prompted it were a bitter contempt for the feminine nature
of my own body. The sense of fullness and swelling, of curves and softness,
the awareness of plenitude and abundance, which filled me with disgust and
alarm, were actually the qualities of a woman's body (pp. 19-20).

So fat means several things. It means femininity in the purely
physiological sense, in that it is an inevitable accompaniment of
sexual development and maturation and that it contours the female
body in characteristic patterns which differentiate it from a male
body. But in addition to that, fat by virtue of its (current)
association with lower socio-economic groups and its variability as a
marker distinguishing male and female economic and sexual functions,
has come to signify "feminine" status in a way that is perceived as
negative, not just by anorexics, but by the population at large. Thus,
in taking their fear of fat to life-threatening extremes, anorexics are
simply obeying society's dictates in a more drastic manner than the
rest of us.

INSIDE/OUTSIDE: IMAGE DEPENDENCE
Viewed in this way, one might well turn the question on its head and
ask not, "Why do so many women become anorexic these days?"
but, "Why are there women who do *not* become anorexic?" Given
the general (and increasing) social pressure against fat as a kind of
moral and economic disgrace, why is *everyone* not anorexic?

One way in which to think about the answer to that question is to
consider the model of anorexia developed in part by Bruch (1978),
and more fully by Minuchin (1978), of anorexia as a *communicative*
disorder.

In *The Golden Cage* (1978:35), Bruch speaks of the "confusion of
pronouns" in the families of anorexic patients. "It is rare that any
one member speaks in direct terms about his or her own ideas and
feelings. Each one seems to know what the other feels and truly
means, at the same time disqualifying what the other has said."

This theme of confusion of boundaries plays a large part in the
theories of both Bruch and Minuchin. Bruch (1973), struck by her
patients' willingness to undergo an ordeal that most people would do
anything to avoid, hypothesized that anorexics must have a
fundamentally obscured inner sense of their own physiological states
of hunger or satiety, and suggested that inappropriateness of early
parental response to the anorexic patient was a possible explanation.

Put at its simplest anorexics have from an early age learned to be more responsive to others' perceptions of their needs than to the needs themselves.

Minuchin, on the other hand, approaches the problem from the point of view of family subsystems. The communication style in which the feelings of individual members of a family system are seldom communicated directly by or to the individuals involved, exemplifies some of the traits he found typical of anorexic families — notably enmeshment and over-protectiveness. "She takes my voice," says the brother of anorexic Deborah Kaplan, speaking of his mother (Minuchin 1978:145).

The "confusion of pronouns" mentioned by Bruch is evident here and we may consider that it has a twofold effect on the anorexic. Firstly, it helps to obscure her own inner states from herself, so that she is unable to know, unless she is told by an outside source, what her own feelings are. Minuchin cites a daughter whose mother had told her that "I'm allowed to feel how I want" (Minuchin 1978:72).

Whether the anorexic's alienation from bodily sensation is the result of "inappropriate response," enmeshed communication, or some predisposition within the anorexic herself — and this has not been ruled out — is irrelevant when one considers the results. The anorexic grows up viewing her body as a reflected image of the desires of others. It is not *herself*; it is something exterior and foreign, and at the same time more relevant to others than to herself. Minuchin (1978:59) speaks of the "vigilance" anorexics develop over their own actions; they experience themselves as observers rather than participants in their own physical being.

The anorexic perceives her body and its appetites as imposing alien necessities against which she rebels, while at the same time experiencing the desires of others *towards her* as indistinguishable from her own images of desire. Thus, certain patients of Bruch (1978) carefully taught themselves to want the things they knew their parents wanted to give them. Origin and direction of impulse are fundamentally confused, and it is partly to retire from this confusion that anorexics take such radical steps of shutting things out or of closing down the system.

One answer, then, to the question of why some women become anorexic and others do not lies in the peculiar oversensitivity of anorexics to the wishes of those around them. If they are unable to distinguish between their own desires and the perceived wishes of their parents, how much more vulnerable do they become to the messages of the culture at large concerning both achievement and beauty as they grow older. The conditions of enmeshment under which the anorexic attempts to mature provide a fertile environment for the development of a disease which — ostensibly — puts a cultural ideal ahead of physical existence.

But this physical disconnectedness has social consequences as well, particularly in adolescence. As Bruch says (1978:39), anorexics

> grow up confused in their concepts about the body and its functions and deficient in their sense of identity, autonomy and control. In many ways they feel and behave as if they had no independent rights, that neither their body nor their actions are self-directed, or not even their own.

Because the family system denies the separation of individual members, it perpetuates itself by preventing the development of autonomy. Anorexia is in many ways a perfect response to such a system — by refusing to "take anything in" the anorexic is at once shutting down the input she receives from outside while at the same time imposing her own will on the other members of the family. Because of their helpless hyperobedience to the wishes of others, anorexics typically consider themselves powerless within the family structure. Nonetheless, there is considerable evidence to suggest that they wield inappropriate power in the family. "The anorectic child is frequently caught in transactions in which she is regulated to respond either like a very young child, or like an adult on a par with her parents" (Minuchin 1978:101). He quotes from a recorded interview in which a young anorexic explains to her parents that their problems are caused by her father's condescension to her mother and her mother's willingness to put up with it; Minuchin comments wrily in the margin that this fourteen year old sounds more like a therapist than like the couple's daughter. Bruch (1973) mentions one patient whose demands resulted in such a bizarre reorganization of family life that her parents ultimately fled to another home and hid from her.

Minuchin also notes the frequency with which anorexic children intervene in the spouse subsystem, and the frequency of child-parent coalitions (triangulation) against one parent in these families. Under these conditions, anorexics vacillate between hypermaturity and infantilism.

The predisposition of adolescents to become anorexic makes a great deal of sense viewed in this context. Psychoanalytic writing has emphasized the sexual fears of the anorexic, forgetting that adolescence is a time not only of sexual development, but of psycho-social development as well. Often anorexia develops when a bid for independence on the part of the child has failed.

Dally and Gomez (1979) found instances of what they called acting out (shouting, rude behavior, etc.) in 20% of their primary anorexia patients in the year preceding onset of the disease. Given the extreme values placed on family harmony in anorexic families one easily imagines the shock, hysteria and outrage with which such displays would be greeted. One can also imagine the anorexic's inability to withstand the pressure of familial criticism and the consequent shift of strategy for independence, i.e., the disease. That

anorexia is a libertarian gesture, a demand for freedom, is also suggested by an interesting relationship between anorexic eating patterns and primitive eating patterns. When anorexics eat what they *do* eat, they eat in small odd amounts and at irregular intervals throughout the day(and the night as well, in many cases — anorexia is apt to induce insomnia). Bruch (1973) points out that this eating behavior resembles the food gathering and eating patterns of pre-agricultural tribes, which existed without set mealtimes or a hierarchical family structure; Bruch suggests that anorexics are in part rejecting the modern patriarchal structure when they "revert" to patterns of an earlier, less power-structured organization.

Minuchin, too, notes an attempt to outmaneuver family power in anorexia. "The child needs opportunities to learn how to accommodate to positions when she has less power and to act autonomously in situations of more power" (1978:100-101), and goes on to mention the "difficulties in dealing with hierarchical organization of anorectic families."

For those who have been as obedient to the will of others as anorexics have been all their lives, a wonderful sense of release and power comes through their disease. Refusing to eat is supremely defiant and supremely obedient at the same time. All of the recovered anorexics interviewed by Bruch in *The Golden Cage* express satisfaction with what they gained from the illness, although the illness itself has come to horrify most of them. In *The Art of Starvation*, Sheila MacLeod (1981) is explicit about the sense of identity and autonomy she gained from her anorexia, and the necessity she felt at that time for precisely those kinds of inner strength. To refuse, literally, to "take in" from the environment allows many anorexics the opportunity to take control over their own bodies for the first time.

THOUGHT ADDICTION, INNER VOICES AND PSYCHIC INCEST

Anorexia nervosa is perhaps most interesting when viewed as a thought disorder. This is where the communicative nature of the disease becomes most apparent, where the disease process itself goes beyond the simple question of eating versus non-eating, into a symbolic realm of transactions that depend for their intelligibility on the untangling of a metaphoric web.

This web involves the anorexic, her body, and the society of which she is a part, and to which she is trying to communicate something by this use — or misuse — of her body. Furthermore, the specific cognitive distortions accompanying anorexia, with their shift of metaphoric level, can be shown to result from a family configuration implicit in the descriptions of the researchers we have been examining.

To begin with, anorexia involves highly elaborated visual distortion.

Studies cited by Bruch (1973) and other researchers confirm the anorexic's inability to "see" her body as it truly is. A ninety-seven pound skeleton can look into the mirror and see "fat"; this delusion persists even in response to such theoretically objective representations as photographs.

The visual distortion, Bruch feels, results in part from the physiological concomitants of starvation and is corrected by weight gain and proper readjustment of hormone levels, but there is some suggestion that the cognitive distortions accompanying anorexia become themselves pleasurable to anorexics. (See, for example, Bruch, 1978:17, discussed more fully below.)

Some evidence suggests that *anorexia nervosa* is a response to intellectual effort and the social context in which it takes place. Dally and Gomez (1979) show us that sexual issues are not nearly as often the trigger for the onset of anorexia as are issues of academic achievement. Many of the patients in their older age groups (11-15) develop the disease in conjunction with the placement exams of the English school system. Observers agree on the high value the families of anorexics place on academic achievement; quite often it is the patients' fathers who have this expectation of them and make it explicit.

Future anorexics are generally extremely conscientious students who earn nothing but praise from their teachers for high marks and good behavior, but when they reach the upper levels, where more is demanded of them and their performance has more consequences, they bog down and find themselves unable to continue. Sheila MacLeod (1981) gives an excellent description of her gradual withdrawal from home and school life as a response to her fears of failing the university entrance examinations. And Minuchin remarks: "A child growing up in an extremely enmeshed system learns to subordinate the self. Her expectation from a goal-directed activity, such as studying or learning a skill, is therefore not competence, but approval. The reward is not knowledge, but love" (1978:59).

Anorexia appears in response to academic hurdles because the anorexic, in spite of her apparently formidable list of academic achievements, is in fact someone who is unable to think very independently. Bruch (1978:45-46) notes: "Notwithstanding the enormous amount of knowledge they have absorbed . . . anorexics' conceptual functioning seems to be arrested at an early level." In fact, Bruch is ready to identify exactly the stage it is, the stage "Piaget called . . . preconceptual or concrete operations; it is also called the period of egocentricity and is characterized by concepts of magical effectiveness . . . the development of the characteristic adolescent phase that involves the capacity for formal operations with the ability for abstract thinking and independent evaluation is deficient in them, or even completely absent."

This stage of thinking determines two aspects of the anorexic's experience. Anorexics think about food in certain highly specified ways. Most of them, for example, are extremely sophisticated in their knowledge of nutrition. They are inveterate calorie counters. Thus, they think about food in highly abstract and symbolic terms which almost come to replace the act of eating itself. It should be emphasized here that anorexics think about food almost constantly; many are deeply involved in family responsibilities concerning cooking and eating.

Once food is inside the anorexic, however, her attitude toward it undergoes a considerable change. It is no longer a matter of numbers or chemical composition; suddenly food is metamorphosed into a dark dragging force that threatens to take over the anorexic, to sink her under suffocating waves of unwanted flesh. To anorexics, food seems to linger ominously in the body; it has a living presence inside them which overpowers them and which they resent, whence their frequent overuse of laxatives and their manic exercise habits.

We see here both consequences of arrested development at this stage of cognitive functioning the substitution of a symbol for what it symbolizes (i.e., a disposition to regard the metaphoric as concrete) in the anorexic's attitude toward food — and everything else — and a predisposition to attribute primitive magical powers either to herself or to objects inside or outside of her.

This cognitive retardation has a willed quality. In the transcripts of his family interviews, Minuchin periodically notes in the margins that the anorexic patient has created a distraction from the issue of her food intake by directing the conversation with her parents onto an extremely concrete level. When they say, "Sweetheart, you have to eat your lunch if you're going to live," the anorexic replies, "But you said I didn't have to eat this hotdog," thus focusing attention on a specific instance of what she will not eat, and away from herself and the more general problem. This bait-and-switch tactic works with the anorexic's parents; in the struggle over "this hotdog," the larger issue is forgotten. The anorexic continues to maintain control over her family by focusing attention on the letter of the law at the expense of its spirit.

Perhaps what makes anorexia so attractive to people suffering from this combination of insecurity, need for achievement and need for approval (anorexics, as Minuchin pointed out above, acquire knowledge for interpersonal rewards, rather than for inner mastery) is this have-it-both-ways quality. Anorexics manage not to eat their cake and have it too. And it is precisely by "obeying" what society and her parents appear to be asking of her that the anorexic draws attention to her problem and forces those around her to acknowledge it and move in response to her will. It is an extremely autocratic gesture, intense in its impact on those surrounding the sufferer.

It is the literal-mindedness of anorexia to take "the body" as a synonym for "the self," and to try to live in the world through a manipulation of "the body," particularly as it is reflected to the anorexic by the perceived wishes of others. Anorexia is the cultivation of a specific image *as an image* — it is a purely artificial creation and that is why it is admired. Will alone produces it and maintains it against considerable physical odds.

Here, as in so many other instances, anorexia creates a paradoxical way of solving certain problems. We have mentioned the anorexic's inability to make a certain set of abstractions, to formulate theory from data, to think independently of the people for whom she is thinking, and so on. This type of thinking creates the predisposition to view the abstract entity of "the self" concretely, as a body, but it also stimulates the anorexic's other impulse, the impulse to escape the body entirely as a way of escaping this funnel of alien desires.

While the anorexic is expressing her relationship to the world through her body, while she is denying it all but the most minimal amounts of food and going to grotesque extremes to exercise it, she is having an inner experience of herself as pure echoing mind. Bruch quotes the experience of a patient called Gertrude:

> My body became the *visual symbol* of pure ascetic and aesthetics, of being sort of untouchable in terms of criticism. Everything became very intense and very intellectual, but absolutely untouchable (1978:17).

Anorexic patients speak of a heightened sense of touch and hearing, of a sense that the world is "gloriously, or unbearably, vivid" (Bruch 1978:13), and of the loss of sense of time and reality.

In part, these experiences can be attributed to the physiological consequences of starvation, but they have an addictive quality. It is as though anorexics choose this manner of achieving a state of permanent ecstasy. Anorexics live in the desert of honey and locusts, perpetually listening to the voice of St. John.

> Being hungry has the same effect as a drug, and you feel outside your body. You are truly beside yourself — and then you are in a different state of consciousness and you can undergo pain without reacting (Bruch 1978:17).

The ecstatic nature of the anorexia experience is described by Bruch's patients, who sound retrospectively as though they believed they had been bewitched. None felt she could control the process; at a certain critical point during the process of weight loss, something at once alien and interior to them took over. Henceforth they entered another world, a world in which a constant interior preoccupation with food, frantic continuous exercise and refusal to engage in the social customs of eating kept them in almost total isolation from other people.

Most of the patients Bruch quotes experience that alien something in themselves which imposes this new world order as male.

...sooner or later a remark about the other self slips out, whether it is 'a dictator who dominates me' or 'a ghost who surrounds me' or 'the little man who objects when I eat.' Usually this secret but powerful part of the self is experienced as a personification of everything that they have tried to hide or deny as not approved by themselves and others. When they define this separate aspect, this separate person seems always to be a male . . . they dreamed of doing well in areas considered more respected and worthwhile because they were 'masculine.' Their overslim appearance, their remarkable athletic performances, with perseverance to the point of exhaustion, give them the proud conviction of being as good as a man and keep 'the little man,' 'evil spirit,' or some other magic force from tormenting them with guilt and shame (1978:55-56).

It is this echoing inner state, dominated by voices and by the "evil man," that provides the clue pointing us toward a new interpretation of *anorexia nervosa*, one that considers the disease as a result of a peculiar combination of forces that we may designate as psychic incest. This concept, based as we shall see on elements of Jungian theory, allows us to reconcile the differing views of *anorexia nervosa* we have encountered thus far.[1]

Most often, the idea of incest suggests a direct sexual relationship. But if we introduce here the Jungian concept of the *animus*, as the contrasexual inner element of a woman which may be projected out, it may be possible to see that incest can involve a highly invested relationship with this masculine figure — in Jungian terms the carrier of the woman's Logos — which is both an inner figure and is projected onto the father.

If we look back at the works of authors previously cited, we note how many indications there are that anorexics are bound in some special relationship to their fathers. In the triangulated families Minuchin describes, for example, the girl is most often allied *against* her mother. But as Bruch (1978) and Dally and Gomez (1979) suggest, the relationship with the father seems to involve a special emphasis on academic achievement and the life of the mind, with the resultant loss of intellectual independence noted above.

That anorexics are caught in a relationship to the animus as it is projected onto the father (cf. the remarks of Bruch's patients about "the little man") is suggested both by the special quality of the bond between anorexics and their fathers and by the emphasis on academic achievement — Logos . Woodman (1980) goes further and argues that such relationships involve a highly specific form of the animus, the *puer aeternus*. In Woodman's view, anorexia involves a rejection of the mother and the mother's body in favor of a delusional relationship with this pure male adolescent spirit who has all the spiritual attributes of divine masculine youth.[2]

1. I would like to acknowledge the contribution of Dr. Byron Lambie of El Cerrito, California, with whom I discussed some of these concepts.
2. From this perspective, the quotation from Chernin cited above seems to offer striking confirmation of the *puer* as the anorexic ideal.

Looked at from this perspective, the concept of incest may be extended from a physically expressed relationship to one of eroticized spiritual union with the *puer*. But while this spiritual union provides the feeling of purity that anorexics find so enticing, it has serious consequences for the anorexic's social and intellectual growth, as well as for her sexual development.

This occurs because the *puer*, the incarnation of intellectual and spiritual purity and high aspirations, is balanced by its opposite, the *senex*, the negative old man. Too great an emphasis on one pole, in Jungian theory, inevitably constellates the opposite. Thus, the anorexic in her attempt to find unity with the pure and holy *puer* finds herself caught between *puer* and *senex*. In order to remain pure and youthful enough to meet the standards of the *puer*, the anorexic must purify her body to the point where sexual development stops or is reversed. At the same time, she must withdraw from the outer world (with consequent loss of autonomy and social development, as noted by Minuchin) in order to avoid its contamination. This tendency to withdraw is reinforced by the devastating inner criticism of the *senex*, whose standards of "badness" are as exaggerated and absolute as are the standards of the *puer* for "goodness."

Acccording to Woodman (1980), the fathers of anorexics are most often *puers* who seek continued contact with the unconscious via idealized relationships with their daughters, on whom they project their feminine *anima* figure. Such men turn to their daughters in preference to their wives, whose maternal qualities they reject. But as the *senex* remains unintegrated in the father, the daughter remains susceptible to the negative pull of this pole of the animus. Further, Woodman suggests that the mother herself often has an over-developed relationship to the animus and a lack of relatedness to her own body and the bodies of those in her care. This kind of mother is apt to impose rigid rules in areas in which rules are inappropriate or impossible to obey (i.e., body functions). In addition to recalling Bruch's remarks (1973) about the "inappropriate quality" of maternal care, such mothering leaves a vacuum where the delusional spiritualized relationship with the father can develop without mediation via rootedness in the female body.

Of course this incestuous identification with the *puer* form of the animus is not limited to anorexics. A growing body of evidence suggests that it is a factor in alcoholism and other forms of drug dependencies as well, and that these addictions are to some extent interchangeable. In order for the symptoms to take on the particular form of refusing to eat, certain other factors must be present as well.

Dally and Gomez (1979) found two common elements in the background of their patients — a family emphasis on matters of food and diet, and a significant degree of personality disturbance in one or both parents. (Visits to a psychiatric clinic were the criteria used to

decide how much disturbance was significant — alcoholism and depression were the problems for which parents of anorexics most frequently sought help.) It is also striking that many families with one anorexic child often have another child near the same condition. Conversely, it is equally common for an anorexic to have an overweight sibling who has been looked down on for having a weight problem. Dally and Gomez (1979) point out the unforgivingly fierce quality of sibling competition in these families. In addition to an incestuous relationship with the animus then, many significant family background elements predispose a given child to become anorexic. Nonetheless, anorexia has significant advantages as a way of expressing animus-relatedness. It intensifies the alienation its victims already feel from their own bodies and makes such willed manipulation of the instincts a precondition for salvation.

Women who are locked into this relationship achieve illusory spiritual and intellectual perfection at the expense of relatedness to their female bodies. According to Ulanov (1979), in women who find themselves overly focused on food and eating, the animus in some sense has *replaced* the ego as the mediating force between the two great forces of instinct and will.

The anorexic's rejection of fat is a rejection of the sexually mature feminine as represented by the maternal image. It is unity with the father against the mother and all that the mother represents. For such a woman subsequently to reach true feminine maturity involves, according to Woodman, an *opus contra naturam*, a conscious working through of aspects of the feminine that cultural and family factors have prohibited from instinctual expression.

THE VOICE OF PERSEPHONE

Having talked about anorexia as the result of a peculiar kind of incest, incest which involves a psychic relationship rather than a physical one, we can turn back briefly to the Freudian interpretation of anorexia as primarily a sexual phenomenon, an oral impregnation phobia to be precise.

Here again the paradoxical double nature of anorexia becomes apparent. For if anorexia results from a psychically incestuous relationship with the father, it is simultaneously an expression of that relationship (via its shift into the magical spiritual world of the *puer*) and a defense against it, an attempt to escape from domination. Sexual development, split off from unity with spiritual and affective life, may return here in the form of what is warded off. If impregnation is feared, it can be argued that what anorexics fear most is impregnation *by the father*, which would make their imprisonment by him complete. Thus the sexual instincts are kept in abeyance as a way to avoid literalizing the incest and making it pervasive.

Further, if we look at *anorexia nervosa* as a communication, as a gesture intended for effect (and how could it *not* be, given the anorexic's fascination with image and reflection?), then we must ask who is its intended audience. Who is to hear what is being said? Who is to respond to this gesture of mingled defiance and obedience, of captivity and escape, of independence and helplessness?

The empirical answer to this question is that anorexia is of far greater interest to women than it is to men. Many women (Chernin 1981) respond to anorexia with envy; some feel its romantic fascination, its overtones of consumption and the love death. Others look on anorexia with horror and pity. But in any case, women's responses to anorexia have an emotional intensity absent from the responses of men.

And here, perhaps, we can see anorexia's main function. If the disease results from an incestuous entanglement with the father, then we can also see it as a cry to the mother for help. The image of Persephone lost in the grip of a dark man in the underworld, unable to eat and awaiting rescue by her mother, seems apposite here. Certainly nothing is as likely to bring a sudden access of maternal attention as a refusal to eat.

Maternal attention is sought partly with the aim of resolving father/daughter incest. If the mother returns to the triangle and takes up her rightful place with the father, then the daughter is relieved of the guilt of this association and is furthermore free to develop independently of her family, to become sexually mature for the first time. When Minuchin "strengthens the spouse subsystem," he is unwittingly forcing the parents to resume sexual partnership and free the daughter from her role as the father's lover. Concomitant with this is a quest for a continuity of identity between mother and daughter. (Minuchin talks about strengthening the mother as a model of competence for the daughter.) By focusing maternal attention on herself in this dramatic way, the daughter is also asking her mother to "feed" her some acceptable solution to the problem of being a woman.

That anorexia can be resolved by movement toward the mature feminine is confirmed by the moment recorded in MacLeod (1981) when she overcame her nausea and inability to eat because her mother had handed her a beautifully polished plum. Conversely, anorexia is maintained in a culture which treats the sexually mature female body as a messy and willful inconvenience: anorexic attempts to achieve spiritual rightness by turning away from the body result in cutting the anorexic off from a physically grounded sense of her own integrity and her own spiritual worth.

The illusion of perfection is the greatest lure offered by the *puer*, but this becomes fatally attractive only when the desire for "goodness" seems incompatible with having a female body. Wood-

man's patients seem to find their way out of their food-related illnesses through a search for the spiritual qualities unique to women. According to Woodman, both anorexia and obesity express a literal minded shift of spiritual aspirations onto food; she notes that bingers most frequently overindulge in foods containing grain, milk or honey, all sacred to Demeter, while anorexics abstain to maintain their purity.

Anorexia, then, calls attention to the plight of its sufferer in a way that is intended to bring resolution to the problem. In its misguided and paradoxical way, anorexia is a search for autonomy, independence, and spiritual growth.

REFERENCES

Beller, Anne Scott, 1977. *Fat and Thin: A Natural History of Obesity* (New York: Farrar, Straus and Giroux).

Boskind-Lodahl, Marlene, 1976. "Cinderella's Stepsisters: A Feminist Perspective on Anorexia Nervosa," *Signs* 2:2 (Winter), 342-356.

Bruch, Hilde, 1973. *Eating Disorders* (New York: Basic Books).

1978 *The Golden Cage* (Harvard UP).

Chernin, Kim, 1981. *The Obsession: Reflections on the Tyranny of Slenderness* (New York: Harper and Row).

Dally, Peter and Joan Gomez, 1979. *Anorexia Nervosa* (London: Heinemann Medical).

MacLeod, Sheila, 1981. *The Art of Starvation* (New York: Schocken).

Minuchin, Salvador, et al., 1978. *Psychosomatic Families: Anorexia Nervosa in Context* (Harvard UP).

Szyrinski, V., 1973. "Anorexia Nervosa and Psychotherapy," *American Journal of Psychotherapy* 27:2, 492-505.

Ulanov, Ann Bedford, 1979. "Fatness and the Female," *Psychological Perspectives* 10:1, 18-36.

Woodman, Marion, 1980. *The Owl Was a Baker's Daughter* (Toronto: Inner City Books).

IMAGES

THE VIRGIN'S ONE BARE BREAST:
FEMALE NUDITY AND RELIGIOUS MEANING
IN TUSCAN EARLY RENAISSANCE CULTURE

MARGARET R. MILES

> A sign is a thing which causes us to think of something beyond the impression
> the thing itself makes upon the senses.
>
> Saint Augustine, *De doctrina christiana* II.1.1

Some of the most puzzling historical images and the most difficult to
interpret are those in which nude human bodies or nude parts of bodies
play a central role in the visual communication. As Julia Kristeva has
remarked, "Significance is inherent in the human body" (1982:10). Yet
no pictorial subject is more determined by a complex web of cultural
interests than visual narrations of the female body; such images are not
susceptible to simple naturalistic interpretation. Moreover, with no other
depicted object is it less safe to assume a continuity or even a similarity
of meaning between its original viewers and the modern interpreter. I
will examine here one historical example of a complex exchange of com-
munications related to visual images of a woman's partially denuded body.

The Virgin/Mother Mary is repeatedly shown in fourteenth-century
Tuscan paintings with one breast exposed. Although this is not a
completely new image, the visual emphasis on the breast that nourished
the infant Christ — and, by identification with him, all Christians —
is startling. Mary is shown nursing or preparing to nurse Christ (Fig. 1),
or, as in a fresco by an anonymous Florentine painter (Fig. 2), cupping
in her hand one breast which she shows to the adult Christ, while pointing
to a group of sinners, huddled at her feet, for whose salvation she pleads.
The inscription reads: "Dearest son, because of the milk I gave you,
have mercy on them." Depictions of Mary with an exposed breast are
numerous from the beginning of the trecento and through the next three
hundred years; it was a popular subject, frequently placed in churches
and monasteries and painted on small devotional objects for private use.[1]

Interpretation of these visual images requires both knowledge of their
cultural context and methodological sophistication. Before we begin to

1. Victor Lasareff posits a Byzantine origin for the *Virgo lactans* image that came into frequent
use in Italy in the Dugento through Sicily and Venice. The "once severe icon theme" changed
dramatically during the thirteenth century to more and more naturalistic treatment, a "completely
genre conception" (1938:35-36).

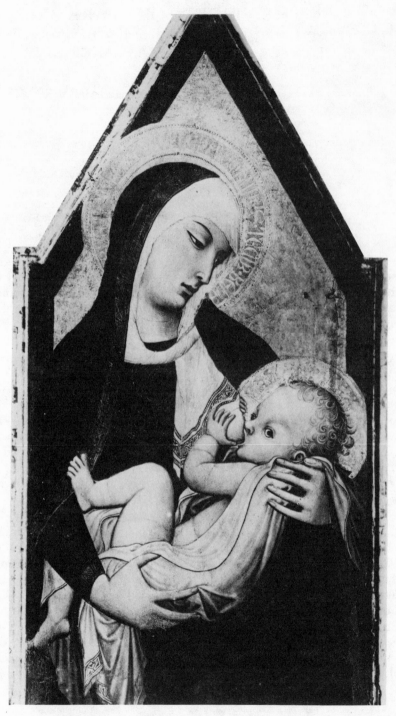

FIGURE 1 Ambrogio Lorenzetti, *Madonna del Latte*.

FIGURE 2 Florentine painter, unknown, early fifteenth century, *The Intercession of Christ and the Virgin.*

examine the various religious and social resonances which the Virgin's
one bare breast was likely to have had in early Renaissance Tuscan culture,
let us make explicit some methodological assumptions. First, a visual
image repeatedly depicted may be assumed to have popular attraction
for people of its original culture. This attraction may relate to its ability
to address the strong anxieties, interests, and longings common to all
or most people of that society. Second, in addition to its general attrac-
tiveness, a visual image presents a range of messages specific to individuals
in particular life situations. On the side of the image, particular and even
idiosyncratic interpretations are permitted by the multivalence of the
image. "All images are polysemous," Roland Barthes wrote; "they imply,
underlying their signifiers, a floating chain of signifieds." The viewer
is able "to choose some and ignore others" (1977:39). On the side of
the viewer, an interest determined by life situation and the need for mean-
ing directs the viewer's conscious or unconscious choice of messages. In
uncritical or nonreflective viewers, this "choice" determines that those
aspects of the painting congruent with their interests will be seen, and
those aspects unrelated to understanding and coping with their lives will
be ignored or, more precisely, not seen.

This essay will focus on the identification of messages intended by com-
missioners and painters and received by the original viewers of images
of the Virgin with one bare breast. Since the messages intended by the
commissioner or painter do not necessarily match the interpretive lexicon
of viewers, a search for iconographic precedents or for a text that explains
the visual elements of a painting is not sufficient if what we seek to under-
stand is a complex communication signaled by the paintings within a
particular community. Moreover, it will be important to determine the
popular accessibility of interpretive associations if we do not wish to focus
on the associations and interpretation of a viewer who was culturally
and educationally privileged in relation to most people in his culture.
I have not, for example, searched for interpretive material in sermons
and texts originating in, and limited to, monastic settings.

How, then, can we find clues that direct our understanding of paintings
of the Virgin with one bare breast? The ratification by texts must still
protect our interpretations from idiosyncratic arbitrariness, but the texts
that help us to identify the messages received by most people will by neces-
sity be popular texts, texts that were available in spoken, sung, or dramatic
form to those who could not read. Popular fourteenth-century Italian
devotional treatises like *The Golden Legend* of Jacobus da Voragine or the
Meditations on the Life of Christ by the pseudo-Bonaventure can provide
us with some of the religious interpretive associations that were popu-
larly accessible.

In addition, the modern interpreter must identify elements of the orig-
inal cultural experience immediately related to the image. Such crucial
variables as life expectancy, availability of food, marriage customs
(Witthoft 1982:43-59), child-rearing practices, gender conditioning, laws,

and punishments are all aspects of communal life which can reveal possible reasons for the popularity of a particular visual image in a particular time and geographic location.

A much more diffuse cultural ground must be sought for messages received than for messages given. One of the most important aspects of this cultural context is visual associations. While the visual associations of a modern viewer to an image of Mary with one breast bared may consist largely of the soft pornography that covers our newsstands, a medieval viewer's visual associations were quite different. "Images of breasts are always sure conveyors of a complex delight" (Hollander 1980:186), but an interpretation of the content of this delight necessitates careful reconstruction of the cultural factors that determined its specific context.[2] The medieval viewer was likely to associate the sight of an exposed breast not with soft pornography, but with an everyday scene in which a child was being nursed. The similarity of the Virgin and actual women was one of the immediate visual associations of the image.

We need, then, to explore visual images of Mary with one exposed breast from three different perspectives: first, in the cultural setting of fourteenth-century Tuscany; second, in the context of publicly accessible religious meanings; and third, as a painting among other contemporary paintings.

I.

The first setting for early Renaissance Tuscan visual images of the Virgin with one exposed breast is the social situation in which these images became popular. Although I cannot reconstruct here a comprehensive picture of Tuscan society, two aspects seem especially relevant to understanding the images. The first is the physical conditions of human life. Even before the onset of pandemic plague in the mid-fourteenth century, severe crises of food supply were frequent. The food surplus of the preceding centuries which had enabled the European population to increase by 30 percent over the population of the tenth century (Gottfried 1983:15) drew to a close in the last decades of the thirteenth century. The already high fertility rates continued to increase throughout the thirteenth century, but additional arable land was no longer in supply.

From 1300 on, crop failures caused food shortages and brought about a continent-wide famine in 1309, the first such famine in 250 years (Gottfried 1983:27). Although the populations of major Italian cities were

2. For a modern example of the complex delight occasioned by the breast, see Wilson Brian Key, *Subliminal Seduction* (New York: New American Library, 1972), pp. 121ff. Key discusses the strong subliminal attraction of a *Playboy* cover (February 1970) that shows a nude model, seen from the side and slightly from the back, holding a stack of magazines with *Playboy* on top at her left breast. Key comments on the model's nursing position: "Notice the curvature of the left shoulder and arm, the tenderness with which the arms support the magazines. . .the expression of nursing tranquility. . .What is a nursing mother doing on the cover of *Playboy*? Very simply, she is nursing the *Playboy* reader. . .She is looking in adoration at the printed word 'Playboy.' "

usually able to find provisions by seizing the harvest from the surrounding countryside, even the wealthy and competently administered city of Florence could not avoid the terror and social chaos caused by hunger. By mid-century, in addition to endemic malnutrition, recurring waves of plague swept western Europe, devastating populations and creating high levels of anxiety concerning personal survival and the preservation of an orderly society. In 1347, even though bread was being issued daily to 94,000 people in Florence, contemporary sources say that 4,000 Florentines died "either of malnutrition or from diseases which, if malnutrition had not first existed, would never have proved fatal" (Ziegler 1969:44). The Florentine chronicler Giovanni Villani wrote:

> The famine was felt not only in Florence but throughout Tuscany and Italy. And so terrible was it that the Perugians, the Sienese, the Lucchese, the Pistolese and many other townsmen drove from their territory all their beggars because they could not support them...The agitation of the (Florentine) people at the market of San Michele was so great that it was necessary to protect officials by means of guards fitted out with an axe and block to punish rioters on the spot with the loss of their hands and their feet (quoted by Schevill 1961:237).

Thus, chronic malnutrition and anxiety over food supply constituted one of the most striking features of Florentine society at the time of the greatest popularity of paintings of the nursing Virgin. In this context of personal and communal suffering and instability, it is not difficult to see reasons why symbolic expressions of nourishment and dependence became attractive to people. Visual images of the infant Christ, held and suckled by his mother, reflected the viewer's sense of dependence and need for support and nourishment.

The second feature of social life that bears a special relevance to the paintings we are considering is the nursing of infants in early Renaissance Tuscan culture. Research in family history has examined practices and attitudes related to infant nourishment; these studies provide an important piece of the social setting of visual images of the nursing Virgin. As Mary Martin McLaughlin states in an article in *The History of Childhood,* "The infant's survival depended on one thing above all else: its access to breast milk of good quality" (1974:115). In a time without refrigeration, the constant availability of milk was a life-or-death matter for infants. Animal milk, in addition to practical problems of preservation and transportation, was considered harmful for infants. Since children were thought to exhibit characteristics reflecting the physical appearance and personality of their milk source, it was not acceptable to imbibe animal milk. A fourteenth-century Tuscan child-care manual states:

> Be sure that the wet-nurse has plenty of milk because if she lacks it she may give the baby the milk of a goat or sheep or ass or some other animal because the child, boy or girl, nourished on animal milk doesn't have perfect wits like one fed on women's milk, but always looks stupid and vacant and not right in the head (Paolo da Certaldo, *Libro di buoni costumi,* quoted by Ross 1974:187).

Infant nourishment also carried complex social connotations. The practice of wet-nursing, although it had existed from antiquity, was written about frequently in fourteenth-century Tuscany. This body of advice, injunctions, and warnings reveals the existence of contradictory or at least ambivalent attitudes as to whether mothers should themselves nurse their infants. Mothers were frequently instructed to nurse their own infants for the good of the infant, since the danger of employing an unsuitable wet-nurse was evident. The most popular preachers of the day, like Bernardino of Siena, urged maternal feeding in their sermons:

> Even if you are prudent and of good customs and habits, and discreet...you often give your child to a dirty drab, and from her, perforce, the child acquires certain of the customs of the one who suckles him. If the one who cares for him has evil customs or is of base condition, he will receive the impress of those customs because of having sucked her polluted blood (Ross 1974:186).

Despite the frequency of these popular sermons on the desirability of maternal nursing, the practice of employing a wet-nurse was common for middle-class urban families. Ross describes the early fortunes of a middle-class child in Renaissance Tuscany: "Birth in the parental bed, bath in the same room, and baptism in the parish church were followed almost at once by delivery into the hands of a *balia* or wet-nurse, generally a peasant woman, living at a distance, with whom the infant would presumably remain for about two years or until weaning was completed" (Ross 1974:184). At the same time the preachers and child-rearing manuals insisted on maternal feeding, the employment of a wet-nurse was for middle-class families a sign of upward mobility, a symbol of gentility (Ross 1974:186). Social meanings were apparently in direct conflict with the strong and consistent advice to mothers from preachers and child-rearing manuals to nurse their own offspring. For many Florentine parents an additional factor came into play: wet-nurses were frequently slave women brought by traders to Tuscany from the Levant in increasing numbers in the fourteenth century.[3] Petrarch called this large slave population *domestici hostes,* domestic enemies. The frequent employment as wet-nurses of women regarded as hostile and untrustworthy must have contributed substantially to the anxiety surrounding wet-nursing (Origo 1955:321ff.). Given this situation of conflicting feelings and values, a great deal of ambivalence must have attended a couple's decision about infant nourishment.

One of the cultural associations with visual images of the nursing Virgin must have been this ambivalence, an ambivalence frequently tipped in

3. Origo emphasizes that slaves were owned by middle-class Tuscan people: "Every prosperous noble or merchant had at least two or three; many had more. Even a notary's wife or a small shopkeeper's would have had at least one, and it was far from uncommon to find one among the possessions of a priest or nun" (1955:321).

the direction of strong guilt feelings in the case of parents whose infants had undergone the not-infrequent fate of infants in the care of wet-nurses — "smothering," perhaps a generic name for death from poor care as well as from deliberate suffocation. From the perspective of the message intended, visual images of the nursing Virgin may have been a deliberate message to women, continuous with popular sermons, urging their emulation of the mother of Christ. It is, however, important to remind ourselves of the probability of a difference between messages intended by the male ecclesiastical or aristocratic commissioner of a religious painting and messages received by different people within the Christian community. The range of messages likely to have been received from visual images of the nursing Virgin will be discussed in the concluding section.

II.

From the third century C.E. on, the Virgin's central theological meaning was that she guaranteed Christ's humanity. Tertullian wrote: "Christ received his flesh from the Virgin...certain proof that his flesh was human" (*De carne Christi* 17). At the Council of Ephesus (431 A.D.), Mary was called Theotokos, God-bearer, in order to affirm that Christ, born from her, was true God as well as true man, and in the technical descriptions of Saint Thomas Aquinas, Mary's humanity was understood as the guarantee of that of her son.

In addition to these theological affirmations of Mary's centrality to the redemption of humanity, theologians understood her importance for the devotional needs of communities. Posing for himself the question "whether the matter of Christ's body should have been taken from a woman," Thomas gives the response:

> Because the male sex excels the female sex, Christ assumed a man's nature. So that people should not think little of the female sex, it was fitting that he should take flesh from a woman. Hence Augustine says, "Despise not yourselves, men, the son of God became a man; despise not yourselves, women, the son of God was born of a woman" (*Summa Theologica* 3a, q. 31, art. 4).

Despite the evident androcentrism of this statement, the use of the quotation from Augustine raises a theme of incarnational doctrine that was fundamental from the earliest theological treatments of the Virgin's role until the Italian Renaissance: the devotional need of women and men for gender parallelism in Christian verbal and visual symbols.

The development of Marian theology took the form of an ever more articulated parallelism between the character of Christ and the events of his life, and the Virgin's attributes and events of her life. Christ's conception was paralleled by Mary's Immaculate Conception, an unscriptural doctrine that was rejected by Thomas and was heavily contested and tortuously argued by theologians from the fourth century onward. Christ's birth and Mary's birth both receive their full share of apocryphal legends. Christ's circumcision finds its parallel in Mary's purification; neither was necessary, but both were willingly accepted. Christ's presentation

in the temple is matched by the apocryphal account, often depicted in paintings, of the Virgin's presentation in the temple at the age of three years. The ministry years of Christ's life do not always find iconographic parallels in events in the Virgin's life, but in popular devotional works the scenes of Christ's ministry were interspersed with liberal accounts of the Virgin's activities and emotions.[4] The Virgin was an indispensable spectator/participant in the passion of Christ. She and her more flamboyant counterpart, Mary of Magdala, provided the hearer of these devotional stories or the viewer of religious paintings with models of the emotions they were instructed to experience. Because Christ's bodily ascension was clearly taught in scripture, the Bodily Assumption of Mary, although unscriptural and heavily contested by theologians until its definition as dogma in 1950, was a devotional requirement as a parallel for Christ's ascension.

Parallel incidents from Christ's life and from the life of the Virgin were articulated visually in religious paintings as well as verbally in sermons and popular devotional treatises. Paintings in churches served as a focus for contemplation and provided access to worship for people for whom worship may have been, as both Catholic and Protestant reformers in the sixteenth century repeatedly claimed, primarily a visual activity. And visual images did not merely delight the predominantly illiterate people of these congregations; they directed the religious affections in fundamental ways understood as essential to salvation. Accessible to all members of Christian communities on a daily basis, religious paintings were the media images of medieval people, informing their self-images and their ideas of relationship, God, and world in strong and immediate ways. The function of these paintings in conditioning religious and social attitudes cannot be overestimated.

All evidence suggests that at no time was Marian popular devotion more prominent in European culture than in the fourteenth and fifteenth centuries. Theologians of various religious orders debated heatedly about the Virgin's attributes and powers; councils invoked Mary's presence and wisdom; academic theologians like Jean Gerson, chancellor of the University of Paris, attested her presence and participation at the Last Supper and the Pentecost. Affirming her appointment to the priesthood, Gerson called her the "Mother of the Eucharist," the one who made the original offering of Christ, the pure victim. But excitement over the Virgin and her power was not confined to a theological elite; the most popular Tuscan preacher of the first half of the fifteenth century, the Franciscan Bernardino of Siena, praised Mary in the most extravagant terms in his lengthy and passionate sermons. He waxed eloquent over "the unthinkable power of the Virgin Mother." This charismatic evangelical preacher stated:

4. Thomas Aquinas's description of Mary's talents indicates his awareness that Christ's power and the Virgin's power might easily be construed as competitive rather than complementary: "She possessed extraordinary gifts but could not use them publicly since it would detract from Christ's teaching" (*Summa Theologica* 3a, q. 27-30).

Only the blessed Virgin Mary has done more for God, or just as much, as God has
done for all humankind...God fashioned us from the soil, but Mary formed him
from her pure blood; God impressed on us his image, but Mary impressed hers on
God...God taught us wisdom, but Mary taught Christ to flee from the hurtful and
follow her; God nourished us with the fruits of paradise, but she nourished him with
her most holy milk, so that I may say this for the blessed Virgin, whom, however,
God made himself, God is in some way under a greater obligation to us through
her, than we to God (trans. in Graef 1963:316-317).

Although theologians protested such exuberant statements of Mary's sig-
nificance, Bernardino's estimation of her power could have been a gloss
on popular imagery, like the Florentine fresco in Figure 2.

III.

How did images of the nursing Virgin differ from what people were accus-
tomed to seeing in their local churches? How were these images related
to other new themes and subjects of religious painting in the same time
and place? Since the artistic environment of most people during the early
Renaissance was limited to images displayed in local churches, we can
expect that new styles or subjects were noticed and their personal meaning
and value more or less consciously understood by the individuals who
were their first viewers.

Visual images of Mary with one exposed breast were part of an artistic
trend in effect since the beginning of the fourteenth century, where the
Virgin was depicted as a humble peasant woman, sometimes barefoot
and seated on the floor or ground. Painted in a naturalistic style, these
Madonnas of Humility could hardly be in more striking contrast with
the depictions of the Virgin they replaced. Throughout the thirteenth
century the Virgin had been pictured as a Byzantine empress, luxuriously
robed, heavily jeweled, and seated on a throne surrounded by angels
and worshipers. The visual message of the new Madonnas suggested the
Virgin's accessibility, sympathy, and emotional richness (Meiss
1964:132ff). Depictions of the nursing Virgin and child in which the child
twists around to engage the viewer's eye employed an established visual
device for inviting the viewer to participate in the pictured scene
(Baxandall 1972:72ff). Within this artistic movement toward portraying
scriptural figures as humble people with strong feelings, the bare-breasted
Virgin represents perhaps the furthest extension of homey simplicity and
unpretentious accessibility. Paintings of the nursing Virgin by Simone
Martini and by painters associated with his workshop and influence, such
as Lippo Memmi, Simone Mormion, Botticelli, Taddeo Gaddi, Andrea
di Bartolo, and others, indicate a Tuscan origin for the image (Meiss
1964:133ff).

There are, however, some especially vexing problems associated with
the representation of nude bodies or parts of bodies in religious painting.
Recently Leo Steinberg has called attention to a large number of
Renaissance paintings that feature a nude Christ, arguing that these
paintings presented simultaneously the "full humanity" and the inno-
cence and sinlessness of Christ in visual form. In some images of the

resurrected Christ, power appears to be a primary message; Christ is shown with an artfully draped but unmistakable erection. Steinberg finds this an appropriate device for communicating the resurrection; the res-erected phallus, "the body's best show of power," is the sign and guarantee of Christ's vivified flesh. "The supreme power," he writes, "is the power that prevails over mortality," a power "reasonably equated with the phallus" (Steinberg 1984:90). Yet reactions to these paintings by many of their first viewers were negative. Some of the most famous, like Michelangelo's epic depiction of the Last Judgment on the apse wall of the Sistine Chapel, were soon painted over, and in 1563 the Council of Trent officially, though not always effectively, banned nudity in religious painting.

Nudity or partial nudity in religious paintings creates tensions of two kinds in viewers. First, there is a tension between cultural and natural meanings. The bare-breasted Virgin, for example, evokes visual asso-ciations that emphasize her similarity with other women; yet popular devotional texts and sermons frequently contradicted these evoked asso-ciations by insisting on her difference. The *Meditations on the Life of Christ* describe an illustration of the nursing Virgin thus: "How readily she nursed Him, feeling a great and unknown sweetness in nursing this Child, such as could never be felt by other women!" (pseudo-Bonaventure 1961:55). Second, nudity in religious paintings creates a tension between erotic attraction and religious meaning.

Anne Hollander, in *Seeing through Clothes,* has argued that nudity in art always carries a sexual message; visual depictions of a nude body are never so thoroughly devoid of sexual associations as to become a perfect vehicle for an abstract theological message. At the same time, nudity can intensify the narrative, doctrinal, or devotional message of the painting by evoking subliminal erotic associations. In a religious paint-ing that intends to stimulate in viewers a complex response of affective piety, nudity must be carefully balanced with other visual content so that an erotic response does not dominate, causing the viewer's engage-ment with the painting to collapse into "mere" sensuality. On the one hand, then, nudity must be depicted naturalistically enough to evoke the viewer's erotic interest; on the other hand, it must not be dominant enough to render this erotic attraction primary. The religious message must dominate, with the erotic component in a subordinate and sup-portive role.

Were images of the Virgin with an exposed breast more successful than many of the paintings of a nude Christ in maintaining a balance of erotic and religious messages? Two pictorial devices guaranteed that the religious message of paintings of the nursing Virgin — the viewer's participation in an intimate scene in which humanity and divinity are closely woven — would be strengthened rather than undermined by its erotic content. First, in the early Renaissance examples shown here, the large breast which Christ sucks did not meet the contemporary cultural requirements for an erotic female image; on secular female nudes and

clothed figures of the Renaissance, breasts are small and high. In order to create an erotic response, pictured nudity must "display the emphatic outline, posture, and general proportions of a body customarily clothed in fashionable dress, so as to make it seem denuded" (Hollander 1980:88). In erotic painting, viewers are led to imagine that they are seeing a denuded body of the kind that their cultural visual conditioning has designated as sexually appealing.

Second, in depictions of the nursing Virgin or the Virgin showing the breast with which she nursed the Christ child, Mary's dress does not display the provocative disarrangement of an erotic exposure of the breast. Moreover, the covered side of Mary's chest is perfectly flat in the examples shown here, while the exposed breast is round and ample. The viewer's impression is not one of a privileged glimpse of a normally concealed breast, but rather that the cone-shaped breast from which the Christ child is nourished is not actually a part of Mary's body, but an appendage. The paintings could be a literal visual translation of Jacobus da Voragine's text: "Such indeed was Mary's innocence that it shone forth even outside of her, and quelled any urgency in the flesh of others...Although Mary was surpassing fair, no man could look upon her with desire" (Jacobus 1969 ed., 150).

IV.

We must now gather the religious, social, and visual contexts of early Renaissance Tuscan paintings of the Virgin with one bare breast in an interpretation of the messages likely to have been given and received by the original viewers of these images. Jane Gallop's statement that "the visual mode produces representations as a way of mastering what is otherwise too intense" is helpful for our analysis (1982:35). In addition, these visual images of the Virgin are *men's* images of a woman; as far as can be determined, not a single Renaissance image of this type was commissioned or painted by a woman. As men's images, they express and attempt to "master" a cultural situation in which, as we have seen, human life was extraordinarily vulnerable and precarious. Far from presenting a simple message encouraging viewers to greater affective piety, these paintings expressed, and evoked in viewers, highly complex and ambivalent responses.

Because of the social conditions prevailing when it became a popular image, the nourishing breast was simultaneously a symbol of threat and of comfort, focusing a pervasive, chronic anxiety over nourishment. In a society in which women's milk was a practical, emotional, and religious issue, the nursing Virgin was an intensely ambivalent symbol, evoking for all people a closely-woven mixture of danger and delight and, for women, contradictory social meanings and emotional quandaries surrounding the nursing of infants. The "bad mother," either the natural mother who did not choose to nurse her child or the irresponsible or incapable wet-nurse, was a source of continuous cultural and personal anxiety, as popular sermons and child-rearing manuals demonstrate.

Unlike actual women who might or might not be acceptable mothers, the Virgin represented a fantasy of a totally good mother. She was a mother who could be counted on to nurse not only her son, but through him all Christians. Mary was called *mater omnium* and *nutrix omnium* (Meiss 1964:151-152). These scenes depicting physical nourishment at a woman's breast, the earliest delight of all fourteenth-century people, evoked both fundamental sensual pleasure and spiritual nourishment. Mary's humility, obedience, and submissiveness in unquestioningly offering her body as shelter and nourishment for the Christ child must have been part of the message intended by male commissioners and painters. The Virgin was presented as model for actual women.

At the same time, however, visual images of the nursing Virgin might have evoked in viewers a positive sense of the nourishing power of women at a time of personal anxiety and cultural crisis. If the Virgin gained cosmic power by nursing her son, what was to prevent actual women from recognizing their power, derived from the same source, and irresistible to their adult sons? Images of the nursing Virgin signify power to conceive, to nourish, shelter, and sustain human life, a power that may well have been understood by fourteenth-century people threatened by famine, plague, and social chaos as "the body's best show of power." It was understood, nevertheless, as a power that must be firmly directed to the socially desirable ends of a patriarchal society, that is, to keeping women "in their place." Women must be guided to accept the model of the nursing Virgin without identifying with her power — a power derived from her body, but ultimately a social as well as a physical power.

Did men have reason to be uneasy about women's social power, in addition to their anxiety about women's physical powers? The conditions of social instability that existed in early Renaissance Tuscan towns were those in which women are most likely to be able to consolidate and extend personal and social power (Kelly-Gadol 1976:810). Some women were able to exercise economic independence, to own and manage business enterprises, and to dispose of their own property without their husband's consent. The cost of dowries had never been higher, indicating the importance to men of advantageous marriages for their sisters and daughters — advantageous to the men, that is, whose wealth and power often depended to a large extent on such marriages. Moreover, women were living longer than men, as a 1427 Florentine population census attests (Herlihy 1975:15).

There is, however, little evidence that women identified with the Virgin's power. A delicate message of social control was communicated, apparently effectively, by the creation of a dissonance between verbal messages and visual messages: the latter emphasized the *similarity* of the Virgin and actual women, but it was the *contrast* between actual women and the Virgin that was prominent in the messages conveyed by late medieval and early Renaissance preachers, theologians, and popular devotional texts. A spiritual attachment to the Virgin was presented as an alternative to appreciation of and attachment to one's actual mother. This theme

had appeared as early as the twelfth century as a leitmotif in the writings of Cistercian women and men. Aelred of Rievaulx wrote of the Virgin: "It is she...who has given us life, who nourishes and raises us...she is our mother much more than our mother according to the flesh" (Bynum 1982:137, n. 90). Moreover, it was not only the mothering Virgin who was supposed to take the place of an actual mother in the life of a monk; Bernard of Clairvaux, the most influential author on late medieval spirituality, assimilated the role of mothering to the male Jesus, just as contemporary abbots described their role within monastic communities as one of providing motherly care and spiritual nourishment (Bynum 1982:145). Dame Julian of Norwich, the fourteenth-century English recluse, gave a vivid account of Jesus as contrasted to and displacing an earthly mother in her *Showings:*

> We know that all our mothers bear us for pain and for death. O, what is that? But our true Mother, Jesus, he alone bears us for joy and for endless life...This fair, lovely word "mother" is so sweet and so kind in itself that it cannot truly be said of anyone or to anyone except of him and to him who is the true mother of life and of all things. To the property of motherhood belong nature, love, wisdom, and knowledge, and this is God (Julian of Norwich 1978:297-299).

Theological descriptions of Mary or of Jesus as ideal mother use maternal imagery as a vehicle for drawing a strong contrast between the ideal woman and actual women. In fourteenth-century popular devotional literature, there is no comparable effort to curtail men's identification with the male Christ. The appearance of God in the male sex was understood as privileging that sex, making men less vulnerable to evil than women. The 1484 *Malleus Maleficarum* states that men are much less likely to associate with the devil in witchcraft than women because they belong to Christ's sex: "And blessed be the Highest who has so far preserved the male sex from so great a crime: for since He was willing to be born and to suffer for us, therefore He has granted to men this privilege" (Kramer and Sprenger 1971:47). While men are encouraged to identify with the male Christ, women's identification with the female Virgin is blocked by verbal emphasis on the unbridgeable chasm between the ideal Virgin and actual women, and by presenting attachment to the mothering Virgin as an alternative to attachment to actual mothers.

Paintings of the Virign with one bare breast constitute a remarkably explicit objectification of what was almost certainly the most pressing personal and collective anxiety of fourteenth-century Tuscan people — the uncertainty of food supply. We have no direct evidence as to how women understood and reacted to these images. Embedded in the intricate social fabric, these images "worked" to the extent that their communication remained subliminal. Just as modern women are not continuously conscious of the shaping of our self-images and behavior by the media images we live with daily, medieval women probably could not have articulated the specific effect of *their* media images — paintings on the walls

of churches — on their affective lives and their actions. Yet they were certainly affected by these messages.

No simple reduction of the conflicting messages of verbal and visual communication to a single dominant message to and about women can do justice to the complexity of fourteenth-century Tuscan culture. Rather, both visual messages that acknowledge women's power over life and death and verbal messages that deny the identity of actual women with the powerful Virgin must be considered if we are to represent accurately the ambivalence toward women of a strong but threatened male culture. The visual images we have examined from the perspectives of their social context, their religious significance, and their visual environment have helped us to explore a complex form of social control in an early stage of the Italian Renaissance. Images of the Virgin with one bare breast both formulate and attempt to control one of the most awesome powers of women, the power to nourish.

REFERENCES

Aquinas, Thomas, 1969. *Summa Theologiae,* Blackfriars edition (New York: McGraw-Hill).

Barthes, Roland, 1977. *Image-Music-Text* (New York: Hill and Wang).

Baxandall, Michael, 1972. *Painting and Experience in Fifteenth Century Italy* (New York: Oxford University Press).

Bonaventure (pseudo), 1961. *Meditations on the Life of Christ,* An Illustrated Manuscript of the Fourteenth Century, trans. and ed. Isa Ragusa and Rosalie B. Green (Princeton: Princeton University Press).

Bowsky, William A., 1981. *A Medieval Italian Commune: Siena under the Nine, 1287-1353* (Berkeley: University of California Press).

Bynum, Caroline Walker, 1982. *Jesus as Mother: Studies in the Spirituality of the High Middle Ages* (Berkeley: University of California Press).

Gallop, Jane, 1982. *The Daughter's Seduction: Feminism and Psychoanalysis* (New York: Cornell University Press).

Gottfried, Robert S., 1983. *The Black Death: Natural and Human Disaster in Medieval Europe* (New York: The Free Press).

Graef, Hilda, 1963. *Mary: A History of Doctrine and Devotion,* vol. I (New York: Sheed and Ward).

Herlihy, David, 1975. "Life Expectancies for Women in Medieval Society," in *The Role of Women in the Middle Ages,* ed. Rosemary Thee Morewedge (Albany: State University of New York).

1984, with Christine Klapisch-Zuber, *The Tuscans and Their Families: A Study of the Florentine Castato of 1427* (New Haven: Yale University Press).

Hollander, Anne, 1980. *Seeing through Clothes* (New York: Viking Press).

Jacobus di Voragine, 1969. *The Golden Legend,* trans. Granger Ryan and Helmut Ripperger (New York: Arno Press).

Julian of Norwich, 1978. *Showings,* trans. Edmund Colledge, O.S.A., and James Walsh, S.J. (New York: Paulist Press).

Kelly-Gadol, Joan, 1976. "The Social Relation of the Sexes: Methodological Implications of Women's History," in *Signs: A Journal of Women in Culture and Society* I, n. 4, pp. 809-823.

Kramer, Heinrich, and James Sprenger, 1971. *The Malleus Maleficarum,* trans. Montague Summers (New York: Dover).

Kristeva, Julia, 1983. *The Powers of Horror* [trans.] (New York: Columbia University Press).

Lasareff, Victor, 1938. "Studies in the Iconography of the Virgin," *Art Bulletin* XX, 26-65.

McLaughlin, Mary Martin, 1974. "Survivors and Surrogates: Children and Parents from the Ninth to the Thirteenth Centuries," in *The History of Childhood,* ed. Lloyd de Mause (New York: Harper Torchbooks).

Meiss, Millard, 1964. *Painting in Florence and Siena after the Black Death* (New York: Harper Torchbooks).

Origo, Iris, 1955. "The Domestic Enemy: The Eastern Slaves in Tuscany in the Fourteenth and Fifteenth Centuries." *Speculum* XXX, n. 3.

Ross, James Bruce, 1974. "The Middle Class Child in Urban Italy, Fourteenth to Early Sixteenth Century," in *The History of Childhood,* ed. Lloyd de Mause (New York: Harper Torchbooks).

Schevill, Ferdinand, 1961. *History of Florence* (New York: Frederick Ungar).

Steinberg, Leo, 1984. *The Sexuality of Christ in Renaissance Art and in Modern Oblivion* (New York: Pantheon).

Witthoft, Brucia, 1982. "Marriage Rituals and Marriage Chests in Quattrocento Florence," *Artibus et Historiae* III, n. 5.

Ziegler, Philip, 1969. *The Black Death* (New York: Harper Torchbooks).

"THIS HERALDRY IN LUCRECE' FACE"

NANCY J. VICKERS

"But, good lieutenant, is your general wiv'd?"

"Most fortunately: he hath achiev'd a maid
That paragons description and wild fame;
One that excels the quirks of blazoning pens,
And in th' essential vesture of creation
Does tire the ingener." *Othello*, II.i.60—65

The brief exchange between a governor and a lieutenant that figures as epigraph to this essay is curiously about the limits of description. As they stand in the stormy port of the "warlike isle" of Cyprus (1.43) awaiting the "warlike Moor Othello" (1.27), Montano and Cassio digress from appropriately warlike concerns to evoke Othello's exquisite and doomed bride, Desdemona. Cassio comments that she is so beautiful as to be beyond description: her charms surpass all praise that the rhetorician can muster; they cannot effectively be listed ("blazoned") or captured in rhetorical conceits ("quirks"); indeed, even the most ingenious of poets ("the ingener") would exhaust himself in attempting to do them justice.[1] Cassio thus recites not only the strengths of Desdemona but also the weaknesses of a poetic tradition that, from the classics to the Renaissance moderns, had celebrated the beauties of woman's body.

Like Shakespeare's warlike exchange, that tradition was, in large part, the product of men talking to men about women. The canonical legacy of description is a legacy shaped predominantly by the male imagination for the male imagination. This is not, of course, to deny the possibility of the flattery poem; praising a woman to her face might well be intended as a preamble to seduction, as a maneuver for advantage. But in this essay, I will focus on those occasions in which men praise beautiful women among men, on the rhetorical strategies such occasions generate, and finally on some

1. The text from *Othello* is cited as in *The Riverside Shakespeare* (1974). Shakespeare's text is here characteristically unstable: for a variant on 1.65, see the Arden edition (1958); for an alternate interpretation of the verb "tire" (as from "attire"), see the Variorum edition (1886).

logical consequences of being matter for male oratory. Indeed, I will argue that occasion, rhetoric, and result are all informed by, and thus inscribe, a battle between men that is figuratively fought out on the fields of woman's "celebrated" body.

When, in "The Laugh of the Medusa," Hélène Cixous maintains "that there is such a thing as *marked* writing" she alludes to those literary codes that reinforce "a libidinal and cultural — hence political, typically masculine — economy" and thus constitute "a locus where the repression of women has been perpetuated" (1980:249). "By writing her self," Cixous continues, "woman will return to the body which has been more than confiscated from her, which has been turned into the uncanny stranger on display" (p. 250). This essay scrutinizes one manifestation of that "uncanny stranger" in an attempt to define both the motives for and the strategies of "display"; it examines a telling example of description through comparison — a fundamental tactic of rhetorical invention — by pressuring a single, canonical metaphor as it appears in Shakespeare's narrative poem *Lucrece* (1594).[2] For here the poet transforms the repetition of convention into its subversion; he simultaneously masters and undermines the descriptive mode he employs.

The warlike metaphor in question — the beautiful woman's face is (is like) a shield — informs descriptions of Shakespeare's heroine throughout the poem. By the late sixteenth century, gunpowder had, of course, seriously diminished the defensive usefulness of shields. Less and less the practical gear of the warrior, they remained, however, his emblem; they were used in nostalgically chivalric court entertainments; in pageants, tilts, and tourneys; and in a variety of decorative contexts where they displayed symbolic figurations of gentlemanly pedigree. Aristocratic Elizabethans were fascinated by the "colorful paraphernalia of heraldry" which "tended to proliferate as the practical function of knighthood disappeared" (Ferguson 1960:17; see also Stone 1965:23—27). That interest was related, Lawrence Stone has argued, to the "extreme development" of patriarchal family structure that characterized the period: ". . . it was the male line whose ancestry was traced so diligently by the genealogists and heralds, and in almost all cases via the male line that titles were inherited" (p. 591; cited by Kahn 1976:46). *Lucrece* both reflects and reinforces that fascination; from beginnning to end,

2. All quotations from *Lucrece* are as in the Arden edition of *The Poems* (1960) and will be indicated by line number in the text. The criticism on *Lucrece* is too abundant to be outlined here, but four discussions of the poem have particularly influenced this study: Clark Hulse (1978) on the iconic nature of *Lucrece*; Richard Lanham (1976) on the centrality of rhetoric as motive; Coppélia Kahn (1976) and Catharine R. Stimpson (1980) on the relationship of rape and the politics of patriarchy. I am also indebted to four Dartmouth colleagues whose suggestions have, as always, been invaluable: Kevin Brownlee, Carla Freccero, Marianne Hirsch, and Peter Saccio.

Shakespeare expands his imagistic network by exploiting the highly codified vocabulary of heraldic convention.

The images here at issue are those that constitute the evolving portrait of Lucrece. Since, in this essay, descriptive passages will be discussed in the order in which they appear, a brief synopsis of the poem's action might usefully situate them. *Lucrece* opens as Tarquin, the son of a usurper king, leaves the Roman military encampment outside the city of Ardea. His hasty departure was inspired, the narrator hypothesizes, by Collatine's laudatory description of his wife, Lucrece. A relative, friend, and fellow soldier of Collatine, Tarquin has determined that he must possess his comrade's chaste and beautiful wife. When he arrives at Collatia, Lucrece welcomes him and provides him with lodging. During the night he rapes her and leaves. Lucrece's grief takes the form of a series of laments and a lengthy meditation on a "skilful painting" (l.1367) of the fall of Troy in which she seeks an image sufficient to mirror her suffering. She sends for Collatine, and, when he and his men arrive, she tells them about the rape, swears them to revenge, names the rapist, and commits suicide. Brutus seizes the moment to call for the banishment of Tarquin, and, inspired by the display of Lucrece's body, the Romans consent. Indeed, Roman history recounts their reaction as a revolt: they overthrow the government of Tarquin's father and replace a monarchy with a republic. Collatine and Brutus are its first consuls. Shakespeare's poem is clearly divided by the rape at its center: in its first half, where the extensive descriptions of Lucrece appear, the motives and meditations of the rapist dominate; in the second, the lamentations of the victim.

<p style="text-align:center">*</p>

Lucrece opens with a contest. Its initial focus is on "lust-breathed Tarquin" (1.3) as he speeds away from the Roman camp, but within the space of one stanza that focus shifts to present a flashback revealing the origins of his uncontrollable desire:

> Haply that name of "chaste" unhapp'ly set
> This bateless edge on his keen appetite,
> When Collatine unwisely did not let
> To praise the clear unmatched red and white
> Which triumph'd in that sky of his delight;
> Where mortal stars as bright as heaven's beauties,
> With pure aspects did him peculiar duties.
>
> For he the night before, in Tarquin's tent
> Unlock'd the treasure of his happy state:
> What priceless wealth the heavens had him lent,
> In the possession of his beauteous mate;
> Reck'ning his fortune at such high proud rate
> That kings might be espoused to more fame,
> But king nor peer to such a peerless dame.

<p style="text-align:center">*</p>

Beauty itself doth of itself persuade
The eyes of men without an orator;
What needeth then apologies be made,
To set forth that which is so singular?
Or why is Collatine the publisher
 Of that rich jewel he should keep unknown
 From thievish ears, because it is his own?

Perchance his boast of Lucrece' sov'reignty
Suggested this proud issue of a king;
For by our ears our hearts oft tainted be.
Perchance that envy of so rich a thing,
Braving compare, disdainfully did sting
 His high-pitch'd thoughts, that meaner men should vaunt
 That golden hap which their superiors want. (11.8—21; 29—42)

Shakespeare locates the ultimate cause of Tarquin's crime, and Lucrece's subsequent suicide, in an evening's entertainment. The prose argument that precedes the poem adds further clarification:[3] "In their discourses after supper everyone commended the virtues of his own wife; among them Collatinus extolled the incomparable chastity of his wife Lucretia." The prose next narrates an event that Shakespeare significantly writes out of the poetry: the competitors ride from Ardea to Rome to test their wives and, with the exception of Lucrece, all are "found dancing and revelling, or in several disports." It is for this reason that "the noblemen yielded Collatinus the victory, and his wife the fame." The argument, in contrast to the poem, then, remains faithful to Shakespeare's two principal sources, Ovid and Livy.

> Young Tarquin entertained his comrades with feast and wine: . . . Each praised his wife: in their eagerness dispute ran high, and every tongue and heart grew hot with deep draughts of wine. Then up and spake the man who from Collatia took his famous name: No need of words! Trust deeds!
> (Ovid, *Fasti*, II.725—726; 731—734)

> The young princes for their part passed their idle hours together at dinners and drinking bouts. It chanced, as they were drinking . . . that the subject of wives came up. Every man fell to praising his own wife with enthusiasm, and, as their rivalry grew hot, Collatinus said that there was no need to talk about it, for it was in their power to know . . . how far the rest were excelled by his own Lucretia. (Livy, *From the Founding of the City*, I.lvii.5—7)

Rereading Shakespeare's classical models reveals the radical nature of his transformation of them.[4] The descriptive occasion remains the

3. It should be noted that the authorship of the "Argument" has been questioned. Michael Platt usefully compares the frame provided by the "Argument" to "an action whose beginning is 'kings' and whose end is 'consuls' " (1975:64).
4. Numerous critics have pointed out the discrepancy between the "Argument," in line with the sources, and the poem. For a particularly persuasive description, followed by an interpretation very different from my own, see Battenhouse (1969:7—8); see also Lanham (1976:96) and Bullough (1957:180). On the folly of Collatine's boast see Battenhouse

same — the lighthearted boasting contest — but the all important test, ironically proposed by Collatine in both Ovid and Livy, has been eliminated. In *Lucrece* Collatine becomes a foolish orator, not an enemy of words but their champion. He who stops the descriptive speeches is now blamed for not knowing when to stop: "When Collatine unwisely did not let / To praise. . ." (11.10—11). Moreover, in both Latin subtexts the sight of Lucrece inflames Tarquin's passion; in *Lucrece* he sets off for Collatia without having seen her. The result, then, of this rewriting is a heightened insistence on the power of description, on the dangers inherent in descriptive occasions. Here, Collatine's rhetoric, not Lucrece's behavior, wins over his companions; Collatine's rhetoric, not Lucrece's beauty, prompts Tarquin's departure.

What transpires in Tarquin's tent, then, is an after-dinner conversation during which, in a "pleasant humor" ("Argument"), his warlike guests amuse each other through a contest of epideictic oratory — oratory intended to persuade, in this case, through hyperbolic praise of its female subject.[5] Shakespeare's soldiers present "discourses" ("Argument"), and his narrator characterizes them as orators (1.30). Collatine is labeled a "publisher" of his possession (1.33), his descriptive speech is called a "boast" (1.36), and his rhetoric, thus, is specifically in the mode of "blazon." The verb "to blazon," "to describe in proper heraldic language, to paint or depict in colors, to inscribe with arms . . . in some ornamental way, to describe fitly, to publish vauntingly or boastfully, to proclaim," first appears in English in the sixteenth century.[6] Although French in origin, from *blasonner*, it is related to and reacts upon the earlier English verb "to blaze," "to proclaim as with a trumpet, to publish, to divulge, to make known; and, by extension, to defame or celebrate, to depict, to portray." In France, *blasonner* was so commonly used that it signified little more than "to describe," but its usage was rooted in two specific descriptive traditions, one heraldic and the other poetic. A *blason* was, first, a codified heraldic description of a shield, and, second, a codified poetic description of an object praised or blamed by a rhetorician-poet. The most celebrated examples of French poetic blazon were the *Blasons anatomiques du corps fémenin* (1543), a collective work in which each poem praised a separate part of the female body. The metaphor, "woman's face (or

(1969:10—12); Bullough (1957:180); Donaldson (1982:50—51); Kahn (1976:53); Lanham (1976:96); Platt (1975:66); and Stimpson (1980:58—61).

5. Numerous sixteenth-century texts evoke similar descriptive occasions. Frederico Luigini's *Il Libro della bella donna*, for example, concludes a day of hunting and a hearty meal with an after-dinner game in which each hunter forms in words an ideal woman.

6. All references in this essay to sixteenth-century definitions of terms cite the Oxford English Dictionary.

body) is a shield," literalizes this double extension of the term "blazon" — text describing a shield and text describing a body. Collatine's boastful publication of Lucrece's virtue and beauty, then, inscribes itself within a specific mode of rhetorical praise, a mode grounded in and thus generative of metaphors of heraldic display.

A question of purpose imposes itself: to what end does Collatine blazon Lucrece? Why is he not content to enjoy his "treasure" (1.16), his "priceless wealth" (1.17), his "fortune" (1.19), in silence? Within the economy of competition, of course, wealth is not wealth unless flaunted, unless inspiring envy, unless affirming superiority. Tarquin's family has recently assumed power and is thus "espoused to more fame" (1.20), but it is Collatine who owns the "peerless dame" (1.21). In the play of power between Tarquin and Collatine, at least for the privileged duration of this after-dinner sport, Collatine has carried the day — or rather, the evening. Description within a like context clearly serves the describer and not the described. Praise of Lucrece is more precisely praise of Collatine, be it as proud possessor or as proud rhetorician. But more important, Collatine's descriptive gesture entails a risk inherent in the gesture itself: he generates description, he opens Lucrece up for display, *in order to* inspire jealousy; and jealousy, once inspired, may be carried to its logical conclusion — theft. The cause of the rape ("the act of taking anything by force, violent seizure (of goods), robbery, and, after 1481, violation of a woman") is precisely that Collatine's self-serving oratory has fallen on "thievish" rather than passive, but none the less envious, ears. As Catharine Stimpson points out, "men rape what other men possess" (1980:58; see also Kahn 1976:71, n. 19). The rapist is indeed the villain of the piece, but the instigation of this particular villainy is more correctly located along the fine line walked by the boaster. Rape is the price Lucrece pays for having been described.

The matter for Collatine's rhetoric, the argument suggests, is Lucrece's chastity; the poem, however, progressively shifts its reader's perspective. Although virtue is always at issue, it soon competes with beauty for the distinction of being Lucrece's most appreciable quality. Beauty, the narrative voice insists, does not need the embellishments of an orator: "Beauty itself doth of itself persuade" (1.29). It "excels the quirks of blazoning pens," and is sufficiently persuasive "in th' essential vesture of creation" (*Othello*, II.i.63—64). And still, in Tarquin's tent it seems that Collatine called upon all of the conceits of descriptive convention to outdo his comrades at arms. Shakespeare's narrator succinctly re-presents Collatine's speech:

> When Collatine unwisely did not let
> To praise the clear unmatched red and white
> Which triumph'd in that sky of his delight;

Where mortal stars as bright as heaven's beauties,
With pure aspects did him peculiar duties. (11.10—14)

Less important than the conventional nature of the language — red
and white complexion; face like a clear sky; eyes bright as stars — is
the choice of detail that figures in the narrator's description of
Collatine's description. The body Collatine praised, we are told, is a
partial body, a face; its distinctive features are the colors of its flesh
and the brightness of its eyes. Color and brightness define Lucrece.
By the time the reader, like Tarquin, first "sees" Lucrece, the stage
has been set for a repeat performance of a now familiar rhetorical
portrait:

When at Collatium this false lord [Tarquin] arrived,
Well was he welcom'd by the Roman dame [Lucrece],
Within whose face beauty and virtue strived
Which of them both should underprop her fame.
When virtue bragg'd, beauty would blush for shame;
 When beauty boasted blushes, in despite
 Virtue would stain that o'er with silver white.

But beauty in that white entituled
From Venus' doves, doth challenge that fair field;
Then virtue claims from beauty beauty's red,
Which virtue gave the golden age to gild
Their silver cheeks, and call'd it then their shield
 Teaching them thus to use it in the fight,
 When shame assail'd, the red should fence the white.

This heraldry in Lucrece' face was seen,
Argu'd by beauty's red and virtue's white;
Of either colour was the other queen,
Proving the world's minority their right.
Yet their ambition makes them still to fight;
 The sov'reignty of either being so great,
 That oft they interchange each other's seat.

 *

Now thinks he that her husband's shallow tongue, —
That niggard prodigal that prais'd her so, —
In that high task hath done her beauty wrong,
Which far exceeds his barren skill to show.
Therefore that praise which Collatine doth owe
 Enchanted Tarquin answers with surmise,
 In silent wonder of still-gazing eyes. (11.50—70; 78—84)

In the presence of the "silent war of lilies and of roses" (1.71), in
Lucrece's "fair face's field" (1.72), Tarquin stands awestruck, frozen.
And yet, his mind is filled with Collatine's evening oratory; before a
real, as opposed to a rhetorical, beauty his thoughts tellingly return
to an assessment of the paradoxes inherent in Collatine's speech.
Tarquin mentally characterizes the previous blazon of Lucrece as

an expression of both a prideful need to possess and a foolish propensity to squander. But more important, when the reader "sees" what Tarquin sees, that spectacle proves to be little more than a heraldic amplification of one element of Collatine's description, an amplification operated through the introduction of a conceit that literalizes the rivalry already prefigured in the narrator's synopsis — her "unmatched red and white . . . triumph'd" (11.11–12). Lucrece's face becomes an animated shield colored in alternating red and white. Collatine's original praise was "unwise" to dilate or expand upon that coloration, and yet here her milky complexion and rosy blush fill four stanzas. Shakespeare's narrator, it appears, would outdo Collatine in rhetorical *copia*.

The form the expansion assumes, moreover, makes plain the implications of the heraldic metaphor upon which it depends: here metaphor re-enacts the descriptive scene the narrative has just recounted. What we read in Lucrece's face is the story of a competition that, although between allegorical queens, is entirely cast in the vocabulary of gentlemanly combat: first, beauty and virtue strive for predominance, "virtue bragg'd" (1.54), and "beauty boasted" (1.55); then, moving to territorially figured counterclaims for the right to display the other's colors, they shift ground to a field where the "red should fence the white" (1.63); and, finally, skirmish becomes serious as two ambitious warriors confront each other, "The sov'reignty of either being so great, / That oft they interchange each other's seat" (11.69–70). The warlike tale inscribed in Lucrece's face is, then, the tale of *Lucrece*: it proceeds from a boasting match — as in Tarquin's tent; to a claim for the opponent's "field" and "colors" — as we will see in the rape; to an exchange of sovereignty — as will follow the action of the poem.

Lucrece is fully blazoned only when Tarquin approaches her bed. He draws back the curtain, and his eyes begin "to wink, being blinded with a greater light" (1.375): the beauty of Lucrece "dazzleth" (1.377) her spectator into a state of suspended contemplation. The narrator describes Lucrece's body part by part, metaphorically identifying it with a city or country to be conquered (Kahn 1976:56–57). Although his description introduces new colors, it opens and closes with variations on Collatine's "red and white." Tarquin's initial assault, in the form of a touch, awakens Lucrece, and he tellingly explains his presence by evoking not what he has just seen with his eyes (her hands, her hair, her breasts) but rather what he had previously "seen" with his ears:

> First like a trumpet doth his tongue begin
> To sound a parley to his heartless foe,
>
> *
>
> But she with vehement prayers urgeth still
> Under what colour he commits this ill.

Thus he replies: "The colour in thy face,
That even for anger makes the lily pale
And the red rose blush at her own disgrace,
Shall plead for me and tell my loving tale.
Under that colour am I come to scale
 Thy never-conquer'd fort: the fault is thine,
 For those thine eyes betray thee unto mine.
 (11.470–471; 475–483)

Tarquin would persuade Lucrece with flattery. Indeed, taken out of
the context of a rape, his language is that conventional to "loving
tales": he celebrates her complexion; he represents her as a vir-
tuously unassailable fortress; he praises the irresistible beauty of her
eyes.

Tarquin goes on to define two moments in which Lucrece's beauty
has acted upon him: first, the moment in which her described
beauty destined her to be raped; and second, the moment, after his
period of self-examination, in which her perceived beauty reinforced
his conviction. It is clear, however, that the determining moment is
the first: in *Lucrece* vision is shaped by description. The rapist
returns obsessively to the narrator's five-line synopsis of Collatine's
winning blazon; he locates motive in that initial fragmentary portrait;
he speaks to his victim only of the bright eyes that "charge" and of
the red and white that "color" her shield. Although Tarquin assigns
responsibility to Lucrece, "the fault is thine" (1.482), his rhetoric
of praise reveals its agonistic subtext. Indeed, his descriptive stra-
tegies literally repeat those of Collatine: he moves from Lucrece's
complexion to her eyes; his final line, "For those thine eyes betray
thee unto mine" (1.483), usurps the "peculiar duties" (1.14) of
Collatine's conclusion.

In addition, Tarquin's pun on the word "color" — a word that
appears more often in *Lucrece* than in any other Shakespearean text
— signals the rhetorical origins of the crime. Lucrece asks under what
"colour" [pretext] he "commits this ill" (1.476), and he responds
that the color in her face will serve as orator to justify his action,
that under that color he rapes her. This word play is not new to
Tarquin; he has already used it in his self-vindicating soliloquy:

O how her fear did make her colour rise!
 First red as roses that on lawn we lay,
 Then white as lawn, the roses took away.

 *

Why hunt I then for colour or excuses?
All orators are dumb when beauty pleadeth.
 (11.257–259; 267–268)

Semantic play here depends upon the sixteenth-century possibilities
of the term "color": the "colors" of Lucrece's flesh — the red and

white of her face — are indistinguishable from the "colors" of heraldry — the symbolic colors on the shield that is her face — which, in turn, are indistinguishable from the "colors" of Collatine's rhetoric — the embellishing figures that fatally represent that face. Here body, shield, and rhetoric become one.

After the rape, the "heraldry in Lucrece' face" is transformed: she perceives herself as marked or tainted (Kahn 1976:46–47); her face wears "sorrow's livery" (1.1222). When Collatine arrives, he stares "amazedly" at "her sad face" (1.1591), at "her lively colour kill'd with deadly cares" (1.1593), and asks "what spite hath [her] fair colour spent" (1.1600). As the color pours out of Lucrece's body (Price 1945:282), her father and her husband compete for possession of the corpse: "Then one doth call her his, the other his, / Yet neither may possess the claim they lay" (11.1793–1794). Her father laments the loss of that "fair fresh mirror" that revealed in its complexion — its red and white — the blush of his youth: "O from thy cheeks my image thou hast torn" (1.1762). Her husband "bathes the pale fear in his face" — white — (1.1775), in Lucrece's "bleeding stream" — red, now tainted with black — (1.1774), and then, significantly, fails to make rhetoric of his experience:

> The deep vexation of his inward soul
> Hath serv'd a dumb arrest upon his tongue;
> Who, mad that sorrow should his use control
> Or keep him from heart-easing words so long,
> Begins to talk; but through his lips do throng
> Weak words, so thick come in his poor heart's aid
> That no man could distinguish what he said. (11.1779–1785)

Shakespeare's poem closes as it opened, as men rhetorically compete with each other over Lucrece's body. Now that the victorious orator has been rendered incomprehensible, another takes over with a call to revenge. The events that begin in a playful rhetoric of praise end in a serious rhetoric of blame. *Lucrece*, then, is clearly "about the rhetoric of display, about the motives of eloquence" (Lanham 1976:82), but what is "displayed" at each privileged moment is the woman's body raped at the poem's center.

<div align="center">*</div>

Lucrece is rare among Shakespeare's texts in that it is dedicated: "*Lucrece*: To the Right Honourable Henry Wriothesley, Earl of Southampton and Baron of Titchfield." Its dedicatory epistle predictably expresses devotion to its young dedicatee; it suggests that the poet's "untutored lines" are hardly worthy of their noble patron. Shakespeare's lines, of course, are anything but "untutored"; for *Lucrece* is a masterpiece, that is, a piece "made by an artist to prove he is a master" (Lanham 1976:82). The closing of the London

theaters in the early 1590s compelled young playwrights to impose themselves as masters of alternate genres; patrons, like Southampton, had to be courted and rival poets conquered. The glossy rhetorical surface of *Lucrece* — the insistent foregrounding of "display pieces" that has prompted so much critical praise and blame (Bradbook 1952:115) — serves, above all, to demonstrate the prowess of the poet. The representation of the warrior's shield — the shield of Achilles, the shield of Aeneas — figures, of course, among the most canonically valorized tests of any descriptive poet who, in outdoing the painter, would outdo other poets also (Hulse 1978:13).[7] Entered in a contest of skill, Shakespeare's encomium of Lucrece, like Collatine's, stands as a shield, as an artfully constructed sign of identity, as a proof of excellence.

Shakespeare, it must be noted, is not the first to enter such a contest armed with such a metaphor. The rivalry among the original *blasonneurs*, each one displaying *his* part of woman's body, was quite literally fought out: Maurice Scève triumphed by virtue of the superiority of his "Eyebrow." In *Astrophil and Stella* XIII, Astrophil (Sidney) praised Stella (Penelope Rich) by inventing a competition among male gods as to "whose armes the fairest were" (1.2): Cupid won, "for on his crest there lies / *Stella*'s faire haire, her face he makes his shield" (1.10).[8] Combattants offer up blazons — poems or/as shields — for aesthetic judgment: they seek the status of best among poets or best among gentlemen. Far from being simply an "invention fine" (*Astrophil and Stella* I.6), a clever conceit that lavishes old praise in a new way, the heraldic metaphor "woman's face is a shield" emblematizes the conflict that motivates it. Here celebratory conceit inscribes woman's body between rivals: she deflects blows, prevents direct hits, and constitutes the field upon which the battle may be fought. For to describe is, in some senses — as *Lucrece* so eloquently reminds us — to control, to possess, and ultimately, to use to one's own ends.

There is something troubling about the "heraldry in Lucrece' face" — be that the face of Lucrece or of *Lucrece*. As a shining and resistant rhetorical surface,[9] the metaphor "woman's face is a

7. Hulse is correct in showing that at one point the face of Tarquin is briefly related to a shield (1978:14). I read that hypothesized image, "Yea, though I die the scandal will survive/And be an eye-sore in my golden coat" (11.204—205) not as a counterpoint to, but rather as determined by the earlier explicit, lengthy identification of Lucrece's face with a shield.

8. Bradbrook states that "the heraldry of Lucrece's face is set forth in a manner derived from" this sonnet (1952:110—111).

9. In an observation that disturbingly underlines the problem, Michael Platt notes that "the reader must penetrate the brilliant, artificial, and enchanting surface of *Lucrece*" (1975:61).

shield" operates a stylized fragmentation and reification of the female body that both transcends the familiar clichés of the battle of the sexes and stops the reader short. The fourteenth-century Italian humanist Coluccio Salutati suggestively associated such dazzling rhetoric with another image of a face on a shield: "Medusa," he wrote, "is artifice, is eloquence" (1951:417; translation mine).[10] He made this identification through the elaboration of a false etymology, through an interpretation of the name of Medusa's father, Forcus, as derived from the Latin *for* ("to speak"). Medusa figures in two contexts as a face on a shield: first, Perseus uses a shield to reflect her image and thus avoid looking at her directly, her mediated image permiting her decapitation; and second, when the battles of Perseus are done, he gives the head of Medusa to Athena who bears it on her aegis, an aegis copied by later warriors. As the face that one carries into battle, that turns men to stone, that curiously converts life into art, the power of the head of the Medusa resides in its ability to stupefy. "Whatever the horror the Medusa represents to the male imagination," writes John Freccero, "it is in some sense a female horror. In mythology, the Medusa is said to be powerless against women, for it was her feminine *beauty* that constituted the mortal threat to her admirers" (1972:7). That threat is, moreover, a threat of forgetting: "Medusa signifies oblivion, which is without doubt rhetoric, which changes the state of mind of a man making him forget previous thoughts" (Salutati 1951:417; translation mine). In the single stanza between the description of Collatine's boast and the vision of Lucrece's face as shield, we return to a Tarquin speeding to Collatia, "His honour, his affairs, his friends, his state, / Neglected all. . ." (11.45—46). Collatine's rhetoric has indeed stupefied the opposition, has functioned as did perfect shields "in such glorious and glittering manner, that they dazzled the eyes of the beholders" (Guillim 1660:6). Here, rhetorical display and heraldic display are of a single purpose; and here, both depend upon the figuration of a woman's face.

The association with the image of the Medusa, a beautiful woman punished with monstrousness for a forbidden sexual encounter — some traditions define it as a rape — introduces a deep ambivalence into the "heraldry in Lucrece' face." The monstrous becomes the other side of the beautiful; the obsessively spoken part — the face — the other side of the obsessively unspoken but violated part — the genitalia (Ferenczi 1927:360; and Freud 1963:105—106 and 174); and fear of the female body is mastered through polarized figurations that can only denigrate or idealize. As the display of an image

10. I am indebted to Albert Ascoli for bringing Salutati's text to my attention.

becomes so powerful that it triggers a revolution,[11] the motives, strategies, and consequences of description assume alarming proportions. In the "world of harms" (1.28) that is the warlike context of *Lucrece*, the secret of survival is clearly neither to be a shield, nor to see a shield, but to know how to use one.

11. Neil Hertz, turning to a sequence of nineteenth-century texts that use the head of the Medusa as an emblem of revolution, suggestively analyzes "the representation of what would seem to be a political threat as if it were a sexual threat" (Hertz 1983:27).

REFERENCES

Battenhouse, Roy W., 1969. *Shakespearean Tragedy: Its Art and Its Christian Premises* (Bloomington: Indiana UP).

Les Blasons anatomiques du corps fémenin, 1543 (Paris: Charles Langelier).

Bradbrook, M.C., 1952. *Shakespeare and Elizabethan Poetry: A Study of His Earlier Work in Relation to the Poetry of the Time* (New York: Oxford UP).

Bullough, Geoffrey, ed., 1957. *Narrative and Dramatic Sources of Shakespeare*, vol. 1 (London: Routledge and Kegan Paul).

Cixous, Hélène, 1980. "The Laugh of the Medusa," trans. Keith Cohen and Paula Cohen, in: Elaine Marks and Isabelle de Courtivron, eds., *New French Feminisms* (Amherst: Univ. of Massachusetts).

Donaldson, Ian, 1982. *The Rapes of Lucretia: A Myth and Its Transformations* (Oxford: Clarendon).

Ferenczi, Sandor, 1927. *Further Contributions to the Theory and Technique of Psychoanalysis*, ed. John Rickman (New York: Boni and Liveright).

Ferguson, Arthur B., 1960. *The Indian Summer of English Chivalry: Studies in the Decline and Transformation of Chivalric Idealism* (Durham: Duke UP).

Freccero, John, 1972. "Medusa: The Letter and the Spirit," *Yearbook of Italian Studies*, 1–18.

Freud, Sigmund, 1963. *Sexuality and the Psychology of Love*, ed. Philip Rieff (New York: Crowell-Collier).

Guillim, John, 1660. *A Display of Heraldrie*, 4th ed. (London: Blome).

Hertz, Neil, 1983. "Medusa's Head: Male Hysteria under Political Pressure," *Representations* 4, 27–54.

Hulse, Clark, 1978. " 'A Piece of Skilful Painting' in Shakespeare's 'Lucrece'," *Shakespeare Survey* 31, 13–22; reprinted in 1981, *Metamorphic Verse: The Elizabethan Minor Epic* (Princeton: Princeton UP).

Kahn, Coppélia, 1976. "The Rape in Shakespeare's *Lucrece*," *Shakespeare Studies* 9, 45–72.

Lanham, Richard A., 1976. *The Motives of Eloquence: Literary Rhetoric in the Renaissance* (New Haven and London: Yale UP).

Livy, 1939. *From the Founding of the City*, trans. B.O. Foster, vol. 1 (London: Heinemann).

Luigini, Frederico, 1554. *Il Libro della bella donna* (Venice: Plinio Pietrasanta).

Ovid, 1931. *Fasti*, trans. James George Frazer (London: Heinemann).

Platt, Michael, 1975. "*The Rape of Lucrece* and the Republic for Which It Stands," *Centennial Review* 19, 59–79.

Price, Hereward T., 1945. "Function of Imagery in *Venus and Adonis*," *Papers of the Michigan Academy of Science, Arts, and Letters* 31, 275–297.

Salutati, Coluccio, 1951. *De Laboribus Herculis*, ed. B.L. Ullman, 2 vols. (Zurich: Thesaurus Mundi).

Shakespeare, William, 1886. *Othello*, ed. Howard Furness (Philadelphia: J.B. Lippincott).

 1958 *Othello*, ed. M.R. Ridley (London: Methuen).

 1960 *The Poems*, ed. F.T. Prince (London: Methuen).

1974 *Othello*, in: G. Blakemore Evans, ed., *The Riverside Shakespeare* (Boston: Houghton Mifflin) 1198—1248.

Sidney, Sir Philip, 1962. *The Poems of Sir Philip Sidney*, ed. William A. Ringler, Jr. (Oxford: Oxford UP).

Stimpson, Catharine R., 1980. "Shakespeare and the Soil of Rape," in: Carolyn Ruth Swift Lenz, Gayle Greene, and Carol Thomas Neely, eds., *The Woman's Part: Feminist Criticism of Shakespeare* (Urbana, Chicago, London: University of Illinois Press), 56—64.

Stone, Lawrence, 1965. *The Crisis of the Aristocracy 1558—1641* (Oxford: Clarendon).

EDGAR DEGAS
AND THE REPRESENTATION
OF THE FEMALE BODY

CAROL M. ARMSTRONG

In Western painting the female body has a genre all its own, that of the female nude. As the master genre of the official French salons of the nineteenth century (Clark 1985:79ff), it can be said to have been conceived as a genre with no other purpose but the deployment of the gaze and the brush — the "pure" acts of looking, forming, touching, painting, whose aim was to display as much while meaning as little as possible, to aestheticize and idealize the gaze and the object of delectation, and to metaphorize tactile response through facture and formal rhymings. The female nude would come to constitute one of the principal leitmotifs of avant-garde practice, from Courbet to Matisse and Picasso; and it is no wonder that the erotic appropriation of the body in paint would so easily lend itself to aestheticization and abstraction (Steinberg 1972:174ff; Duncan 1973). That potential was there from the very beginning of the genre.

One of the things any painted object does is to resist signification at some level because of its very objecthood. And the female nude — because of *its* objecthood — may be seen as almost emblematic of that level of resistance. In fact, the female nude has been linked to that stratum of painting most in tension with the work of signification — the stratum we connect to what we call, inadequately, "abstraction": facture, the handling of paint per se, foregrounded as an obvious fact of the painting. Femaleness and facture, facture and the female nude, they go together somehow. One need think only of Titian, the first great painter of the female nude in the Western tradition.

The link between facture and the female body was made, in Titian's case, by Paul Valéry (1938[1936]:58): "It is easy to see that for Titian, when he painted Venus in the plenitude of her perfection *as goddess and as painted object...to paint was to caress,* to join two kinds of sensuality in one sublime act, in which possession of the Beauty through all the senses was joined" (italics mine).* Valéry's passage is about the erotic possession

* Unless otherwise noted in the References, the English translations from the French are mine.

of the female body, thematized in the painting of the female nude. But it also states a relationship between the female body, the corporeality of the act of painting, and the physicality of paint itself, between gaze and painterly touch, viewed body and painted object; thus, at least implicitly, it emphasizes facture as an issue.

The female nude was also linked to the other level of painting that we connect to "abstraction" — to form per se. Valéry had this to say about Ingres, the nineteenth-century master of the female nude and the artist whom Degas most admired: "M. Ingres pursues grace to the point of monstrosity; the spine is never supple or long enough for him, the neck never flexible enough, the thighs never slick enough, or bodily curves conducive enough to the gaze which envelops and touches them as it sees them" (ibid). Grace, long spine, flexible neck, slick thighs, curves and contours: this is the language used by Valéry to describe Ingres's nudes. The gaze turned on the female nude in this case (and the disembodied touch which it implicates) is an eroticized gaze, but it is also a highly aestheticized one. In fact, eroticism and aestheticization are here inextricably linked — *form* is declared as the object of the erotic gaze. If one considers just these two passages and these two painters, it would seem, then, that the female body in Western painting, or at least the female nude as a genre, is purely a matter of facture and form, and that formalist practices of criticism would be and have been more appropriate to it than semiotic ones.

The justice of this view is suggested in another passage by Valéry on Degas's nudes. In the same text that I have been quoting, Valéry treats Degas's engagement with the nude thus: "All his life, Degas sought in the Nude, observed from all sides, in an unbelievable quantity of poses...the unique system of lines that would formulate any given moment of the body with the utmost precision and the utmost generality" (p. 59). According to Valéry — and in this respect his is a common modern judgment — Degas's treatment of the female nude was particularly formalist (elsewhere Valéry calls Degas an "abstract artist"; p. 48). But, again according to Valéry, Degas's formalism was peculiar: of a structural, systematic nature, grounded in the study and formulation of the body's movements, and hence of its dematerialization into motion and design, it seemed to be both antierotic and genderless, or at least androgynous — a fusion of the terms of the male and the female body (p. 59). This too was a common judgment about Degas and the female nude.

Valéry's commentary is important because it is representative of the formalist attitude toward Degas's nudes. Another well-known writer, whose very different judgments about Degas and the female body are significant, is Joris-Karl Huysmans:

> ...not just a case of a man's wavering distaste for women — it is even more than that — it is the penetrating, sure execration that these women themselves feel for the deviated joys of their own sex, an execration which fills them with atrocious desires and leads them, all on their own, to soil themselves, proclaiming loud and clear the

humid horror that they feel for their own bodies — which no lotion, no amount of cleaning, will clean (Huysmans 1894 [1889]:27).

Countless critics contemporary to the artist argued for a case of misogyny; Huysmans's piece on Degas's nudes of 1886 was merely the most notorious and explicit of these arguments (1894:22ff). On the other hand, many writers since then have argued against the case of misogyny; Huysmans's text is the basis of the best of the recent counterarguments, that of Edward Snow, who claims that it is the male viewer, not the female body, whose position is made deeply problematic in Degas's nudes (1979:25ff). It is not my concern to argue for or against Degas's misogyny; based on a sentimental fascination with the artist's biography rather than on an engagement with his complicated representational concerns, this debate is a highly reductive one — in fact, I believe that the pronouncements of critics like Huysmans and Snow may be considered as two sides of one representational coin. It *is* my concern to show how the questions of form and facture as attached to the female nude and the notion of the antierotic representation of the female body may be juxtaposed, with an eye toward understanding the significance of the formalism of the female nude, both as a genre and in this one artist's practice.

I have chosen to write about Degas's oeuvre because he was the "classical" painter of the female body of the nineteenth century, preoccupied with its representation almost to the exclusion of all else; and he was the one "avant-garde" painter, besides Manet, his closest contemporary, who responded critically to the master genre of official painting, the female nude. In the following study of a selected group of his works, I would like to show that Degas's nudes may be seen as a deliberate revision of the syntax of the female body and of the structure of viewing in which it was traditionally situated; that they may be seen as describing a relationship between viewer, space, and body that speaks to the traditional positioning of the *male* body, the meaning of its exteriority, its projection into a field of vision, and ultimately into disembodiment and invisibility; finally, that they problematize the formalism of the female nude, and the meaning of its apprehension through form and facture. These are all; as I also intend to show, connected issues.

Degas's treatment of the female body begins with an engagement in history painting and genre pictures, in other words, with the female body inserted into narrative and anecdotal situations. In both cases Degas begins with references to neoclassical compositions and to the repertoire of gender conflict associated with history painting. Instances of each are found in the *Spartan Youths* of 1860 (Fig. 1), Degas's first and most important history painting, and in *The Interior* (more luridly known as *The Rape*) of 1868 (Fig. 2), which the artist termed his "genre painting." Both images purport to illustrate scenes from texts, one classical, *The Life of Lycurgus* (Pool 1964:307ff), one realist, Duranty's *Les Combats de François Duquesnoy* (or alternatively Zola's *Thérèse Raquin* — Bell 1965; Reff 1976:307ff). In

FIGURE 1 Edgar Degas, *The Spartan Youths.*

FIGURE 2 Edgar Degas, *The Interior.*

both the artist appropriates a format associated with David's history paintings — the rifted, divided-down-the-middle, frieze-space format of *The Oath of the Horatii*, for example (Fig. 3). As in David's imagery, both paintings depict the matching-off of the sexes, though in neither case is there a public message to justify the gender-conflict theme.`

Indeed, in *The Spartan Youths* the opposition between male and female, which is the staple of much history painting and such an important element of David's pictures, is thematized to the exclusion of all else. This painting is a rehearsal rather than a significant event, a simple scene of athletic practice; there is no story to be told here. The oath represented by David in the unified, stiff-armed gesture of the sons of Horatius at the crucial moment of the story (the moment when the Horatii swear to fight to the death the representatives of the opposing kingdom, the three sons of Curatius, in defense of Rome) is transformed into a non-narrative gesture of challenge made from the female to the male half of the painting. There is no narrative context for the opposition of the sexes; it is simply the theme of *The Spartan Youths*.

In *The Interior* Degas refers once again to the Davidian composition, to the oppositional format replete with the looming gap in the middle, here resonating with lurid orthogonals — the lines of the floorboards which, in the traditional single-point perspective system, would have marked the viewer's lines of sight. And once again Degas seems to take the opposition between male and female as his subject. The meaning of this opposition has often been debated. There have been several attempts to read *The Interior*, most notably those of Quentin Bell and Theodore Reff. None of them, however, has been conclusive, for although the painting is full of clues (the furnishings, the open valise, the corset strewn on the floor, as well as the contrast between clothed and unclothed, dominant and defeated figures) and although it seems obviously illustrative and hence demands to be read, *The Interior* is like a piece of detective fiction with no solution; it is a picture that seems to require a caption. It has received one, in the title *The Rape* that has been pinned to it by critics, equally inconclusively (Degas apparently denied it).

Thus the opposition between male and female that was the sole subject of *The Spartan Youths* has become a puzzle in *The Interior*. Again this is because of Degas's transformation of the narrative structure of the history painting upon which he was drawing. If in *The Spartan Youths* he took the active pole of David's narrative painting and transformed it beyond recognition, in *The Interior* he turns to the still side, to the figures of the women in the *Oath* and that of Brutus in the painting of that name. Both figures are still in *The Interior*, as still as the objects about them; there is no gesture to counter and make meaning of their stillness and the resonating gap between them, no active/passive relationship to make sense of the opposition between male and female, as there is in the picture's neoclassical sources.

FIGURE 3 Jacques-Louis David, *The Oath of the Horatii.*

There is a gaze, however. Indeed, *The Interior* thematizes the visual relationship between male and female that informs the genre of the female nude. For it is not quite right to say that there is no gesture here, no action: the male figure in *The Interior* gestures and acts through his gaze. As a body, he is all gaze; his activity is constituted as that of viewing, and the relationship between the two as that of viewer to body, a subject acting upon an object through the gaze. This relationship is substituted for the earlier narrative opposition on which it appears to be based — the verb of looking simply replaces that of acting. That is the "text" of this picture; it is also its definition of the male part in the representation of female bodies (Berger 1972:45-64).

As for the female figure in *The Interior*, she is there in that domestic space, with her blank white back turned to the viewer, to signal the captionlessness of the picture. She is described as a piece of muteness which meets and deflects a gaze. And this is the picture's definition of the female place in painting. Where David's *Oath* spelled out the male and female roles in history painting — the male half as that of significance, the side which signals the message; the female half as that of stillness, the side which works against the grain of the narrative, opposed to the main drive of the story and to its message — Degas's *Interior* translates those roles

into that of the look and that of the object. The relationship between the two, constituted in oppositional terms, is declared as the problem of the picture.

The importance of the *Spartan Youths* and *The Interior* resides in their reconstruction of the narrative relationship between male and female bodies, and their problematizing of the opposition between the two. This is how Degas begins; it is important, I think, to see his nudes against such a background.

One of these nudes is the *Bather* of 1885 (Fig. 4), a rare instance, in Degas's oeuvre, of the reclining, frontal nude, but an important picture to him, since he executed it twice. Though like his other nudes it has no textual source, it does have a pictorial one, Cabanel's *Birth of Venus* (Fig. 5); this famous example of the academic nude was also painted twice, once in 1863 and then again in 1875. The *Bather* is a significant image and its reference to *The Birth of Venus* a significant move, for it problematizes both the official pose and pretext for the nude and the traditional means of apprehending it through form and facture.

The *Bather* declares itself as an object of the gaze — if nowhere else, in the arm flung over the face of the woman to hide her gaze, to hide from ours, to define the gaze as the issue. This arm bears further looking at; it is Cabanel's arm, which in turn is Ingres's arm (Cabanel's *Venus* seems to derive from Ingres's *Odalisque and Slave* of 1842; see Fig. 6). Not only the arm over the face is borrowed, but the other arm as well, the exposed breasts, the swing of the hip and knee — in short, Degas's *Bather* is a wholesale reworking of *The Birth of Venus* (and, secondhand, of the *Odalisque and Slave*), in which the mythological and oriental justifications for the nude are deleted.

Manet's *Olympia,* with its quote of Titian's *Venus of Urbino,* is the more famous version of a lifted pose, and a more obvious challenge to the official nude and its official pretexts (Clark 1980, 1985). Olympia's challenge lay in her ambiguous identification as prostitute, courtesan, and sixteenth-century nude, in her deadpan gaze, her high positioning and her refusal of the langorous, curvaceous pose of self-abandonment, in her coiffure and traces of bodily hair, the Baudelairean cat and the bouquet of flowers sent her by her client: flat, deliberate misreadings of Titian's *Venus* which conspire to unsettle the pretext for the nude, the reading and enjoyment of her body and the status of the male viewer.

In Degas's *Bather,* by contrast, there is no gaze to meet, half-meet, or not meet ours; the gaze of the nude is explicitly covered. There is no tipping of the body up and away from us — quite the contrary — no question of a model's or a woman's identity, no question of setting or client, nor even any question of quoting. Although the *Bather* makes reference to the pose of another nude, it does so without the overt quotation marks and the broad mistranslations typical of Manet's practice in general.

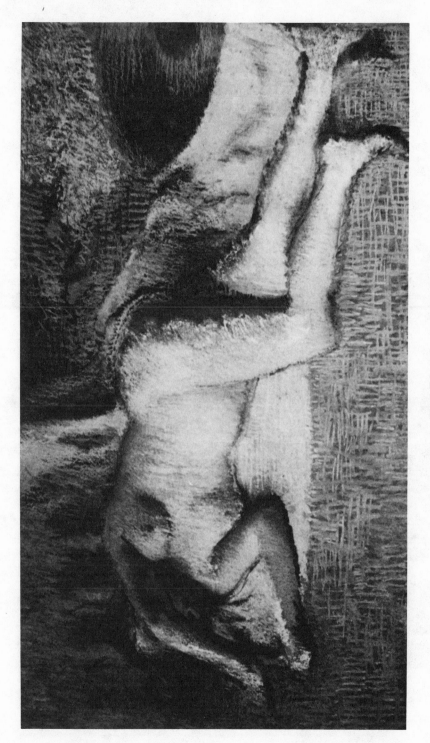

FIGURE 4 Edgar Degas, *Bather.*

FIGURE 5 Alexandre Cabanel, *The Birth of Venus*.

FIGURE 6 J. A. D. Ingres, *Odalisque and Slave*.

Yet Degas's *Bather* carries on a dialogue of its own with the official imagery of the nude, and its lifting of Cabanel's pose is an equally problematizing one. For as much as the *Bather* declares herself as an object of the gaze, so are her masses and contours rearranged in such a way as to deflect and resist its pressure. Take the gesture of the arm again: where in Ingres's *Odalisque* and Cabanel's *Venus* it is lifted back to expose and stretch the line of the breast and continue the line of hip and waist, and where in the latter it is flung over the brow to almost hide, and in so doing to stress, the flirtatious glance of the nude, in Degas's *Bather* the arm is angled over the face to cancel out the inviting glance, and though fully exposing the chest, it transforms the fleshy hill of breast into the bony angle of an awkward shoulder. The same is true of the arm on the floor, pushed against the chest so that a comparison between breast and elbow is forced. Flesh is turned into bone; movements of stretching and facts of contact become ones of torsion and pressure; and a gesture of exposure, ease, and self-abandonment becomes one of protection, discomfort, and mortification. Added to this is the rearrangement of hip and leg, pulled over to combine a side view with a frontal one, to transform a sensuous thigh into a straining rump and flank, to hide flatly both pubis and pelvis rather than to disclose them. Hands and feet have become unfinished stumps, lengths of titian hair a blunt rope of russet, the face a half-obliterated skull. There is something of an image of martyrdom in all this, in these deliberately rearranged, angled limbs. In its transformation of *Venus,* the *Bather* manages a conflation of Susannah and St. Sebastian.

The *Bather* has no textual source, it is true; but Degas himself, in speaking of his nudes, was wont to refer to the Susannah theme: "Two centuries ago I would have painted *Susannah at Her Bath;* now I paint mere women in their tubs" (Halévy 1960:14). (The Susannah theme is also suggested in the oppositional relationship between male gaze and female body in *The Interior* and in the apocryphal title given it, *The Rape.*) Moreover, implicitly and explicitly, writers have likened Degas's female figures to the bodies in the works of the German, French, and Flemish primitives, to the mortified limbs and flesh of crucifixions and martyrdoms, frequently characterizing his stance vis-à-vis the female body as a cruel one:

> What is Gothic in Degas is Gothic in the severest sense. Gothic line, but tenser, more jagged...than any of the primitives of France...Degas rejected all softness, he seized an ankle, but not the flesh. The puppets which nestle together softly in Ingres, move by taut wires in Degas, and their motion is the dance of death. Not a sound emanates from their mummified faces. Bones have expressions and human backs are bent in anguish, arms howl and legs whine (Meier-Graefe 1923:79-81).

The characterization of the *Bather* as Susannah-cum-St. Sebastian, as Venus reinterpreted as Susannah, and Susannah in turn reinterpreted as St. Sebastian, is not so far-fetched; it is partially indicated in the writings of critics contemporary to the artist. Like these writings, it is exaggerated, but it is also somehow right. Yielding flesh transmuted into straining

bone, bounding curves into joints pulled and pushed around; the relaxed, abandoned, sensuous body of the goddess of love transformed into the resistant, disarticulated one of the martyr, and the look declared as a kind of pressure, a violence inflicted on the body like a rape or a subtle torture — in sum, the body of delectation turned into that of mortification, in both senses of the word: this, though perhaps overstated, is the meaning of Degas's transformation of Cabanel's *Venus*.

Manet's Olympia is as notorious for the way she is painted as she is for her quotation of the pose of the *Venus of Urbino*. Titian's famous facture is transformed in *Olympia* into stark, unmodulated contrasts and broad, harsh areas of signboard paint which refuse the union of visuality and tactility so fundamental to Titian's *impasto* — the translation of gaze into caressing touch suggested in Valéry's passage on the great painter of the female nude, the transformation of painted surface into the fleshy thicknesses of the female body.

This brings us to the problem of facture in Degas's *Bather*. It is foregrounded as a concern; this should be immediately evident. Yet the picture does not at first glance constitute a refusal or a denial of tactility. On the contrary, Degas's *Bather* presents the viewer with just as many invitations to touch as does Cabanel's *Venus* or Ingres's *Odalisque*. In the *Venus*, the garland of putti echoes the contour of the body, inviting the gaze of the viewer to turn into touch through the almost-but-not-quite gesture of the putto farthest to the right; in the *Odalisque*, the spill of hair is echoed in the loops of the hookah pipe, the swing of the hip in the curve of drapery over the balustrade in the back, and the smoothness and slickness of white flesh in the filmy white drapery and satin garment, while the thumb resting on the curve of her forearm presents the viewer with an incident of vicarious tactility; in Degas's *Bather*, touch is everywhere evoked, concentrated, and diffused — in the masses of drapes, material, and toweling surrounding the bather's body, and in the web of pastel strokes on the surface of the paper, covering and hovering over her form. The implications and invitations to touch, the inviting, softening echoes of the body in its surroundings, the vicarious details of contact seen in Cabanel's and Ingres's pictures are loaded directly, in Degas's *Bather*, into the fact of facture itself.

Thus touch as an extension of the sight of the female body is something not only allowed but declared in the surfaces of Degas's *Bather*, or so it appears. There is no challenge there. Yet it is a peculiar allowance, a strange declaration, for inasmuch as this body is constituted through facture-as-touch, so is it lost: the object of sight seems to recede, to disintegrate behind the fabric of touch. The body lies behind and separate from the gauzy web of white laid over it — it is virtually obliterated by its surface, a uniform mesh of hatching lines normally associated with the chiaroscural definition of mass and volume and with the printerly evocation of light and shadow, here made into a kind of screen stretched flat so that its warp and woof are displayed.

The palette of yellow, orange, and green that constitutes the peculiar surface of the *Bather* is a further confusion of the traditional distinction between line and color, hence between surface and edge, skin and volume, sensuous and intellectual appropriation of the body. Color is displaced into the materials of the room and displayed as a weave of separate threads of pigment, while the body caught up within it seems by contrast rather drained of color. Moreover, surfaces and edges — the body's expanses and its limits — are confused, as in the meeting of thigh and calf, and the blending of body and ground seen in the feet and nether thigh. All the means of defining the body are unraveled here: the contour that defines the buttock is repeated, given a kind of nervous, electric jolt in that wriggling second line, as if to mark a fundamental, deliberate hesitation in the very act of defining, delimiting, and delineating the body.

Thus the means of graphic and painterly definition of surface and form are disassembled, transformed into a constitutive field that will not hold together. Not only is the uniform texture of a painted surface put at a fundamental remove from the real textures of skin, flesh, and blood; it is also a surface in which vision and touch are at odds, rather than in harmony with one another. In fact, it would now seem that Degas was concerned to show that the artist's (and hence the viewer's) constituting touch was *not* an extension of the sight of the body, as suggested in the rhymings in Cabanel's *Venus* and Ingres's *Odalisque*, but a kind of obliteration and negation of it. This is supported by the way the web of pastel replicates the weave of canvas, pulling the field of touch away from the body which it is supposed to create and apprehend, back to the very ground on which it is laid.

Degas's reworking of the facture associated with the nude is consistent with his reworking of its form and pose: both are stated as problems in the imagery of the female body. While the nude is returned to the ground-floor level of form and facture, the easy coalescence of the latter into body and the sublimation of the viewer's response are blocked. Because they are pulled apart, form and facture are declared as the constructs of gaze and touch, shown to be subject to a viewing and constituting presence which is allowed no release from these activities. At issue in the formalism of the nude is an elision between the erotic and the representational appropriation of the female body: in the *Bather*, that elision is forbidden.

The *Bather* is an exception among Degas's nudes because of its frontal pose; more commonly they are turned completely away from us. This is the case in the Jeu de Paume *Tub* (Fig. 7), part of a series of some ten nudes that Degas exhibited together in the last Impressionist show of 1886. Such was the insistence on backs turned to the viewer that Huysmans termed this series an "insulting adieu" — a final retreat from, a rejection and negation of, the viewing public (Huysmans 1894:23). Such also was the insistence on privacy and exclusion, on a world of female

FIGURE 7 Edgar Degas, *The Tub.*

bodies existing in relation only to themselves, that Degas himself gave the series a title consisting of a list of reflexive verbs: "Suite de nus se baignant, se lavant, se séchant, s'essuyant," thereby insisting not only on the ablutionary activity of the nudes but on their reflexive actions and gestures, on the reflexive life of the female body; this was a fact noted by Huysmans as well. In the following commentary I shall use *The Tub* to represent the series as a whole.

The Tub presents the viewer with a back and a reflexive gesture — the elbow angled around to reach at the back, the sponge glued to the nape of the neck. Though similar to the details of vicarious and imminent contact seen in Ingres's and Cabanel's nudes, replete with the stress on ear and nape, this gesture subtly negates the message of such details. For this body's very physical, indeed muscular contact with itself, its emphasis on touch, is directed away from rather than toward the viewer. It is not an invitation — quite the contrary. It is not only the gesture that is reflexive and exclusive but the body as a whole, folded entirely over on itself, the line of breast and midriff sandwiched against a thigh, an exterior contour become an interior crease, outermost joint connected to innermost fold of a uterine shape, the other outer contour forming a line that circles back on itself, emphasizing closure. These forms of circularity and closure are echoed in the shape of the tub itself and in the handles, hips, and backs of the pitchers on the ledge — rhymings like many others in the genre of the female nude, but deflecting rather than delectable ones, parts of a system of abstract design that confirms closure and refusal of the gaze rather than access and enjoyment. This, then, is a female body that is entirely reflexive, existing in relation to itself, deflecting and excluding the viewer, refusing all exteriority. As such, it negates the traditional function of the female nude: to be present to the gaze of others; it negates as well the function of the nude's aestheticization and abstraction: to provide a sublimated mode of appropriation.

The female nude, when free of narrative situations, is most often constituted frontally and horizontally — as a kind of landscape, its significant part the torso, its limbs merely elongations of the line created by the supine, stretched-out torso. This is the case in the *Venus* and the *Odalisque,* and despite its torsion, in the *Bather* as well. The body in *The Tub* is constituted rather differently; its geography is difficult to read. Neither fully horizontal nor vertical, it reads first as all torso, without legs either to continue its line or to support it; then as all arms; then as a series of stumps — the elbow, the feet, the U-shaped body. As much as the *Bather,* the figure in *The Tub* is a matter of torsion and tension, forcefully arranged into a complex of opposing, straining limbs — with her feet in runner's starting position, her absent calves, her thighs swung back behind her stiffened supporting arm, her hip swung around and flattened out, her shoulder dislocated, her arm pulled back to press against the frame and to meet her arched and crease-marked neck. No easily supine geography, this; in fact, hers is a body caught uneasily between landscape and architecture — the landscape of the reclining torso and the upright architecture

of supporting, articulating, and gesticulating limbs — between the body continuous and fluid and the body sectioned and branched; in short, between male and female bodies as they are constituted in their most extreme representational poles (as in David's *Oath*, for example).

But there is more than that here, more than a body caught between horizontality and verticality, landscape and architecture, geography and gesture, male and female. It is a body inverted and reversed, and as such, although it is closed and in the process of being cleaned, it might be said to belong to the category of the grotesque as Mikhail Bakhtin defines it (1984:303ff). This comparison is appropriate only insofar as Degas's images work to upend bodily canons; his is by no means a popular imagery of the body. It is perhaps also more appropriate to Degas's private series of images of groups of naked prostitutes of approximately 1880, with their thighs splayed, their legs and rumps in the air, black hairy heads likened to black smudged genitalia, masturbating and mooning the viewer. There is nothing so blunt in *The Tub* or in the series to which it belongs, yet it does pertain, albeit more subtly, to the same corporeal category. Certainly Huysmans, with his emphasis on onanistic gesture and women soiling themselves, described the nudes this way — and not entirely without reason, given their reflexivity.

The Tub fits the category of the grotesque in its disarrangement of the order of the body. The figure in this painting is depicted as a function of its rear and nether portions — all support for and extension of its butt and haunches, around which the whole mass of the body pivots. The geometry and symmetry of the body in *The Tub* are further disrupted by its one-arm support stance, so that it is an arm, and not the legs, which supports the body; a hand which makes contact with the floor and is thereby compared to the feet; thighs, not arms, which are aligned along the sides of the body; and finally, the continuous line formed by the arms which marks not the body's symmetry, but its vertical axis.

Thus *The Tub* is a representation of a female nude whose bodily syntax has been entirely disarranged: reflexive and closed, tilted and inverted, caught between the male and the female poles of verticality and horizontality, gestural extremities and uterine interiority — joined reflexively, in a kind of pictorial onanism, as Huysmans saw. Not only is the female body constituted as an object that deflects the gaze and externalizes the viewer, thus negating the function of the nude; it is also presented as a profoundly unreadable entity, precisely because the female body as a field of sight and touch, as well as its function as gesture, are all turned in on themselves.

Edward Snow argues — in contrast, he claims, to Huysmans — that it is the position of the male viewer and the place of the male body, its externalization and disembodiment, that are most in question in images like *The Tub*. This seems correct: the reflexivity, the reversals and inversions characteristic of *The Tub* are all ways of calling into question the male figure, as viewer and as bodily presence. If the reflexive gestures and

forms work to turn the linguistic function of the body against and in on itself, quite literally — they are gestures that turn against communication, that turn in on the body's thicknesses and silences — they also speak to the fact of exclusion. The rhymings of this image — to abstraction and aestheticization as closure, circularity, interiority, rather than delectation and appropriation — speak to the pressure of exclusion as well.

Images like *The Tub* have been considered voyeuristic — by the artist himself, in his invoking of the Old Testament narrative of Susannah and the Elders; he also tells us that he wished to see and depict the nude as if through a keyhole (Lemoisne 1946-49:107). This confirms, in part, the notion of exclusion — voyeurism is predicated on being *outside*; but in part it contradicts it, for the other, the outsider, the possessor of the gaze, is implicated at every turn. This is the case in *The Tub*, where everything about the framing of the nude forces an awareness of an outside gaze and an external presence: the overhead view, the way the body and its space are so closely aligned with so many edges — the elbow with the upper frame, the rim of the tub with the lower frame, the woman's buttocks with the ledge. And then there is the ledge itself seen impossibly overhead, its cropped objects and its protruding elements stressing the fact, and the pressure, of the edge. Not only is this an impossible, awkward, too-close view which speaks so much to exclusion that it allows no place for the viewer to stand — one would have to climb atop the ledge to see it thus, yet one may not, since it is rather insistently vertical; it also easily implies a threat, an unseen presence, with whom we are forced to identify, as we identify with the camera angle when it moves with a perpetrator or a protagonist and forces us to see past thresholds, past the edges of doors and windows, to a victim's unaware back. Edges, and the fact of proximity: if they speak of exclusion, they also speak of the pressure of imminence, of imminent inclusion. In *The Tub* the line is trod between exclusion and inclusion, proximity and barrier, presence and absence; it is thus that we are made aware of the viewer (whom we, along with Snow and Huysmans, assume to be male) as a thing outside and unseen, a gaze without a body, a position in space characterized by its exteriority and its invisibility.

All the pressures of detachment, disappearance, and disembodiment that belong to the Western gaze are included in *The Tub*. I am thinking here of the peculiar system of corporeality that attaches to the traditional single-point perspective, in which the body of the viewer (again usually assumed to be male), located in a fixed place outside the painting and defined as prior to it, is dematerialized into a single point — a position in space; into lines of sight, a transparent field or plane of vision intersecting those lines of sight, and a vanishing point — the condensation of the gaze and the body of the viewer into another single point which reflects the viewer back at himself in the form of invisibility. In this system the field of vision, the transparent plane bisecting the imaginary lines

extending out from the body of the viewer, literally represents disembodiment — the body extended beyond itself to become a projection, a transparency, a rectangle, and a system by which negative space is ordered (Bryson 1983:104-106).

It might be wrong to confuse the single-point perspectival system of the West, and all that it implicates, with the possessive "perspective" on the female body. Yet both seem to be at issue in *The Tub*: both are implicated and both negated. Degas's art is very much a spatial one, full of interior spaces marked by obvious orthogonals; one need think only of *The Interior*. These are not seen in *The Tub*, but it is nevertheless the suggestion of depth, below the ledge and behind the basin, that makes the implied proximity, the emphasis on edges, and the flatness of this image resonate. Indeed, it helps to see *The Tub* as a play on the normative, perspectival view, uprooting the rooted viewer, moving him out of position and shoving him toward and above the plane of the picture; robbing him of his measurable distance from it and thus of his sense of geometrical kinship to it; cutting a piece out of the view (the line of the ledge is like a fragment of an orthogonal, cropped and dislocated, cut out of its proper spatial, proportional, and positional context, adhering to the frame), and finally excluding the horizon, the lines of sight, and the vanishing point — all the means of reading spatial and positional relationships. This is not a simple neglect of perspectival space; it is a deliberate dislocation of it, of all its principles of positioning, centering, measuring, distancing, exteriority, and priority. The disembodiment of the male viewer is thus doubly treated in *The Tub*: through the looming sense of his invisibility promoted in it, and through his spatial dislocation. On the other hand, the intransigent physicality, the folded-over thickness and thereness, the formal presence of the female body are also doubly stressed — through the facts of its reflexivity and its illegibility.

This is to say that we see *The Tub* from two points of view, belonging to the male and the female body: that of interiority on the one hand, and that of exteriority on the other; that of physicality and that of disembodiment — a represented physical presence closed off through its very representation, and an outside viewing presence profoundly dislocated through the very acts of viewing and representing. There is more than just the female body at stake here, and certainly more than misogyny: representation and corporeality in general, so fundamentally linked in the Western tradition, are put in tension with each other. So are physicality and discursivity (the discursivity, in this case, of the gaze and the point of view), the one internalized and the other externalized, the centrality and subjecthood of the male body dislodged and the objecthood of the female body affirmed, yet closed off. The positions and meanings of both the male and the female body in Western painting are thus disclosed and foreclosed upon.

The Tub shares features with *The Interior* and its replacement of the narrative opposition between male and female with a scopophilic one;

it shares features with the *Bather* and its problematization of the form and facture of the nude, and the pressures of gaze and touch that attach to it. *The Tub* contains the same turned back as *The Interior* and the same viewing presence, now outside the frame of the image. It has the same pressured, angled-around feeling to it as the *Bather,* the same refusal of appropriation. And, I might add, it shares the same reflexivity: constituted at the level of facture in the *Bather,* in the equivalence that it asserts between field of touch and ground of representation (rather than represented body); constituted at the level of gesture in *The Tub,* where there are traces of the same web of pastel marks in the room and across the back of the woman, like traces of her own sponge-wielding gesture. In both pictures the field of corporeal representation closes back on itself, in one negating the body, in the other the viewer. The reflexivity of *The Tub* is what accounts for the peculiar illegibility of its body; it also accounts for the polarization of interiority and exteriority, subject and object, male and female presences, all in the representation of one body, whereas in *The Interior* they were laid out side by side like separate parts of a broken sentence. Neither celebratory (Snow) nor vitriolic (Huysmans) — or perhaps they are both — Degas's representations of female bodies are deconstructive. If they are radical in any way, it is after this fashion: in their declaration and separation of the subject and object of the female nude, in their exposure and closure of the metaphors and means of union and sublimation engaged in it.

I began by saying that the female nude was attached to formalist rather than semiotic preoccupations, and by commenting on the relationship between the female nude and twentieth-century abstraction. I want to end with this point: while later, bolder artists maintained and celebrated the female nude as a formalist field, it was the conservative, "misogynist" Degas who operated on it, prying apart its subject and its object. (Valéry considered Degas a kind of scientist, a modern equivalent of Leonardo [Valéry 1936:53]; Freud's interpretation of Leonardo [Freud 1910] is appropriate here.) The female body — the object — constituted as a field of closed form, facture, and gesture, is declared as unapprehensible; the viewer — the subject — remains separate, his myth of sublimated union through aesthetic vision denied him. Each is folded away from the other. This is Degas's special entry into the world of abstraction, via the route of the female nude. How different it is from that of the most notorious formalist of our century, Pablo Picasso (who admired Degas's work and owned some of his images of prostitutes), with his tremendous myth of virility and his myriad pictorial devices for formal apprehension and erotic appropriation. The appropriate myth for Degas, whether biographically true or not, is that of abstinence (rather than misogyny); certainly that was the myth that Huysmans and Valéry preferred, not to mention Snow, more recently. For the relationship between the subject and object, between the sexes of painting, played out so disjunctively in Degas's nudes is best described as a structure of celibacy.

242 CAROL M. ARMSTRONG

This is the nature of Degas's pictorial engagement with the female body, and of his formalism. If there is a certain sadness in his enterprise, this is where it lies.

REFERENCES

Bakhtin, Mikhail, 1984. "The Grotesque Image of the Body and Its Sources," in *Rabelais and His World* (Bloomington: Indiana University Press).

Bell, Quentin, 1965. *Degas: Le Viol.* Charlton Lectures on Art (Newcastle-upon-Tyne: University of Newcastle-upon-Tyne).

Berger, John, 1972. *Ways of Seeing* (London: British Broadcasting Corporation and Penguin Books).

Bryson, Norman, 1983. *Vision and Painting: The Logic of the Gaze* (New Haven, Conn.: Yale University Press).

Clark, Timothy J., 1980. "Preliminaries to a Possible Treatment of 'Olympia' in 1865," *Screen* (Spring 1980), 18-41.

—— 1985. "Olympia's Choice," in *The Painting of Modern Life: Paris in the Art of Manet and His Followers* (New York: Knopf).

Duncan, Carol, 1973. "Virility and Domination in Early Twentieth Century Vanguard Painting," *Artforum* XII:1-4 (December), 30-39.

Freud, Sigmund, 1957 (1910). "Leonardo and a Memory of his Childhood," in *The Standard Edition of the Complete Psychological Works of Sigmund Freud,* ed. James Strachey, vol. XI: *Five Lectures on Psychoanalysis, Leonardo da Vinci and Other Works* (London: The Hogarth Press).

Halévy, Daniel, 1960. *Degas parle* (Geneva: La Palatine).

Huysmans, Joris-Karl, 1894 (1889). *Certains* (Paris: Tresse et Stock).

Lemoisne, P.A., 1946-49. *Degas et son oeuvre,* vol. I (Paris: Arts et Metiers Graphiques).

Meier-Graefe, Julius (trans. J. Hobroyd Reece), 1923. *Degas* (London: E. Benn Limited).

Pool, Phoebe, 1964. "The History Pictures of Edgar Degas and Their Background," *Apollo* LXXX (October), 306-311.

Reff, Theodore, 1976. *Degas: The Artist's Mind* (New York: Metropolitan Museum of Art and Harper and Row).

Snow, Edward, 1979. "Painterly Inhibitions," in *A Study of Vermeer* (Berkeley: University of California Press).

Steinberg, Leo, 1972. "The Algerian Women and Picasso at Large," in *Other Criteria* (New York: Oxford University Press).

Valéry, Paul, 1938 (1936). *Degas Danse Dessin* (Paris: Gallimard).

SEXUALITY AT A LOSS:
THE FILMS OF F.W. MURNAU

JANET BERGSTROM

F.W. Murnau was a prestige director in the Weimar cinema, both by industry standards and in the eyes of the public, when he accepted William Fox's offer in 1925 to work in Hollywood. The contract was signed soon after *Der Letzte Mann* (*The Last Laugh*) had its spectacular world premiere in Berlin; by the time Murnau arrived in the United States about a year later, American critics were describing *The Last Laugh* as the greatest achievement of film as an art form the world had ever seen. Meanwhile, Murnau had increased his own reputation as an artist-director with the release of two more UFA super-productions, *Tartuffe* and *Faust*.[1] Fox organized a fairly massive publicity campaign around signing the "German genius," promoting as "the world's greatest film artist" a director he was willing to pay a high price to import. As a commodity negotiated from one national cinema to its most important competitor, Dr. Murnau or F.W. Murnau, Ph.D., as he was often deferentially referred to by every level of the critical establishment, conformed to a highly desirable image at this time in the United States — the cultured European artist-intellectual.[2] That William Fox would bring in such a unique talent was meant to indicate to the press, and thereby to the public, that Fox Films was committed to making quality motion pictures, like the larger studios it was aiming to catch up with in another arena — the marketplace (Allen 1977).

1. UFA (Universum Film Aktien Gesellschaft) was the largest studio in the German film industry. At an annual meeting, the board of directors would decide on the high-budget, "quality" films to be produced that year.
2. Murnau's honorary title came from the fact that he had studied art history and literature at the University of Heidelberg; he had also been called Herr Doktor in the studios around Berlin, partly because of his learning and partly because of his habit of wearing a surgeon's white coat when working (Eisner 1973).

In order to help achieve Fox's goal, Murnau was given control that became legendary over his first American film, *Sunrise*.[3] Time and expense were unimportant so long as the desired effect was achieved. Consequently, time and cost over-runs were fabulous. William Fox, as far as can be determined, stayed out of the production almost entirely.

Sunrise, released in 1927, received even more critical applause than *The Last Laugh*. Although not all reviewers were happy with the simplicity of the plot or the stylized acting, everyone seemed overwhelmed by its visual beauty. Both cinematographers, Charles Rosher and Karl Struss, received an Academy Award. Murnau had made the camera the star of the picture, to paraphrase an opening-night review. However, *Sunrise* was not a popular film; it was very expensive and it did not make money. William K. Everson, eminent historian of the American silent cinema, claims that "The enormous critical success of *Sunrise*, however, caused it to be the single most influential picture of the period. . ." (Everson 1978:322), and that "the impact of *Sunrise* as a film, and of Murnau as a new artistic leader, was enormous, especially at Fox" (p. 327).

But Murnau's career with Fox was to last for only two more films, and in neither case was he able to maintain anything like the control he had had over *Sunrise*. William Fox was apparently no longer willing or able to finance prestige at a loss. This law of the marketplace was typical of the American way, which would sooner or later be felt by all the émigrés invited to Hollywood. Murnau made only one more film, *Tabu* (1929), an independent production shot in the South Seas with the documentary filmmaker, Robert Flaherty. A few days before *Tabu* opened, Murnau was killed in a freak car accident on his way to Santa Barbara, California.

CONVENTION, SEXUAL IDENTITY, AND THE SPECTATOR:
WEIMAR VERSUS HOLLYWOOD

Murnau's decision to leave the German film industry for Hollywood meant, among other things, that he would undertake to make films for a different audience and within the context of a somewhat different set of formal and narrative conventions. The consensus after his death seemed to be that Dr. Murnau was a misfit in the American studio system, unlike, for example, Ernst Lubitsch, who had left a very successful and much-publicized career in Germany about five years before Murnau, but who had made the transition look easy by establishing himself almost immediately as a major Hollywood director. What might have rendered Murnau "unfit"

3. First-hand descriptions of the elaborate care taken with the production and the difficulties it presented can be found in Eisner (1973), Struss (1976), and Brownlow (1968).

for Hollywood? In responding to this question, I am particularly interested in seeing how conventions relating to sexual identity, the spectator, and modes of abstraction do or do not carry over from one highly conventionalized national cinema to another, namely, from Weimar to Hollywood. These are, I feel, the key issues in Murnau's case.

The emphasis here is different from that found in most discussions of "the Germans" coming to Hollywood. It is misleading to talk about the German émigrés as if one were describing a single, homogeneous group. In fact there were wide differences in times and circumstances of arrival, as well as differences in individual personality and approaches to filmmaking. Second, my essay relies on an understanding of conventions in cinema at a given point in their development, not on personalities. Although personal idiosyncrasy plays a part in how conventions may be used, disregarded, or adapted, it is a secondary consideration. For example, the "fact" that Lubitsch fit into the Hollywood social/business world with delight and ease, while the "cultured" Murnau remained "aloof," has limited explanatory power when it comes to the reception of their films in the United States. Lubitsch was one of the first of a long line of Weimar directors to become successful in Hollywood, even if their successes were far from identical, while Murnau stands out as a major exception. I would suggest that the ways in which Murnau treated conventional aspects of cinematic representation — in particular his formulation of sexual identity and of a mode of looking virtually required of the spectator — were among the most important reasons both for his success in Germany and for his lack of acceptance as an "American" director.

On the one hand, I am interested in Murnau as an example of a Weimar director who, like Lubitsch and others later with their own configuration of personal and professional circumstances, difficulties, and successes, attempted to enter another highly conventionalized cinema. On the other hand, I want to explore Murnau's particular contribution to the cinematic conventions of his day, and the extent to which the experimentation he was engaged in could carry over to the American cinema. A comparison between the Weimar and Hollywood cinemas need not, of course, be formulated in terms of directors; Murnau is meant to be seen here as a director in the context of the conventions of his day — his audience(s), his possibilities, his limitations. Examples from Murnau's films will come from *Nosferatu* (1922), *Faust* (1926), and *Sunrise* (1927). References to his other films are absent only because of lack of space, as all his films relate, in different ways, to the issues at hand.

Among the many newspaper obituaries of Murnau that have been preserved, I came upon one that contains an unusually interesting appraisal of Murnau's reception in the United States:

Then came Murnau's version of the Faust legends, which was certainly one of the most beautiful motion pictures ever made. As a matter of fact, it was so superior in its pictorial loveliness that, in some curious manner, a number of distinguished observers were frightened by it. Suddenly they developed an inordinate interest in virility, and announced sadly that the exquisite visual qualities of *Faust* gave it an effete touch which was out of keeping with the stark, grim manliness that was inherent in films. . . . Then, too, there was that weakness of the director in handling women. Both in *The Four Devils* and *Sunrise* [Janet] Gaynor was unnecessarily handicapped, in the former by a role which the director neglected; in the latter by a clumsy blonde head-dress. In both pictures the character of the villainess . . . was overstressed in the early Theda Bara manner (Watts 1931).

It is noteworthy that this columnist connects the element most generally admired in Murnau's films, pictorial beauty, with the aspects most widely criticized by American reviewers at the time of the films' release and by later commentators, namely the lack of virility in male protagonists (especially the young Faust) and the unrealistic representation of female characters. Extreme pictorial loveliness of an almost abstract nature is juxtaposed with a lack of virility; their proximity is enough to inspire fear. I would like to suggest that, unlike the American cinema, the Weimar cinema's tendency to abstraction allowed for modes of viewing more commonly associated with the fine arts, specifically with looking at paintings, to cast a kind of aesthetic veil over images of feminized male figures as well as one-dimensional female characters. This mode of viewing itself was made possible by the circulation of the films within a cultural tradition that put a high value on the arts. It could be assumed that in Weimar Germany Murnau had an audience with an art historical awareness, even if only in a very generalized sense; beyond that, for a more restricted group, references could be made to particular genres and styles of painting.

If women were one-dimensional in Murnau's films, that dimension was not physical or sensual, unless it corresponded to the notion of sensuality in death, familiar from the Romantic tradition in literature, or the morbid fascination with the female body in Symbolist and Pre-Raphaelite painting, realized by artists such as Puvis de Chavannes, Millais, Munch, Moreau, Redon, and Fuselli. In this regard, a number of images from Murnau's films come to mind: the final shots of Gretchen in *Faust*, of Nina in *Nosferatu* (both of whom die), and of the wife in *Sunrise* floating in the water as if drowned and then laid out on her bed surrounded by her long, wavy hair as if she were dead, the severe braids finally undone.[4]

4. See Delavoy (1982) for reproductions of paintings which are similar to these images. I am not, however, trying to argue for a direct reference to the Symbolist and Pre-Raphaelite schools in Murnau's films. As shown by Rohmer (1977), Wood (1976) and others, Murnau's references to art historical sources are extremely varied.

In Murnau's films, the woman's body becomes an abstraction. Compared to its conventional representation in commercial narrative films, the woman's body is at a loss, both metaphorically and literally. As Raymond Bellour has shown in great detail, the classical Hollywood cinema, consistent with a sytem of representations characteristic of the 19th century, came progressively to locate its representation of sexuality, and the symbolic significance of sexual difference in establishing identity, in the body of the woman (Bellour 1979, Bergstrom 1979). Laura Mulvey, from an explicitly feminist perspective, extended a similar claim to narrative cinema in general (Mulvey 1975). This was also often true of the Weimar cinema, although unlike the American cinema, class identity is usually as strongly marked in both iconographic and narrative terms as sexual identity, and the two are almost always won or lost in the same moment. Typing by social class was so important to Weimar narratives that it often obscured the significance of sexual definition. In Murnau's films, however, the reverse seems to be true: sexual identity is emphasized over class identity. Furthermore, femininity, insofar as it can be associated with eroticism or sexuality, has been displaced from the woman's body to several kinds of substitutes. The woman's body is at a loss literally in that it has a reduced physical presence, lacking a sexual dimension; metaphorically, the symbolic function of the woman's body in establishing sexual difference is greatly diminished. The few exceptions to this pattern serve only to reinforce it: the City Woman in *Sunrise* is exclusively sexual, but exactly for that reason her symbolic connotations are as one-dimensional as the desexualized, ethereal type of female character which predominates in Murnau's films. Substitutes to make up for this loss can be located in Murnau's films at the level of story and characters, and can also be seen in the mode of apprehension of the film by the spectator.

To say that the woman's body becomes an abstraction is to assert something more than the general reliance on abstracted situations and characters in the Weimar cinema. In order to understand the significance of this statement, the investigation of Murnau's use of conventions to represent the woman's body and sexuality more generally will have to be deferred temporarily, as his particular use of conventions — that is, his reworking or displacement of certain internalized "rules" of the Weimar cinema — cannot be understood without first establishing what these conventions were.

Certainly abstraction was more obvious in the Weimar cinema than in Hollywood films. Abstraction was already accessible, acceptable, and familiar because of the tradition of Expressionist theater, by the twenties no longer an avant-garde movement but part of mainstream theatrical productions. Most noticeably, one finds types clearly designated as such: characters often do not have names, but are

meant to denote a position, generally within a family and/or class structure.[5] Thus the credits may list "the mother," "the son," "the prostitute," "the countess," "the boss," etc. However, within the films there is often no need for even these labels because the symbolic function of characters is readily apparent, conventionally related to problems of both class and sexual identity, and because an elaborate iconography of costume, makeup, and acting stylization, largely derived from Expressionist theater (Eisner 1969), had been developed to grant the spectator an immediate *visual* identification with the various types who would enter into the narrative.

What is not immediately apparent, however, is that this cinema used a *popular* acceptance of abstraction through a limited repertoire of character types (very uncharacteristic of the American cinema, for example) in stories that are often highly ambiguous. Moreover, the structural ambiguity of many Weimar plots (such as the myriad variations on the theme of the double) was made increasingly convincing *as ambiguous* by means of stylistic or formal devices that seemed to be the area of greatest experimentation within this cinema. Formal innovation came to function stylistically, and according to industry voices "artistically," so as to render fundamentally *unstable* the foundation for the types which were so readily identifiable. Power as it relates to class and sexual definition is not comprehensible in this cinema aside from the concept of instability. Siegfried Kracauer is correct in observing the endless attempts at class rise that end in failure and impotence, or a fall out of class altogether into prostitution, anonymity, madness, or death (Kracauer 1947). In these typical stories of unstable symbolic identities, stylistic conventions are continually reworked both to increase abstraction and to underscore the idea of ambiguity.

The use of space, an important example, is markedly different here from the way it developed in the Hollywood cinema. The 180-degree rule, for example, is one of the fundamentals of the classical American continuity style. The camera is supposed to remain on one side of an imaginary line in the different positions it may occupy to film a scene. Although it is an oversimplification, one could think of the spatial arrangement of a traditional theater and its audience. The purpose of the rule is to help the viewer maintain spatial orientation with respect to the scene — to help build the illusion that it is a real space (and a real story) before one's eyes. The more general principle that applies is the "rule" of invisible

5. Many "pre-classical" narrative films, regardless of their country of origin, feature types familiar from popular melodramatic forms (novels, plays, puppet shows, etc.). A familiar example would be the use of stereotypes by D.W. Griffith. The types refined by the Weimar cinema, however, while still owing something to melodrama, were developed more directly from the repertoire of Expressionist theater and its merging into the *Neue Sachlichkeit* movement in the mid-twenties. This would be an extremely interesting area to investigate.

editing (by no means reducible to any set of formulas): the spectator should follow story and characters, and should not notice style, particularly editing or camera as such.[6]

However much the phrase occurs in the critical literature, it does not make sense to talk about violations of the 180-degree rule in the context of the Weimar cinema, because either one would have to say that it is routinely violated, or one would have to observe that it is not a convention of editing in Weimar films. In general, the use of space is flexible to the point of extreme disorientation with respect to the relative place of elements within what one might expect to be a coherent space. Great use is made of point of view shots which may or may not be attributed later to an unexpected character, glance/object set-ups where it may or may not be clear who is looking and thus what the significance of the object is, and alternation that joins highly disparate spaces which may or may not be explained in terms of story.

This last variant might consist of simple chase-type crosscutting or complex alternation that includes many elements and highly imaginative uses of ellipsis and associational montage. For example, the opening scene of Fritz Lang's *M* (1931), which has frequently been analyzed as an accomplished example of Weimar experimentation, is built on an extremely subtle and complicated system of alternations. The intended meaning, in one sense, is absolutely clear: through alternation on both sound and image tracks, and through variations of presence and absence of the little girl, her mother, and the anticipated murderer, we know Elsie's mother's worry as it becomes fear, and we know Elsie moves from danger to death. But the point, formally, is that Lang can present this in highly elliptical fashion, so that we feel we can make assumptions based on what we in fact have not seen. In his films, this technique often works against the spectator as a trap, but precisely a trap made possible by a highly conventionalized system of elliptical editing.

Ambiguity in editing could also be related to the other area of pride in Weimar cinematic specialization: camera style and lighting. Instability of class, sexual identity, and space is often correlated with the manipulation of vision, with what the characters and/or audience are allowed to see. This directed and thematic use of light, within a system that generally favored low light levels compared to Hollywood or pre-Weimar German films, was also inspired by the theater of Max Reinhardt and others, but was transformed with great inventiveness by film directors and their cinematographers (Eisner 1969).

6. For the classic, highly readable account of editing conventions, particularly the Hollywood continuity system, see Reisz and Millar (1981). For a condensed version, see Bordwell and Thompson (1979, chapter 6).

Murnau's reworking of these conventions relating to abstraction and ambiguity is evident in at least two important areas: his use of the familiar device of the double, and, on a level that pertains to the spectator's mode of viewing, his self-conscious use of the Weimar cinema's highly promoted and successful image as art cinema.

Murnau's own media image as a film artist, not just a director, clearly fit into the larger picture of his industry and its desire to build and maintain an audience. The German film industry took pride in characterizing itself as superior to other national cinemas artistically, and had developed a commerical appeal for its films based on a "high art" self-identification. There are constant references to film as art in the trade and popular film journals of the twenties in Germany. This became a selling point both in competing for domestic audiences, primarily with American films, and in building up a healthy and widely-reviewed export business. From the perspective of American trade journals, where the success of this campaign could be seen indirectly, the corner on artistry that German films seemed to be consolidating in the eyes of influential American critics was undeserved, unwelcome, and contested.[7]

The theme of the double was popular from the 19th century Romantic tradition of German literature; Lotte Eisner, in *The Haunted Screen*, frequently refers to this tradition when describing typical plots of Weimar films (Eisner 1969). Among her examples are the story of the man who loses his shadow or mirror image and gains an evil twin (*The Student of Prague* syndrome); stories of split personalities, greatly varied; and the representation of mental or psychological derangement, accomplished through an exaggerated, stylized shift in acting in which, typically, the character slows drastically in pace, stares fixedly but no longer sees the external world, sometimes sees apparitions, often gropes along a wall, and almost invariably puts hand to head.

ABSTRACTION AND AMBIGUITY: THE DISPLACEMENT OF SEXUALITY IN MURNAU'S FILMS

To turn from this general discussion to Murnau's specific contribution, I believe that although the kinds of conventions outlined here are limited in number, it is reasonable to assume that the contemporary audience for Weimar cinema was already accustomed to types, to a conceptual cinema that was in certain regards highly conventionalized. It can be argued, further, that this "popularizing" of abstraction and ambiguity allowed Murnau to represent sexuality in a displaced and abstracted fashion — that is to say (with the foregoing discussion in mind) that he was able to reshape or modify

7. Journals consulted include the *Lichtbildbühne, Der Film Kurier, Der Film, The American Cinematographer*, and *Variety*.

conventions in a way that could still be seen as falling within the norms of his audience and industry.

For example, Murnau's use of the double in *Nosferatu* and *Sunrise* has been linked by Robin Wood to the repression of sexuality (Wood 1976, Wood and Lippe 1979).[8] According to Wood's argument, Nosferatu, the vampire, represents sexuality itself, and as such must be eliminated from the world of the narrative. His double is Jonathan, who shares none of Nosferatu's characteristics, lacking in particular both power and sexuality. Nosferatu's antagonist is not Jonathan, but his wife, Nina, who sacrifices her own life for her husband. In a highly ambiguous gesture, where she seems both to need and to repudiate sexuality/Nosferatu, she attracts and keeps the vampire with her until the cock crows at dawn. Nosferatu then disintegrates into vapor, and Nina dies. Wood draws a convincing parallel between Nosferatu and the City Woman in *Sunrise*, both creatures of the night, the unnatural, and sexuality. The City Woman clearly represents evil, and a threat to nature, the family, and civilization. (One might add that visually, as well as functionally, she is very close to Mephisto in *Faust*, dressed in black satiny materials, and is, like him, the character with the greatest physical presence in the film.[9]) Her failure to entice the man from the country to murder his wife, sell his farm, and go away with her to the city is viewed by Wood as analogous to the necessary destruction of the vampire at the end of *Nosferatu*. This victory over sexuality, however, is not only won by default — the man remains passive throughout — but it has its price.

> As with *Nosferatu* . . . the sharp division remains between "pure" love and eroticism. The wife of *Sunrise* quite lacks the blanched and angular quality of Nina, the appearance of a female Christ-on-the-Cross, but, although very feminine, she strikes the spectator as decidely unsensual (an impression to which her tightly knotted hair contributes a great deal). And sensuality, again, is depicted unequivocally as evil and destructive (Wood 1976:17).

The chief double Wood sees in *Sunrise* is the husband, who is alternately a "monster" and "normal," depending on whether or not he

8. I am not addressing Wood's reformulation of this thesis, from the repression of sexuality to the repression of homosexuality, although I agree that Murnau's known homosexuality adds an important dimension to understanding his films. However, it is difficult to refer to this dimension, particularly when attempting to describe a shifting, unstable homoerotic charge that the films seem to carry. Wood's analysis proceeds in a different direction than mine; he also does not seem to be using "repression" in its psychoanalytic sense. For a more recent elaboration of Wood's views about the repression of homosexuality deforming filmic systems, see his article on *Raging Bull* (Wood 1983).

9. The degree to which a character in a film is endowed with the illusion of physical presence, and for what reasons, has been an on-going concern in the *Cahiers du Cinéma* over the past ten years. The study of Lang's *Hangmen Also Die* by Jean-Louis Comolli and François Géré (1978) is particularly important.

is under the sway of the City Woman. The entire second half of the film is devoted to repudiating (more or less successfully) the monster in him, ending with the departure of the City Woman.

It seems to me important for Murnau's representation of sexuality that the system of the double, which is emphasized by Wood, is brought into another old and accepted system, much-analyzed in other contexts: a system of triangulation where the one desiring and the love object are connected indirectly through a mediator. It is partly this overlay of conventional systems which masks the indirect sexual substitutions that make narratively unacceptable representations of desire possible on another level. In Murnau's case, this systematic complication of the way sexuality is represented allows for sexual investment in semi-conventional terms, with aesthetic references used as the basis for the presentation of images that might or might not be called homoerotic. A system of relays, delays, and necessarily deferred gratification is built up out of a series of basically static views of compositions that recall paintings, and that call upon the viewer to look at the image on the screen as if he or she were looking at a work of art.[10] There is a culturally sanctioned precedent for appreciating the sensuality of young men's bodies, for example, in the history of art. For if one asks what position is assigned to the woman in Murnau's films, one quickly realizes that this question is subordinate to a more insistent one: where is the location of the feminine? Although the representation of the feminine is not necessarily stable, many important examples can be found of a clearly-coded feminine displaced onto the body of an aestheticized male-gendered character.

Such, for example, is the image of the young Faust that gave American critics pause — too feminine, not only in face, expression, and body (revealed by his velvety costumes), but also in the postures he habitually adopts. How do we first see him? Through the mediation of Mephisto, we see with the aged and despairing Faust the beautiful face of a young man, like a portrait, shimmering in a bowl of liquid poison he intends to drink to end his life. "Is it death?" asks Faust. "It is your youth," replies Mephisto.[11] A few moments later, Mephisto holds out Faust's youth to him again as an image in

10. Eric Rohmer's invaluable study, *L'organisation de l'espace dans le "Faust" de Murnau* (1977), shows how even very elaborate, moving shots in the film preserve the compositional balance of classical, representational painting. One can see, therefore, how movement in the frame and camera movement can still create the impression of a series of static views.
11. Quotations that appear to be dialogue are taken from intertitles, both here and later in this paper. For *Nosferatu* and *Faust*, I am relying on the prints restored by Enno Patalas that are housed in the Munich Filmmuseum, although I am retaining, for the moment, the anglicized version of characters' names. In the original, German version of *Nosferatu*, for example, Nina was called Ellen. Her name was changed to avoid copyright problems resulting from too close an adaptation of Bram Stoker's *Dracula*.

The Bowl of Poison

a mirror, and with this image, seduces him into signing the pact that gives him one trial day to experience Mephisto's services. Throughout the film, Mephisto is the figure who mediates, suggests, and defines Faust's desire until the climactic moment of Gretchen's call for help. And although Faust ultimately establishes his identity through his relationship to Gretchen — sin and redemption — throughout the film we are able to treasure his youth as a sensuous, artistic wonder, much as the old Faust is taken with the image of the young Faust.

Because the young man is said to represent his own youth, Faust's desire is designated by the narrative as natural, rather than as the result of a sexualized seduction. Desire for the young Faust is represented as being even more indirect by the fact that Mephisto, the mediator, is necessary to Faust's temptation. That the temptation is sexual is made clear by the first act Mephisto performs after endowing Faust with the young man's body: he presents a diaphanous vision of a woman, almost naked in transparent veils, as the pleasure Faust's youth is entitled to. The young man eagerly accepts. Thus, the woman's body is presented (very briefly) as sexuality, and in a way that directs our narrative interest away from the sight of the young Faust himself. Her sexuality is presented as the work of the devil, as entrapment, for Faust will sign his soul away a few scenes

later to avoid interrupting this first gratification of his sexual appetite. Given all this narrative and stylistic machinery, the viewer is left to enjoy the beauty of the young Faust without thinking twice. Moving or still, his image *as* image welcomes the gaze. In the film, there is no image of a woman that can compete with it, except for Gretchen. But she represents, almost exactly like the wife in *Sunrise* and not unlike Nina in *Nosferatu*, the asexual madonna, with a powerful and different sort of attraction.

The shifting of doubles into triangular patterns is equally pronounced in *Nosferatu*; the displacement of sexuality is also evident, although it is not so dazzling or obviously aestheticized as in *Faust*. The film can be read, as Robin Wood sees it (Wood 1976), as the story of Nosferatu's desire for Nina and her reciprocal desire (albeit unwilling) for him, i.e., for sexuality. However, we can also read it as the seduction of Jonathan by Nosferatu, and Jonathan's compliance, mediated by the figure of Nina, whom the narrative presents simply as the wife trying to save her husband. Two scenes soon after Jonathan's arrival at the remote castle make the triangular connection between Nina, Jonathan, and Nosferatu quite clear. Jonathan is offered dinner at a long table set only for one. Nosferatu sits with him, studying a letter that describes in weird hieroglyphics the house Jonathan has been sent to sell him. He peers over the top of the letter to stare at Jonathan as he eats. Jonathan uneasily slices a piece of bread, the clock strikes midnight, he cuts his thumb, and Nosferatu approaches rapidly to suck the wound: "You've hurt yourself. Your precious blood." Jonathan backs slowly away from him, stumbling on the low tier of stairs behind him, then falling back into a chair, eyes wide. Nosferatu sits down next to him. It is in the same position, almost reclining, that Jonathan awakens the next morning. He examines his neck with a mirror, interpreting the vampire's mark as insect bites. After a brief scene where we see Jonathan writing to Nina, a title tells us that evening has come. Now Jonathan is again with Nosferatu, at a table looking at the letter Jonathan has brought. A cameo portrait of Nina that has fallen out of Jonathan's satchel catches Nosferatu's eye. He picks it up, oblivious to Jonathan and his papers. "What a beautiful neck your wife has." He then announces: "I am buying the house . . . the beautiful, deserted house that faces yours. . . ."

Nosferatu's desire for Jonathan is always mediated by Nina, just as his desire for Nina is mediated by Jonathan. The meaning of this apparent interchangeability, however, is altered by the different ways in which we are given each body as an image. While Nina has certain feminine attributes — she is ethereal, unphysical, progressively more fragile and ill — Jonathan has others. The unnatural kiss that the vampire finally gives Nina, that kills both of them (not all that different from the scene at the stake at the end of

Faust) is, initially, given to Jonathan, who serves as a substitute. Unlike Nina's rigidity, his body offers no resistance, even in his fright when the vampire enters his bedroom. Jonathan's acquiescence (no matter how unknowing or unwilling in narrative terms) nourishes the vampire, and like the young Faust, the attitudes his body repeatedly adopts could be termed feminine. As in the example just cited, he is frequently made to step slowly backwards, and then drape himself across a chair, a bed, or some other piece of the decor. Because Jonathan's body is always softened by his costumes, particularly the folds of his frock coats, he often appears simply as a male figure arranged for us to see.

In narrative terms, Jonathan represents the passive, impotent male so common in the Weimar cinema, as Kracauer has observed. Iconographically, his image as the immobilized male character, literally and symbolically deflated, also fits Kracauer's description, but Kracauer's explanation of how this iconographic convention is linked to the displacement of power need not follow, or at any rate, need not be exclusive.[12] Through an overlay of conventions, Murnau at the same time evokes a different kind of looking by the way he positions Jonathan in the image, one that is both non-narrative and

12. Kracauer's argument, in short, is that German films, reflecting German society during the Weimar period, featured powerless characters, and prefigured the craving for an authoritarian leader which culminated in the rise of Hitler (Kracauer 1947).

Jonathan after the First Night with Nosferatu

non-judgemental. For once in the Weimar cinema, the passive, masochistic male is seen sympathetically, not as an object of pity. His posture can be interpreted as feminine, but not – or not only – according to the typical scenario of symbolic defeat. It may be translated as a quotation from the highly valued tradition of painting. The moment of loss of power, as Robin Wood points out even about Nosferatu, is poignant. In other words, the emphasis is displaced from class and from sexual identity (which is *apparently* preserved as normal) to an erotics of looking. Conventions of narrative cinema which, in these films, center on heterosexual relationships and never introduce a non-heterosexual character (unlike many other Weimar films) are overlaid by the conventions of a less goal-oriented way of looking.

The displacement of desire from the woman's body to the man's, and, importantly, to other, more generalized substitutes, works because Murnau can call on a different sort of spectator convention than is operative in most narrative films – as if another system of reading were superimposed over the classical mode. This is only possible because abstraction and ambiguity are already strongly established, and in fact overdetermined, in Weimar cinema. Unlike the American continuity system, where the ideal is for everything to serve a purpose, here not everything need fit into an explicable narrative economy. The acceptance of ambiguity implies a kind of tolerance, a willingness to forego certainty.

LOOKING AND GENDER IN WEIMAR CINEMA
Looking at paintings is not the same as looking at films, and I would like to suggest that the kinds of paintings Murnau is recalling in his visual themes and compositions, such as the portraits of Rembrandt or Vermeer, or the landscape paintings of Caspar David Friedrich or Altdorfer (as Eric Rohmer [1977] has studied in the case of *Faust*), are intended to elicit a contemplative look. In the contours and postures of the young Faust it is difficult to avoid thinking of the Endymion reproduced by Barthes in *S/Z*. One might speculate that this look is analogous to that special kind of looking Laura Mulvey described as characteristic of Sternberg's use of Marlene Dietrich – a visual spectacle that, unlike what is supposed to happen in American, action-oriented films, functions to stop the narrative (Mulvey 1975). In Mulvey's analysis, this out-of-time look is always tied to the woman's body; in fact, her entire discussion of pleasure in looking at narrative film centers on characters who will claim attention within the visual field. Pleasure derived from looking at the woman's body is only possible through two processes for the spectator: voyeurism or fetishism. These processes correspond, according to a Freudian schema, to two modes of pleasure in looking (scopophilia): active and passive. Mulvey implies, through omission

of any discussion of the female spectator, that the woman experiences narrativized visual pleasure in the same way that the male spectator does. Mulvey's argument, the most provocative to have appeared on the subject of the woman's body in film, has served to highlight the following question: what about the female spectator? Why should one assume that her relationship to the woman on the screen is the same as a man's? This problem has led to a theoretical impasse; the problem appears to be locked into an inadequate conceptualization of feminine sexuality within psychoanalytic theory.[13]

But it seems to me that this is the wrong question to begin with, unless one is interested in the female spectator only from historical and sociological perspectives. Setting up viewer identification in terms that oppose the "male spectator" to the "female spectator" impoverishes the psychoanalytic description of sexual identity. Likewise, assigning fictional characters fixed sexual identities that correspond to gender is often unhelpful in understanding the movement of desire in particular films. Perhaps there is another avenue available within a psychoanalytic framework which leads toward a non-reductive description of sexual orientation and pleasure, less dependent on gender-defined objects, or simply less object-oriented.

In his early and enduring work, *Three Essays on the Theory of Sexuality* (1905), Freud proposed a conceptual framework for a model of sexual identity that is much more flexible than Mulvey's polemic would lead one to believe. He makes an extremely important distinction between sexual object and sexual aim. This allows Freud to differentiate between inversion and perversion, and among a number of perversions (including voyeurism and fetishism). The individual's adult sexual identity is defined not only by the choice of love object (male/female), but also by the preference of sexual aim (active/passive). In fact, each category (object and aim) describes a spectrum of real or imaginary choices. Object choice, therefore, is not the sole determinant of sexual identity. Another important thing to notice is that Freud essentially redefines the meaning of "choice" by maintaining that sexual desire is characteristically unstable, both in object and in aim. Most fundamentally, because

13. Mulvey wrote a kind of response to criticisms of her neglect of both the woman as spectator and the woman as a more independent screen image, which was formulated as a comparison between *The Man Who Shot Liberty Valance* and *Duel in the Sun* (Mulvey 1981). Although the article attempts to suggest a theoretical place for the female spectator, it lacks the clarity and forcefulness of the original argument. Mulvey does not talk about visual pleasure, or "the look" here, but chooses to "emphasize the way that popular cinema inherited traditions of storytelling that are common to other forms of folk and mass culture, with attendant fascinations other than those of the look" (p. 13).

Freud argues for a predisposition to bisexuality, the field of choice of both sexual object and sexual aim is defined as a continuum where the end points (male/female and active/passive) are ideal, or theoretical. Freud's theory of bisexuality means neither "either/or" (heterosexual or homosexual) nor "both" (if that means two fixed choices).

While Mulvey makes use of the distinction between object choice and aim, she uses them as if they were both gender-specific in narrative cinema; woman is object, man is subject of the gaze: "the image of woman as (passive) raw material for the (active) gaze of man" (p. 17). The contemplative look that seems central to erotic pleasure in Murnau's films might be conceptualized in terms of a passive sexual aim, unlike Mulvey's "(active) gaze of man," and libidinal investment need not be tied to any single or gendered object. I am proposing that the erotics of looking, specifically in Murnau's case but more generally as well, could be freed from the exercise of lining up spectators or characters according to a male/ female dichotomy. This is not to deny the importance of identification or classification based on gender; on the contrary, it allows gender identification to be interpreted as part of a more complex picture. If we can tentatively say that the desire in looking at paintings has a passive aim, we can see how pleasurable variations in imagining sexual identification and orientation can become acceptable to a large audience — which would probably not be possible if translated into object choice.

The description of narrative cinema offered by Mulvey, among others, is character-centered and accounts for visual pleasure strictly in terms of the way figures are viewed within a setting (decor or action). While in Murnau's films there are figures that attract our visual attention, even if their narrative function and their visual pleasure function are not aligned exactly as in the classical American cinema, Murnau also gives an important place to images of landscapes (or compositions that recall genre paintings of the sea, country people, or even the city) which invite the same kind of contemplative look. I believe that this look is continuous with figure-oriented images in Murnau's films, and that both are invested with a generalized, non object-oriented sexuality.

On the one hand, there are memorable images of landscapes which are clearly associated through montage or superimposition with sexuality, and which are connected, with more or less abstraction, to a character's imaginary point of view. The City Woman and the man she is seducing conjure up sexualized landscapes together — or possibly he has visions that she evokes for him. The landscape composition of the marsh lit by the moon, visible at first as the backdrop for their sexual meeting, is transformed into a highly sexualized image of the city, with fan-like montages of jazz musi-

cians, dancers, the amusement park; and then is brought back to the marsh through the City Woman's erotically-charged dance. Two shots from *Faust* bracket the film and associate the faces that mean negative and positive sexuality for Faust: first, the huge face of Mephisto fills the screen, superimposed over the city, breathing out the plague; near the end of the film, an immense close-up of Gretchen is superimposed over the landscape as she calls out to Faust for help. On the other hand, there are many landscape compositions elsewhere in *Sunrise* and abundantly in *Faust* and *Nosferatu* that are reminiscent of the lonely, quasi-religious genre paintings of the German Romantic tradition. They correspond to a very generalized sexuality which is not made explicit in the narrative; it is aestheticized directly for the spectator and for the fulfillment, in the slow pace of the images, of visual pleasure.

Through Murnau's displacement of sexual investment in the image from its narrative position as melodrama (the drama of the heterosexual couple as centerpiece for narrative and symbolic conflict), sexuality as a denoted presence is, in a sense, lost to abstraction. But by the same techniques or strategies, sexuality is gained in a more general and all-pervasive sense for the spectator. For not only is the spectator encouraged to feast his or her eyes on all the carefully composed sequences of images, which are loosely organized as an alternation of landscape and figure, but the spectator is also encouraged to relax rigid demarcations of gender identification and sexual orientation.

The "problem" of *Sunrise* in the United States lay in the fact that the American public was presented with a film made according to the conventions of another cinema that were significantly different from its own. The success of Murnau's reworking of conventions — overlaying narrative and stylistic conventions from the Weimar cinema with pictorial conventions from another tradition — was dependent on an audience willing to look at a film with the pace and attention required in looking at paintings. This meant, for the Weimar cinema, an audience that recognized and valued art and was also accustomed to cinematic conventions of abstraction and ambiguity. The American audience, on the other hand, was in the midst of a cinema that was perfecting conventions of narrative and visual action and economy of detail. The failure of *Sunrise* as a popular film could have been predicted. However, the experimentation that can be seen in Murnau's films — the alternation in attention between narrative and non-narrative elements used to displace sexual identification — is not only of historical interest. The attempt to understand Murnau's use of convention and innovation can help us see new possibilities for the cinematic representation of sexual identity.

REFERENCES

Allen, Robert C., 1977. "William Fox Presents *Sunrise*," *Quarterly Review of Film Studies* 2:3, 327–338.

Bergstrom, Janet, 1979. "Alternation, Segmentation, Hypnosis: Interview with Raymond Bellour," *Camera Obscura* 3–4, 71–103.

Bellour, Raymond, 1979. *L'Analyse du film* (Paris: Editions Albatros). (This is a collection of Bellour's film analyses originally published during the period 1965–1978.)

Bordwell, David and Kristin Thompson, 1979. *Film Art* (Menlo Park, Ca.: Addison-Wesley).

Brownlow, Kevin, 1968. *The Parade's Gone By* (Berkeley and Los Angeles: University of California Press).

Comolli, Jean-Louis and François Géré, 1978. "Deux Fictions de la haine: 1) Les bourreaux meurent aussi," *Cahiers du Cinéma* 286, 31–47.

Delevoy, Robert L., 1982. *Symbolists and Symbolism*, trans. Barbara Bray, Elizabeth Wrightson, and Bernard C. Swift (New York: Rizzoli).

Eisner, Lotte, 1969. *The Haunted Screen*, trans. Roger Greaves (Berkeley and Los Angeles: University of California Press).

1973 *Murnau* (Berkeley and Los Angeles: University of California Press).

Everson, William K., 1978. *American Silent Film* (New York: Oxford UP).

Freud, Sigmund, 1953 (1905). *Three Essays on the Theory of Sexuality* (London: Penguin).

Kracauer, Siegfried, 1947. *From Caligari to Hitler* (Princeton UP).

Mulvey, Laura, 1975. "Visual Pleasure and Narrative Cinema," *Screen* 16:3, 6–18.

1981 "Afterthoughts on 'Visual Pleasure and Narrative Cinema' Inspired by *Duel in the Sun*," *Framework* 15–16–17, 12–15.

Reisz, Karel and Gavin Millar, 1981. *The Technique of Film Editing* (London and Boston: Butterworth).

Rohmer, Eric, 1977. *L'organisation de l'espace dans le "Faust" de Murnau* (Paris: UGE).

Struss, Karl, 1976. "Karl Struss Remembers," in: John and Susan Harvith, eds., *Karl Struss: Man With a Camera* (exhibition catalogue) (Bloomfield Hills, Mich.: Cranbrook Academy of Art).

Watts, Jr., Richard, 1931. "Sight and Sound," *New York Herald Tribune*, March 18.

Wood, Robin, 1976. "Murnau," *Film Comment* 12:3, 4–19.

1983 "The Homosexual Subtext: *Raging Bull*," *The Australian Journal of Screen Theory* 15–16, 57–66.

Wood, Robin and Richard Lippe, eds., 1979. *The American Nightmare* (Toronto: Festival of Festivals).

LADIES SHOT AND PAINTED:
FEMALE EMBODIMENT IN SURREALIST ART

MARY ANN CAWS

I think that is absolutely amazing, really phenomenal. Talk about complications!

André Breton, to Pierre Unik

CONSPICUOUS CONSUMPTION: CAGING IN AND OUT

When Pierre Unik told Breton that he consulted, in lovemaking, his part-
ner about what she enjoyed, Breton was amazed. Why not? asked Unik.
Because, replied Breton, her likes and dislikes "have nothing to do with
it." (See *La Révolution surréaliste*, no. 11, 1928.) Indeed. Breton's attitude
may strike *us* as phenomenal, given our present assumptions about an
egalitarian society, about an equal ardor consuming both and all members
of unions — but of course, talk about complications, Surrealism had a
few.

I want to reflect on some problems in the representation of female
bodies in Surrealist photography and painting, touching first their
canonization, their consecration, and the laying on of hands, and then
the relation of this representation to the supposed consumer, for his or
her conspicuous or clearly visible consumption. Since, in the latter
concern, *we* are plainly concerned when we look (whoever we are assumed
to be), just as where we speak or write, we may be assumed to be looking
at our own gaze (*con-spicere*, to look intensively). Problematic above all
is the notion of our own consuming of what we see as if in collusion
with the artist or photographer.[1] For both the representation as produced

1. As for the painter or the photographer, he can keep himself at a certain distance from his creation,
or then enter it: he manipulates, that is, his stance. Michael Fried, in examining the ways in which
Courbet represented himself in a painting by a woman's gesture which would seem to repeat the
very gesture of painting, absorbing himself corporally within it, undoing his pose as a simple observer
before the painting conceived as a spectacle, describes Courbet as putting into question "the onto-
logical impermeability of the bottom framing-edge — its capacity to contain the representation,
to keep it in its place, to establish it at a fixed distance from both picture surface and beholder"
(Fried 1980a:100-101). Some of the techniques Courbet uses to reduce his own separation, to undercut
the territory of the one who would be looking from the outside, to abolish any possibility of an
objective or impersonal point of view — these techniques are not neutral or neutered, but often
serve, in *The Bathers*, for example, through the use of a feminine body and a female gesture to affirm
the corporality of the link between the painting and the one who looks at it as the object of desire
and union, corporality affirmed as natural and also cultural, as if nature were to take pleasure
in her representation in art.

by the agent or manager or mediator of the reading — artist or photographer — and the reactions of the onlooker or reader of the image must be reexposed in the light of a certain recent criticism putting into question the whole binary system of subject and object. This is a revision overdue and all the more problematic in Surrealism, which already wanted to overcome the split between seer and seen, visionary and view: thus, a problematics of the problematic, and how it is received.

I see this, speaking from the point of view of onlooker, as a tripartite problem: our view of the object, in this case, the woman portrayed in whole or part (of which more later); our view of the agent or mediator or middle-person; and our view of ourselves as consumers of the object as mediated and managed. To talk, again, about complications: insofar as it is a question of women's bodies, the female onlooker is — willing or not, partially or wholly — identified with the body under observation and under the rule of art. Her reaction to the middle term or the management will be colored by that identification, her consuming function modified by the pleasure or anger with which she differentially views what I have been calling the laying on of hands (*management*, from "hand," like mannerism, and — of course — like "handling").

For how could we possibly think that a seeing woman writing about women being touched with the brush, perfectly *captured* in paint, or accurately shot by a camera's eye, about these artistically ogled and consumed beings, would have an "objective" point of view? Her lens will be at least set with an angle to it, since there is no stranger's summit on which to stand aside and above. She, we are bound to think and say, is implicated, heavily.

Implication is nervously involved in looking at André Masson's rendering, for the Surrealist Exhibition of 1938, of a mannequin at once painted, caged, and captivated (Fig. 1). Her head is imprisoned in a bird cage, her face caught exactly within the cage door and her mouth masked, with a pansy directly over the opening. Under her arms, pansies match that one, so that neither in speaking nor in making gestures is she able to present herself unmediated or untouched, unornamented. The cage is not domestic but rather of the jungle variety — thus her presentation as vaguely exotic, beflowered. Over the join of her thighs is a complicated decoration for a double thrust of hiding and priding, as we might read in the peacock eyes (or, reread, the evil eyes) with the curving plumes in the form of fallopian tubes.

A found object, severed in the middle as mannequins may often be, she is set up with odd lighting so that one breast seems larger than the other: it is marked above by lines of shadow, significantly in the form of a spider, as if entrapment were to be in fact the key to the reading of the object. The shadows under the left eye and the dark circlet just below the neck stress the embattled nature of the shady and shiny lady with her jungle hat. She cannot speak; she is entrapped even as she is decorated, wearing at once too much and too little, dressed up and dressed down, naked

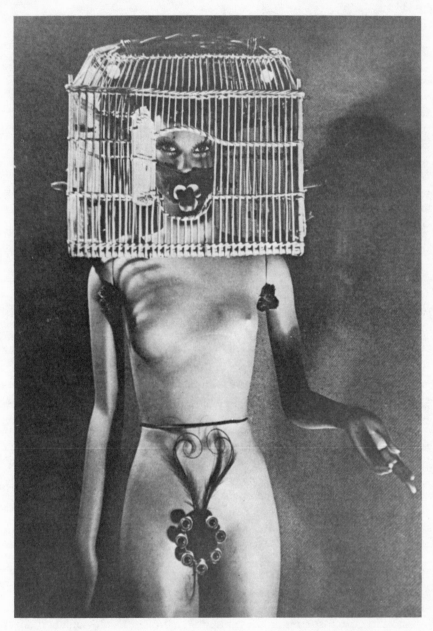

FIGURE 1 André Masson, mannequin for the Surrealist Exhibition of 1938.

and rendered mute, added to and subtracted from, but most of all entrapped. We've come a long way, baby, from the fig leaf to the chastity belt to this prize covering flower.

As for the head so encaged, it calls strongly to mind another female entrapment, this one the capturing by Man Ray of a live female model whose torso is bare and whose head is perfectly netted in a wire mesh hat, through which her eyes look out, as unsmiling as her mouth (Fig. 2). Is this a reflection on hat styles, on consumerism as negative display, or on capturing a prey who is rendered simultaneously mute and speaking of objecthood? The slope of her shoulders denotes a submission to the netting and the capture, and the caption is a quote from Breton's piece "Il y aura une fois" which the photo illustrates: "These girls being the last ones to point themselves out in a haunted house scandal. . ." The haunting, I submit, is more than a little sexually oppressive and less than innocent.

Xavière Gauthier's attack, in her *Surréalisme et sexualité* (1971), on the male Surrealist artist and writer's point of view regarding the female sex object has often come under attack itself for its "reductionism" and its "simplifications." A contemporary reexamination of the issue — of which this can only be a preliminary sketch — might well want to take into account two more recent works, neither directly concerned with the male-female issue, but both of indirect and yet certain relevance. The first is that of Rosalind Krauss, in her chapter entitled "The Photographic Conditions of Surrealism" in *The Originality of the Avant-Garde and Other Modernist Myths,* where she examines the techniques with which Surrealist photographers rob — by their spacing and delays and doublings — the image of the sense of presence. Quoting Jacques Derrida on the split between the time of the meaning of the sign and that of the mark or sound as its vehicle ("The order of the signified is never contemporary, is at best the subtly discrepant inverse or parallel — discrepant by the time of a breath — from the order of the signifier"), Krauss explains how, for Derrida, this spacing can be "radicalized as the precondition for meaning as such, and the outsideness of spacing. . .revealed as already constituting the condition of the 'inside' " (Krauss 1985:106). Thus "spaced," she continues, the photographic image is deprived of the sense of presence which — since it is the mark of the object — we have counted on. Doubling, or the showing of this spacing by a double imprint, is the most important strategy in Surrealist photography for letting the sense of difference and deferral penetrate the image (and so, we might want to add, the imagination). "For it is doubling that produces the formal rhythm of spacing — the two-step that banishes the unitary condition of the moment, that creates *within* the moment an experience of fission" (p. 109). Doubling destroys the impression of singularity, of the original.

Since, as Krauss says, Surrealist convulsive beauty depends on the belief in "*reality as representation*," and since "Surreality *is*, we could say, nature convulsed into a kind of writing" (p. 112), her discussion is crucial

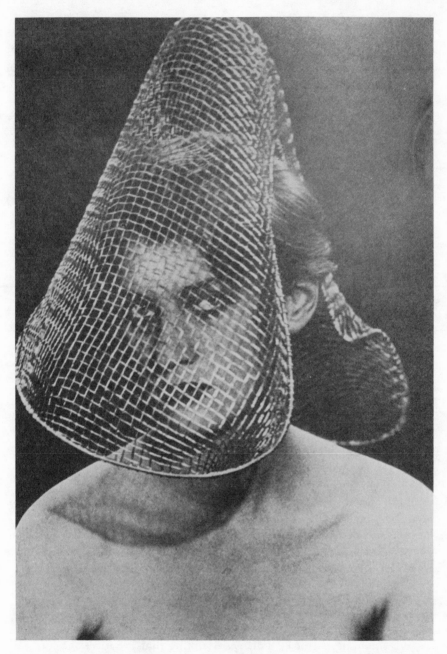

FIGURE 2 Man Ray, photograph in *Le Surréalisme au service de la révolution,* no. 1, 1930.

to the points I want to make about the representation of the female image, as I consider the writing of the female into the making and the seeing of Surrealist art. The denial of presence is exactly the problem with such photography, as we see ourselves seeing ourselves in it. In the image by Man Ray, *Monument to de Sade,* which Krauss takes as one of her two initial examples, a woman's posterior is seen rotated to the left and up, to echo a simple cruciform design imposed upon it: "Never could the object of violation be depicted as more willing" (p. 88). So the issues of depiction, collusion, and consumption are massively complicated even by the formal echoes, as we read them.

If we consider the point of view of a leading modern female exponent of Surrealist views, looking at the identical posterior and the identical cruciform shape as they fit each other, the difference in interpretation takes on its complicated colors to color our own text. Annie Le Brun, reading the same image of the *Monument to de Sade,* finds it the supreme example of revolutionary eroticism, the very illustration of the nudity of loves, and gives it the caption: "this condemned part of our history, the splendid return of the flame of human freedom against the idea of God"; and for the blurb of Jean-Jacques Pauvert's volume *L'Anthologie de lectures érotiques,* she comments: "Whether we like it or not, the body remains our only means of transportation, body of the other, body towards the other, body neither of one nor the other, body always other" (Le Brun 1985:183, 185).

I have worried before, in the case of modernism, about representing a body as if speaking before some parliament and about some body that should speak for itself, yet finds itself, instead of representative, just represented (Caws 1985); I have tried, elsewhere, to consider the images repeated and even integral in a series of representations of the fragmented body as a piece of the whole body of art (Caws 1984). She who would understand that body, in its own figure and embodiment, is obligated to *take it up,* and this taking-it-up is already taking a position, this position taken already implying its own struggle, hoping to find therein its own strength.

The body laid flat to be exposed, the body bedded and eaten by the eyes after the camera or the brush — this body demands, it would seem, a completely other point of view from the body sighted in the polite nineteenth-century garden picking fruit, or cuddling a child, or simply and politely seated or tabled, as in Mary Cassatt's women taking tea, chatting and consuming, as if the proper response there were to be a tabling and a sipping, a gentle consuming of impressions as opposed to the more violent Surrealist mode.

But the artist's point of view is of necessity manipulating, and not just in Mannerism: all art is derived from the hand, after the eye. By the hand this model is treated and seated, tabled and bedded. Linda Nochlin has shown us convincingly (and graphically) how, since the nineteenth century, the woman's body has been presented for the man's erotic

pleasure, rarely the man's body for the woman's (Nochlin 1973). Commenting on the woman's nudity as she has been traditionally exposed before the eyes of all, John Berger contrasts, quoting Kenneth Clark's *The Nude* as his source, nakedness (the state of being unclothed) with nudity (a conventionalized way of seeing), summarizing the argument as "Nakedness reveals itself. Nudity is placed on display." He then points out that the display is always for the male spectator (Berger 1972:54). The woman's exposure is not — and Breton would surely agree — a matter of her own sexuality, but of the sexuality of the observer, whose monopoly of passion is such that bodily hair (assumed to represent sexual power and passion) is not ordinarily placed on *her* objectified body (Berger 1972:55). Alienated from her body and from its probable representation, present and future, the model suffers in fact the destiny that René Char predicted at the end of his own classic Surrealist text of 1930, *Artine:* "The painter has slain his model" (Char 1976 [1930]:13). Char refers here to an interior model as replacing the exterior one: we who have been the model so often exterior may learn at least to exteriorize our anger over some of the manhandling.

PLEASURABLE FICTIONS OF PRESENCE

But back to the binary. The idea of a union, so desired, between painter and object of gazing and creation, fictional as it is, and of a specific problematic, may suffice to create a general fable which can so depart from the apparent realm of fiction as to become real. These are fictions indeed, these unions of body and brush or sight, but real fictions, sustaining as they can — and only they — the object of art as the representation of any onlooker's desire. The problem is, of course, the "any." Whose *is* the body of this art, and whose the fiction? Whose is the pleasure, where is it taken, and from whom? And, apart from the commercial *gain* of the management, what is its fruit? Who consumes what, however surreptitiously, and who is consumed, even by a glance?

It is, true enough, just as we are often told, a privilege to be photographed by, to be *captured so well by,* the camera or the brush of a great artist. How could we ever, either as model models or as model onlookers, have thought that any model would refuse to bear or enjoy the fruit of the entrails of mother art itself, at the hands or through the lens of its most celebrated representatives? We have then, it is supposed, to give credit, photographic and artistic, to the great mediators of the image as they pass it on to us; since they are also, in this cycle as I see it, the mediators of us to ourselves, we might want to pause before giving entire credit to the entire story, or to their descriptions as our story.

Narrative always fecundates; more stories are ceaselessly produced for us to live and read them, for them to efface our critical doubt, however dubiously we first begin to participate in bearing and having and seeing. Are we to refuse looking as part of being looked at? The whole issue of looking at ourselves as looked at calls into question how and where

we may be thought to possess ourselves, within this fiction of painless consuming of images-as-other. They are not, in this case, entirely other, nor can we pretend to see them as such. We are folded up in and into — implicated — and even tied up in and by our seeing.

IMPLICATIONS: TAKING OUR PLACE, AND WHOSE PLEASURE?
Are we obliged to be represented by, to participate in such problematic representations as that of a body offered in a caged display? What of a woman looking at an Other Woman clothed or caged, naked and yet neat and perhaps even integral, or dismembered like a doll of Hans Bellmer, untidily lying somewhere on some stair or floor, or then stretched out and spread out even more awkwardly like Marcel Duchamp's nude half-body with her legs wide apart, hidden and revealed behind his wooden door with its peephole in his construction called, aptly enough, and in the plural because, in fact so much is given, *Etant donnés*... or *Given*...? Does the woman looking take the stance of another or of a same, and what pleasure does she take in spying? Is the prey *taken* or the likeness perfectly *caught* in art *given* to her too, only as she can be co-opted into spying?

Only in utopia, some might say, would spying on the other have no place, whichever other we are not the same as. But the pleasures of participating and showing, modeling and making, consuming and enjoying the other — all these would seem to depend on a binary system. Michael Fried's examination of Diderot's attitude in front of Tintoretto's *Susannah and the Elders* is one of the most relevant texts in relation to such spying, for the Tintoretto renderings pose a special problem about a gaze seen as illicit. "The canvas," says Diderot, "encloses all of space, and no one is beyond it. When Susannah exhibits herself bare before my look, opposing to the stares of the old men all the veils in which she is swathed, Susannah is chaste and the painter too; neither one nor the other knew I was there" (Fried 1980b:96). John Berger points out about the version Tintoretto made of Susannah looking at herself in the mirror that she joins the spectactors of herself, whereas in the other rendering, as she looks at us, we are the obvious spectators and she judges us as such, as female nudes usually do (Berger 1972:47). In either case the spectator is committed, along with the old men, to gazing at Susannah.

Is there some way of looking that is not the look of an intruder, some interpretation from which we could exempt ourselves as consumers? Julia Kristeva reminds us how the verbal play of debt, of nearness and presence, is found from the beginning implicated in the notion of interpretation (*interpretare,* to find oneself indebted toward someone, based on *praesto,* meaning "near at hand" — *praesto esse,* present, *praestare,* to present, like some object, money in particular). But, she says, "the modern interpreter avoids the presentness of subjects to themselves and to things. For in this presentness a strange object appears to speaking subjects, a kind of currency they grant themselves — interpretation — to make certain

they are really there. . . Breaking out of the enclosure of the presentness of meaning, the *new* 'interpreter' no longer interprets; he speaks, he 'associates,' because there is no longer an object to interpret" (Kristeva 1983:80). Here the dimension of desire appears, and interpretation as desire returns the contemplator and participator in Surrealist art back to the very subject: how might we desire to function so as not to be implied in the *incorporation* and *embodiment* of the desire of another, when our body is interrogated, subjected to the act of painting as to the act of love, but without choosing our partner?

There again, difference sets in, between the gaze and the glance, for example, the latter implying less presence to the painting or photograph, the former requiring a lengthy implication in the folds of the scene or portrait. Norman Bryson, in his remarkable study *Vision and Painting: The Logic of Gaze,* examines the distinction between two aspects of vision, the gaze or look he calls vigilant, dominating, and "spiritual," and the glance we could think of as subversive, random, lacking a principle of order (Bryson 1983:93). The look, as he explains, implies an act always repeated, an impulse that would want to contain what is about to escape, as in the expression *reprendre sous garde* = *regard.* This gaze gone hard, this stare, tends toward a certain violence, a will to penetrate, to pierce, to fix in order to discover the permanent under the changing appearances, which implies a certain anxiety in the relation between spectator and object seen. The glance, on the contrary, creates an intermittence in vision, an attack, as in music, which withdraws afterwards into the calm of non-seeing; this would be the plebeian aspect in contrast with the aristocratic nature of the gaze, visible to the gaze of the other (p. 99).

The gaze fixed into a stare would not permit the other thus transfixed to leave the battlefield or the pleasure-bed, or the canvas. It would hold the other there, at the table of consummation and consuming. In contrast, the glance inflicts its momentary violence, and sometimes on the slant, with no return permitted, leaving to the other a certain freedom. In Surrealist painting and photography, I would submit, the gaze or the stare and the glance seem often to be called for as if simultaneously, summoned and as it were renewed: "Always for the first time," as in the Breton poem of that title. The sustained gaze will then be subject to momentary impulses of the glance as violent assault, under which the model will be obliged to sustain the onlooker's spontaneous desire in a paradoxical permanence.

The Surrealist body represented, taken (in) by the gaze and glance of the spectator, presents no margin of interpretation. By the desire of Breton as critic, all distance is to be suppressed between seeing and the object seen, between the look of desire and the prey, between two objects imagined or seen together (Breton 1928:199-200). Unless the female — for it is usually *she* — submits actively to such a stare, giving what is in any case taken by the male, she will have no role except enforced submission. The *prise de vue,* that expert taking of the view, that shooting of the model,

is a one-way venture, far from the erotics of exchange, open only to a willing relation of dominator and dominated.

TRANSLATING BUSINESS

What is rendered by Surrealist art is rarely qualifiable as totalization. More frequently than not, only a fragment of the body is exposed to brush or lens, as in Mannerist emblematics: an eye for Magritte, either seen in the crack of a door (*The Eye*) or in sublime solitude, divorced from its other and with clouds floating across it (*The False Mirror*), or (in *The Portrait*) delicately placed in a slice of ham upon the plate; a breast for Duchamp or Eluard, sometimes ornamenting a book cover slyly enjoining us to *Please Touch*; a series of clasped hands or wide-open eyes for Ernst (to illustrate Eluard's *Répétitions*); a photograph of legs repeated, or of one 'glove, for Breton's *Nadja*. This process, by metonymy and synecdoche referring to the whole body by the handling and exhibition of one part, can of course be considered celebratory, as in Breton's famous poem called "Free Union" in which each part of the woman loved is chanted in turn. This would be a traditional translation according to a mode now classic, no more troublesome than the instant interpretation of such famous lines as Ronsard's "A ce bel oeil dire adieu," which we read as saying farewell not just to one gorgeous orb, not even to both, not even just to the face, but to the whole being, in a crescendo which has — by the time we get there — lost all shock value, to become a standard reference point.

But modern views about translation, such as those expressed in the volume *Difference in Translation* (Graham 1985), teach us about mis-use as being more creative than standard use, about mis-translation as a possible challenge to a too simply $A = B$ relation by exercise on the pressure points of textuality, in which a relation of surface is also kept, and not just a relation of substance to substance as ordinary useful merchandising.[2] The *business* of translation as textual business too puts a new light on the light put on the Surrealist body and its polyvalent representations. We cannot just refer the fragmentation of the Surrealist body back to Mannerism with a good conscience, but must see it with the *presentness* demanded by modern art and theory. Thus, the female body seen by Hans Bellmer as a lifeless rag doll, rounded and thrown down like some castoff propped up for the picture, may enrage as it enlightens us; the double exposure of one pair of breasts above another in a photograph in the *Minotaure*, one of each pair larger and in profile, the other smaller and pointing the other way, like four eyes unwilling to meet the observer's stare, may send us back to the vertical superpositioning of many pairs of eyes in *Nadja* as well as to the other

2. See in particular the essay by Philip Lewis on "mis-using," in Graham 1985:31-62. Barbara Johnson uses the term "pressure points" for the moments when an ambivalence in sense is sensed as necessary (Graham 1985:142-148).

repetitions of fragments of females, but it will not add up, however we calculate, to wholeness. In each pair there is visible difference, which the repetition only aggravates. Horizontal opposition plays against vertical sameness in an image contrary to all intuition. This is a perfect image of delay and spacing, as in the analysis done by Krauss, wherein presence is abolished from the photograph (Krauss 1985:109).

PARTS AND THE POLITICS OF THE WHOLE

When a fragmented image is said to represent us, as we are supposed to represent woman, we may either refuse such synecdochic enterprises of representation or demand, if not totalization of the model, then at least reintegration, according to terms both private and public. To be sure, being partial prevents our being seen as homogeneous, and thus acts against the exclusion or appropriation of "all of us," all of our mind and body, since we are seen only in part.[3] We learn our politics in various ways, and these displacements and impositions may lead to rebuttal, or then to a demand for differentiation between the brilliant and revelatory, and the simply deforming and defaming. What we see as we are stared at may inform our own returning stare, or our own newfound anger, or help us to see something about ourselves, to accept it, refuse it, or change it.

One of Magritte's images, *Les Liaisons dangereuses* (Fig. 3), playing on Laclos's novel of the same name, shows a woman down to her ankles, her head bent down in profile. A mirror is located exactly in the middle of her body, with the middle part — that portrayed in the mirror — reversed in the center of the image. It is also reduced and raised, so that the parts — upper, central, and lower — have no way of matching. The deformation can be read as central to the self, for the woman divided is also watching herself — without seeing us see her from behind. The mirror she holds is, as traditionally, the sign of "vanitas," which, as John Berger points out, condemns her and has her connive in "treating herself as first and foremost, a sight" (Berger 1979:51). Not a pleasant sight, and conducive rather to self-loathing.

The awkwardness invades every inch of what is presented as vision on the interior of the frame. Never, in this body pictured and centrally interrupted, is the center to be either focused in the right sense or beautiful; never is the flow of vision to be integral; never is grace to visit this figure, from which the middle is forever excluded. Beneath her chin runs the hair continued, seen from the back, like the beard of some Slavic

3. Gayatri Chakravorty Spivak, writing on the "politics of interpretation," points out the hidden marks of ideology at work, such as "excluding or appropriating a homogeneous woman," and points out the totalizing appropriations of the "masculist" critic in relation to feminist criticism and to Third-World criticism. But, it is clear, "Male critics in search of a cause find in feminist criticism their best hope... Feminism in its academic inceptions is accessible and subject to correction by authoritative men; whereas... for the bourgeois intellectual to look to join other politico-economic struggles is to toe the line between hubris and bathos" (Spivak 1983:348, 366).

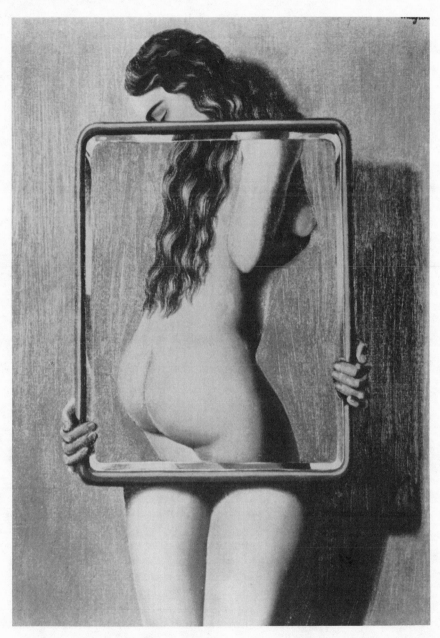

FIGURE 3 René Magritte, *Les Liaisons dangereuses,* 1936.

god; and more mythical figures are called in to help us read the picture, which is never satisfactory, and from which we are always shut out. Turning away, her posture resembles that of Cranach's Eve, with her back forever framed, her belly lit by a thin lighted line. Her head droops like that of a dead woman, or the bent head of a Madonna. She refuses to meet our eyes, as if desperately seeking the privacy she is supremely denied. This enormously pessimistic picture, with which — strangely, and perhaps because of the echoes — it is hard to empathize, into which we cannot enter, might be read as *Woman reading woman*.

This negative view is forever bound to be that of Magritte's self-regarder as she fails to locate her image in the mirror image, an image as reversible as it is inescapable. Self-loathing is presented as part of female presence. Now to this image such contemporary reflections as those we might make upon the pride and glory of the naked state (from Eve to photographic models) are totally foreign: the picture, as picture, makes no room for pride — only heavy astonishment at there being no frontal state to observe, for either insiders or outsiders. Deprived of natural frontal beauty, seen only askance and from the side, completely under the domination of the male painter, the model simply exhibits the shame of self and the difficulty of self-reading.

Quite to the contrary of such formulations — baldly categorizable as the nude ashamed and self-concealing, the fragmented doll, and so on, images setting up the display of the female, reading herself or as she is read, for the delectation or violent pleasure of male eyes — would be the free exchange of the ideas of possible images, between sexes as between persons and nature, all these translations at once erotic and artistic, the translations of difference which we could freely enjoy under the light of the narrative fecundated by a couple or many. I want to examine in particular a few images of the positive, or then of the double-edged or ambivalent, in photographs by Man Ray and in two paintings by Magritte.

Man Ray's extraordinary image of a female torso called *Retour à la raison,* reprinted in *La Révolution surréaliste* (no. 1, 1924), is a film still from his three-minute film of the same title. Made by the capture of a female body moving behind a striped curtain, this torso appears with stripes of shadow across the bare flesh like those of a tiger, one snaking up the center, all like some elaborate body painting. The torso, leaning slightly backwards, inviting the gaze, is posed against the rectilinear form of a window, so that the curves of animal and human play out their contrast. Nature is brought to the human, and the curved to the straight. The diagonal stripe across the torso echoes the window line, whereas the slightly fuzzy or at least irregular shadow to the right echoes, as if with human hair, the subjective statement of the photograph itself. This is, it seems to me, a positive image, adding to the beauty of the female form. This imposition is quite unlike the imposition of the penis against a woman's nose in a photomontage by Wilhelm Freddie called *Paralysexappeal,* in which the addition can only insult and enrage a female

observer. The Man Ray imposition of the natural on the human can be read only as beautiful; in no way is the body deformed, it is rather augmented by its natural possibilities. Thus do we learn about merging the one with the other, as in the surrealist game of "l'un dans l'autre," the one in the other, where one object is considered as augmented by the other and each rendered more interesting: their union is not forced but imaginative, and multiple in its possibilities.

In another but frontally posed torso (Fig. 4), the imprint of the curtain with its meshing pattern over the bareness works a strange and convincing convergence. The bare body behind the grill, or its representation, is nevertheless liberated as it is, precisely, baring its breasts; the baring is all the more emphasized in relation to what appears to be a binding corset, dropped to expose the navel, thus creating a double liberation, above and below. That the face of the woman is seen in only some versions, not in *Retour à la raison* nor in many of the other Man Ray photographs with the bare torso striped or bound, permits the body's presentation as emblematic, and as emblematic of beauty itself, in all its splendid convergence of the bound and the free. The protrusion of the breasts balancing the indentation of the navel is marked as the other, and natural, opposition, whereas the body exposed by the side of the curtain which would be thought to cover and to veil makes the drama of the whole presentation. This, like *Erotique-voilée,* celebrates a complicated ambivalence in paying homage to simple unadorned beauty, celebrates the art of photography in paying homage to nature, and, in encouraging the juxtaposition of the notions of superimposed pattern and evident freedom, celebrates the play of the intellect in relation to the body.

To this union of possibilities, human and artistic, we might compare, for the blend of figure and nature held in exchange, the extraordinary photograph by Brassaï (Fig. 5) which appeared in the Surrealist journal *Minotaure* (no. 6, 1934) of part of a naked woman's body from shoulder to buttocks, seen from behind as she lies stretched out with her ridges and furrows and monumental beauty responding to the long body of a mountain's profile, matching curve to curve beyond her, and above it the sky, as if reclining in like pose above the mountain, its bright curves mirroring the light body of the woman against the darker ground, like two female bodies stretched out to hold between them all the earth and its own full and swelling beauty. Surrealism's flexible and often sentimental vision serves to encourage such harmony between natural landscape and the culture of art, holding in poetic embrace contrary elements past their binary opposition, as in Breton's memorable and significant expressions "the air of water" and "the flame of sea." These expressions illustrate the Surrealist basis of convulsive beauty, the reading of one thing into another. The image can in fact be read equally well from the top and from the bottom, in perfect figural harmony.

Breton's statement, in *Nadja* and elsewhere, that "beauty will be convulsive or not be" is illustrated by Breton's own choice of an image by Man Ray to accompany his essay on this subject in the *Minotaure.* The

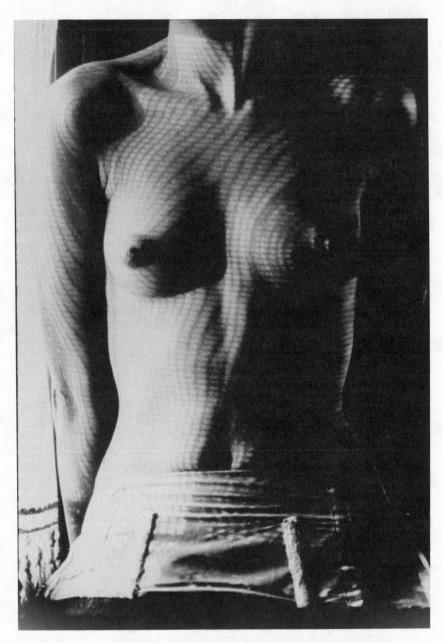

FIGURE 4 Man Ray, photograph, 1920s.

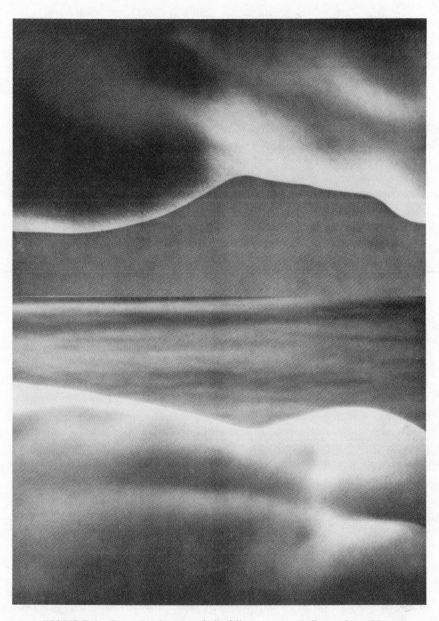

FIGURE 5 Brassai, photograph in *Minotaure*, no. 6, December 1934.

image (Fig. 6) is full-page and striking, called "Erotique-voilée," thus marked by being at once open and secret. Méret Oppenheim is pictured leaning on a gigantic and complicated wheel, nude and facing us, with her left hand and arm raised, imprinted with grease, while her right hand presses on the metal. In the upper right-hand space between the outer rim and the spokes, chosen elements of her body are as if *caught:* the hair under her raised arm, appearing just under the rim, and her right nipple, appearing just over the spoke. This image is emblematic, I think, of the double reading of Surrealism's celebrations of *blasons* or separate body parts, for the elaborate divisions of the wheel stress, above all else, the disjunction of parts.

According to a first and positive reading, all the pressure here can be seen as light — the eroticism also, even as it is veiled. The interaction between machine and woman is entered into with complicity and elegance, as Méret looks down with a slight smile at the wheel itself, which, although it could be seen to interrupt her body quite as definitely as the Magritte mirror interrupts the self-reflective woman, is also the instrument of her willing revelation — in parts — and the object of her admiration. She has no shame about her body and no fear of the wheel: around her neck is a simple black circlet, like a visual echo of the wheel shape, and her lips are closed over her teeth, while the wheel has tooth-like notches on one of its vertical spokes. In a visible yet subtle complementarity, the wheel reveals what she conceals; it both adds and subtracts.

In this upbeat reading, the medieval spinning wheel brings its long tradition to the song of the body, spinning out the tale of how woman harmonizes with her partner, the object, from ancient to *Modern Times.* She is in complete understanding with her mechanical lover, so that even the orifices of her body (her navel, her ear) rhyme with the openings of the wheel; the elements are strengthened each by the other, force without forcing. The woman shot is here celebrated by both wheel and camera, to both of which she may seem to give, smiling and thus as if freely, her bare form to be caressed and pictured, with no intrusion upon her intimate secret. Art and mechanics wed the modern female form, which learns to reread itself as if by a printing press, the wheel replacing for us the spinning out of our tale. The woman awakens in her new image against the traditional rhythm to be hummed or sung, now to be printed against the background of the past. Here the primitive strength of the domestic meets a more contemporary magic of imprinting and metallic reproduction: woman in the round, we might read, and about to be multiplied in so many images.

An opposite reading is equally possible. Here the wheel allies itself with the grease marked upon the body as referring to a torture wheel, for Saint Catherine or any other woman foolish enough, unfortunate enough, to be caught by it. In this grim tale the potential violence of convulsive beauty remains implicit, as does the reflection of the wheel upon her body; the aggression of the metallic form, that deliberately seg-

menting master, is as divisive — she will be, like us, torn apart — as it is permanently imprinting for the Surrealist design. This reading joins the photograph of what is both openly erotic and openly veiled to the stance of those other Man Ray photographs, where cages are placed over the woman's head (bodyless in the photo) and body, metallic over living. Here the living weds the metallic, only to reinforce the latter.

But the photograph published in *Le Minotaure* is a cropped version, and the longer original says still other things in this second reading (Fig. 7). The etching wheel is moved by handles, and the handle of the outer and smoother wheel now appearing makes a definitely phallic protuberance above the intimate region formerly cropped from the photograph. Adding this reading is like adding an appendage, an appurtenance, to the photograph and the female form within it. Already, as we know, in the 1950s and 1960s the printmaking tradition, or the lithographic revival, inspired the rolling of models in printer's ink to inscribe their *real traces* as art. Here, the model, having become a partner of the printmaking process, still suggests her own implication, by the ink upon her arm and hand (she, the artist Méret, after all) which was already visible in the cropped version, and by the smile now seen as even more complicitous even in the act of photography. The two photographs make an odd doubling, for the smile seems somehow to change its focus, as she looks down at her exposure, the handling of it, and the *handle* to it. At this point, and in this rereading, we think back to the Magritte rendering of *Les Liaisons dangereuses,* as the woman closes her eyes to her own exposure in the mirror and behind: these relations in their accent on process involve a still other danger and, I would submit, the viewer is far more involved. Even the act of second reading is a confession of further involvement — for otherwise, why would we feel the need to look again? *In what process are we indeed involved?*

An equally ambivalent reading can be made or *taken* of Magritte's painting called *Representation* (Fig. 8), a painting seen as a mirror, or a mirrored form painted as a painted form, showing quite simply the mirrored form of a woman from her lower stomach to her thighs, with the heavy frame around it shaped to its outline, as if deliberately keeping and holding just that part of the woman, metonymic of the way she is seen, with the mirror object as discreet and appealing as a statue, and not much more lifelike. What represents here, and what is represented? the reader is bound to ask. Is it the self-reflexivity of the form looking at itself as framed, by itself, as a mirror? Does the title indicate that to represent is to mirror, that to frame is to wed outline to form, that to look at ourselves framed up is already to represent ourselves? More than any of Magritte's other works, this one is surely about how the metaphor of representation works, how it makes a whole from what would seem a most partial part, a public artistic statement about what would seem the most private form. This is *representation* itself, and how we react to its selection out from the rest, to its enframing in its fragmentation, may

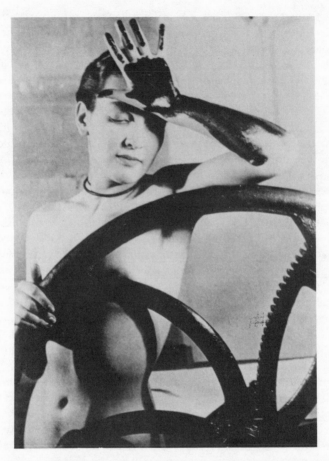

FIGURE 6 Man Ray, *Erotique-voilée, Minotaure,* no. 5, May 1934.

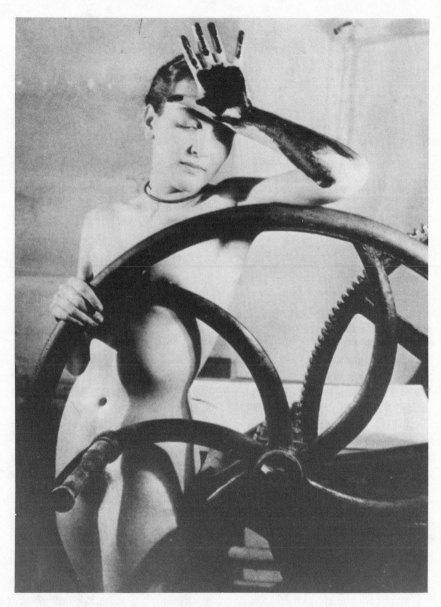

FIGURE 7 Man Ray, *Erotique-voilée*, uncropped version.

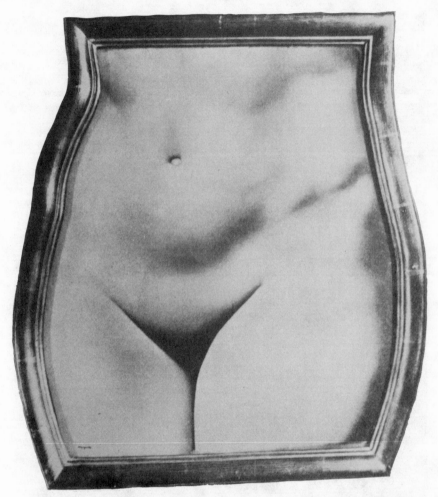

FIGURE 8 René Magritte, *Représentation,* in Alain Robbe-Grillet, *La Belle Captive.*

depend on what credit we give to the representers of representation, as
well as on what credit we think they give to us.

The final image I wish to comment on is itself of a complication worthy
of mirroring the spoken complications with which I began. ("Talk about
complications!") Perhaps the most captivating and most complicated of
all the representations of the female body that Magritte is responsible
for is *La Lumière des coincidences* (Fig. 9). Upon a table stands a frame,
in which there is pictured a statue of a female torso, stumps marking
the arms and legs, while upon another table nearer to the observer there
stands a candle, burning like the famous candle in de La Tour's Repentant
Magdalene pictures, with its very substance lit by the flame. The heavy
metaphysical light of a *vanitas,* of a *memento mori* shines here, and the

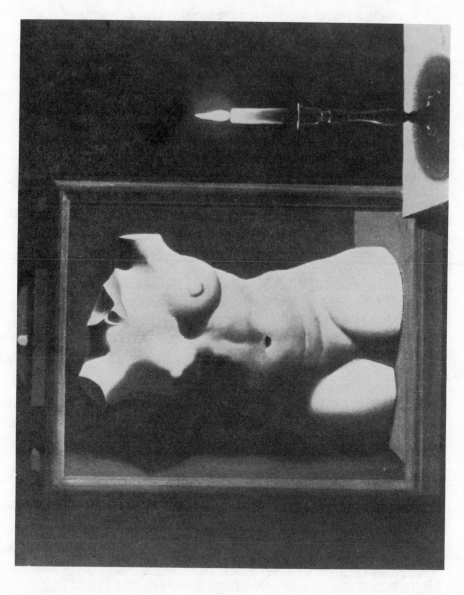

FIGURE 9 René Magritte, *La Lumière des coïncidences*, *Minotaure*, no. 8, June 1936.

implicit weight of the statue, representing female form in massive beauty, sculpted instead of painted, mixes these genres for an odd reflection on representing. A statue is painted as a statue in a painting about painting: the mixing of genres, of conceptions, adds to our own perception of what representation is, what painting may be, and how complicated a simple form can become. Like the *Representation* of representation just commented on as emblematic of how we look at looking, this picture is about seeing, enframing, and models in their treatment as parts and as wholes.

Here the frame and the included statue are *tabled* and *set up* for our own illumination, surely, while the raised stumps of the statue seem to summon help and love, or at least our willing perception of the summons. As is proper for a *vanitas*, the shadow of the statue within the box is reflected on the wall, while the front table, tipped up, intersects with the box, until the objects in the painting and their harmonies of dark and light are doubly boxed in and framed, until containing and self-containment seem to reach perfection in their very shadowing. Nothing here is cut off by its intersection; nothing feels lost even as it is severed; nothing feels merely painted or merely caged. The substance is adequate to the meditation, uninterrupted and profoundly lit, poetic as it is erotic, contemplative and profound. This we are given; how we interpret it depends on our relation to meditation and to its partial giving, its partial concealing and its partial lighting.

Ambivalent or monovalent in the reading, stuffed, shot, and shown, in our dismemberment and our displacement, captured and presented to the gaze or the glance, aging into observers of ourselves as object, we can still hope that past the fragments of our exposed individual bodies there may be imagined, in all its deepest integrity, our own representing body. Our interpretation must move past the easily assimilable and its confines as just *Representation,* to incorporate our delight in the modern as we imagine it and our refusal of dumb mastery.

GIVING CREDIT AND GIVING THE LIE

To what might we choose to give ourselves and our being seen, and, more especially, why, and to what end? The gift, Marcel Mauss reminds us, must circulate, and in its interior country. What interior country has the artist's model, real or painted or shot, that naked lady in the iron cage? In Robert Desnos's great novel *La Liberté ou l'amour!* Louise Lame (the Lady Blade, as it were, Jack the Ripper's rival) is naked under her leopard-skin coat. She has, however, the privilege of laying it down, and takes that privilege, giving it as a leopard would his spots. But the caged lady, not measured here against some beast as in the celebrated story "The Lady and the Tiger," has little privilege and no choice. To be able to give or to give oneself, one must know oneself to be free. To be given in free exchange, to be willingly kept in ocular circulation, to serve as object for readerly and visual reception, not to hold out on the viewer, is already surely an act of generosity, if not forced. We have to be able to refuse it; and the portrayal of the bare self as caged even if smiling,

even if the cage is chosen as a fashion, should make us grit our teeth, and, more properly, arm our wits and tongues.

Lewis Hyde's recent book entitled *The Gift: Imagination and the Erotic Life of Property,* which takes its point of departure from Mauss in order to apply his theories on the gift to poetry as a human (and therefore giving) relationship, redefines the word *erotic* under this angle. To the theories of Mauss, Hyde adds emotion in the place of economics: what cannot be given does not exist as a gift, including the gift of talent, or a body and spirit of lyricism. A gift, he says, is anarchist property, "because both anarchism and gift exchange share the assumption that it is not when a part of the self is inhibited and restrained, but when a part of the self is given away, that community appears" (Hyde 1979:92). The fragmented self — even a part of us — thus given away uninhibitedly, after Mannerism into Surrealism, and to all observers equally, may redeem — should we acquiesce in it — the sort of communal vision that a more classic holistic tradition was not able to save. Rather than yielding our minds up with our modeled and remodeled bodies, we must give our readings of our representations, and our opinions as to which deserve anger and which, celebration. We must, in short, read freely and choose how we are to read our representing. Good and true reading is a gift, one we must hope to develop, and one on whose exchange we must work.

But more specifically, our reaction by our contribution to this volume is itself what giving is about. "A gift that cannot be given away is not a gift...*The gift must always move*" (Hyde 1979:xiv, 4). To *contribute,* says Hyde, "one's ideas to a journal, or a colloquium, or a book and thus to *share* them, is the mark of a gift which has learned to circulate" (p. 77). We are creating, then, a network of giving by this circulation, giving a part of ourselves to the community of readers. The more a gift is shared, the more it is sacred; what is given leaves a free place, so that energy accrues in the procedure of free circulation.

In the major images I am presenting or *giving* of ourselves as *taken,* painted, and shot, our individual and collective interpretations must move past the paralysis that might set in from too prolonged and too accepting a stare at those fragments of our exposed bodies. We must at least glance beyond the "imposing" *Paralysexappeal* of Wilhelm Freddie as well as the conforming and constraining frame for our confinement that Magritte presents as *Representation* itself; beyond the mechanics of our delight in our own modernness, as in Man Ray's picture of Méret Oppenheim and the printing press, a contemporary celebration of the textual in which the nude is seen in (sadomasochistic) textual and visual collusion, replacing both the torture wheel and the only seemingly innocuous spinning wheel of an earlier age.

COLLECTIVE INTEGRITY
In networks and interpretive communities, to use Stanley Fish's term (Fish 1983), in their embodiments of our imaginations, our desires, and our truths, we would find an integration of ourselves, not just represented

by representing. Refusing totalization as a *masterly* concept and preferring integration in its place, we are already making a strong statement about how we can deal with fragments and how we do not have to deal with tyranny and its currency of forced consumption. Giving credit where credit can be read as deserved, if it is not always necessarily and truly due, our free reading of images positive or even ambivalent makes its generosity out of sharing what it feels and sees.

This reconstruction of us all — of these bodies dismembered, violated, and undone on the one hand, of these bodies harmonious and celebrated and supplemented by nature, art, and even the machine on the other — cannot take place until the very speaking core of our interpretive community takes its truest pleasure and deepest joy in the exchange of our ideas taken up and understood together, in our essential difference and in our common comprehension, in our joint understanding and speech and work — in short, in our equivalent of the philosophical *conversation* (Rorty 1980:318). We would put our ideas in common for a free exchange of views, the ideas of all those "whose Ideas are Eaten in Conferences" (Hyde 1979:79). Our will to discussion as to art, not just as passive models and dolls gone to pieces, but as inducers of the circulation of ideas as of talent, turns us from consumer and consumed to creator and life-giver, after all that labor. "In a modern, capitalist nation," Hyde concludes his chapter called "A Female Property," "to labor with gifts (and to treat them as gifts, rather than exploit them) remains a mark of the female gender" (Hyde 1979:108). Our true labor may be working out the greatest possible realization of some conversation about sharing and female networking, developing it toward a collective wholeness that our final gift to each other may represent.

From our free reading of the renderings we encounter, from our discussions there may develop — in time as in our texts and those we contemplate — the collective integrity we would most want, as a body, to work toward: *beyond* the traditional candle and mirroring frame, as a reminder of our deaths and of the life of our art, in their marvelous coincidence and their unequaled flame. Modern, like the wheel, striking, like the straight-on stomach shot, old-timey, like the candle, representation — with its complications mirroring and complicating our own — is our recurring concern. Our willingness to share in it and discussions that include our part in it, partial but shared, prove our strength abiding and most whole.

REFERENCES

Berger, John, 1972. *Ways of Seeing* (London: Pelican).

Breton, André, 1928. *Le Surréalisme et la peinture* (Paris: Gallimard).

Bryson, Norman, 1983. *Vision and Painting: The Logic of the Gaze* (New Haven, Conn.: Yale University Press).

Caws, Mary Ann, 1985. "Representing Bodies: Cloaking, Veiling, and Ellipsis from Mannerism to Modernism," in Monique Chefdor, Ricardo Quinones, and Albert Wachtel, eds. *Modernism: Challenges and Perspectives* (Urbana: University of Illinois Press).

1984. "Partiality and the Ready Maid, or Representation by Reduction," *Journal of Aesthetics and Art Criticism*, XLII/3 (Spring), pp. 255-260.

Char, René, 1930. *Artine*, trans. M.A.C., in Mary Ann Caws and Jonathan Griffin, ed. and trans., *Poems of René Char* (Princeton: Princeton University Press, 1976), pp. 8-13.

Fish, Stanley, 1983. *Is There a Text in This Class? A Theory of Interpretive Communities* (Baltimore, Md.: Johns Hopkins University Press).

Fried, Michael, 1980. "Representing Representation: On the Central Group in Courbet's *Studio*," in Stephen Greenblatt, ed., *Allegory and Representation* (Baltimore, Md.: Johns Hopkins University Press).

1980b. *Absorption and Theatricality: Painting and Beholder in the Age of Diderot* (Berkeley: University of California Press).

Gauthier, Xavière, 1971. *Surréalisme et sexualité* (Paris: Gallimard).

Graham, Joseph, ed., 1985. *Difference in Translation* (Ithaca, N.Y.: Cornell University Press).

Greenblatt, Stephen, ed., 1980. *Allegory and Representation* (Baltimore, Md.: Johns Hopkins University Press).

Hyde, Lewis, 1979. *The Gift: Imagination and the Erotic Life of Property* (New York: Vintage).

Johnson, Barbara, 1985. "Taking Fidelity Philosophically," in Joseph Graham, ed., *Difference in Translation* (Ithaca, N.Y.: Cornell University Press).

Krauss, Rosalind E., 1985. *The Originality of the Avant-Garde and Other Modernist Myths* (Cambridge, Mass.: MIT Press).

Kristeva, Julia, 1983. "Politics and the Polis," in W. J. T. Mitchell, ed., *The Politics of Interpretation* (Chicago: University of Chicago Press).

Le Brun, Annie, 1985. *A distance* (Paris: JJ Pauvert, aux éditions Carrère).

Lewis, Philip, 1985. "The Measure of Translation Effects," in Joseph Graham, ed., *Difference in Translation* (Ithaca, N.Y.: Cornell University Press).

Mitchell, W. J. T., 1983. *The Politics of Interpretation* (Chicago: University of Chicago Press).

Nochlin, Linda, ed., 1973. *Woman as Sex Object: Studies in Erotic Art, 1730-1970* (New York: Newsweek; reprinted, London: Allen Lane). (See especially Nochlin, "Eroticism and Female Imagery in Nineteenth Century Art.")

Rorty, Richard, 1980. *Philosophy and the Mirror of Nature.* Second printing with corrections (Princeton, N.J.: Princeton University Press).

Spivak, Gayatri Chakravorty, 1983. "The Politics of Interpretation," in W. J. T. Mitchell, ed., *The Politics of Interpretation* (Chicago: University of Chicago Press).

JEAN RHYS:
POSES OF A WOMAN AS GUEST

ALICIA BORINSKY

FIRST POSE

She is sitting at a table in some café. It is in Paris. She is English-speaking. Money is a problem. We are aware of her being badly in need of clothes. She lives in a rented room for which she can pay only after a number of sacrifices and humiliations. The money does not belong to her. There is a story to each bill, a humiliation that precedes every small triumph. She is trying to survive. Her life is tough but she has a reserve of elegance; there are things that she just will not do.

She is a woman who will enter into casual relationships but she is so vulnerable to them that she cannot be called "easy." She is, in fact, quite difficult. There is a distinct tone of contempt in her description of others. She is capable of isolating details of their appearance and referring to them as though they were the traits of some revolting animal; in her helplessness there is the superiority of extreme detachment from the world. She is also an aristrocrat. A dandy in a city only marginally her own, she ages and nervously checks herself in little purse mirrors. It is clear that she is constantly preparing herself for something. She is waiting.

As we read Jean Rhys's fiction, with the sad Hopper-like woman in the foreground, other characters emerge giving shape to the peculiar form of her helplessness. They are the ones for whom she speaks, the source of her bland determination, passing crutches for her walks in the city. In this pose — and the term is better suited than perspective, because of the role that silence plays in our perception of her — the reader shares some hope with her: there will be some money coming her way, she will be able to get a new dress, the city will give her a break.

"Then she would feel horribly fatigued and would lie on the bed for a long time without moving. The rumble of the life outside her was like the sound of the sea which was rising gradually around her"

(1982a:12). Julia Martin in this work, *After Leaving Mr. Mackenzie*, seems to be spent after having had a particularly sad love affair; lost in memories in a hotel room for which she may not be able to pay. But her fatigue is more than anecdotal. It is her basic relationship to her surroundings and it affects not only her dealings with the world constituting her present but also the kind of remembrances that inform her past. As she recollects, "Her mind was a confusion of memory and imagination. It was always places she thought of, not people. She would lie thinking of the dark shadows of houses in a street white with sunshine; or of trees with slender dark branches and young green leaves, like the trees of a London square in spring, or of a dark-purple sea, the sea of a chromo or of some tropical country that she had never seen" (p. 12). The extreme poverty of Julia is complete. Being alone — an almost permanent state in the minds of Jean Rhys's characters — is an experience lived with the same kind of apathy that exists in her when she is with somebody else. Her past life has very little weight for her. People show up through descriptions of their faces accompanied by chunks of speech yielding an uncanny brutality to whatever words are said, rather than entering into the worldliness of conversation.

Who are the women in Jean Rhys's fiction, and what makes them so tired? As we see them in the novels and short stories, their pose at the café table with a drink becomes more and more defined. It is not a plural but a singular. There are not many stories told in each of these books. It is always the same woman. The silence that she exudes is there also for herself. We should not mistake it for a sign of interiority. She does not bore herself because she does not have the imagination needed to envisage a state other than inaction. Her apathy is a telescope through which she views others. This woman is also, and perhaps above all, an aesthete of uncompromising standards. Her surroundings make her moods: a chair in the improper place, ugly curtains, the wrong light, are enough to sustain and direct her emotions towards events. They are, in fact, the events.

WHAT SHOULD I WEAR?
Store windows offer possibilities for the pose. They are for this woman alternative lives; a way to change. She does not buy clothes merely to be seen in them. As she puts on something new she gains access to a narrative where she is featured in a more intense plane. One suspects that she wants to trick herself into being alive. Shopping for clothes is not easy because it involves the complex network of decisions that are predicated against her natural state of apathy, and because she is broke. Each of the garments acquired tells the story of who paid for them. No piece of clothing is neutral. Leaving a lover or being left by him is often accompanied by an envelope with money that arrives a few days later, when the woman is staying

by herself in the hotel. Sasha Jansen in *Good Morning Midnight* (1982b), recovers from having left her dead child in the hospital. She goes to the hair dresser to become "a very good blondcendré" (p. 62); we know that the death of the child has affected her because "I had expected to think about this damned hair of mine without any let up for days. (Is it all right? Is it not all right?) But before the taxi has got back to Montparnasse I have forgotten all about it" (p. 62). She sits in the Luxembourg Gardens watching the fish, trying to bring herself back to enthusiasm, which means trying to command the initiative to change the pose, stand up and go. Where? "I must go and buy a hat this afternoon, I think, tomorrow a dress" (p. 63). This time she is not successful and perhaps because of that, unable to change her story, she meets the young Russian she already knows. Sasha is young; it is still possible for her to feel happy with a new dress, a new hat and a good drink. It is as though we could measure the degree of happiness of particular events in her life through the clothes she was wearing and the rooms she inhabited: "Well, London. . . . It has a fine sound, but what was London to me? It was a little room, smelling stuffy, with my stockings hanging to dry in front of a gas fire. Nothing in that room was ever clean; nothing was ever dirty, either. Things were always half-and-half. They changed one sheet at a time, so that the bed was never quite clean and never quite dirty" (p. 113). Her recollection of her marriage is a recollection of rooms and clothing: "Then I wake up and it's my wedding day, cold and rainy. I put on the grey suit that a tailor in Delft has made for me on tick. I don't like it much" (p. 115).

The beautiful and young Marya Zelli opens up *Quartet* (1981a) by getting up from her table at the Café Levenue in Montparnasse after having sat there for an hour and a half. As she takes a walk the reader knows that she is admired by passers by, that she has enough people talking to her in the street because of her attractiveness, that she can shake them off by faking not to know the language. As her marriage to a shady character is interrupted by the intervention of the police — he is imprisoned — she becomes a victim of her beauty. When she sells her wardrobe to survive, the searching look of the buyer, Madame Hautchamp, does more than examine clothes. In giving up her clothes for money, Marya Zelli makes herself vulnerable to the analysis and manipulation of others; we witness the dismantling of her posing. Hoping to pay a lower price for them, Madame Hautchamp dismisses their usefulness; her gesture also has the effect of isolating Marya's pose, making it visible to the reader: " 'My sister in law is a *teinturière* and I can make an arrangement with her to hang them for sale in her window, otherwise I could not buy them at all. And, as it is, I can't offer you much. This, for instance, this *robe de soirée*. . . .' She pointed out the gem of the

collection: 'Who would buy it? Nobody. Except a woman *qui fait la noce*. Fortunately, my sister in-law has several clients *'qui font la noce.'* 'But I don't see why it must be that sort of woman' argued Marya. 'It is not a practical dress,' said Madame Hautchamp calmly; 'it's a fantasy, one may say. Therefore, if it is bought at all, it will be bought by that kind of woman" (p. 36).

Marya Zelli has been changed into a destitute. The novel documents the effects of the loss of her wardrobe. Lodging and clothes become central in the entanglements that follow. The contracts that she has with other characters are ways of getting clothes and of keeping a roof over her head. Marya is 28 years old. Her clothes have been sold not to another woman who might think of wearing them but to an intermediary who, in turn, will give them to her sister-in-law to sell to her clients. The clients have to be a specific *type* of woman. These are not clothes for everyday people. They are not for those who are described as shabby or merely respectable as they push baby carriages in the Luxembourg. Other clothes. Different. Special occasions. A special kind of woman. Toward the end of *Quartet*, when Marya is visited by Miss Nicolson in the retreat for which that wealthy Mr. Heidler has paid, for Marya to recover from the end of their affair, we read about her clothes: "Miss Nicolson stood sturdily in the sun, long-bodied, short-legged, neat, full of common-sense, grit, pop, and all the rest. She was dressed in grey; she wore a green scarf and a becoming hat. Her small feet were shod with crocodile-skin shoes" (p. 158).

As Marya is shocked by the hairy legs that may be intuited through the delicate silk stockings worn by Miss Nicolson, she is also disconcerted by the fact that such a woman would tell her that she loved beauty. The hairy legs and the love of beauty frame another statement that does not stir Marya's interest, it is about how much Miss Nicolson hates women. Their relationship is very brief and does not accomplish much. They leave each other, two figures striking very different poses, clad in clothes that codify their messages neatly tucked away from uncertainty. It is, indeed, as though women belonged to different tribes according to how they dress. In selling her clothes Marya becomes available to whoever might pay for new ones. She does more than shop when she chooses a hat, a dress. She is renewing her pact with life. She chooses to go back to the world being presentable. Being presentable . . . what exactly might that mean once the issue of respectability is not at stake? It is being in the present. Having new clothes voids her past, makes her start all over again. But the illusion of movement, the break represented by doing away with her previous appearance hides the more solid and choking bond that makes the property of the clothes possible: the political relationship between Marya, Julia, Sasha, the woman in Jean Rhys's texts, and whoever gives the money. As the bills go

from hand to hand we perceive the desperation in the question about *what* to wear, for it stands for the fear of being alone, of not having not a *what* but a *whom* to wear. Her affairs dissolved in failure, the signs of success are clothes to start another narrative, the tenacity of a repetition with which this woman clings to her helplessness.

LOOKING AT WOMEN

When Marya observes Miss Nicolson she wonders about the hairs showing through the silk stockings as though she were the witness to some hidden identity. The woman in the proper dress is radically different from her, whose legs anticipate disorder, lack of control, a dark self. Miss Nicolson is a mystery; she is a lady. We do not know how ladies get their clothes, but the underlying assumption in Jean Rhys's work is that there is a harmony between a lady and her attire. There is a certain kind of calm exuded by expensive materials and muted colors. No flashiness here, no nervousness about where the next garment will be coming from. In *Voyage in the Dark* (1982c), eighteen year old Anna Morgan sits at a table with Laurie — described as a friend and a tart — and two casual male acquaintances. Anna is wearing one of Laurie's dresses since her own black velvet dress is torn. As they talk, they realize that they are being watched from another table: " 'What do you think about the lady at the next table? She certainly doesn't look as if she loves us.' I said, 'I think she's terrifying,' and they all laughed. But I was thinking that it was terrifying — the way they look at you. So that you know that they would see you burnt alive without turning their heads away; so that you know in yourself that they would watch you burning alive without even blinking once. Their glassy eyes that don't admit anything as definite as hate. Only just that underground hope that you'll be burnt alive, tortured, where they can have a peep. And slowly, slowly you feel the hate back starting. . ." (p. 120). More seasoned than Anna, Laurie fights the stare with contemptuous phrases about the other woman's looks: " 'What right has a woman with a face like a hen's — and like a hen's behind too — to look at me like that?' Joe started to laugh. He said, 'Oh, women. How you love each other, don't you?' " (p. 118).

The situation — a class conflict among women because of dress where the "lady side" exercises the powerful weapon of a stare to freeze the other side into a reactive hostile pose — appears time and again in these works. In the passage quoted, the intervention of one of the men frames the conflict in a larger context. For him, the woman who stares and the ones who are offended by the stare are all the same. He can laugh it all off as a confirmation of the incapacity that women have to love one another. As the woman from the next table tries to humiliate Laurie and Anna with her look, the three of them become victims of the joke between the two men. There is

no breaking away from restaurants, cafés, streets, where women look at each other or at themselves in a world where ultimately the joke is on them.

What right has a woman who looks like a hen to look at another woman? We suspect that if the woman were different she would have the right to stare the other two down. What would she have to be like? In the first place she should not look like a hen or a hen's behind; that is, she should be attractive. A woman could look at another woman with critical eyes only if she herself has passed the test of beauty. Anna and Laurie feel the stare as a formidable aggression because it comes from an ugly face. They cannot understand the power generating its criticism since in their world it seems clear that being attractive is all that counts. The female starer shows the energy of a different domain of experience, the pure detachment of somebody who does not feel hate but who would like to obliterate the two women completely, see them burn slowly in front of her eyes. The violence of this silent combat is framed by the easy-going insult of Joe. He can use a cliché to say what he thinks about the situation. His perception is eminently utterable: women hating other women. He is happy about the rediscovery of an old truth; his laughter is the result of pleasure at the repetition of an event that helps constitute his own relationship to women. Joe can afford to be light, and the women can also afford to be blind to the violence in his joke while they choke at the unutterability of the separation involved in the stare. He has a language, he is at peace with the world. We know that for him these women are marginal.

Anna is inexperienced. Going out with Laurie and the two men is for her a rehearsal of a possible role. She is trying out for a part. But she is not doing very well. One of the problems is that she does not have anything to wear. Laurie lends her a dress and the use of her bathroom. The results, nevertheless, do not seem to be altogether satisfactory: "By the time we had finished dinner and were having liqueurs Laurie seemed a bit tight. She said, 'Well, Carl, what do you think of my little pal? Don' you think I've found a nice girl for you? 'A peach,' Carl said in a polite voice. 'I don't like the way English girls dress,' Joe said. 'American girls dress differently. I like their way of dressing better.' 'Ere,' 'ere,' Laurie said, 'that'll do. Besides, she's got one of my dresses if you want to know.' 'Ah,' Carl said, 'that's another story then.' 'Don't you like the dress, Carl, what's wrong with it?' 'Oh, I don't know,' Carl said. 'Any way, it doesn't matter that much' " (pp. 118–119).

The men can criticize the dress without being blamed for cruelty or detachment. Anna's sense of wellbeing depends so much on their approval that the reader feels relieved when Laurie avows that it is not Anna's fault: the dress does not, in fact, belong to her. The scene is played out in a very low key. While the criticism of the female

stare from the other table conveys brutality, this one is merely the stating of a fact that only obliquely refers to Anna. It is directed against *all* English girls and is to the benefit of *all* American girls, just as the conflict with the women at the other table is supposed to embody a universal conflict among females. Girls, women . . . Carl talks and generalizes without asking himself for the source of his eloquence. Through him reality itself seems to be speaking. These women, the men's guests in the restaurant, have accepted the invitation to listen. Laurie is not angry at the other for not liking her; she is angry at the usurpation of a power of criticism and humiliation that she only grants to men.

The part that Anna is trying for is Laurie's life. *Voyage in the Dark* documents the difficulty of such a passage in almost anonymous terms. Anna's past has no weight for her; there are few memories, mostly of landscapes and relatives who are more than happy to get rid of her. She has no special sense of revulsion at Laurie, perhaps some disagreement about the pitch of her voice after drinking. There is no strong attachment to any man that would counteract the shape of her relationship to the world. Anna's inexperience makes the voyage into womanhood in terms of Laurie dark. The reader knows of no passion individually ascribed to either Laurie or Anna that would distinguish them from the rest of the women in their financial situation. They seem to be as anonymous to themselves as they are to those who, when speaking about them, speak about women in general. The journey ends with an abortion where the doctor refuses again to acknowledge any individuality to this story: "He moved about the room briskly, like a machine that was working smoothly. He said, 'You girls are too naive to live, aren't you?' Laurie laughed. I listened to them both laughing and their voices going up and down. 'She'll be all right,' he said. 'Ready to start all over again in no time, I've no doubt'" (p. 187).

Like Carl and Joe, the physician feels the pleasure of repetition. Anna will be ready to start all over again in no time. Although he does not know her, he knows *who* she is and understands the terms of her future so well that his recognition of her type makes Laurie laugh. In talking about Anna, he also talks about Laurie. He says "you girls. . ." the way Joe talked about "you women. . . ." Laurie accompanies him in his hilarity. The joke is on her but she is a good sport and she hopes that in the end, money will come her way from male pockets to pay for the laughter.

SECRETS

There are women who choose their clothes from a different position. They are solid, they are ladies. One such woman is described in the pages of the short story, "Illusion" (1981b), first as an observer of other women: "When pretty women passed her in the streets or sat

near her in restaurants she would look appraisingly with the artists' eye and make a suitably critical remark. She exhibited no tinge of curiosity or envy. As for the others, the *petites femmes*, anxiously consulting the mirrors of their bags, anxiously and searchingly looking around with darkened eyelids; 'These unfortunate people' would say Miss Bruce. Not in a hard way, but broadmindedly, breezily: indeed with a thoroughly gentlemanly intonation. . . . Those unfortunate little people!" (p. 140). Miss Bruce is generous and wholesome. She also does something, she is a painter. A working woman, then, of a profession that gives her the right to talk about the world in aesthetic terms. This woman is in control and is able to show generosity toward the anxious *petites femmes*. Together with the right to exhibit the kind of generosity that shows contempt ("Those unfortunate people!") she is given the instrument of gentlemanly intonation. She is speaking as though it were from the other side, away from the battle field. She is, when speaking generously about the *petites femmes*, a *he*. She patronizes them with a gentleman's voice, impersonates a man to show that special affectionate contempt that allows her to be grateful for the effort to make a good impression while preserving the right to withdraw approval. Miss Bruce does not appear to have a nervous relationship to clothes:

> She always wore a neat serge dress in the summer and a neat tweed costume in the winter, brown shoes with low heels and cotton stockings. When she was going to parties she put on a black gown of crepe de chine, just well enough cut, not extravagantly pretty. In fact Miss Bruce was an exceedingly nice woman.
>
> She powdered her nose as a concession to Paris; the rest of her face, beautifully washed in the sunlight or the electric light as the case might be, with here and there a few rather lovable freckles. She had, of course, like most of the English and the Americans in Paris, a private income — a respectably large one, I believe. She knew most people and was intimate with nobody (p. 141).

For Miss Bruce, being in control of her appearance also means withdrawing from intimacy. Unlike the nervous *petites femmes*, she can afford to go almost unnoticed, not check herself in her mirror, avoid make-up. Independently wealthy, not so young, she is a different kind of person. But the story is about the illusion of such an appearance. Through an accident the narrator enters Miss Bruce's room and gets a chance to look at her wardrobe: "In the middle hanging in the place of honour, was an evening dress of a very beautiful shade of old gold: near it another of flame colour: of two black dresses the one was touched with silver, the other with a jaunty embroidery of emerald and blue. There were a black and white check with a jaunty belt, a flowered crepe de chine — positively flowered! — then a carnival costume complete with mask, then a huddle, a positive huddle of all colours, of all stuffs" (p. 142).

As the narrator — one of the *petites femmes*, we intuit — looks

with compassion at the beautiful garments that she believes are condemned to a permanent dark existence in the closet, the reader witnesses a reversal of roles. For it is now the *petites femmes* who seem to be free from constraints. At least they are not afraid to take their clothes into the street, exhibit their *illusions* – as the story would like to call them – in the open air. The café becomes a theater for an unmistakable and instant intimacy between the wearer of an extravagant garment and the beholder. The *petites femmes* offer themselves to the eye without denying their thirst for a narrative they attempt to embody through their dress. It is in the nature of these *petites femmes* to be observed. They dress to be noticed, they are afraid of the critical stare of other women, anxious about the judgement of males, self conscious and mercurial in their own eyes. Miss Bruce, we know, is the kind of woman who looks at other women. When she goes out into the street her gentlemanly tone and her austere looks redeem her from the charges that the woman in *Voyage in the Dark* had to endure. Miss Bruce has the right to look, judge, criticise as long as her statements of taste come out in the voice of a man. What about her clothes hanging in the wardrobe? What room do these have in the double nature of her voice? How does this secret weigh in the general economy of her relationship to other women? The story closes with Miss Bruce's acknowledgment of the narrator's discovery:

> "I suppose you noticed my collection of frocks. Why should I not collect frocks? They fascinate me. The colour and all that. Exquisite sometimes!" Of course, she added, carefully staring over my head at what appeared to me to be a very bad picture, "I should never make such a fool of myself as to wear them. . . . They ought to be worn I suppose." A plump, dark girl, near us, gazed into the eyes of her dark, plump escort, and lit a cigarette with the slightly affected movements of the non-smoker. "Not bad hands and arms, that girl," said Miss Bruce in her gentlemanly manner (p. 144).

Miss Bruce is a ventriloquist who has chosen to follow a double path toward womanhood. It is as though only through her male tone were she able to inflect her stare at other women with some form of generosity; the female narrator is attracted to her secret, she *knows* about that closet where the attributes of the *petite femme* silently rub against each other in the whisper of their exquisite materials and daring colors. Is Miss Bruce really a collector? And what might our question mean? As we pause to look at these two female characters dining together distinguished by their outer appearance, we witness the partial triumph of the *petite femme*. The male voice in the other woman's austere appearance gives her the right to appraise the "girl" at the next table, but we perceive that her detachment is maintained at a high cost; it involves the multiple layers of secrecy. Curled up against itself, her voice tempts her out of her sex for an excursion into maleness at the expense of her sensuality. We know about her

fascination with clothes; we know, in fact, that her strength would not be there if it were not for the other women whom she calls unfortunate, the ones whom − in a way − she keeps in a closet.

In talking about herself as a collector, Miss Bruce refuses to acknowledge the possibility of a narrative where she might be part of a plot wearing those clothes. But as soon as this answer to the question of her being a collector is given, another aspect of her layered voice becomes audible. Her male tone is a testimony to her attraction to the *petites femmes*; Miss Bruce's self-sufficiency consists of being able to pay for her own clothes. Her being independently wealthy allows her to hide her thirst for plots in the closet. Her freedom from need though, is also represented as a burden: a secret. Being a collector implies a more or less detached relationship to objects assembled by a hand that grants them the coherence of a single will to appropriate them. Those objects are separate only insofar as they might hold a reminder of their having been elsewhere before they became part of a collection. Collecting creates a common space, it fosters familiarity among terms foreign to each other. In Miss Bruce's closet, the bright dresses rehearse the street sensuality of stories they cannot properly evoke. They have been paralyzed, taken away from the political tension they seem to embody for the women who put them on to sit in cafés, go to hotels, be guests of more or less well to do passing males. But the insidiousness of the clothes is hard to avoid, the rustling of those skirts, the contact of those creases penetrates the independent woman who pays her own way and cannibalizes her femaleness. Just as she locks them in the closet and comes out dressed in a way that is a naked testimony to her lack of need of men for money, so she speaks like a man. We suspect that her money talks when she admires the "girl," but we also realize that as a woman she cannot properly be called a collector of clothes. Her femaleness is being held hostage in the closet while the transformation of her tone goes out into the street to talk about it in the form of "those unfortunate women."

Are we to say, then, that the *petites femmes* are unfortunate? Perhaps. We note the bareness of their dress, the precarious barrier between them and others. In seeing them, one can summarize the stories they participate in, one knows the shape of their desire. Their make-up, their clothes are artifices through which they advertise themselves; ways toward an intimacy that makes them appear naked. When Anna puts on Laurie's dress in *Voyage in the Dark*, she makes herself vulnerable to comment about all English girls as compared to all American girls. A virgin, she puts on a dress that tells her future. She stands as her own Aleph with a borrowed − and, because of that, intensely owned − story. But Miss Bruce is also unfortunate as a woman; she needs a partner. Not a man; she is enough of one. She needs a *petite femme* whom she can patronize. She does not look at

herself in mirrors when she is in cafés because it is enough for her to see those she calls "unfortunate creatures" to see herself from the perspective of her secret. The reader thinks that she will pay for this dinner. Miss Bruce may invite other women from her maleness. What will she do with the dresses now that the secret has been materialized as such? A friendship among women is suggested in this story. A painful, manipulative friendship grounded in the suffering of a frivolity so unspeakable that it exiles Miss Bruce from her own sex.

READING AND LOOKING

> I was lying on the sofa, reading *Nana*. It was a paper-covered book with a coloured picture of a stout, dark woman brandishing a wine glass. She was sitting on the knee of a bald-headed man in evening dress. The print was very small, and the endless procession of words gave me a curious feeling — sad, excited, frightened. It wasn't what I was reading it was the look of the work, blurred words going on endlessly that gave me that feeling (*Voyage*, p. 9).

As she reads *Nana*, the character of *Voyage in the Dark* is taken away from the intellectual pretext of the book, the story of Nana, to accede to the physical reality of print. The picture on the cover does not merely connote the book to be read but also, and more importantly, holds a prophetic function, since it announces a possible future for the reader. The dark woman contrasting with the white bald head of the man in whose lap she is sitting . . . the dark words as they become blurred against the white paper effacing their individuality, engaging in confusion with their medium. Such is the story of Nana as seen by the reader in *Voyage in the Dark*. The physical reality of print and the visual representation of the story are enough both to silence and to give eloquence to the text.

What is this kind of reading? How does it achieve its peculiar incompleteness; what feeds its oversights? In attempting to answer these questions we arrive at a profile of the woman in Jean Rhys's work, not the double-natured artist embodied by Miss Bruce, whom we shall encounter again later, but the *petite femme*. The act of reading is unfocused, the sofa on which the reader lies, the details of the picture in the book are not left aside. On the contrary, their tenacious materiality inflects the exercise to the extent that words lose their representational function to become pictures — rather than signs — in a flowing current of ink. This reading is not, in fact, a reading. It is an unsettling of the category of meaning where the "look" of words creates a feeling independent of their function in the writing. But, at the same time, is this not a faithful "reading" of Nana? Does it not restore to Zola's heroine her role in a story where she represents the materiality of desire? The seemingly anti-intellectual access to the novel becomes, then, a taking of sides with one interpretation of the text, a figure for an unwritten part where the presence of Nana is felt in its contaminating effects.

The "look" of the words, the look of a woman, a good looking lady, the right to look at somebody critically, the fear to be seen in the wrong clothes, the look of window displays, the sight of neighboring windows in hotels. . . . The world of Jean Rhys is a superimposition of situations where the scene of reading we have described unfolds its peculiar, illuminating stillness. For the dispersion of facts in their constitutive details is at the core of her stories. If we had to tell her novels or short stories, we would, for the most part, get them confused because *we* become Anna Morgan reading *Nana* although we pay due attention to the meaning of words. In her firmly grounded aesthetic world, the choice of stockings is as important as conversations among characters; everything coexists because in spite of the painstaking decisions (what to wear, what color curtains for the hotel room, what to eat. . .) one important move will never be made: there is no choice as to what might constitute a center, either for moving the plot from the point of view of the narrator or for suffering if we see things from the perspective of the characters. Having an abortion, a miscarriage or the wrong color hair, being left by a lover or making a mistake with the purchase of a hat, everything deserves the same kind of affect, that is to say, the same range of discourse. The *petites femmes* do not have the kind of relationship to the world that allows them to have priorities, secrets, a focus. They are victims of a pact that is never quite questioned; they dress and act for a male gaze that will, inevitably, humiliate them in the end. They stay in hotels. The rooms are suitable frames for their lack of personal history. Hotel rooms are always renewed, their continuity is precisely the lack of traces they present to the person who stays, the assurance that whoever stays there will never own them completely but will be a *guest*.

Jean Rhys has drawn a detailed picture of the woman as guest in her books: The hotel rooms, the bills paid by occasional lovers, the meals never prepared at home but consumed in restaurants in situations that emphasize the political dependence on the one who pays the bill, the clothes bought for special occasions, the few jobs never lasting long enough to constitute a profession or even an occupation. In her love stories, this woman is always the *other woman*, the one who represents a marginal detail in somebody's story, who is in turn a marginal detail within her own unfocused succession of details. This guest has no money but also no ambition. Her role is permanently to be there as an occasion for the selfishness or generosity of others; her being a parasite is not a vocation exercised with the passion and capacity for manipulation associated with the role in literature. It is more of an unquestioned, passive acceptance of things as they are even to the point of constituting her own appearance from the images of mannequins in display windows.

This guest serves as a minor exciting character in the lives of other characters who have little room in the narrative. The reader shares her amazement at the repetitive nature of these encounters and occasionally participates in the only hope of the texts: a return home. Going back home means not being a guest any more, being in control of one's own past. But for the characters in Jean Rhys, going home means variously, finding out that a sister has gained true access to a mother who barely remembers the other daughter, encountering accusations of not having lived up to expectations, a mere shrugging of the shoulders at the request for financial help, or else some financial help given in the hope that she will simply leave. In other words, when she goes home this *petite femme* is an unwanted guest.

The elegance of the *petite femme* is to be praised in the androgynous voice of Bruce. It is a beckoning to maleness, a search for continuation of the support that freezes her in a position of helplessness. The passivity of this *petite femme* is hard to achieve and requires constant attention. In her public pose, she waits for somebody to start out a story; her secret is held by Bruce's wardrobe in the independent sensuousness of female outfits being refused permission to be worn in the streets. Bruce's formidable transgressive act makes her an independent woman who shuts her passivity in the closet. Such is the way shown to her by money, her capacity for not being a guest. Bare because of her eloquence and inviting, the *petite femme* makes of herself a political emblem for the selfishness of the one who ends up paying the bill.

But what about Anna reading *Nana*? These reflections take us back to the root of her oblivion of the meaning of the words in the novel. However important the representational value of the written word, the main relationship remains for Anna one between a bald man and a woman, his guest. In disregarding any other way of reading, Anna distracts herself from the Zola text to plunge into what becomes a form of self-observation. In Nana (whose real name is Anna), she sees herself very much in the same way that she — and the other *petite femmes* — see themselves in each other and in the mannequins of the window displays. Reading, then, not for plot, not for explanation but for the flow of writing that ends in the shaping of a couple: young woman, old man. In that asymmetry the *petites femmes* find the source of their weakness and the intense desperation of their elegance.

THE FEMALE DANDY

The *petite femme* is an urban dandy: careful of detail, unable to make a living, conscious of everybody's looks, a barometer of taste. She has the traits of an aristocrat without money. She despises the ones who give her hospitality; her detachment is the result of a critical eye. She plays roles. In the often repeated situation in these

texts portraying the needy woman who goes to ask for money either from a wealthy relative or an ex-lover. Julia in *After Leaving Mr. Mackenzie*, goes to her Uncle Griffiths's house:

> She said: "I left on Thursday. It's funny, for it seems much longer ago than that." "I see," said Uncle Griffiths. "So you made up your mind to come over and pay us a flying visit, did you?" But this was merely rhetoric. He had summed her up. He knew, both from what Norah had told him and from his own observation, that she had made a mess of things and was trying to get hold of some money. She said: "I don't know why I came. A sort of impulse, I suppose." "Good God," said Uncle Griffiths. His voice always sounded as if he were speaking between closed teeth. "If I were you," he went on, "I should go back again. Things are very difficult over here, you know. Hard. Yes, yes — hard times." She said: "I daresay, but you see, I haven't any money to go back with" (*Mr. Mackenzie*, pp. 81–82).

The money is given, after a moment where characters meet with more or less tension. Julia lives from day to day thanks to various forms of help but the narrator's perspective — which is a way of giving the reader Julia's perceptions — condemns relentlessly those giving it or merely patronizes them by calling the lover she had had at nineteen, for example, *chic* because of his promptness in answering letters and requests. The superiority of the *petites femmes* is grounded in their dandyism, in the mixed interest and detachment with which they cling to the sector in society that they may parasitize. A pact is forged between those with extra money and the *petite femme*; the mainstream characters who appear engaged in the task of earning a modest living are seen as openly threatening and disagreeable, or simply gray. It is interesting that many of them are female hotel attendants or landladies of various sorts portrayed as being unattractive, cold and calculating. Those are the women who live off hotels and whose sexuality is implied as being at war with the lonely female occupant of the room.

What would happen if these female dandies lost their clothes, their interest in dressing, their passion for the stillness of the pose? In *Good Morning Midnight* we catch a glimpse of the work — and of the irony — needed to maintain the pose in place:

> I call the waiter, to pay. I give him a large tip. He looks at it, says, "Merci," and then "Merci beaucoup." I ask him to tell me the way to the nearest cinema. This, of course, arises from a cringing desire to explain my presence in the place. I only came in here to inquire the way to the nearest cinema. I am a respectable woman, *une femme convenable*, on her way to the nearest cinema. Faites comme les autres — that's been my motto all my life. Faites comme les autres, damn you. And a lot he cares — I could have spared myself the trouble. But this is my attitude to life. Please, please, monsieur et madame, mister, missis, and miss, I am trying so hard to be like you (*Midnight*, p. 106).

Without clothes, without the tension generated by the interest in being observed, these *petites femmes* would not exist. They are the

aesthetic hope of the streets, an objectionable poetry produced by the weak loving chance money. It is also by chance that the free and rich Miss Bruce is known to have a closet full of anxiety-ridden dresses. Being a respectable woman, *une femme convenable*, is the result not of firm roots in a hypothetical mainstream but of a careful planning of tactical positions. Miss Bruce's dandyism remains a virtuality in her closet.

Such convergences may indeed constitute a clue to the condition of the feminine in Jean Rhys. The flatness of her heroines' gaze passes for common sense, but as we imitate their position and observe Miss Bruce at dinner with her guest, the apparent differences between the two women fade into a disturbing darkness.

REFERENCES

Rhys, Jean, 1981a (1929). *Quartet* (New York: Harper and Row).
　　1981b (1927) "Illusion," in: *Tigers are Better-Looking* (London: Penguin Books).
　　1982a (1931) *After Leaving Mr MacKenzie* (New York: Harper and Row).
　　1982b (1938) *Good Morning Midnight* (New York: Harper and Row).
　　1982c (1934) *Voyage in the Dark* (New York: Norton).

DIFFERENCE

WOMAN AS A SEMIOTIC OBJECT

CHRISTINE BROOKE-ROSE

There have been a few delightful moments, during my desultory and decidedly non-expert readings in semiotics, when the subject made me laugh out loud instead of terrorizing or, same thing perhaps, boring me stupid.

One of them occurred early on when I read "The interaction of semiotic constraints," by A.J. Greimas and François Rastier (1970), where the logical rectangle of contraries and contradictories which Greimas adopts as deep structure of his narrative grammar and which is said to represent "the elementary structure of significance," is used to show how the model works when semantically invested in, for example, sexual relations. The first model is the *social* one (model A), in which the Culture/Nature opposition subsumes, on the one hand, permitted sexual relations (Culture) and, on the other, excluded ones (Nature):

A.

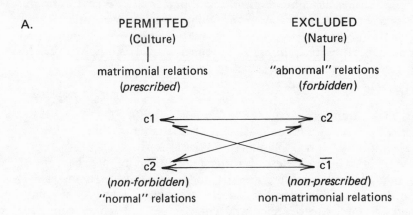

PERMITTED
(Culture)
|
matrimonial relations
(*prescribed*)

EXCLUDED
(Nature)
|
"abnormal" relations
(*forbidden*)

c_1 c_2

$\overline{c_2}$ $\overline{c_1}$

(*non-forbidden*) (*non-prescribed*)
"normal" relations non-matrimonial relations

Further semantic investment (i.e., more particular) then gave, "for traditional French society," the following:

c1 *prescribed*	c2 *forbidden*
conjugal love	incest, homosexuality
$\overline{c2}$ *non-forbidden*	$\overline{c1}$ *non-prescribed*
male adultery	female adultery
	(pp. 141–143; my translation)

Thus the old double standard, lingua in sheer semiotic cheek, is made explicit as an "elementary structure of significance." The model does not attempt to account for systems in which both marriage and incest are prescribed (e.g., Egyptian dynasties), presumably regarded as exceptional.

Two further models are then given: B, *economic* (e1, profitable / e2, harmful; $\overline{e1}$, non-profitable / $\overline{e2}$, non-harmful), where the "non-profitable" falls conveniently in the position of the further semantic investment "female adultery," and the "non-harmful" in that of male adultery; and C, *individual* or personal (p1, desired / p2, feared; $\overline{p1}$, non-desired / $\overline{p2}$, non-feared), where the "non-desired" falls conveniently in the position of female adultery, and the "non-feared" in that of male adultery (pp. 144–146).

These two models, when articulated with the first, allow for 16 different kinds of sexual relationships — surely a poor generating model — of which some are balanced, some weakly conflictual and some strongly conflictual. For example, in Balzac, the relations of Père Rigou with his servant are "non-forbidden, desired, non-harmful; those of the servant with Père Rigou are non-prescribed, feared and non-profitable; there is therefore conflict, however the relations are expressed." These semiotic situations are said to "help us define 'romantic insatisfaction' " and perfect love is said to be the manifestation of the relations from two groups of permutations:

1. *prescribed A + prescribed B* [matrimonial + profitable, and presumably desired, though the third model is implicit in the notion of perfect love]
forbidden A + forbidden B [abnormal + harmful]
2. *prescribed A + non-forbidden B* [matrimonial + non-harmful, i.e., male adultery]
prescribed B + non-forbidden A [profitable + "normal," i.e., male adultery] (pp. 147–148; my translation).

I wonder whether these formulae for perfect love have been programmed into the computers of matrimonial agencies instead of "tastes" in common, ages, and social situations. I know they have been programmed into the computers of male and female genes for thousands of years, and are not likely to be truly effaced in the mere few centuries since women began to try and think of other possibilities for themselves. For of course many things have changed, and the double standard in adultery is no longer or not really what women have been protesting about; after all, they managed to ignore

it throughout history. What they protest about is the constant displacement of the double standard into every other aspect of life, and in such insidious ways that it has not always been, and is still not always, easy to bring up into consciousness. Feminist studies have pinpointed so many of these, in every tone from the wise to the strident, that I shall not do so here; it is perhaps important however to understand the original structure of which these are displacements, and which no doubt was an "elementary structure of significance," but in conditions which in theory have all but disappeared, and in practice keep returning in other forms.

For the double standard in adultery goes back of course to the natural physical fact, so insupportable in patrilineal societies, that *pater semper incertus est*, and that therefore the only method of being *certus* is social: lock up your wives or hedge them about with equivalent taboos, lies and terrors; men could sow as many bastards as they had women but woe to the women who bore them.

This archaic inherited situation is at the back of all women's minds, and afforded me another moment of semiotic delight with Greimas's actual proposals for a narrative grammar (1970), when the same logical rectangle is used to explain a narrative sequence as "a topological representation of the circulation of value-objects between deixies" (p. 177; my translation).

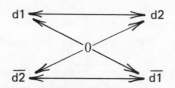

"Thus the circulation of values, interpreted as a sequence of transfers of value-objects, can follow two itineraries:

(1) $F(d1 \to 0 \to \overline{d1}) \longrightarrow F(\overline{d1} \to 0 \to d2)$
which, in the particular case of Propp's Russian tales can be interpreted: society (d1) suffers a lack, the traitor ($\overline{d1}$) ravishes the king's daughter (0) and transfers her elsewhere to hide her (d2).
(2) $F(\overline{d2} \to 0 \to d2) \longrightarrow F(\overline{d2} \to 0 \to d1)$
which means: the hero ($\overline{d2}$) finds somewhere (d2) the king's daughter (0) and gives her back to her parents (d1)."

"And if the king's daughter, settling a pillow by her head or throwing off a shawl, and turning toward the window should say That is not it at all, that is not what I meant at all. . ." (quotation from my novel *Thru*, pp. 89–90, a fiction about fictionality, a narrative about narratology, where cheek in pen I adapted *Prufrock* and juxtaposed it with the above passage from Greimas).

It would seem, then, that in the "elementary structure of significance" even the king's daughter does not escape woman's fate as object of exchange, which Lévi-Strauss has shown lies at the basis

of social organization (1949). Another good semiotic moment came when Lévi-Strauss returned to the topic ten years later (1958), and wondered whether we might not achieve insight into the origin of language via the marriage-regulations that represent "a much more crude and archaic complex" in communication. Poets, he says, are the only ones who know that words were once values as well as signs, and women are considered by the social group as "values of the most essential kind," although we do not understand how these values became integrated into systems endowed with a significant function:

> This ambiguity [values and signs] is clearly manifested in the reactions of persons who [re 1949 analysis] have had against it the charge of "anti-feminism," because women are referred to as objects. Of course it may be disturbing to some to have women conceived as mere parts of a meaningful system [note the sliding up from "objects" to "parts of a meaningful system," which is of course the case with men too, so that it all seems less sexist although men created the system]. However, one should keep in mind that the process by which phonemes and words have lost — even though in an illusory manner — their character of value, to become reduced to pure signs, will never lead to the same results in matters concerning women [because women lost their character of value in no illusory manner?]. For words do not speak, while women do: as producers of signs, women can never be reduced to the status of symbols or tokens [So: why were they?] (p. 61).

It is of course as a woman that I have inserted this quibbling polemic — purposely confusing values and signs — into Lévi-Strauss's discourse, since he kindly allows me to speak in order not to be reduced to a token.

I am naturally not arguing against his description of the facts in the societies studied, any more than I was denying the facts described by Greimas's structure. I am merely noting a certain relish in those facts and, here, an amusing speciousness and bad faith in the arguments used in defense, which even attributes the "ambiguity" (i.e., the confusion of values with signs, as in my polemic) to the reactions of those who protest, when the whole problem is that the confusion is inherent to the system, allowing the necessary circulation of women as "essential values" to degenerate into a negotiated exchange of women as value-objects, in other words, tokens, signs. And since signs do "speak," if only through the "symptom-signifier," the system was doomed from the start, or rather, had to depend for aeons on women's silence, on the repression of their signified into the unconscious.

Such women who did "speak" their signified were usually castigated as too close to both nature and truth for comfort, in other words, as witches, and in more "scientific" times as hysterics (see Cixous and Clément 1975) — indeed the very word *hysteria*, from *'ustera*, womb, uterus, is misogynous (see Rousselle 1983, ch. 4, "Virginité et hystérie," for the early medical history of the word).

It is also interesting that female oracles (the prophetess, or pythoness) were on the one hand reduced by legends of their origins to "twittering birds" (Herodotus 1954:Bk. 2, Penguin p. 152), and on the other taken over, very early, by male gods, that is to say reduced to priestesses of Zeus, Apollo, etc., speaking in their name, so that kings and leaders could nevertheless continue to consult them with respectability. As for the priestess of Athene at the oracle of Pedasus, she was said to grow a beard at impending disaster (Herodotus 1954:Bk. 1, Penguin p. 112). And did not soothsayers see the sooth they said in *entrails* of birds (twittering?)? Indeed, I have always found it comical — and rarely, if at all, treated — that both Judaism and Christianity should have as Genesis the story of a woman's *scientific* curiosity, not only as to the Knowledge of Good and Evil but also, surely, to see if the prophecy/threat would be fulfilled, if the theory would fit the facts, for which daring, rapidly transformed into Original Sin, she was scapegoated into bearing the consequences for ever, though the story in fact "motivated" the already existing consequences.

Lévi-Strauss goes on to argue that it is for this very reason, women not reduceable to tokens, that the position of women as actually found in this system of communication between men may give us an image of the type of relationship that might have existed between human beings and their words at a very early period in the development of language:

> As in the case of women, the original impulse which compelled men to exchange words must be sought for in that split representation that pertains to the symbolic function. For, since certain terms are simultaneously perceived as having a value both for the speaker and the listener, the only way to resolve this contradiction is in the exchange of complementary values, to which all social existence is reduced (p. 62).

Yes, but why such an uncomplementary deal in the "exchange of complementary values"? For what is valorized by the system is men not women, and even today's society is for instance far more cruel to unattractive women than it is to unattractive men, who can still consider the offer of marriage and name as a signal honor to be bestowed, and women still on the whole go along with that. It is as if, in the comparison with language, only the terms used by the speaker had any value, the speaker in the system being man.

Lévi-Strauss adds that these speculations may be judged utopian: by utopia does he mean the possibility of research into the topic words/women as objects of exchange (a dangerous desire), or does he mean the close link between such objects as a utopian ideal? Men have peopled their heavens either with objects erotic *ad aeternam* or with sexless angels, and their utopias have never imagined much of a role for women, nor indeed for poets. Perhaps that is not

perchance? Erotics is a silent art, and angels are imagined as com-
municating without words. Well, let's talk about women's words
preventing her reduction to a token.

The old comedy theme of the mute woman (*The Devil and his
Dame*, Jonson's *Epicoene* or *The Silent Woman*, Molière's *Médecin
malgré lui*, and others), whose torrent of words is let loose by
marriage or love-philtre, certainly reveals a male fantasy of the
dream-woman as dumb. Debax, in "Et voilà pourquoi votre femme
est muette" (1980), analyses this phenomenon as essentially one of
power. For man to exercise his sovereignty nothing must arise as
equivalent to his word (or his beating stick) that maintains her in
obedience, so the male imagination constructs a mute ideal, a
"quality" in woman, which can be expressed as a wish or regret
(Sganarelle, M.M.L.II.iii), or as dream, as an actual virtue (*The Devil
and his Dame*), or else the fantasy becomes actual situation in the
theater (Debax, p. 32):

> To reduce woman to silence is to reduce her to powerlessness; that is how
> the masculine will to castrate operates [Debax's note: It operates literally in
> *Titus Andronicus*: Lavinia's tongue is cut off, as are her hands, a symbol of
> total powerlessness]. Thus — perhaps because of this — women's will to revolt
> necessarily passes through the use of language, the tongue [*la langue*].
> Language, the tongue, is woman's weapon (Debax, p. 33; my translation).

Debax reminds us that the letting loose or "liberation" of the
tongue always occurs at the moment of marriage:

> The young girl's muteness therefore figures her virginity, her ignorance of
> sexual commerce, or her fear before the act. Marriage — or union — reveals
> her sex (masculine perspective). According to the dominant masculine theory
> her self-affirmation should stop there, and she should acquire speech only to
> abandon it at once. If she continues to make herself heard she becomes a
> "shrew," she becomes guilty of "amazonian impudence" [*Epicoene*]. Marian
> [in *Devil*] challenges this ["'Tis better to be a shrew, Sir, than a sheep"]. This
> defiance is the response to intolerance; for man only one authority is con-
> ceivable, his own, one sex, his own, one discourse therefore, his own. Sir John
> Daw [in *Epicoene*] gives the credo of this anti-feminism in doggerel verses
> one must quote to appreciate their full flavour:

> > Silence in woman, is like speech in man
> > Deny't who can
> > Nor is't a tale
> > That female vice should be a virtue male,
> > Or masculine vice a female virtue be.

> Thus the trick is played: a difference of behaviour, of sex, of appearance,
> etc., is interpreted in terms of an opposition of contraries: if man is strong
> woman is weak; if man speaks woman must be silent. So was created an image
> of woman in negativity to that which man was forging of himself. We are at
> the heart of the dynamism of racism (Debax, pp. 34—35; my translation).

We are also back with Greimas and his contraries/contradictories
silence/speech; non-silence/non-speech — a clear displacement of

the original double standard. Certainly the obverse image to that of the silent woman is that of the nagging wife, the scold, later the *castratrice*, who must be fled, silenced, abolished somehow, just as the "lying" or awkwardly truth-telling poets must be excluded from the Republic.

It is no doubt the mootest of moot points whether women are what they are because of men or vice versa. The "nag" image is always post-marriage and therefore conceived, unconsciously, as a result of it. Perhaps however it is also calqued on the mother, who taught men language and scolded them in words, though girls do not have such a reaction. There is no answer to that question.

George Steiner (who would hate to be considered as a semiotician) takes up the problem from a more subtle angle in the first chapter of *After Babel* (1975), in which he contends that all communication is translation, both diachronically (language changing much faster than we feel) and synchronically. And as to the latter, he marvellously discusses the different "languages" of represser/repressed (classes, adults/children, men/women). On men/women he reminds us that "the headings of mutual reproach are immemorial. In every known culture, men have accused women of being garrulous" (41), then asks if they are, in fact, "more spendthrift of language" (which is a nice way of putting it). He tries, gallantly, to relate men's undoubted conviction of this to ancient perceptions of sexual contrast:

> The alleged outpouring of women's speech, the rank flow of words, may be a symbolic restatement of men's apprehensive, often ignorant awareness of the menstrual cycle. In masculine satire, the obscure currents and secretions of woman's physiology are an obsessive theme (p. 42).

But here too there seems to be an unconscious double standard, not commented on, men's secretions being super-valorized. It is interesting that Steiner deals with the "converse" idea — men's professions of delight in sweet and low registers, and of course in silence — *after* their terror of the word-torrent, as if the fantasy of silence were, as it seems to man, something to dream of in vain as against the awful reality, instead of, as is more likely, something imposed by man in the first place, and found, to his delight, in the young girl brought up to that end. Obviously Steiner knows this:

> The motif of the woman or maiden who says very little, in whom silence is a symbolic counterpart to chasteness and sacrificial grace, lends a unique pathos to the Antigone of *Oedipus at Colonus* or Euripides' Alcestis. A male god has cruelly possessed Cassandra and the speech that pours out of her is his; she seems almost remote from it, broken. Though addressed to an inanimate form, Keats's "unravished bride of quietness" precisely renders the antique association of feminine quality with sparseness of speech. These values crystallize in Coriolanus' salute to Virgilia: "My gracious silence, hail!" The line is magical in its music and suggestion, but also in its dramatic shrewdness. Shakespeare precisely conveys the idiom of a man, of a personage

brimful with overweening masculinity. No woman would so greet her beloved (pp. 42–43).

But Steiner also gives voice to women (inevitably via men). Women, he says, have not been slow to answer, and Elvira's

> Non lo lasciar più dir;
> il labbro è mentitor. . .

has rung down through history. Men are deceivers ever. They use speech to conceal the true, sexually aggressive function of their lips and tongues. Women know the change in a man's voice, the crowding of cadence, the heightened fluency triggered off by sexual excitement. They have also heard, perennially, how a man's speech flattens, how its intonations dull after orgasm. In feminine speech-mythology, man is not only an erotic liar; he is an incorrigible braggart. Women's lore and secret mock record him as an eternal *miles gloriosus*, a self-trumpeter who uses language to cover up his sexual or professional fiascos, his infantile needs, his inability to withstand physical pain (p. 43).

He tells us that of course the grounds of differentiation are largely economic and social, that "sexual speech variations evolve because of the division of labour, the fabric of obligation and leisure within the same community is different for men and for women" (in some languages women even have a slightly different grammar and vocabulary), and women are excluded from most male forms of communication (he quotes *taceat mulier in ecclesia* to show how far back it goes). And he tells us that two great artists in particular, Racine and Mozart, had the extraordinary ability to render that crisis in sexual identity and communication between men and women (pp. 44–45). The tone-discrimination (between Susanna and the Countess in *Figaro* "is made even more precise and more dramatically different from that which characterizes male voices by the 'bisexual' role of Cherubino. The Count's page is a graphic example of Lévi-Strauss's contention that women and words are analogous media of exchange in the grammar of social life." Stendhal, Steiner tells us, carefully studied Mozart's operas and this can be seen in "the depth and fairness of his treatment of the speech-worlds of men and women in Fabrice and la Sanseverina in *La Chartreuse de Parme*." Today, he adds, "when there is sexual frankness as never before, such fairness is, paradoxically, rarer. It is not as 'translators' that women novelists and poets excel, but as declaimers of their own, long-stifled tongue" (pp. 44–45).

Curiously, although agreeing with Lévi-Strauss, whilst admitting elsewhere that "anthropology — itself a term charged with masculine presumptions — distorts evidence as does the white traveller's edge of power over his native informant" (p. 44), Steiner epigraphs his book with an interesting quotation from Heidegger:

Man acts as if he were the shaper and master of language, while it is language which remains mistress of man. When this relation of dominance is inverted,

man succumbs to strange contrivances. Language then becomes a means of expression. Where it is expression, language can degenerate to mere impression (to mere print). Even where the use of language is no more than this, it is good that one should still be careful in one's speech. But this alone can never extricate us from the reversal, from the confusion of the true relation of dominance as between language and man. For in fact it is language that speaks [. . .] (". . . Dichterisch Wohnet der Mensch. . . .")

So it would seem that man thinks he shapes and masters and exchanges words and women, while all the time language is shaping and mastering him (and women), so that his exchanges and controls and double standards must be as mutable as language itself. Perhaps that is what man cannot stand, to think he is in control and can shape his dream, and to discover that he is not, that his dream "speaks" otherwise and controls him? Perhaps (more playfully), women so took it out of men in those mythical Mother-goddess days (mythical as "Old religion" but also because ethnologists apparently now agree that matriarchy never existed), that men in their phylogenetic system never forgave them? And are we now, alas, in for an equally long period during which women, in their post-consciousness torrent of abuse, will never forgive men for the use men made of them since? There is no answer to that question either. Meanwhile, perhaps we should be grateful for being told that, like words, we have always been considered as values "of the most essential kind." For instance:

> I am not surprised that with so many people and so many beasts the rivers sometimes failed to provide enough water: what does surprise me is that the food never gave out, for I reckon that if no more than a quart of meal was the total daily ration for one man, the total daily consumption would have amounted to 110,340 bushels — and this without counting what was consumed by the women, eunuchs, pack-animals and dogs (Herodotus 1954, p. 507).

Well at least food was consumed. After all, women and pack-animals are useful and must be kept alive. Ah, you (men) will say, but those were just testicle-emptiers, *le repos du guerrier*, we do not treat our lady-loves like that. Of course. The blanket bodily transfer of women as value-objects in complex social systems forms part of a highly privileged status compared to that of garbage-bags accompanying armies. The social exchange of women was for pleasure, release, *and* procreation, which had to be patrilineal, hence the "protection" of women, etc. All other developments, towards more grace in the winning, on the one hand, and harder bargaining in the buying — higher dowries — on the other, are mere displacements and refinements.

And there are displacements within such displacements, as systems of exchange become more sophisticated or simply more conscious: winning a woman through prowess or with six camels easily becomes winning her through prowess with money or prowess with words,

both objects of exchange. But women's amorous discourse was traditionally silent (gestures, looks, tricks and "wiles"), or else like Chaucer's Criseyde needed a Pandarus, and Shakespeare's examples of the delightfully witty and verbally autonomous girl in love (Rosalind, Viola, etc.) are disguised as boys.

Today we seem to have an almost complete inversion in the ideal of the strong silent man and the "free" forward girl, but it seems superficial, a fashion resulting from a dying discourse, because women well-versed in types of amorous discourse often get the impression that a man brings out this or that type as he might bring out a wallet, and men versed in women's "wiles" must have the same impression, but inverted, of a contract passed. Nevertheless, any reticence or objections a woman might voice are still silenced, not only, as before, by the power of man's desire as expressed in his discourse, but, supreme irony of sexual freedom, by accusations of prudery, frigidity, repression (etc.): where "virtue" was once accepted, or mocked, as a token in the language of negotiation, men have learnt to use the very freedom won by woman to replace that token. Having "won" her, and assuming he wants to keep her, he still tends towards two types of possessive behavior: the Pygmalion urge (forming her to his own desires, and ceasing his love should she herself take wing), or the demolition enterprise (using his very love to prevent her, in innumerable ways and whatever his verbal assurances, from achieving any kind of self-expression). Should she protest, he then withdraws into silence, which at this point becomes his strength, a wall against which women beat in vain. That is surely when she becomes a frustrated scold. Woman's silence — traditionally — is initial, first out of fear, then out of guilt; man's silence is final, first out of guilt, then out of fear. A perfect chiasmus, traces of which undoubtedly remain in most sexual situations today, starting as game, ending as war. Some endure them as war, others learn to play them as game throughout.

And the game is also in language, *pace* Lévi-Strauss. In almost every sentence we betray the deep-rootedness of that "elementary structure of significance." I remember when Umberto Eco, in a seminar at New York University, gave an example of coreferential ambiguity:

1. John sleeps with his wife twice a week, and so does Bill. I pointed out that the ambiguity was largely social, rather than linguistic, and that there was no ambiguity at all in:
2. John mows his lawn twice a week, and so does Bill.
3. John washes up for his wife on Sundays, so does Bill.
4. John takes his son to school every day, so does Bill.

And so on. Umberto Eco completely agreed with me, was delighted, put the whole problem in his book (1979, Introduction),

and quoted me in a footnote, for which I thank him. Interestingly however, he invents a completely new sentence:

> Christine Brooke-Rose (personal communication) suggests that no ambiguity would arise were the sentence /Charles walks his dog twice a day. So does John/. It means that in (7) [(1) here] one of the first moves of the interpreter is to evoke the intertextual frame "adulterine triangle," since thousands of texts record such a situation. On the contrary, no text (as far as one remembers) records the story of a morbid passion of two men for the same dog, and it is enough to activate the common frame "walking *his own* pet." Thus no ambiguity arises (pp. 41, n. 12).

Ye-es. I find it odd, all the same, that this charming semiotician should alter my several examples for the one possibility in which man — and woman for that matter — is particularly possessive, namely a dog, a pet, a substitute (dumb) companion. It is surely not really a question of "morbid passion," or even of passion *tout court*, but of a dog as toy, as object-alive, like a woman. And precisely because of that I for one *can* read the sentence as ambiguous, not in the sense of passion or rivalry, as in adultery, but in the sense of a possession shared between friends, as in wife-sharing.

All the sentences are in fact intertextually sensitive, but not with the same intertext: in (2) a lawn is a proud possession for show but mowing is a chore, so Bill would hardly share it regularly; in (3) washing up is also a chore; both are cliché situations, objects of jokes, etc. In (4) a son is not a possession, an acquisition, which can be shared as a relationship. And in all three the frequency adverbial alone clears the ambiguity pragmatically, which it does not in (1), nor (really) in the dog sentence.

I am of course quibbling again, to take up my prerogative as speaking value not token. Perhaps the real counter-example should have been:

5. Sue sleeps with her husband twice a week, so does Mary.

Is it ambiguous? As ambiguous as (1)? Or not *quite*? And if it is, would it have been so in the nineteenth century, as surely (1) would have been? Or perhaps the test-sentence should have been:

6. The Sultana plays with her eunuch twice a week, and so does the princess Fatima.

or even:

7. The sergeant beats the pack-animal every two minutes, and so does the corporal.

A corporal ending indeed. At any rate, I cannot help wondering whether semiotics is not a peculiarly reactionary discipline, and semioticians unconsciously nostalgic for deep, ancient, phallocratic, elementary structures of significance.

316 CHRISTINE BROOKE-ROSE

REFERENCES

Cixous, Hélène and Catherine Clément, 1975. *La Jeune Née* (Paris: Editions 10/18, Bourgois).

Debax, Jean-Paul, 1980. "Et voilà pourquoi votre femme est muette," in: *Caliban XVII* Tome XVI, Fasc. 1 (L'Université de Toulouse Le Mirail), 23–27.

Eco, Umberto, 1979. *The Role of the Reader — Explorations in the Semiotics of Texts* (Bloomington, Indiana: Indiana UP).

Greimas, A.J. (with François Rastier), 1968. "The interaction of semiotic constraints," *Yale French Studies* No. 41, entitled *Game, Play Literature* (in French in 1970).
1970 *Du Sens* (Paris: Seuil).

Herodotus, 1972 (1954). *The Histories*, trans. Aubrey de Selincourt, rev. A.R. Burn (Harmondsworth: Penguin Classics).

Lévi-Strauss, Claude, 1949. *Les Structures Elémentaires de la Parenté* (Paris: Presses Universitaires de France).
1963 (1958) *Structural Anthropology*, trans. Claire Jacobson and Brooke Grundfest Schoepf (New York: Basic Books).

Rousselle, Aline, 1983. *Porneia — De la Maîtrise du Corps à la Privation Sensorielle — IIe–IVe Siècles de l'ère Chrétienne* (Paris: Presses Universitaires de France).

Steiner, George, 1975. *After Babel* (New York and London: Oxford UP).

SEXUALITY, SIN, AND SORROW:
THE EMERGENCE OF FEMALE CHARACTER
(A READING OF GENESIS 1—3)

MIEKE BAL

1. THE EMERGENCE OF A MYTH: COLLOCATION

"Let the woman learn in silence with all subjection. But I suffer not a woman to teach, not to usurp authority over the man, but to be in silence. For Adam was first formed, then Eve. And Adam was not deceived, but the woman being deceived was in the transgression" (I *Tim*. 2:11—14).

This passage from the letter to Timothy[1] presents the two main arguments out of the eleven enumerated by Trible (1978:73), which are commonly alleged in favor of misogyny on the basis of the second story of the creation and of the fall, *Gen*. 2:4b—3:27. More recently, Alter (1980:146) sums up the common interpretation of the text as follows: "[it is] an etiological tale intended to account for the existence of woman, for her subordinate status, and for the attraction she perenially exerts over man." Most of the arguments Trible collected can not at all be derived from the Biblical text as it stands, and she convincingly refutes them. The relevant passages which I will study here are those concerning the creation of the female body, the transgression, and its consequences.

As for "Paul"'s arguments specifically, they are both the most frequently alleged and the most obviously wrong. They are so in three senses. First, as factual reports on the story, they do not find support in the text when carefully read; second, even if they did, the conclusion from these — fictive — facts would not have to be these value judgments; and third, even if these judgments were justified, there would not be the slightest logical link between them and the prohibition based on them. As I will argue later, it is not

1. This passage is used in a very illuminating article on the issues of feminist theology by Fokkelien van Dijk-Hemmes (1982) which borrows its title from it: "For Adam was first formed, then Eve. . . ." The identity of the author of this letter is dubious. Since he is usually identified with Paul, I will refer to him as "Paul."

obvious that Adam the man was first formed; even if he had been, that gives him no qualitative superiority, on the contrary; even if it did, there is hardly any relation between being a less successful product of divine pottery and the proscription on talking, teaching and exercising authority. As for the deception, neither of the two human beings was deceived, and both equally transgressed.

Even if I will, eventually, analyze the relevant passages (*Gen.* 2:21—22 and 3:5—6), my point in this paper is not to establish anachronistically a "feminist" content of the Bible. If my interpretation of Eve's position will show her in a more favorable light than is the case in the common uses of the text, I do not want to suggest that this is a feminist, feminine or female-oriented text. Rather, I will try to account for the nature and function of a patriarchal myth which is related to an ideology that cannot be monolithic. Efforts to make it so are the more desperate since it is an impossible aim. Therefore, that traces of the problematization of the represented ideology can be found does not automatically imply an improvement in the situation.

But as I have said, this is not my main point. Nor is it my first goal here to denounce the uses that have been made of the text, though that is already a more interesting issue. For the confrontation between the extant mythical text and the documents of its later use, like "Paul"'s version, and the subsequent innumerable ones which produce the myth as it still functions, displays a chronological evolution of patriarchy which contains a paradox.

Since it is obvious that ancient Hebrew society, like most ancient societies, was thoroughly misogynist and since, on the other hand, today's Western society claims to have evolved toward respect for equal rights and emancipation, we could expect an evolution from a sexist text to more "equal" readings. We could expect commentators, for example, to stress the positive sides in the Eve character and the negative ones in Adam, both being present in the text, so that a fairer image of the first human couple would emerge. The fact that it goes mostly the other way around, as I have demonstrated for the Samson and Delilah story (Bal 1984), provides insight into the dynamic nature of myth, into the actual state of sexual ideology, and into the necessity of *reversal* as a political move (Derrida 1972: 56—57). Nevertheless it seems rather discouraging that we have to appeal to ancient Jewish Patriarchs to defend our character against today's progressive atheists.

For the present volume, the most interesting point in "Paul"'s words — and that is my motive for taking them as a starting point — seems to me the "collocation" of the emergence of the female body in narrative signs and the assumption of the moral corruption of the character endowed with that body. As I will demonstrate, the proper name is the *site* of this collocation. If "Paul" uses this combination

as an argument for the elimination of women from the realm of moral and intellectual authority, it serves equally well for the justification of pornography, rape and other semiotic and physical kinds of violence. *Mens insana in corpore insano*: since both sides of the character are considered as unredeemably inferior, misuse can go against both spirit ("Paul"), and body (rapists and pornographers).

Of course, it is a common insight since the vulgarization of Freudianism, that the female body scares man by its otherness, its "lack" and its obscurity; and that, on the other hand, the boy's discovery that the idealized and monopolized mother is a sexual, and, hence, publicly available being, inspires the little future patriarch with contempt for her as a moral being. Both mechanisms have their causes, their simultaneous origins, their projectional and self-destructive aspects. But this does not necessarily entail an automatic *collocation*, the saying-together, the absolutely unavoidable urge to take for granted logically that *since* Eve's body is claimed to be a lesser performance than Adam's, she is the morally weak one, available for use by the forces of corruption or, by another projectional move, that she embodies those forces — a combination of concepts so automatic that it became *the* semiotization of the female.

This collocation has a narratological and an anthropological impact. From a narratological point of view, the development from one myth — the text as it stands — into the other — the sexist view formulated by "Paul" — is the result of what I propose to call the *retrospective fallacy*. It consists of the projection of an accomplished, singular and named character-image on previous textual elements which *lead* to the construction of that character. It is this circularity which entails the realistic illusion. As such, it contributes to the production of myths. A certain reading of *Gen.* 1–3, for example that of the historical-critical school, interpreting the combination of the two creation stories and the story of the fall, has projected the last part of the third story onto the second, repressing the first considered as an alien, later account. They have read it in that manner because they failed to understand that this text was a semiotic object. As such, it created narrative, not the world. It presents an account of the making of humanity in a progressive development of character. Missing that point results in the retrospective fallacy: readers project the accomplished characters Adam and Eve, who appear at the very end of the third story, onto their previous stages of particularization. Hence, the concept of character is at once a cause of the sexist myth and a means to deconstruct it.

From an anthropological point of view, this collocation is another instance of an ambivalent conceptual "origin" which had to be repressed after being mythified: the split of body and soul, a later invention, which, just like patriarchy, became such a heavy burden

on the shoulders of the same humanity that invented it. Man, unsatisfied with himself, fearful of his drives and disgusted by his demanding body, found a way out by assuming that this body was very different from himself. But he knew very well that this would not work. The power of the body would not make sense in such a structure. Therefore, the perception, from the outside and hence monolithic, of the woman, who in her otherness could seem more whole, posed a problem of envy. Envying her apparent wholeness, blaming her otherness, he decided she was entirely corrupt. Thus, the myth of origin was corrupted. The split between body and soul was retrospectively projected upon Eve as a character, as she was interpreted after the working of the retrospective fallacy: so attractive in body, so corrupt in soul, and hence, dialectically dangerous because of her attractiveness.

But the repressed returned, among other instances, in twentieth-century Freudianism. In Freud's theory of bisexuality the woman, "with her combination of masculine and feminine modes and her two sexual organs, one 'male' and one 'female,' is the general model of sexuality, and the male is only a particular variant of woman" (Culler 1983:171). This is how Freudianism joins age-old *Genesis*, where bisexuality is precisely the starting point.

2. THE EMERGENCE OF THE HUMAN BODY: INCOMPLETENESS

Let us follow, step by step, the construction of the character. The signs of the female body do not emerge right away. First, a sexless creature is formed. The first body, *the* body, unique and undivided, is the body of the earth creature, the work of Jahweh the potter.[2] From *Gen.* 2:7 to 2:20, this creature has no name, no sex and no activity. It emerges as a character-to-be, showing by what it does not have, how a character should be. The word *hā-'ādām* is not attributed to it by Jahweh. It is used only by the narrator. Therefore, we can assume that it is not a proper name but a common name. As a minimal description of the concept it signifies, it is strikingly adequate. It is derived from the word used to indicate the material aspect of the earth, *hā-'ªdāmâ*. The pun is very pointed. As we will see, the creature is first of all characterized as *taken from*, differentiated from, a larger environment. This principle of differentiation, which is the main characteristic of the creation in *Gen.* 1 is, at the same time, a basic semiotic principle. First, the creature receives the signs of life. Borrowing from Jahweh's breath it receives life so that it becomes a living *nephesh*, a living creature. The body is down-to-earth, life comes from the divine. This is the occasion for the later

2. I use Trible's translation, which best renders the two aspects of the word *hā-'ādām*: created, formed from the earth, *hā-'ªdāmâ*; and sexually undifferentiated. In general, my analysis is based on Trible's adaptation of the Revised Standard Version (King James version, 1611).

idea of the split between body and soul. *Nephesh*, however, can neither mean soul nor spirit, since that would attribute the same feature to the animals (2:19). This life principle or totality of the self (Wolff 1974:10−25) is sometimes located in the blood (*Lev.* 17:11), which implies that it is bodily anchored.

The unfinished state of the earth creature, both as a represented human being and as a literary character, is stressed by the word used to indicate it, which recalls its modest origin and status: made of clay, it is as yet only a species, not an individual. It has no proper name yet. The word will become a name much later. As for action, the creature is still a puppet; entirely passive, it is put into the garden among the trees to grow. No features can be derived from this non-action.

In fact, the creature is put there twice, the accounts of this event bracketing the growth: 1:26−27, 2.7. The second instance of this partial repetition (Rimmon-Kenan 1980), however, implies a future virtual activity (which will not be carried out): the tilling and keeping of the garden, a serving, respectful domination over nature. Thus, slowly, the specificity of human life emerges, but in a paradoxical way: as a name not to be attributed yet, as an activity not to be executed.

Trible (1978:80−140), in her seminal study on the feminine in the Bible which marked an important step in feminist theology, stresses the sexually undifferentiated nature of this earth creature. Properly speaking, it is not androgynous or bisexual, since sexuality is still to be created. Later versions do interpret it as such, however. In the younger, liturgical version of *Gen.* 1:26−27 Elohim creates man as male and female, in his own likeness, and in *Gen.* 5:1−2 this androgyny is explicitly attributed to the being named *hā-'ādām*, the earth creature. The use of the plural pronoun in both 1:27 and in 5:2 does not justify a singular, male interpretation of this instance of the earth creature. I will argue later that the first creation story should not be considered as different, let alone alien, with respect to the second one.

Apart from this intertextual evidence, there are at least two text-internal arguments supporting the sexually undifferentiated nature of *hā-'ādām* within *Gen.* 2:4b−*Gen.* 3, which therefore includes the future woman as well as the future man. If the word exclusively indicated the man, then the prohibition of 2:16−17 to eat from the tree of knowledge would not hold for the woman. However, in 3:2−3 she repeats the prohibition to the serpent. Secondly, the woman then, would not have been expelled from the garden, for in 3:22−23 Jahweh mentions only *hā-'ādām*. Perhaps she still lives there. . . .[3]

3. Both arguments can, of course, be explained away. In the first case, the man can have

In the text of *Gen.* 2:4b−15, the signs construct a concept that holds many features and at the same time lacks many. It holds features that get lost later, like the narrow bond between this concept of humanity and the earth, its absolute object-position and the moral innocence, and impotence that it enhances, its uniqueness. It lacks many other things among the features that constitute character: sex, name, action: responsibility. What makes readers assume this creature is male? What, by another equally strange twist, makes them assume that this mistaken priority implies superiority? Unable to read an unfulfilled character, they supply the lacking features. Apparently they have a concept of character in mind in which proper names and sexual identity are inherent qualities.

3. THE EMERGENCE OF THE FEMALE BODY: SEXUALITY

The next step, after the signifying of sheer existence, is a further differentiation. The one singular creature becomes plural. If readers can very easily supply the lacking features, the character itself can not. It is Jahweh God, not *hā-'ādām*, who decides that "His" work is unfinished.

> It is not good for *hā-'ādām* to be alone
> I will make for it a companion corresponding to it (2.18)

The lack of sexual difference causes loneliness, but the being who lacks it cannot be aware of what it never had. It takes some time, however, before Jahweh understands that simply to *add* beings will not do. The animals, outsiders as they are, do not *correspond*[4] to the human creature. For it is the tension between the *same* and the *different* that creates sexuality. The earth-being has to be severed, separated from part of itself in order for the "other half" of what will then be left to come into existence.

A deep sleep makes the earth creature unconscious. It almost returns it into *hā-'ªdāmâ*. This sleep is the death of the undifferentiated earth creature. It will emerge from it differentiated.[5]

repeated the interdiction to the woman. This counter-argument falls, however, under Knights's case against the "How many children had Lady Macbeth" questions (1964). It is a character/person confusion, which fails to account for the semiotic status of character. The second argument could be eliminated by the already-stated domination of man over woman (3:16): she just had to follow him. This counter-argument is overdoing the text's sexism. There is no reason to assume that the Eve who has not yet come into existence is textually eliminated altogether. Paradoxically, Trible defends this reading (1978:115−139).
4. I will not elaborate upon the obviously sexist but common translation "a help fit for him." The "him" being already a faulty translation, the rest cannot make sense. Besides, such a translation misses the deep insight into the nature of sexuality that is worked in this text. At that, the word translated as "help" is too often used with reference to God to allow such a humble interpretation.
5. If *hā-'ādām* actually was a male, then the creation of the woman would be very much like castration.

The organ taken from it is supposed to be the *rib*. This word has been widely discussed. Some scholars think it means *side*. It could, then, be a euphemism for "belly," as "feet" often stands for "testicles." In that case, it could refer to the womb, an apparent reversal of sexual function which is not at all unthinkable in the case of this undifferentiated earth creature. A second suggestion which is not incompatible with the previous one, is made by Oosten and Moyer (1982:80). They believe that Kramer (1961:102–103) rightly connected this mytheme with the Sumeric myth of Enki in paradise. In this myth, the goddess Nin-ti is created from Enki's rib. *Ti* means rib as well as "the making of life." Although the pun is lost in Hebrew, the association may have made sense: the "mother of all living" who emerges in *Gen.* 3:20 is herself made from (a piece of) living material. Such a reversal of object and subject would be typically mythical.

The verb used for Jahweh's forming of the earth creature was the specific verb for pottery; the verb used in 2:22 refers specifically to architecture and the construction of buildings. The action is both more difficult, more sophisticated, and requires more differentiated material. The difference would indicate a higher level of creation. This is consistent with the poetics of the Bible. Just as the creation of humanity in the version of *Gen.* 1–2:4b is the climax of the creation of the world, so the creation of humanity as it is specified in the version under consideration is performed in two progressive phases of perfection. This refutes the first conclusion that "Paul" draws from his first mistake. The material used no longer consists of dust, of clay, but of bone and flesh, already enriched with *nephesh*. The result is also higher: it is no longer an undifferentiated creature, but a sexual being, more precisely, a woman.

> And Jahweh God built the rib which he took from
> [undifferentiated] *hā-'ādām* into woman ['*iššâ*] (2:22).

Of the two words, '*îš* and '*iššâ*, which in this text indicate sexually differentiated beings, '*iššâ*, woman, appears first. It is '*iššâ* who changes the meaning of *hā-'ādām* from earth being into earth man. In this semiotic sense, the woman was formed first, then the man (*contra* "Paul").

But there is no reason to overstate her case. In the same way that the man can only come into being by his differentiation from the woman, as a next step in her creation, she has to be recognized as different, and receive in her turn her sexual identity from the man. Again, Jahweh disposes of the not-yet-completed character which cannot act. He brings her to *hā-'ādām* who, by the recognition of the other assumes his own sexual identity. The recognition of

sexuality is worded in his poetry, the first speech he utters.[6] If the woman is the first to be signified, the man is the first to speak. The attribution of speech to the man, the next step in the creation of humanity, displays the thoroughly equalizing dialectic of the process. Alter (1981:65–67) gives an interesting account of the poetics of direct quotation in biblical narrative. Quotation is one device of characterization, and is, like naming, related to a high degree to the biblical view of humanity. The distribution of speech and names among the different potential characters is, therefore, a relevant issue.

The lyric *hā-'ādām* performs, consists of two parts. First, he recognizes the woman as part of the same *hā-'ādām* of which he himself is a leftover:

> This, finally, bone of my bone
> and flesh of my flesh (2:23a).

After the failures of 2:19–20, this is a joyful celebration of their common nature, their brother-and-sisterhood. The man is, then, not the parent from whom the woman is born, as another obvious reading would have it, but if we stick to these inappropriate family metaphors, rather her brother. He is the son of *hā-'ādām*, she the daughter.[7] This interpretation of the first humans as not really the very first, is much more congenial with other creation myths, in which a first being, symbiotic with earth and/or heaven, is replaced by a second or even a third one. Zeus is a case in point.

After the recognition of their similarity, *hā-'ādām* the Second[8] celebrates difference. The phrase creates a problem of interpretation.

> This shall be called woman ['iššâ]
> because from man ['iš] was taken this (2:23b).

A problem here is the use of the sexually marked noun *'iš*. Indeed, it would be more convenient for me if the noun *hā-'ādām* had been used, so that I could assume it was used in the first, indifferentiated sense. There are two ways out. A first possibility includes that as in allotropy, the change of physical properties within the same substance, the man retrospectively assumes that he always had this sexual identity. He focalizes his earlier version from his actual state. Just as adults have no memories of their early childhood, during which they were not yet full subjects, let alone of their prenatal

6. In 2:19 he only *named* the animals. And there was no direct quotation.

7. Their subsequent relationship remains incestuous. Anthropology would claim that this incest motif requires their future enmity, which must safeguard socialization. Difference, that origin of humanity, must be protected against sameness. This gives an anthropological explanation of sexual antagonism.

8. The second born, after the woman; the second *hā-'ādām*, after the first, undifferentiated one; yet, the future Adam the King, reigning, after Jahweh, over the world including woman.

life, the man understandably cannot imagine that he was once a non-sexual being. This need not make us angry at him, nor at the narrator who quotes his words in this way. The analogy suggests an interpretative frame, the psychoanalytic one, on which I cannot dwell here, but which is obviously relevant. Already, the word *hā-'ādām* has definitely lost its previous meaning, as subsequent readings show.

However plausible and, indeed, acceptable this explanation is, there is another possibility, equally plausible. The phrase "taken from" does not mean "made out of" but "taken away from" in the sense of "differentiated from." The man, then, is right. Out of *hā-'ādām* Jahweh made *'iššâ* and *'iš*, by separating the one from the other. Similarly, in the previous phase of the creation, Jahweh made *hā-'ādām* by separating it from the rest of the earth, *hā-'ªdāmâ*, which by that separation changed radically: its unity was broken, it became less chaotic, it lost a potential humanity, and it begot a potential caretaker and master. This interpretation of the creation/ differentiation of the sexes is thus more consistent with the overall conception of creation in *Genesis*.

After unity and separation, the narration sums up; sexuality is a return to unity. Yet more than that:

> Therefore, a man leaves his father and his mother
> and cleaves to his woman
> and they become one flesh (2:24).

Love resembles death: just as death will be presented (3:19) as a return to origin, so love is presented here as a return to the union of one flesh. The phrase holds the following elements:
— it is the man who joins the woman
— love is a return to an earlier stage ("therefore")
— parents are mentioned.

The "invention" of parents as the species of people to be left behind is a logical consequence of what has happened. A couple was formed by the separation out of unity; "therefore," the initial state of unity will permanently harass man with nostalgia; the same unity will be sought and the same separation will follow. Hence, history starts here. The narrator generalizes, prospects and prospectively retrospects: he installs chronology. Unlike the woman, who began by her differentiation from the earth creature, the man will remember the original unity of *hā-'ādām*, of which he was leftover after the separation. Therefore it is the man who will search for the unity, rather than the woman.

The man as speaker, creating history and the succession of generations, carries out the next step in the creation of literary character. Promoted as he is from an undifferentiated, sexless creature to Everyman, he still has no proper name, no individuality. But he does,

now, occupy the historical position of the son-becoming-father.

So far, we can conclude about "Paul"'s first claim: although it is possible to assume that strictly speaking the woman was the first to exist, being the first to be signified, I see no anthropologically interesting point in such a claim. It would be indebted to a suspect, fashionable ideology, in that it would overrate the priority of signs over the subject. For the man is the first signifying subject. If the woman is differentiated first, the man is the first to recognize sexual difference. I contend that this distribution of semiotic roles implies a dialectic equivalence of sign and subject which mutually constitute each other. Man and woman, then, were created at the same time.

This makes a case against those commentaries which assume a contradiction between the two creation stories. Alter (1981:142–143), for example, in a most interesting discussion of the poetics of the Bible which often includes several factually contradictory but hermeneutically complementary versions of one event, distinguishes between the realistic (2:46–45), and the theological (1–2:4a) version of the creation. The editors, Alter claims, assumed that God created man and woman as equals (*Gen.* 1), but on the other hand, saw that in society there was no such equality. Therefore, they included the "sexist" version of *Gen.* 2. Alter's view seems plausible in so far as later interpretations have turned *Gen.* 2 into the sexist story it became. The "equal rights" version, then, has to be explained away. But its return in 5:1–2 makes the repression problematic. Alter's defense of the paradoxical coherence of *Genesis* was, however, uncalled for. The text as it stands does not at all contradict *Gen.* 1. In fact, it provides a specified narration of what events are included in the idea that "God created them male and female." This synecdochic composition turns *Gen.* 1–2 into one coherent creation story.[9] As we will now see, the same compositional principle turns *Gen.* 1–3, and subsequently the whole book, into a coherent story. For, similarly, *Gen.* 3 will laterally elaborate upon the implications of the other specification of *Gen.* 1:27: he created them in his likeness. And that is another story.

4. THE EMERGENCE OF ACTIVITY: 'SIN'
In the next episode, being and action mutually constitute each other. In its reception, features are drawn from action, and action is supposed to be based on features.

9. Coherency is not, in my view, an absolute literary category. On the contrary, I conceive it as a reading device, and subsequently as a device for the interpretation of editorial policy. In the present case, I want to claim that the eventual authors of the younger, first version, did not present a theological counterstatement to the second, older one. They were accurate readers and wrote a piece that completed retrospectively the imaginary representation of this particular conception of creation through differentiation.

Phase One: Awareness of the Body

Between a-historical existence and the beginning of history, the last sentence of *Gen.* 2 can be considered as a transition:

> Now they both were naked, *hā-'ādām* and his
> woman, and they were not ashamed (2:25).

Whether or not the so-called Jahwist editors have combined the stories of the creation and the story of the fall, initially different, the collocation is significant. The story, however, represents a different phase in the unfolding of narrative as a genre.

The sentence supplies information that prepares for the events to happen. It states the duality of the future characters, and it maps the semantic field of the story: nakedness *versus* shame. The semantic field will unfold as follows:

Before the fall, "naked" is the opposite of "ashamed," for naked, they do not know shame: naked $\leftarrow - - - - \rightarrow$ ashamed.

They are like innocent children. The implication: $\begin{matrix} \text{naked} \\ \uparrow \\ \text{not ashamed} \end{matrix}$

on the left side of Greimas's semiotic square (Greimas 1970) evolves into the right side, where "not naked" implies "dressed," and dress is caused by shame, whence the implication: $\begin{matrix} \text{ashamed} \\ \uparrow \\ \text{not naked} \end{matrix}$.

The awareness of nudity immediately seems to entail shame.

The complete square, then, is:

After the story of the creation of the body, after that of sexually differentiated bodies, comes the story of the development from unawareness to awareness of the body. It is the first "inner view," representation of feelings, and hence a step further in the construction of character. But awareness and shame are not immediately related. The first mention of shame, however ambiguous, is made by the man in 3:10 when the man replies to Jahweh that they hid because they were naked. It is Jahweh's appearance, not nakedness itself, that gives shame. In fact, it is the *confrontation* between characters that establishes this influential semantic turmoil. Confrontation is the narrative aspect unfolded in this episode of awareness.

Phase Two: The Possibility of Action

The first being appearing in this phase of the development of character is the serpent. It is an ambivalent creature, ontologically, morally, as well as narratologically. It is an animal, but it talks. It is

the first being to confront another one, the differentiated woman, but it uses the plural verb form, hence it addresses the man, too. Woman and serpent are both still generalizations of a species or sex, but the confrontation (Barthes 1977) brings them a step closer to the status of character, and promotes the narrative status of the fabula. The serpent, then, is the first potential character to open the possibility of *action* in this story (Bremond 1972).

The main feature of the serpent is slyness.[10] That feature is morally ambivalent. It implies cleverness, but not necessarily deceit. The serpent displays the feature in its speech:

> Did God really say, you shall not eat from every tree in the garden? (3:1b).

Presenting God's interdiction as so absolute, so tyrannical, the serpents provokes revolt. But it is not so easy to eliminate this "every" as a lie. In 2:16–17 Jahweh said seemingly the opposite: *hā-'ādām* could eat of every tree except one. Let us see what trees are then left.

Phase Three: Choice

In 2:9 the available trees are described: Jahweh "caused to grow every tree pleasant to look at and good to eat," thus introducing the senses of sight and taste. But then the text seems to give a description of those pleasant trees: "the tree of life in the midst of the garden, and the tree of the knowledge of good and evil." Does the collection of "every tree" consist of only two species, or just one? This passage has rightly given rise to much discussion. Westermann (1966) assumes that there is only one tree, which is twice described because two versions of the story have been combined here. The phrase would mean, then: "the tree of life [. . .] namely, the tree of knowledge." This interpretation draws support from the woman's reply to the serpent. She describes the forbidden tree, the one of knowledge, as "the tree in the midst of the garden." Extra-textual support can also be drawn from mythological tradition. In many myths, there is a tree of life guarded by a serpent (Eliade 1964: 310–324). Neither type of argument is relevant in relation to the formation of the myth based on *this* text. The problem to be dealt with, in this interpretation, is the relation between "life" and "knowledge of good and evil." If, as is highly plausible, the knowledge alluded to includes sexual knowledge, this problem is only apparent. The two descriptions become synonymous, and life, or immortality, has the same value as knowledge. Oosten and Moyer (1982:72) suggest that the moral attribute "of good and evil" may have been added later. This would imply that the moral judgment on sexuality is a later invention.

10. For an interesting interpretation of the serpent, see Ricoeur (1967:252–260).

The other possibility, that is, the existence of two specific trees, draws support from the end of the story. Angry because man has gained the knowledge that makes him nearly divine, Jahweh expels him from the garden and appoints a guardian at the tree of life. The interpretation by the woman in 3:2—3, then, would be mistaken. This has often been alleged as evidence of stupidity, a feature eagerly attributed to her, but cannot account for the ongoing discussion between her and the serpent in which knowledge and divinity, and not life, are at stake. Also one may wonder why Jahweh would suddenly start to worry about a tree which until then had not been prohibited.

There is a third possibility. There may be, indeed, two different trees, one supplying immortality and one supplying knowledge, If, as the synonymical use of the verb *jada* for "to know" and "to have sex" suggests, this knowledge includes sexual knowledge; it does indeed supply immortality, not to the individual but to the species, and the trees, different before knowledge, become interchangeable after. The confusion of the two trees by the woman is then not only understandable, but even very wise. Therefore, I disagree with Trible (1978:119), when she proposes an unnecessarily easy theological solution to the differences in the three descriptions of the tree (2:17; 3:3; 3:11). She explains them as evidence of their utter unimportance: the tree is just the tree of Divine Command. I would, rather, suggest that the three versions hold a progressive and dialectical circumscription of what is at stake. In 2:17 it is knowledge, including sexual knowledge with its consequence for life; in 3:3 the idea of death as the other side of life is mentioned; in 3:11 sheer disobedience or, in another sense, emancipation from blind command, provides the passage from the one to the other: assuming sexuality, humanity can do without impossible immortality.

The serpent's next statement, then, is not in contradiction with Jahweh's argument for the interdiction. Jahweh has said (2:17): "When you eat from it, you will surely die" while the serpent retorts: "indeed you will not die [. . .] your eyes will be opened and you will be like God, knowing good and evil" (3:4—5). Indeed, sexual knowledge, be it morally colored or not, does "open your eyes" and makes you both die and not die. It makes you live on in the children it allows you to produce. It creates history: the chronological succession of generations in life and death. Also, "the woman saw that good was the tree." In the Hebrew of the Bible, the verb "to see" has a strong connotation of truth: to see is to have insight into what really is, behind false appearances or incomplete information. It is "desired to make one wise." The wisdom alluded to cannot be but the acceptance of human condition, including death, and the continuity of history it allows. What features does this entail for the woman? We are far removed, here, from the belly-

oriented stupidity this woman is so often blamed for. On the contrary, she is open to reality, and ready to assume it.

The tree-symbolism has deep roots in the anthropology of prehistorical taboos. Reed (1975) discusses the origins of totemism which includes sexual and food taboos. The basic principle of the system is the fact that no distinction existed between the two drives. Hence the tree, or rather, its fruit, does not represent or symbolize sexuality; it includes it. Both food and sexuality are aspects of life and of the possibility of its maintenance. Both have to be protected, by totemization, from life-threatening misuse. The knowledge of how to avoid such misuse is rightly indicated as knowledge of good and evil. According to Reed (1975:279), the misuse pointed to is cannibalism which is *lack of differentiation*. Eating your own kind (or mating with your own kin) is threatening for the species because it exhausts the kind. It is plausible that primitive man could hardly distinguish between human and (other) animal species; his own clan *versus* the other beings was the only distinction he could make. The taboo on a certain animal could help him to learn to make distinctions. With this idea in mind, we can explain the various descriptions of the tree(s) as well as the meaningfulness of the transgression. The tension between "every tree" and the poor collection of available trees described in 2:9 is resolved when we consider the distinction between "every tree" and any specific tree as the main point at stake. The general idea is that as soon as the humans know how to distinguish, they will not eat (nor touch, as the woman, significantly, adds) anything harmful. But next, we must distinguish in our turn between Jahweh's and the woman's view, according to their respective relation to the human species. In view of this learning process, Jahweh the teacher prohibited a tree in order for the humans to learn differentiation. But he prohibited specifically the tree of knowledge. Why this one? Because it would make them like God. This is a matter of focalization. In God's eyes, eating the divine-making substance would be eating one's own kind. For the woman, the latter argument does not count, because the humans were not yet divine. The knowledge made them divine precisely because it implied the capacity to distinguish, hence to *avoid* eating one's own kind. The decision to strive for that capacity, that is, for the wisdom mentioned in 3:7, displayed the success of Jahweh's teaching. The prohibition itself implied the possibility of transgression, a motivated transgression justified because it was based on the very capacity of differentiation that was its issue.

But if the serpent was right in its promise of wisdom instead of death, was Jahweh then wrong after all?[11] This interpretation rests

11. From here on, Trible is, I am afraid, taken in by her religious feelings, which make her overstate the character of Jahweh. She fails to take its literary status seriously when she

on the equal position of the serpent and Jahweh in relation to truth. Both are sly, withholding information but not actually lying. Jahweh stresses one aspect — mortality — the serpent the other — knowledge — of the same idea. Both, in collaboration, trick the humans into accepting the unavoidable, that is, to renounce the childish fantasy of individual immortality. The woman, interpreting the words of both actors in relation to the interest of human life, makes her own decision. If, as many middle-eastern myths have it, the serpent, as the representative of immortality because of its capacity to renew its skin, is God's helper as the guardian of the tree of life, then our serpent does an excellent job. Also, the serpent with its double tongue, evolving into the dragon with its flaming tongues, may very well be the same creature as the cherubim with flaming sword of *Gen.* 3:24.

Phase Four: Action

Serpent, tree and deity are thus defined in relation to the first narrative action performed in the myth. The tree, as a provider of temptation, the serpent as the actual tempter, and god as the prohibitor of the action are equally endowed with narrative functions. They share the actantial position of the *destinateur*: they all play minor but indispensible parts in the fabula. It is their status as structurally related characters that the woman, by her action, in relation to which they occupy this position, calls into being. For what happens?

The woman paradoxically fulfills the creation of humanity to God's likeness, and, by the same token, the creation of literary character in which God is created to man's likeness. It was the likeness to God which the serpent presented to her as the main charm of the tree. This likeness included the free will to act which was implied in the interdiction itself. Jealousy about the eventual equivalence is alleged as Jahweh's motive for the interdiction. Jahweh's later reaction proves the serpent was right. The author and his characters turn out to be equal antagonists in the fabula in which the author is dramatized. The woman promotes her own status in the narrative. Her disobedience is the first independent act, which makes her powerful as a character. Not only has she the power to make the man eat, hence to make him know (her), disobeying in his turn; but she also manages to turn the almighty God of *Gen.* 1 into a character with equal status, equal features, equal feelings. From now on, this

assumes, for example, that Jahweh's recognition of the human couple's divine likeness (3:22) is an ironic reversal of what He really thinks (1978:136). This may save his divine superiority but does not account for his fear and defensiveness in 3:22—24. Trible's mistake is that she exempts Jahweh from the mutually structuring semiotic relations between all the characters.

creating Spirit (*Gen.* 1:2) has a body which seeks the freshness of the garden, strolls in it and looks for its fellow-inhabitants; it has a personality which makes him angry, and even, later (3:22), afraid. It is no longer in a position to "take" and "put" the human objects wherever it wishes. Speech becomes dialogue; action, confrontation. The relationship between them is now basically horizontal, both in terms of actantial power and in terms of space. It had to be like that: exclusive power, in *Gen.* 1, prevented narrativization. The only act performed there was the semiotization of chaos. Shared power, included in the creation of male/female in "H" is likeness, initiates confrontation, struggle, events, time, history, and narrative.

5. THE EMERGENCE OF CHARACTER: SORROW

The next and final step is the attribution of the proper name. It becomes possible after the attribution of definite, restrictive features. As we have seen, the woman and the man, transgressing Jahweh's prohibition, established the structural network of actantial positions. The woman was the leading actant; she did not exactly sin, she opted for reality. Therefore, it is not obvious that Jahweh's reaction should be considered as a punishment. It seems more plausible to take it as an explicitation of the consequences of the human option, as another representation of the reality of human life.

The episode consists of a series of interpellations. As the other side of speech, interpellation adds another trait to the construction of character. Interpelling them, Jahweh acknowledges responsibility, hence the character-position of each actant. First, he addresses the man. The expression of shame betrayed the man: "who told you you were naked?" (3:11). Indeed, the awareness of nakedness was the immediate consequence of the acquisition of knowledge. Speaking and spoken to, focalizing (his shame) and focalized, acting, the man now fully participates in the narrative process. The man tries to blame both the woman and Jahweh who gave her to him. Then Jahweh turns to the woman, who blames the serpent. The serpent, then, is next addressed, but not as a full subject able to speak. Jahweh immediately curses it, without asking any question. Thus, he limits its position as a character. It is thrown back into its state of speechless animal. The content of the curse is simply the subsequent realistic image of serpents as crawling and dangerous animals.

The woman is not cursed. The content of Jahweh's words to her is not even presented as the consequence of what she has done, let alone a punishment. Here again, we seem to have a faithful depiction of reality. But how real is reality?

> I will greatly multiply your labor and your childbearing
> in pain you will bring forth children
> and your '*iš* is your desire
> and he will rule over you (3:16).

The word "multiply" is a little strange, since no children have been born yet. The use of the world "labor,"[12] repeated in the address to the man, suggests that this is a distribution of labor among the sexes: the man will work for food, the woman for children. The establishment of sexual roles is carried out in these lines (3:16—19). Now, the second part of this speech is most disturbing for feminists. It is tempting to claim that the almighty "equal rights" Elohim of 1:27 is developing here into an ordinary male character, affected himself by the invention of sexual roles which he is acting out. There is one surprising detail, still. The relation of desire, which, as the precondition of pregnancy, could be expected to be mentioned first, only follows the mention of childbearing, the consequence of pregnancy. This suggests that the relation of domination comes up as an afterthought, judged less important, perhaps less fatal, than the pain of labor. The hierarchy would then be based on a different degree of realism. This idea slightly nuances the image of Jahweh the male character.

Oosten and Moyer (1982:83) propose a more far-reaching idea. They draw attention to *Gen.* 4:7. In an entirely alien context, namely, when Jahweh explains to Cain why his offering had been rejected, we suddenly read:

> and unto you [shall be] his desire
> and you shall rule over him.

Indeed, in 4:7 the phrase does not make sense at all. Therefore, the authors suggest that initially it was part of Jahweh's speech to the woman in *Gen.* 3: 16—19; later editors did not notice the logic of reciprocity, because reality did not exactly display equal rights between the sexes; hence, they displaced the lines.

The suggestion is attractive, since it undercuts one argument against the misogynist interpretation of the text. Two text-internal arguments support it, even if they are not compulsive. First, the man has explicitly expressed male desire in his celebration of love (2:24), and it would make sense for Jahweh to stress its negative side here, just as he reverses the gentle "keeping and tilling" of the earth into hard labor. Second, Jahweh is clearly more severe on the man than on the woman. He explicitly blames him, and in-directly curses him by cursing the earth from which he was taken and to which he shall return. It seems plausible, therefore, that he would subordinate the man as well.

Even if this philological detail can influence our evaluation of the ideological flavor of the mytheme under consideration, it certainly

12. Trible translates it as "toil." I prefer "labor" because it implies a double pun: one on work for the woman as equivalent of work for the man (Trible's suggestion), and one on work for the woman as equivalent of her pain, the one held by the English use of "labor" for birthgiving.

is of minor importance in relation to its main tendency. For, with a narrative logic proper to these stories, Jahweh carries out the next phase in the formation of characters by attributing to them, as a complement to their actantial position, bundles of features which determine the realm of their future actions and limit their possibilities. He does that in a way for which we have few reasons to be grateful: by fixing sexual roles. As an ideological agent, he creates "those identities of man and woman, the fictions of oppression" against which modern critique claims to struggle (Heath 1982:168).

The relations between the sexes are fixed in terms of the semantic axes of fertility and domination, and are, as such, arbitrary: other axes could have been chosen. Fertility necessitates labor, and domination presupposes desire as its precondition, according to Jahweh's statement. Yet, if it is true that modern medical science still maintains the realism of the idea of unavoidable labor, the relation between desire and domination seems hardly "natural." Power and domination establish the organization of social life, while, more specifically, the distribution of roles in reproduction, where woman produces children and man food, organizes work.

Looking back, retrospectively, to the creation of sexual difference, it is striking that the difference was established as an empty, purely relational category, more or less in the same sense as Saussure's networks of oppositions without positive terms. Neither the woman nor the man is described as anatomically typical. We are far removed from today's conception of sexuality as anatomical difference:

> In our culture, we refer to the classificatory divisions based on anatomy as sexual divisions. This is because anatomy has become synonymous with sexual identity and activity (Coward 1982:280).

Mentioning labor and desire, Jahweh predicts this evolution. It is in this episode only, and not before, that characters come into being endowed with "relevant" semantic features, in other words, that the relevance of their features is fixed. If there is a sexist ideology inscribed in this text, it is not until this passage that it can be pointed at.

Since the characters are completed now, they can receive the label that makes them memorable: the proper name. It is, again, the woman who is the first and only character explicitly named. Again, this priority in the formation of character is balanced by the fact that the man is the first and only subject of naming. As we have seen, the word *hā-'ādām* had been used by the narrator as self-evident; the serpent was only indicated by its generic name; *'îš* and *'iššā* were nouns used for sexual differentiation. Eve, *Hawwah* that name which means, as her mate says, "the mother of all living," is solemnly applied to *'iššâ* in view of her sexual and social role. The name is, like most Biblical names, motivated, hence descriptive (for an

account of possible functions of Biblical names, see Bal 1984). The man, in giving her this particular name, further determines the character: Eve is imprisoned in motherhood. There is no more question of the sexual attraction celebrated in 2:23–24.

Confronted with this dubious title of honor, "Paul"'s violent reaction is highly suspect. Indeed, in stressing the prohibition for women to teach, he seems to react to this motherly function inscribed in the proper name. At the same time, the collocation of the inferior body and moral inferiority stands in opposition to motherhood: "Notwithstanding she shall be saved in childbearing," continues "Paul" in I *Tim.* 2:15. The question arises: do women deserve contempt in spite of, or because of their motherhood? Christian morality, echoed in the invention of "pure" motherhood in the character of Mary, the anti-Eve (whose virginity, of course, is mythical; see Warner 1976), holds the former; psychoanalysis, in stressing the problems the child has to live through because of the exaggerated bond with the mother, suggests the latter. The very invention of Mary, sadistic as it is in its requirements imposed on women, paradoxically shows the impossibility of overcoming the tension between the two positions. Mary was supposed to correct Eve in that she was the "pure" mother, but the very notion is self-contradictory. Eve, Mary's presumedly negative counterpart, had in fact a better start, representing both sexuality and motherhood. The man, however, fails to appreciate this: after his celebration of love, now forgotten, he exclusively stresses the other side of woman: motherhood. Thus, Eve, starting in wholeness, is now condemned to predict Mary.

But there is more. The proper name in narrative can be structurally related, not only to the features of the character itself, but also to other names. Hamon (1983:107–149) studies the system of proper names in Zola's novels. He comes up with the term *actant phonétique* which he defines as follows (p. 122):

> constant group of phonemes, characterized by its recurrence and its stability [. . .] fundamental unity situated between the general signifier of the text, that which we have called its rumor(s), and the particular proper name of the character-actor.

The interest of such a concept lies in its structural aspect. Avoiding pointless and arbitrary interpretations of isolated phonetic features, a procedure we cannot dream of anyway in the case of ancient texts, it draws attention to the construction of relations between characters. This seems to make sense in the case of the Hebrew Bible, where naming is a meaningful act meant to establish the relation between the character and its main feature. The puns we met with earlier, especially *hā-'ᵃdāmâ/hā-'ādām*, suggest such a relation between characters. The earth is left behind as a non-character, and the future character Adam will return to it later. In this respect, the fact

that the woman, as the first representative of a sexually differ-entiated human being, is the climax of the creation, and the fact that she is appointed as the future creator/provider of "all living," may very well be signified in the resemblance between her name and Jahweh's, the consonants H and W being the phonetic actant which oppose the creators to the creatures, signified by D and M. Again, this is not meant to imply a female superiority but a functional analogy between the two creative forces. Adam, by giving the woman that name, is the very character who stresses this creative function. In his address to the man, Jahweh in turn highlights Adam's func-tional relationship to the earth which, presented both as an anta-gonistic and as a related force, is endowed with the actantial position of the opponent. Hence, the four are cross-determined: Adam relates Hawwah to Jahweh; Jahweh relates Adam to earth. The characters are, now, completed: interrelated, endowed with features, their names make them memorable. Thus, at the end of the story, the myth of Eve begins.

CONCLUSION

Naming, as we have seen, is the labeling of the character that com-pletes its formation. But its complete state does not necessarily imply all its previous states. *Gen.* 1–3 provides ample evidence to the contrary. The confrontation between the two myths allows us to understand the ideological effect of the named character. Hamon (1983:107) describes the effect of the proper name as follows:

> To study a character is to be able to name it. To act, for the character, is also, firstly, to be able to spell out, address, call and name the other characters of the narrative. Reading is to be able to fix one's attention and one's memory on stable points in the text, the proper names.

These remarks interestingly join the findings of the present analysis. While studying the text it has been impossible to name the character Eve until the very end. Doing so would have disfigured the design of the text. Second, naming has been the man's prerogative. This enhances the paradox of semiotic creation: he was the first to name, which, according to Hamon, is a condition for action. But she was the first to be named, hence, to be "the other character" indispens-able for him to be a character at all. Thus they mutually create each other, differently, in a different act.

As for the third aspect of Hamon's statement, the slow emergence of the proper name has caused a serious reading problem which compulsively stimulated readers to assume the retrospective fallacy which I hold largely responsible for the erroneous uses of the text. For what happened to our test-reader "Paul?" He started at the end, that is, at the proper name. This enabled him to "fix his memory." This implies the possibility of combining the name with the sexist

myth already attached to it ("it is the same Eve"), and which is motivated by, and reinforces, his contempt for women. He endowed the named character with those features the combination allowed him to draw from the previous story which nourished that contempt for women, namely, the "secondary" creation of her body and the "first" disobedience in her action. He fixed them together as if they belonged to the same being, unproblematically. In the case of a development story, however, starting at the end means losing sight of the development. In the linear reading, the self-evidence of those features is questioned by the very concept of development.

The construction of character has followed a specific line in the story. First its existence was posited, but then it was not yet a sexual being. Then it was sexually differentiated, addressed, and successively endowed with different aspects of subjectivity. It became the subject of awareness, hence of focalization; of speech; of possible action, of choice and of actual action. It was characterized by description. Then, only then, it was named: Adam the man, Eve the woman. "Paul" entirely missed that construction. Hence, he missed the point of the creation story. For that point is creation, by differentiation, of humanity, of character.

REFERENCES

Alter, Robert, 1980. "Sacred History and the Beginnings of Prose Fiction," *Poetics Today* 1:3, 143–161.
 1981 *The Art of Biblical Narrative* (New York: Basic Books).
Bal, Mieke, 1984. "The Rhetoric of Subjectivity," *Poetics Today* 5:2, 337–376.
 1984 "Réfléchir la réflection: du nom propre à la mise en abyme." *Annali del l'Istituto Universitario Orientale*, 7–47.
Barthes, Roland, 1974. *S/Z* (New York: Hill & Wang).
 1977 "Introduction to the Structural Analysis of Narratives," in: *Image-Music-Text* (London: Fontana) 79–124.
Bremond, Claude, 1972. *Logique du récit* (Paris: Editions du Seuil).
Briffault, Robert, 1952. *The Mothers. A Study of the Origin of Sentiments and Institutions* (New York: MacMillan).
Culler, Jonathan, 1983. *On Deconstruction* (London: Routledge & Kegan Paul).
Coward, Rosalind, 1982. *Patriarchal Precedents* (London: Routledge & Kegan Paul).
Derrida, Jacques, 1974. *Positions* (Paris: Minuit).
Dijk, Fokkelien Hemmes van, 1982. "Want eerst is Adam geformeerd en daarna Eva. . .," *RO* 25–41.
Eliade, Mircea, 1964. *Traité d'histoire des religions* (Paris: Payot).
Greimas, Algirdas Julien, 1970. *Du sens* (Paris: Editions du Seuil).
Hamon, Philippe, 1983. *Le personnel du roman. Le système des personnages dans les Rougon-Macquart de Zola* (Genève: Droz).
Heath, Stephen, 1982. *The Sexual Fix* (London: MacMillan).
Knights, L.C., 1964. "How Many Children had Lady Macbeth?" in: *Explorations* (New York: New York UP) 15–54.
Kramer, S.N., ed., 1961. *Mythologies of the Ancient World* (New York: Anchor Books).
Oosten, Jarich and David Moyer, 1982. "De mythische omkering; een analyse van de sociale code van de scheppingsmythen van Genesis 2.4b–11," *Anthropologische verkenningen* 1:1, 75–91.

Reed, Evelyn, 1975. *Women's Evolution. From Matriarchal Clan to Patriarchal Family* (New York: Pathfinder Press).

Ricardou, Jean, 1971. *Pour une théorie du nouveau roman* (Paris: Editions du Seuil).

Rimmon-Kenan, Shlomith, 1980. "The Paradoxical Status of Repetition," *Poetics Today* 1:4, 151—160.

Sarraute, Nathalie, 1965. *L'ère du soupçon* (Paris: Gallimard).

Trible, Phyllis, 1978. *God and the Rhetoric of Sexuality* (Philadelphia: Fortress Press).

Warner, Marina, 1976. *Alone of All her Sex. The Myth and the Cult of the Virgin Mary* (New York: Vintage Books).

Weinsheimer, Joel, 1979. "Theory of Character: *Emma*." *Poetics Today* 1:1—2, 185—212.

Westerman, C., 1966. *Genesis 1—11*. Neukirchen.

Wolff, Hans Walter, 1974. *Anthropology of the Old Testament* (Philadelphia: Fortress Press).

THE POLITICS OF WOMEN'S BODIES: REFLECTIONS ON PLATO

MONIQUE CANTO

As I have already said... such tactics will not deter us from insisting on our principle that there must be the completest association of the female sex with the male in education as in everything else... If women are not to take their part along with men in all the business of life, we are bound, are we not, to propose some different scheme for them?...

Should they perform menial offices, exactly like slaves? Should they stay at home and take care of the belongings of their men? Or should they be granted dispensation from the meanest labor and encouraged to cultivate their minds and bodies, to make for themselves a life that is far from unworthy or frivolous, occupied with the concerns of the household and the education of the children but taking no part in preparations for war, that is, in politics in the broad sense, in debate over public issues.

I can only speak as I think. A legislator should be thorough, not halfhearted; he must not, after making regulations for the male sex, leave the other to the enjoyment of an existence of uncontrolled luxury and expense, and so endow his society with a mere half of a thoroughly felicitous life in place of the whole.

The foregoing passage (part of it directly quoted, part of it my own summary) is a feminist political manifesto. It is important to be clear about the meaning of the term. Feminist politics is politics that could not exist without women. And since politics requires that we know who we are, who are our friends and who our enemies, women must constantly apprise themselves of their strength, and exercise it. Above all, they must know how to fight, and they must be sure that everyone knows that they know. Everything depends, therefore, on presence. Feminist politics is real only if women, together with their bodies, their works, their labor, and their voice, are present in a place where everyone can see them — let us say, in the marketplace. Finally, it may be worth mentioning in passing what the political woman's modern utopia would look like: it would consist of women

Translated by Arthur Goldhammer.

in control of certain *media*, i.e., certain objects and forms of communication, or again, of women in control of an ideology that would make it impossible for woman's image to usurp the place of woman's reality. What the manifesto demands is nothing less than the presence of women on the political scene.

But it contains something more as well. For women, necessary as they are to life in the city, define two possibilities without which political life would be inconceivable. One of these has to do with existence, with life understood in temporal terms. Procreation is woman's work, but if women are included in the city it may be a political idea as well. The second possibility has to do with desire, the primary datum of human life and the general form of all life. Now, every city must come to terms with pleasure and pain, with the whole realm of the emotions; for pleasure and pain are the vital principle of the city itself, yet their inevitable excesses threaten the city's very existence. The city's only recourse is to politicize the emotions, but it cannot discharge this function unless women are granted a fully legitimate political role. Thus the politics of women's bodies has far-reaching implications. The two most important questions about the city are: How can it maintain its present form? and, How can it insure that its citizens' desires are satisfied by what it is? To both these questions woman-as-political-animal provides an answer. With woman, a place can be found in political theory for both procreation and the representation of desire — and hence also the satisfaction of desire. Procreation and representation are related questions, moreover; taken together, they indicate the difficulty of conceptualizing, within a given political framework, the possibility of reproduction: reproduction of the real in order to satisfy desire, and reproduction of human life so that the city may endure. In both cases, reproduction is possible only if a difference exists, for without difference the idea of the same and the idea of the other make no sense. In both cases, woman is necessary in order for this difference to be present. But this difference is above all an insistence upon the political. The whole question is where this difference resides: inside or outside the city. The answer to this question will determine the strategy that women must adopt. Women must know how to fight, because no human politics has ever been conducted in the realm of the same. So much is stated in the manifesto. A politics of women's bodies gives rise to a politics of the real, precisely because only such a feminist politics can make reproduction — a major gamble in which a city can easily lose its model and its norm — one of the principles of the political.

Thus far we have spoken of cities, pleasures, pains and procreation. As terms of political discourse these may appear outmoded. It is true that the political manifesto cited above was composed by an ancient, but his thinking in regard to women and the conditions of political

life is not as old-fashioned as it may seem. In fact, the question he raises is rarely asked, and it has never been answered quite so candidly since (the answer is: the female body politic). And when he speaks of women's bodies, he means the real thing: naked women, pregnant women, women armed like warriors and, above all, women who have to be looked at. But enough. The time has come to identify the source of these ideas.

The text with which this essay begins is a passage from Book VII of *Laws*, the long dialogue that Plato wrote toward the end of his life.[1] It is clearly a testament, not only because of the ideas it contains but even more because of the manner in which they are set forth. The dialogue unfolds serenely, without conflict. Three old men discuss, while walking, the best laws for a city to adopt and the nature of a perfect constitution. There are no serious disagreements among them, and no real objections are raised. Thoughts are expressed in a straightforward way, without subterfuge or irony. Such tranquility of thought is not frequently encountered in Plato's dialogues, where the idea being presented often has to be defended against the laughter, sarcasm, or violence of one interlocutor or another. This is particularly true where women are involved. Plato discussed women frequently, even in the *Laws*. The protagonist of *Laws*, the Athenian, prior to stating as clearly as he does that the presence of women in the city requires that they know the art of war, just as men do, and that no genuine political life is possible without them, repeatedly raises the question of women's bodies, as if this question had a special bearing on the very definition of political reality. We know what conclusion he draws: that women are at the heart of the city, hence they are also at the heart of war; furthermore, if they keep solely to slavery, the household, or private culture, there is no political life.

The line of argument that leads to this conclusion is surprising: it involves a detailed consideration of the place of women's bodies in the city. But before we can comprehend this detail, which is what makes Plato's thought on this subject interesting, we must answer another question: Is it possible for women to occupy this kind of political position? Plato deals with this in another dialogue, the *Republic*, the tone of which is quite different from that of the *Laws*. The *Republic* is a kind of inspired outline, in which answers to questions are sketched out but not developed with precision. Hence some of those answers are extreme, provocative, or utopian (*Republic* V, 449a–465d). Yet they pave the way for the minute

1. *Laws* VII, 805d–807c. All English citations from the works of Plato are taken from *The Collected Dialogues of Plato*, eds., Edith Hamilton and Huntington Cairns (New York: Pantheon-Bollingen, 1963). The translators are as follows: *Republic* — Paul Shorey; *Symposium* — Michael Joyce; *Laws* — A.E. Taylor (Translator's note).

precision of the *Laws*, in which the question of women and politics is always inextricably bound up with that of political reality. Yet even this minute precision does not exhaust the question. For Plato also considers the woman issue in a mythological context. Woman's necessity comes from elsewhere, from an archaic time, from another, and completely self-absorbed, meaning of the feminine. The myth recounted by Aristophanes in the *Symposium* gives the basic idea (189d—193c).

The *Laws*, with its scrupulous, detailed, and precise history, must be set alongside two narrative treatments of the same theme. The first of these is found in the *Republic*: this is the *mise en scène*, what Plato calls the *drama*, of the feminine in the city. It is an abstract scheme for conceptualizing a community composed of men and women. The second occurs in the *Symposium*, where it is asserted that political life and the female body have a common origin. This idea is also somewhat extreme, and we should bear in mind that Aristophanes, the author of the myth, is gifted with the art of the comic poet. Hence we have a history, a drama, and a comic fable, all asserting the political necessity of the female body. The question must be a very difficult one to have called forth so many different answers, and if we wish to know exactly what Plato thought about it, and how his thoughts have influenced one way of thinking about women's bodies, then doubtless we must patiently follow the development of his thinking from the beginning. Let us begin, then, with the drama of the *Republic*, the first certain entry of women's bodies into the city.

The question of women, says Socrates in the *Republic*, is the initial move in a discussion devoted to the nature of the best city. Indeed, if the condition of public happiness is that the good of the citizen should coincide with the good of the state; if citizens must share all pleasures and pains in common; and if nothing apart from their own bodies belongs to them; then "the possessions of friends will be in common" and there will be no exclusive possession of women and children (V, 449a—d and 451b—c). Now, the condition of such a community of women and children is that men and women hold all political functions in common. To prove this, however, Socrates dismisses the question of the real: don't ask me to prove that what I'm describing is realizable, he says, just let me show that, if such a community were to be achieved, it would procure the greatest of benefits for the city. The question of the real is deferred to the *Laws*. In the *Republic*, Socrates deals with the possible (V, 457d—458b). Women, he says, have the same aptitudes as men. Hence there are no functions reserved for men alone, from which women are excluded. On the contrary, women should receive the same education as men in music, gymnastics, the art of war, and horsemanship. They must exercise "unclad in the palaestra together

with the men, not only the young, but even the older" (V, 452b).
With this training they will have access to responsibilities identical to
those of men: medicine, philosophy, government. No doubt their
physical resources are inferior to those of men, but even here we
must beware of hasty generalization. At bottom, there is only one
enduring difference between the two sexes according to Socrates: the
male "begets" whereas the female "bears" (V, 454e and 458c—d).

Thus the difference between man and woman lies in the com-
plementarity of their roles in procreation. But since the meaning
of the community of men and women is in the first place political,
only a political idea of procreation would be capable of neutralizing
the effects of this difference. That procreation should be the city's
first concern is actually what Socrates is proposing when he calls for
child-rearing in common. Men and women, attracted to one another
by "erotic necessity," are married according to their excellence and
obliged to see and meet one another frequently, so as to multiply
opportunities for procreation. Children are turned over to nurses at
birth to live in a special quarter of the city. Mothers will come to
suckle offspring only so long as their breasts are full of milk, and
children are to be presented to them in such a way that no mother
will recognize her own. Hence there is nothing to distinguish the
mother from the father of a child. A man "will call all male offspring
born in the tenth and the seventh month after he became a
bridegroom his sons, and all female, daughters, and they will call him
father." Similarly, every possible step is to be taken to prevent a
woman from calling a child her own (V, 460b—461e). The living all
belong to the city, and the first resolutions adopted by the state are
designed to emphasize the fact that birth is a matter of deliberate
policy: both public policy, which establishes the laws governing
marriage and celebrates the institution (punishing men and women
who copulate without proper regard to selection or without any
intention to procreate), and secret policy, which determines who
shall mate with whom and prevents union between partners whose
coupling would, for one reason or another, be undesirable (459e).

The possibility of making procreation the first political act is thus
the condition that necessitates, and also legitimizes, the identity of
the civic functions of men and women. "Civic functions" comprise
duties pertaining to both internal government, or law and order
within the city, and defense of the constitution against all enemies,
domestic and foreign (V, 464a—465c). Now, the idea of a politics for
which procreation is the primary issue, which, as we have seen, is the
basis of the community of male and female functions in domestic
government as well as in the conduct of war, is inconceivable unless
both men and women, men's bodies and women's bodies, are equally
present in the center of the city. This is the other meaning of
community: community is the space within which men and women

circulate, meet, and enter into union with one another, the place where they can see and be seen. Women, in this city whose political life they make possible, show themselves and look about them, openly and without reserve. Their body is a political body.

Thus the gynaeceum, the place of women, no longer harbors either the secret or the private. Nor is there any longer a place reserved to women alone, because men and women now live together throughout the city. The public space is necessarily held in common. Together men and women in fact constitute and delineate this space, and keep it under surveillance in order that it shall remain what it is, always identical to itself, absolutely excluding any real presence of the other. Socrates suggests that it may be necessary to tell the men and women of the city "a sort of Phoenician tale," a myth of foundation, according to which all citizens believe that they are brothers (414c—417b) — even the women, because, as political bodies, they are the same as men, and because, like the men, they work to drive otherness to the periphery of politics. This shows that within the city woman is in no sense the representative of otherness. It also shows that the civic space is apparently unable to tolerate the presence of any kind of otherness, not even to the extent of affirming the difference between men and women. But the city in which men and women have, so to speak, the same political body is a city that subsists outside history. It is also a city without images or desire.

"In this city we do not wish it to be possible that a being can be said to be manifold." Socrates dismisses the poet and condemns imitation. Imitation can not only reproduce multiple examples of any being, but can also alter that being, introduce mulitiplicity into what was unique, and engender an infinity of further replicas that are both alike and different. Imitation generally takes the form of images (*Republic* X *passim*, especially 595c—607a). The city will, therefore, be deprived of those images that Socrates shows to be the obvious objects of human desire. Not that images are the only such objects. Desire for the good or for absolutely real being are surely more essential. But only the desire for images allows us to grasp the faculty of desiring as a specific, autonomous faculty that cannot be reduced to either reason or feeling (*Republic* IV, 439b—441d). Furthermore, desire is the point of reference for the reality of pleasure and pain, so that, when pleasure and pain are wholly political, it is desire that makes citizens happy about whatever is good for the city and unhappy about whatever is bad. Fundamentally, the requirements that there exist no private pleasure or pain, that whatever is susceptible of gratifying or frustrating desire should not be the property of any isolated individual, and that no citizen may say of an object or person sought by desire that "this is mine, this satisfies my desire" — all these conditions are basic to the most human reality of the community present in the city (*Republic* V, 464c—465c).

But since the city must be protected against both temporality and otherness, all desires are educated so that they direct themselves to a single object, itself identical with those who feel desire: the city itself is the object of its own desire. This common desire, so easily identified when it is desire for images, wants nothing other than an image of what the city is, i.e., a reality formed in identity, at the edge of history and at the limit of representations (*Republic* III *passim*, especially 398a–403c). What is more, this desire is maintained distinct from any evolution in its own formula, from any modification in the objects that satisfy it. No innovation is allowed, says Socrates, because for the city, the slightest change would be fatal (*Republic* II, *Laws* II; III; VII, 799a–c). In the city composed of men and women, politically mingled, unions are celebrated and representations sacralized outside of real time; they are the expression of a desire for the same, which, so long as man and woman exist, is already impotent to articulate amorous desire. In the city of the *Republic*, the political body of women is not really desired. Nor does it desire. Desire requires a real relation to temporality and density of representations that yield pleasure only because they are representations of otherness. Now, in order to legitimate the public presence of woman in the city, both of these conditions would have had to be eliminated. The body of women protects the city against time and images. It is dedicated to the same. Women's politics creates the ascesis of desire.

The object of politics receives a quite different treatment in the *Laws*. No doubt the idea is the same, but the basis upon which it stands is different. The three old men engaged in conversation are representatives of three real cities, Athens, Sparta, and Crete, to which they constantly refer in the course of their discussions. All three are trying to describe political reality in a way that takes account of time and history on the one hand, and pleasure, pain, and the emotions that determine the orientation of human desire on the other; these are the conditions of existence of any real city. Thus, the primary data of political discussion in the *Laws* are the real effect of time, which causes people to age, change, and deteriorate; and the need for pleasure, for which a political definition must be sought in a public manner as soon as a city is established (e.g., *Laws* III, 673a–b). Hence the first propositions in *Laws* are intended to explain the essential connection between politics and temporality as well as to discover the representations with which desire can exert its intrinsic force and overcome whatever threatens to alter it or to alienate it from the city's ends. The three old men accordingly discuss cities that live in time, and their first concern is to examine the political effects of public intoxication, poetic representations, and civic choirs (*Laws* II, 652–654c). The presence of history and the power of images are there to bring politics back to reality. What

remains, then, of the astonishing idea put forward in the *Republic*? The idea that women and men are in the same position, that the female body is one reason why politics exists, and that it must be present in the center of the city as well as in war; the idea that the female body is a body politic that reproduces itself under the strict control of the law, in procreation and representation, and in such a way as to stretch identity to its limit and to exhaust the reality of desire. Is the body politic so absolutely separated from desire? Let us turn now to the text of *Laws* to find out.

"A state should be like a well-compounded bowl," in which the masculine and the feminine, politically associated, can mix to form "a healthful and modest draught." Hence men and women who are citizens of the city must assemble, meet, and marry (*Laws* VI, 773c–d). Mixing is the first condition of politics, and this condition cannot be satisfied without the presence of women. But the civic "compound" of the *Laws* is different in composition from the "political identity" of the *Republic*. The main difference is that the former compound makes sense only thanks to the persistence of "otherness" within it, rather like "a web or other piece of woven work (in which) woof and warp cannot be fashioned of the same threads" (*Laws* V, 734e–735a). The meaning of marriage depends on the difference between the men and women who enter into it. The reproduction that is necessary to political life will therefore play itself out in relation to otherness. The "well-compounded bowl" is Plato's most general image for political reality, which he seems to · have conceptualized as requiring a mixture in which otherness must be present and its effects dealt with one way or another. A truly political law is also a mixture, combining declaration and exhortation; or perhaps I should say that a law is the *mise en scène* of a declaration, which makes it persuasive in the city and which combines the general disposition with the concrete conditions under which that disposition is to be put into effect (*Laws* IV, 722c–724e). This dual nature of law is expressed by the distinction, made by the Athenian, between the law proper and its "preamble," which is understood to be not just an introductory text but a fundamental summary of the historical development of the law and the forces that threaten its integrity; thus the preamble invests the law with its full political reality. It is something rather similar to this, a condition constitutive of political reality, that makes it possible to establish the presence of women at the center of the city.

Women, therefore, participate in politics by constituting the reality of the city's life out of a mixture of time and the other. But how can one express in these terms, which are already political, a constitution that would incorporate the presence of women as a necessary condition? This was no doubt the difficulty that the political construction set forth in the *Republic* sought to avoid, by

saying nothing about how such a constitution would allow for "difference" and "historical change" (*devenir*). Women were of necessity included in the city, but in return a "limit-reality" was ascribed to time and desire. In *Laws* the political presence of women is harder to express and at times leads to incredible statements. But what the Athenian is trying to conceptualize with such obstinacy and at times in such strange ways is the possibility of a political reality that is able to come to terms with difference and images, with the force of time and the force of desire. For this, women are absolutely necessary.

Thus the city constitutes itself by coming to terms with the place of women. But we must be careful about what this means. It does not mean a numerically real presence but rather a condition of activity: the feminine must be there in order to reproduce and represent. And in the city itself, the origin of politics is assignable only through the presence of women: theirs is a dual mode of presence, a model of dissociation that makes it possible to articulate the transition to the political condition. The status of women in the city is dual, as is that of tragic representation and poetic imagery. All three seem capable of movement, circulation, and encounter, capable of being the one and the other, of facing in two different directions; it is upon these resources that the city must draw to sustain its own political functioning, but it must also control the real destructive power they contain (*Laws* III, 700a–701b; IV, 719a–e). The first concern of politics is to gain control over the profusion of images, to prevent them from being misused and misappropriated. The poet is the first person to be received into the city, and his poetry is real insofar as it satisfies the political desire for representations (*Laws* II, 667b–673d). Women are allowed in the city, but without dowry or artifice – in order to guard against luxury, rivalry, and the passion for money that is linked to the conquest and seduction of women (*Laws* V, 742a–744, 774d). This of course means that neither women nor images are commodity values and, more generally, that no object has value apart from the political reality of which women are the condition. Values are, as it were, constituted by women, who are the foundation of the political order. A real women's politics is what makes possible the transition from nature to the city.

Now, this politics is what orders the representations that are also, along with women, the condition of political life. Furthermore, the first law of any city that proceeds according to nature is, according to the Athenian, a law regulating *genesis*, not only human procreation but also the genesis of the political (*Laws* IV, 721a–d). It is against this same apparent circularity that the political presence of women stands out. Women are otherness, indeed the very condition of otherness, the basis of political life. This accounts for their dual function. Women in the city are also at war – not in the sense of

being in combat, but rather in the sense that they bear the stamp of an otherness that they themselves must render political. The women of the *Republic* relegated difference to a place outside the city — and first of all the difference between themselves and men; but it is with this difference that the women of *Laws* constitute the political. This is a highly singular way of reckoning the same and the other, of somehow waging war within the city. Being in the city, women negotiate what their functions will be in terms of the same and the other, and it is once again the idea of their political bodies that permits this dual presence to be secured (*Laws* VI, 771a–776e). Real time and desire are the two true actors that figure, along with women, in this second act of the *gunaikon drama*. In *Laws* the need for a political presence of women, first set forth in the *Republic*, is assumed as a basis for conceptualizing the possibility of a representation and a desire of the political body of women.

First, time: everything in the discussion in *Laws* serves to make it real. The men who are talking are old, and they talk at great length, often repeating what they said an hour or two before or much earlier in the morning (*Laws* I, 625a–b). They know the force of time in history: initially, the state of the world was perfect, says the Athenian, and the effect of time suggests that the god has been slowly but inexorably withdrawing from his work. But no politics is conceivable outside man's temporal condition, which the succession of generations obliges us to measure. When the gods governed man under the reign of Kronos, there was no time, there were no generations, and there was no politics. The historical condition is not necessarily fatal to the city, however; it does entail change and decadence, but it also makes possible renewal and progress. And then, too, the human race has neither beginning nor end. It has a genuine affinity with temporality and hence cannot escape desiring its own reproduction. Births must therefore be controlled, and women are once again the primary object and the first principle of political regulation (*Laws* VI, 771b–774c). This is where the two fundamental dimensions of political reality come together. Time is the element in which human desire is elaborated. The elaboration of desire feeds on representations and images that constitute the reality of pleasures and pains. Finally, the political presence of women makes it possible to articulate the necessity and efficacy of this elaboration. It is again a function of the female body politic to negotiate the reality of a desire for the city.

The desire of the citizens, essentially linked to temporality, thus depends for its expression on images and representations of otherness. Apparently, this is the price to be paid for the constitution of political affect; it explains why the Athenian at first recommends that public intoxication be required periodically (*Laws* II, 671a–672e). What makes this a political measure, however, is

essentially that it represents an ordeal: citizens must submit to the power of the wine and allow their souls to be assaulted by their most extreme desires before the eyes of their fellows. Such public revels are thus a form of mock combat in which each person must publicly overcome and vanquish his or her desires, i.e., in which each person must come to terms with otherness. All citizens' acts, as well as all acts of the rulers, derive their political meaning from this constant war with the other. The issue is always one of maintaining and preserving otherness — and thus of delineating its place — or, to put it another way, it is to exert oneself, to involve oneself in negotiations with the other, so as to determine oneself in relation to it. This is why public banquets are necessary and why free movement at home and abroad to trade and converse is an important political issue: it is necessary to accept otherness and try to shape it to one's purpose (*Laws* VI, 760a—761d, 762c—765b). All marriage laws, which express the obligation to achieve a desired civic composition and which are so crucial to political life, can be translated back into terms of transfer, installation, and movement. The Athenian does not shrink from giving a general statement of the problem of sexual union: legislation concerning marriage must be laid down, he says, simultaneously with the architecture of the city itself. Both are indeed at the very root of the political, whose first principle they express: the need for composition, the joining of the one with the other.

Women therefore make politics possible to the extent that their presence in the city gives evidence and assurance to the forms of temporality and otherness that are the principle of all political life. Women also represent the necessity of the following challenge, which every city must meet despite the enormous risk involved: to make sure that time and desire, which threaten the political order, become its surest foundations. To make procreation, pleasure, and pain political would make politics the fundamental dimension of all forms of existence, that to which all behavior, all discourse, and all life would owe their legitimacy. This latter possibility no doubt plays upon the whole question of the relations between public and private. If it were conceivable that all private acts could be given a political interpretation, then nothing could challenge the existence of the city (*Laws* VI, 780a—c). The private part of existence is in fact an important form of otherness, which the terms of politics must allow for and at the same time try to shape. Within the city space the portion allotted to private life is first made concrete in the reality of a private place: in an emblematic sense, the gynaeceum is that place apart in which all that is not political is gathered together. But it is not merely an emblem: the gynaeceum is the most commonly cited example of the persistence of private space within the city.

But the gynaeceum is women's space, hence an impediment to the

political constitution. In another sense, however, the political constitution seems to rest entirely on the women's portion. On the one hand women seem to prevent the city from achieving a true political organization, while on the other they represent the only means of impressing the form of political reality upon the city: how are these two aspects of the status of women to be reconciled? This question is most difficult to answer, because it bears upon the reality of a desire which, in this women's politics, would be transferred to the body represented by the city.

When one builds the city, says the Athenian in *Laws*, one is both spectator and spectacle (*Laws* VI, 779d). This is especially true of women, whose presence in the city, as I said earlier, is to a remarkable degree torn in two directions: on the one hand it stands for what is not yet political but must become so, and on the other hand it stands for that which makes the political real. Women certainly occupy a dual role, because they represent the existence of the private sphere and the need to make the private wholly public in order to establish the political realm. In other words, the reality of time and emotion are given a political formulation. The *Republic* tried to show how this might be done, but there the point was to demonstrate the need for a total community of function and status among men and women in order that politics be possible. The ensuing conditions are utopian in the sense that they do not take the reality of history and desire into account. But the *Laws* follows up this analysis by attempting to define just how women are present in the city and hence to represent the transition to politics, not in a chronological sense, but by designating the political institutions upon which the transition from private to public depends.

It stands to reason that these institutions will have something to do with women — women negotiating on their own behalf with the otherness which in part they represent. This may take the form of engaging in gymnastic exercises, in common forms of apprenticeship, and in an education identical to that of men, in order to show that men and women present in the city must be treated in the same way (*Laws* VI, 757a—e; VII, passim; VIII). It may also take the form of marriage laws, which politicize the desire that impels the man who wishes to reproduce himself to enter into union with an other. No man in the city may willfully deprive himself of a woman, says the Athenian, nor of images nor even of what brings gratification through pleasure (*Laws* V, 721a—e). The political condition necessarily includes such gratification; indeed, gratification is instrumental in its definition. But it is up to women to determine the conditions of their presence in the city and the associated imagery. One institution is crucial above all others, the Athenian continues; in this institution there is enacted a scene in which women are the only actors and whose sole purpose is to represent the transition from the private to

the public. This scene also figures in real time: women represent themselves and are themselves desired as images. It hardly needs to be said that this scene, in which the transition from the private to the public is shown in a clear political light, when left to the initiative of women who make use of every means of representation available, is a scene of seduction, which shows seduction as the first political act, an act of public mastery over a private weakness. What is this scene, an institution? In fact it is a warrior's custom that inscribes the power of war as one of the forces of the city. It is also an incredible act: nothing less than a women's banquet in the center of the city.

The women's symposium then, is the touchstone of the city. Ordinarily women live apart, withdrawn from public life and confined to their own private world, as a result of which it is easy to accuse them of secrecy and cunning; now, however, they must come to the center of the city to eat, drink, and speak, together and in the view of all. Fundamentally, it is the same with women as with representations: both are deceitful so long as they remain private, but become legitimate as soon as they become public and produce a political effect. That the banquet scene is possible attests to the reality of a desire directed to the body of women, which confirms the force of the representation, of political reproduction. In a sense it is a celebration of the primordial political act. It belongs to women, who act here as in war. This is what allows the transition from a half city, which is not a city at all, to a double city, which is the only city of political reality. As the Athenian says, this custom is the expression of the only true foundation of politics (*Laws* VI, 780d—781e).

Body, desire, women as the foundation of politics — it is also a tale of war, which brings together the same and the other. Desire and time must both account for their objects: the same or the other. Politics no doubt depends on woman, for the feminine directs desire toward love's first destinations. The need for women is spelled out in a myth, taken from another banquet, the *Symposium*, where it is recounted by Aristophanes. There are two conditions of love. One is narcissistic: the person loves only himself, he is the offspring of the sun, the earth, and the moon, and one may call him, accordingly, man, woman or hermaphrodite. But these terms are not really appropriate, for they only make sense in relation to a difference of which the narcissist takes no notice. The other condition of love is adulterous: love is addressed to another person, another person divided in two as a result of the terrible punishment inflicted by the gods on those who loved only themselves (*Symposium*, 190a—b).

The reality of time and of otherness is linked to the adulterous condition of love and hence to the existence of a sexual world. The three kinds of beings who live in the prior condition of narcissistic love do not yet form three sexes. For they are three complete beings,

who cannot love any but themselves and who bear toward themselves a love that the subsequent tradition would call divine love, to be understood reflexively, as the love that God directs toward his own perfection. Now, God cannot abide any challenge to his privilege of love. His punishment is therefore to cut each of these original beings in two. The main effect of this is to put an end to the narcissistic state in which these creatures have lived. From that point on, desire is separate from its object, and it becomes necessary to seek the former object (the self in a sense, but located within another) outside the self. The possibility of male and female, the very idea of difference (understood in the first instance as sexual difference) begins with this separation. The reality of human love and of time and desire are absolute consequences of this division. And the feminine itself may be thought of as one way of defining the separation of desire and its object. In this sense, any search for another, even if that other is represented as having the same sex as oneself, attests to the presence of otherness and time. For the necessity of the other and the reality of becoming are preconditions for conceiving the human world, the sexual and political world, the world of men and women, of cities and images, the world, finally, that is forced to become more fully conscious of the conditions of its own existence because of woman's political share and presence in this world.

Women are necessary, then, to conceptualize the status of *eros* and to involve humankind in politics. In the mythology of the *Symposium* Plato even goes so far as to attempt a sort of amorous ontology from which the need for women's political presence might be deduced. Above all, if love, subject as it is to time and desire, always seems to be directed toward the other, as the *Symposium* shows, the only way for love to discover its reality and truth is for the one and the other to be united, as in the union of both sexes in the city, for example, without which there is no true politics. Yet in this union otherness must remain present as a condition of thought: this is what the fact that men and women must remain warriors teaches us. Women especially must celebrate, in a banquet and by the act of their political and combative body, the reality of desire and time. Women must prove through war the reality of the other whom they represent. Apart from such a war, women's politics and women's liberation are inconceivable.

And this is precisely the message of the feminist manifesto that was no doubt Plato's last word on the question — in any case it concludes his remarks on women in the *Laws*. Yet to make women the equals of men and to envision the political possibilities raised by such equality — to give women the education and capabilities they need to govern with perfect confidence both the public and private spheres, the household and the state — is not possible unless they are

also given access to all the resources of war. Only on that condition do they enter into the political, as a force of otherness.

To say this openly will no doubt provoke laughter in cetain quarters. Socrates in the *Republic* and the Athenian in the *Laws* expect nothing else by way of response, not even criticism or refutation. Laughter, sarcasm, or silence is all they look forward to as soon as they speak of political women, of women's bodies in the city, and above all of women of war (*Republic* VI, 452b—e; Laws VI, 780c—d). Socrates and the Athenian have nothing more to say: they simply repeat what they have already said. People are going to laugh at the idea of women in the city and at war, but in fact it will be politics that they laugh at, and also at the human condition, which bears the stamps of time, desire, fear, and the search for the other. And perhaps anyone who can laugh at the human condition is not yet a man.

REREADING AS A WOMAN:
THE BODY IN PRACTICE

NANCY K. MILLER

"Would it not stand to reason that men and women read differently, that there must be a fundamental disparity between what they bring to, do to, demand from and write about texts? And if we do read differently, is it not necessary to figure out how and where we do so? To what extent is the 'body of scholarship' on any given author really *two* bodies?" These questions, formulated by Susan Winnett as the rationale for a special session at MLA (1983) called "Reading and Sexual Difference," are the pre-text and context of what follows.[1] I have chosen to address the question of sexual difference literally (to the letter, as it will emerge), taking its terms, for the purposes of argument, as a question of identity tied to a material body circumscribed by and in the *practice* of reading and writing.

Feminists have no sense of humor, as Wayne Booth has shown.

In a celebrated moment at a symposium organized by *Critical Inquiry* in 1981 on the "Politics of Interpretation," Wayne Booth, then President of MLA, came out as a male feminist; or at least, as an admitted "academic liberal," embraced the "feminist challenge" to *reread*, recognizing what "many feminist critics have been saying all along: our various canons have been established by men, reading

1. The plan for the session paired a man and a woman reader with a single text. Peter Brooks and I worked, though not together, not reading each other beforehand, on *Les Liaisons Dangereuses*; J. Hillis Miller and Julie Rivkin, on *The Egoist* (both novels considered by some to be written by male feminists). The first part of my title picks up on the section in Jonathan Culler's *On Deconstruction* (1982:43-63), entitled "Reading as a Woman." The second part of my title seeks to re-ground to strategic ends the "*hypothesis* of a female reader" (p. 50) that Culler importantly foregrounds to situate feminist criticism in the contemporary critical landscape. (The hypothesis, minus the emphasis, is originally Elaine Showalter's.)

books written mostly for men, with *women as eavesdroppers*" (1982:74; emphasis added). Taking Rabelais as the authorial example to illustrate his point, Booth addressed the question of ideology and aesthetic response; of sexual difference and the pleasure of the text:

> When I read, as a young man, the account of how Panurge got his revenge on the Lady of Paris [as you recall, he punishes the lady for turning him down by sprinkling her gown with the pulverized genitals of a bitch in heat; he then withdraws to watch gleefully the spectacle of the assembled male dogs of Paris pissing on her from head to tow] I was transported with delighted laughter; and when I later read Rabelais aloud to my young wife, as she did the ironing(!), she could easily tell that I expectd her to be as fully transported as I was. Of course she did find a lot of it funny; a great deal of it *is* very funny. But now, reading passages like that, when everything I know about the work as a whole suggests that my earlier response was closer to the spirit of the work itself, I draw back and start thinking rather than laughing, taking a different kind of pleasure with a *somewhat* diminished text (p.68).

Booth's account of his conversion experience is of course important and gratifying for a feminist critic;[2] but what I want to take off from here is not so much his self-conscious rereading *as a man*, as his staging, within the scene of his own discourse of a woman's point of view, his placing of a "voice," however muted, that he finds absent from Rabelais's, and Bakhtin's, dialogics (pp. 61, 65). Mr. Booth does not tell us how he knew what parts his wife did not find funny, or why. But let us guess that listening to this story from a book "written mostly for men," Mrs. Booth felt a bit like an eavesdropper, like a reluctant voyeur called upon to witness a scene of male bonding (a man and his best friends) which excluded her. Or perhaps, as a woman (reader), she put herself, for a moment, in the Lady's place.

To reread as a woman is at least to imagine the lady's place; to imagine while reading the place of a woman's body; to read reminded that her identity is also re-membered in stories of the body.

Like the young Mrs. Booth, the ironing notwithstanding, I too can easily tell when I am supposed to find something funny. I can tell, read to or reading, when I am expected to be transported, as "fully

2. Of Booth's and Culler's recognition of the power of feminist theory to throw canonical assumptions into question, Elaine Showalter comments: "To women who have been writing feminist criticism this phenomenon must be gratifying and unsettling" (1983:131). In many ways I share what I will call Showalter's "anxiety of recuperation," the concern — though we work with different metaphors — that male critics, speaking as men to other men, will recast and reappropriate (perhaps to equalize the codes, we could think of this process as a kind of laundering) the insights of a less glamorous *practice*, like ironing, the better to neutralize, through another sort of canonization, the disruption that feminism promises. But, at the same time, and specifically here in the case of Booth, I note first of all that the irony of the ironing is of course not lost on the rhetorician: "(!)." And perhaps most important, as Carolyn Heilbrun argues in "The Threshold of Gender," the fact remains that, "by testifying... Booth rendered it impossible for teachers of Rabelais to chuckle quite so mindlessly over that passage (there is now a text to refute that laughter)."

transported" as those we might think of as the *dominant responders* (or "dr's") — one's husband, one's teachers, the critics; though clearly I am not nearly so good a sport. So let us turn now to a less "carnivalesque" but equally witty example of the canon; to an epistolary novel of the Enlightenment in which every reader is perforce an eavesdropper, or rather a voyeur reduced to the scopic delights that may be derived from reading someone else's mail.

In letter 47 of *Les Liaisons Dangereuses* the Vicomte de Valmont explains to his correspondent, Mme de Merteuil, that while making love to Emilie, a courtesan, he writes a passionate love letter to Mme de Tourvel — the woman in the novel he is trying to seduce — literally, or so he would have the Marquise believe, *on* Emilie.[3] Writing vividly "to the moment," Valmont codes his "undressed" physical exertions in the rhetoric of "dressed" amorous discourse:[4] "I have scarcely enough command of myself to put my ideas in order. I foresee already that I shall not be able to finish this letter without breaking off," etc. Double meanings follow upon each other like a rigorously expanding metaphor; and the foreseen interruption of the (in)scription occupies (neatly) the blank space between paragraphs. The performance over, Valmont forwards the letter — 48 in the volume — to Merteuil, leaving it open for her to read, seal, and mail (he wants, he says, to have the letter postmarked from Paris). Emilie, the woman as desk, and the first reader of the love letter, Valmont recounts, "a ri comme une folle," she "split her sides laughing." "I hope you will laugh too," Valmont adds, by way of

3. There is, despite the insistence on the physical aspect of the action — producing "a letter written in bed, in the arms, almost, of a trollop" — a peculiar effacement of (the) woman's body in and as representation. It is curious to note that critics do not seem to agree, or rather do not seem to be able to *say* exactly what goes on here. Peter Brooks, in his presentation at MLA, imag[in]ed the letter written on Emilie's "bare backside." Jacques Bourgeacq argues (against "the literary tradition that limits Emilie's role in the composition of the letter to the use of her back") that Emilie actively participates in the action; that the "action external to the letter" as he euphemizes it, "organizes the text itself" (1980:185-86; my translation). Thomas Fries, reading deconstructively the modeling of sexual difference in the novel, seems to assimilate the ambiguity implicit in the positioning of the woman's body to the general problematics of the novel, to the "figurality of language and more precisely in the figure Latin rhetoric calls *dissimulatio*" (1976:1308). For him this ambiguous manipulation of knowledge is the source of the pleasure of the text; he cites "one of the supposedly most scandalous passages of this book, the famous letter *written from and on some lower part of Emilie's back*," as a typical example (p. 1309, emphasis mine). The blockage of mimesis is, I think, tied to the narrative framing. By the use of a figure which is either periphrasis, or catachresis, or both — "in the arms, almost" — interpretation is both forced and inhibited. Paradoxically, this "undecidability" does not interfere with the reading effect which derives from the reading *process*, from the semiosis: one knows that a woman's body is being enlisted in a male production of language.

4. I allude to and play with the distinctions in letter writing styles established in Altman (1978).

preparing Merteuil's response to his text and its context: his one-man show.

Readers, on the whole, have responded to the optative and been amused. In an essay entitled, "The Witticisms of M. de Valmont," a critic observes:

> Doubtless many readers will find this instance of Valmont's sense of humor particularly intolerable, and will rebel at this display of poor taste. To them this long series of double meanings will not endear the Vicomte, nor make him in any way more charming. But *willy-nilly*, as they read this letter, *they will become a party in his conspiracy*, for the simple reason that they will understand the hidden though transparent meaning of the letter, to which the addressee, Mme de Tourvel, cannot but remain blind. Moreover, these morally inclined readers who, to be sure, will condemn Valmont on elementary grounds of decency, *will also have to appreciate*, on a *strictly intellectual or even perhaps esthetic level*, Valmont's remarkable though devilish intelligence and his enviable mastery of stylistic devices (May 1963:182—183; emphasis mine).

This model of double reading, which opposes the "morally inclined" to the "strictly intellectual or even perhaps esthetic," and valorizes the victory of the latter position — since it implies a narcissistic alliance between two hegemonic modes ("enviable mastery") — describes very nicely the plight of the feminist critic of whom it is regularly said, as Booth imagines it will be said of him: "I've lost my sense of humor or I don't know how to read 'aesthetically'" (p. 68).

In a more recent work on Laclos, the double reading becomes triple and the aesthetic grounds, hermeneutic. The critic, glossing letter 48 and in particular the coding of scriptus interruptus — "I must leave you for a moment to calm an excitement which mounts with every moment, and which is fast becoming more than I can control" — concludes: "This is a blatant example of *double entendre*, amusing and well done; it demands a rereading, and maybe even a third reading, at first to laugh, and then to wonder" (Rosbottom, 1978:108).

The third reading then wonders about the transmission of information in the novel, the ways in which the novel insists upon "the process of signifying," and takes as its subject, "how things mean" (p. 109). But it might also wonder whether it is really the perception of the double register in itself — "the very table on which I write, never before put to such a use, has become in my eyes an altar consecrated to love" — that compels complicity. It seems, rather, that the appeal of the letter derives from a masculine identificatory admiration for Valmont's ability to do (these particular) two things at once. This is of course not to deny that to conjoin in representation activities not normally conjoined is textually arresting — like that of Aesop's master, who, to save time, pissed as he walked, as Montaigne relates in "Of Experience", or, *a contrario*, Gerry Ford, of whom it was said, in the cleaned up version, that he could not

walk down the street and chew gum at the same time. But I do want
to insist (at the same time) on the specific, almost textbook
phallogocentric reference (referents) of Valmont's conjunction.[5]

Let us move now from the ways in which sexual difference can be
said to structure the scene of production, the actual production of
reading material, to the scene of reception, the reading of the letter,
and the glossing of its text.

We should recall that the dominant trope of the act of novel-
reading in the eighteenth century is the figure, or allegory, perhaps
even the fact, of the *lectrice*, the woman reader reading. *Les Liaisons*
provides us both with the standard model, Mme de Tourvel — the
beleaguered heroine in a story she does not understand, reading, as
fortification against the plotting hero, volume two of *Christian
Thoughts* and volume one of *Clarissa*; and the model ironized, Mme
de Merteuil. The super woman reader who would be (male) author
(early in the novel she proposes to write Valmont's memoirs in his
place), the marquise instead *re*reads from Crébillon, Rousseau and La
Fontaine to prepare for her part in the fiction she embodies but
cannot represent in letters; or rather, which she at the end re-presents
as truth at the cost of disfiguration.

The tropology of the woman reader reading is also evoked in the
novel's frame as the Editor rehearses his "anxiety of authorship"
with a particular emphasis on the reception of the work by a female
readership.[6] Thus in his prefatory moves, the Editor invokes the

5. A conjunction, and therefore sexualization, that, as I will argue, dangerously privileges
the letter writer over the letter reader; and conflates predictably, virility and authority: "the
juxtaposition of the lover's desire for sexual gratification and the writer's penetration into
his subject is too strong to be overlooked" (Fries, 1976:1309). And Michel Butor, enlisted
by Fries, supplies a depressing and acute parenthesis on the subject of the lover as writer
(1964:50): "what is most surprising in Valmont's famous letter to the Présidente written by
using Emilie as a desk, is not that he interrupted it to 'commit a downright infidelity,' it's
the transformation of the woman into a desk, into a means of writing to another [woman];
it's that in her bed and almost in her arms, he began with the letter, and the infidelity
committed, he had nothing more pressing to do than to start writing again" (my
translation). Male desire, then, originates not in the "arms" of a woman present, but in the
desired absence of the woman to be written to. Would it not be possible to argue that the
effacement of the woman's body in representation is here due precisely to its
transformation into instrumentality? Emilie must remain invisible since her function is
merely and classically to facilitate the exchange of women and/or signs.
6. I am playing here with the phrase Sandra Gilbert and Susan Gubar have constructed —
against Harold Bloom's model of a male "anxiety of influence" — to account for the
psychological posture of the female artist: her "need for sisterly precursors and successors,
her urgent sense of her need for a female audience" (1979:50).
The Editor's anxiety here, despite its parodic valence (a kind of hypocritical
cross-dressing) as an eighteenth-century topos, a conventional dissimulation, like Valmont's
and Merteuil's, of one's access to and manipulation of authenticity, may, I think, usefully be
construed as an *anxiety for female authorization* which in turn veils a desire for recognition
by men of his status as (stand-in for) a penetrating writer, a social theorist rewriting
Rousseau.

sanction of a "real" woman reader to authorize his publication: a good mother, who, having read the correspondence in manuscript, declares her intention (in direct quotes) to give her daughter the book on her wedding day. This singular "already read" fantasized wishfully as a collective imprimatur — "if mothers in every family thought like this I should never cease to congratulate myself for having published it" — consoles the Editor for the more limited readership he "realistically" imagines for this collection.

Like Emilie, the bad daughter (*la fille*), the first woman reader, the good mother, has a sense of humor, even wit: *de l'esprit*. But are they reading as women? Put another way, what would it mean to place oneself, to find one's place as a woman reader within a phallic economy that doubly derives female identity through the interdigitated productions of the penis and the pen. Thus, on the one hand, the body-letter receives the sperm-words, she is the master's piece, the masterpiece;[7] and on the other, she figures as metaphorical "woman," disembodied because interchangeable: I hope you will laugh too.[8]

If we follow out the privileged hermeneutic chain, Emilie, Merteuil, me, you (all of us narratees doubled into whores by the act of reading itself), it seems fair to claim that the female reader of this novel is expected to identify with the site/sight, topographical and visual, of her figured complicity — like that of the classical *lectrice*, Mme de Tourvel — within the dominant order. Tourvel is the "immasculated" reader, who is "taught to... identify with a male point of view... Intellectually male, sexually female, one is in effect no one, no where, immasculated" (Fetterley, 1978: xx, xxii). What is it possible for a woman to read in these conditions of effacement and estrangement; in a universe, to return to our previous discussion, where the rules of aesthetic reception and indeed of the hermeneutic act itself are mapped onto a phallomorphic regime of production?

7. In " 'The Blank Page' and the Issues of Female Creativity," Susan Gubar summarizes the history of this figuration: "This model of the pen-penis writing on the virgin-page participates in a long tradition identifying the author as a male who is primary and the female as his passive creation — a secondary object lacking autonomy, endowed with often contradictory meaning but denied intentionality" (1981:247). It is interesting to note that for "virgin" we can here substitute "whore" and leave the meaning of the argument intact. (Though one might also want to read a desire for the virgin in Valmont's hieratic acrobatics: "the very table on which I write, *never before put to such use*, has become in my eyes an altar consecrated to love.")

8. Jean Biou, in "Une lettre au-dessus de tout soupçon," underscores the oppressive power of this representation: "Letter XLVII supplies in effect an imaginary scenario founded on two opposed but not contradictory principles: on the one hand, the division of women — in the double sense of the division of labor and the breakdown of a potential solidarity — on the other, the unique employment of women, sexual employment" (1983:197; my translation).

The third reading I evoked earlier might not so much ponder the (im)possibility of fixing meaning, or admire the text's "modernity," as interrogate the particular kind of phallic modeling that attaches itself to the very process of encoding and decoding, or vice versa. A third reading might wish instead to reevaluate the reciprocities of sexual and scriptional practices, and rethink a metaphorics of writing and reading that figures, and at the same time paradoxically *grounds*, "woman" as material support for a masculine self-celebration; a metaphorics that specularizes *double entendre* — which we might freely understand as the trope of interpretation itself — as the couple man/woman (man over woman) and fetishizes the superscription of the masculine. (This might also be thought of as a working definition of the canon.)

But even a third reading produces for me not only a "*somewhat diminished text*," and a "different kind of pleasure," to return to Wayne Booth's formulation but finally an acute desire to read something else altogether and to read *for* something else.

In closing, therefore, I want to evoke another (almost) eighteenth-century author, and another — for me more congenial — staging of the scene of reading, writing, and sexual difference. I am referring to the famous moment in Jane Austen's last novel, *Persuasion*, when Captain Wentworth drops his pen. "While supposed to be writing only to Captain Benwick," (p. 239) and while eavesdropping on a conversation between his friend Captain Harville and the heroine Anne Elliot about men's and women's inconstancy and constancy, Captain Wentworth, in a room full of people, writes a love letter.

The pen falls as Anne sets forth what we have come to call the sex/gender arrangements of our culture: the division of labor that grants men, among other things, the professions, and women, the private world of feelings. Here a woman figuratively picks up the pen, as Austen's heroine decorously but specifically protests against that troping of the spheres, against the penmanship of the hegemonic culture: "men have had every advantage of us in telling their own story. The pen has been in their hands. I will not allow books to prove anything." The "histories" from which one quotes to prove one's point were all, as Captain Harville is quick to grant, written by men. In *Persuasion*, which recycles the epistolary and retrieves its earlier (more Rousseauian) desire for the proper destination, Wentworth delivers his letter by hand its "direction hardly legible, to 'Miss A.E.—.' "[9] And we read *with* her: "While supposed to be writing only to Captain Benwick, he had been also addressing her!" (p. 239).

9. I am indebted here to Nancy Nystul, a doctoral candidate in the Department of English and Comparative Literature at Columbia University, for her critical insights about Austen's revisionist incorporation of older literary modes.

To miss this letter is to run the risk of believing that the pen is nothing but a metaphorical penis, even though we know, as we stand here ironing, that that has never been entirely true.[10] For if Valmont writes to (and on) women in order, ultimately to be read by men — other libertines, literary critics, etc. (women are, we know, always and merely the cover and site of exchange for this founding homosocial contract)[11] — then Wentworth, "at work in the common sitting room," as Gilbert and Gubar have persuasively imagined him, "alert for inauspicious interruptions, using his other letter as a kind of blotter to camouflage his designs," much like "Austen herself" (1979, 179)—, writes, I would argue, *as a woman* to a woman in order to be read by women.[12] (Paradoxically, this shift in *address* is made possible by the historical development of the female readership in the eighteenth century, whose authorization, we saw, the Editor of *Les Liaisons* anxiously and ironically hypothesized in his preface.) By having Captain Wentworth both drop his pen because of the sound of a woman's voice, and write a love letter in dialogue with the claims of her discourse, Austen, I think, operates a powerful revision of the standard account: she puts the pen in the hand of a man who, unlike Valmont (or Lovelace) wishes to have his feelings for the other "penetrated" (p. 240). This wish for transparence, however nostalgic, may be said to deconstruct the familiar logic of the body as parts, and by that move writes the possibility of a body beyond parts; a body, therefore, through which the stories of sexual difference would have to be figured otherwise.

10. I would like to thank Carolyn Heilbrun, who remembered it for me. In their ground-breaking work on women writers, Gilbert and Gubar have forcefully documented the power of this account of literary paternity, the damage it has done to the female imagination (1979, 1981). My argument operates here at an angle to their poetics, with the emphasis falling on the metonymic, or literal valences of the penis as pen, on the one hand, and the pen as metaphor beyond the phallus on the other.

11. I allude here to Eve Kosofsky Sedgwick's refinement of the concept of male bonding that makes it possible, through the use of the term "homosocial," to understand the continuum of social and genital arrangements that structure male power relations in Western culture (Sedgwick, forthcoming).

12. This portrait of the male artist in love perhaps rewrites, by feminizing, an earlier, more virile dropping of the pen. I am thinking of the prelude to the celebrated scene in *Clarissa* in which Lovelace, "writing on" to his friend Belford, is surprised at 5 o'clock in the morning by a fire alarm: "My pen (its last scrawl a benediction on my beloved) dropped from my fingers" (Letter CXXVI, Vol. II, p. 500). This pretext allows Lovelace to penetrate into Clarissa's room to encircle "the almost disrobed body of the loveliest of her sex." Clarissa picks up a "pair of sharp-pointed scissors" to prepare a Portia-like defense. These are the classical penetrations of Western culture.

REFERENCES

Altman, Janet, 1978. "Addressed and Undressed Language in *Les Liaisons Dangereuses*", in: *Laclos: Critical Approaches to Les Liaisons Dangereuses* (Madrid: Studia Humanitatis), 223-258.

Austen, Jane, 1975 (1818). *Persuasion* (Harmondsworth, Middlesex: Penguin).

Biou, Jean, 1983. "Une lettre au-dessus de tout soupçon," in: *Laclos et le libertinage: 1782-1982, Actes du Colloque du Bicentenaire des Liaisons Dangereuses* (Paris: Presses Universitaires de France).

Booth, Wayne, 1982. "Freedom of Interpretation: Bakhtin and the Challenge of Feminist Criticism,"*Critical Inquiry* 9:1 (September 1982), 45-76.

Bourgeacq, Jacques. "A partir de la lettre XLVIII des *Liaisons Dangereuses*: Analyse stylistique," *Studies in Voltaire and the Eighteenth Century*, 183, 177-188.

Butor, Michel, 1964. *Répertoire II* (Paris: Minuit).

Culler, Jonathan, 1982. *On Deconstruction: Theory and Criticism after Structuralism* (Ithaca: Cornell UP).

Fetterley, Judith, 1978. *The Resisting Reader: A Feminist Approach to American Fiction* (Bloomington: Indiana UP).

Fries, Thomas, 1976. "The Impossible Object: The Feminine, The Narrative (Laclos's *Liaisons Dangereuses* and Kleist's *Marquise von O...*), *MLN* 91:6, 1296-1326.

Gilbert, Sandra, and Susan Gubar, 1979. *The Madwoman in the Attic: The Woman Writer and the Nineteenth-Century Literary Imagination* (New Haven and London: Yale UP).

Gubar, Susan, 1981. " 'The Blank Page' and the Issues of Female Creativity," *Critical Inquiry* 8:2 (Winter 1981), 243-264.

Heilbrun, Carolyn G., 1984. "The Threshold of Gender" (ms.).

Laclos, Choderlos de, 1951 (1782). *Les Liaisons Dangereuses* (Paris: Gallimard).

1977 (1782). *Les Liaisons Dangereuses*, trans. P.W.K. Stone (Harmondsworth, Middlesex: Penguin).

May, Georges, 1963. "The Witticisms of Monsieur de Valmont," *L'Esprit Créateur* 3:4, 181-187.

Nystul, Nancy, 1984. "The Rhetoric of *Persuasion*," *Textual Realisms: Four Studies of the Nineteenth-Century Novel* (diss).

Richardson, Samuel, 1968 (1747-48). *Clarissa, Or The History of a Young Lady* (London, New York: Dent, Dutton).

Rosbottom, Ronald, 1979. *Choderlos de Laclos* (Boston: Twayne).

Sedgwick, Eve Kosofsky, forthcoming. *Between Men: English Literature and Male Homosocial Desire* (New York, Columbia UP).

Showalter, Elaine, 1983. "Critical Cross-Dressing: Male Feminists and The Woman of the Year," *Raritan* 3:2 (Fall 1983), 130-149.

FEMALE FETISHISM:
THE CASE OF GEORGE SAND

NAOMI SCHOR

In this age of feminism and poststructuralism I shall surprise no one
by asserting that theory has a body and that that body like all bodies
is sexed. The widespread use of the epithet "phallocentric" to
qualify conceptual systems which place the phallus and the values it
represents in a hegemonic position implicitly recognizes that sexual
morphology informs the most apparently disembodied theories. In
the past few years I have begun to explore the ways in which
feminist modes of reading might be grounded in representations of
the female body. My concern is not to counter phallocentrism by
gynocentrism, rather to speculate on the modes of reading that might
be derived from representations of the female body, a sexual body
whose polycenteredness has been repeatedly emphasized by feminist
theoreticians (Irigaray 1977). Specifically I have been concerned
with the appropriation of psychoanalytic concepts (e.g. paranoia in
Schor 1981) to ends for which they were not originally intended. In
what follows I move from a striking representation of the female
body in works by George Sand to the elaboration of a textual
strategy specifically geared to taking this seemingly aberrant
representation into account. Thus the writer's fetishism becomes the
critic's, fetishism on fetishism we might say.

In George Sand's early novel, *Valentine*, there occurs a scene
which bodies forth in lapidary fashion the challenge posed by Sand
to psychoanalytic, and perhaps to all feminist critics. I am referring
to an episode in one of the final chapters, where the constantly
deferred consummation of the adulterous passion of the low-born
Benedict and the aristocratic Valentine is about to take place.
Benedict has surprised Valentine in her oratory at the very moment

when she is renewing her vow to the Madonna not to succumb to her illicit desires. In deference to Valentine's pleas, Benedict respects her vow, but at great cost: his diminished physical resources strained to the breaking point by this final heroic effort at sublimation, he swoons into a death-like trance. Distraught by Benedict's cadaverous appearance, Valentine drags him into her bedroom, that *sanctus sanctorum* into which Benedict had smuggled himself on Valentine's wedding night. There Valentine proceeds to brew him some tea. Thus, in the space of less than a page, the sublime heroine is metamorphosed into a bustling nineteenth-century angel of the hearth, ministering to the needs of an exhausted Byronic hero: "At that moment, the kind-hearted and gentle Valentine became the active, efficient housewife, whose life was devoted to the welfare of others. The panic terror of a passionately loving woman gave place to the sollicitude of devoted affection" (1869:303-304; 1978c:306).[1] It is at this critical juncture, when what is being emphasized is Valentine's sudden dwindling into domesticity, that the passage I want to comment on is located:

> When she brought him the calming beverage which she had prepared for him he rose abruptly and glared at her with such a strange, wild expression that she dropped the cup and stepped back in alarm.
>
> Benedict threw his arms about her and prevented her running away.
>
> "Let me go," she cried "the tea has burned me horribly."
>
> She did, in fact, limp as she walked away. He threw himself on his knees and kissed her tiny foot, which was slightly reddened, through the transparent stocking; then almost swooned again; and Valentine, vanquished by pity, by love, and, above all, by fear, did not again tear herself from his arms when he returned to life (p. 304; p. 306).

What, we cannot fail to ask, is the significance of this unusual foreplay, this pre-coital wounding followed by the eroticization of the injured limb? Freud's essay on fetishism seems to provide the elements of an answer: what we have here is a classical instance of fetishistic eroticism, on the order of Chinese footbinding. The adoration of the previously mutilated foot typifies the fetishist's double attitude to "the question of the castration of women"; whereas the mutilation of the foot corresponds to the recognition, indeed the reinscription of woman's castration, its adoration signals a persistent denial of the same fact.

Now if the masculine signature of the author were backed up by a certifiable male identity — if George Sand were really a man — the enlisting of the fetishistic model in our decoding of this episode

1. All quotations from Sand will be in English, but page references to corresponding French editions will also be provided, and will precede the page references to the translations.

would be relatively unproblematic, except, of course, for those readers who reject the psychoanalytic approach to literature altogether. But George Sand was, as we well know and cannot ignore, a woman. And that fact, I will argue here, complicates the task of the feminist psychoanalytic critic, for it is an article of faith with Freud and Freudians that *fetishism is the male perversion par excellence*. The traditional psychoanalytic literature on the subject states over and over again that there are no female fetishists; female fetishism is, in the rhetoric of psychoanalysis, an oxymoron.[2] If such is the case, the question becomes: what are we to make of an episode imagined by a woman author which so clearly, so prophetically rehearses the gestures of what has come to be known as fetishism? I insist on the word prophetically, for my argument hinges on the fact that Sand is pre-Freudian. The inscription of a scene of fetishism in a novel by a post-Freudian woman author would have a very different resonance.

2. The theoretical consequences of this traditional view are far reaching. For example, Mary Ann Doane demonstrates that the task of theorizing the female spectator is complicated by the female spectator's presumed inability to assume the distancing built in to the male spectator's fetishistic position: "In a sense, the male spectator is destined to be a fetishist, balancing knowledge and belief. The female, on the other hand, must find it extremely difficult, if not impossible, to assume the position of fetishist" (1982:80).

The question of female fetishism — why it does not exist, what its clinical specificity would be if it did — is one that has elicited only sporadic interest in the literature of psychoanalysis. In the remarkably complete bibliography included in the special issue on Perversion of the *Revue Française dei Psychanalyse* (Luissier, 1983), André Lussier lists four references to case studies of female fetishism: 1) G.A. Dudley (1954); 2) Ilse Barande (1962); 3) G. Zavitzianos (1971); 4) G. Bonnet (1977). To this list one should add an article which appears in the same special issue as the bibliography: François Sirois (1983). While all these articles reiterate the rarity of cases of female fetishism, all are case studies of female patients exhibiting sexual perversions on the order of fetishism. The major theoretical stumbling-block for these analysts is the Freudian equation: fetish = maternal penis (see below). Dudley attempts to circumvent this obstacle by dephallusizing the fetish altogether, arguing that the "fetish may... be a substitute for other infantile objects besides the penis" (p. 33). Zavitzianos, on the other hand, concludes that in the case of his female fetishist patient, "the fetish symbolized not the maternal penis (as is the case in male fetishism), but the *penis of the father*" (p. 302). While taking Zavitzianos's hypothesis into account, Bonnet displaces the problem by rereading Freud via Lacan and introducing the crucial Lacanian distinction between *having* and *being* the phallus. For Bonnet, "the female fetish... is inscribed in both the problematics of having and of being" (p. 244). The female fetishist, according to Bonnet, is less concerned with having/not having the penis, than with being/not being the maternal phallus. Ultimately, at least in the case study presented, the female fetishist is more "fetished" (fétichée) than fetishizing. The female fetishist is a woman who responds to her mother's desire by wanting to be her (missing, absent) phallus. This theoretically sophisticated and innovative case study has interesting implications for the case of George Sand because it involves an Oedipal configuration bearing some resemblance to Sand's: an absent father — Sand's father died when she was four years old, the patient's parents were divorced when she was small — and a possessive mother who uses her daughter as a phallic substitute. For an earlier Lacanian approach to the question of female fetishism, see: Piera Aulagnier-Spairani, Jean Clavreul, et al. (1967).

Before going on to review Freud's arguments in favor of the exclusive masculinity of fetishism, I would like to bring into play a passage drawn from another novel by Sand. The benefit to be derived from this superimposition of the scene from *Valentine* on its homologue in *Mauprat* is threefold: first, it lends to our inquiry the urgency inherent in a recurrent scenario; second, it serves to make manifest the mobility of the fetish, its aptitude to press into service any wound inflicted on the female body (the fact that the female fetish par excellence in Sand should be a wound is not insignificant, for wounds *per se* are not generally fetishized by men); third, it eliminates any doubt as to the agent of the injury — for in the scene from *Valentine*, the spilling of the tea is not clearly assumed by either of the participants. In *Mauprat*, the wounding takes place in the course of a long conversation between Edmée and Bernard throughout which they are separated — *more* Pyramus and Thisbe — by the wall of Edmée's chapel. Once again we find the female protagonist sheltered from the intrusion of male desire by the protective walls of her religious sanctuary. If, as Nancy Miller has shown, the pavilion in *Valentine* — but also in *La Princesse de Clèves*, perhaps the paradigmatic novel of female fetishism — is the u-topic locus of "ideality and sublimation" (Miller 1983:137), the oratory — a female space *within* the patriarchal château walls — figures a liminal space where the struggle between male desire and female sublimation is played out. In this instance the inside/outside barrier is breached by the female character, as Edmée reaches her hand through the barred window of her chapel to touch the unsuspecting Bernard, who stands sobbing against the wall. At one point in their interminable dialogue, Bernard reverts back to his earlier wild child behavior and tries to force Edmée to kiss him:

...Edmée, I order you to kiss me."

"Let go, Bernard!" she cried, "you are breaking my arm. Look, you have scraped it against the bars."

"Why have you intrenched yourself against me?" I said, putting my lips to the little scratch I had made on her arm (1969:127; 1977:141).

Lest we imagine that Bernard is simply kissing the scratch to make it well, further on in the novel the erotic charge of the wound, here bound up by a small piece of cloth which assumes the function of fetish by metonymy — metonymy on metonymy — is made quite clear.

At that period it was the fashion for women to have their arms half bare at all times. On one of Edmée's I noticed a little strip of court-plaster that made my heart beat. It was the slight scratch I had caused against the bars of the chapel window. I gently lifted the lace which fell over her elbow, and, emboldened by her drowsiness, pressed my lips to the darling wound (p. 36; p. 154).

If, as I noted above, the author of this scene were male, we could satisfy ourselves with the assumption that the male character somehow bodies forth male fantasies of wounding and reparation, male recognition and denial of woman's castration, ultimately male horror of female genitalia. The "darling wound" would then appear as the "*stigma indelebile*," in Freud's words, of the "aversion, which is never absent in any fetishist, to the real female genitalia" (Freud 1953-74, 23, 154). In short, if the author of *Valentine* and *Mauprat* were a man, that is so classified in the symbolic order, we would describe him as a text-book case of fetishism, before the letter.

How does Freud go about masculinizing fetishism? To begin with, as Freud states in the opening sentence of "Fetishism," his analysis is based exclusively on the case histories of *male* patients: "In the last few years I have had an opportunity of studying analytically a number of men whose object-choice was dominated by a fetish" (p. 152). One might justifiably remark that this statement does not preclude the existence of women whose object-choice would be similarly ordained. When, however, Freud goes on to explain the meaning and the significance of the fetish — it is a "penis-substitute" — the masculinity of this perverse object-choice becomes explicit: "To put it more plainly: the fetish is a substitute for the woman's (the mother's) penis the little boy once believed in and — for reasons familiar to us — does not want to give up" (pp. 152-153). It is finally in these "familiar reasons" for the little boy's unshakeable belief in the maternal phallus that the masculinity of the fetish is grounded, as Freud's reconstruction of the primal scene of fetishism shows: "What happened, therefore, was that the boy refused to take cognizance of the fact of his having perceived that a woman does not possess a penis. No, that could not be true: for, if a woman had been castrated, then his own possession of a penis was in danger; and against that there rose in rebellion the portion of his narcissism which Nature has, as a precaution, attached to that particular organ" (p. 153). The implied threat to his bodily integrity represented by the woman's lack of a penis powerfully motivates the little boy to deny his perception. It is the fact that he has, so to speak, something to lose that makes the little boy so vulnerable to the fear of castration.

Now what of the little girl, she who is, in Freudian terms, always already castrated, thus impervious to all threats of castration? How does she respond to the evidence of sexual difference, which entails or presupposes her inferiority? A careful reading of Freud's writings on female sexual development strongly suggests that many little and big girls are engaged in a rebellion against the "fact" of castration every bit as energetic as the fetishist's. Indeed, if one takes as one of the hallmarks of fetishism the split in the ego (*Ichspaltung*) to which the fetish bears testimony, then it becomes possible to speak, as does

Sarah Kofman in *L'Enigme de la femme* (1980), of female fetishism, for the little girl's ego can be split along the very same fault lines as the little boy's. Denial is not a male prerogative, as is proven by the behavior of those women who suffer from what Freud calls a "masculinity complex":

> Or again, a process may set in which might be described as a "denial," a process which in the mental life of children seems neither uncommon nor very dangerous but which in an adult would mean the beginning of a psychosis. Thus a girl may refuse to accept the fact of being castrated, may harden herself in the conviction that she *does* possess a penis and may subsequently be compelled to behave as though she were a man. (Freud 1963:188).

Sand's Lélia might provide an apt literary instance of such a viriloid woman, not so much because she appears at the ball in male travesty, but because she has adopted the costume of the dandy, and the female dandy is an oxymoron on the same order as the female fetishist. In Baudelaire's words: "Woman is the opposite of the dandy" (Baudelaire 1961:1972). Encased in the dandy's hard protective shell of impassivity, as cold and as chiseled as a classical marble statue, Lélia is an eminently phallic figure. Thus it should come as no surprise that in the remarkably complex scene by the side of the stream in which Lélia and her sister Pulchérie are precipitated from sameness into the alterity of sexual difference, Lélia is cast as a man, and, further, her masculine sexual attributes promoted as representing an aesthetic ideal:

> "I even remember something you said, which I couldn't explain to myself," replied Lélia. "You made me lean over the water, and you said, 'Look at yourself. See how beautiful you are.' I replied that I was less so than you. 'Oh, but you are much more beautiful,' you said. 'You look like a man.' " (1960:158; 1978:103-104).

But there is more to fetishism than the splitting of the ego, more to female fetishism than the masculinity complex, more to Sand than the male impersonation which has garnered such a disproportionate share of attention. Sarah Kofman, who is the leading — not to say the only — theoretician of female fetishism, has recently argued that what is pertinent to women in fetishism is the paradigm of undecidability that it offers. By appropriating the fetishist's oscillation between denial and recognition of castration, women can effectively counter any move to reduce their bisexuality to a single one of its poles. In Kofman's Derridean reading of Freud,[3] female fetishism is

3. On the relationship between Derridean undecidability and (female) fetishism see Kofman (1981:83-116). The very first question to arise during the discussion that follows Kofman's presentation is: "Does the generalized fetishism of *Glas* allow a female fetishism?" to which Kofman responds: "A generalized fetishism, defined as a generalized oscillation, does not exclude a female fetishism, since it implies the generalization of the feminine and the end of the privileging of the phallus, which ceases to be a fetish" (p. 112).

not so much, if at all, a perversion, rather a *strategy* designed to turn the so-called "riddle of femininity" to women's account.

Feminists have been quick to seize on the *political* benefits to be derived from this strategy; in a review article published in the most recent feminist issue of *Diacritics*, Elizabeth L. Berg writes: "In *L'Enigme de la femme* Kofman gives us a theoretical framework for reconciling two tendencies of feminism which have tended to remain in apparently irremediable contradiction: the claim for equal rights and the claim for acknowledgment of sexual difference" (Berg 1982:13). But the feminization of fetishism has important implications for *textual strategies* as well. Indeed, if the recent special feminist issues of both *Diacritics* and *Critical Inquiry* can be taken as symptomatic of the current discursive moment, then fetishism can be said to pervade the critical debate of both Franco-American and Anglo-American feminists of the early eighties. Refusing to opt for either of the exemplary positions argued in the *Diacritics* issue by Peggy Kamuf and Nancy Miller,[4] the "transatlantic" (Jardine 1981) feminist literary critic finds herself saying something on the order of Octave Mannoni's legendary fetishist: "Je sais bien, mais quand même." Anglo-American critical fetishism, on the other hand, is coded in Gestalt-like terms. As Elaine Showalter writes: "woman's fiction can be read as a double-voiced discourse, containing a 'dominant' and a 'muted' story, what Gilbert and Gubar call a 'palimpsest.' I have described it elsewhere as an object/field problem in which we must keep two oscillating texts simultaneously in view" (Showalter 1981:204). In short, to borrow E. H. Gombrich's celebrated example of a perceptual aporia, the female fetishist critic somehow accommodates her vision so as to see both the rabbit and the duck at the same time.

To read Sand's recurrent scenes of fetishistic eroticism in the perspective of female fetishism is to give full play to what I will call for lack of a less awkward term, her insistent and troubling *bisextuality*. The wounds inflicted on the female protagonist's body as a prelude to her sexual initiation are the stigmata neither of a turning away from femininity, nor even of a feminist protest against woman's condition under patriarchy, but rather of a refusal firmly to anchor woman — but also man — on either side of the axis of castration. In Sand's texts this perverse oscillation takes the form of a breakdown of characterization which is quite possibly Sand's most radical gesture as a writer. Just as her episodic adoption of male dress threatened the structuring difference of bourgeois society, her occasional rejection of firm boundaries between characters subverts the fiction of individuation that is the bedrock of conventional realism. Nowhere is Sand's bisextuality more prominent than in *Lélia*

4. See Peggy Kamuf (1982:42-47) and Nancy Miller (1982:48-53).

where, as Eileen Boyd Sivert has noted, there is a remarkable "slippage of personality" (Sivert 1981:59)[5] between the characters, whose identities are so unstable as to be in constant danger of an uncanny coalescence. *Lélia* is, of course, an experimental work situated at the outermost limits of nineteenth-century French fiction, yet the breakdown of individuation which it bodies forth is at work to some degree in much of Sand's major fiction, notably in her manipulation of doubles. Indeed, I would suggest that ultimately *female travesty*, in the sense of women dressing up as or impersonating other women, constitutes by far the most disruptive form of bisextuality: for, whereas there is a long, venerable tradition of naturalized intersexual travesty in fiction, drama, and opera, the exchange of *female* identities, the blurring of ˙difference *within* difference remains a largely marginal and unfamiliar phenomenon. Now what we might call the first generation of feminist Sand critics argued that female doubling in Sand corresponds to her failure to imagine female desiring subjects: what we have instead, the argument goes, is a traditional masculinist split representation of woman, yet another mother/whore figure who can only be synthesized in the eyes of a desiring male beholder, such as Raymon in *Indiana*.[6] While generally in agreement with this feminist critique of Sand's representation of woman, I would argue that the striking commutativity of Sand's female doubles — Noun and Indiana, Lélia and Pulchérie, but also Louise and Valentine — causes male desire to misfire at the same time as it perpetuates the myth of the exclusive masculinity of libido. When, in a hallucinatory scene in *Indiana*, a drunken Raymon imagines that through the servant Noun travestied as her mistress he is making love to the inaccessible Indiana, he experiences bliss, but when, in an uncanny repetition of that scene after Noun's suicide, Indiana entices Raymon with a luxuriant mass of hair shorn from the drowned woman's scalp, Raymon's love for Indiana precipitously and definitively dies, and he exclaims: "You have inflicted a horrible wound on me" (1862:95-96; 1978a:164).

5. This slippage might usefully be compared to the "ontological slipperiness" Leo Bersani sees at work in Emily Bronte's *Wuthering Heights* and Lautréamont's *Les Chants de Maldoror* (Bersani 1967:198). Bersani makes no distinction between male-authored and female-authored fictions of "depersonalized desire": nevertheless, the question of the *femininity of undifferentiated characterization* must be raised if only because of the work carried out by such theoreticians of the object-relations school as Nancy Chodorow, who asserts that "separation and individuation remain particularly female developmental issues," rooted in women's mothering (Chodorow, 1978:110). The difficult question then becomes: how does one articulate the bisextuality of female fetishism and the metamorphoses of the "deconstructed self" on the one hand, and the perverse oscillation of female fetishism and the indissolubility of the mother/daughter dyad on the other?

6. The interpretation I am alluding to here is the one elaborated by Leslie Rabine (1976:2-17), according to whom the pure Indiana and the fallen Noun are complementary figures.

In closing I must give voice to a persistent doubt that nags at me as I attempt to think through the notion of female fetishism. What if the appropriation of fetishism — a sort of "perversion-theft," if you will — were in fact only the latest and most subtle form of "penis-envy"? At the very least a certain unease resulting from the continued use of the term fetishism, with its constellation of misogynistic connotations, must be acknowledged. What we have here is an instance of "paleonymy," the use of an old word for a new concept. To forge a new word adequate to the notion of female fetishism, what we need now is what Barthes called a "logothète" (Barthes 1971:7),[7] an inventor of a new language.

7. Barthes describes his book as: "le livre des Logothètes, des fondateurs de langues" (p. 7).

REFERENCES

Aulagnier-Spairani, Piera, Jean Clavreul, et al., 1967. *Le Désir et la Perversion* (Paris: Seuil).

Barande, Ilse, 1962. "Pérette et son 'gai'," (d'un cas de phobie d'impulsion et de comportement fétichiste chez une femme). Mémoire de candidature au titre de Membre adhérent à la Société Psychanalytique de Paris.

Barthes, Roland, 1971. *Sade/Fourier/Loyola* (Paris: Seuil, coll. Points).

Baudelaire, Charles, 1961. *Oeuvres complètes* (Paris: Bibliothèque de la Pléiade).

Berg, Elizabeth, 1982. "The Third Woman," *Diacritics* 12, 11–20.

Bersani, Leo, 1976. *A Future for Astyanax: Character and Desire in Literature* (Boston: Little, Brown and Co.).

Bonnet, G., 1977. "Fétichisme et exhibitionnisme chez un sujet féminin," *Psychanalyse à l'université* 2, 231–257.

Chodorow, Nancy, 1978. *The Reproduction of Mothering: Psychoanalysis and the Sociology of Gender* (Berkeley: University of California Press).

Doane, Mary Ann, 1982. "Film and the Masquerade: Theorising the Female Spectator," *Screen* 23, 74–87.

Dudley, G.A., 1954. "A Rare Case of Female Fetishism," *International Journal of Sexology* 8, 32–34.

Freud, Sigmund, 1963 (1925). "Some Psychological Consequences of the Anatomical Distinction Between the Sexes," in: Philip Rieff, ed., *Sexuality and the Psychology of Love* (New York: Collier), 183–193.

 1953–1974 (1927). "Fetishism" in: James Strachey, ed., and James Strachey et al., trans., *The Standard Edition of the Complete Psychological Works*, Vol. 21 (London: Hogarth Press), 149–157.

Irigaray, Luce, 1977. *Ce sexe qui n'en est pas un* (Paris: Editions de Minuit).

Jardine, Alice, 1981. "Pre-Texts for the Transatlantic Feminist," *Yale French Studies* 62, 220–236.

Kamuf, Peggy, 1982. "Replacing Feminist Criticism," *Diacritics* 12, 42–47.

Kofman, Sarah, 1980. *L'énigme de la femme: La Femme dans les textes de Freud* (Paris: Galilée).

 1981 "Ca cloche," in: Philippe Lavoue-Labarthe and Jean-Luc Nancy, eds., *Les Fins de l'homme: A partir de Jacques Derrida* (Paris: Galilée), 83–116.

Luissier, André, 1983. "Bibliography," in: *Perversion*, A Special Issue of *Revue Française de Psychanalyse* 47, 132–142.

Miller, Nancy, 1982. "The Text's Heroine," *Diacritics* 12, 48–53.

 1983 "Writing (from) the feminine: George Sand and the Novel of Female Pastoral," in: Carolyn Heilbrun and Margaret Higonnet, eds., *The Representation of Women in*

Fiction: Selected Papers from the English Institute 1981 (Baltimore: The Johns Hopkins UP).

Sand, George, 1962 (1832). *Indiana* (Paris: Michel Lévy).

1869 (1832). *Valentine* (Paris: Michel Lévy).

1960 (1833). *Lélia* (Paris: Garnier).

1969 (1837). *Mauprat* (Paris: Garnier-Flammarion).

1977. *Mauprat,* trans. Stanley Young (Chicago: Academy Press Limited).

1978a. *Indiana,* trans. George Burnham Ives (Chicago: Academy Press Limited).

1978b. *Lélia,* trans. Maria Espinosa (Bloomington: Indiana UP).

1978c. *Valentine,* trans. George Burnham Ives (Chicago: Academy Press Limited).

Schor, Naomi, 1981. "Female Paranoia: The Case for Feminist Psychoanalytic Criticism," *Yale French Studies* 62, 204–219.

Showalter, Elaine, 1981. "Feminist Criticism in the Wilderness," *Critical Inquiry* 8, 179–206.

Sivert, Eileen Boyd, 1981. "Lélia and Feminism," *Yale French Studies* 62, 45–66.

Zavitzianos, G., 1971. "Fetishism and Exhibitionism in the Female and their Relationship to Psychopathology and Kleptomania," *International Journal of Psycho-Analysis* 52, 297–305.

HUYSMANS:
WRITING AGAINST (FEMALE) NATURE

CHARLES BERNHEIMER

In the final chapter of her brilliant new book, *Breaking the Chain: Women, Theory, and French Realist Fiction*, Naomi Schor makes the sweeping claim that "representation in its paradigmatic nineteenth-century form depends on the bondage of woman" (1985:142). This thesis, with which I concur, leads Schor to propose a revision in the familiar canon of nineteenth-century French literature whereby "Villiers de l'Isle-Adam's *L'Eve Future* would displace J.-K. Huysmans's *A Rebours* as the ultimate text of post-realism, for Villiers's futuristic fantasy of a female android is the logical conclusion of a century of fetishization of the female body" (1985: 145–146). I intend to demonstrate here that this proposed displacement is unnecessary in terms of Schor's own thesis. *A Rebours* fetishizes the female body with a violence that is, if anything, greater than that displayed in *L'Eve Future* because the perils entailed by failure are more intensely and vividly imagined both in regard to male sexual identity and to the very possibility of representation. *L'Eve Future*, with its idealizing plot that rejects the inadequate biological woman in favor of an artificial, if finally unintelligible replicant, dramatizes a philosophically sophisticated response to a phantasmatic fear of female sexuality that permeates every aspect of Huysmans's portrayal of the biological world.[1]

Yet a focus on Huysmans's (mis)treatment of women does indeed suggest a necessary revision of traditional literary history: the collapse of the distinction he was himself at pains to establish between naturalism and decadence. In the preface to *A Rebours* written in 1902, eighteen years after the novel's publication, Huysmans explains his reasons for breaking with the naturalist school, of which his own early works had been exemplary, and with

1. For a rigorously deconstructive reading of *L'Eve future*, see Gasché (1983).

Zola, the master whom he had eloquently defended as recently as 1876 in a pamphlet entitled "Emile Zola et *L'Assommoir*." By 1884, he writes, naturalism was turning in circles, having exhausted its stock of observed phenomena and reached a dead end in its artistic method. Nothing new could be expected from this approach, now become predictable, repetitious and sterile. At the time, however, Huysmans did not perceive this situation clearly: "I was vaguely searching to escape from a blind alley where I was suffocating, but I had no well-defined plan and *A Rebours*, which liberated me from a literature without issue, giving me new air, is an entirely unconscious work, imagined without preconceived ideas, without any designs set aside for future use, without anything at all" (1977:60).[2]

Huysmans presents naturalism as a function of deliberate intention, a mode of writing without unconscious depths, exhausted because its material was limited on the one hand to an inventory of surfaces and sensations, and on the other to a reduction of emotions to instinctual appetites. This corresponds remarkably to the picture of naturalism that has prevailed in the traditional histories of literature. Granted, some critics have argued that Zola was above all a creator of myths, but this perception has for the most part caused them to associate his visionary qualities with Romantic tendencies also present, for instance, in Balzac. Only recently have psychoanalytic and feminist interpretations of Zola begun to uncover the obsessive phantasies that pervade and drive his writing.[3] Reading in terms of a phantasmatic scenario, one begins to suspect that Huysmans's "unconscious" project in *A Rebours* was not so much to turn away from naturalism as to revitalize its sources in the unconscious and to find a new language in which he could at once express and control an obsession whose power had been lost in codified literary forms: the obsession with the female sexual body. In what follows I will attempt to trace the operation of an obsessive phantasmatic economy in Huysmans's writing and will briefly demonstrate some of the striking similarities in the ways Zola and Huysmans figure and disfigure the woman's body.

Huysmans's fictions open most transparently onto the stage of the phantasmatic in the many remarkable dream narratives interspersed throughout their representational space. These accounts are, on the one hand, carefully controlled literary structures, whose themes and images derive from and elaborate material already presented in the text, and whose artistic purpose is to give the reader the illusion of actual oneiric experience. On the other hand, these narratives are not simply representations of consciously contrived

2. All translations from the French are my own.
3. See, for example, Borie (1971, 1973), Jennings (1972–1973, 1977) and Schor (1975, 1976).

phantasmatic scenarios but are also products of what one might call a textual unconscious, an unconscious revealed in and through the process of writing, whose compulsive obsessions may be found to influence even those elements of the narrative apparently most invulnerable to unconscious elaboration. Thus the dream texts in Huysmans do not puncture the surface of an otherwise smooth-flowing narrative discourse; rather they reveal the driving force of that discourse and suggest the confused interpenetration of conscious invention and unconscious phantasm in his creative process.[4]

Toward the end of a horrifying nightmare that takes up all of Chapter X of *En Rade* (1887), Jacques Marles sees an incredibly ugly woman sitting on the rim of one of the towers of the church of Saint-Sulpice. Jacques wonders what this foul creature might be, "a sordid trollop who was laughing in a lewd and mocking manner, . . . her nose crushed from the end, her mouth wasted, toothless in front, decayed in back, barred like that of a clown by two streaks of blood. . . . She held out over the square the double bag of her old breasts, the badly closed shutters of her paunch, the wrinkled sacks of her vast thighs, between which was displayed the dry tuft of a filthy seaweed mattress!" (1976:210). Overcoming his initial fear, Jacques manages to identify this grotesque, mutilated, degraded female through a remarkable feat of reasoning: "He succeeded in persuading himself that this tower was a well, a well that rose up in the air instead of sinking into the ground, but indeed a well." This, he says, explains everything, and he concludes: "This abominable whore was [the embodiment of] Truth" (p. 211).

Although in his nightmare Jacques Marles goes on to meditate on the many ways Truth acts as a prostitute (adopting every conceivable posture so as to caress each individual according to his particular lust for certitude), the bizarre reasoning that enabled him to identify this lascivious hag remains unexplained. How does a tower become an inverted well? One might begin to suggest a tentative answer by returning to the dream-event that marks the onset of this final episode of Jacques's dream. He has lost his cane, surely an unambiguous phallic symbol, and feels that "at this precise moment this event took on an enormous importance. He knew in a peremptory way that his life, his entire life, depended on that cane" (p. 207). In the manner of dreams, Jacques subsequently forgets all about his lost cane, but what happens next vividly illustrates the horrifying, life-menacing significance his unconscious attributes to being caneless. The scene seems to stage the birth of a primal phantasy. One wall of the courtyard in which Jacques finds himself is made entirely of glass, behind which is a turbulent mass of water. Slowly

4. For an astute analysis of the function and structure of dream narratives in Huysmans, see Carmignani-Dupont (1981).

a female body emerges into the water, head first, from below the pavement. She seems attractive at first, adolescent, virginal, but then Jacques notices that she is bleeding from wounds in the hips caused by the iron teeth of a huge crane that is lifting her up. She appears to accept her suffering "with a languorous and cruel smile, suggestive of an agonizing pleasure" (p. 208). As Jacques rushes forward to rescue her, he hears the sound of balls falling and realizes that the woman has lost her beautiful blue eyes: "All that remained at their place were two red holes that blazed, like fire-ships, in the green water. And these eyes sprang up again, motionless, then again detached themselves and bounced back. . . . Ah! how frightful were those successions of azure gazes and of sockets bathed in blood! He gasped for breath in front of this creature, splendid as long as she remained intact, hideous as soon as her eyes became unstuck and fell away. This constantly interrupted beauty juxtaposed to the most terrifying ugliness . . . was a horror without name" (p. 209).

The imagery of castration is unmistakable here. Woman lures man with the illusion of her being intact, complete, inviolate. In this state, she invites the male to phantasize that she is no different than he. Indeed, the attributes of the adolescent body emerging from the water (tiny breasts with rigid nipples, a firm torso, a flat stomach, a slightly lifted leg that hides the sexual organs) all suggest a disguised phallic image. However, the attraction of sameness is destroyed with the discovery of woman's gaping wound, the hideously bloody sign of her lack. Moreover, this discovery is not made once and for all. Woman's beauty is constantly interrupted, the eyes repeatedly return to their orbits, then again become unglued. Castration thus measures out the very rhythm of temporality. Translated into spatial terms, this is the truth of the tower that is actually a well in reverse. (In the dream, the young woman, once lifted by the crane onto the tower of Saint-Sulpice, becomes the toothless bloody-mouthed old whore.) Female lack absorbs the male erection into her bottomless pit. Indeed the erection is nothing more than the pit turned inside out.

This turn, whereby the inside shows itself on the outside is, in Huysmans's morbid imagination, an essentially pathological phenomenon. The wound of castrated woman festers and becomes syphilitic. "Everything is syphilis," Des Esseintes observes in *A Rebours*. "And he had the sudden vision of a humanity ceaselessly mined by the virus of ages past" (1977:197). What is inherited from father to son, "the unusable legacy," is the virus that thrives in the female sexual organs and erodes the surface of the skin with pitted wounds and puffed-up chancres. Des Esseintes's nightmare vision of Syphilis personified is accompanied, significantly, by castration imagery. First the woman he is with, whom he is unable to recognize, despite her having been "implanted for a long time already in his

inmost being and in his life" (p. 199), loses her teeth and vainly tries to replace them by thrusting bits of the white stems of clay pipes into the holes in her gums.[5] The figure of Syphilis herself is then vividly imaged as both castrating and castrated. As Des Esseintes approaches this seductive, naked figure with a mixture of horror and fascination, black Amorphophalli (exotic plants the black stalks of which, scarred with gashes, he had compared earlier to "damaged Negro members," p. 194) suddenly spring up on every side and he feels "utter disgust at the sight of these warm, firm stalks twisting and turning between his fingers" (p. 203).

As Freud (1963:212) observes in his essay on Medusa's head, "a multiplication of penis symbols signifies castration" while mitigating its horror by replacing the dreaded absence by a plurality of presences. Paradoxically, woman becomes phallic through the power she derives from her violent mutilation. Once the pullulating male members have disappeared from the stomach of Syphilis — who is also identified as "the Flower" — Des Esseintes is confronted with the horrible truth that haunts his unconscious as it does Jacques Marles's: "He saw the savage Nidularium blossoming between her uplifted thighs, with its swordblades gaping open to expose the bloody depths" (p. 203). Thus the female sexual organs, flowers of evil, are armed with the very instruments of their own laceration.

It is important to see that Huysmans's phantasy here is not simply that woman is castrated, but that her sexuality operates a kind of undecidable mixture of male and female attributes. Huysmans associates this operation with a confusion of animal and vegetable realms. Woman as diseased phallic flower becomes, in the hallucinated imagination of Gilles de Rais (as recreated by Durtal in *Là-Bas*), woman as salacious self-fornicating tree:

> Here the tree appeared to him as an upright living being, with its head down, hidden in the hair of its roots, its legs in the air, spreading them apart then dividing them again into new thighs that open in turn, then become smaller and smaller as they move away from the trunk; there, between these legs, another branch is thrust, in a motionless fornication that repeats itself and diminishes, from twig to twig, up to the top; there again the trunk seems to be a phallus that rises and disappears under a skirt of leaves, or on the contrary that emerges from a green fleece and plunges into the soft belly of the earth (1908:171).[6]

The branches of this tree, whose identification with female sexuality becomes clear when the entire forest is transformed into a night-

5. This dental imagery recalls the memory Des Esseintes evoked earlier of his own mutilation by a brutal doctor who, while pulling out a tooth, seems, on the level of unconscious association, to be simultaneously castrating and raping him. See Carmignani-Dupont (1981: 60–61) and Collomb (1978:84).

6. My attention was drawn to this passage by Jean Decottignies's illuminating discussion of it in his excellent article on *Là-Bas* (1978:78).

marish vision of "female triangles, great V's" (p. 172), these proliferating branches are at once female thighs open to penetration by the phallus, and the phallus itself. Increasing our sense of undecidability, Huysmans suggests furthermore that the tree can be read interchangeably as emerging upwards from the earth or plunging downwards into it. Thus female sexuality, by subverting the stability of gender difference, upsets the order of high and low, active and passive, animal and vegetable. Ultimately it infects the entire biological world with the diseased blood flowing from its gaping wounds. A terrifying vision of organic decomposition and degeneration is the final stage of Gilles de Rais's hallucination:

> On the treetrunks Gilles now sees disturbing polyps, horrible gnarls. He becomes aware of exostoses and ulcers, of deeply-cut wounds, chancrous tubercles, atrocious blights; it is a leprosarium of the earth, a venerial clinic of trees, among which a red hedge suddenly comes into view . . . [whose] falling leaves tinged with crimson make him feel as if he were being soaked in a rain of blood (p. 172).

It is tempting to limit the significance of these repellent images of female sexuality by ascribing them to the idiosyncrasy of Huysmans's peculiar neurotic sensibility. But Huysmans is only taking to its extreme point an obsessive fear of woman's sexual nature that pervades the male novelistic imagination throughout the nineteenth century. While I propose to demonstrate this thesis at length elsewhere, I do want to suggest here the remarkable closeness of Huysmans's phantasies of a morbidly productive feminine sexuality to Zola's equally phantasmatic portrayals of woman's desire in terms of organic inflammation and/or progressive decay.

Nana's decomposing body is the most memorable and best known image in Zola's works of active female sexuality revealed in the immediacy of its morbid physical degeneracy. Zola describes Nana's corpse, "a heap of pus and blood, a shovelful of putrid flesh" (1961: 1485), in such nauseating detail, less because he wants to punish her for her sins against bourgeois morality than because he is driven to expose the phantasmatic origins of her power in his unconscious. As Michel Serres (1975:239–242) has observed, Nana is a virus of epidemic proportions that corrupts everything it touches. The attraction she generates is in the service of the corruption she causes and, ultimately, embodies. Her bisexuality is a crucial element in Zola's portrayal of her corrupt nature. For her sexual contagion infects man and woman alike, decomposing them, making them like her, undoing their difference, until all are absorbed into her putrefying corpse, symbol of the decadence of an entire age and of its phantasmatic obsession.

A less famous passage in Zola that prefigures Huysmans's treatment of female sexuality occurs in *La Curée*. An immense hothouse, teeming with the same kinds of exotic tropical plants with which

Des Esseintes, thirteen years later, will fill up his country retreat, here constitutes the sexually charged environment in which Renée Sacard first imagines, then consumates, incest with her son-in-law. Zola describes the greenhouse as a kind of living organism, female, in heat, exuding sexual fluids and a "penetrating, sensual" (1960: 357) *odor di femmina*. Stimulated by this vertiginous excess that fuses animal and vegetable — the twisted red leaves of the Begonia and the white, pointed leaves of the Caladium seem to the lovers "the rounded forms of hips and knees, sprawled on the ground, subject to the brutality of bloody caresses" (pp. 486–487) — Renée becomes increasingly masculine: "It was above all in the hothouse that Renée was the man" (p. 486). She easily dominates the passive and effete Maxime, "cette fille manquée" (p. 485), through her perverse and voracious sexual energy. Thus she becomes phallic precisely through her association with what is most intensely and characteristically female. And it is in her capacity as the phallic woman, the woman become man by the force of her sexual desire, that she resembles, "like a sister" (p. 485), the black marble sphinx that crouches at the very center of the great hothouse.

The enigma of the Sphinx is thus not quite as unreadable as Naomi Schor maintains in her article on femininity in Zola. She argues that in "a mythopathology particularly active in the nineteenth century . . . the literarity of woman seems to be linked to her marmorisation, her enigmatisation" (1976:192). But as Freud points out in an essay Schor cites, the decapitated head of Medusa, symbolic of castration, turns the observer to stone, i.e., gives him an erection. The mystery of the sphinx is that she is at once decapitated (in the sense that her head is added on to an animal's body) and marmoreal, at once castrated and phallic. But this phantasmatic doubling of woman's power is, I insist, a secondary formation generated by the initial perception of female lack, of the terrifying wound. Woman does not constitute in herself the undecidability of difference: she produces it as a phantasized effect of the organic lesion that, in the obsessed male imagination, fissures her being. Thus it is no accident that Zola ends his extraordinary description of hothouse incest by evoking, in images that directly foreshadow Huysmans, the voracious mouth of woman as a bleeding red flower that figures her castration: "[Renée's] mouth then opened with the avid and bleeding brilliance of the Chinese Hibiscus. . . . She had become the inflamed daughter of the hothouse. Her kisses bloomed and faded, like the red flowers of the great mallow, which last only a few hours and are ceaselessly revived, like the ravaged and insatiable lips of a giant Messalina" (p. 489).[7]

7. This passage is perceptively analysed by Jean de Palacio in a fascinating article (1977). See also his complementary discussion (1981).

Dramatically visible on the very surface of the Huysmans text, castration causes a fissure in the surface of the real, punctures the skin of representation, erodes its containing membranes, infiltrates and contaminates its tissues. "Specialist of skin diseases," writes Alain Buisine in a suggestive article on the pathological porosity of Huysmans's world, "the describer ["descripteur"] is a dermatologist who can never stop detailing the lamentable state of innumerable membranes of all kinds" (1978:61). Fascinated, compelled, unable to avert his eyes, Huysmans, from his first book to his last, never stops detailing the ontological consequences of the exorbitant female wound as it corrupts, infects, rots, and decomposes the real. His much-touted evolution from naturalism to decadence to satanism to catholicism did not entail any fundamental change in his conception of the physical world, only changes in the perspective from which that world was viewed.

For instance, take this description in *En Rade* of the castle of Lourps where Des Esseintes was born: "In short, the infirmities of a terrible old age, the catarrhal expulsion of the water, the vitriolic blotches of the plaster, the rheum of the windows, the fistulas of the stone, the leprosy of the bricks, a whole hemorrhage of refuse, all had attacked this miserable hovel that, alone and abandoned, was slowly dying in the hidden solitude of the forest" (1976:70–71). The rotting body of the moribund castle bears a remarkable resemblance to that of the saint whose hagiography Huysmans wrote after his conversion, *Sainte Lydwine de Schiedam* (1901). Her entire organism is rotten with purulent ulcers, pustulant tumors, gangrenous nerve-destroying maladies (her arm hangs by one strand): "The forehead split apart from the roots of the hair to the middle of the nose; the chin broke away under the lower lip and the mouth became swollen; the right eye died out; . . . she lost blood through the mouth, the ears, the nose" (1932:81), and, as if this were not enough, "then it was the lungs and liver that decayed" (p. 82) (I pass over additional infections) until finally she gets the bubonic plague. And the miracle is that she lives 38 years in this devastated state! For her afflictions are not natural. They are the signs written in her flesh of her privileged relation to God, crowned ultimately when she receives the stigmata. By mystical substitution, she is continuing Christ's mission of suffering on earth as an expiatory victim. Thus she invites her suffering, actually requesting and receiving from her beneficently sadistic master a third plague-ridden abcess "in honor of the Holy Trinity" (p. 82).

There is, however, a significant difference between Jacques Marles's anxious observation of the ruinous castle "dans un état désorbité d'âme" (1976:71; literally, "in a disorbited state of mind") and Saint Lydwine's delighted perception of her body's progressive ruination: Jacques is overwhelmed by his inability to deal rationally

with a world in decomposition whereas Lydwine is able to read her physical disintegration as a text. Her numerous wounds and dismemberments do more than signify the horrifying reality of castration: they suggest the possibility of a dialogue between the biological world and a transcendent one.[8] Her physical suffering signifies the overcoming of the female organism; her gaping wounds are filled with the Divine Word; her disfiguration, in the very exorbitance of its violence, is contained in and by God's purpose. While the narrative of Lydwine's life connects castration and temporality in the, to Huysmans, satisfying mode of excess,[9] it simultaneously sublimates that narrative out of temporal sequentiality into a transcendent mode of symbolic repetition. Lydwine's reception of the stigmata is not a further emblem of her castration, but a symbol of her being intact as a member of the mystical body of Christ dedicated to the continued repetition of his Passion. It is, furthermore, one of the signs of Saint Lydwine's mystical intactness, of her symbolic equation with Christ, that her decomposing body is miraculously sublimated: "In a constant miracle, [God] made her wounds into cassolettes of perfumes; plasters removed pullulating with vermin gave off delightful scents; her pus smelled good, delicate aromas emanated from her vomit" (p. 88).

Although Freud never presented a coherent theory of sublimation, the focus of his thinking on this issue concerns the displacement of sexual energy onto non-sexual activities, such as artistic creation and intellectual inquiry. In *The Ego and the Id* he associates this displacement with "the main purpose of Eros — that of uniting and binding — in so far as it helps towards establishing the unity, or tendency to unity, which is particularly characteristic of the ego" (1962:35). Melanie Klein (1975) corroborates this holistic view of sublimation: according to her, it involves a tendency to repair and restore the wholeness of the good maternal object that has been shattered by the sadistic destructive instincts. What is peculiar about sublimation in Huysmans is that its goal is the restoration of a purely phantasmatic image of wholeness, that of the phallic mother. This phantasized figure, let it be stressed, is not perceived as a sexually

8. Jean-Luc Steinmetz has made this point before me in his stimulating article "Sang sens" (1978). "The sheer number of ailments that assail Lydwine," writes Steinmetz (p. 86), "finally indicates clearly to her that a frighteningly incarnated language binds her to unity. And this language is in fact a writing applied onto living flesh."

9. In *Les Foules de Lourdes*, published in 1906, two years before his death, Huysmans declares himself so blasé about ordinary cases of mutilated, putrefying human bodies "sans luxe d'horreur particulière" (1934:291; "without the special attraction of any particular horror") that only the most "exorbitant cases" (p. 291) can still give him "the giddiness of excess" (p. 292). Such satisfying horror, literally dis-orbited, is provided by "larval heads like that of this woman whose eye was brandished, resembling that of a slug, at the end of a tentacle" (p. 291).

desiring subject. She is not the sphinx, associated with woman's power to destabilize sexual identities, but rather an image of sexual sameness that functions to erase the traumatic fact of difference and define identity as universally masculine. Huysmans strives to sustain this phantasy even as he recognizes its unnatural artifice, its deceiving sublimation. This duplicitous perverseness, I will argue, makes sublimation in Huysmans less an ego-syntonic process than an ego-splitting one.

But let us begin by identifying some of the manifestations of unifying sublimation in Huysmans's texts. Sublimating artifice is, of course, the function of many of Des Esseintes's experiments. His perfumes, for example, are all, with the single exception of jasmin, artistic *representations* of natural odors fabricated from diverse alcoholates and essences. They are simulacra, without organic content. Moreover, the perfumes, like Lydwine's body, are readable as texts, written in a coded language with various dialects and styles. Des Esseintes learns to understand "the syntax of odors" (1977:224) and to perform "the exegesis of those texts" (p. 226). The great attraction of this exercise is precisely its sublimating function: unity is reconstituted as a rigorously structured code, a system of signs whereby the mechanism of a work may be dismantled and reassembled. This enables the male artist, stand-in for God the Father, to imagine himself at the creative origin, or rather that origin, in Edward Said's terms (Said 1975), is now conceived not in a genealogical perspective but rather as an intentional beginning, a deliberate rupture with the syphilitic organic cycle.

This rupture initiates an artistic mode that is consciously anti-biological, willfully unrealistic, and artfully superficial. The motivating scenario is symbolic re-memberment: the maternal phallus must be returned to its phantasized place. Thematically, in *A Rebours* this involves the creation of simulacra, or artifacts that simulate nature without having nature's organic interiority. The surface without depth, made-up, factitious, this is the ideal field for phantastic re-membering. By means of what Des Esseintes calls "a slight subterfuge, an approximative sophistication of the object" (p. 106), he hopes to obtain what the doctrine of mystical substitution obtains for Saint Lydwine in Huysmans's later book, that is, the sublimation of nature's degenerative violence into symbolic form. The danger, of course, is that this formal representation will be so emptied of living content that it will be entirely sterile, synthetic, inert, like the landscape Des Esseintes glimpses in his dream just before the terrible appearance of the figure of Syphilis: "a hideous mineral landscape . . . a wan, gullied landscape, deserted, dead" (p. 202). The simulacrum, to be effective, must not destroy biological process but must rather exhibit it as that which has been denied, controlled, marked, like Des Esseintes's monstrous flowers,

with the artist's stamp. "Through this cunning strategy," comments Alain Buisine (1978:67–68), "disincarnation proceeds by a spectacular exhibition of the organic, the evacuation of the real involves its display: ostentation in order to protect oneself from what one would have preferred never to have seen."[10]

This, of course, is precisely the strategy of the fetishist, and indeed one could argue that Huysmans's entire literary project is generated according to the formula Octave Mannoni (1969) considers typical of fetishistic behavior: "je sais bien, mais quand même" ("I know perfectly well, but just the same"). Referentially, Huysmans is constantly evoking and vividly illustrating castration — he knows all too well about woman's difference — but still he wants to deny it. The force of this denial perversely contaminates the supposedly desexualized (or unisexualized) sphere of sublimated activity with sexual energy. Sublimation is thus not an escape from repression but a function of it. Indeed Jean Laplanche has persuasively demonstrated that the generative source of sublimation "involves the idea of a sort of repeated, continual neocreation of sexual energy, hence the continual reopening of an excitation. . . . This extemporaneous sexuality," argues Laplanche, "woven into the creation of a work is . . . ultimately linked to the question of traumatism" (1980: 240–250). In my interpretation the traumatism involved in Huysmans's case is his perception of the absence of the mother's penis. Huysmans experiences this trauma, reopens its excitation, by portraying biological life on the model of female castration as a diseased hemorrhaging, an entropic loss of vital energy, but a loss that ostentatiously displays its biodegradable contents.

The morbid brilliance of this display, Des Esseintes maintains, has been effectively represented only at a few times in history when the arts reflected the disintegration of tyranically conventional social orders. In these decadent periods truth emerged from repression, and the exorbitant wound was revealed as the diseased being of the real. Significantly, Des Esseintes chooses images of biological decay to describe a language infected by decadence, the Latin language of the fifth century: "Completely rotten, she sagged, lost her members, spilling out her pus, retaining, in all the corruption of her body, hardly any firm parts" (p. 125). Such a putrefying verbal body, like the physical body of Saint Lydwine, obviously threatens the very possibility of intelligible representation. It takes an artist of the caliber of Baudelaire to express "thanks to a muscular and firmly fleshed-out style . . . those regions of the soul from which monstrous mental vegetations branch out" (pp. 261–262).

10. On the simulacrum, the entropic pathology of organic life, and the crisis of representation in Huysmans, see the excellent articles by Françoise Gaillard (1978a and b).

Baudelaire's style, Huysmans implies, incarnates a male triumph over female monstrosity. It has the power "to fix in curiously healthy terms the most fugitive of morbid states" (p. 262). Huysmans's own style represents, I believe, an effort to perform a similar fixation of temporal morbidity. This project works to attack the referential function of language and to subvert the organic model of narrative development.

The narrative structure of *A Rebours*, like that of *Bouvard et Pécuchet* which it resembles and from which it may derive, is discontinuous.[11] The order of the chapters could easily be changed without appreciably affecting the story. Rather than unfolding the complexities of a novelistic plot, the chapters are juxtaposed as largely self-contained units. In the Preface of 1903, Huysmans writes of his "desire . . . to break the limits of the novel, to bring art, science, history into it" (p. 71). Each chapter, he declares in a suggestive formula, is "the sublimate of a different art" (p. 60). These "sublimates" act as experimental vehicles to stimulate phantasies and thereby displace present reality. The phantasies, which may evoke past experiences, in life or in the library, as well as imaginary possibilities, constitute the signified of much of the narrative. They have no logical or natural place in a temporal continuum. But however heterogeneous their referential contents may be, these carefully cultivated phantasies all have the same function of denying the real. Structural discontinuity in the Huysmanian novel is in the service of unifying sublimation. For Huysmans, denial is vital — and denial always bears specifically upon the traumatic perception of female castration. Thus it is no accident that in his Preface Huysmans declares that his formal project to "abolish the traditional plot" requires the suppression of "passion, woman" (p. 71). But we have seen that this repressive sublimation of the trauma of woman actually serves to maintain that trauma as a continual source of sexual excitation stimulating the writing process. "In fetishists," writes Freud, "the detachment of the ego from the reality of the external world has never succeeded completely (1969:60)." "In very subtle cases the fetish itself has become the vehicle both of denying and of asseverating the fact of castration" (1963:218).

Huysmans's writing is a function of this dilemma, associated by Freud with the splitting of the ego. Huysmans uses techniques of rupture and discontinuity to re-member the surface of the text as "a token of triumph over the threat of castration and a safeguard against it" (Freud 1963:216). He inserts great masses of dense erudite material, sometimes taken verbatim from unidentified sources. He cites literary texts at length and analyses their merits.

11. This connection is brought out in detail by Jean-Luc Steinmetz (1975).

He makes lists of exotic proper names, of plants, of stones, of authors. He loves rare, difficult words and a deliberately tortured syntax. The effect of all this is to create a textual surface that, like the tortoise's shell Des Esseintes orders encrusted with precious stones, is studded with elements alien to biological life. The text's linear development and its referential function are constantly being interrupted as the reader encounters verbal entities, large or small, that impose their presence on his attention because of their rarity as objects, their material density, their provocative strangeness. Thus Huysmans's text can accurately be called ornamental, and the connection brilliantly established by Naomi Schor (1983) in regard to one of Des Esseintes's favorite novels, *Salammbô*, between textual ornamentation and fetishism applies perfectly here. As Schor reminds us, the ornamental should not be conflated with the secondary or accessory. Art history teaches that the original function of ornament was of a magical and metaphysical order. And this is precisely its function for Huysmans. The encrusted verbal surface serves, in Des Esseintes's formula, to "supplement the vulgar reality of facts" (p. 105). The supplement magically denaturalizes and sublimates. The female wound is repaired in phantasy by a textuality that finds its source not in nature but in the dictionary, the catalogue, the archive, the library. Textuality becomes intertextuality . . . and we begin to realize that the example of Huysmans, if it could be shown — as I believe possible — to have a certain general applicability, would suggest that the modernist movement in the arts (beginning in France with Flaubert, Baudelaire, and Manet), with its emphasis on the discontinuous, the self-reflective, the opaque, was involved in a sublimating, fetishizing effort to deny the female sexual body. This defensive effort, however, was doomed by the very terms of its expression. As long as (female) nature remains at the origin, the supplement can never take the place of that which it augments. Huysmans's dazzling verbal gems are encrusted upon a biological ground subject to the organic death process. "Mais quand même, je sais bien." It was not until he discovered the Supreme Dictionary, the Divine Word, that decomposition composed itself, and Huysmans was finally able to sublimate the temporal world into a textual Other.

REFERENCES

Borie, Jean, 1971. *Zola et les mythes: Ou de la nausée au salut* (Paris: Seuil).
 1973 *Le Tyran timide* (Paris: Klincksieck).
Buisine, Alain, 1978. "Le taxidermiste," *Revue des sciences humaines* 43, No. 170–171 (April–September), 59–68.
Carmignani-Dupont, Françoise, 1981. "Fonction romanesque du récit de rêve: l'exemple d'*A Rebours*," *Littérature* 43 (October), 57–74.
Collomb, Michel, 1978. "Le Cauchemar de Des Esseintes," *Romantisme* 19, 79–89.

Decottignies, Jean, 1978. "*Là-Bas* ou la phase démoniaque de l'écriture," *Revue des sciences humaines* 43, No. 170–171 (April–September), 69–79.

Freud, Sigmund, 1962. *The Ego and the Id* (New York: Norton).

1963a "Medusa's Head" in: *Sexuality and the Psychology of Love* (New York: Collier), 212–213.

1963b "Fetishism" in: *Sexuality and the Psychology of Love* (New York: Collier), 214–219.

1969 *An Outline of Psycho-Analysis* (New York: Norton).

Gaillard, Françoise, 1978a. "En rade ou le roman des énergies bloquées" in *Le naturalisme*: Colloque de Cérisy (Paris: 10/18), 263–277.

1978b "A Rebours: Une écriture de la crise," *Revue des sciences humaines* 43, No. 170–171 (April–September), 111–122.

Gasché, Rodolphe, 1983. "The Stelliferous Fold: On Villiers de l'Isle-Adam's *L'Eve Future*," *Studies in Romanticism* 22 (Summer), 293–327.

Huysmans, J.-K., 1908 (1891). *Là-Bas* (Paris: Plon).

1932 (1901) *Sainte Lydwine de Schiedam*, vol. 1 (Paris: Editions Crès).

1976 (1887) *En Rade* (Paris: 10/18).

1977 (1884) *A Rebours* (Paris: Folio).

Jennings, Chantal, 1972, 1973. "Zola féministe?" *Les Cahiers naturalistes* 44, 172–187, and 45, 1–22.

1977 *L'Éros et la femme chez Zola: De la chute au paradis retrouvé* (Paris: Klincksieck).

Klein, Melanie, 1975. "Infantile Anxiety-Situations Reflected in a Work of Art and in the Creative Impulse" in: *Love, Guilt, and Reparation and Other Works 1921–1945* (New York: Delta), 210–218.

Laplanche, Jean, 1980. *Problématiques III: La Sublimation* (Paris: Presses Universitaires de France).

Mannoni, Octave, 1969. "Je sais bien, mais quand même" in: *Clefs pour l'imaginaire ou l'autre scène* (Paris: Seuil), 9–33.

Palacio, Jean de, 1977. "La féminité dévourante: Sur quelques images de la manducation dans la littérature décadente," *Revue des sciences humaines* 42, No. 168 (October–December), 601–618.

1981 "Messaline décadente, ou la figure du sang," *Romantisme* 31, 209–228.

Said, Edward, 1975. *Beginnings: Intention and Method* (New York: Basic Books).

Schor, Naomi, 1975. "Mother's Day: Zola's Women," *Diacritics* 5 (Winter), 11–17.

1976 "Le sourire du sphinx: Zola et l'enigme de la féminité," *Romantisme* 13–14, No. 183–195. English translation in Schor (1985).

1983 "Salammbô enchaînée, ou femme et ville dans *Salammbô*" in: *Flaubert, la femme, la ville: Journée d'études organisée par l'Université de Paris V*, ed. Marie-Claire Bancquart (Paris: PUF), 89–104. English translation in Schor (1985).

1985 *Breaking the Chain: Women, Theory, and French Realist Fiction* (New York: Columbia University Press).

Serres, Michel, 1975. *Feux et signaux de brume: Zola* (Paris: Grasset).

Steinmetz, Jean-Luc, 1975. "Des Esseintes en procès" in: *Mélanges Pierre Lambert consacrés à Huysmans* (Paris: Nizet), 77–98.

1978 "Sang sens," *Revue des sciences humaines* 43, No. 170–171 (April–September), 80–90.

Zola, Emile, 1960. *La Curée* in *Les Rougon-Macquart*, Vol. I, ed. Henri Mitterand (Paris: Bibliothèque de la Pléiade).

1961 *Nana* in *Les Rougon-Macquart*, Vol. II, ed. Henri Mitterand (Paris: Bibliothèque de la Pléiade).

NOTES ON CONTRIBUTORS

CAROL M. ARMSTRONG, Assistant Professor in the Department of History of Art at the University of California, Berkeley, received her Ph.D. in art and archaeology at Princeton University. Her essay on Degas is an extension of her dissertation on Degas and his critics, and derives in large part from a graduate seminar which she gave at Berkeley on Degas and the tradition of the female nude.

MIEKE BAL is Professor of Literary Theory and French Literature at the University of Utrecht. She is the author of *Narratology* and of numerous articles on narrative theory. She is currently completing a book on the theory of the subject, focusing on women in the Old Testament.

ELLEN L. BASSUK is a psychiatrist and Associate Professor of Psychiatry at the Harvard Medical School. She is working on a study of the mentally ill homeless population in Boston.

JANET BERGSTROM is Assistant Professor in the Film/Television Studies Program at UCLA. She is co-editor of *Camera Obscura: A Journal of Feminism and Film Theory*, and has published widely on avant-garde cinema and feminist film theory. She is currently working on a study of conventions in the films of Murnau, Lang, and Lubitsch.

CHARLES BERNHEIMER is Associate Professor of English and Comparative Literature at the State University of New York at Buffalo. He is the author of *Flaubert and Kafka*, and is currently completing a book on the prostitute in 19th-century French cultural discourse.

ALICIA BORINSKY is Associate Professor of Modern Foreign Languages and Literatures at Boston University. She has published poetry, as well as criticism on Borges, Cortázar and other Latin American writers. She is currently completing a book on figures of reading.

CHRISTINE BROOKE-ROSE is a novelist and Professor of Anglo-American Studies at the University of Paris VIII. Her latest novel is *Amalgamemnon*. Among her theoretical works are *A Grammar of Metaphor* and *A Rhetoric of the Unreal: Studies in Narrative and Structure, Especially of the Fantastic*.

EVA CANTARELLA teaches classical jurisprudence at the University of Parma. She is the author of *L'ambiguo malanno: Condizione e immagine della donna nell'antichità greca e romana*, and is currently working on a study of capital punishment in antiquity.

MONIQUE CANTO teaches philosophy at the University of Amiens. She has published essays on Plato and the Sophists. Her current research is on the problem of the dramatization of thought.

NOELLE CASKEY teaches composition at the University of Berkeley, where she is completing an individual Ph.D. program in literature, psychology and linguistics. Her poetry has appeared in anthologies in Italy and the United States.

MARY ANN CAWS is Distinguished Professor of French and Comparative Literature at Hunter College and at the Graduate School of the City University of New York, and Executive Officer of the French Ph.D. Program. Her books include *The Poetry of Dada and Surrealism*, *The Inner Theatre of Recent French Poetry*, *The Eye in the Text: Essays in Perception, Mannerist to Modern*, *The Metapoetics of the Passage: Architextures in Surrealism and After*, and *Reading Frames in Modern Fiction*. She is past president of the Modern Language Association, editor of *Le Siècle éclaté: dada, surréalisme, et les avants-gardes* (Paris), and coeditor of *Dada/Surrealism*.

MARY ANN DOANE teaches film and theory in the Semiotics Program at Brown University. She has published articles in *Yale French Studies*, *October* and *Screen*, and is working on a book on the women's film of the 1940s.

MARGARET HIGONNET is Professor of English at the University of Connecticut. She has co-edited *The Representation of Women in Fiction*, and published on Jean-Paul Richter, Schlegel and Mme de Staël. She is currently co-authoring a book on the 18th-century debate on suicide.

NANCY HUSTON is an English-Canadian who lives in Paris and writes in French. An active feminist and a mediocre but impassioned harpsichordist, she is the author of *Jouer au papa et à l'amant*, *Dire et interdire: éléments de jurologie*, *Les Variations Goldberg*, *Mosaïque de la pornographie*, and *Histoire d'Omaya*.

ALICE JARDINE is Associate Professor of Romance Languages and Literatures at Harvard University. She is the author of *Gynesis: Configurations of Woman and Modernity*, co-editor of *The Future of Difference*, and has published many essays on contemporary French thought.

JULIA KRISTEVA is a psychoanalyst and Professor of Linguistics at the University of Paris VII. Her books include *Séméiotiké: recherches pour une sémanalyse*, *Polylogue*, *Des Chinoises*, *Pouvoirs de l'horreur: essai sur l'abjection*, and *Histoires d'amour*.

MARGARET R. MILES is Professor of Historical Theology at Harvard Divinity School. Her books include *Augustine on the Body* and, most recently, *Image as Insight: Visual Understanding in Western Christianity*, which explores the use of visual images as historical evidence. She is presently working on a book on the meanings of nudity in the Christian West.

NANCY K. MILLER is Professor of Women's Studies and Director of the Women's Studies Program at Barnard College. She is the author of *The Heroine's Text: Readings in the French and English Novel, 1722—1782*, and editor of *Poetics of Gender*. She is currently working on a book of essays on French women's writing.

THOMAS G. PAVEL is Professor of Literary Studies at the University of Québec in Montréal. He has published a critical study on Corneille and essays on literary semiotics, as well as a novel, *Le Miroir Persan*. His latest book is *The Poetics of Plot: The Case of English Renaissance Drama*.

NAOMI SCHOR is Professor of French Studies at Brown University. She is the author of *Zola's Crowds* and of *Breaking the Chain: Women, Theory, and French Realist Fiction*, and co-editor of *Flaubert and Postmodernism*. She recently completed a very short book on the detail.

CATHARINE R. STIMPSON is Professor of English and Director of the Institute for Research on Women at Rutgers University, and was the founding editor of *Signs: Journal of Women in Culture and Society.* She is the author of critical works on contemporary education, culture and literature, and of a novel, *Class Notes.*

SUSAN RUBIN SULEIMAN is Professor of Romance and Comparative Literatures at Harvard University. She is the author of *Authoritarian Fictions: The Ideological Novel as a Literary Genre,* and co-editor of *The Reader in the Text: Essays on Audience and Interpretation.* She is currently working on a study of French avant-garde writing from the Surrealists to the "new French feminists."

NANCY J. VICKERS is Associate Professor of French and Italian at Dartmouth College. She has published essays on Dante and Petrarch, and co-edited a special issue of *Poetics Today* on Medieval and Renaissance representation. She recently completed a book, *The Anatomy of Beauty,* on the *blasons anatomiques* and school of Fontainebleau painting.

ILLUSTRATION CREDITS